KONGO ACROSS THE WATERS

UNIVERSITY PRESS OF FLORIDA

Florida A&M University, Tallahassee
Florida Atlantic University, Boca Raton
Florida Gulf Coast University, Ft. Myers
Florida International University, Miami
Florida State University, Tallahassee
New College of Florida, Sarasota
University of Central Florida, Orlando
University of Florida, Gainesville
University of North Florida, Jacksonville
University of South Florida, Tampa
University of West Florida, Pensacola

University Press of Florida

Gainesville · Tallahassee · Tampa · Boca Raton

Pensacola · Orlando · Miami · Jacksonville · Ft. Myers · Sarasota

Kongo across the Waters

Edited by Susan Cooksey, Robin Poynor, and Hein Vanhee

with editorial assistance by Carlee S. Forbes

TERVUREN

Published in collaboration with the Royal Museum for Central Africa, Tervuren, Belgium.

18 17 16 15 14 13 6 5 4 3 2 1

LIBRARY OF CONGRESS CATALOGING-IN-PUBLICATION DATA
Kongo across the waters / edited by Susan Cooksey, Robin Poynor, and Hein Vanhee ; with editorial assistance by Carlee S. Forbes.
pages cm
Includes bibliographical references and index.
ISBN 978-0-8130-4915-1 (cloth : alk. paper) — ISBN 978-0-8130-4945-8 (pbk. : alk. paper)
 1. Art—America—African influences. 2. Art, Kongo—Influence. 3. Performing arts—African influences. 4. Kongo (African people)—Influence. 5. African American art—African influences. 6. African diaspora in art. I. Cooksey, Susan, editor. II. Poynor, Robin, 1942–, editor. III. Vanhee, Hein, editor. IV. Forbes, Carlee S.
N7399.C6K66 2013
709.6751'0973—dc23 2013029226

The University Press of Florida is the scholarly publishing agency for the State University System of Florida, comprising Florida A&M University, Florida Atlantic University, Florida Gulf Coast University, Florida International University, Florida State University, New College of Florida, University of Central Florida, University of Florida, University of North Florida, University of South Florida, and University of West Florida.

University Press of Florida
15 Northwest 15th Street
Gainesville, FL 32611-2079
http://www.upf.com

Kongo across the Waters has been made possible by generous contributions from the following donors.

AEC Trust
Dr. Madelyn Lockhart
University of Florida Office of the Provost
University of Florida Foundation
University of Florida Office of Research
University of Florida International Center
University of Florida Center for African Studies
Art History Program, School of Art and Art History, College of Fine Arts,
 University of Florida
Christie's
C. Frederick and Aase B. Thompson Foundation
Hyatt and Cici Brown
William and Hazel Hough
Robert and Janet Kemerait
Nella Taylor
Drs. Israel and Michaela Samuelly
Robert Haiman
Mary Kilgour

Anonymous Donors
John Early Publications Endowment, Samuel P. Harn Museum of Art,
 University of Florida
Harn Program Endowment, Samuel P. Harn Museum of Art,
 University of Florida
Londono Family Endowment, Samuel P. Harn Museum of Art,
 University of Florida
Myra Englehardt and Lawrence E. Malvern Endowment, Samuel P. Harn
 Museum of Art, University of Florida

This exhibition is supported by an indemnity from the Federal Council on
 the Arts and the Humanities.

This book was published in conjunction with the exhibition *Kongo across the Waters* organized by the Samuel P. Harn Museum of Art, University of Florida, Gainesville, Florida, and the Royal Museum for Central Africa, Tervuren, Belgium.

Samuel P. Harn Museum of Art
University of Florida
Gainesville, Florida
October 22, 2013–March 23, 2014

Jimmy Carter Presidential Library and Museum
 In partnership with the Ivan Allen College of Liberal Arts,
 Georgia Institute of Technology
Atlanta, Georgia
May 17, 2014–September 21, 2014

Princeton University Art Museum
Princeton University
Princeton, New Jersey
October 25, 2014–January 25, 2015

New Orleans Museum of Art
New Orleans, Louisiana
February 27, 2015–May 25, 2015

Contents

Message from the President
of the University of Florida

It is my pleasure to welcome you to *Kongo across the Waters*, a collaborative exhibition and publication by the Samuel P. Harn Museum of Art at the University of Florida and the Royal Museum for Central Africa in Tervuren, Belgium.

This is a pathbreaking project on many levels. It is the Harn's first joint exhibition with an international partner—in this case, one of the most renowned museums of African art in the world. It features 162 singular works, including masterpieces from the Royal Museum for Central Africa that have rarely, if ever, traveled to other museums. And it traces the historical arc of a large region of Central Africa and its influence on the West, beginning with the rich Kongo kingdom first encountered by Europeans in the 1400s and extending through slavery and early African American art to contemporary art on both sides of the Atlantic.

Kongo across the Waters also continues progress toward a vision of higher education as a fundamentally international endeavor—one in which art plays a growing role.

The numbers tell one chapter in this story. At the national level, there are 31 percent more international students studying at U.S. colleges and universities than there were a decade ago, according to the Institute of International Education.

We see similar rapid growth at UF. With 6,000 students from nearly 140 countries, UF ranks sixteenth among all universities in our numbers of international students. More than 2,000 U.S. students at UF study abroad, contributing to a record number of U.S. students spending part of college elsewhere in the world.

As students become more international, so do university programs. At UF, we continue to develop the Beijing Center for International Studies in China; the International Education Center in Hyderabad, India; and the UF Center for Chile. Meanwhile, the focus of our ten-year Southern Association of Colleges and Schools accreditation effort is on internationalizing the university.

From the Harn's new David A. Cofrin Asian Art Wing to installations by internationally noted artists such as Konstantin Dimopoulos's "Blue Trees," arts and culture on our campus reflect this global focus. *Kongo across the Waters* demonstrates the richness of the arts' contribution. As we commemorate the 500th anniversary of

Ponce de León's 1513 discovery of Florida, these artworks reveal how much of America's early history was shaped by our interaction with Central Africa and its people.

Following the grand opening of *Kongo across the Waters* at the Harn, the exhibition will move on to the Carter Presidential Library and Museum in Atlanta, the Princeton University Art Museum and the New Orleans Museum of Art. Wherever you experience the exhibition, and as you read this impressive publication, I know you will gain great appreciation for the art, history and continuing global influence of Central Africa.

J. Bernard Machen

Message from the Director
of the Samuel P. Harn Museum of Art

Since the University of Florida's Samuel P. Harn Museum of Art first opened its doors to the public in 1990, African art has been at the heart of the museum's collections, exhibitions, research and educational programming. Many groundbreaking exhibitions and publications over the past twenty-three years have introduced museum visitors to the wonders of the arts of Africa while contributing to scholarship in the field and putting the University of Florida and the Harn Museum on the map nationally and internationally as a center for the study of African art.

For the first time with *Kongo across the Waters* the Harn Museum of Art has partnered with a European museum to jointly organize a touring exhibition and produce the accompanying publication. I am indebted to my colleague David Sammons, Dean of the University of Florida International Center, for first introducing us in 2011 to Guido Gryseels, Director of the Royal Museum for Central Africa (RMCA). During his visit to the University of Florida campus, we initiated the partnership that led to the present exhibition. Within a few weeks of those first conversations, Curator of African Art Susan Cooksey, Professor Robin Poynor and I journeyed to Tervuren, Belgium, to begin working with Dr. Gryseels, Curator Hein Vanhee and other curators and scientists at the RMCA on plans for the exhibition. We are deeply grateful to all of our colleagues and friends in Tervuren for joining forces with us on this exciting project and for their innumerable contributions to its success.

The three co-curators of *Kongo across the Waters*, Susan Cooksey, Robin Poynor and Hein Vanhee, have sustained a phenomenal pace in bringing the project to fruition in only two and a half years. They were motivated by the goal of opening the exhibition in 2013, the year of the statewide Viva Florida 500 commemoration of the 500th anniversary of the arrival of the Spanish in Florida. As part of this observance, *Kongo across the Waters* commemorates the arrival with Juan Ponce de León of a conquistador named Juan Garrido, the first African documented to step foot on American soil. The exhibition examines 500 years of cultural exchange between the Kongo region of West Central Africa and the southeastern United States through the presentation and explication of some 162 works of art created by artists on both sides of the Atlantic over those centuries.

Joining the co-curators in planning the exhibition and writing the accompanying publication were a distinguished group of consulting scholars from a range of academic disciplines, each of whom is acknowledged and thanked by the curators elsewhere in this volume. I, too, am sincerely grateful to these colleagues for contributing so much to the success of the project. Similarly, many people at the Harn Museum of Art and the Royal Museum for Central Africa have given generously and tirelessly of their expertise and talents to make the exhibition and publication possible, and each is deserving of sincere thanks and appreciation. In addition to the masterpieces of Kongo art on loan from the RMCA, many other museums, institutions and individuals have made treasures from their collections available, for which we are very grateful.

Support for the exhibition has been provided by many generous institutional and individual donors, with lead gifts from the AEC Trust, the University of Florida Office of the Provost, the University of Florida Foundation, the C. Frederick and Aase B. Thompson Foundation, Hyatt and Cici Brown, William and Hazel Hough and anonymous donors. We are grateful to have received support in the form of an indemnity from the Federal Council on the Arts and the Humanities, and a sponsorship from Christie's. We are grateful to Dr. Madelyn Lockhart for generously underwriting much of the cost of this publication, continuing her long-standing support for research and scholarship at the Harn Museum. We are also very grateful for the support of the University of Florida's International Center; Office of Research; Art History Program in the School of Art and Art History/College of Fine Arts; and Center for African Studies. Additional support has been provided by the Harn Museum of Art's John Early Publications Endowment, Harn Program Endowment, Londono Family Endowment, and Myra Englehardt and Lawrence E. Malvern Endowment.

Sincere thanks go out to our colleagues at the three museums who will host the show after it closes at the Harn Museum of Art—the Jimmy Carter Presidential Library and Museum in partnership with the Ivan Allen College of Liberal Arts at the Georgia Institute of Technology, the Princeton University Art Museum and the New Orleans Museum of Art. We are grateful that they are partnering with the Harn and the RMCA to bring *Kongo across the Waters* to a wider audience.

Rebecca Martin Nagy

Message from the Director General,
Royal Museum for Central Africa, Tervuren, Belgium

Kongo across the Waters is a great opportunity for the Royal Museum for Central Africa to share its expertise on Africa and to showcase some of its magnificent collections. The innovative and original approach of the project, with its double focus on Kongo culture in Africa and its creole forms in the United States, also encourages and enables the RMCA to broaden its own research horizons and to reach out to new audiences.

The Royal Museum for Central Africa is the privileged custodian of a unique documentation on the rich cultural and natural resources of Central Africa. Since the late nineteenth century, thousands of objects, photographs, recordings, reports and personal documents have been deposited in its storage rooms. Every registered item is the result of a unique exchange between, most often, a European temporary resident in Africa and one or more African individuals. Some of these exchanges are well documented while others remain mute. Some happened quickly while others were extended, facilitated by relations of friendship and confidence. Some exchanges were brutal and determined by the inequalities of colonialism. Research paradigms and collecting strategies changed over time and are now guided by international standards and ethical considerations.

The complex institutional history of the Royal Museum for Central Africa has motivated the management and staff to develop a strong vision on research and the dissemination of knowledge in the present age. Proper custodianship now means transparence, openness and international cooperation. This is realized through a range of projects with partners in Africa and across the globe, wherein dialogue and mutual learning are not just corollaries, but key objectives. Research at RMCA needs to be relevant, and its collections should be made easily accessible to both accustomed and new visitors.

Kongo across the Waters allows the Royal Museum for Central Africa to further pursue its mission and to be part of a growing new field of inquiry. Specific African cultural knowledge was carried across the Atlantic and left its imprint on many objects, songs and tales in the United States and elsewhere. It is fascinating and challenging to compare African American art and artifacts with collections at the RMCA

and discover that they partly bear the same cultural DNA. Some of the particulars of this history are confronting and disturbing, yet to remain silent is not an option. The impact of African cultures outside the African continent deserves a place high on the research agenda, so that we may come to a better and more complete understanding of how much Africa was, and still is, part of both Europe and the Americas.

I wish to express my sincere gratitude to all of our colleagues and friends at the Samuel P. Harn Museum of Art and at the University of Florida, for having embarked with us on this delightful journey of discovery and learning. *Kongo across the Waters* is another milestone in a rich history of scientific and cultural collaboration between Belgium and the United States!

Guido Gryseels

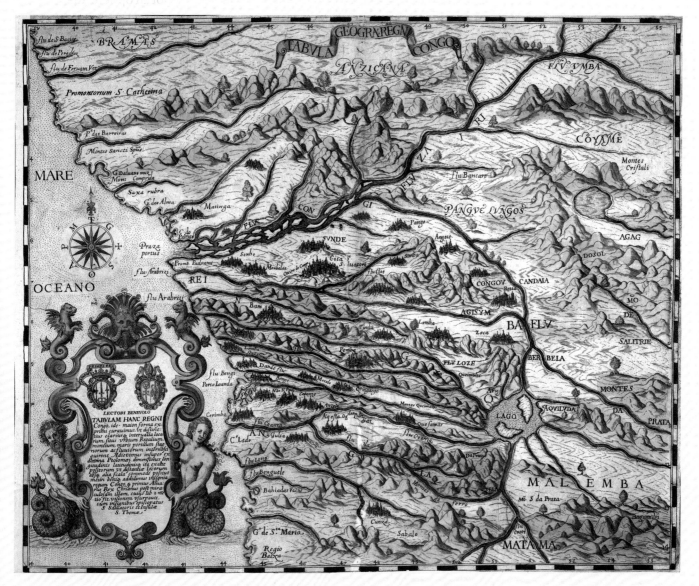

Cat. 0.1. Tabula Geogra Regni Congo, map of the Kongo kingdom published by Filippo Pigafetta (Italian, 1533–1604). Engraved by Johann Theodor de Bry. 1598. Ink on paper. Map size 11.9 × 14.6 in. (30.3 × 37.2 cm). Paper size 12.3 × 15.1 in. (31.3 × 38.6 cm). Map and Imagery Library, George A. Smathers Libraries, University of Florida.

This beautifully illustrated map mostly reflects sixteenth-century European imagination about the Kongo kingdom, with imaginary rivers and lakes and fortified medieval style towns scattered over its territory. The largest of these is the kingdom's capital, São Salvador. The map's legend features the coat of arms of King Alvaro I of Kongo (r. 1568–87).

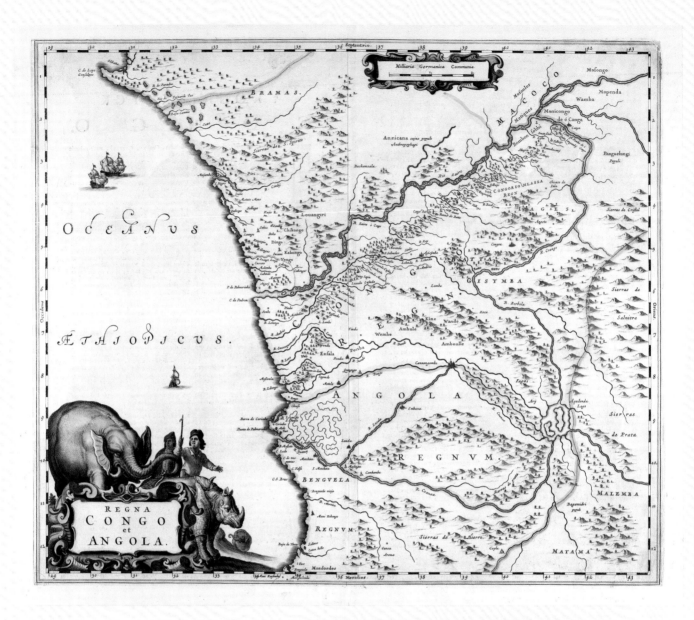

Cat. 0.2. Regna Congo et Angola, map of Kongo and Angola published by Joan Blaeu (Dutch, 1596–1673). 1662. Ink on paper. Map size 17.8 × 20.9 in. (45.2 × 53.2 cm). Paper size 20.9 × 24.3 in. (53.2 × 61.8 cm). Map and Imagery Library, George A. Smathers Libraries, University of Florida.

The map shows the itinerary of the Dutch traveler Jan van Herder, who traveled from Luanda via São Salvador to the Kwango River in 1642. Some of his observations are noted on the map in Middle Dutch, among which several mentions of a *Tolhuÿs* (toll house), indicating places where passing trade caravans had to pay tribute.

Kongo across the Waters

Introduction

SUSAN COOKSEY, ROBIN POYNOR AND HEIN VANHEE

This book and the traveling exhibition it accompanies are meant to mark a milestone in the history of African presence in North America. They are the fruit of a particular challenge taken on by a number of scholars in 2011 to provide an important complement to the Viva Florida 500 program to commemorate 500 years of European presence in 2013. When the Spanish conquistador Juan Ponce de León set foot on *La Florida* in April 1513, his crew comprised two free Africans who had adopted the Spanish names of Juan Garrido and Juan Gonzalez Ponce de León.[1] This means that with the first Europeans came also the first Africans to the North American continent.

Little is known about the biographies of Juan Ponce de León's two African crew members. As far as we know, their precise African origins were not recorded, nor do we know how and when they arrived on the Iberian peninsula and enlisted in the crew of a Spanish voyage of exploration. We do know that Portuguese sailors had systematically explored the Atlantic coasts of Africa in the previous century and established contact with various African peoples. Among these were the Bakongo, who lived south of the equator in the region that stretched out both north and south of the lower reaches of the Congo River. Prior to their first encounter with Portuguese sailors in 1483, the Bakongo had constituted a vast kingdom mostly south of the Congo. This kingdom, called Kongo, much impressed the Portuguese for its political organization and for the high development of particular forms of art. Subsequent voyages brought to Europe fine gifts from the Kongo king and the nobility, among which were trumpets made of elephant ivory and delicately woven cloth made of raffia fiber.[2] In 1491 the Kongo king Nzinga a Nkuwu converted to Roman Catholicism and was baptized as João I. He was succeeded in 1509 by Afonso I, who spread the new religion over most of the kingdom. Thousands of Kongolese received baptism and religious instruction from European missionaries sent to Kongo.[3]

In the decades preceding Ponce de León's arrival on Florida's shore, the Iberian peninsula had welcomed several emissaries from the newly discovered African lands, among whom were students from the Kongo kingdom. Some would have had

Fig. 0.1. Photograph of an old
wooden cross possibly dating
back to the 18th century,
Mbata, Lower Congo, DRC, by
Verschaffel, 1913. RMCA Pho-
tographic Archives, Tervuren,
Belgium, AP.0.0.27094. By
permission of RMCA.

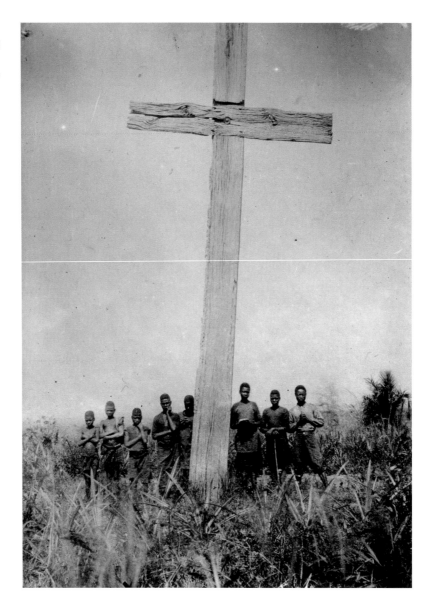

preliminary instruction in Kongo, and their interest in literacy and religious matters would no doubt have favored their integration in European circles. Were the Africans arriving with the Spanish in Florida in 1513 of Kongo origin? We know of Juan Garrido that he arrived in Lisbon in the 1490s, where he received baptism. From there he moved to Seville and eventually crossed the Atlantic.[4] This means that a Kongo origin is not impossible, but the truth is that we do not know.

More important than the specific African origin of the free black conquistadors is the simultaneous arrival of the first Europeans and the first Africans in North America, the historical and symbolic importance of which cannot be overstated. Both European and African immigrants, crossing the Atlantic in various "waves" in the following centuries, shaped together with native American populations the history and culture of the United States. Many of these migrations were forced and brutal. The first enslaved Africans reached North America via the Caribbean in the course of the sixteenth century.[5] A bit more than a century after the arrival of Ponce de León, the

transatlantic slave trade brought the first direct imports of Africans to British North America. An estimated 388,000 of them followed, to work predominantly on the plantations of the Carolinas and Georgia (54 percent) and in the Chesapeake region (33 percent). Smaller numbers were brought to estates farther north along the East Coast and to the emerging Gulf states in the South.[6] Enslaved Africans brought with them little more than their memories, shaped by the many diverse cultures in which they had grown up. The new cultures that developed in America were marked by the common experience of slavery and by the varied cultural backgrounds of enslaved individuals.

Since the beginning of the twentieth century, historians and anthropologists have studied African American cultures from a variety of angles. They have emphasized the unique contributions of African American communities to the development of contemporary American culture and also pointed at specific cultural manifestations whose origins can be traced to specific regions in Africa. The past twenty years have seen a welcome increase in African Diaspora studies, informed by new theory and by an important advance in the historiography of the slave trade. With the publication of this book and the organization of a traveling exhibition, *Kongo across the Waters* wishes to bring some of this new scholarship to the attention of a wider audience.

While many different African cultures have left their imprint on American culture, this project's focus is on the historical and cultural connections between the United States and Kongo. Not to be confused with the two modern states named Congo (Democratic Republic of the Congo, or Congo-Kinshasa, and Republic of the Congo, or Congo-Brazzaville), by Kongo we mean a region in West Central Africa inhabited by peoples speaking Kikongo. Kongo had the single largest contribution

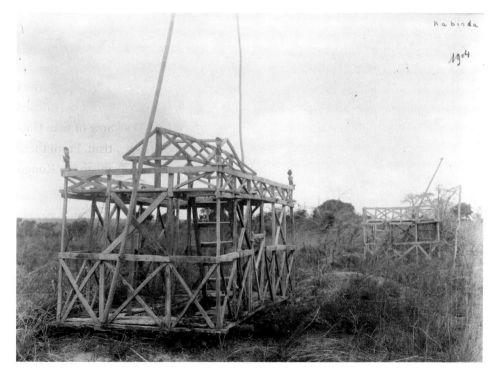

Fig. 0.2. Photograph of old tombs in the coastal region of Cabinda, Angola, 1904. CICM Archives, KADOC, Leuven, Belgium. By permission of CICM.

to the transatlantic slave trade to North America. About one fourth of the enslaved Africans arriving on (future) United States territory originated from Kongo or at least were familiar with Kongo culture. Twentieth-century scholarship long underestimated the Central African cultural contributions to African Diaspora cultures.[7] Research in the past two decades has provided an important corrective to this situation.

The first aim of this project is to familiarize readers and visitors with Kongo history and culture, going back to the first encounters between Kongo and Europe, and tracing cultural developments from the sixteenth to the twentieth century. Since many Kongolese were during this period carried as slaves to North America, our second aim is to explore how they have contributed to the process of culture formation in communities consisting of enslaved Africans and/or descendants of enslaved Africans. This we do by looking at African American folk arts from the nineteenth and twentieth centuries, which may be linked historically with West Central Africa. Importantly, these are more than just "cultural survivals." The process of African American culture formation was characterized by a creative blending of different African traditions, determined by the changing demographics of the slave trade as well as by national policies. The term *creolization*—borrowed from linguistics—best describes this process: particular beliefs, techniques or objects may—like words—be traceable to a specific region in Africa, like Kongo, but they are fundamentally embedded in new cultures that have multiple origins. Our third aim is to explore how Kongo art and visual culture continues to transform and inspire today, and this we do by looking at a number of contemporary artists working in Africa and in the United States.

Scholars researching the African Diaspora have stressed the importance of understanding the historical cultures of the African homelands, and Kongo has a lot to offer in this respect. It is beyond the scope of this introduction to provide a complete overview of the relevant scholarship on Kongo and on the African Diaspora in the United States, but some general remarks can be made. Presenting a fairly unique case in African history, the earliest literature on Kongo goes back to the end of the fifteenth century, when chroniclers wrote down the accounts of Portuguese sailors returning from the Kongo kingdom.[8] The sixteenth and seventeenth centuries left extensive descriptions of the political, social and religious organization of Kongo.[9] The many accounts left by Jesuit and Capuchin missionaries and the descriptions published by Lopes and Pigafetta (1591), Dapper (1668) and others were first mined in the twentieth century by the missionary historian Jean Cuvelier, who published a monograph on the history of the Kongo kingdom in 1941.[10] Although a major achievement for its time, the book reflected Cuvelier's missionary agenda and lacked the theoretical and methodological foundations of the discipline of African history as it took off in the 1960s.

A new generation of historians was greatly inspired by the kingdom of Kongo and its surrounding regions and published a series of critical revisions. About the kingdom itself, the more influential have been Anne Hilton, Susan Herlin Broadhead and mostly John Thornton.[11] Historians writing on the precolonial history of the wider region of West Central Africa have included José C. Curto, Roquinaldo Ferreira,

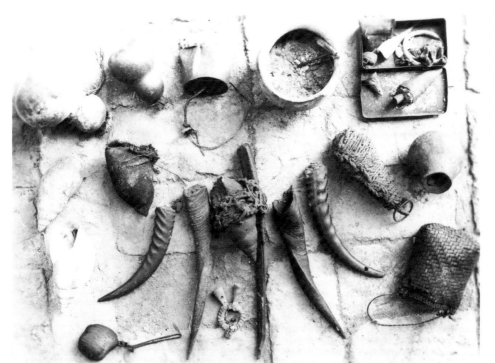

Fig. 0.3. Photograph of non-figurative *minkisi*, including a ceramic pot, basketry, small gourds, antelope horns and a spiral shell, early 20th century. CICM Archives, KADOC, Leuven, Belgium. By permission of CICM.

Beatrix Heintze, Linda Heywood, Phyllis Martin, Joseph C. Miller, John Thornton, Jan Vansina, Jean-Luc Vellut and Jelmer Vos.[12] Several among them developed a particular focus on the political and social dynamics of the slave trade and broadened their research to include specific regions in the Americas where many West Central Africans were taken by force. Thornton and Heywood, in particular, have exemplified the Atlantic approach to African history, looking beyond the demographics of the trade in order to include in their analyses cultural carryovers and transformations.[13]

Given the extensive missionary activity deployed in the region at the end of the nineteenth century and the geographical proximity of important colonial centers, the colonial ethnography dealing with the Bakongo is abundant, both in published form and in the archives. The Belgian Catholic missionaries Leo Bittremieux and Josef Van Wing, the British Baptists William H. Bentley and John H. Weeks and the Swedish Karl E. Laman did pioneering work in recording traditional knowledge, in documenting the Kikongo language and in publishing religious and other texts in Kikongo.[14] The most prominent was Laman, who brought together an extraordinary archive of more than 10,000 manuscript pages in Kikongo, written between 1914 and 1916 by young Kongo men who were in the service of Protestant missions as teachers and catechists. Their notebooks contain information about all aspects of Kongo life at the time, mostly provided in response to a questionnaire that Laman had given to them. Laman's Kikongo-French dictionary was largely based on this archive, as was his four-volume monograph on the Bakongo, published after his death in 1944. Although the book suffered from some ethnographic homogenization imposed on the original source material, it contrasted with the vast library of colonial ethnography

that had been established by then and which had led to important misunderstand-ings about the social, political and religious culture of Kongo.[15]

Field research carried out by anthropologists in the 1960s broke with colonial conventions and considerably deepened our understanding of Kongo culture and society. Albert Doutreloux, Wyatt MacGaffey and John Janzen sought to reinvesti-gate different aspects of social, political and religious life.[16] Subsequently, MacGaffey and Janzen made further use of their knowledge of Kikongo to reexamine the origi-nal texts written by Laman's collaborators. This proved particularly rewarding in the context of their attempts to investigate the cosmological assumptions underlying political and therapeutic rituals, and to reinterpret the composition, use and func-tion of ritual objects and the ritual investiture of chiefs.[17] In addition, John Janzen encouraged the emerging Kongo researcher Kimbwandende Kia Bunseki Fu-Kiau to describe Kongo cosmology, the publication of which was received as an impor-tant contribution to the study of African philosophy.[18] Both anthropologists also engaged with history and offered critical reflections on historical analyses of preco-lonial Kongo. Janzen was among the first to add an Atlantic perspective to the study of an important Kongo cultural phenomenon when he described the continuity and adaptation of the Lemba therapeutic cult in Haiti.[19] Based on an analysis of Kikongo texts from the Laman archive, MacGaffey's *Kongo Political Culture* challenges histori-ans and political scientists in what most of them consider to be relevant data (or not) and calls for a more serious consideration of African cosmology and ideology.[20]

Building on the work of historians and anthropologists, art historians Joseph Cor-net, Ezio Bassani and Robert Farris Thompson studied Kongo art and visual culture. Cornet did research in the 1970s for the newly established museum in Kinshasa, in-cluding among the Woyo, a Kongo subgroup.[21] Ezio Bassani's research in museums and archives enabled him to identify individual Kongo artists and workshops, to publish important early sources and to compile an impressive inventory of art and artifacts brought from Africa, including from Kongo, to Europe before 1800.[22] Cor-net's interest in Kongo funerary art led to a collaboration with Thompson, who was using techniques of comparative ethnography to explore the transatlantic connec-tions between Kongo and African American visual cultures. The result of this was a groundbreaking exhibition and book, titled *The Four Moments of the Sun: Kongo Art in Two Worlds* (1981).[23] Thompson further developed the theme of Atlantic connec-tions in subsequent publications, drawing on a wide range of sources, extending his field of inquiry to dance, music and contemporary art and challenging other scholars as he often pushed his analyses into the realm of controversy. Outstanding connois-seurship also developed at the outer fringes of academia, with mostly Raoul Lehuard and Marc L. Felix as the tireless proponents of Kongo art, bringing scholarship to new audiences through publications and exhibitions.[24]

Museum audiences were familiarized with Kongo art through both survey ex-hibitions of African art and projects focusing specifically on Kongo. *Astonishment and Power*, staged at the National Museum of African Art in 1993, focused on Kongo

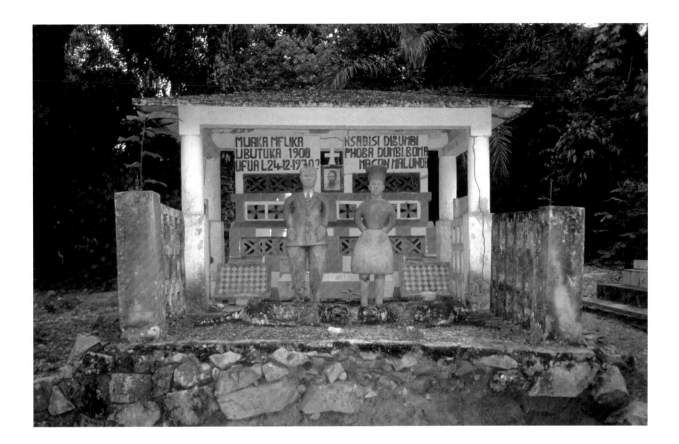

ritual art and on the contemporary African American artist Renée Stout, whose art intuitively links with Kongo art and aesthetics.[25] The exhibition *Le geste Kongo* at the Musée Dapper in Paris in 2002 celebrated the richness of expression in Kongo art.[26] Marc L. Felix organized the first traveling Kongo exhibition in China.[27] In Europe, Leuven and Leipzig recently had focus exhibitions on Kongo art.[28]

The questions raised by Thompson and Cornet in their exploration of Kongo-American connections were not entirely new but had been discussed by scholars researching the African Diaspora at least since the beginning of the twentieth century. Introducing a collection of essays under the title *Africanisms in American Culture* in 1990, Joseph Holloway summarized the different approaches that had previously structured the debate. In a pioneering study titled *The Myth of the Negro Past* (1941), Melville Herskovits emphasized the African carryovers in African American culture, arguing that various cultural "survivals" could be traced back to the African continent. In disagreement with Herskovits was Edward Franklin Frazier, who believed that the experience of slavery had been so devastating that their African cultural heritage had been lost. For him African American culture had evolved in response to the harsh realities of slavery and racism, independently of African influence. Many scholars attempted to prove Frazier wrong and did so with varying degrees of success. Herskovits's approach, however, was criticized as well, for presenting a static view of African American cultures, and for limiting his quest for African origins mostly to West Africa.[29]

Fig. 0.4. Photograph of a Yombe tomb with colorful human and dog figures in cement, Mayombe, Lower Congo, DRC, by Hein Vanhee, 1999. By permission of the author.

In the past two decades scholars have moved past the debate over cultural "survivals" and in so doing have benefited from advances in theory as well as from the disclosure of data that allow us to reconstruct in unprecedented detail the history of the slave trade. In an influential essay, anthropologists Sidney W. Mintz and Richard Price distanced themselves from what they considered to be static conceptions of African diasporic cultures in the Americas as either essentially African or acculturated. They argued for the recognition of both cultural continuity and the creative and innovative ways in which new cultures had been shaped in radically reconstituted social contexts. Although they dismissed Herskovits's West African focus, they also insisted on the necessity to look beyond formal correspondences to deeper cultural principles, ideas and values, which are often shared by different African cultures and may present another kind of cultural continuity.[30] Meanwhile historians increasingly took an Atlantic perspective and put more emphasis on the importance of fluidity and circulation, of commodities, peoples, cultural practices and ideas, rather than on fixed structures and identities. Atlantic history became more concerned with connections, for example, between the political history of Africa, the changing dynamics of the slave trade and ultimately the formation of new cultures in the Americas.[31]

A longstanding emphasis on demographic studies within imperial and maritime historiography led in the 1990s to the development of large databases for the study of the transatlantic slave trade. The most important source today is the online database *Voyages*, containing data on more than 35,000 slave voyages or an estimated 80 percent of the total trade.[32] Complementary datasets are *Afro-Louisiana History and Genealogy* and *African Origins*.[33] Demographic studies led to a reassessment of the numbers of Central Africans in the transatlantic slave trade and identified them as the single largest group. Subsequently more attention was also given to the cultural contributions of Central Africans. Holloway's 1990 collection of essays provided a first step in that direction, and the theme was more fully explored in the essays collected by Linda Heywood in *Central Africans and Cultural Transformations in the American Diaspora* (2002).

In *Many Thousands Gone* (1998), historian Ira Berlin insisted on how much American slavery varied across time and space, and on the importance for African Diaspora studies to take this into account. Berlin introduced the idea of a "charter generation" of slaves in the seventeenth century, whom he called "Atlantic creoles." Unlike the later "plantation generation," those of the charter generation were closer to the culture of their masters and could benefit from a certain degree of social mobility. He also questioned the idea of a unilinear process of creolization, suggesting that the massive slave imports in the eighteenth century may have altered the slaves' sense of identity and led to a sort of re-Africanization.[34]

Taking up Berlin's idea of the charter generation of slaves being significantly acculturated to European values, Heywood and Thornton have argued that these slaves came predominantly from West Central Africa. In Kongo, interior struggles between dynastic groups and military conflicts with the Portuguese and other outsiders

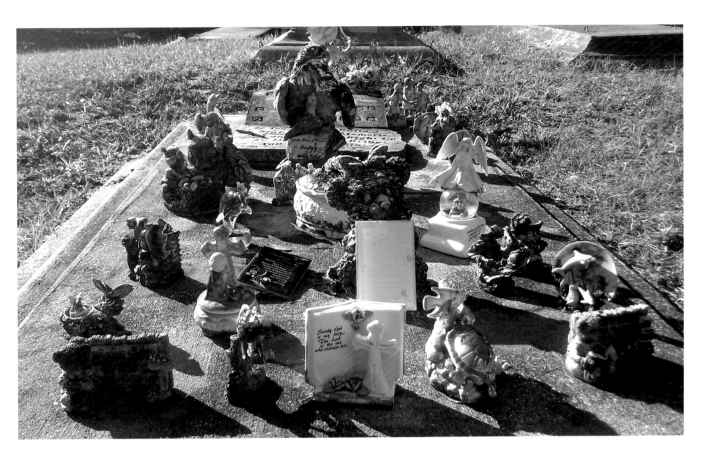

caused many Kongolese in the seventeenth century to be enslaved and sold to European traders. A significant number of them were captured from Portuguese ships by Dutch and British privateers and brought to North America. Heywood and Thornton argued that the charter generation's "creole culture," which included adoption or familiarity with Catholicism, had developed in the Kongo-Angola region. This may have enabled Kongolese to negotiate a different slave-master relationship than was possible for later generations.[35]

Acknowledging the fact that slavery produced different outcomes in different times and in different places, and making use of the detailed documentation on the specifics of the trade, a variety of scholars have reviewed the origins of regional cultures in the United States. Gwendolyn Hall has looked at how African American identities were formed in Louisiana, and at the importance of cultural import there from Kongo, which Jason Young also found in the Lowcountry, looking more specifically at religion.[36] The last two decades also saw an increasing interest from archaeologists into the African American past, with pioneering work published by Leland Ferguson in 1992.[37] As archaeologists drew attention to African American pottery (colonoware), housing styles and material traces of ritual activity, scholars of folklore like John Vlach wrote about basketry traditions, face jugs, memory jars and decorated walking sticks.[38] A selection of such African American arts and artifacts is presented in the exhibition *Kongo across the Waters* and discussed in various chapters in this book.

Fig. 0.5. Photograph of a tomb at an African American cemetery, decorated with turtle, dolphin and bird figures, Florida, USA, by Hein Vanhee, 2013. By permission of the author.

This book is structured in a number of longer and shorter essays, written by leading scholars on Kongo and the Kongo Diaspora. The longer essays bring current scholarship to bear on broader themes. The shorter essays focus on more specific issues, a particular object or form of expression, a historical figure or a featured artist. Interspersed with these essays are a number of visual intermezzos presenting a small set of compelling images accompanied by a short caption. We call them focus presentations.

The essays and focus presentations generally fall into three parts. The first part deals with the culture of the Kongo kingdom and the dynamics of the transatlantic slave trade, and subsequently focuses on the late nineteenth and early twentieth centuries. The essays address processes of cultural exchange, religious renewal and economic development, and explore various themes in Kongo art history.

The first five essays look at the early period of contact between the kingdom of Kongo and the Portuguese, at the reception of esteemed Kongo diplomats in Europe and the loss of many enslaved Kongolese to the transatlantic slave trade. Linda Heywood and John Thornton's opening essay explores the culture of the Kongo capital Mbanza Kongo in the fifteenth and sixteenth centuries. Art historian Cécile Fromont looks at art in the era when Kongo kings and elites converted to Christianity. The essay by archaeologist Geoffroy Heimlich discusses rock art in the Lower Congo region and its intersection with Kongo visual culture. Jelmer Vos addresses the changing patterns of the transatlantic slave trade between West Central Africa and North America, as well as the dynamics of enslavement in Kongo and the integration of enslaved Kongolese in the North American economy. This first section concludes with a discussion by Linda Heywood and John Thornton of Kongo's diplomatic missions to European courts and to the Vatican.

The next six essays reflect on Kongo in the nineteenth and early twentieth century. Hein Vanhee and Jelmer Vos describe the interplay between the booming "legitimate" commerce in the Congo estuary and on the Atlantic coast and the ambitions of local Kongo rulers, both south of the Congo River involving the Kongo king, and to the north where Yombe chiefs competed with one another. The political ideology of chiefship is reflected in carved ivory tusks made on the Loango Coast, and Nichole Bridges' essay compares these with African American carved wooden canes produced more or less in the same time period on the other side of the Atlantic. In particular, she addresses themes and forms in the so-called Emancipation Cane, a post–Civil War example that displays imagery and a narrative scheme that resembles the style of Kongo ivory tusks and wooden staffs. John Janzen discusses the dynamic nature of Kongo religion, suggesting that the pattern of incorporating new forms and objects in rituals constitutes a "tradition of renewal" that can be documented over almost five centuries. Ethnomusicologist Rémy Jadinon considers the historical and musical contexts of a visually compelling instrument, the Kongo pluriarc. Wyatt MacGaffey examines iconography and style in Kongo art and focuses on the aesthetic impact of anthropomorphic *minkisi*. The many European objects imported during the nineteenth century inspired both subject matter and style in Kongo art,

and art historian Julien Volper examines how the imagery of the imported Toby jugs may be recognized in commemorative grave figures as well as other Kongo objects.

The second part examines the transmission of Kongo cultural traditions to North America and their transformation in the contemporary African Diaspora cultures. Drawing on archaeology, linguistics, anthropology and history, they take a multidisciplinary look at culture in its broadest sense, integrating aspects of religion, cuisine, music, arts and crafts and commemorative practices.

This part opens with two essays that present the work of archaeologists. The first essay by Christopher Fennell looks at colonoware, *dikenga*-like configurations and *nkisi*-like caches found in early African American dwellings and other sites where African Americans of Kongo descent were present. The second essay presents the work of a team, comprising Kathryn H. Deeley, Stefan F. Woehlke, Mark P. Leone and Matthew Cochran, on two excavations in Annapolis, Maryland. It offers a description and analysis of several artifacts, including a bundle of "medicines" found under a sidewalk on Fleet Street and a circle-cross configuration of objects below the floor of the eighteenth-century home of James Brice, former governor of Maryland. The following two essays present research in linguistics. Jacky Maniacky discusses linguistic connections between Kongo and the African American communities in the southern United States and remarks on the importance of methodology and the critical use of sources. Birgit Ricquier investigates specific aspects of culinary vocabulary that have survived the Middle Passage. Historian Jason Young's essay discusses Kongo influences on African American visual, literary and performative arts. Young offers some valuable insights as to how early Kongo-inspired forms of expression were integrated into the core of America's artistic and cultural heritage. Art historian Dale Rosengarten investigates the Lowcountry tradition of coiled grass baskets and discusses them in terms of their historical connection with Kongo. The next essay, by Freddi Williams Evans, discusses the Kongo and related dances being performed in the early nineteenth century at New Orleans' Congo Square, as well as the musical instruments being manufactured and played there by enslaved individuals. Historian Mathilde Leduc-Grimaldi considers how Central Africa, particularly the Kongo region, was represented in the United States in the nineteenth and early twentieth century in popular travelers' accounts and visual media. She is interested in the ways in which these representations affected popular understanding and imaginings of Africa. The final two essays of this part address African American yardwork throughout the southeastern United States. Anthropologist Grey Gundaker discusses yard shows that suggest Kongo-derived principles of defining sacred space. Art historian Kellim Brown hones in on a specific yard in Tampa, Florida, and describes how Kongo aesthetic concepts inform the selection and spatial arrangement of found objects to create personal and emotionally charged spaces.

Contributions to the third part of this book explore the ways in which Kongo traditions continue to inspire contemporary artists, in both Africa and North America. Art historians Susan Cooksey and Robin Poynor chart the course of artists with diverse cultural backgrounds in the modern and contemporary eras who have sought

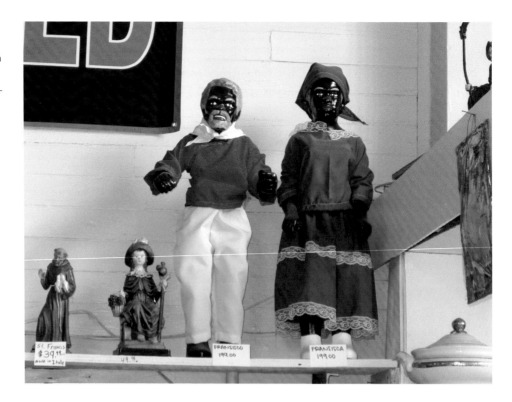

Fig. 0.6. Photograph of the Kongo ancestors Fransisco and Fransisca, at $199 each in a New Orleans botanica, by Hein Vanhee, 2012. By permission of the author.

affinity with African, and specifically Kongo, art and culture. The following four essays discuss the work of artists living in the United States who are heavily influenced by Kongo art and ideas. Michael D. Harris writes about Renée Stout and her self-identification as an artist/conjurer who is inspired by Kongo *minkisi*. Carol Thompson elucidates Radcliffe Bailey's borrowing of Kongo ideas and aesthetics in his quest for personal and collective histories in America and in Africa. Donald Cosentino discusses the many African sources of Haitian Vodou—including its Kongo origins—as represented in Edouard Duval-Carrié's paintings of *lwas*, *bisimbi* and other Vodou beings. The concluding essay by art historian Judith Bettelheim looks at two installations by the Cuban American artist José Bedia in which he expresses his relationship with the Afro-Caribbean religion Palo Monte.

Kongo across the Waters offers readers a journey across time and space, in multiple and opposite directions. In sixteenth-century Kongo, we find religious iconography that connects to twentieth-century African American visual culture. In twenty-first-century American art, we find forms and ideas that reinterpret Kongo ritual art from the nineteenth century. Many such linkages can be made, and the idea of crossing waters, as alluded to in the title, may capture metaphorically the ambition of this project. "Across the river/water" is a recurring trope in Kongo mythology to indicate where "our people" originally came from. Kongo stories of origin usually narrate in some detail how that river was crossed and which other peculiar events marked the journey to "our land." The specifics of all that explain why "we" are divided into a number of groups, and why we are here and so-and-so are elsewhere. The river may be on the map, but in the story it serves as a cosmological boundary between society as we know it and elsewhere.

Kongo across the Waters is therefore a metaphor that describes one of the rich historic cultures of our world, having developed across the centuries *on this side of the water* into a complex set of ideas, beliefs and forms of expression, both in Africa and in its many diasporas. This book is meant to familiarize readers with Kongo culture, with its historical depth and with the many influences it continues to have on our increasingly globalized cultures.

Kongo across the Waters may also be *on the other side of the water*, a "land" taken as the origin or the source of things. It may be the African continent, which is often looked at as a potential source for self-empowerment or for inspiration, by those who feel historically or spiritually connected to it. Or it may be the Other World, where the ancestors and spirits live, a capricious world from where technology comes, and foreign aid, across an ocean that has a name on the map but is also a cosmological boundary. To appreciate what is *on this side* and imagine what may be *on the other* is what this book is about.

Notes

1. Landers, *Black Society in Spanish Florida*, 10–12. There is some discussion as to whether Juan Gonzalez Ponce de León really was of African descent; see Ayes, *Juan Ponce de Leon: His New and Revised Genealogy*.

2. See Bassani and McLeod, *African Art and Artefacts in European Collections*, for an overview of early collections.

3. For a recent discussion of Kongo's early engagement with Christianity, see Heywood and Thornton, *Central Africans, Atlantic Creoles*, 49–67.

4. Gerhard, "A Black Conquistador in Mexico"; Restall, "Garrido, Juan."

5. Landers, *Black Society in Spanish Florida*, 12–18.

6. Quantitative data derive from *Voyages: The Transatlantic Slave Trade Database*, http://www.slavevoyages.org (accessed on April 1, 2013).

7. The introduction by Heywood in Heywood, *Central Africans and Cultural Transformations*, summarizes the situation.

8. See chapter 1 in this volume.

9. For an excellent discussion, see Thornton, "Religious and Ceremonial Life."

10. The book was published in Dutch as *Het oud-koninkrijk Kongo* in 1941. A French edition followed in 1946. On the importance of Cuvelier's historical work, see Thornton, *The Origins and Early History*, 90–95.

11. Hilton, *The Kingdom of Kongo*; Broadhead, "Beyond Decline"; Thornton, *The Kingdom of Kongo* and *The Kongolese Saint Anthony*.

12. For an overview of the bibliography, see Vos, "Kongo and the Coastal States of West Central Africa."

13. Thornton, *Africa and Africans in the Making of the Atlantic World*; Heywood and Thornton, *Central Africans, Atlantic Creoles*.

14. Bittremieux, *La société secrète des Bakhimba* and *Mayombsch Idioticon*; Van Wing, *Etudes Bakongo* (2 vols., 1920–38); Van Wing and Penders, *Le Plus Ancien Dictionnaire Bantu*; Laman, *Dictionnaire Kikongo-Français* and *The Kongo* (4 vols.)

15. For a discussion of the work of Laman, see Janzen, "Laman's Kongo Ethnography" and MacGaffey, *Kongo Political Culture*, 34–42.

16. See Doutreloux, *L'ombre des fétiches*; MacGaffey, *Custom and Government*; Janzen, *Lemba*.

17. See Janzen and MacGaffey, *An Anthology of Kongo Religion*; Janzen, *Lemba*; MacGaffey, *Art and Healing* and *Kongo Political Culture*.

18. Fu-Kiau, *Le Mukongo et le monde qui l'entourait*.

19. Janzen, *Lemba*.

20. MacGaffey, *Kongo Political Culture*.

21. Cornet, *Pictographies Woyo*.

22. Bassani, "Kongo Nail Fetishes," "Un grand sculpteur du Congo," and *Un Cappuccino nell'Africa nera del Seicento*; Bassani and McLeod, *African Art and Artefacts in European Collections: 1400–1800*.

23. Exhibition at the National Gallery of Art, Washington, D.C., 30 August 1981–31 May 1982; Thompson and Cornet, *The Four Moments of the Sun*.

24. See, for example, Lehuard, *Art Bakongo*; Felix, Meur and Batulukisi, *Art & Kongos*; and Felix and Lu, *Kongo Kingdom Art*.

25. Exhibition at the National Museum of African Art, Washington, D.C., April 1993–January 1994; MacGaffey and Harris, *Astonishment and Power*.

26. Exhibition at the Musée Dapper, Paris, 18 September 2002–19 January 2003.

27. *Kongo Kingdom Art: From Ritual to Cutting-edge*, traveling exhibition staged at the Guangdong Museum of Art, 30 December 2003–31 March 2004; at the Shanghai Art Museum, 21 April–4 June 2004; and at the National Museum of China, Beijing, 6 July–9 October 2004.

28. *Mayombe: Masters of Magic*, exhibition at Museum M, Leuven, Belgium, 8 October 2010–23 January 2011; *Minkisi: Sculptures from the Lower Congo*, exhibition at the Grassi Museum für Völkerkunde, Leipzig, Germany, 7 December 2012–2 June 2013.

29. Holloway, *Africanisms in American Culture*, ix–x.

30. Mintz and Price, *The Birth of African-American Culture*, 11–13.

31. See Thornton, *Africa and Africans*; Heywood and Thornton, *Central Africans, Atlantic Creoles*.

32. Eltis, "Construction of the Trans-Atlantic Slave Trade Database."

33. *Afro-Louisiana History and Genealogy* (www.ibiblio.org/laslave) was developed by historian Gwendolyn Hall; *African Origins* (www.african-origins.org) has data on Africans liberated from transatlantic slave vessels.

34. Berlin, *Many Thousands Gone*, 15–92.

35. Heywood and Thornton, *Central Africans, Atlantic Creoles*, 236–40, 290–93, 298.

36. Hall, *Slavery and African Ethnicities*; J. Young, *Rituals of Resistance*.

37. Ferguson, *Uncommon Ground*.

38. Vlach, *By the Work of Their Hands*.

I

Kongo in Africa

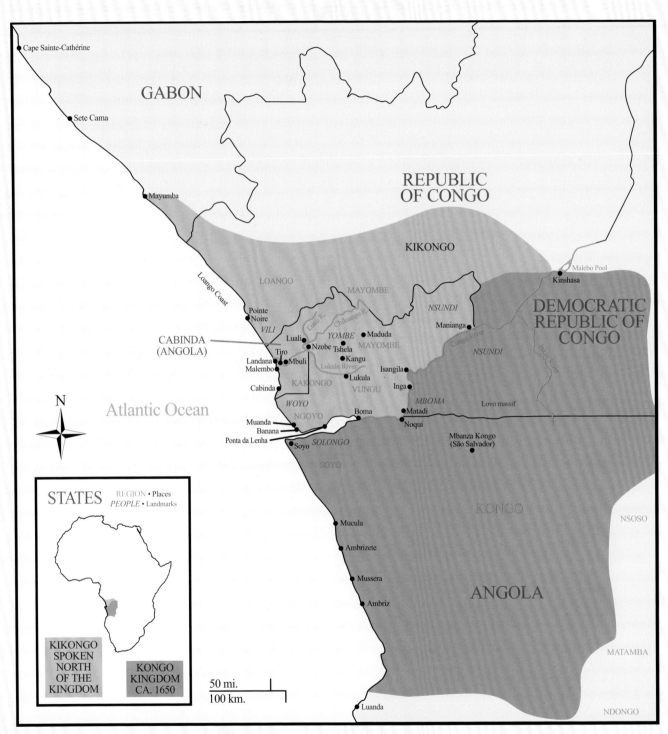

Map of the Kongo kingdom and surrounding regions

The Culture of Mbanza Kongo

LINDA HEYWOOD AND JOHN THORNTON

The first documentary description of Mbanza Kongo, written by the Milanese ambassador in Lisbon in 1491, presented it as a fine town, as large as Évora, Portugal's second largest city, and with "houses better than are found in all of Guinea."[1] The city sat on the top of a plateau some ten miles in circumference and presented an impressive and formidable appearance to early visitors traveling by road from the valley below, as it does today if one approaches it by car or looks down on it from an airplane. A driver today approaching at night can see the lights of the city from miles and miles away, thanks to its elevation (fig. 1.1). Its elevation, defensibility and use as a political, religious and cultural center contributed to its status as the perpetual capital of Kongo, even when its political role was diminished. Mbanza Kongo continues to be the cultural center of the Kongo population today.

The city had already served as a political center and cultural capital even before the arrival of the Portuguese in 1483 and the conversion of the king to Christianity. When King Nzinga a Nkuwu received his Portuguese visitors in Mbanza Kongo in 1491 he "summoned all the princes and barons of his kingdom so that they could participate in so much glory and jubilation," a sure indication of its political role. The king organized a large public festival with mass participation to receive the visitors. The crowd was both very large and highly organized, as they, men and women, marched "in battalions" singing songs of praise accompanied by a variety of African musical instruments. The king was dressed in the appropriate finery for Central African royalty, "a rich robe according to their taste (*sua modo*), naked from the waist up, with a finely made and very tall hat made of palm cloth on his head" and on his left arm he wore an ivory bracelet of local manufacture. There were already signs of cultural mixing, as the king had already incorporated "a horse tail worked with silver," and he wore from his "waist down a Damask cloth that the king of Portugal had sent."[2]

At this first meeting, Portuguese and Kongolese were two distinct national groups, as both parties adhered to their own etiquette in this initial contact, for after the leader of the Portuguese delegation greeted the king of Kongo with "the ceremonies of Spain," the king, clearly following his own equivalent custom, "took soil in his hand and ran it over the chest of the captain," and afterward put it on his own chest

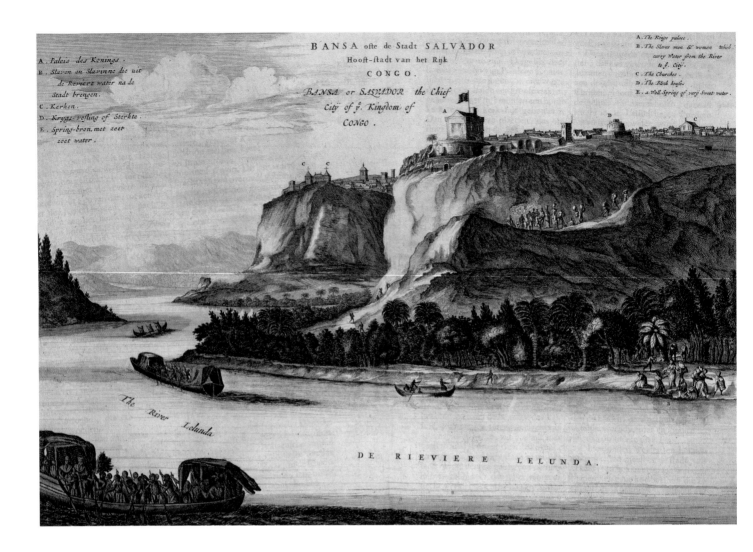

BANSA ofte de Stadt SALVADOR
Hooft-ftadt van het Rijk
CONGO.

BANSA or SALVADOR the Chief
Citÿ of ÿ. Kingdom of
CONGO .

The River Lelunda

DE RIEVIERE LELUNDA.

Fig. 1.1. View of Mbanza Kongo. Engraving published in Dapper 1668. RMCA Library, Tervuren, Belgium. By permission of RMCA.

"according to his status and custom." This embassy with all its gifts was part of King João II of Portugal's plan to convert this country into a European-style society. It was no wonder that the wide range of presents to the Kongo king was intended to display the full array of what Europeans considered important in their culture, including "stonemasons, carpenters, Christian women, farmers with the tools of their trade." Beyond this João presented his African counterpart with a richly decorated horse with marks of Portugal and a variety of rich cloths such as damask and silk as well as horse tails richly detailed with silver—in short, "many things of this quality." A message from João delivered by the embassy explained that this was done so that Nzinga a Nkuwu could dress "in your armor" as a European noble.[3]

In addition to these material gifts with the prospect of the physical transformation of Kongo, João also hoped to engineer its spiritual transformation. Nzinga a Nkuwu had agreed to be baptized as a Christian, persuaded by Kongo subjects (including nobles) who had been visiting Portugal ever since the two countries first came into contact in 1483. The conversion took immediate material form in 1491, for along with the ambassadors, João also included a bell for the church, which the stonemasons

completed in a month, thanks to the labor of thousands of Kongolese who carried the stones from far away. João sent the bell along with royal chaplains and "all that was needed for the Divine Office."[4] Scholars have debated the degree to which Kongo adopted Portuguese culture and religion; however, there is no doubt that Mbanza Kongo became the center for the development of a mixed Euro-African culture.

The first evidence of this cultural transformation was the physical appearance of the city, notably in the construction of stone buildings. As far as is known, the church, dedicated to Our Lady of the Conception, was the first stone building in the area.[5] Nzinga a Nkuwu's son Afonso, baptized along with his father on 3 May 1491, accelerated the transformation of the city with a building program that led to the construction of several churches, a palace surrounded by a stone wall for himself, and a whole quarter, also encircled with a stone wall, for Portuguese who took up residence in his kingdom.[6] In order to build one of these churches, Afonso cut down a "thick woods" where the kings' ancestors were buried, a direct incorporation of Kongo spiritual space meant to represent the symbolic transformation of the religious life of the country.[7] In fact, the church was nicknamed *mbila*, the Kikongo term for "grave," because of this.[8]

This building program continued throughout the sixteenth and into the seventeenth century.[9] In fact, King Garcia II (1641–61), whose reign is often considered the height of the kingdom's grandeur, initiated a major renovation program, reconstructing ruined stone buildings and constructing a two-story stone palace for himself, the only two-story building in the country.[10] By the end of the sixteenth century the city had six public churches, and nobles had a number of their own private chapels.[11] The presence of these buildings gave Mbanza Kongo, called São Salvador since 1580, an appearance even more like Évora than it had at first, but the use of local building techniques and materials, even on the churches, could not eliminate its African elements.

As a part of Afonso's move to Christianize the country, he constructed schools; the first ones included walled enclosures to keep the students confined, and soon the educational system extended into the countryside as well.[12] Literacy became widespread among the elite as a result, and the use of literate means extended beyond religion to other elements of Kongo life. A parcel of administrative documents dating between 1591 and 1604 found among the papers of Antonio Manuel, the Kongolese ambassador to Rome, showed orders, grants using Portuguese forms, signed with seals, including even tax stamps, though payments for services were made in Kongo's money, units of *nzimbu* shells.[13]

Afonso's leadership was also evident in his approach to incorporating some of Portuguese law into Kongo law. Afonso received texts and studied Portuguese law; he obtained the Portuguese law code, the Ordenações Manuelinas, as soon as it was published in 1516, and he read and studied it carefully.[14] While Kongo did keep much of its own legal system, it adopted the notion of a legal inquest, or at least keeping a record of one; as early as 1517, Afonso was conducting inquests using Portuguese forms and formulary, and in 1550, King Diogo I conducted a similar inquiry into a

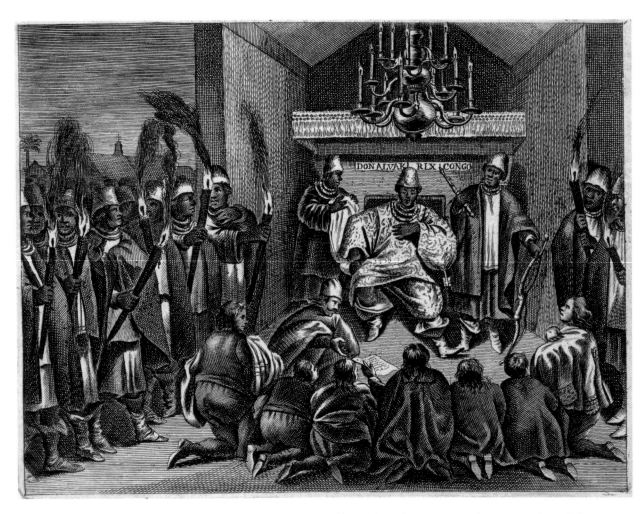

Fig. 1.2. Dutch ambassadors visiting the court of Kongo in 1642. Engraving published in Dapper 1668. RMCA Library, Tervuren, Belgium. By permission of RMCA.

treason plot to overthrow him.[15] Holding their own in this, Kongolese did not normally take oaths in the name of saints, though they were Christians, but of their ancestors, a powerful component of Kongo's variant on Christianity.[16]

Olfert Dapper's description of Mbanza Kongo represents the city as the Dutch embassy saw it in 1642, when the city had absorbed the fruit of the cultural endeavors. For example, he wrote that the common houses of the city were "built in an urban manner (*stadts-gewijze*); most of them large, well-made, circled with fences, but all are thatched, except for some built by the Portuguese." The royal palace was an interesting combination of European and African features, almost, Dapper recounted, the size of a city unto itself, surrounded with four encircling concentric walls, of which the outer one, facing the public square and Portuguese quarter was made of plastered stone (*kalk en steen*), while the inner three were of wattle "in the same manner as the commoner city-dwellers' houses (*gemeene burger-huizen*)." The king had his lodgings in multiple buildings rather than a single grand structure; "dining and sleeping rooms are hung about in the European manner with very neatly made straw mats."[17]

Every day the king had a great many nobles, who lived within the royal enclosure, come and dine with him. He called each noble individually and gave each of the great nobles a portion of the king's fare on wooden platters, while lesser nobles came forward in groups of seven or eight and received their food in pots.[18] This food and

its origins reflected Kongo's participation in the revolution of cuisine brought about by intercontinental contacts. Kongo had adopted maize and manioc from America to become the widespread ingredient of *nfundi*, or the "daily bread" of Kongo, but also trees that shaded the city: tamarind, orange and other exotic fruit trees.[19]

The lively social life of the city was marked by feasts and celebrations involving many people. Lower-class people might organize celebrations, especially if they had good luck, in which one would organize a feast and invite many other people, with a great deal of food and drink. In the end, the group would parade their leader around, hailing him as "the king of Kongo."[20] The death and burial of a king would occasion lengthy public festivals of mourning; the festival following the death of Pedro II in 1624 was recounted in great detail by the visiting Jesuit Mateus Cardoso. These mourning festivals might last for eight days, but smaller festivals were conducted on the anniversary of the king's death, so that a good many royal festivals would be observed. Not only kings but nobles also had these sorts of funerals and subsequent anniversaries. Coronations also warranted similar large-scale public celebrations.[21]

Church activities were a center of cultural life in the city. According to Bishop Francisco de Soveral in 1631, weekly services of the church had so many people that they could not be accommodated in the churches, and the services were held in the vast central square to hear mass.[22] Special events like the arrival of important emissaries or groups of foreign missionaries, papal dispensations or other signs of good fortune would be accompanied by great festivals, usually of a Christian inspiration that added to the round of weekly masses in the churches and even more frequent ones held by lay brotherhoods for the dead.[23]

The greatest religious festival in Kongo was the celebration of the Feast of Saint James Major on 25 July. The festival celebrated the miracle that Afonso was said to have witnessed in overcoming a challenge from his pagan brother in 1509 and was coupled with a gathering of people from all over the country. In addition to paying taxes and celebrating a military review, the festival involved celebrations and exhibitions of dancing and music.[24]

São Salvador underwent dramatic and tragic changes following the reign of Garcia II with his magnificent city. A failed war with Portugal over a border province killed Garcia's son and successor Antonio I in 1665, setting off a disastrous civil war that eventually destroyed the city. In 1678 the last inhabitants fled the city for mountain fortresses in the provinces, and it lay abandoned to wild animals for many years.[25] But if the city was abandoned, its attraction and significance was not lost on its people. No king could claim to rule Kongo without occupying the city, and when one of several pretenders to the throne, Pedro IV, wanted to be crowned in 1696, he brought old men to identify the ruined buildings and do reconstructions to hold what were still considered vital ceremonies at the appropriate places. But Pedro could not remain; threatened by another pretender, he returned to his own mountain fortress of Kibangu the next day.[26]

The role of reoccupying the city fell instead to a young woman, Beatriz Kimpa Vita. Claiming to be an incarnation of Saint Anthony, Beatriz demanded that the

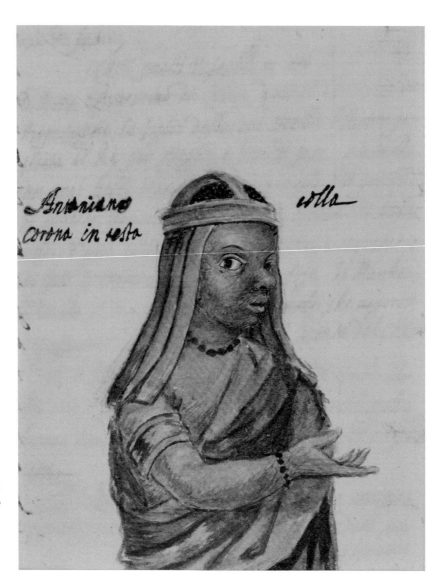

Fig. 1.3. Watercolor of a follower of the Antonian movement, by Bernardo da Gallo, 1710. Archivio "De Propaganda Fide," Scritture Originali riferite in Congregazioni generali, vol. 576, fol. 314. By permission of Congregazione per l'Evangelizzazione dei Popoli.

kings reoccupy the city, and when they could not she did so herself in 1705, attracting great bands of followers to her. Beatriz declared herself the arbitrator of who would be king. She took up residence in the cathedral, and from there she claimed that she visited heaven to speak with the Almighty about the kingdom's future. She leaned increasingly to crowning Constantinho da Silva and welcomed Pedro IV's own wife into her congregation. But her rule was short-lived; Pedro IV captured her, tried her for witchcraft and burned her alive on 6 July 1706.[27]

While Beatriz's movement does not appear to have left much of a long-term religious impact in the country, her movement's success in repopulating the city emboldened Pedro IV to move his army and followers to it in 1709. There he met and defeated the forces of João II's army and won the support of the other pretenders, at least to restore nominal unity to the country. While Kongo did not return to the centralized monarchy of the seventeenth century, it did adopt a rotational succession to the throne, with the inhabited city as the central representation of the kingdom.

Eighteenth-century kings ruled a decentralized kingdom that was inclined to conflict between the regional powers that claimed to be in the royal rotation. The kingdom had lost its unity, civil war still erupted regularly and smaller skirmishes between the rivals continued unabated, filling slave ships for America if achieving nothing else.[28] In earlier times Kongo had limited and regulated the slave trade, but during the period of civil war, more and more people became vulnerable to enslavement. The city had always had numbers of slaves, but increasingly people of all classes were being sold abroad.[29]

Since no king could rule without occupying São Salvador, any successful king needed to keep the city populated with his followers and could then hold the town against all comers. The rural population was quite mobile and dotted the old capital with relatively lightly built residential structures that were easily built and therefore easily abandoned. There was little actual rebuilding of the ancient ruined churches, making São Salvador a bit like medieval Rome, where ruins abounded as part of the landscape. Visitors were shown ruined churches whose names and dedications were known to all by tradition and whose roofless walls were still used as religious spaces.[30]

The eighteenth and early nineteenth centuries witnessed a cultural renaissance, and Kongo artists produced the remarkable Christian art for which the country is famous. Crucifixes and images of the saints, rich with both African and European imagery and iconography, were produced throughout the country, but the city, as

Fig. 1.4. Photograph of the royal graves at Mbanza Kongo, by D. Rinchon, 1928. RMCA Photographic Archives, Tervuren, Belgium, AP.0.0.39507. By permission of RMCA.

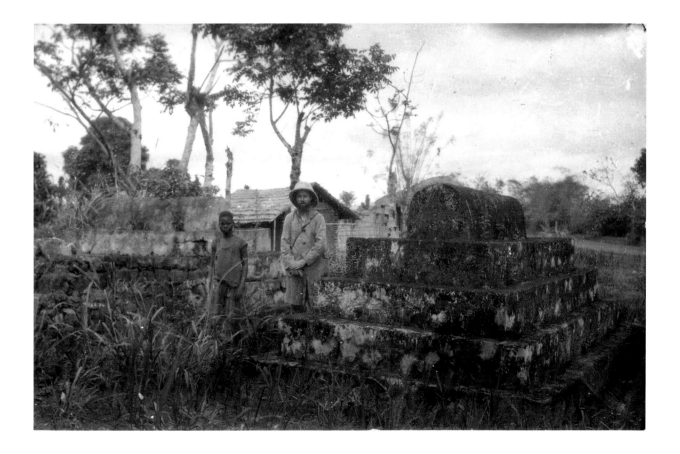

always, remained the religious capital (see catalogue section 1). The former slaves of the Capuchin missionaries' hospice in São Salvador took on the role of guardians of much of the royal religious insignia and regalia. Their precinct was a shrine of sorts, even though the Capuchins abandoned the city in the late eighteenth century, with only a few temporary visits in the following years.[31]

The religious role of São Salvador was clearly marked by the outrage that ensued when King André sequestered the relics held by the Capuchin hospice before his death in 1842. Henrique, who succeeded him in power and demanded that the relics be restored, noted that his succession was marked by a civil war between the ex-slaves of the Capuchin hospice and those of the cathedral. Following Henrique's death in 1856, another civil war erupted, this time concerning, among other things, the desecration of Henrique's grave, a serious offense in Kongo culture. The eventual winner of this dispute, who took the name Pedro V, even though he was the seventh king to bear this name, did so with help from the Portuguese of Angola. Pedro V swore vassalage to Portugal upon taking the throne and for a time endured a Portuguese fort in his city, but the Portuguese withdrew in 1870. As this happened, however, Pedro was able to make São Salvador into a commercial center, as further discussed in chapter 6. He attracted merchant houses from several European countries, as well as Baptist missionaries who came to the city in 1879.[32]

Notes

1. Letter of Milanese Ambassador in Lisbon, 6 November 1491, in Capelli, "A Proposito di Conquiste Africane." He obtained this information from Portuguese sailors just returning from Africa.

2. Rui de Pina, Untitled Italian Chronicle (1492), fol. 86vb, in Radulet, *O cronista Rui de Pina*, 98–99.

3. Rui de Pina, *Cronica de el Rei D João Segundo* (1515), cap. 60, in Radulet, *O cronista Rui de Pina*, 145–46.

4. Milanese Ambassador in Capelli, "A Proposito di Conquiste Africane," 461.

5. Rui de Pina, *Cronica*, cap. 61.

6. For more details on Afonso's building, see Thornton, "Mbanza Kongo/São Salvador."

7. Afonso to João III, 25 August 1526, Brasio, *Monumenta Missionaria Africana*, 1, 476.

8. Christovão Ribeiro, 1 August 1548, Brasio, *Monumenta Missionaria Africana*, 15, 161.

9. Heywood, "Mbanza Kongo/São Salvador."

10. Biblioteca Nacional de Madrid, MS 3533, Antonio de Teruel, "Descripcion narrative de la mission serafica de los Padres Capuchinos . . . en el reyno de Congo," 179 on reconstruction.

11. Testimony of Antonio Vieira, 1595, "Interrogatoria de Statu Regni Congensis," Brasio, *Monumenta Missionaria Africana*, 3, 502.

12. Afonso to Manuel I, 5 October 1514, Brasio, *Monumenta Missionaria Africana*, 1, 322.

13. Archivo Segreto Vaticano, Arm II, vol. 91, fol. 137, Alvara appointing Antonio Manuel *mestre* of Mpemba, 16 December 1600; fol. 230, Provision of Gonçalo da Silva Mendonça, Procurador of Congo, 19 October 1593 (specifying rights in burials), fol. 202, Provizão of Alvaro II to Antonio Manuel, 19 June 1599 (specifying salary in money for Antonio Manuel serving as *mestre* in São Salvador and secretary in Mpemba).

14. Rui d'Aguiar to Manuel I, 25 May 1516 in Góis, *Chronica*, pt. 4, chap. 3, published from the original MS (of 1545) and the printed version, Brasio, *Monumenta Missionaria Africana*, 1, 361–62.

15. Heywood and Thornton, "King Diogo."

16. Cortona, "Breve Relatione," 325.

17. Dapper, *Naukeurige Beschrijvinge,* 562.

18. Dapper, *Naukeurige Beschrijvinge,* 579.

19. Dapper, *Naukeurige Beschrijvinge,* 561–62.

20. Dapper, *Naukeurige Beschrijvinge,* 572.

21. Thornton, "Regalia."

22. [Francisco do Soveral] "Infra scriptam relationem de statu Cathedralis ecclesiae Sancti Salu-atoris . . ." 1 April 1631, Brasio, *Monumenta Missionaria Africana,* 8, 13.

23. Heywood, "Mbanza Kongo/São Salvador."

24. Dapper, *Naukeurige Beschrijvinge,* 575.

25. Thornton, *Kingdom of Kongo,* 84–96.

26. Thornton, *Kongolese Saint Anthony,* 45–49.

27. Thornton, *Kongolese Saint Anthony,* 168–85.

28. Thornton, "Guerras Civis."

29. Heywood, "Slavery."

30. Rafael Castello de Vide, "Viagem do Congo . . ." ed. Arlindo Correira, 16 October 2007, http://arlindo-correia.com/161007.html.

31. Thornton, "Master or Dupe," 121–22.

32. Thornton, "Master or Dupe," 125–26.

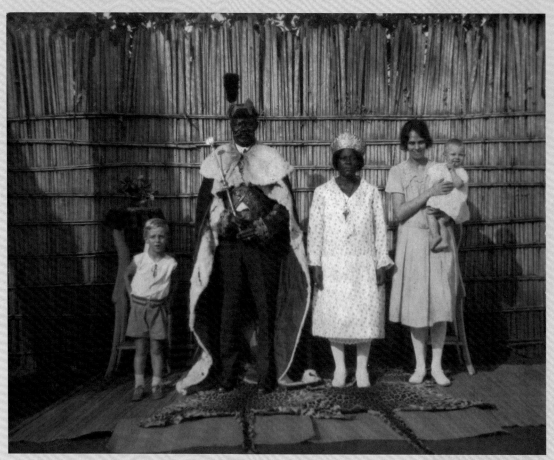

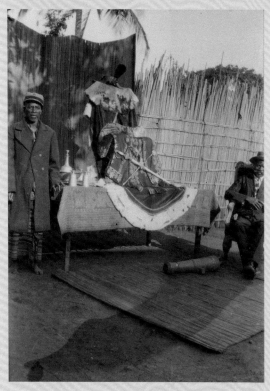
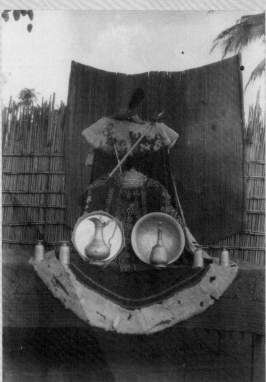

Top: Ill. 1.1. Photograph of King Dom Pedro VII and Queen Dona Isabel with European visitors, Mbanza Kongo, Angola, late 1920s. BMS Archives, Oxford. By permission of Angus Park library and archive, Regent's Park College, University of Oxford.

Above left: Ill. 1.2. Photograph of the dress and regalia of King Pedro VII, Mbanza Kongo, Angola, by D. Rinchon, 1928. RMCA Photographic Archives, Tervuren, Belgium, AP.0.0.39506. By permission of RMCA.

Above right: Ill. 1.3. Photograph of the dress and regalia of King Pedro VII, Mbanza Kongo, Angola, by D. Rinchon, 1928. RMCA Photographic Archives, Tervuren, Belgium, AP.0.0.39533. By permission of RMCA.

King Pedro VII of Kongo (r. 1923–55)

In 1923, under the auspices of the Portuguese, Pedro Lenga was elected as King Pedro VII of Kongo. According to Portuguese sources, he enjoyed great support at the capital, partly because he was known to be a fearless elephant hunter. He was a great diplomat as well. Educated by Portuguese Catholic missionaries, he was said to be a loyal subject of Portugal, but he also met frequently with resident Protestants of the Baptist Missionary Society. He attached great importance to court protocol and loved to display his ceremonial dress and regalia.

In 1928 he was visited by Father D. Rinchon, who took a series of photographs that he later donated to the Royal Museum for Central Africa. Rinchon's photographs show the king's ceremonial costume and regalia, including a crown, military helmet, saber, scepter and tea set. Most of these regalia have been preserved at Mbanza Kongo. They are in the Museu dos Reis do Kongo, inaugurated on July 31, 1992, and they feature in the catalogue of its permanent exhibition, published in 2007. Although most of the objects do not seem to be older than the nineteenth century, their conservation throughout the twentieth century attests to the importance of a living Kongo memory and identity.

HV

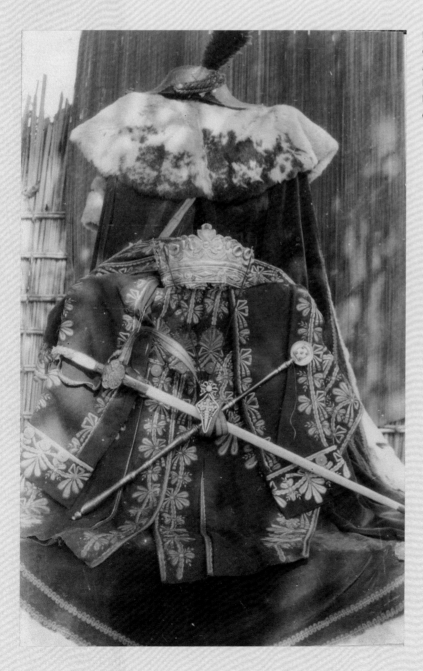

Ill. 1.4. Photograph of the dress and regalia of King Pedro VII, Mbanza Kongo, Angola, by D. Rinchon, 1928. RMCA Photographic Archives, Tervuren, Belgium, AP.0.0.39513. By permission of RMCA.

2 ◈

By the Sword and the Cross

Power and Faith in the Arts of the Christian Kongo

CÉCILE FROMONT

From its rulers' bold adoption of Catholicism circa 1500 to its unraveling in the face of European colonialism in the late nineteenth century, the historical kingdom of Kongo functioned as an independent kingdom whose ruling class professed Christianity and actively participated in the religious, diplomatic and commercial networks of the early modern Atlantic World. During that period, the elite of the kingdom sent exquisite ivories and luxurious textiles to their European counterparts, who delightedly placed them among their prized treasures (cat. 1.4 and 1.6).[1] The great leaders of the Kongo in turn adopted cosmopolitan regalia, mixing locally significant insignia with emblems of European origin. They wore with particular pride large iron swords and elaborate brass crucifixes that encapsulated in their form, material, and use the essential social, religious, and aesthetic values of the kingdom in its Christian era. Inspired from European models and evocative of local symbolism, swords and crosses emblazoned the elite's redefinition of their realm as a Christian land on their own terms through an innovative correlation of deep-rooted, local traditions with once foreign, but soon naturalized European ideas and visual forms.

The Kongo kingdom's elite eagerly acquired and used many types of swords, including locally crafted or imported scimitars or slender rapiers. However, the swords of status that twentieth-century Kongo rulers from regions once under the purview of the kingdom still treasured under the name of *mbele a lulendo*, or swords of honor, followed over the centuries a distinct, stable pattern (cat. 1.1, 1.2, 1.3).[2] Around a meter long, Kongo honorific swords are characteristically crafted with the blade, guard and handle in the same plane. A long and wide double-edged blade ends in an elaborately shaped and decorated guard, topped with a round pommel, often pierced with two eyelike openings, lending to the swords a distinct anthropomorphic air. Decorated ivory or wooden handles complete the design (fig. 2.1).

The form of the swords derives from Iberian examples that reached central Africa with the first Portuguese explorers at the end of the fifteenth century and memorializes the conversion of the kingdom that soon followed this first encounter. Written

Fig. 2.1. Detail of Kongo honorific sword. RMCA collection, Tervuren, Belgium, HO.1955.9.20. By permission of RMCA.

and oral histories of the events that led the kingdom's rulers to adopt Catholicism showcase the weapons prominently. In the different iterations of the story, iron swords providentially appear in the hands of Saint James and an army of knights, under a resplendent celestial cross, to help the great early Christian king of Kongo, Afonso, secure the throne and impose Christianity as the realm's official religion.[3] The miraculous swords of the narratives gave legitimacy to the incoming king in both local and Christian terms; they associated his accession to the throne with deep-rooted central African metaphors of iron kingship as well as with the European-derived symbolism of the weapons as emblems of nobility and Christian knighthood. These stories proved very successful, and the swords became paramount symbols of Kongo Christian might and prestige for centuries.

The coat of arms that the kings of Kongo used from the sixteenth to the nineteenth century, for example, shown here on an early map of the kingdom first published in Rome in 1591, consists of five swords arranged on an escutcheon, recalling the miraculous apparition of the narratives and giving heraldic form to the link between kingship and iron that existed in central Africa since time immemorial (fig. 2.2). Beyond heraldry, swords appeared in the Christian Kongo during coronations, elite burials, and ceremonial displays of allegiance. They shone in particular in *sangamento* dances, when they swayed in the hands of elite men whose acrobatic leaps and bounds made awe-inspiring showcases of strength and agility (fig. 2.3). It is the vigorous arm and dynamic gestures of the ideal *sangamento* dancer that the swords' top parts recall.

Fig. 2.2. Detail of Kongo coat of arms, from a map titled *Tabulam hanc Regni Congo*, 1598. University of Florida Map and Imagery Library at George A. Smathers Libraries, University of Florida.

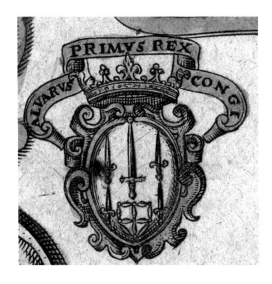

Fig. 2.3. Watercolor of 18th-century Capuchin missionary witnessing a *sangamento*, Sogno, Kingdom of Kongo, 1740s. By Bernardino Ignazio da Vezza d'Asti; 7.75 × 11 in. (19.5 × 28 cm). Biblioteca Civica Centrale, Turin, MS 457, fol. 18.

Under the piercing, wide-open eyes of the pommel, the guard and handle outline broad shoulders and thick arms in animated attitudes of strength and determination, one arm up, the other down, or fists firmly planted on the hips. These canonical Kongo gestures and their association with iron also notoriously appear in the stance of nineteenth-century central African power figures.[4] The spellbinding *nkisi* Manyangu in cat. 4.3, who probably once held an iron blade in his right hand, stands at the ready in this very attitude; the equally intimidating *nkisi nkondi* in cat. 4.2, for his part, stands in a more restrained posture but bears an iron sword planted in the chest.

If the swords evoked ideas of strength and aggression, they also encompassed a religious dimension. They often heralded the sign of the cross at the end of their guards (fig. 2.1) and in designs etched on their handle's surface. Related engravings

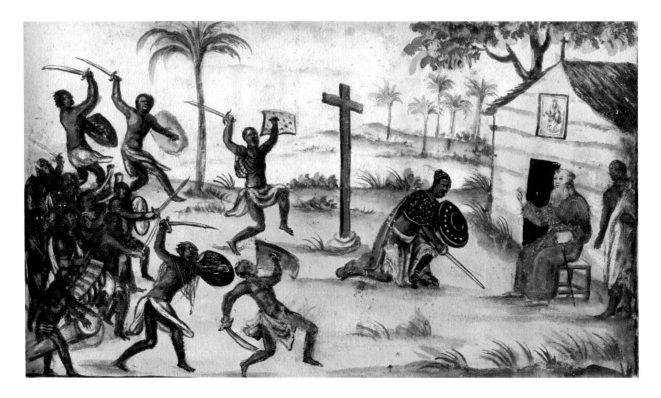

Fig. 2.4. Detail of designs etched on the blade of a sword. RMCA collection, Tervuren, Belgium, HO.1955.9.21. By permission of RMCA.

also occasionally decorated the blade itself (fig. 2.4). These motifs evoked the celestial cross that accompanied the apparition of Saint James but also closely echoed the patterns found on Kongo crucifixes, the other prominent insignia of the Kongo Christian elite. The X-shaped crosses on the blade of the sword in fig. 2.4 and on the loincloth of the Christ in cat. 1.9 draw close parallels between the two objects worn together as part of Kongo regalia. In the crucifixes, Kongo artists entwined the Christian narrative of Christ's death and resurrection rendered in expressive representations of the dying man with central African ideas of a fluid connection between life and death, expressed in local terms with the sign of the cross. The multivalent associations of the cruciform motif with ideas of death and regeneration probably predated the advent of Catholicism in the region and functioned in the kingdom as a powerful symbol both within and without the orbit of the Church.[5]

Large Kongo crucifixes made of precious copper alloy (cat. 1.7 to 1.12) were key emblems of power that remained, as did the swords, among the local rulers' most regarded treasures into the twentieth century. From the kingdom's Christian era to the colonial period, swords of honor and crucifixes defined and expressed might and prestige. Today, they continue to testify to the central and enduring role that Christianity played in the ways in which members of the Kongolese elite defined themselves and legitimated their authority from circa 1500 to the colonial era.

Notes

1. Bassani, "Ivoires et Tissus Kongo."
2. Wannyn, "Les armes ibériques et autres du Bas-Congo."
3. Fromont, "Dance, Image, Myth, and Conversion in the Kingdom of Kongo."
4. Thompson, "La gestuelle kôngo."
5. Fromont, "Under the Sign of the Cross in the Kingdom of Kongo."

The Capuchins' Didactic Documents

The Capuchins created documents to instruct future missionaries for work in Central Africa. One of these was *Missione in prattica: Padri cappuccini ne Regni di Congo, Angola, et adiacenti*, written and illustrated by Bernardino Ignazio di Vezza d'Asti in about 1750. Some twenty full-page color images with captions, along with nine pages of text, demonstrated what prospective missionaries would encounter, how they were to work in Kongo and what was expected of them in adjusting to the new social and natural environment. Local peoples and their customs could be studied in preparation for the journey, and prospective missionaries were informed about the way to organize church services in Kongo and about how to interact with Kongolese Christians. For example, one vignette shows a missionary arriving with his entourage. The village head greets him dressed in regalia, backed up by his own entourage of warriors wielding weapons and musicians playing local instruments. The caption informs the viewer that a chief's permission was required to establish a mission. Another watercolor shows a Capuchin conducting mass while his assistants, the chief and his people kneel in worship. Captions for such scenes might instruct how to set up portable altars and how they should be left up all day to be seen, thus encouraging devotion among those who observed. Other vignettes referred to what the Capuchins saw as idolatry and the work of sorcerers, as for example, a scene of a missionary torching a "fetish house." The Capuchins had little tolerance for African ritual. Their interventions had the objective of exposing the impotence of spirits and "sorcerers." The *Missione in prattica* tells us about mid-eighteenth-century European ideas about Central Africa and also informs about what was going on in Kongo in that period, albeit through Friar Bernardino's eyes.

RP

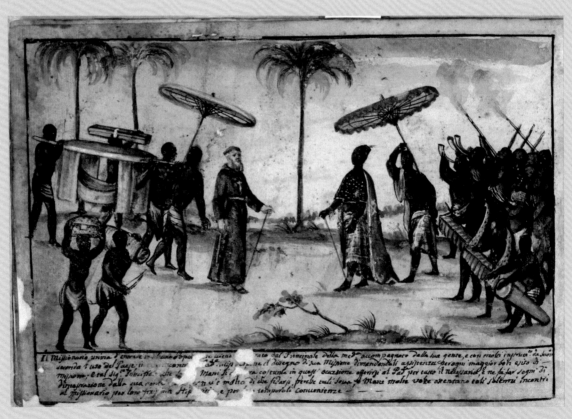

Ill. 2.1. Capuchin Missionary Being Greeted by a Village Head. Sogno, Kingdom of Kongo, 1740s. *Missione in prattica: Padri cappuccini ne Regni di Congo, Angola, et adiacenti*, Biblioteca civica centrale, Torino, MS 457. By permission of Biblioteca civica centrale, Torino.

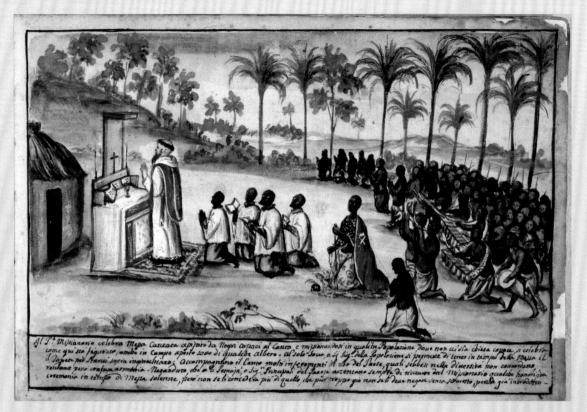

Ill. 2.2. Capuchin Missionary Celebrating Mass. Sogno, Kingdom of Kongo, 1740s. *Missione in prattica: Padri cappuccini ne Regni di Congo, Angola, et adiacenti*, Biblioteca civica centrale, Torino, MS 457. By permission of Biblioteca civica centrale, Torino.

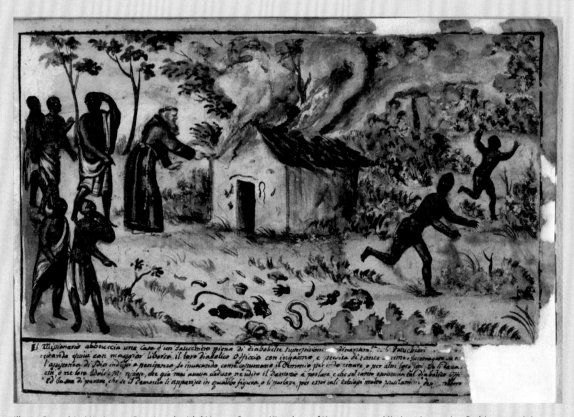

Ill. 2.3. Capuchin Missionary Burning the Idol House. Sogno, Kingdom of Kongo, 1740s. *Missione in prattica: Padri cappuccini ne Regni di Congo, Angola, et adiacenti*, Biblioteca civica centrale, Torino, MS 457. By permission of Biblioteca civica centrale, Torino.

3 ◈

Rock Art as a Source for the History of the Kongo Kingdom

GEOFFROY HEIMLICH

The rock art of Lower Congo extends from Kinshasa to the Atlantic coast and from northern Angola to southern Congo-Brazzaville. Although already reported in the nineteenth century by James Tuckey during his exploration of the Congo River, it has never been the focus of a comprehensive research project. As a result, its age has long remained uncertain.

The Lovo Massif is situated north of the kingdom of Kongo, in a region inhabited by the Ndibu, a subgroup of the Kongo people.[1] Although Kongo has been, since the end of the fifteenth century, one of the best documented kingdoms of Africa, both through historical records and through ethnographic and anthropological studies in more recent times, in archaeological terms it remains largely unknown.[2] However, with 102 sites surveyed so far, including sixteen decorated caves, the Lovo Massif has the largest concentration of rock art in the entire region.[3] Hundreds of limestone outcrops with carved surfaces, punctuated by numerous caves and rocky overhangs, rise up over an area of about 400 square kilometers (fig. 3.1).

Through the research I have undertaken, it has been possible to obtain for the first time direct dates for the rock art of Lower Congo. The study of the previously unknown decorated caves of Tovo and Nkamba, in particular, has allowed us to ascertain the chronology and the interpretation of the rock images.

The Decorated Cave of Tovo: Kongo Cross and Kimpasi

The Tovo cave is situated on top of an outcrop, which it crosses from side to side. The drawings are in the first room, where they are partly obliterated, and in the upper gallery, which is difficult to access. In this gallery geometric drawings are predominant, in contrast to the first room that has lizards and anthropomorphic shapes.

From the gallery a narrow passage leads into a confined room. Two crosses whose lines intersect in the middle are associated there with an indeterminate drawing (a coat of arms?) (fig. 3.2). This same type of cruciform motif is found in the first room, without being associated with a particular pattern. These two crosses have

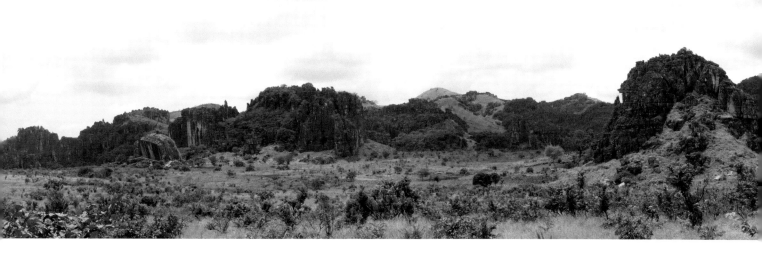

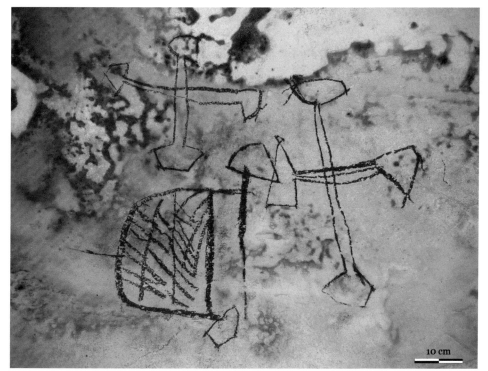

Above: Fig. 3.1. Photograph of the limestone rocks of the Lovo Massif, Lower Congo, DRC, 2010, by Geoffroy Heimlich. By permission of the author.

Right: Fig. 3.2. Photograph of crosses painted on the rocks inside the cave of Tovo, Lower Congo, DRC, 2011, by Geoffroy Heimlich. By permission of the author.

been dated by carbon-14 between 1633 and 1804 cal AD. A careful study of the wall has revealed the presence of a resin (copal?). This seems to have been added subsequent to the indeterminate drawing dated between 1515 and 1800 cal AD.

Could rock art be related to the initiation ceremonies of Kimpasi? As reported in the second half of the seventeenth century by the missionaries Girolamo da Montesarchio and Giovanni Antonio Cavazzi, Kimpasi took place south of the Congo River.[4] Initiation occurred when the community felt the need to avert the calamities with which it was afflicted. Kimpasi was considered a place of resistance to Christianity, and the missionaries saw it as a major obstacle to their work. Father Cavazzi described an enclosure forbidden to the uninitiated and he referred to it as the "Wall of the King of Kongo." There the "Nequiti" engaged in secret rites, "in the most remote

of all places." The main ritual consisted of an initiation ceremony where the future initiates were designated to undergo death and resurrection in a sacred compound.

In the Kongo worldview, as frequently observed by missionaries in the seventeenth and eighteenth centuries, the cross was an important symbol of the passage between the world of the living and the hereafter. Closely associated with Kimpasi, the cross was used to mark the entrance of the initiation compound or, during the rituals, to reinforce the power of an "idol." Unlike the Latin cross, whose lines intersect at three quarters, Cécile Fromont defines the "Kongo cross" as composed of two segments intersecting at right angles at the center, forming the diagonals of a lozenge.[5] This is how the cross is depicted at the cave of Tovo.

Oral traditions collected in the Lovo Massif seem to confirm the Kimpasi hypothesis. Two outcrops close to the Tovo cave are still known today for having hosted Kimpasi until the beginning of the twentieth century. At one of them, Mongo dia Ngiandilwa, three previously unknown sites have been inventoried. Their rock images include the Kongo cross and are similar to those of the cave of Tovo. One of my informants who is a Kimpasi initiate has also revealed to me that during the initiation, paintings in red and black were made.

The Decorated Cave of Nkamba: An Older Art

Like the Tovo cave, the cave of Nkamba is located on top of an outcrop, which it drills from side to side. A decorated frieze situated at the entrance of a profound network is of interest to us here (fig. 3.3). Two motifs call for our attention, in particular because of their postures: on the right there is a human figure with the left hand on the hip and the right arm raised, and on the left, a lizardlike shape with the left arm down and the right arm raised.

These two poses frequently occur in Lower Congo rock art. Figures shown as either smoking a pipe, or armed with a bow, a sword, a shield or a gun, most often adopt such poses. Being characteristic of Kongo art, these poses appear, for example, on the carved hilt of the prestige swords of the sixteenth century (cat. 1.1, 1.2 and 1.3). Manufactured in European fashion, they were part of the regalia of the Kongo elite.[6]

Fig. 3.3. Photograph of drawings on the rocks inside the cave of Nkamba, Lower Congo, DRC, 2010, by Geoffroy Heimlich. By permission of the author.

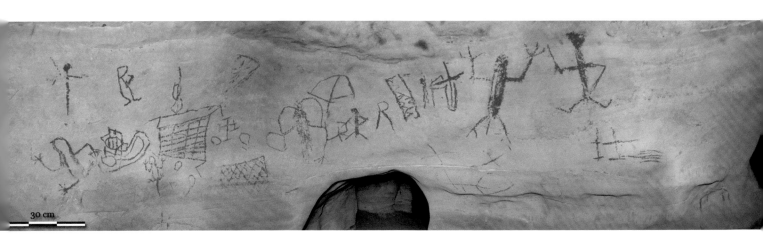

30 cm

The end of the hilt, often pierced with two holes, looks like a head, and the part that protects the hand resembles the arms of a human figure. This same gesture is found on the coat of arms of the kingdom of Kongo. Following the design of King Afonso I in 1512, it depicts two characters with one arm raised and the other hanging down. Kongo nobles were also represented in such a pose, albeit slightly later, in an engraving published by Girolamo Merolla in 1692 and in another one published by Louis Degrandpré in 1787.

The human figure on the right has been dated by carbon-14 between 1290 and 1625 cal AD. This date confirms the symbolic importance of this posture in Kongo visual culture, which may well go back to the thirteenth century. It is all the more significant since we still do not know for how long the kingdom of Kongo had existed prior to the arrival of Europeans. Just like historical records and oral traditions, rock art can provide historians with primary documentation that offers a glimpse of the past of the kingdom of Kongo.

Notes

1. This is the topic of my doctoral thesis, which is in preparation under the supervision of Pierre de Maret (Free University of Brussels) and Jean-Loïc Le Quellec (University of Paris I). I wish to thank the Institute of the National Museums of Congo, the Center for Research and Restoration of the Museums of France, the French Institute of South Africa and the Royal Museum for Central Africa in Tervuren, Belgium.

2. The interdisciplinary project "KONGOKING" of Ghent University, the Free University of Brussels and the Royal Museum for Central Africa, started in 2012, intends to undertake the first systematic archaeological research on the origins of the kingdom.

3. Heimlich, "Lower Congo Rock Art" and *Archéologue au Congo*.

4. da Montesarchio, "Viaggio"; Cavazzi, *Istorica descrizione*, 85–86.

5. Fromont, "Under the Sign of the Cross."

6. Fromont, "Dance, Image, Myth, and Conversion." Sending out a message of strength, power and aggression, this pose echoes the movements of the *sangamento* dancers and their use of these swords during this martial ritual.

The Kongo Cross across Centuries

As attested by the atypical crosses of the Nkamba cave, which may date back to the thirteenth century, the cross is a key symbol within Kongo cosmology, independent of European influence. Other crosses, such as those of the Tovo cave, which date from the seventeenth to the eighteenth centuries, are similar to crosses found in Kongo Christian art, as exemplified by Kongo crucifixes or markings on tombstones.

The cross was one of the major signs of the Kimpasi initiation ceremony, much to the annoyance of European missionaries. Placed in the middle of a shrine and flanked by two anthropomorphic statues, the cross referred to the cyclical passage from death to afterlife, during the initiation ceremonies of Kimpasi. The cross thus marked important places for Kimpasi ritual. Other markers were strangely shaped stones and twisted, red-colored roots—known to be embodiments of *nkita* spirits—which have been found in one of the decorated caves. Nowadays, several local Kongo chiefs still relate some of the rock art of the Lovo Massif to Kimpasi.

At the confluence of Kongo and Christian religious thought, the cross was a symbol of equal importance to both religious cultures, belonging to Kongo traditional religion as well as Christianity.

GH

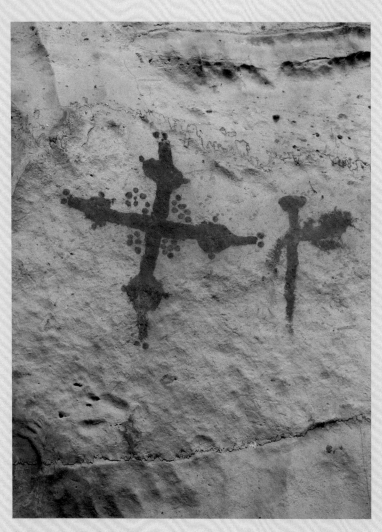

Ill. 3.1. Photograph of a cross at the rock art site of Mbanza Mbota, Lower Congo, DRC, 2008, by Geoffroy Heimlich. By permission of the author.

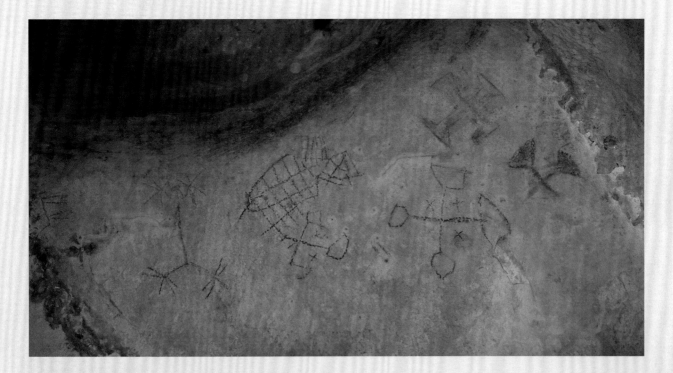

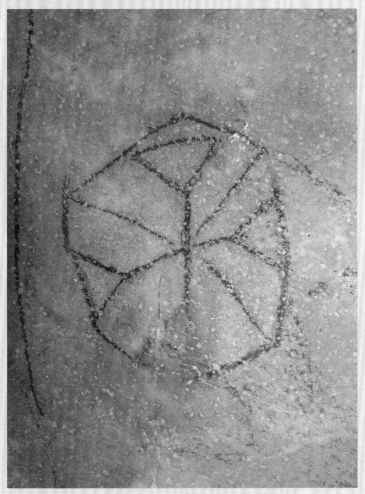

Above: Ill. 3.2. Photograph of crosses in the cave of Ntadi Ntadi, Lower Congo, DRC, 2008, by Geoffroy Heimlich. By permission of the author.

Left: Ill. 3.3. Photograph of a cross in the cave of Ntadi Ntadi, Lower Congo, DRC, 2008, by Geoffroy Heimlich. By permission of the author.

Kongo, North America and the Slave Trade

JELMER VOS

The transmission of Kongo culture to the United States resulted from the forced migration of Central Africans that began about 1619 and ended almost two and a half centuries later, in 1860. In this period, an estimated 92,000 slaves were carried from West Central Africa to mainland North America, which was around a quarter of all enslaved Africans arriving directly from the home continent.[1] West Central Africa was, indeed, the largest African region of origin of slaves in North America besides Senegambia. The overwhelming majority of Central Africans arrived between 1720 and 1808, when their labor supported the expansion of the tobacco, rice and cotton economies of the American South. Practically all had left Africa via the Congo River or ports along the coast north of the river, the so-called Loango Coast. Many of the slaves shipped from the Congo River and the Loango Coast were of Kongo origin.

Central Africans in North America

In 1619, "twenty-odd negroes," taken on the high seas from a Portuguese slaver that had sailed from Luanda, were set ashore in Virginia. Although the African origins of these individuals remain obscure, some might have come from the Kongo region north of Portuguese Angola.[2] This case, well known among scholars of American slavery, is representative of the first generation of Central Africans in British North America. Except for those carried by the *Good Fortune*, a vessel from London that sailed from the coast of Angola (possibly Soyo) to Virginia in 1628, all Central Africans arriving in North America in the first half of the seventeenth century were captured from Portuguese ships by Dutch or British privateers.[3] The main port of the Portuguese slave trade in Africa was Luanda, which drew captives from a wide hinterland that included the kingdom of Kongo.

In addition to the hundreds of enslaved Central Africans seized from Portuguese vessels, the Dutch carried close to a thousand captives from Loango to New York before the British annexation in 1664. All these would become part of what historian Ira Berlin has called the "charter generation": African men and women who had

a working knowledge of European languages and cultures and were often able to negotiate their freedom in nascent New World societies. In New Netherland, these so-called Atlantic creoles were employed on farms and in urban jobs at the side of white Europeans and were allowed to trade for themselves and accumulate property. In early colonial Virginia and Maryland, where the British ruled, coerced labor was not yet exclusively identified with African descent, and black bondsmen lived and worked alongside white indentured servants, while more than a few earned their freedom.[4]

After 1676, the British slowly replaced the institution of indentured servitude with black slavery in the Chesapeake, as tobacco was becoming an increasingly important export crop. But until 1710, direct slave imports from Africa remained modest compared to the transatlantic slave trade to other parts of the New World, and hardly any of the African captives the British brought to their North American colonies in this period came from West Central Africa.

Table 4.1 Central African captives delivered in the United States, 1628–1858

	Northern United States	Chesapeake	Carolinas and/or Georgia	Gulf states	Unspecified, United States	Totals
1628–1630	0	100	0	0	0	100
1631–1640	0	0	0	0	0	0
1641–1650	0	0	0	0	0	0
1651–1660	434	0	0	0	0	434
1661–1670	682	96	0	0	0	778
1671–1680	0	0	0	0	0	0
1681–1690	0	0	0	0	0	0
1691–1700	0	0	0	0	0	0
1701–1710	0	231	0	0	0	231
1711–1720	0	220	0	0	0	220
1721–1730	0	3,505	306	319	304	4,434
1731–1740	3,401	9,597	18,362	0	222	31,582
1741–1750	878	1,343	287	0	325	2,833
1751–1760	0	4,042	3,183	0	0	7,225
1761–1770	0	2,307	5,754	0	0	8,061
1771–1780	0	681	2,638	0	0	3,319
1781–1790	0	0	2,445	199	0	2,644
1791–1800	0	0	474	394	0	868
1801–1810	0	0	26,439	1,489	0	27,928
1811–1820	0	0	0	1,230	0	1,230
1821–1830	0	0	0	0	0	0
1831–1840	0	0	0	0	0	0
1841–1850	0	0	0	0	0	0
1851–1858	0	0	303	0	0	303
Totals	5,395	22,122	60,191	3,631	852	92,192

Source: Estimates Database. 2009. *Voyages: The Trans-Atlantic Slave Trade Database.* http://www.slavevoyages.org/tast/assessment/estimates.faces (accessed August 11, 2012).

From the second decade of the eighteenth century, however, the slave trade to North America expanded rapidly with the development of rice and, later, indigo cultivation in the Carolinas and Georgia and with the further growth of tobacco in the Chesapeake (fig. 4.1). This coincided with an increase in the number of captives arriving from West Central Africa, who had thus far formed only a marginal portion of the North American slave population. In the 1720s most Central Africans still ended up on plantations in Maryland and Virginia where, nonetheless, they always remained numerically less significant than those from Senegambia or the Bight of Biafra. But after 1730 the forced migration of Central Africans was largely directed to South Carolina and Georgia, which were fast becoming the new centers of the North American plantation economy. Here, in the Lowcountry South, Central Africans were dominant. About a third of all enslaved Africans arriving in the ports of Charleston and, since the 1760s, Savannah had left Africa via the Loango Coast or the

Fig. 4.1. Map illustration showing slaves engaged in indigo production. From "A Map of South Carolina and a Part of Georgia," by De Brahm 1757. University of Florida Map and Imagery Library at George A. Smathers Libraries, University of Florida.

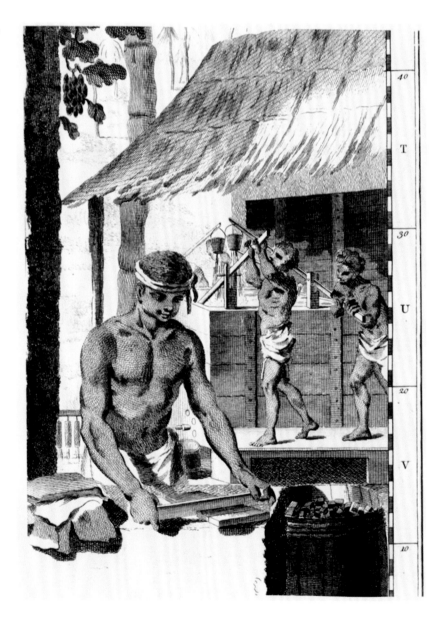

Congo River. Especially through the transmission of cultural and religious practices, including Christian rituals, they left a massive imprint on the formation of slave society in North America. For instance, the homegrown Catholicism of many enslaved Kongolese was fundamental to the creation of the "Angolan" communities of runaway slaves in Spanish Florida and the Stono rebellion of 1739 in South Carolina.[5]

The boom in North American slave imports, which turned Charleston into a leading New World slaving port, ended with the onset of the American Revolution in 1776. Following the revolution, only Georgia (after 1783) and South Carolina (1804–7) allowed slave ships from Africa entry into their Atlantic harbors. This new generation of enslaved Africans, still predominantly from West Central Africa, was especially brought in to satisfy a growing demand for labor among cotton planters in the American South.

Direct slave imports from Africa became rare after 1808, when the United States officially abolished the slave trade. However, in the first decade after abolition, Florida and New Orleans still managed to import more than 5,000 slaves illegally from Africa; many of these were carried from the Congo River on vessels using the Spanish flag. Except for the 1720s, when French vessels disembarked close to 8,000 West Africans on Louisiana shores, the Gulf Coast was never a major site of direct slave imports from Africa. The same is true for Florida, where only after the British takeover in 1763 were slaves brought in from the African continent, albeit in small numbers and hardly any from West Central Africa.[6]

In short, it was during the time of the "plantation" and "revolutionary" generations,

Fig. 4.2. Painting of slave houses at the Mulberry plantation, South Carolina, ca. 1800. Gibbes Museum of Art, Charleston, South Carolina. By permission of the Gibbes Museum of Art.

from the 1720s to 1808, that most enslaved Central Africans reached North American shores, some 20,000 in the Chesapeake and 60,000 in Georgia and the Carolinas. Much smaller numbers arrived in the Middle Colonies, in particular New York, and the Gulf states. All but a few had been shipped from the Congo River and the three main harbors on the Loango coast: Cabinda, Malembo and Loango-Boary. In contrast to Portuguese Angola, immediately south of the Kongo kingdom, these were places where British and American slavers enjoyed freedom of trade. Moreover, the hinterland of this coastal zone, where many of the captives were taken, was inhabited by Kongo and related peoples.

African Origins

The trade in slaves from West Central Africa to North America was almost exclusively carried out by merchants from Great Britain and the United States. In the seventeenth century, Dutch traders shipped a thousand Africans from Loango to New York, while French companies brought some 300 from Cabinda to Biloxi in 1721 and another thousand from the Loango Coast to Georgia and Louisiana in the 1780s and 1790s. But these are small numbers compared to the approximately 106,000 Central African captives carried to North America on British and American vessels. An estimated 90,000 of these survived the infamous Middle Passage, the transatlantic crossing that on average lasted two months. About a quarter of all the enslaved were children (under age fourteen) and almost 70 percent were male. Significantly, all were shipped from places north of Portuguese Angola—Ambriz, the Congo River, and the Loango Coast—where traders from different nations competed for slaves supplied by local African brokers.

The slave trade from the Loango Coast to North America began in earnest in the 1730s, when rice cultivation (which started in the late seventeenth century) was expanding in the Lowcountry South. Close to 40,000 Central Africans were shipped to North America in this decade, more than double the number dispatched from any other African region in the same period. Perhaps in response to the Stono rebellion, the slave trade between the two regions was minimal in the 1740s, but increased again in the quarter century before the American Revolution. The trade reached new heights in the four years before abolition (1804–7), when South Carolina reopened its ports for African slave imports and more than 30,000 Central Africans were captured to labor on Southern cotton fields.

During the eighteenth century, trade to North America was concentrated in three ports on the Loango Coast—Cabinda, Malembo, and Loango-Boary—but after 1800 the Congo River became by far the most important place of slave embarkation for British and American vessels.[7] Close to 68,000 slaves arrived in North America from the Loango Coast, practically all before 1808. Even if part of different kingdoms, all ports along this coast were supplied with slaves by Vili merchants from the kingdom of Loango, who had specialized in the long-distance trade of copper and ivory since the late sixteenth century. The Vili procured slaves from a wide range of sources:

from modern Gabon in the north, from Malebo Pool (Kinshasa) in the east, from the kingdom of Kongo, and from as far south as the hinterland of Portuguese Angola. Documentary evidence shows that since the seventeenth century, Vili merchants settled in towns along the main trade routes in Kongo and Angola. Although there are no historical records to determine exactly where most of the captives shipped from the Loango Coast originally came from, it is generally thought that the Kongo region was a chief, if not the most important, source of slaves.[8]

In contrast to the sixteenth and seventeenth centuries, when the Kongo kingdom sold few of its own subjects into the Atlantic slave trade, after 1700 many exported captives were the victims of political conflicts, kidnapping and judicial proceedings within the region. The peace agreement of 1709, which put an end to a civil war that had ravaged the country during more than four decades and had divided the kingdom into several autonomous provinces, was followed by continuous factional struggles within Kongo. The lives of many freeborn Kongolese became increasingly vulnerable, as political opponents enslaved each other's followers and people found guilty of treason, witchcraft, adultery and other crimes were frequently sold into slavery.[9]

In this period, the main destinations for enslaved Kongolese—besides those who were retained in Kongo—were the Loango Coast, Boma on the Congo River, Ambriz, and Portuguese Angola. In Luanda, most slaves boarded vessels destined for Brazil, but some were kept in local households. Such was the fate of twenty-five-year-old Ana, who was born around 1725 in the kingdom of Kongo but had been kidnapped at a young age and then sold to Josefa, a freed black woman in Luanda.[10] On the coast just north of Portuguese Angola, Ambriz became an important outlet for the slave trade in the 1780s, although already in 1752 the British vessel *Happy* carried more than 100 enslaved individuals from there to Rappahannock, Virginia. The only other recorded voyage from Ambriz to North America took place during the illegal phase of the trade. In 1858 the infamous American schooner *Wanderer* managed to disembark some 300 captives from the Kongo coast in Savannah, after which it was captured by the U.S. authorities. Perhaps altogether 2,000 reached North America via Ambriz.

For the shipment of enslaved Kongolese to North America, the Loango Coast and the Congo River were clearly more important places of departure. Several routes connected the Kongo realm to ports on the Loango Coast. The main geographical factor influencing regional patterns of trade was the Congo River, which for much of its course downstream from Malebo Pool is barred by cataracts, rapids and rocks. From all over Kongo, slave traders gathered at Manianga, Isangila and Inga, which were crossing points on the river that gave access to paths leading to the Loango Coast. From the capital São Salvador (Mbanza Kongo), itself a key node in the regional long-distance trade, slaves also crossed the river at Boma, from where they were further dispatched to Cabinda and Malembo. In the Congo estuary, the south bank port of Mpinda (Soyo) had long since lost its function as Kongo's principal export outlet, but the local Solongo people continued to sell their slaves across the river in Cabinda.

Fig. 4.3. Photograph of Ponta da Lenha, Lower Congo, DRC, by J. A. da Cunha Moraes. Published in da Cunha Moraes 1885.

After 1800, the Congo River itself became the main channel for the slave trade to North America. Approximately 22,000 were transported to the southern United States from the river, where Boma was the main place of trade. Boma was first seriously exploited as a slaving port by British traders in the final decade of the eighteenth century, but it gained increasing importance after the United Kingdom and the United States outlawed the Atlantic slave trade in 1807 and Brazilian, Cuban and a few American slavers began to use the Congo River as a refuge to evade the British navy. During the illegal phase of the trade, the movement of slaves in the Kongo region was increasingly directed toward Boma, from where captives were carried further downstream for shipment at Ponta da Lenha or Cabinda (fig. 4.3). As the only port on the Loango Coast, Cabinda flourished in this period, and an estimated 1,200 were shipped from there to the southern United States after 1808.

By the mid-nineteenth century, when Brazil was about to ban the slave trade so that Cuba would remain the only country in the Americas still systematically importing Africans, the Congo River had become the main site of human trafficking along the Atlantic coast of Africa. In this period, the slave trade from the river increasingly victimized male children. Records of a French scheme to contract allegedly free migrants in the river around 1860 indicate that most Central Africans offered for sale at

the Boma market hailed from the Lower Congo region (fig. 4.4). Most came from Boma itself, but other localities that many ransomed slaves identified as their place of origin were Kongo (Mbanza Kongo and vicinity) and Nsundi.

The French also collected information on causes of enslavement. Most of those sold into the Atlantic trade around this time were born into slavery. As the most vulnerable group in their home communities, they were the easiest victims of the commercial forces corrupting Kongo society during the era of the slave trade. In addition, numerous freeborn individuals had been sold into slavery by their own families. For many young adults and children the reason for their enslavement had been an alleged theft by a parent. Men and women were also frequently enslaved as they themselves were accused of stealing. But parents could meet their fines for debts, judgments and theft by transferring their children. Children were thus often victimized to compensate for the crimes or financial obligations of their parents.[11]

The brief life stories of liberated Central Africans interviewed in Sierra Leone around 1850 by the German missionary Sigismund Koelle confirm that, notwithstanding the blatantly violent procedure of kidnapping, often more delicate mechanisms were used to produce slaves in the Kongo region in the first half of the nineteenth century. A number of the interviewed ex-slaves had been surrendered by

Fig. 4.4. "A French Free Emigrant on His Way to the Barracoon of M. Régis," drawing by Lt. Henry Hand, 1858. Public Record Office, London, FO 84/1070. By permission of the Slavery Images Database, sponsored by the Virginia Foundation for the Humanities and the University of Virginia Library.

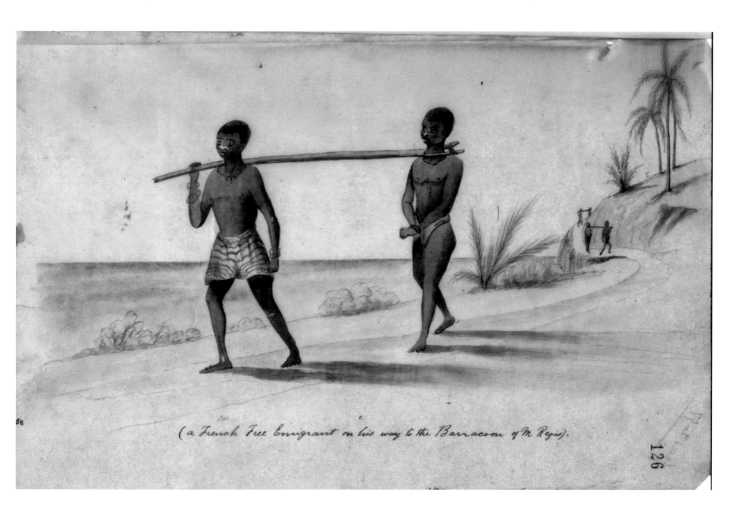

(a French Free Emigrant on his way to the Barracoon of M. Regis).

their elders, including a Teke man who was sold at the age of seventeen and brought through Mayombe to the Loango Coast. Others, again, had been sold because of crimes committed by their relatives. These included the case of Kumbu from Mayombe who, already a father, was enslaved after his sister was accused of witchcraft, and the case of a Mbete man who was enslaved after his mother had run away from his father when he was sixteen years old; for several years he was traded from one place to another before ending up onboard a slave ship in Loango. Still others had been enslaved on account of adultery, debt and "bad conduct."[12]

Such was the background of the last Central Africans who arrived in the United States on slave ships. In 1860, 250 years after the first Africans landed in Virginia, the U.S. navy intercepted three slaving vessels off the coast of Cuba. Two of them, the *William* (carrying 513 captives) and the *Wildfire* (507) had obtained their human cargos in the Congo River (ill. 4.3). The slaves were set ashore in Key West, where the African Cemetery is a telling monument to their harrowing voyage.[13] Within six weeks of landing at the Keys, the surviving captives were sent to Monrovia to be apprenticed to Americo-Liberian settlers. The ethnic label given there to recaptured Africans, "Congoes," aptly reflected the origins of many.[14]

Notes

1. In addition to 389,000 captives arriving directly from Africa, an estimated 113,000 slaves reached mainland North America via other parts of the Americas, especially the West Indies. See Eltis, "U.S. Transatlantic Slave Trade," 352–53. An assessment of the demographic impact on North American society of Central African captives arriving via the Caribbean is beyond the reach of this article. All the quantitative data used here, as well as the information on individual slave ships, derive from two sources: *Voyages: The Trans-Atlantic Slave Trade Database* (http://www.slavevoyages.org) and Eltis and Richardson, *Atlas of the Transatlantic Slave Trade*. I thank David Eltis and Paul Lachance for their advice on the use of these data.

2. Thornton, "African Experience." Because of an oversight, the enslaved Africans of the 1619 voyage are not represented in the estimates of the *Voyages* website and, therefore, do also not appear in table 4.1.

3. Heywood and Thornton, *Central Africans, Atlantic Creoles*, 5–48, 250–53, 262–67.

4. Berlin, *Generations of Captivity*, 23–39.

5. For a recent treatment of these topics, see Young, *Rituals of Resistance*.

6. In total, both states received an estimated 22,000 slaves directly from Africa. Less than one fifth were of Central African origin. Intercolonial traffic to Louisiana, which became especially important after the Haitian revolution in 1791, might help explain why more than a third of all identified ethnicities of slaves in Louisiana from 1719 to 1820 were Kongo. See Hall, *Slavery and African Ethnicities*, 43–44.

7. Mayumba was the northernmost port on the Loango Coast, but few British slavers traded there. Perhaps a thousand slaves were imported into North America from Mayumba.

8. Martin, *External Trade*, esp. 117–35.

9. Heywood, "Slavery and Its Transformation." For a general assessment of the export of Kongo slaves in the aftermath of the civil war, see Thornton, *Kongolese Saint Anthony*, 203–14. In the 1710s, few of these slaves would have reached North America directly, although some arrived here via the West Indies.

10. Arquivo Nacional da Torre do Tombo (Lisbon), Tribunal do Santo Ofício, Inquisição de Lisboa, proc. 5067: Sumário dos examens aos escravos do sargento-mor João Pereira da Cunha, capitão-mor do presídio de Ambaca (Lisboa 1750–51).

11. Vos, "Without the Slave Trade."

12. Koelle, *Polyglotta Africana*, 13–15.

13. Mel Fisher Maritime Heritage Society, "The Last Slave Ships."

14. Younger, "Liberia and the Last Slave Ships."

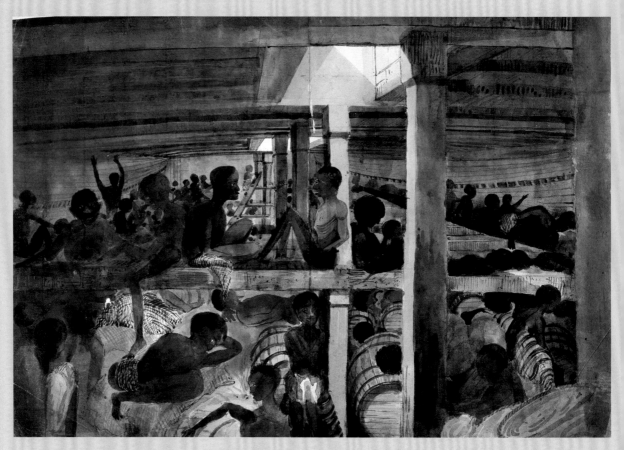

SECTIONS OF A SLAVE SHIP.

CABIN

HOLD

18 Feet

40 Feet

3 Feet 3 In.ͤ in height.

Ill. 4.1. Drawing of the "Sections of a slave ship," early 19th century. Published in Walsh, 1830.

Ill. 4.2. Watercolor of the slave deck of the Brazilian slave vessel *Albanez*, captured by the British Royal Navy in 1845, by Lt. Francis Meynell, 1845. Album of Lt. Meynell's water colors (MEY/2), National Maritime Museum, London (neg. A1818). By permission of the National Maritime Museum, Greenwich, London.

Images of the Middle Passage

In the final decades of the slave trade from West Central Africa, ships carried ever-larger cargos of enslaved Africans across the Atlantic, including the few illicit slavers that sailed to the United States in this period. When the British navy captured the Brazilian slave ship *Albanez* at the Cuanza River in Angola in 1845, it had 150 captives on board. Close to six hundred were kept nearby on improvised rafts ready to be embarked. The U.S. navy seized the American bark *Wildfire* off the coast of Cuba in April 1860 with 507 African captives on board. The slaves, who were mostly young males aged between ten and sixteen, had been purchased on the Congo River. Within six weeks of landing at Key West in Florida, the surviving slaves were sent to Liberia. Although the United States, which had abolished the slave trade in 1808, was only a minor destination during this phase of the slave trade, many slavers feeding the Cuban and Brazilian markets sailed under the U.S. flag.

JAV

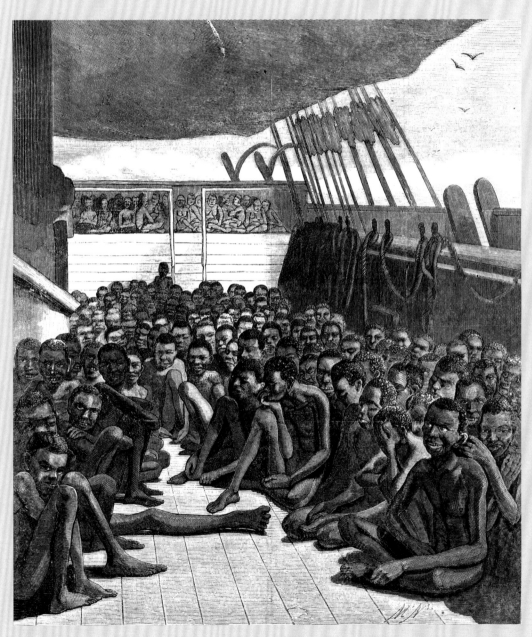

Ill. 4.3. View of the slave deck of the *Wildfire*, captured in April 1860 by the U.S. navy close to Cuba, engraved from a daguerreotype, published in *Harper's Weekly*, vol. 4 (June 2, 1860), p. 344.

5 ◇

The Kongo Kingdom and European Diplomacy

LINDA HEYWOOD AND JOHN THORNTON

The kingdom of Kongo was unusual among African countries in the degree to which it tried and was able to have a diplomatic presence in Europe and engage in other forms of Atlantic diplomacy. The conversion of Kongo kings and nobility to Christianity in 1491, their support of a school and religious system that allowed for the growth of self-sustaining literacy in Portuguese and the country's participation in the developing early modern Atlantic trade all contributed to the interest the kings and nobles showed in having a presence in Europe. Kongo students regularly visited and studied in Portugal in the early sixteenth century, and Henrique, the son of King Afonso I (c. 1456–1545), was elevated to the rank of bishop in 1518 after such a stint of European study. Virtually from the beginning of his reign (1509), Afonso sought relations not only with Portugal, but also with the Vatican, as he understood that the church could be a strong international ally that was independent of Portugal.

Afonso knew that in order to have effective control over the church in Kongo, he needed to have his own bishop, and his son Henrique met this need. After Henrique died and the Portuguese crown decided to undermine Kongo's independence by attempting to take control of the Kongo church by putting it under the bishop of the newly formed See of São Tomé in 1534, Afonso had to move to protect his autonomy. King Alvaro I (1568–86), who gained power some two decades after Afonso, as well as the kings who followed him, took action to claim the right to appoint his own bishops.

In the face of continued Portuguese diplomatic and military aggression that became more intense during his reign, Alvaro increased diplomatic contacts with Rome. First he sent Antonio Vieira, who had lived in Kongo for several years to go to Rome (Portugal prevented this); then, in 1588, he dispatched Duarte Lopes, a Portuguese New Christian (converted Jew). Lopes' mission was successful, and the papacy agreed to create a new episcopal see in São Salvador in 1596.

However, the fruits of this victory were limited. Portugal claimed the right of patronage over the new bishop and insisted on appointing Portuguese bishops. Relations between the kings of Kongo and their bishops (who often resided in Luanda,

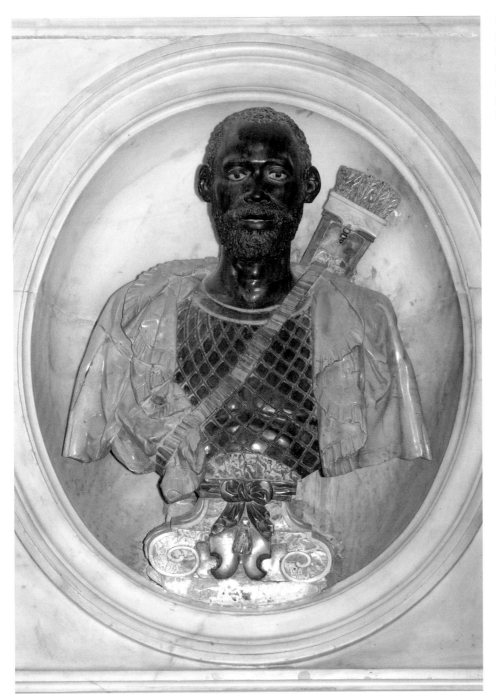

Fig. 5.1. Bust of Kongo's ambassador Antonio Manuel, by Francesco Caporale, 1608. Basilica di Santa Maria Maggiore, Rome. Photograph by Patrizio Sauzzi, 2004. By permission of Patrizio Sauzzi, Rome.

the capital of Angola, rather than in São Salvador) were cool and sometimes openly hostile.

In 1604, Alvaro II (1587–1614) decided to send another ambassador, a Kongolese named Antonio Manuel, to represent him in Rome. Antonio Manuel had been a schoolmaster and secretary in Kongo in his earlier life and had handled delicate diplomatic matters between the king of Kongo and his disobedient but powerful Count of Soyo. Alvaro appointed him Marquis of Funta (a small district in Soyo) and dispatched him to Rome. Antonio Manuel passed first to Brazil, where, among other

things, he freed a Kongo nobleman who had been captured illegally and enslaved there.

However, his trip from Brazil to Portugal became more complicated. As the ship in which he was traveling made its way to Portugal, it was captured by Dutch pirates, and although he managed to escape, most of his funds were stolen. When he arrived in Portugal he had very few funds and had to request help from Kongo residents in Lisbon and sympathetic churchmen. At the time of his mission the crowns of Spain and Portugal were united, and neither was eager to allow the mission to pass. As a result, Antonio Manuel spent four years seeking support from wealthy sponsors all over Europe to complete his mission, which he did in 1608, although he died soon after reaching Rome.[1]

While Antonio Manuel was unable to achieve the mission of regaining Kongo control over the bishops, he did manage to win the concession of having a "protector" of Kongo established in Rome, this being the Spanish prelate Juan Baptista Vives. Vives served as protector during another difficult time of Kongo's relations with Portugal. In 1622, after defeating the armies of Ndongo and pillaging the country, the Portuguese governor of Angola, João Correia de Sousa, decided to take an army into Kongo.

The Portuguese army was routed by Kongo's forces in battle early in 1623, and Kongo diplomacy kicked into high gear. Pedro II, then ruling in Kongo, sent letters to the pope and the king of Spain, declaring that the governor had no right to invade his Christian country. He asked that the captured people be restored. The pope wrote encouraging letters to him and sent letters of inquiry to the authorities in Spain. The result was that the king of Spain promised to restore some of the prisoners, and more than a thousand were returned from plantations in Brazil.

But the major point of Kongo diplomacy was their correspondence with the Low Countries and with the newly formed Dutch West India Company in the 1620s. In

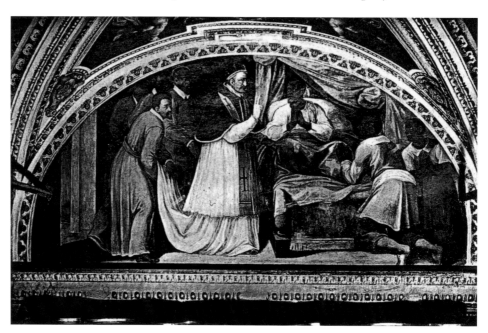

Fig. 5.2. Fresco showing Kongo's ambassador Antonio Manuel and Pope Paul V. Vatican Library, Rome. Reproduction published in Caraman-Chimay Borghese 1916.

Fig. 5.3. Coin commemorating
Kongo ambassador Antonio
Manuel's visit to Pope Paul
V. Vatican Library, Rome.
Reproduction published in
Caraman-Chimay Borghese
1916.

1613, Pedro II proposed that the Dutch ally with Kongo and invade Portuguese Angola. The Dutch agreed and sent a fleet under Piet Heyn, who would later become a major Dutch hero, to attack Luanda. But the conciliation that he had won in Rome made the invasion and support less attractive. Pedro II died before the Dutch came, and his son and successor, Garcia I, decided not to support the invasion. So when the Dutch fleet arrived, no Kongo army was there to join in the invasion.

While the initial negotiations did not result in a war, the relations between the Low Countries and Kongo continued. When Portuguese armies continued pressing on Kongo's vassals on the south, King Garcia renewed the alliance with the Dutch West India Company. This time, the joint invasion came to pass. A Dutch fleet seized Luanda in 1641, and Kongo armies operated with Dutch forces to drive the Portuguese from their positions close to the city, forcing them to retreat up the Kwanza River to their inland fort of Massangano. The Dutch were unwilling to press the Portuguese hard, but Kongo continued the alliance, especially after Queen Njinga of Ndongo and Matamba joined in the battle against the Portuguese.[2] During the course of this war both Kongo and its province of Soyo sent embassies to the Dutch in Brazil and then to the Estates General in the Low Countries. Soyo's mission was led by Miguel de Castro (see ill. 5.1).[3] While the Dutch abandoned their positions in Brazil in 1648, Kongo continued to maintain diplomatic relations with Portugal, Rome, and the Low Countries throughout the rest of the seventeenth century.

Notes

1. Heywood and Thornton, "Central African Leadership," 194–207.
2. Heywood and Thornton, *Central Africans, Atlantic Creoles*, 145–46.
3. Relevant documentation, and a commentary reconstructing the two embassies, is found in Jadin, *L'Ancien Congo et l'Angola, 1639–1655*, vol. 1, 373–75.

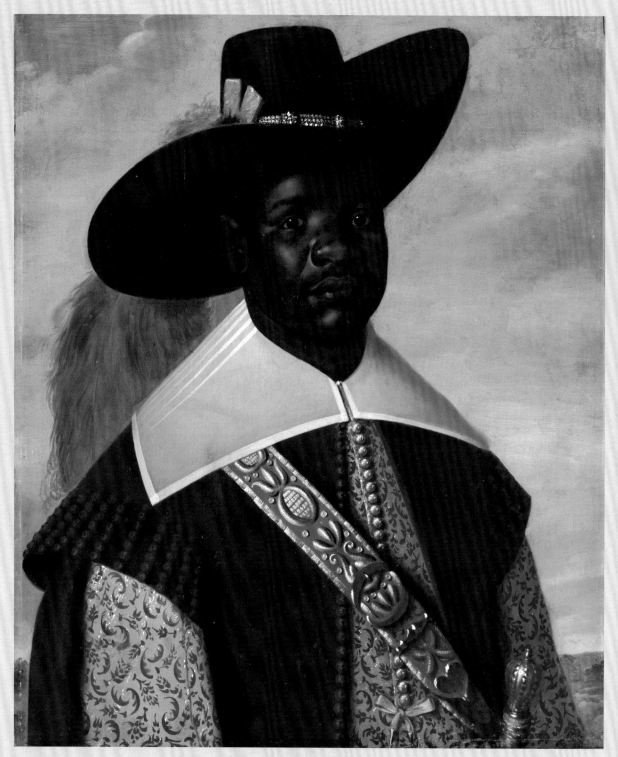

Ill. 5.1. Jasper Beckx, Miguel de Castro, Ambassador from the Kingdom of Kongo. 17th century. By permission of Statens Museum for Kunst, Denmark.

Portraits of Kongo Diplomats

Kongo representatives were being sent to Europe soon after contact was initiated between Kongo and Portugal. Some have been portrayed in European paintings and sculptures. For example, Alvaro II sent Antonio Manuel as envoy to Rome, where Paul V had intended to receive him with great pomp. The ambassador, however, was gravely ill after his long trip via Brazil and the Iberian peninsula, and he died days after his arrival in Rome. A bust by the artist Francesco Caporale can still be seen at Santa Maria Maggiore (fig. 5.1).

Another ambassador whose impressive image was recorded by a European artist is Dom Miguel de Castro, who was sent as the Kongo emissary to the Netherlands in the 1640s. Also traveling by way of Brazil, Dom Miguel sat for a portrait, painted by Jasper Beckx (previously attributed to Albert Eckhout). Dom Miguel's servants, Pedro Sunda and Diego Bemba, were also portrayed, each carrying an object reflecting arts and crafts that could conceivably be diplomatic gifts from Kongo—an ivory tusk and a basketry casket. In 1654 Johan Maurits, governor-general of Dutch Brazil and an employee of the Dutch West India Company, gave the three paintings to King Frederik III of Denmark. Maurits donated much of his collection to Leiden University and to European aristocrats such as Friedrich Wilhelm I of Brandenburg, Frederick III of Denmark, and Louis XIV of France. Such items, including taxidermy specimens of rare fauna, paintings, weapons, and articles of indigenous apparel, were prized by the recipients for their collections, which encouraged discussion among the aristocratic and scholarly public. These paintings of the Kongo diplomat and his servants were exhibited in King Frederick's Kunstkammer along with other paintings and objects related to the colonies.

RP

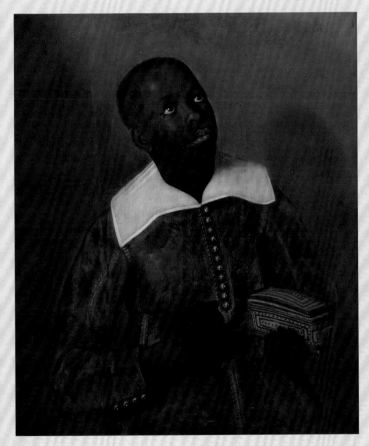

Ill. 5.2. Jasper Beckx, Dom Miguel de Castro's servant with a decorated casket. 17th century. By permission of Statens Museum for Kunst, Denmark.

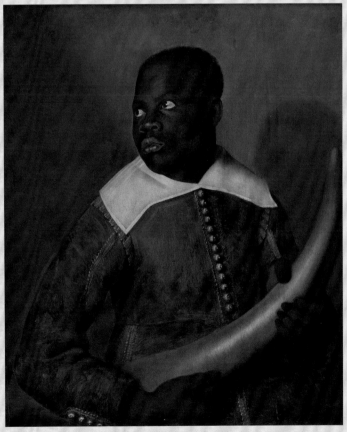

Ill. 5.3. Jasper Beckx, Dom Miguel de Castro's servant with an elephant tusk. 17th century. By permission of Statens Museum for Kunst, Denmark.

KONGO KINGDOM ART

Swords of Honor

Kongo nobles carried great iron swords, *mbele a lulendo*, with dignity. Local copies of swords and sabers imported from Europe symbolized the power of the chief, the village and the kingdom. During the era in which Kongo was Christianized and merged its own traditions with those introduced by the Portuguese, swords of honor and other adopted regalia seemed to be a summary of the social, religious and aesthetic values of the kingdom.

While they were inspired by European models, *mbele a lulendo* were at the same time evocative of local philosophical, political and religious symbols, communicating the elite's redefinition of their kingdom as a modern Christian land. The once-foreign objects and ideas quickly became Kongo. While *mbele a lulendo* maintained ideas of European nobility and referenced St. James's miraculous intervention in Kongo politics and the struggle for the kingship, at the same time their forms relate to traditional Kongo ideas and values.

Iron is symbolic of the historical roots of African kingship. The pommel, grip and hand guard can be read as a human form in a one-hand-up, one-hand-down pose, similar to poses taken in *sangamento* performances and those associated with linking the human world with the world of the dead in other art forms.

Crosses cut into the pommel or the ends of the guards can refer simultaneously to the Christian cross and to the pre-European-contact "crossroads" symbol that delineates the boundary between the spirit world and the human world.

Mbele a lulendo served multiple functions. Carried by leaders as symbols of position, the swords played roles in coronations, displays of allegiance and other court events, judicial activities, religious ritual activity and funeral observances.

RP

Right: Cat. 1.1. Sword of honor, Kongo peoples. Lower Congo, DRC. Late 16th century. Wood, iron, 35.5 × 5.3 × 1.25 in. (90.1 × 13.5 × 3.2 cm). Collection Royal Museum for Central Africa, Tervuren, Belgium, HO.1955.9.22.

Facing page, left: Cat. 1.2. Sword of honor, Mboma peoples. Matadi, Lower Congo, DRC. ca. 16th–17th century. Iron, 35.4 × 1.8 in. (90 × 4.5 cm). Collection Royal Museum for Central Africa, Tervuren, Belgium, HO.1955.9.20.

Facing page, right: Cat. 1.3. Sword of honor, Mboma peoples, Matadi, Lower Congo, DRC. ca. 16th–17th century. Iron, ivory, 33.1 × 1.96 in. (84 × 5 cm). Collection Royal Museum for Central Africa, Tervuren, Belgium, HO.1955.9.21.

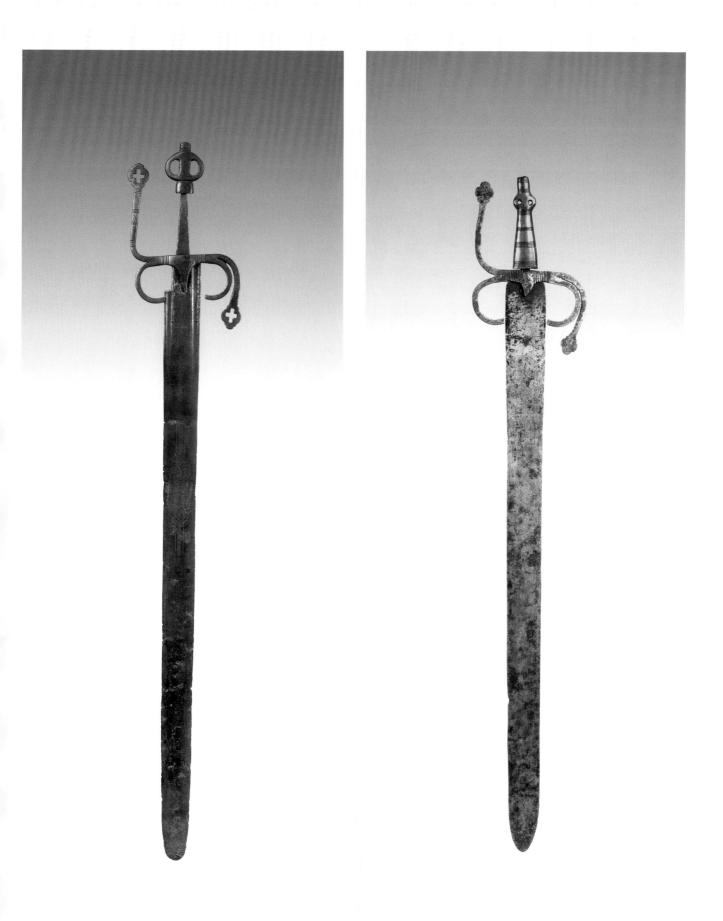

Trumpets for Kings and Chiefs

Beginning in the late fifteenth century, Europeans arriving at the Mbanza Kongo court witnessed impressive displays of prestige and luxury goods, such as fine textiles, decorated drums and sculpted ivory horns, that surrounded the king. Portuguese chronicler Ruy de Pina's 1491 account reports that on entering the court of the Mani Kongo the European visitors were greeted by many noblemen who blew ivory horns and played other instruments. Reports from these explorers fueled fantastical artistic representations of the Kongo court. Examples include the engravings by Johan Theodore and Johan Israel De Bry that accompanied Duarte Lopes's 1597 account and Jacob Van Meurs's engravings for Olfert Dapper in 1668 (fig. 1.2). Europeans were able to bring a part of this splendor back to Europe via the exchange of gifts and via trade.

The ivory trumpets here, called *mpungi*, were crafted with great care from the tusks of elephants, hollowed from the inside and scraped thin. Such delicate trumpets were used only within the retinues of chiefs who had the right to use them as part of their hereditary regalia. Historical accounts describe how such ivory trumpets were played during the funeral ceremony of an important chief and upon the occasion of the investiture of his successor. They were also used at feasts, for rousing men during times of war and for announcing visitors.

Mpungi trumpets have been finely created to display the intricate geometric patterns that are characteristic of Kongo style. While both horns show this geometric style, cat. 1.5 includes a reference to the cross of the Order of Christ, showing the malleability of Kongo geometric designs with Christian imagery. The side placement of the mouthpiece is typical more generally of African-style trumpets. The addition of the lugs, however, shows European influence and suggests that this object was commissioned for European consumption.

CSF

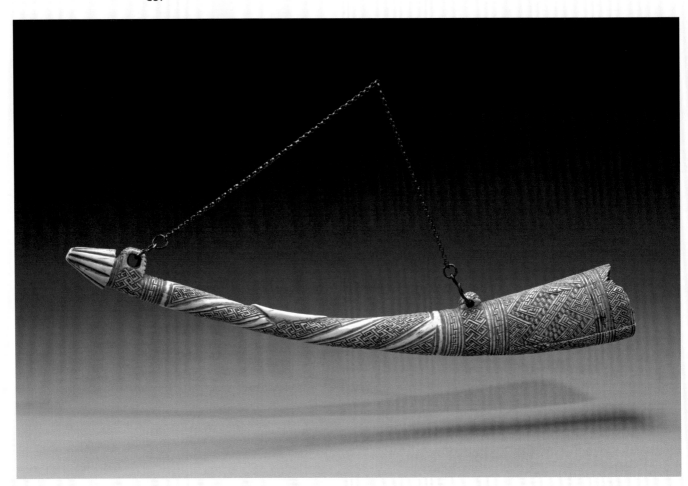

Facing page: Cat. 1.4. Decorative trumpet, Kongo peoples. Angola. 16th century. Ivory, silver, 6.77 in. (17.2 cm). Collection of Ethnic Art and Culture, Hong Kong, FC85 0694.

Right and below: Cat. 1.5a and cat. 1.5b. Horn, Solongo peoples. Angola. 18th–19th century. Ivory, 41.1 × 4.1 × 5.9 in. (104.5 × 10.5 × 15 cm). Collection Royal Museum for Central Africa, Tervuren, Belgium, MO.1967.63.802.

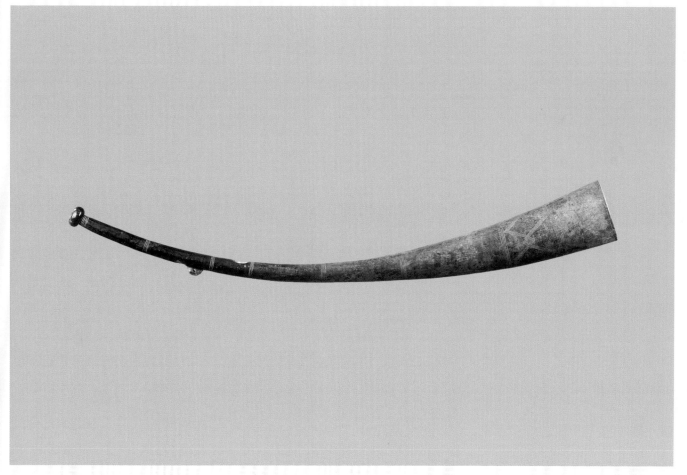

Embellished Raffia Textiles

Mention of raffia textiles in early European accounts, beginning in the late fifteenth century, conveys the astonished and amazed reactions that the Europeans had for Kongo raffia textiles. An account from Duarte Pacheco Pereira (1505–8) states, "in this kingdom of the Congo they produce cloths from palm fibers with velvet like decoration, of such beauty that better ones are not made in Italy. In no other part of Guinea is there a country where they are able to weave these clothes as in this kingdom of Congo." Like the ivory trumpets, textiles were exchanged with Europeans, and now the textiles appear in museum collections in Europe.

Throughout West Central Africa, raffia products serve as indicators of status and may be used to understand Kongo spirituality. A 1668 illustration of the Loango king from Dapper shows the monarch surrounded by fine objects, including a textile displayed behind him. Production of these embroidered textiles could take as many as fifteen to sixteen days. The intricate geometric patterns worked into raffia textiles are similar to those in many other Kongo art forms. And it is suggested that they not only are decorative but may be interpreted as complex representations of Kongo spirituality.

CSF

Cat. 1.6. Mat, Kongo people. Democratic Republic of Congo/Angola. ca. 18th century. Raffia fibers, 20.4 × 21.65 in. (52 × 55 cm). Collection of the British Museum, Af, SLMisc.424.

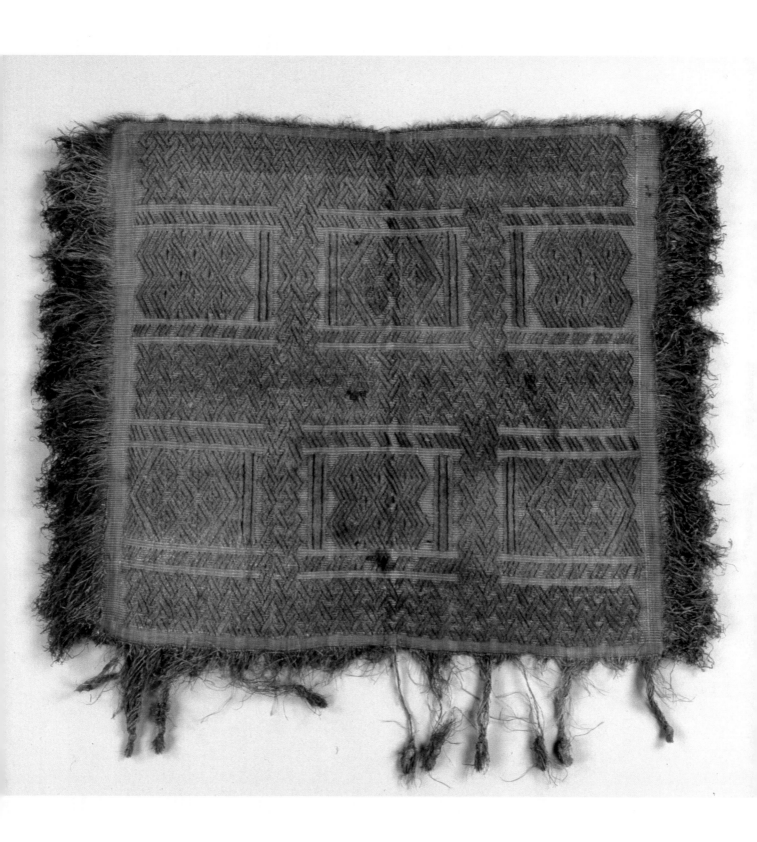

Crucifixes

With the conversion of Nzinga to Christianity in 1491, Kongo nobles quickly adopted Catholicism. Christian ritual and Catholic objects for ritual and devotional purposes were introduced from Europe. For some 200 years Christianity was the dominant religion, in some instances blending with the principles of traditional Kongo beliefs.

Crucifixes quickly made their way into the oeuvre of Kongo artists. Some were created out of wood, and cast brass figures were attached. Earlier examples followed the naturalistic proportions of European models fairly closely.

Kongo ideas of a fluid connection between the realm of the living and that of the dead had seemingly long been symbolized by the sign of the cross. The motif's association with ideas of death and regeneration predated the advent of Catholicism in the region, as suggested by rock paintings dated to an earlier period. Cross patterns served as powerful symbols both within the church and in the broader Kongo world. They served to demarcate a ritual space through which communication with the other world could be established. Such crosses drawn in the earth were called *dikenga*. The motif symbolized the connection between the human world and the world of the dead. The horizontal arm represents the divide between those realms, while the vertical axis demonstrates that the boundary may be crossed in either direction. The *dikenga* refers simultaneously to the cardinal points, to the stages of life and to the movement of the sun during the day. East signifies dawn, birth and the beginning of life in this world. North refers to noon and adulthood. West indicates dusk or sunset and the end of life. South denotes midnight and the world of the dead or the spirit world.

RP

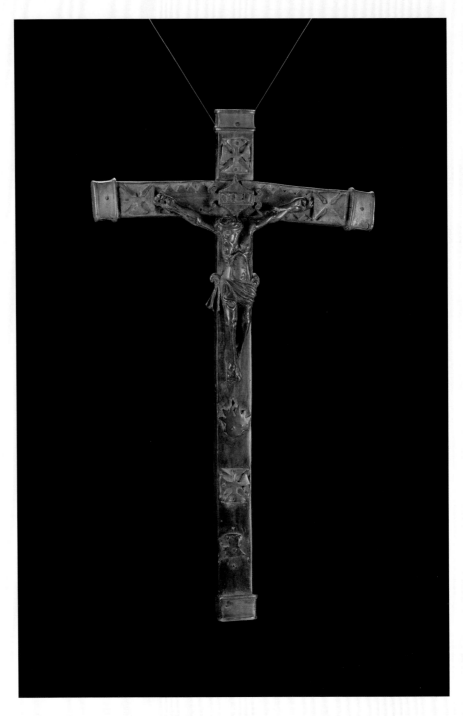

Facing page: Cat. 1.7. Crucifix, Kongo peoples. DRC. 17th century. Wood, brass, 17.7 × 10.6 × 2.36 in. (45 × 27 × 6 cm). Collection Royal Museum for Central Africa, Tervuren, Belgium, HO.1949.21.1.

Below: Cat. 1.8. Crucifix, Kongo peoples. Lower Congo, DRC. 18th century. Wood, copper alloy, 15.35 × 6.6 × 0.8 in. (39 × 16.7 × 2 cm). Collection Royal Museum for Central Africa, Tervuren, Belgium, HO.1955.9.2

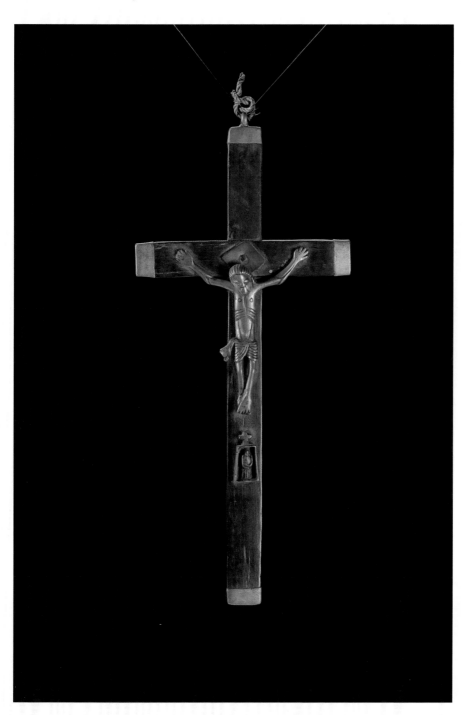

Cast Crucifixes

The naturalism of earlier crucifixes gave way to more stylized and abstracted examples. In many instances the cross, as well as the Christ figure, were cast in open molds. In some cases, as in cat. 1.9, the cast cross was applied to a wooden one. In others, such as in cat. 1.10 and cat. 1.11, the cross could stand alone.

The cast cross allowed additional figures, usually shown in an attitude of prayer, thus called orants, often perched on the horizontal arm, as seen in cat. 1.9.

The Christ figure here is stylized, the face severely abstracted and hands and foot treated as fanlike forms. On the upper portion of the vertical, above the Christ figure, a secondary personage has one hand on the lower abdomen and the other up, on the chest.

Cat. 1.10 shows the Christ figure as even more abstracted—its arms and legs mere spindly forms. The orant figures on the horizontal arms are echoed by two figures projecting to either side of the base. The figure below the Christ is a half figure, its arms folded across the chest. To the right of the central figure, another figure projects from the vertical. Likely a matching figure once jutted from the left side as well. Above the Christ figure, an S-shaped line seems to be an abstraction of the scroll depicted on some European crucifixes. Sitting at the apex of this complex composition is a figure holding an open cylindrical form. At the end of each cross arm, a small secondary cross projects. The cross has a stand incorporated at the base to allow the cross to stand alone.

Four praying figures sit on the cross-arm of the crucifix in cat. 1.11, while three severely abstracted versions fill the upper portion of the vertical bar. A single figure at the base adopts a praying gesture and looks up to Christ. This object was provided with a cast loop for suspension.

RP

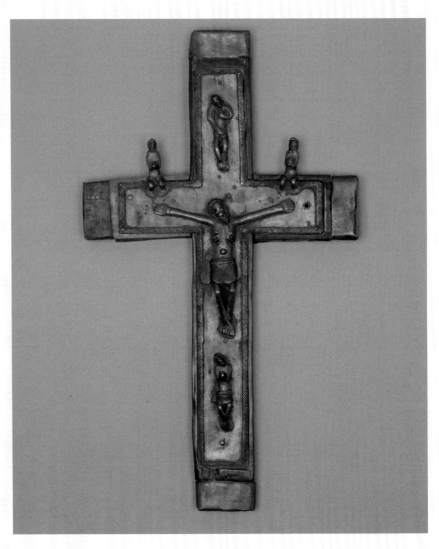

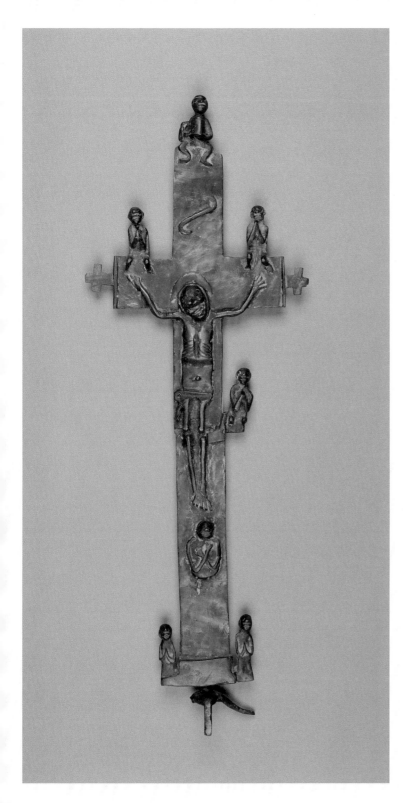

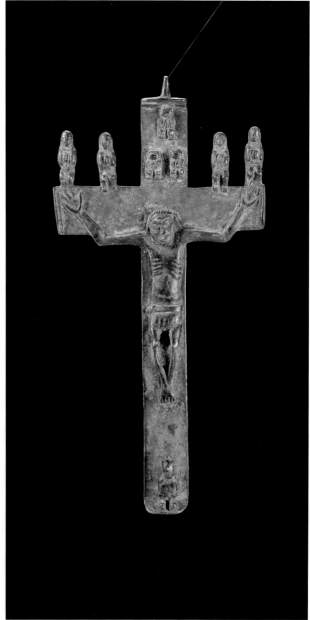

Facing page: Cat. 1.9. Crucifix, Kongo peoples. Lower Congo, DRC. 18th century. Wood, copper alloy, 15.5 × 9.25 × 1.26 in. (39.5 × 23.5 × 3.2 cm). Collection Royal Museum for Central Africa, Tervuren, Belgium, HO.1955.9.17.

Left: Cat. 1.10. Crucifix, Kongo peoples. Lower Congo, DRC. 18th–19th century. Metal, 20.5 × 7.5 × 1.97 in. (52 × 19 × 5 cm). Collection Royal Museum for Central Africa, Tervuren, Belgium, HO.1953.46.1.

Above: Cat. 1.11. Crucifix, Kongo peoples. Lower Congo, DRC. 18th–19th century. Copper alloy, 13.4 × 6.7 × 1.77 in. (34 × 17 × 4.5 cm). Collection Royal Museum for Central Africa, Tervuren, Belgium, HO.1998.52.3.

Unusual Variations on Crucifixes

On occasion crucifixes were crafted that seemed unorthodox. For example, at first glance the cast figure mounted on a wooden cross in cat. 1.12 seems merely to be an abstracted version of other cast crucifix figures. Closer examination shows that the chest and torso are spangled with indentations. Is this indicative of the leopardization of the Christ, conflating his power with that of the lordly leopard and Kongo chiefs who were associated with the animal?

The form in cat. 1.13 was obviously intended to be suspended from a wooden cross as well. Rare crucifix figures such as this, in which the Christ figure is replaced by a female figure carrying a child, are interpreted by some as a reference to the prophetess Dona Beatriz Kimpa Vita, an early eighteenth-century visionary who claimed she was visited by St. Anthony, who took over her body. Her mission was to restore the authority of the Kongo throne and to reoccupy Mbanza Kongo/São Salvador as the capital of the kingdom. Although Beatriz was not crucified, she was martyred. A Capuchin priest saw to it that she was arrested on charges of heresy and burned at the stake in 1706. After her execution, the Antonian movement she founded continued for several decades, but many of the devotees of the movement were enslaved and sent to the Americas.

RP

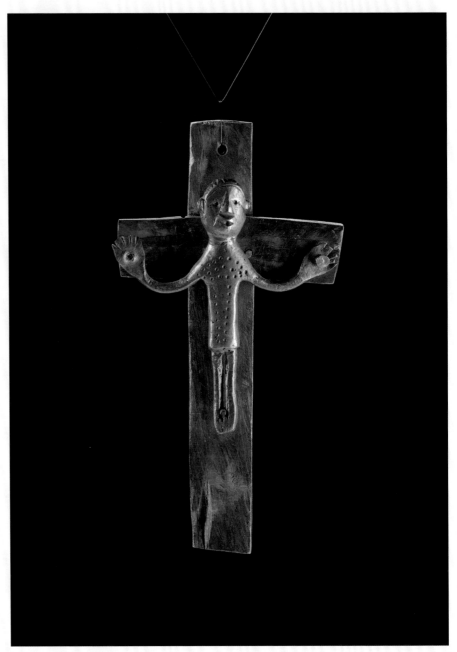

Facing page: Cat. 1.12. Crucifix, Kongo peoples. Lower Congo, DRC. 19th century. Wood, brass, 7.87 × 4.13 × 1.18 in. (20 × 10.5 × 3 cm). Collection Royal Museum for Central Africa, Tervuren, Belgium, HO.1955.9.13.

Below: Cat. 1.13. Female Christ crucifix figure, Kongo peoples. Lower Congo, DRC. 19th century. Brass, 6 × 6.5 × 1.38 in. (15.3 × 16.5 × 3.5 cm). Collection Royal Museum for Central Africa, Tervuren, Belgium, HO.1973.48.1.

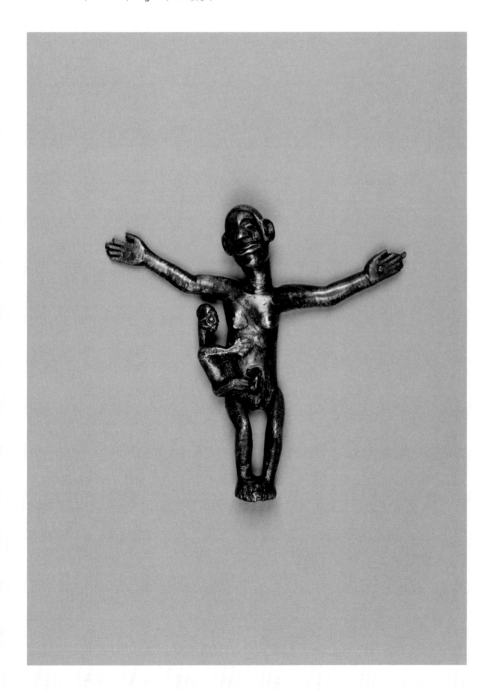

The Dignity of Kongo's Church Masters

As the number of ordained clergy in the kingdom was always small in proportion to the entire population, Christianity in Kongo relied heavily on lay ministers. These were drawn from the nobility of Kongo and called "masters of the church." Their main role was to teach, so that basic elements of the doctrine, as well as prayers and songs, were known by the people when the priest passed by to perform the sacraments. Jesuit and Capuchin missionaries repeatedly reported on the effectiveness of these "masters." Their activities explain the continuity of Christianity in Kongo in times when no European missionaries were in the country.

Lay ministers had their own symbols of authority, among which were staffs with finely decorated brass finials. Watercolor illustrations made by a Capuchin missionary in the 1740s suggest that these had the form of a simple cross, but elsewhere talented smiths produced more elaborate versions. The two finials here show a human figure, sitting and with folded hands as if in prayer. The figure is put against a square frame that has either a cross on top of it or leaflike decorations all around at the corners. This motif may refer to the improvised altars and chapels that missionaries built on their travels though the countryside.

HV

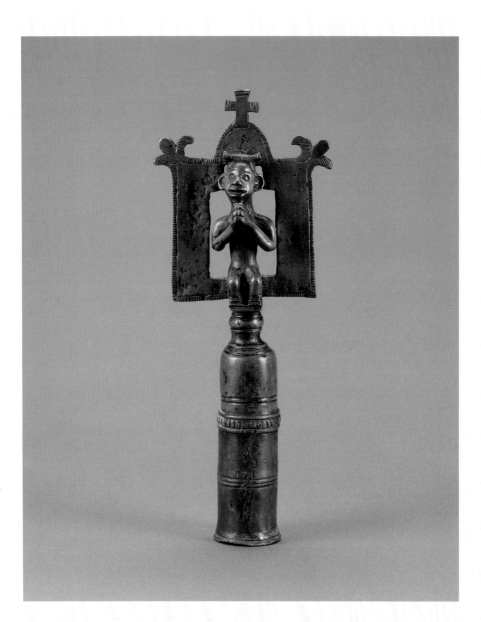

Left: Cat. 1.14. Staff finial, Kongo peoples. Lower Congo, DRC. 17th–18th century. Brass, 9.88 × 4 in. (25.1 × 10.2 cm). Collection Royal Museum for Central Africa, Tervuren, Belgium, HO.1955.9.29.

Facing page: Cat. 1.15. Staff finial, Kongo peoples. Lower Congo, DRC, 17th–18th century. Brass, 11.02 × 4.65 × 2.2 in. (28 × 11.8 × 5.7 cm). Collection Royal Museum for Central Africa, Tervuren, Belgium, HO.1953.100.1.

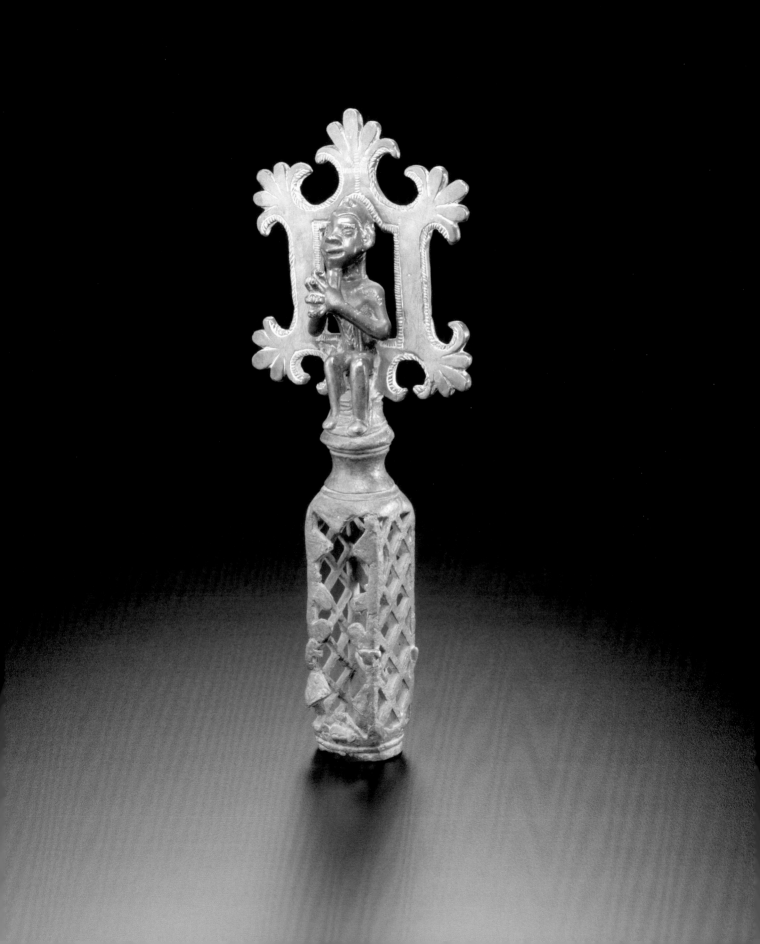

To Rub Oneself with a Saint

European missionaries operating in the kingdom of Kongo in the sixteenth and seventeenth centuries spread the cults of the Virgin Mary and Saint Anthony of Padua, which both became very popular. Both saints continued to be invoked in the absence of missionaries. The Capuchin missionary Giacinto da Bologna reported in 1750 on the strength of the devotion for the Virgin Mary, in regions that had not seen a priest for several decades.

Local artists produced figurines of Saint Anthony in ivory, terra cotta, brass and copper alloy. They were called *Toni Malau* and usually showed the saint holding the infant Jesus upright on his left hand, while his right hand held a cross. Some rare and more elegant examples show the infant sitting on the bent left arm and the cross held by the right hand against the chest. Figurines of the Virgin Mary were called *Sundi Malau* and, like the *Toni Malau*, usually had an eyelet at the back so they could be worn as pendants. The saint figurines were used as individual talismans and also for healing. They were brought in contact with wounded or sick parts of the body, which explains the worn look of many of them.

HV

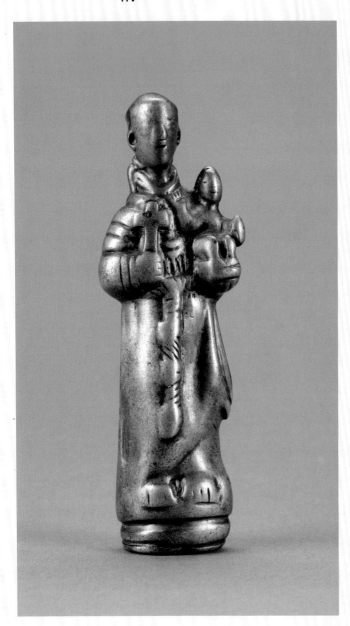

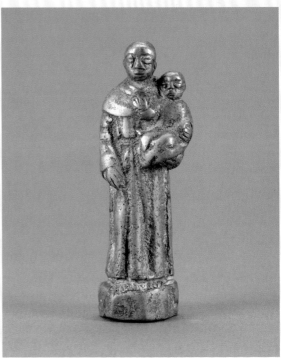

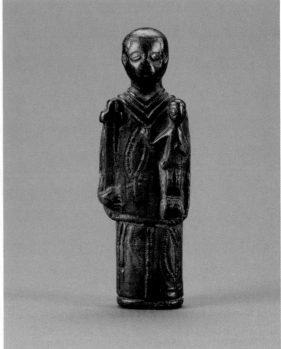

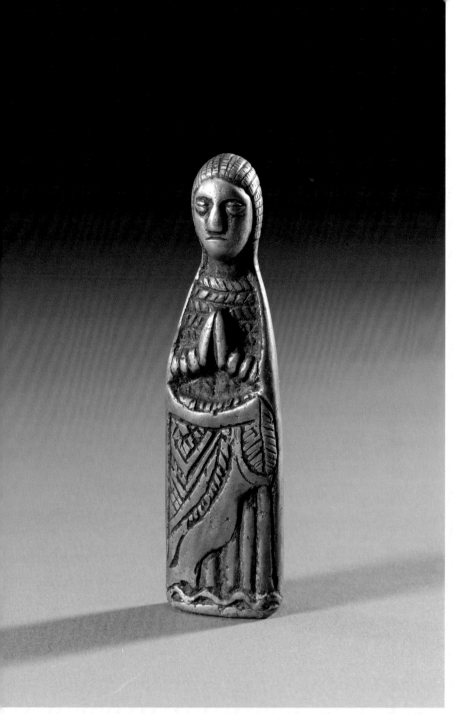

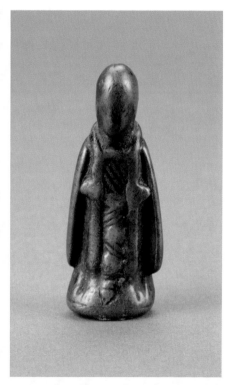

Facing page, left: Cat. 1.16. Figure of Saint Anthony, Kongo peoples. Lower Congo, DRC. 17th–18th century. Copper alloy, 4.53 × 1.38 in. (11.5 × 3.5 cm). Collection Royal Museum for Central Africa, Tervuren, Belgium, HO.1955.9.23.

Facing page, right top: Cat. 1.17. Figure of Saint Anthony, Kongo peoples. Lower Congo, DRC. 18th–19th century. Copper alloy, 4.13 × 1.57 × 1.38 in. (10.5 × 4 × 3.5 cm). Collection Royal Museum for Central Africa, Tervuren, Belgium, HO.1998.52.5.

Facing page, right bottom: Cat. 1.18. Figure of Saint Anthony, Kongo peoples. Lower Congo, DRC. 18th–19th century. Terra cotta, 4.92 × 1.77 × 0.98 in. (12.5 × 4.5 × 2.5 cm). Collection Royal Museum for Central Africa, Tervuren, Belgium, HO.1964.29.3.

Above left: Cat. 1.19. Virgin Mary pendant, Solongo people. Lower Congo, DRC or Angola. 18th century. Brass, 3.75 in. (9.5 cm). Collection of Ethnic Art and Culture, Hong Kong, FX01 9944.

Above right: Cat. 1.20. Figure of a missionary, Kongo peoples. Lower Congo, DRC. 18th–19th century. Brass, 2.05 × 0.87 × 0.51 in. (5.2 × 2.2 × 1.3 cm). Collection Royal Museum for Central Africa, Tervuren, Belgium, HO.1955.9.24.

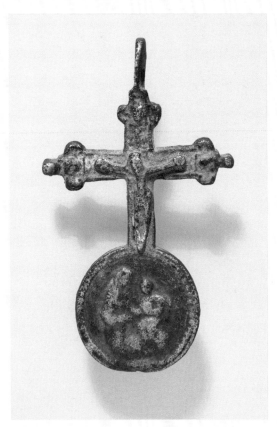

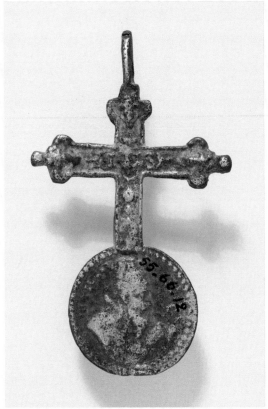

Religious Medals from Eighteenth-Century Kongo

Adherents of Catholicism in seventeenth- and eighteenth-century Kongo produced religious artifacts based on European models but often with a local twist. Religious medals present an interesting case where imported elements were assembled into something typically Kongo. On the facing page is a medal made of the upper part of an ordinary European crucifix that has been soldered onto a twenty-reis Portuguese coin, minted in Porto in 1698 for use in Angola. The coin bears the name of Pedro II, "king of Portugal and of Aethiopia" (the classical term for sub-Saharan Africa). Masterfully soldered onto this coin is a figure of Saint Anthony of Padua, holding the infant Christ and a cross (*facing page*). The backside indicates its value and exhorts the owner to make moderate use of it: *Moderato splendeat usu*.

The example above shows a small crucifix mounted on a worn religious medal that depicts a biblical scene on the one side and the head of a man on the other. The backside of the crucifix bears the mark *IhS*, an old monogram that refers to the first three letters of *Jesus* in Greek. As we know that this mark was used as an identifying seal by the Jesuits, the small crucifix may well date back to the mid-sixteenth or first half of the seventeenth century, when Jesuit missionaries were active in Kongo.

HV

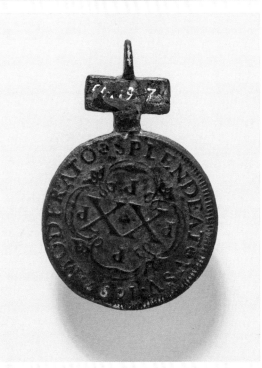

Top left and right: Cat. 1.21. Religious medal, Kongo peoples. Lower Congo, DRC. 17th–18th century. Brass, 2.48 × 1.46 in. (6.3 × 3.7 cm). Collection Royal Museum for Central Africa, Tervuren, Belgium, HO.1955.66.12.

Above and facing page: Cat. 1.22. Religious medal, Kongo peoples. Lower Congo, DRC. 18th century. Metal, (1.97 × 1.46 in. (5 × 3.7 cm). Collection Royal Museum for Central Africa, Tervuren, Belgium, HO.1954.19.7.

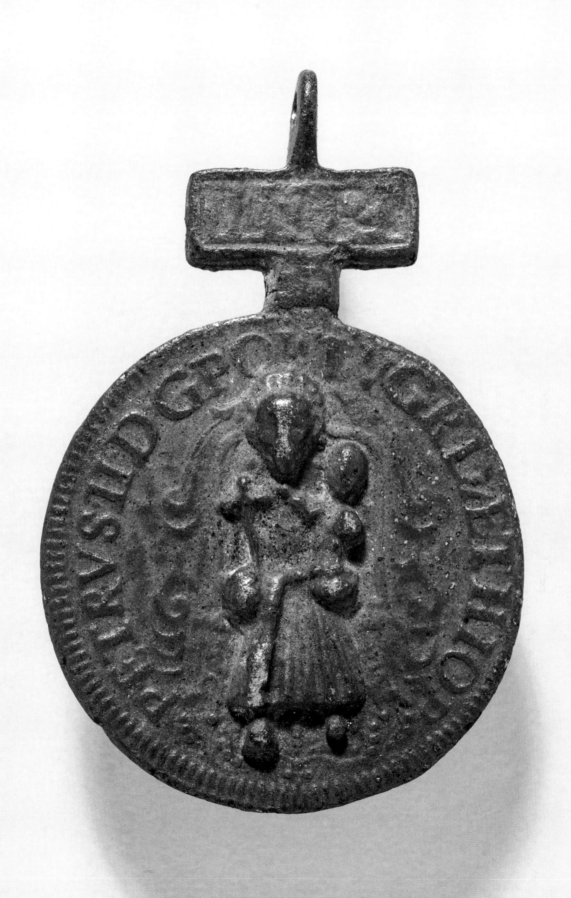

6

Kongo in the Age of Empire

HEIN VANHEE AND JELMER VOS

Introduction

The Atlantic slave trade from Central Africa, begun in the sixteenth century, came to an end in 1866. During the last fifteen years of the trade, Cuban slavers fueled the export economy of the Lower Congo region. In this same period, a small number of British and Dutch merchants also opened factories along the Congo coast for the conduct of "legitimate" commerce, but this new export trade in products really took off only after Great Britain and its allies had effectively suppressed the export trade in slaves. From the 1870s, African communities along the Atlantic coast and the banks of the Chiloango and Congo Rivers responded en masse to demands for raw materials from industrializing countries in the West by turning to the production of vegetable oils and the sale of high-value ivory and rubber. But a decade or so of African initiative and autonomy in Atlantic commerce was followed by the rapid expansion of European imperial power. This chapter looks at the impact of the new export trade on community life north and south of the Congo River and traces cultural continuities between the late nineteenth century and earlier times.

From Slave Trade to Produce Trade

As the export slave trade was steadily brought to an end, Africans north and south of the Congo estuary began to exploit local resources for the production of palm oil and kernels. In addition to palm produce, villages south of the river cultivated peanuts for export and specialized in the trade of high-value commodities such as coffee, ivory and rubber. In ports like Ambriz, Musserra, Ambrizete (N'Zeto) and Mucula—some of which had first grown as entrepôts for the illegal slave trade—African middlemen brokered trade between European merchants and the caravan traders bringing ivory, rubber and coffee from regions inland (fig. 6.1). Around 1900, however, commerce in these coastal ports suffered as prices for coffee tumbled and the rubber trade was increasingly directed to Noqui on the south bank of the Congo River. By this time, wild rubber had come to dominate the export trade of northern Angola.

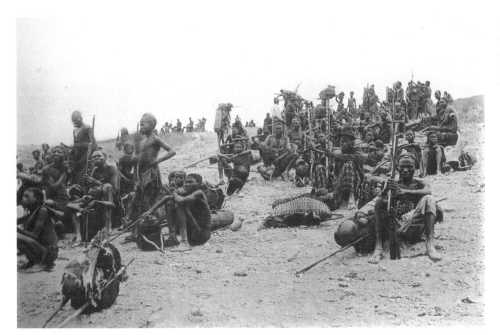

Fig. 6.1. Photograph of the arrival of a trade caravan, Angola, by J. A. da Cunha Moraes. Published in da Cunha Moraes 1887.

The product was largely collected in regions east of the Kwango River and then carried by large groups of porters to European factories in bundles weighing up to fifty pounds.[1] Wild rubber and palm oil were also the main products feeding legitimate commerce north of the Congo River, the first being traded especially between Cape Sainte-Catherine and Pointe Noire, and the second between Pointe-Noire and the Congo River.[2] The 1870s saw the establishment of many new trading factories on the Atlantic coast and along the lower Chiloango and Kwilu Rivers. Prior to the construction of the railroad connecting Matadi to Malebo Pool in the 1890s, these northern export routes for produce were considered no less important than the Congo River.[3]

During the first decades of legitimate trade, African entrepreneurs controlled the organization of production and, to some extent, also dictated the terms of trade. Palm oil was extracted from the pulp of palm fruits, packed in leaves and carried in baskets to the coastal factories. There the oil was boiled in large iron cauldrons, after which the purified oil was drawn off and measured. Then the price was negotiated and payment was made in cloth, earthenware, gunpowder, cutlery, guns, spirits and various other European luxury goods. Success in trade was sought through the use of various charms, called *minkisi* (sing. *nkisi*), thought to protect traders against misfortunes and the jealousy of others. *Minkisi* existed in different forms and often had portable versions, to prevent travelers from falling ill or being robbed on the road. Many were carved in wood and had the form of a human being, sometimes with small tubes attached to them, said to be "guns" and pointing to the role of such *minkisi* as "witch hunters" (cat. 4.8). Some *minkisi* were tall and had a strong reputation over a wide geographical region, as was the case with Mabiala Mandembe, Mangaaka and Kozo, large "nail fetishes" that could be used to seal trade agreements and hunt down thieves (cat. 4.1).[4] Even European traders had recourse to them, as they noticed the effect of an oath that had been passed before or "hammered into" a *nkisi* of this type.

In the mid-1870s, for instance, Alexandre Delcommune of the French trading house of Daumas at Boma had the "war fetish" of one of the Boma chiefs carried around several markets in order to find the men who had stolen goods from him (cat. 4.2).[5]

Kongo chiefs and their supporting political factions occupied strategic positions alongside navigable rivers and on important overland trade routes. In the early 1870s, German explorers noticed the existence of several toll bars in Mayombe, where passing trade caravans were inspected and taxed.[6] The wealth accumulated through the organization of trade caravans or the levying of tolls was invested in the acquisition of chiefly titles and in the composition of *minkisi*. In Mayombe a hierarchy of chiefly titles existed; the most important ones required the redistribution of considerable wealth, including slaves. In order to protect their trade, African chiefs and brokers carefully checked the movement of European merchants inland. In the 1850s, the Liverpool house of Hatton & Cookson had an agreement with native chiefs that allowed Europeans to go no farther up the Chiloango River than the village of Tiro, five miles from the coast. Such limits were enforced by means of barrages, made of trees cut down and stuck in the water, and by posting guards with poisoned arrows.[7] In the 1860s, the palm oil trade also brought French and Dutch trading houses to the Chiloango estuary, where each firm paid tribute to local chiefs in return for authorization to trade and occupy a piece of land. Competition among both European traders and African chiefs frequently resulted in the violation of trade agreements, which from time to time had to be renegotiated. Europeans often intimidated their African trading partners with the threat of military force. In 1876, for example, the presence of a French warship helped settle a dispute between French traders and Matenda, an important Kongo chief in the Chiloango region. By contrast, Africans usually closed the access roads to the factories to enhance their negotiating powers. Every new trade agreement therefore explicitly stated the formal prohibition to create new river barrages or roadblocks.[8]

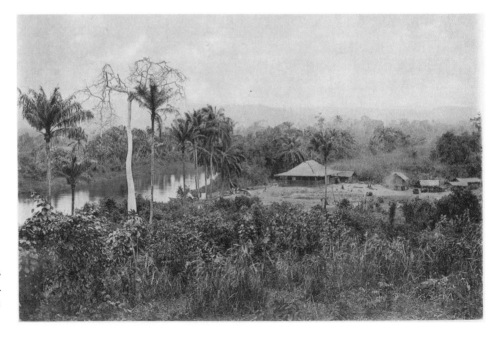

Fig. 6.2. Photograph of a trading post at Mbuli on the Chiloango River, Lower Congo, DRC, by J. A. da Cunha Moraes. Published in da Cunha Moraes 1885.

The 1880s marked the beginning of a new era. Advances in technology, on one hand, and the imperial belief in Europe's "civilizing mission," on the other, drastically altered Western attitudes toward Africa. The introduction of steam launches facilitating transport along small rivers and creeks stimulated traders to get closer to the regions of production. In 1884, after negotiating new tribute settlements with African chiefs, Dutch and English firms sent out agents to explore the Mayombe region via the Chiloango, Lukula and Luali Rivers. In addition, newly created colonial states embarked on campaigns to establish direct control over land and labor. Kongo chiefs were often duped into signing treaties by which they ceded sovereignty to the European states in return for a small tribute. After the Berlin Conference of 1885, colonial states began to levy export duties, thus taking taxation powers away from African chiefs. This new regime also helped European trade houses gain more control over the export trade. For instance, the creation of a customs office in 1889 at Nzobe, at the confluence of the Lukula and Chiloango Rivers, made it practically impossible for Kongo traders to ship products down the Chiloango, turning them more dependent on European shipping services. Africans initially resisted European encroachment, but a series of military campaigns in the 1890s firmly established colonial rule throughout the Lower Congo.[9]

As traditional chiefs lost control over the export trade, they also lacked the resources to sponsor the elaborate rituals of chiefly investiture. In the 1890s, the Congo Free State began to develop its "indigenous policy," which coerced chiefs into a relationship of "rights and duties" with the colonial rulers. In return for official recognition by the state, chiefs were required to provide labor and generate tax revenue. For the old elites, therefore, colonialism most often meant a loss of sovereignty and autonomy.[10] At the same time, however, many young upstarts turned the knowledge and skills acquired at trade factories and mission schools to their advantage and used the system of colonial government to rise to a position of considerable wealth and political power.[11]

The Expansion of Slavery

Slaves figured prominently in contemporary artistic representations of the power of chiefs (ill. 7.1, cat. 2.21). Although the export trade in slaves from the Lower Congo ended in the 1860s, slave trading continued internally under the impact of "legitimate" commerce. While previously slaves were principally traded toward the Atlantic coast, in this new era they were moved in different directions, following pockets of wealth that emerged across the Lower Congo. Capital was now increasingly concentrated in places connected to the developing trade in commodities: in coastal zones specializing in the production of vegetable oils, but also in towns and villages in the interior that were important centers for the burgeoning ivory and rubber trades. In these different places, riches made in commerce were commonly invested in slaves.[12]

Wealthy men wanted slaves, in particular women and children, for a number of reasons. In the matrilineal societies of the Lower Congo, where husbands had limited

control over the offspring of their free wives, female slaves were prized for their reproductive powers.[13] Slaves were also kept as a form of security; they were assets owners could use to cover unexpected debts or fines. For instance, the settlement of a trade dispute at Nzobe in 1874 included the payment of several slaves by the losing party.[14] Most importantly, however, men successful in the sale of export crops could expand their agricultural production by investing their newly earned riches in slaves.

By the mid-nineteenth century, women and slaves performed most of the agricultural labor in the Lower Congo.[15] According to the Swedish missionary Laman, who worked among the Sundi from 1891 to 1919, men cleared woods, cut grass and prepared the soil, but women planted and harvested the crops. The peanut harvest was the most important of all, and it was considered a women's crop. "Men who are careful of their dignity and young fops enjoying a vogue avoid all work connected with the soil." Although women sold produce in local markets, men usually controlled the export trade. Laman observed that successful businessmen "were unable to invest their assets in anything but slaves." That they preferred female over male slaves was reflected in their prices: around Malebo Pool, where the Sundi bought many of their slaves, a man was on average worth 150 pieces of cloth, whereas a young woman might cost up to 400 pieces. Compared to male slaves, female slaves offered productive as well as reproductive advantages. Male slaves were also purchased, but they were mainly employed in what were considered manly occupations. As Laman put it, a wealthy person would purchase "a wife in order to get good progeny" and "men to serve as tappers of palm-wine."[16]

Europeans also participated in the internal slave trade. It was a public secret, for example, that Dutch merchants used slaves for physically demanding tasks in their factories and onboard their steamers. They were acquired from inland chiefs and misleadingly called *krumanos*, suggesting that they were free Kru workers from West Africa.[17] Meanwhile, Catholic and Protestant missionaries maintained different policies to redeem young slaves or acquire the custody over "orphans" who commonly had the status of slaves. Correspondence from the Holy Ghost Fathers, who ransomed young slaves from trade caravans and local dealers, shows that many of these children were slaves by birth; others had been sold into slavery as their families lacked the means to feed them, and still others were enslaved to pay for debts, theft or other misdemeanors.[18]

Revival in Mbanza Kongo

European imperialism has had a long-lasting and often devastating impact on the lives of Central Africans, but in the kingdom of Kongo it initially led to a period of economic prosperity, religious revival and political reinforcement. In the era of the slave trade, Mbanza Kongo was an important node in the network of trade routes supplying the Atlantic ports of Central Africa. Now, every year numerous caravans of Zombo traders transporting ivory and rubber from Malebo Pool and the eastern Kongo regions passed through Mbanza Kongo on their way to European factories

on the coast. In the early 1880s, a number of factories operating out of Noqui on the lower river recognized the strategic location of Mbanza Kongo and negotiated with the king to open stores in the old capital for the collection of wild rubber. This development, first of all, strengthened Mbanza Kongo's position in the regional economy, as the king acknowledged when writing in 1884 that "commercial goods are considerably increasing and will abound more if people would be confident to find here all the merchandise needed for their transactions."[19] But the newly established factories also created extra tax revenue for the king and job opportunities for his subjects, as European traders recruited young men as interpreters and porters to carry goods to the Congo River.

Not long before, the Baptist Missionary Society had built a station in Mbanza Kongo, which they intended to use as a base for developing their Congo mission. A Portuguese state-funded Catholic mission led by Padre Barroso soon followed them. King Pedro V could not have been more pleased about this sudden interest of white missionaries in his kingdom. Despite occasional visits of priests from Luanda, Kongo had been without a clergy since the early nineteenth century. Consecutive kings had corresponded with Portugal about a missionary presence in Mbanza Kongo, which they argued was vital for the health of the kingdom and the well-being of its subjects.[20] Besides administering the sacraments, priests were also essential for the investiture of kings and chiefs as well as for royal marriages and burials. The absence of white priests thus seriously undermined the legitimacy of Kongo's ruling class. It did not mean, however, that Christianity had withered in Kongo.

Because Roman Catholic symbols and concepts were an integral part of religious practice in Kongo, Christianity did not die out when priests abandoned the kingdom shortly after 1800. Throughout Lower Congo, nineteenth-century European visitors found evidence of Kongolese practicing the Christian faith. Visiting a place of worship in Soyo in the 1860s, the famous explorer Richard Burton found "a lot of old church gear, the Virgin (our Lady of Pinda), saints, and crucifixes."[21] When a Catholic priest traveled through Kongo in 1876, hundreds of villagers made use of the opportunity to get baptized.[22] Along the banks of the lower river, chiefs wore rosaries to symbolize their power.[23] In and around Mbanza Kongo, meanwhile, people used the cross for protection and venerated Maria images.[24] In eastern Kongo, among the Zombo, the crucifix functioned as a symbol of ancestral power, and large wooden crosses were erected to protect local markets (fig. 0.1, cat. 1.7–1.12).[25]

The religious landscape was somewhat different north of the Congo River, where Kikongo-speaking peoples had been less exposed to Christianity in previous centuries. Jesuit and Capuchin missionaries had tried to convert the inhabitants of the kingdom of Loango in the seventeenth century, and French missionaries had developed similar plans in Loango and Kakongo a century later. In spite of these attempts, Christianity never took root here as it had done in the kingdom of Kongo.[26] That said, French missionaries reported in the 1770s that immigrant communities from the Soyo province south of the river continued to assemble for prayer. In one town, they found a large wooden cross erected in the main square and a modest "church"

Fig. 6.3. Photograph of a Kongo chief with his regalia, Angola or DRC, early 20th century. Archive J. Vissers, Afrika Museum Berg en Dal, Nijmegen, The Netherlands. By permission of Afrika Museum Berg en Dal.

equipped with an altar and a large crucifix. Furthermore, the king of Kakongo had images of saints in his possession.[27]

This familiarity with Christian practices and symbols survived in the coastal regions north of the Congo River during the nineteenth century. Free men and women often had a *santu a mungua*, a "saint's name of the salt," referring to baptism. Common examples were Ndom-Fernando, Ndom-Polo (Paulo) and Ndom-Petelo (Pedro) for men, and Ndona-Madia (Maria), Ndona-Mata (Martha) and Ndona-Zabiele (Isabella) for women. These names were kept as honorary titles within families and were bestowed on children by lineage heads against payment of a fee. Also crucifixes named "dikuluzu," "Santu Manuele," or "Dezo" (Deus) were used by chiefs for common blessings and for the investiture of other chiefs (catalogue section 1).[28]

Unlike their predecessors, the missionaries who arrived in Kongo since the late nineteenth century were unwilling to see the remnants of earlier Christian conversions as orthodox and often expressed aversion at seeing Christian symbols being used as "fetishes." The photograph of an African house with a cross on top, taken by the Capuchin missionary Rinchon in Mbanza Kongo in 1928 and labeled as "the temple of a fetish priest," nicely illustrates this new attitude (fig. 6.4). The colonial-era missionaries were so disengaged from the past that they were ignorant of one of Kongo's main Christian institutions, the Order of Christ. Kongolese nobility used this originally Portuguese religious-military cult to control access to senior titles. The king of Kongo conceded investiture with the support of a Catholic priest. Membership entitled chiefs to use Christian objects such as the cross to protect them from evil and to establish tax-collecting stations in the countryside. Investment required wealth on the part of the chief, as fees had to be paid and a periodic contribution of tribute and military assistance was expected. But the long absence of priests in the nineteenth century hampered investitures. Moreover, the priests who came to Kongo toward the end of the century were completely unaware of the order's

existence. In 1881, Padre Barroso was taken by surprise when asked by King Pedro V to install a number of privileged individuals in the Christian knighthood. Before being upgraded to the status of nobleman, the candidates had to swear: "I promise to be faithful to the Catholic religion; I promise to do what the priests order and promise obedience to the king of Kongo and to the king of Portugal; God punish me if I do not keep these promises."[29]

With the renewed presence of Portuguese priests in the kingdom, investitures in the Order of Christ continued into the twentieth century.[30] Thus in Mbanza Kongo new life was blown into old institutions during the early colonial period. Indeed, for many Kongolese the new priests represented continuity with the past, and this continuity probably explains the welcome reception to which missionaries were generally treated throughout Kongo.[31]

Also on a political level, colonialism in the kingdom of Kongo did not immediately present a rupture with the past. Pedro V, also known as "the last independent

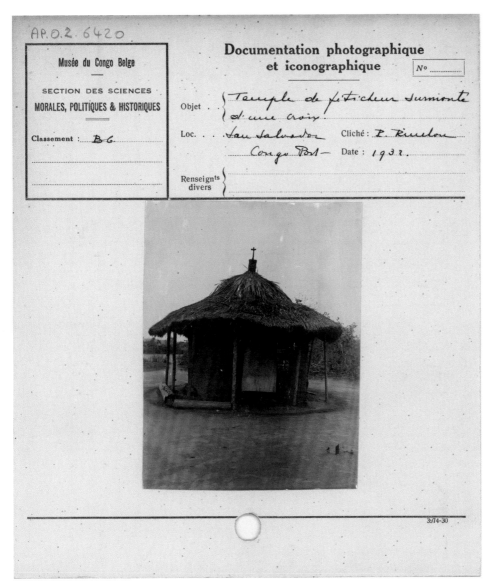

Fig. 6.4. RMCA card file for the photograph titled "Temple de féticheur surmonté d'une croix," São Salvador, Angola, photograph by D. Rinchon, 1928. RMCA Photographic Archives, Tervuren, Belgium, AP.0.2.6420. By permission of RMCA.

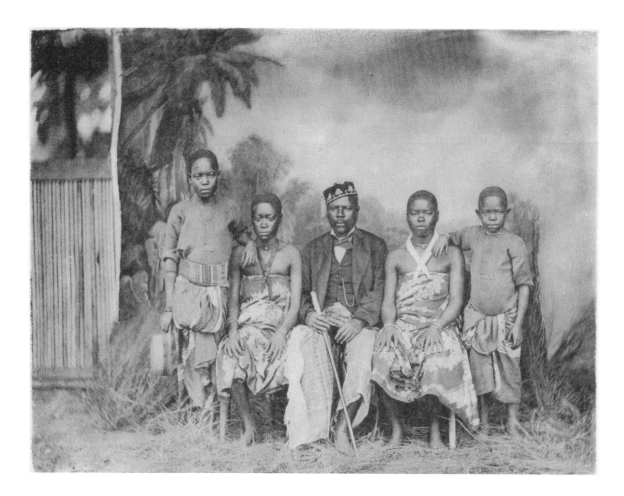

Fig. 6.5. Studio photograph of a Kongo trader and his family, Angola or DRC, by J. A. da Cunha Moraes. Published in da Cunha Moraes 1885.

king of Kongo," had gained the throne in 1860 with the help of the Portuguese in Angola.[32] After Portuguese troops deserted Mbanza Kongo in 1870, Pedro V repeatedly petitioned to Portugal for a new military presence, hoping that Portuguese support would extend his sway over his local rivals.[33] The Berlin Conference, which assigned the Kongo kingdom to Portuguese Angola, worked in Pedro's favor. For a quarter century, successive Kongo kings were instrumental in the establishment of colonial rule in northern Angola; colonialism, in turn, greatly enhanced the power and reputation of the kings at Mbanza Kongo vis-à-vis their neighbors. It was only around 1910 that the shadier sides of imperial rule became apparent to the kingdom's subjects, as they increasingly suffered under the imposition of colonial tax and labor demands.[34]

Conclusion

The end of the Atlantic slave trade ushered in a period of increasing commercial activity in the Lower Congo region. Many African families turned to the production of vegetable oils for export, while villages inland specialized in the capture and trade of elephant tusks and wild rubber. Trading centers on the coast and along navigable rivers multiplied, as did the number of African caravan leaders, brokers and interpreters (fig. 6.5). In the beginning Africans controlled production and bartered with their European trading partners on level terms. African traders invested their profits in the

acquisition of slaves and, especially north of the river, in the composition of charms and the elaborate rituals of chiefship. Toward the end of the century, however, chiefs gradually lost their economic power base as Europeans took control over the export trade. South of the river, by contrast, the kings of Kongo initially benefited from the increased presence of Europeans, and during the early years of colonialism old Kongo institutions were revitalized. But this revival was short-lived, and the consolidation of colonial rule in the early twentieth century resulted in the impoverishment of Kongo chiefs and traders throughout the Lower Congo region.

Notes

1. Vos, "Of Stocks and Barter."
2. Martin, *External Trade*, 154.
3. de Rouvre, "Guinée Méridionale."
4. MacGaffey, *Kongo Political Culture*, 111–12.
5. Delcommune, *Vingt Années*, 96–99.
6. Bastian, *Deutsche Expedition*, 239.
7. Puleston, *African Drums*, 63–64.
8. See the treaty signed at Landana on 10 August 1876, in "Mission du Congo," 466–69.
9. de la Lindi and Gilliaert, *Force Publique*, 498–99.
10. Fabian, *Remembering the Present*, esp. 280–85.
11. Vanhee, "Maîtres et Serviteurs."
12. Vos, "Without the Slave Trade."
13. MacGaffey, "Economic and Social Dimensions," 238, 243.
14. Güssfeldt, "Zur Kenntniss," 168.
15. Broadhead, "Slave Wives."
16. Laman, *The Kongo*, vol. I, 116, 151; *The Kongo*, vol. II, 31, 56–57.
17. Johnston, *The River Congo*, 19.
18. Vos, "Child Slaves."
19. Arquivo Histórico Ultramarino (Lisbon), SEMU-DGU, Angola, 2ª Rep., Pasta 7, Pedro V to Governador Geral, São Salvador, 18 Feb 1884.
20. See, for example, Henrique II writing to the governor of Angola in 1855; Arquivo Histórico Ultramarino (Lisbon), SEMU-DGU, Angola, no. 1111/1112, doc. 203, Henrique II to Governador Geral, São Salvador, 29 June 1855.
21. Burton, *Two Trips*, vol. 2, 76.
22. Jadin, "Recherches."
23. Pinto, *Angola e Congo*, 185.
24. Weeks, *Among the Primitive Bakongo*, 240.
25. T. Lewis, "Ancient Kingdom of Kongo," 547–48.
26. Thornton, "Religious and Ceremonial Life," 89.
27. Proyart, *Histoire*, 330–31; Cuvelier, *Documents*, 39, 55, 111–14.
28. Bittremieux, "Overblijfselen," 799–800.
29. Brasio, *D. Antonio Barroso*, 23–24.
30. Ladeiras, "Notícia."
31. Hastings, *Church in Africa*, 385–88.
32. Bontinck, "Pedro V."
33. Thornton, "Master or Dupe?"
34. Vos, "Forced Labour."

Antonio, Mambouc of Nzobe in the 1890s

While on a mission to collect documentation for the 1897 Brussels Fair, François Michel passed through the region of Nzobe in 1895, situated at the confluence of the Lukula and Chiloango Rivers. Since the mid-nineteenth century Nzobe chiefs and merchants had participated in the booming Atlantic trade in agricultural products. The importance of Nzobe may be inferred from its mention on printed maps even before the first Europeans visited the area.

In the 1880s, Nzobe became a border region between the Congo Free State and Portuguese Cabinda. The establishment of a customs office in 1889 posed a direct threat to the interests of local traders and a series of violent conflicts broke out. Chief Antonio, who bore the old title of Mambouc, was among the first to make peace with the new state. Michel portrayed him as a dignified and self-confident individual, seated while holding a finely sculpted staff, and flanked by two men holding a saber of European manufacture. In another photograph he is surrounded by thirteen "princes" who invariably display the tokens of their involvement in commerce.

HV

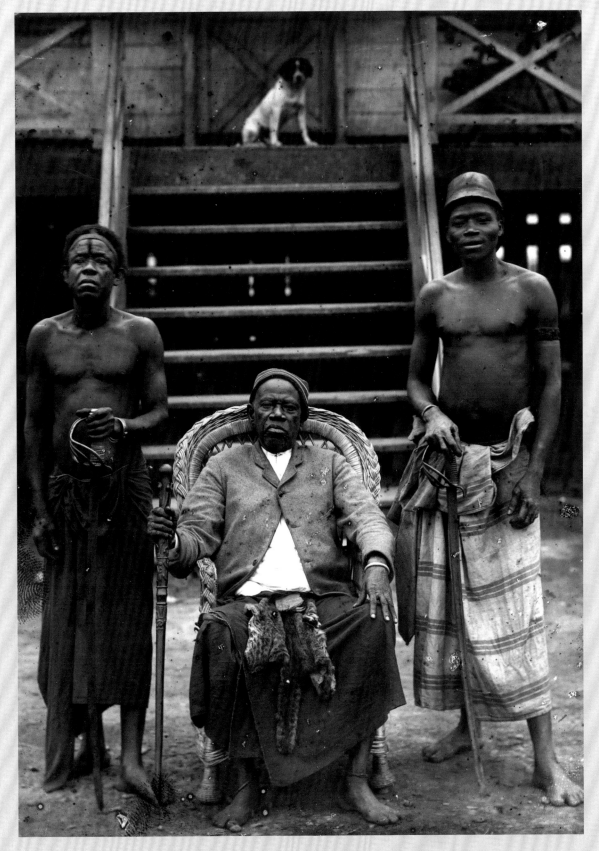

Facing page: Ill. 6.1. RMCA card file for a photograph of chief Antonio, Mambouc of Nzobe, with his following, Mayombe, Lower Congo, DRC, by François Michel, 1895. RMCA Photographic Archives, Tervuren, Belgium, AP.o.o.360. By permission of RMCA.

Above: Ill. 6.2. Photograph of chief Antonio, Mambouc of Nzobe, and two other men, Mayombe, Lower Congo, DRC, by François Michel, 1895. RMCA Photographic Archives, Tervuren, Belgium, AP.o.o.21738. By permission of RMCA.

Transatlantic Souvenirs

A Dialogue of Slavery and Memory in Kongo-Inspired Relief Sculpture

NICHOLE N. BRIDGES

Kongo Commemoration: Slavery Inscribed

Caravans of captive Africans bound by yokes and chains, violent scenes of capture and abuse and the diverse group of European, Arabic and African traders and middlemen involved in the exchange of enslaved Africans abound across the corpus of Loango Coast ivories and their imagery (cat. 2.1 and cat. 2.2, ill. 7.1). Despite their proliferation, these scenes seem to blend inconspicuously into the procession of figures up and around a carved tusk, underscoring the routine centrality of slave trade to the Loango Coast's economy.

Scenes of slave trade and captivity appear consistently throughout the span of Loango carved ivories' production during the early nineteenth to early twentieth centuries, persisting for some fifty years after the last documented ship that held captives departed Loango Bay in the late 1860s.[1] Apart from recording continued illicit slave trade activity after British and American abolition of the trade in 1807–8, the persistence of this imagery stresses how deeply inscribed the traumas of the slave trade were upon the collective Kongo consciousness as an undeniable *lieu de mémoire* that transcends time and space.[2] This short essay explores the theme of slavery as a critical node of memory linking Loango tusk sculptures with the legacy of Kongo visual elements across the Atlantic.

Call and Response: Kongo Resonances in American Canes

The Emancipation Cane

Kongo relief carving for the commemoration of slavery continued across the Atlantic. A wood staff (ca. 1865) in the Brooklyn Museum exhibits a similar Kongo visual

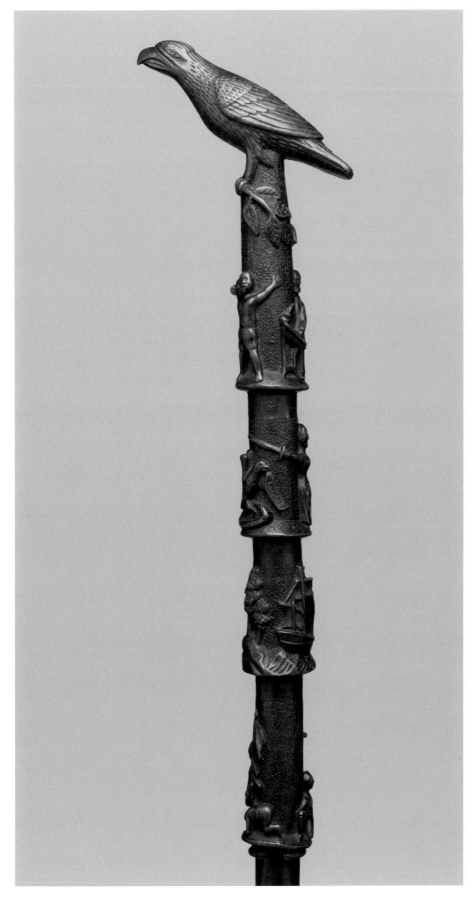

Fig. 7.1. American cane with Emancipation theme, 1865–1900. Wood, metal, 35 × 4½ × 1½ in. (88.9 × 11.4 × 3.8 cm). Brooklyn Museum, Marie Bernice Bitzer Fund and A. Augustus Healy Fund, 1996.179. Photograph by Brooklyn Museum.

vocabulary through its figurative vignettes, which are carved in relief and composed in parallel registers (fig. 7.1). Possibly carved by a Kongophone survivor or descendant of slavery in the United States, the "Emancipation Cane" memorializes enslaved peoples and celebrates the Emancipation Proclamation. This likely sculptural example of Kongo-inspired art in the Diaspora may serve as a response to the Loango ivories' call to commemorate and critique the atrocities of the slave trade.

The wood cane consists of four parallel narrative scenes and a sculpted bird finial atop a metal shaft. As with Loango carved ivory tusks, one reads the imagery from base to summit. The first scene, or the bottom band, portrays two nude figures crouching before a small group of Europeans bearing a tall cross (fig. 7.2). This segment likely represents the Portuguese who arrived on Africa's West Coast at the end of the fifteenth century. A large ship with several sails and an abbreviated rocky shore fill the second register (fig. 7.3). Next, a standing female figure holds out a sword above a bird from whose beak streams a banner inscribed *LIBERTY* (fig. 7.4). The

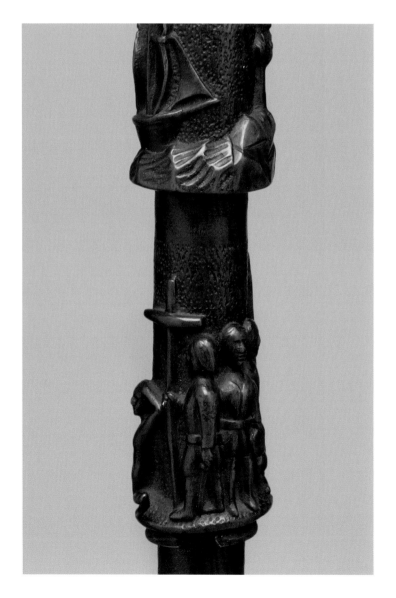

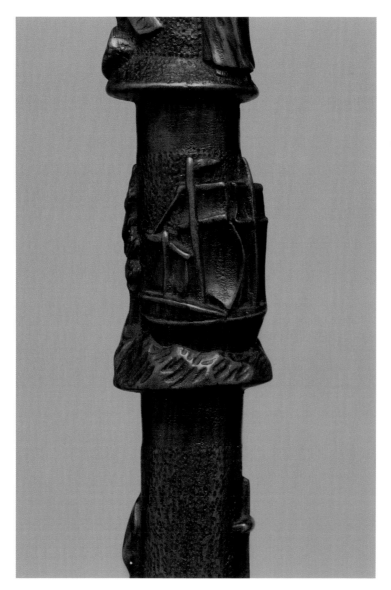

topmost vignette features a freed individual who reaches out both arms (fig. 7.5). Broken chain fragments dangle from his right wrist, and from his left hand a scroll unfurls with the inscription *BE IT KNOWN THAT ALL MEN SHALL BE FREE* (fig. 7.6). Alongside, Abraham Lincoln stands at a sloped table affixed with a quill pen, indicating his 1863 signing of the Emancipation Proclamation (fig. 7.7).

Loango tusk sculptures and the Emancipation Cane draw upon relief-carved, historical Kongo arts. Relief carving and narrative imagery are evident on Kongo-Woyo pot lids, whose imagery communicated local proverbs within households (cat. 4.23 and cat. 4.24). The narrative and mnemonic function of both Loango ivories and the Emancipation Cane corresponds to the abstracted and relief-carved figurative imagery of "scepter-slates" (or *lusumu*), which served as an elder's mnemonic device for recounting history and cosmology to his community (fig. 7.8). This correlates with the souvenir function of Loango tusks. The Western trader, having returned to Europe from his stay on the Loango Coast, would read and describe the tusk's imagery

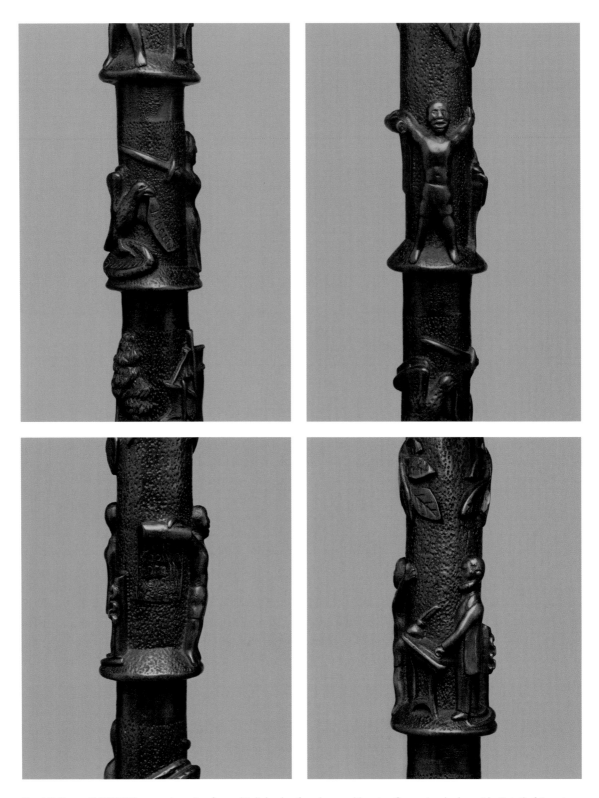

Top, left: Fig. 7.4. "LIBERTY" banner streaming from a bird's beak; a female sword-bearing figure stands alongside. Detail of American cane with Emancipation theme (fig. 7.1). Photograph by and permission from Brooklyn Museum.

Top, right: Fig. 7.5. A newly freed man. Detail of American cane with Emancipation theme (fig. 7.1). Photograph by and permission from Brooklyn Museum.

Bottom, left: Fig. 7.6. Banner and its paraphrase from the Emancipation Proclamation. Detail of American cane with Emancipation theme (fig. 7.1). Photograph by and permission from Brooklyn Museum.

Bottom, right: Fig. 7.7. Bearded figure resembling Abraham Lincoln standing before a quill pen, inkwell and document. Detail of American cane with Emancipation theme (fig. 7.1). Photograph by and permission from Brooklyn Museum.

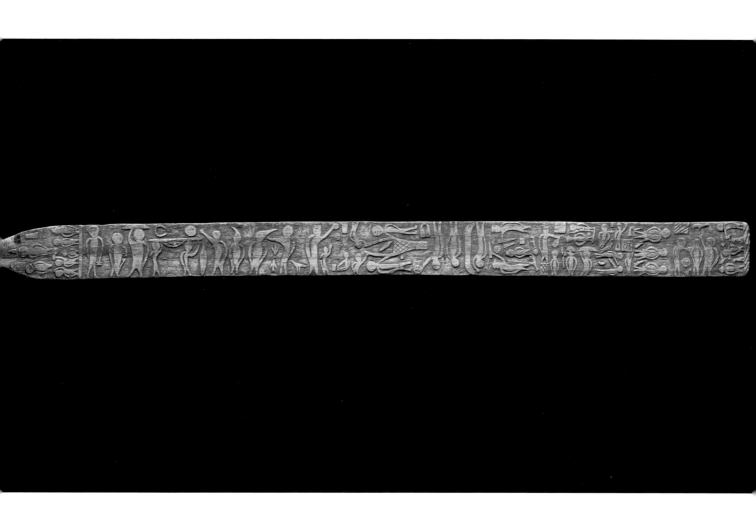

to convey to friends and family all the happenings of life in Africa. For the carver of Loango ivories, these inscribed social histories would seem to depart. However, this narrative appears to have been retrieved across the Atlantic by the carver of the Emancipation Cane.

The Emancipation Cane may be a unique explicit correspondent in the African Diaspora to Loango ivories for its figurative and narrative imagery. However, Loango ivories and Brooklyn's cane are visually linked on a more ubiquitous scale in the United States to the rich corpus of African American folk art canes, which often reveal visual similarities with Kongo leadership staffs in relief-carved figurative imagery and other decorative elements (cat. 6.16 to cat. 6.20).[3] Scholars have long drawn connections between African American or American folk art canes and Kongo staffs. Perhaps the most noted example is a staff in the Yale University Art Gallery collection that was carved by Henry Gudgell, an African American artist who was born into slavery in Kentucky and later relocated to Missouri, where he carved the staff in 1863 (cat. 6.16). Its worn handle with spiraling incisions, segmented and geometric patterned handle and relief-carved reptile (snake, turtle and lizard on the shaft) and figurative motifs highlight a connection between Kongo leadership staffs, the Emancipation Cane and Loango tusk sculptures. Historical Kongo staffs relate visually to the Gudgell staff, the Emancipation Cane and Loango ivories. Such motifs as spiral

Fig. 7.8. Kongo symbolic plaque (*lusumu*), Lower Congo, early 20th century. Wood, 3.1 × 44.9 × 2.7 in. (8 × 114 × 7 cm). Collection Royal Museum for Central Africa, Tervuren, Belgium, EO.0.0.27312.

fluting, coiling snakes, spiral or parallel segmentation and figurative finials appear on many historical Kongo staffs and echo similar motifs on the Gudgell staff's handle (cat. 2.14 to cat. 2.18). Many Kongo staff finials portray a mother and child or *pfemba* motif, a recurrent feature on many Loango ivory tusk finials (cat. 2.1).

Commemorative Segmentation

Spiral or parallel registers typically frame the imagery of Loango tusk sculptures. As souvenir objects ostensibly embellished with scenes of daily life, this structure visualizes the Kongo concept of the life cycle or *luzîngu*, literally "the coil of life" in Kikongo.[4] Sometimes, the spiral on Loango ivories is explicitly rendered as a serpent, a crucial Kongo symbol for rebirth. Parallel registers organize the vignettes of the Emancipation Cane. Also evident on a number of Loango ivories, these parallel registers echo the parallel segmentation of funerary pots (*diboondo*) that were placed atop Kongo graves (cat. 4.15 and cat. 4.16). Suggestive of the spirit's longevity in multiple, successive dimensions of the afterlife, these parallel segments are richly decorated with ideographic signs, some with figures in relief.[5] These significations suggest that segmentation is an important visual frame for memorializing Kongo lives. The spiral and parallel bands, combined with prominent and insistent themes of slavery seen on Loango ivories and the Emancipation Cane, underscore the purpose of these objects to commemorate the enslaved. Loango ivories remember those who departed from the Loango Coast, while the Emancipation Cane venerates those who endured enslavement on the opposite side of the Atlantic.

Conclusion

The Loango ivory tusk sculptures and the Emancipation Cane demonstrate the primacy of indigenous Kongo visual traditions amid rapidly changing circumstances brought about by the Atlantic trade and the displacement of African peoples. The Emancipation Cane reveals that the rich tradition of creating and reading Kongo "graphic writing" persisted outside Kongo itself into the Diaspora, affirming the vital link between the "visual-verbal nexus" and memory in Kongo-derived arts. Through their bold portrayals of captivity and freedom, Loango ivories and the Emancipation Cane illustrate an important resonance between Kongo artistic sources and social memory and illuminate the perspectives of Kongophone sculptors as they commemorated the Africans who were taken by the slave trade and those who survived it.

Notes

1. The slave trade continued to flourish alongside legitimate trade on the Loango Coast through the mid-nineteenth century as Europeans and Americans grappled with enforcing abolition below the equator. See Martin, *External Trade*, 150–57.

2. Nora, "Between Memory and History." Traumatic events can be particularly significant *lieux de mémoire* for collective memory, linking past and present. See Jewsiewicki and Mudimbe, *History Making in Africa*, 1–11.

3. Only a small percentage of these canes can be confirmed as African American in origin. See Austin, "Defining African-American Canes."

4. Fu-Kiau, summer 2004, personal communication.

5. MacGaffey, *Religion and Society*, 63–89.

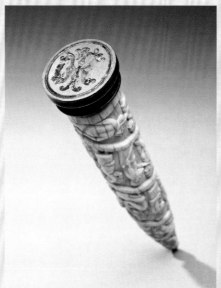

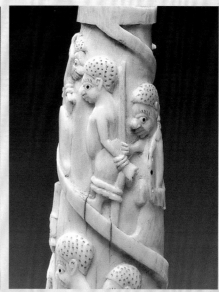

Depicting the Slave Trade

Presented here is a small example of a Loango ivory that has been affixed to a metal stamp. The stamp appears to be a stylized representation of an eagle. The carving, the figures' style, and the characteristic spiraling narrative that reads from the base to the top place this ivory among a corpus of similar examples from West Central Africa. The details depicted here show various aspects of the slave trade. Unlike other examples, this scene does not include references to aspects of European dress or European trade objects and appears to be strictly situated within Kongo. The scene on the middle right (ill. 7.4) shows a yoked slave within a split tree branch. The split tree branch, much like an iron chain, has become a symbol of the slave trade. The scene in the detail on the lower right (ill. 7.5) connects to the image of the split tree branch and depicts the business transaction to sell the slave. The image on the top right (ill. 7.3), near the top of the ivory and at the end of the narrative, continues the story of transporting the slave.

CSF

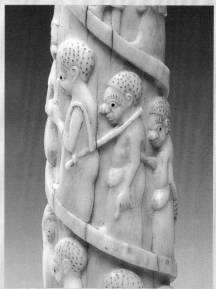

Facing page: Ill. 7.1. Carved tusk made into a stamp, Vili peoples. Lower Congo, DRC. 19th century. Ivory, metal, 7.48 × 1.38 in. (19 × 3.5 cm). Collection Royal Museum for Central Africa, Tervuren, Belgium, EO.1953.26.18. By permission of RMCA.

Top left: Ill. 7.2. Seal. Detail of a carved tusk made into a stamp (ill. 7.1). By permission of RMCA.

Top right: Ill. 7.3. Chained slave. Detail of a carved tusk made into a stamp (ill. 7.1). By permission of RMCA.

Middle right: Ill. 7.4. Slave in a yoke. Detail of a carved tusk made into a stamp (ill. 7.1). By permission of RMCA.

Bottom right: Ill. 7.5. Business transaction. Detail of a carved tusk made into a stamp (ill. 7.1). By permission of RMCA.

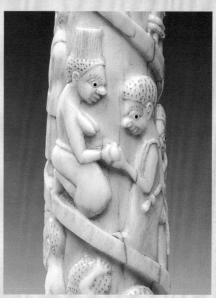

TRADE AND CHIEFS IN THE NINETEENTH CENTURY

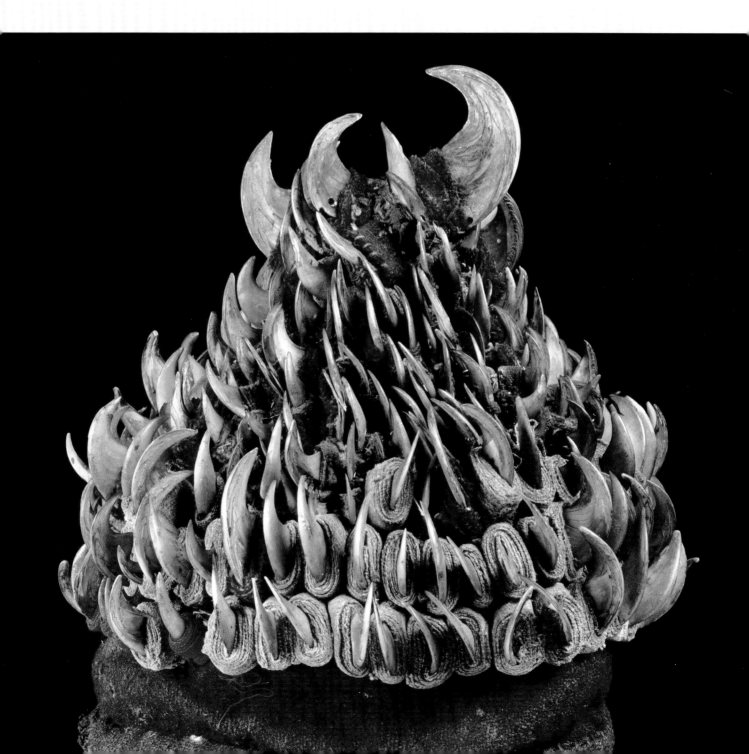

Change in Kongo Society Reflected in Ivory Sculpture

Intended to be read from the base to the summit, these processions of figures reveal many aspects of Kongo society. In chapter 7 of this volume, Nichole Bridges describes the almost inconspicuous incorporation of slavery imagery into the spiraling friezes of these ivories. In addition to depicting the slave trade, the ivories illustrate other aspects of Kongo life.

A wide range of clothing is represented on the tusk. Some figures wear the chiefly *mpu* cap (identifiable by the cap's curved top and embroidered designs) while others wear top hats and bowlers, suggesting European influence. Some men wear wrappers, but others adopt a range of European-influenced clothing, including jackets (with pockets) and long pants. Likewise, some women portrayed on these two examples are bare chested and wear wrapped skirts while others wear dresses with full skirts.

CSF

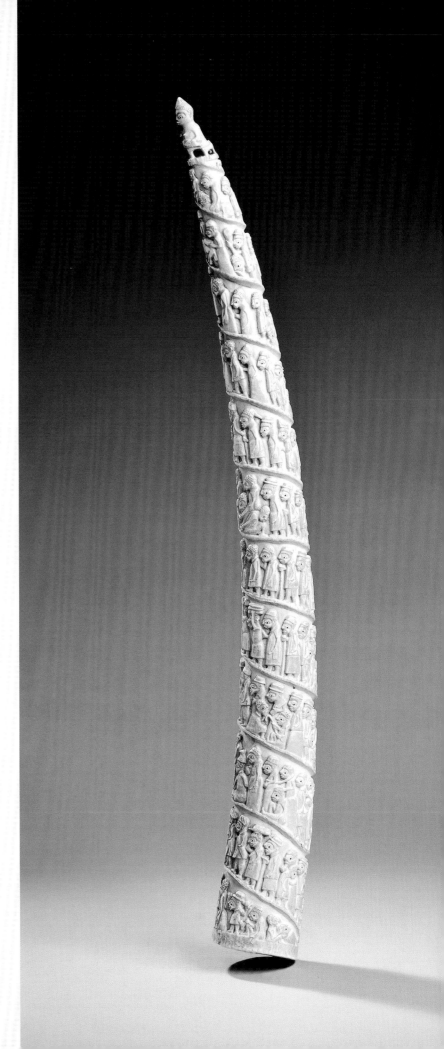

Cat. 2.1. Carved elephant tusk, Vili peoples. Lower Congo, DRC. 19th century. Ivory, 29.33 × 3.35 × 11.41 in. (74.5 × 8.5 × 29 cm). Collection Royal Museum for Central Africa, Tervuren, Belgium, EO.1951.55.3.

Cat. 2.2. Carved elephant tusk, Vili peoples. Loango, Congo-Brazzaville. 19th century. Ivory, 40.47 × 2.36 × 5.12 in. (102.8 × 6 × 13 cm). Collection Royal Museum for Central Africa, Tervuren, Belgium, EO.1979.1.408.

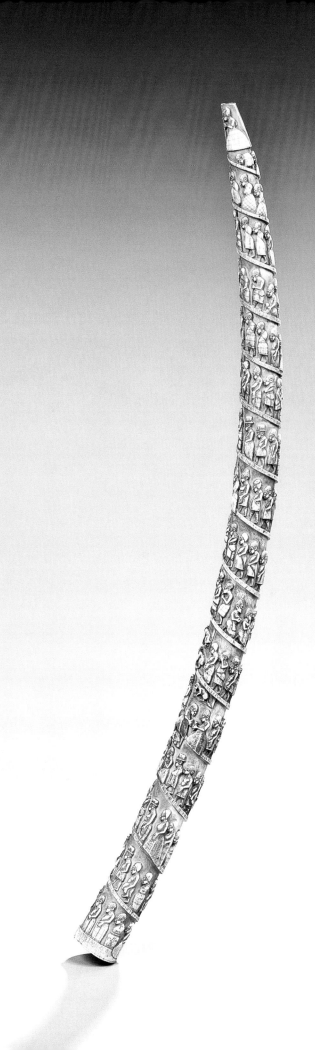

An American Sailor's Kongo Whistle

Europeans commissioned ivories in three areas of Africa: the Sapi region, the Benin Kingdom and Kongo. Stylistic traits of each region varied, as carvers combined both local and European imagery and aesthetics. Like the bas-relief ivories (cat. 2.1 and cat. 2.2), this curious example of an ivory whistle shows aspects of a cultural intersection. Overall, the object is of the type that would have been used on sailing vessels to communicate orders. This similarity suggests that the artist who created this whistle may have seen a ship's whistle and carved ivories for trade or commissioned works. Marc Leo Felix has identified the figure's clothing, consisting of a jacket and cravat, as the dress of an American captain from the late eighteenth or early nineteenth century. The figure also wears earrings, however, that are identical to those worn by the Kongo elites in the eighteenth century. The Kongo sculptor of this object has thus made a hybrid representation, clothing his figure in American dress while adding Kongo-style jewelry to indicate wealth and status.

CSF

Cat. 2.3a and cat. 2.3b. Sailing ship whistle, Kongo peoples. Loango Coast, Angola or Congo-Brazzaville. 18th–19th century. Ivory, wood, 2.76 in. (7 cm). Collection of Marc Felix, FX12 0032.

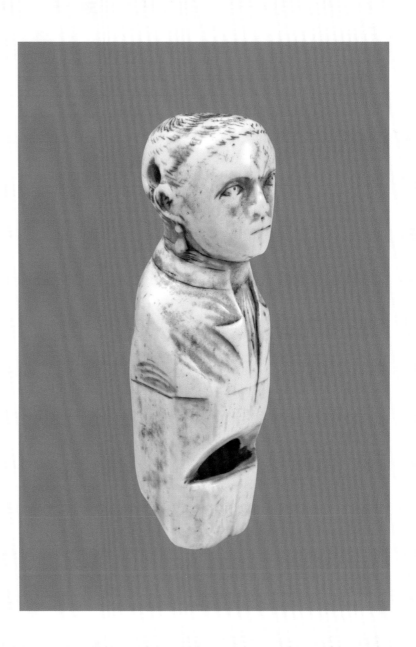

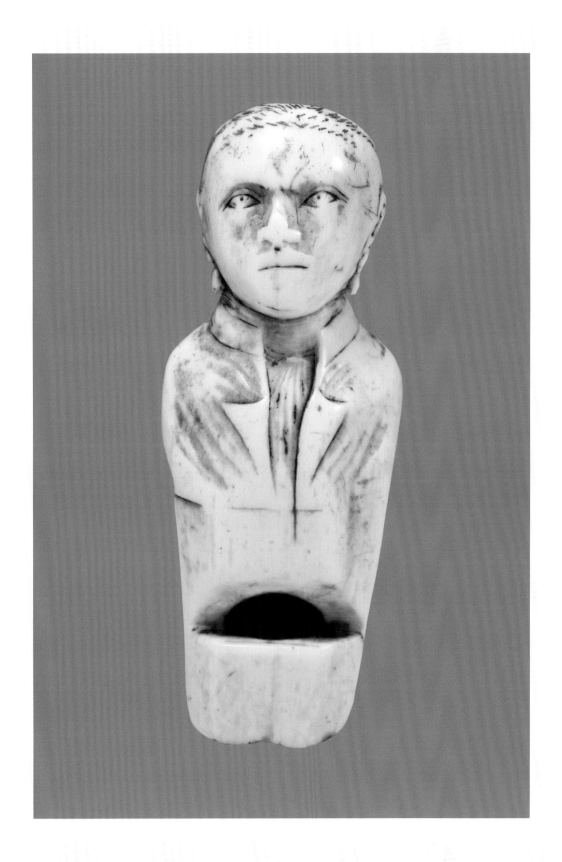

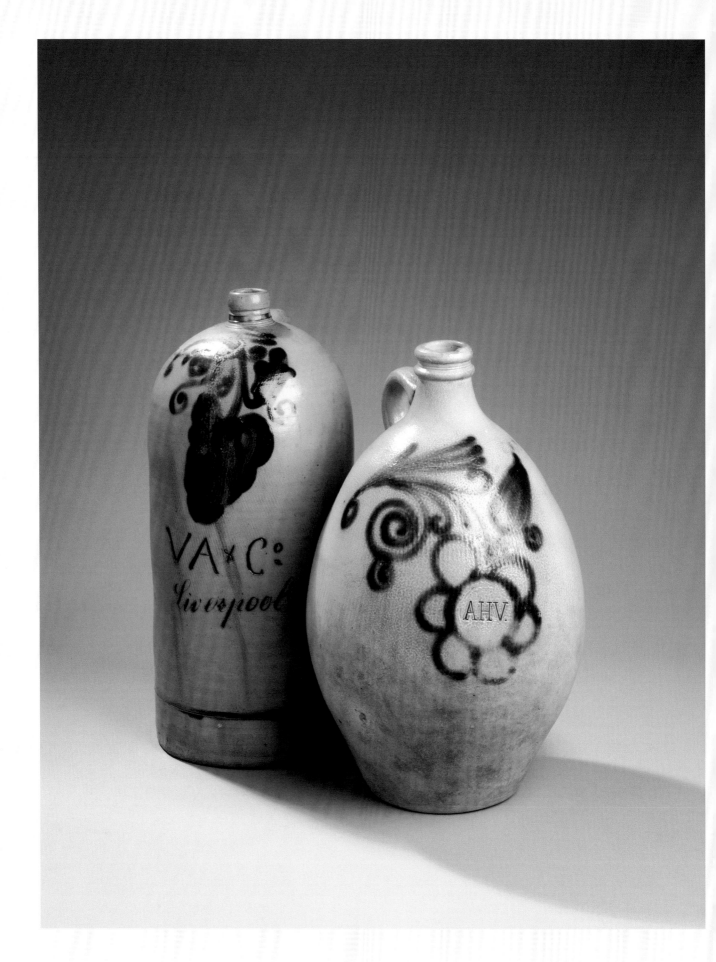

Stoneware Pitchers and Jenever Bottles

Among the European trade articles that were in high demand on the coasts of West Central Africa in the nineteenth century were gray stoneware pitchers and jenever bottles. Many of them have been found in Lower Congo in the twentieth century.

The pitchers were up to seventeen inches tall and decorated with blue floral motifs. Both specimens in cat. 2.4 were presumably made in Germany for trading firms that conducted business in Africa. Some of these had their name marked on the outside of the pitchers. The tallest one bears the initials of the Spanish-Portuguese firm Valle & Azevedo, and *Liverpool* indicated where the firm had moved its head office in 1884. The other bears the monogram *AHV*, referring to the Rotterdam-based firm Afrikaansche Handels Vereeniging. The pitchers were greatly appreciated by Bakongo for their suitability to keep water or palm wine clean and fresh. They were also put on the graves of successful merchants and chiefs.

European trading firms also imported huge quantities of jenever or "Holland gin" in green or brown square glass bottles. The liquor was produced in Holland and in the north of Germany, and the bottles bore either the name of the distiller or the importer. In the examples here, we can read the names of the distillers C. W. Herwig and J. F. Nagel, both from Hamburg, and of E. Kiderlen, from Rotterdam. The fourth bottle has the name of the Dutch importer AHV. Even more than the pitchers, jenever bottles were found in large quantities on Kongo graves.

HV

Facing page: Cat. 2.4. Two pitchers, presumably made in Germany. Collected in Lower Congo, DRC. 1860s–1880s. Stoneware, *Left*: 17.12 × 9.65 × 8.07 in. (43.5 × 24.5 × 20.5 cm), *Right*: 16.5 × 10.04 in. (42 × 25.5 cm). Collection Royal Museum for Central Africa, Tervuren, Belgium, HO.1990.3.2 and HO.1990.3.1.

Below: Cat. 2.5. Four jenever bottles, made in Holland and Germany. Collected in Lower Congo, DRC. Late 19th century. Glass. Collection Royal Museum for Central Africa, Tervuren, Belgium. *Left to right*: 7.87 × 2.56 × 2.56 in. (20 × 6.5 × 6.5 cm), HO.2002.27.2; 8.86 × 3.07 × 2.95 in. (22.5 × 7.8 × 7.5 cm), HO.2002.27.1; 8.27 × 2.56 × 2.56 in. (21 × 6.5 × 6.5 cm), HO.2002.27.3; 9.06 × 2.75 × 2.75 in. (23 × 7 × 7 cm); HO.2012.36.1.

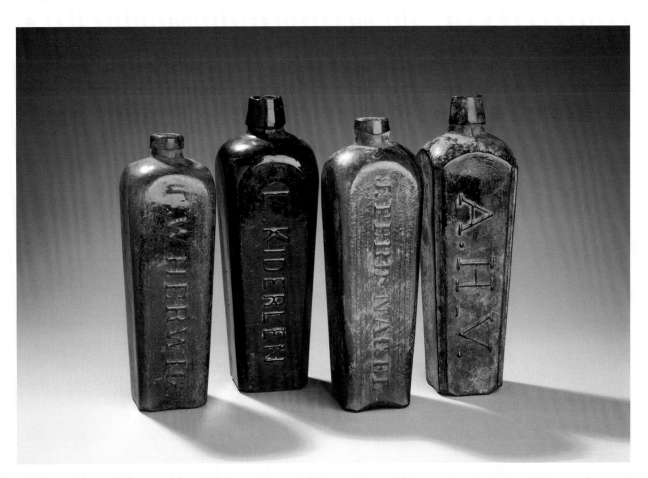

Fancy Wares for the Ancestors

In addition to pitchers and bottles, smaller objects of daily use were also found on Kongo graves, including cutlery, bowls and dinner plates. Early travelers remarked on the peculiar habit of Bakongo to intentionally damage these objects before leaving them on a grave. Late nineteenth-century explorers, such as Henry Morton Stanley, explained this as a way of preventing or discouraging thieves, who might otherwise make secondhand use of them. The British explorer Harry Johnston, however, came to a deeper understanding when he stated that cups and plates were generally broken "in order to 'kill' them, so that they, too, may 'die' and go to the land of the spirits."

The most colorful of European wares left on Kongo cemeteries was no doubt the English Toby jug, a representation of the popular eighteenth-century figure Toby Philpot. European traders offered them to African merchants as early as the 1830s. The Toby jug illustrated here (cat. 2.8) is one of the earliest examples found in Lower Congo. It was originally made in a Staffordshire pottery in the 1820s or 1830s, and the object is exceptionally well preserved. It corresponds to a type called "the Soldier," dressed in a red long coat with yellow buttons, yellow trousers and a tricorn hat, to simulate an eighteenth-century military uniform. Interestingly, some objects indicate that Toby Philpot also inspired Kongo potters to make their own copies.

HV

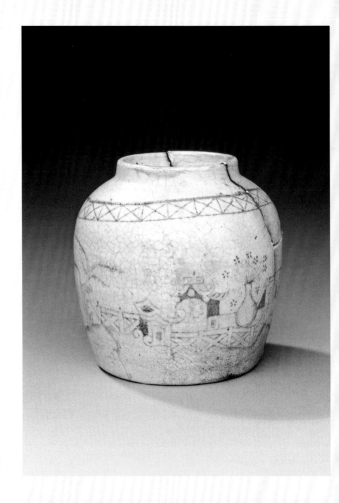

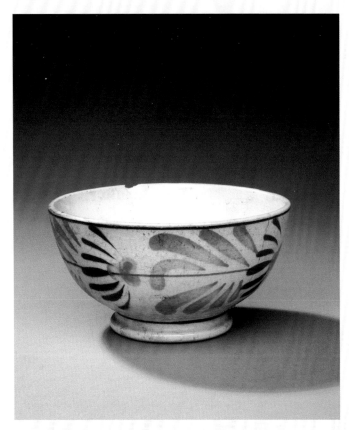

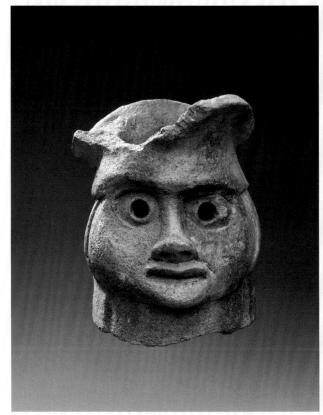

Facing page, bottom left: Cat. 2.6. Bowl, European, unknown manufacturer. Collected in Lower Congo, DRC. Late 19th century. Stoneware, 2.64 × 5 × 5.08 in. (6.7 × 12.7 × 12.9 cm). Collection Royal Museum for Central Africa, Tervuren, Belgium, PO.0.0.80851.

Facing page, top right: Cat. 2.7. Teapot, manufacturer unknown. Collected in Lower Congo, DRC. Late 19th century. Stoneware. 3.7 × 3.46 × 3.39 in. (9.4 × 8.8 × 8.6 cm). Collection Royal Museum for Central Africa, Tervuren, Belgium, PO.0.0.80852.

Right: Cat. 2.8. Toby jug, made in England. Collected in Zaire (province), Angola. 19th century. Stoneware, 9.6 × 5.04 × 5.12 in. (24.4 × 12.8 × 13 cm). Collection Royal Museum for Central Africa, Tervuren, Belgium, EO.1953.74.163.

Facing page, bottom right: Cat. 2.9. Toby jug head, Kongo peoples. 19th century. Terra cotta, 3.15 × 2.56 × 3.15 in. (8 × 6.5 × 8 cm). Collection Royal Museum for Central Africa, Tervuren, Belgium, EO.1949.1.18-1.

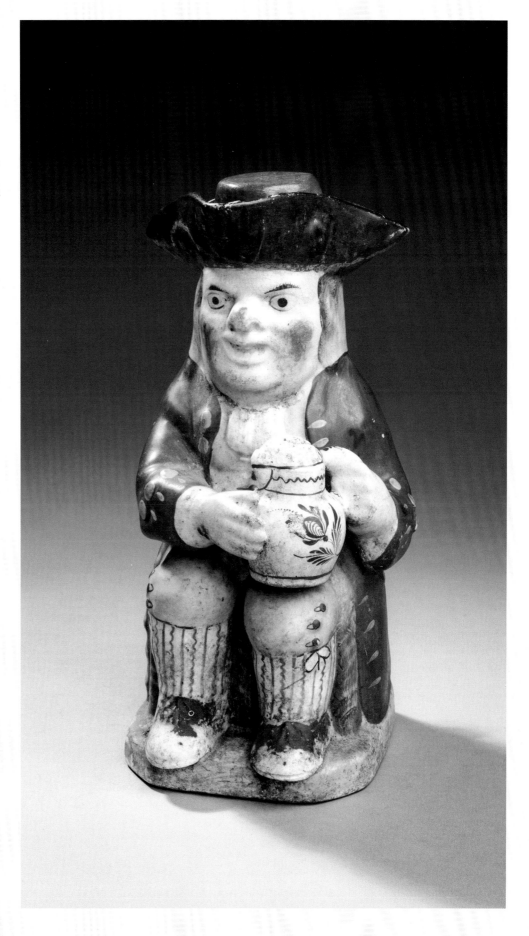

The Curiosities of Kongo Chiefs

In the early 1950s in an Angolan village on the south bank of the Congo estuary, the Belgian ethnologist Albert Maesen purchased a remarkable bronze helmet. The helmet was found on the grave of an important nineteenth-century Kongo chief, called Ne Longo, who died in 1860. It was placed on top of an old English cannon that was standing upright, as is seen on Maesen's photograph (ill. 10.4). According to local informants, the helmet was of French manufacture.

The helmet's front is decorated with a scaly motif in bas-relief, which may be an imitation of the skin of a pangolin. The addition on top of it bears a similar decoration and probably represents its tail. The back of the helmet shows a bas-relief of a kneeling man surrounded by plants and flowers. The object was presumably produced to satisfy the desires of African merchants and chiefs to possess extraordinary and bizarre objects. We know indeed that European theater accessories and discarded military dress ended up on African shores and were used to barter for ivory or agricultural produce. Such objects were often put on the graves of Kongo chiefs, as markers of the mercantile prowess they had exhibited during their life.

HV

Cat. 2.10. Metal helmet found on Kongo grave, probably French. Collected in Northern Angola. 19th century. Bronze, 8.27 × 8.46 × 9.45 in. (21 × 21.5 × 24 cm). Collection Royal Museum for Central Africa, Tervuren, Belgium, EO.1953.74.156.

Cat. 2.11. Ceremonial knife, European, unknown manufacturer. Collected in Lower Congo, DRC. Late 19th century, Metal, silver, 21.26 × 4.13 × 2.56 in. (54 × 10.5 × 6.5 cm). Collection Royal Museum for Central Africa, Tervuren, Belgium, EO.1977.33.1.

The Power to Kill (with Proverbs)

A ritually invested chief's ultimate symbol of power was a finely decorated knife with a copper or brass blade and a handle in wood or ivory. Eduard Pechuël-Loesche, who participated in the German Loango expedition in the 1870s, was among the first to describe such objects, which he called "scepter-knives" (*Zeptermesser*). He reported that only one man, having acquired it from his father, still possessed the knowledge and skill to forge the delicate openwork of the knife. Meanwhile several silver imitations made in Europe had been imported by trading firms and given to chiefs as presents (cat. 2.11).

The *mbele a lulendo*, literally "the knife of power," also called *kiphaba*, was the sign of the chief's power over life and death. At the turn of the century, many stories were told about the old chiefs killing a family member at their investiture, to establish themselves as capable of taking the lives of others. Acts of violence were an important attribute of chiefship, at least symbolically. The idea was frequently expressed in sculpture and art, although many swords and knives, including specimens made entirely of wood, were merely for ceremonial use. The decorative motifs designed in the openwork or gouged into the blade include abstract representations of people, houses, plants and shells. They offered a vocabulary to the chief, who would interpret them with proverbs, according to the needs of the moment.

HV

Facing page: Cat. 2.12. Ceremonial knife, Woyo peoples. Lower Congo, DRC. Late 19th century. Metal, wood, 16.73 × 3.15 × 1.77 in. (42.5 × 8 × 4.5 cm). Collection Royal Museum for Central Africa, Tervuren, Belgium, EO.1952.15.11.

Left: Cat. 2.13. Ceremonial knife, Kakongo peoples. Cabinda, Angola. Early 20th century. Wood, brass, 17.32 × 4.33 × 1.57 in. (44 × 11 × 4 cm). Collection Royal Museum for Central Africa, Tervuren, Belgium, EO.1979.1.77.

Wooden Staffs

According to the origin story of Kongo, staffs called *mvwala* were required for ruling the original clans that made up the kingdom. By the end of the seventeenth century, the kingdom did not wield the power it had formerly exerted. By the eighteenth century numerous small chiefdoms existed in its place, yet the kingdom continued as a mythic symbol that unified Kongo culture.

Staffs served as symbols of legitimate rule for a chief, linking him and his rule to the past, to the ancestors and to the earth. An iron tip at the base allowed the *mvwala* to be lodged in the soil, thus ritually connecting the world of the living community and that of the dead. In some regions during investiture ceremonies for a chief, a circle was inscribed on the surface of the earth, and within it a cross was drawn. The staff was placed where the axes intersect in an effort to empower both the staff and the chief. The *mvwala* was also used in judicial proceedings, and it played a role in funerary ritual in which the staff may represent the deceased.

Carved of wood, the staffs combined geometric forms with representational iconography. Some staffs, such as the Yombe example in cat. 2.14 (*right*), are exquisite arrangements of purely geometric forms repeated along the length. Others such as the Woyo staff in cat. 2.15 (*facing page*) depict the chief sitting in office. Here the leader demonstrates his economic status by wearing a fashionable European hat and coat, but his being Kongo is emphasized by the wrapper around his waist. Below, a female figure grasps a serpent in each hand. The bodies of the snakes wrap around the staff to create parallel lines. The lower part of the staff has several registers, separated from each other by bands around the staff's body. They are filled with scenes and symbolic iconography—men scaling a palm tree, half a seed pod, horns, a long drum, a crab and others.

Iconography on the staff offered a set of ideas. Each icon could refer to any number of proverbs or meanings recognizable to the community. For example, one motif represents the spiral shell *Ta-nsosso*. One proverb associated with the shell admonishes, "Air the disagreement, swallow the rage, and don't hold a grudge." It thus served as a visual pun that linked the sound of its name, Ta-nsosso, and the sound of displeasure that Woyo people made in derision when others insulted them.

RP

Right: Cat. 2.14. Chief's staff, Yombe peoples. Mayombe, Lower Congo, DRC. Early 20th century. Wood, 44.1 × 2.36 in. (112 × 6 cm). Collection Royal Museum for Central Africa, Tervuren, Belgium, EO.1953.74.1212-2.

Facing page: Cat. 2.15. Chief's staff, Woyo peoples. Lower Congo, DRC. Late 19th century. Wood, 47.83 × 1.38 in. (121.5 × 3.5 cm). Collection Royal Museum for Central Africa, Tervuren, Belgium, EO.0.0.7942.

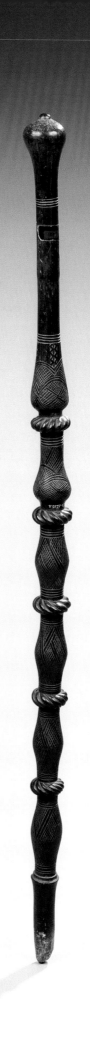

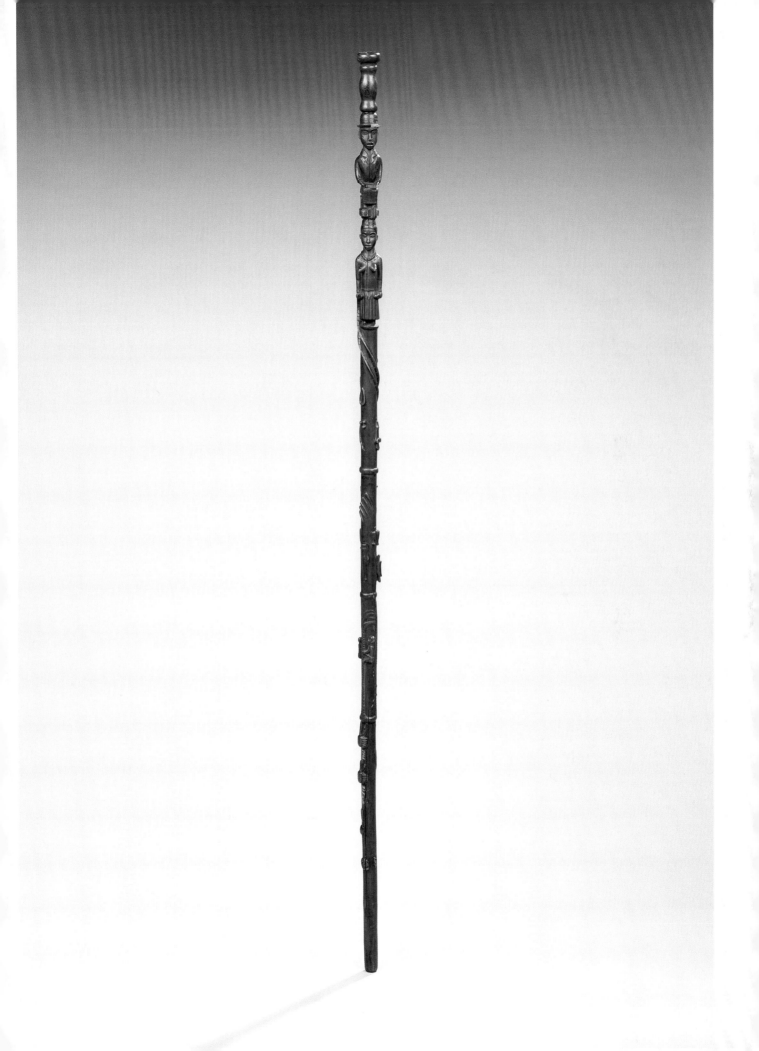

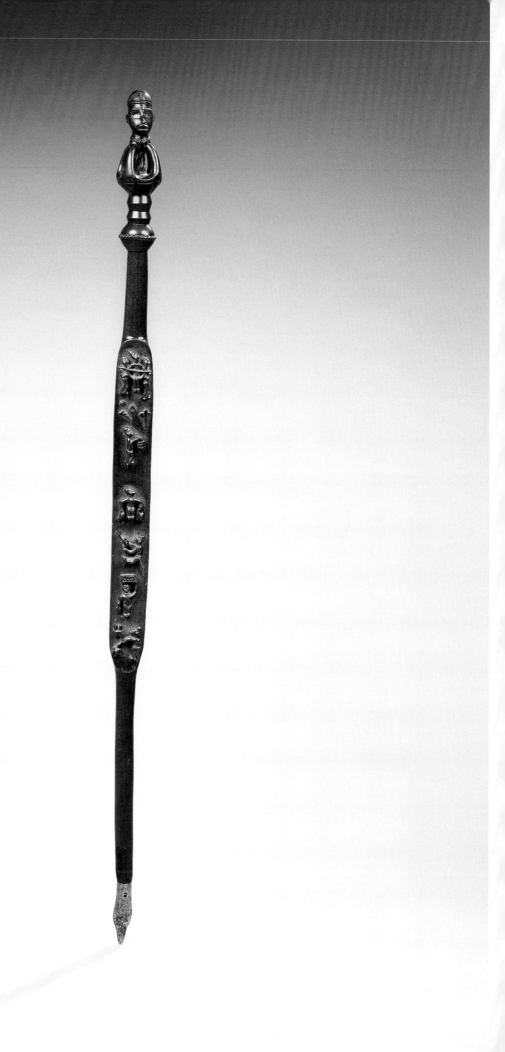

Wooden Staffs

The *mvwala* staff in cat. 2.16 (*facing page*) is a wonderful example of the artist's creative prowess. On top is a head representing a chief. Immediately below are four "arms" suggestive of the four cardinal directions, and referring to the chief's mediating powers between different worlds. Several scenes and iconographic motifs, carved in deep relief, are positioned on a flattened central section. All the figures look up to the chief. The elements are probably to be read from bottom to top. In the lowest register, a smith works with the bellows, perhaps crafting some iron chiefly insignia. Above that, the figure likely represents a trader whose work brings wealth to the community. The figure above that may depict a palm wine tapper (a slave who worked for a free man). The next register illustrates a man with a double bell, the symbol of chieftaincy, and a bird, which may be an offering. The next tier shows someone perhaps proffering a gift, above which is a group of symbols such as a half pod and a spiral shell. The topmost register illustrates two men carrying a chief in a hammock. Altogether the images on the staff seem to be an expression of the chief being served by his dependents for various purposes.

The iconography at the top of the exquisite staff in cat. 2.17 (*right*) either is a reference to a proverb or highlights a very specific story. A snake winds up the staff to grasp the neck of a bird. The portion of the staff on which the serpent slithers seems to project from the head of the seated chief below. As far as we know, the precise meaning of this has not been recorded.

RP

Facing page: Cat. 2.16. Chief's staff, Woyo peoples. Lower Congo, DRC. Early 20th century. Wood, glass, iron, 44.3 × 2.56 in. (112.5 × 6.5 cm). Collection Royal Museum for Central Africa, Tervuren, Belgium, EO.1980.2.560.

Right: Cat. 2.17. Chief's staff, Woyo peoples. Lower Congo, DRC. Early 20th century. Wood, metal, 40.75 × 2.17 in. (103.5 × 5.5 cm). Collection Royal Museum for Central Africa, Tervuren, Belgium, EO.1955.18.1.

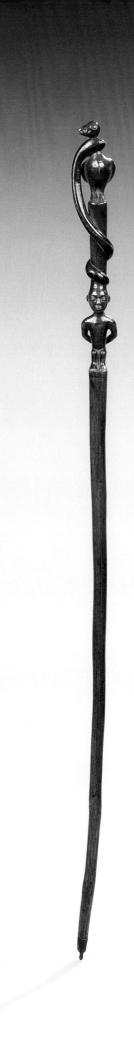

Ivory Staff Finials

Ivory is an especially important medium for royal and chiefly arts in Kongo. When Kongo was described as "the greatest of kingdoms" in Africa by the visiting Portuguese, its sumptuous ivories were already recognized. The king of Kongo sent masterfully carved trumpets of ivory to his counterpart in Portugal. More importantly, the prized material, controlled by Kongo chiefs and kings, played a vital role in visually defining the aristocracy of Kongo.

While some staffs were elaborately carved of wood, others were long wooden canes topped by carved ivory finials. A complex fiber wrapping encases the fifty-two-inch wooden staff in cat. 2.18 (*right*). The ivory figure at the top represents a kneeling female grasping her breasts. The position of the figure embodies ideas of respect and deference and calls to mind the vital role women played in matrilineal societies such as Kongo. Theoretically it referred to the mother of the clan, the founder of the lineage. At the same time, it symbolized fertility.

RP

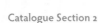

Facing page: Cat. 2.18. Chief's staff, Woyo peoples. Lower Congo, DRC. Early 20th century. Wood, ivory, vegetal fiber, 51.97 × 1.57 in. (132 × 4 cm). Collection Royal Museum for Central Africa, Tervuren, Belgium, EO.0.0.34793.

Below: Cat. 2.19. Chief's staff finial, Yombe peoples. Lower Congo, DRC. Early 20th century. Ivory, 13.39 × 2.95 × 2.36 in. (34 × 7.5 × 6 cm). Collection Royal Museum for Central Africa, Tervuren, Belgium, EO.1950.29.1.

Right: Cat. 2.20. Chief's staff finial, Kongo peoples. Lower Congo, DRC. Late 19th century. Ivory, 4.69 × 1.42 in. (11.9 × 3.6 cm). Collection Royal Museum for Central Africa, Tervuren, Belgium, EO.1979.1.71

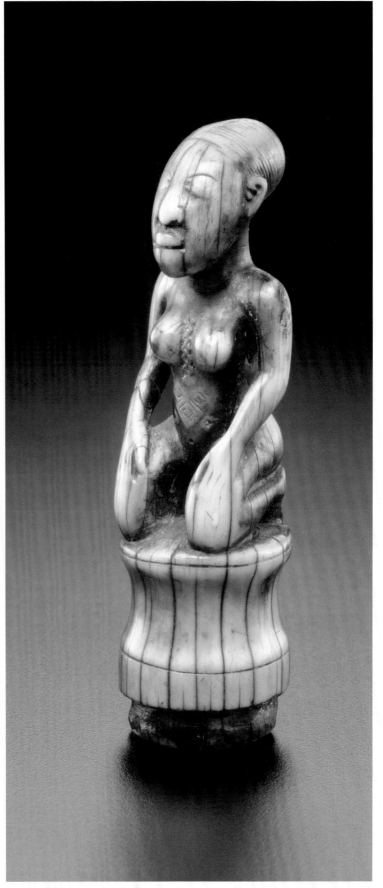

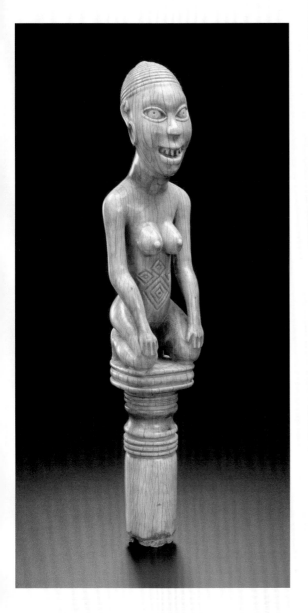

Ivory Scepters

Like staffs, small ivory scepters served as signs of both the political and spiritual authority of Kongo chiefs, referring to the mystical as well as the administrative powers under their command. Artists carved such insignia from the tips of elephant tusks to indicate the original form of the tusk. While some scepters are figurative, others are not, covered instead with geometric patterns.

Cat. 2.21 (*right*) depicts a chief seated, his legs crossed, holding a small tusk in his left hand, perhaps a medicine container, perhaps a self-reference to the scepter. With his right hand he grasps a portion of a root known as *munkwisa*, which he bites. The root is used for many purposes, among them warding off witches. According to Kongo belief, if the chief pointed the *munkwisa* at an individual, the individual could die. Thus, the root can symbolize the power of life and death a chief wields over his followers. *Munkwisa* also symbolizes the chief's own fertility and thus that of his people. The secondary figure below that of the chief is another reference to the life-and-death powers of the ruler in a more direct, more persuasive way. The bound and gagged victim awaits execution at the sitting chief's command. The top of the ivory object once held *bilongo*, ingredients that charged it with power, turning it into a *nkisi*. The iconography is thus a visual summary of both the temporal military power and the spiritual power necessary for a chief to have at his disposal in order to control his domain.

The scepter in cat. 2.22 (*facing page*) is divided into five registers, the top four filled with intricate geometric patterns. Among the motifs are variations of interlace, rosettes and abstracted human faces. The visually packed upper four registers contrast markedly with the lowest register, which is left rather plain except for elegantly worked scallops. Such mastery of geometric decoration has long been demonstrated by Kongo artists in the surface carving of ivory trumpets (see cat. 1.4), the weaving of fine raffia textiles and mats and beautifully created baskets (cat. 1.6, cat. 4.20, cat 2.30 and cat. 2.31).

RP

Right: Cat. 2.21. Ivory scepter, Kongo peoples. Lower Congo, DRC. 19th century. Ivory, resin, fat, 11.42 × 1.77 in. (29 × 4.5 cm). Collection Royal Museum for Central Africa, Tervuren, Belgium, EO.0.0.43708.

Facing page: Cat. 2.22. Ivory scepter, Woyo peoples. Lower Congo, DRC. 19th century. Ivory, 13.98 × 1.97 × 2.95 in. (35.5 × 5 × 7.5 cm). Collection Royal Museum for Central Africa, Tervuren, Belgium, EO.1979.1.260.

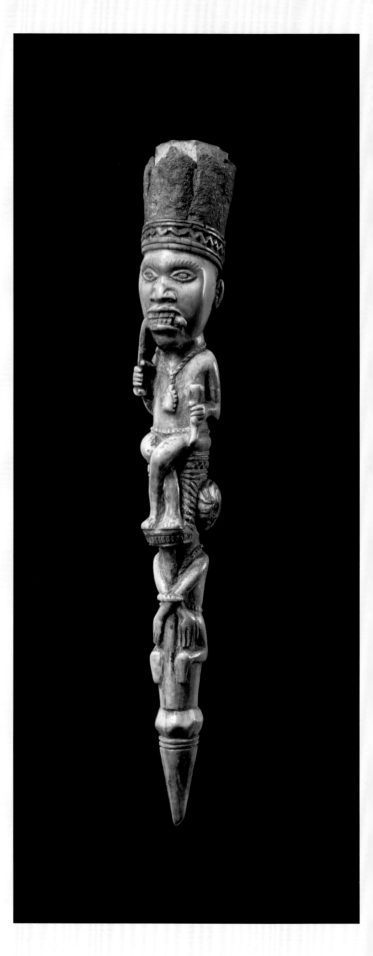

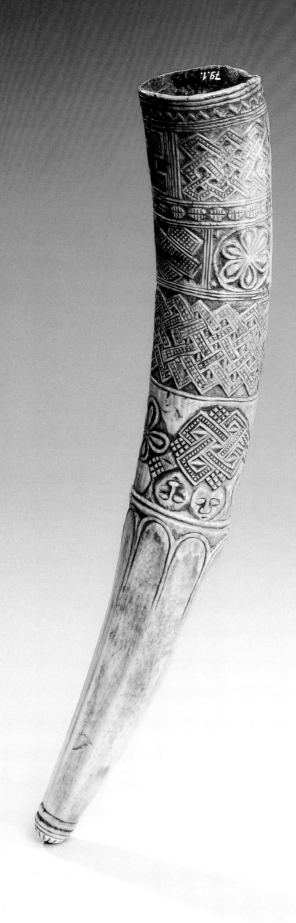

Chiefly Regalia

Hats and capes played an important role in the Kongo king's regalia. In times of the early European contact, raffia shawls were a signal of prestige. Ambassador Antonio Manuel (fig. 5.1) is depicted wearing such a cape during his visit to the Vatican. This form of dress quickly became displaced with the introduction of European textiles.

While kings adopted European styles of dress early on, caps remained an important marker of status. *Mpu*, raffia caps, are embellished with embroidery and pile techniques and feature geometric designs similar to those used to create raffia textiles (cat. 1.6). *Mpu* often appear on other depictions of Kongo kings, including grave sculpture (cat. 4.14) and scepters (cat. 2.21).

Wyatt MacGaffey has explained the ritual role of the *mpu* in the investiture ceremonies for new chiefs. These rituals use the *mpu* as a type of *nkisi*, ensuring the power of the chief. The visual qualities of a *mpu* also relate to a spiritual purpose. *Mpu* are created using a difficult spiraling weaving process in which the raffia threads spiral from the top down to the base of the form. The Kikongo word for spiral, *zinga*, corresponds to ideas of longevity, and the spiral form relates to snakes, animals often associated with the spirits. Many *mpu* also include additional prestige elements—such as leopard claws. Chiefs often use leopards as metaphors and symbols to support their political and spiritual power (cat. 2.34).

CSF

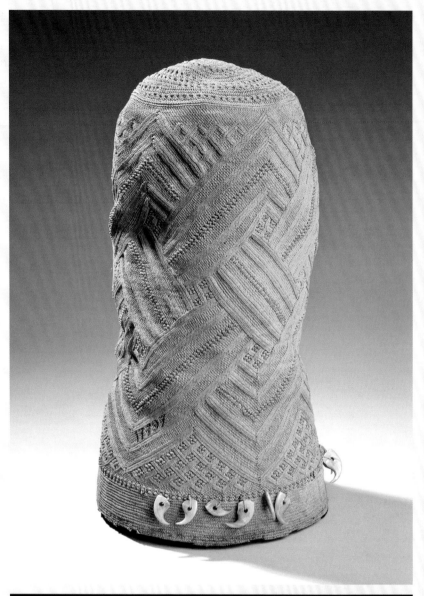

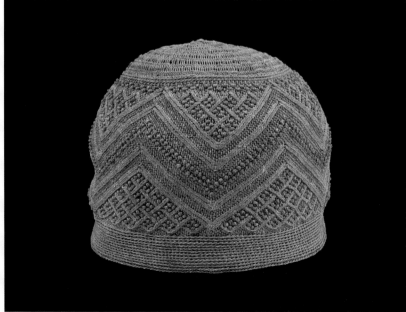

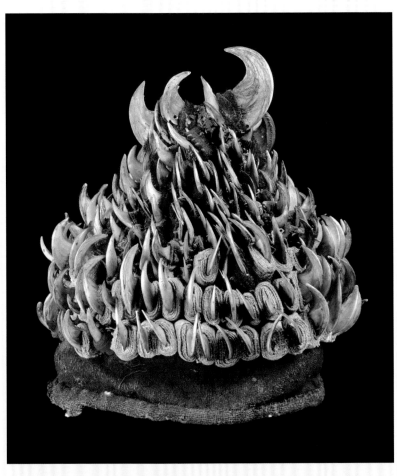

Facing page, top: Cat. 2.23. Chief's headdress, Kongo peoples. Lower Congo, DRC. Late 19th century. Vegetal fiber, leopard claws, 13.2 × 7.1 in. (33.5 × 18 cm). Collection Royal Museum for Central Africa, Tervuren, Belgium, EO.0.0.17797.

Facing page, bottom: Cat. 2.24. Chief's headdress, Kongo peoples. Lower Congo, DRC. Early 20th century. Raffia, vegetal fiber, 5.12 × 5.51 in. (13 × 14 cm). Collection Royal Museum for Central Africa, Tervuren, Belgium, EO.0.0.34448.

Left: Cat. 2.25. Chief's headdress, Kongo peoples. Lower Congo, DRC. Early 20th century. Vegetal fiber, claws, 7.87 × 7.87 in. (20 × 20 cm). Collection Royal Museum for Central Africa, Tervuren, Belgium, EO.1948.27.45.

Below: Cat. 2.26. Chief's cape, Woyo peoples. Cabinda, Angola. Late 19th century. Vegetal fiber, raffia, 21.45 × 29.5 × 1.18 in. (54.5 × 75 × 3 cm). Collection Royal Museum for Central Africa, Tervuren, Belgium, EO.1979.1.308.

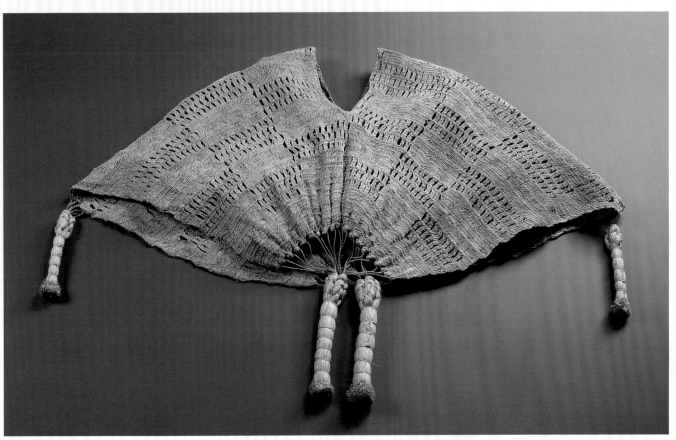

Flywhisks as Symbols of Authority

A buffalo tail flywhisk is an essential part of a chief's regalia and is regarded as a symbol of his power. Motifs carved on the handles reinforce ideas of leadership as understood in the framework of Kongo cosmology. Both flywhisks depicted here were still in use in the 1950s.

A Mboma flywhisk features the figure of a crouching woman who bears geometric designs on her shoulders and chest. The figure refers to the reproductive powers of women, which chiefs sought to control in order to increase the number of their dependents. The object was produced in Mayombe and owned by the Mboma chief of the village of Fuka prior to its destruction in 1937 following an outbreak of sleeping sickness.

A Yombe flywhisk (cat. 2.28) pairs the clasped hand gesture with a pattern of bisected lozenges, an ideographic rendering of two worlds, that of the living and that of the dead. Through this iconography, the flywhisk qualifies the role of the chief as negotiator between different worlds. The object was originally made in Makungu Lengi in Mayombe. It was given to the village chief of Kibuku during his investiture by the chief of Kiondi, who also granted him certain land rights. A note from the collection files of the Royal Museum for Central Africa states that the object was seen in 1953 by A. Maesen, who wanted to acquire it for the RMCA. Maesen did not succeed in his attempt because of the heavy protest from the chief's successor, which attests to the importance still attributed to these objects in the 1950s.

SC

Right: Cat. 2.27. Flywhisk, Mboma peoples. Lower Congo, DRC. Early 20th century. Wood, tail, 19.29 × 2.56 in. (49 × 6.5 cm). Collection Royal Museum for Central Africa, Tervuren, Belgium, EO.1953.74.8033.

Facing page: Cat. 2.28. Flywhisk, Yombe peoples, Boma, Lower Congo, DRC. Early 20th century. Wood, tail, brass, 18.77 × 2.17 in. (47.7 × 5.5 cm). Collection Royal Museum for Central Africa, Tervuren, Belgium, EO.1971.70.1-1.

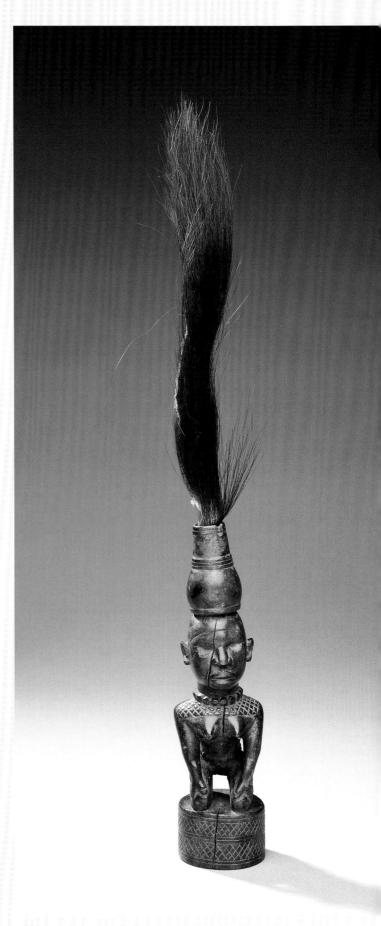

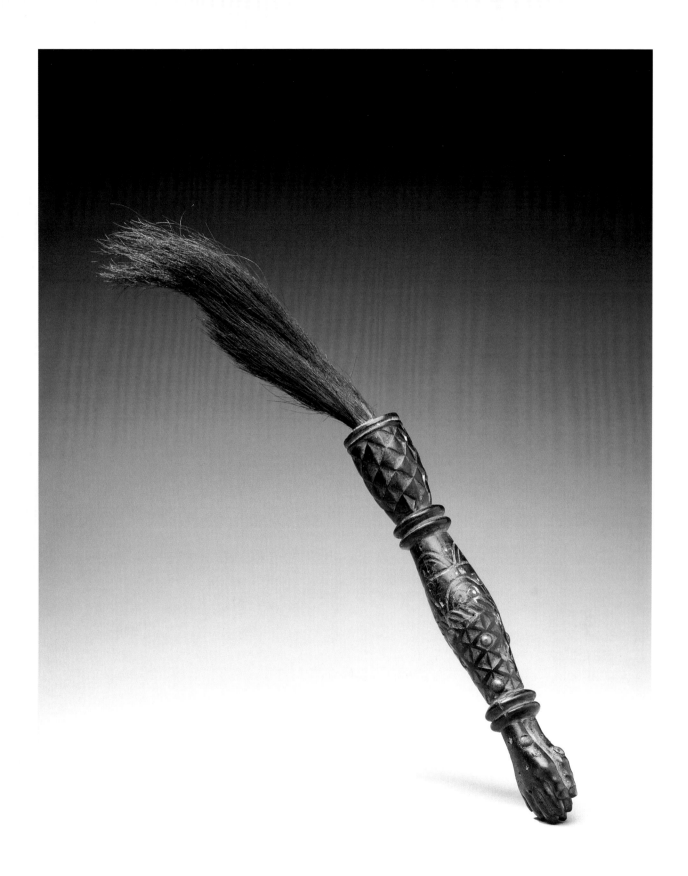

Spoon with Figure

Large spoons with elaborately carved handles were created for ceremonial purposes. The images on the handle vary widely and are metonymic of their function. For the Yombe, spoons were part of a chief's regalia. This spoon bears an image of a standing figure with a *munkwisa* root in his mouth and a severed human head in his left hand. The bitter root is associated with the power of chiefs, who prove their supernatural prowess by chewing on it during investiture ceremonies. If the chief points to someone with the root, he will swell up and die, thus proving him to be a witch. The presence of the *munkwisa* along with the severed head speaks to this spoon as a symbol of authority and the power wielded by Kongo leaders.

SC

Cat. 2.29. Spoon, Yombe peoples, Lower Congo, DRC. 20th century. Wood, 7.75 × 1.875 × 1.5 in. (19.68 × 4.76 × 3.81 cm). Collection of Hyatt and Cici Brown.

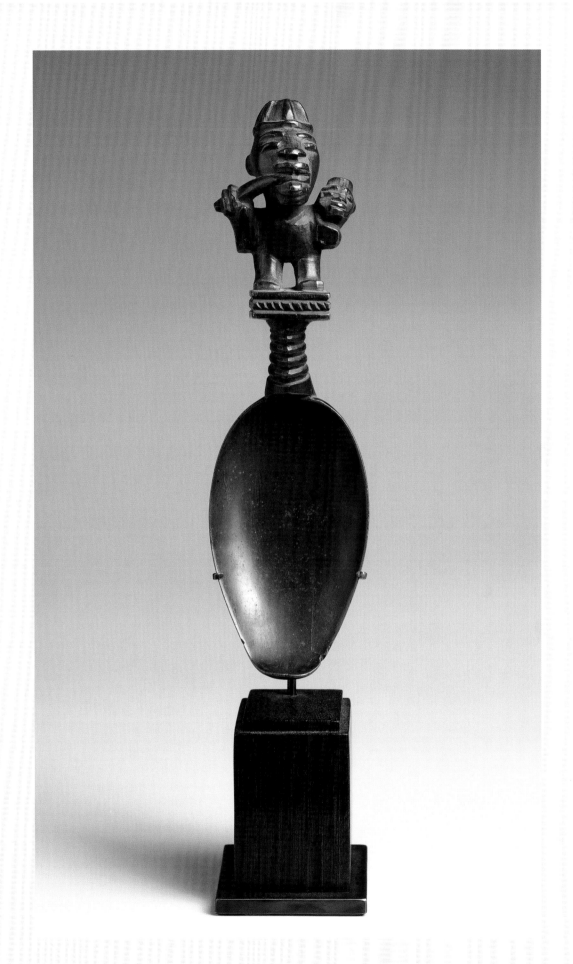

Kongo Baskets

Finely woven baskets have served as containers for clan relics, valuables and objects related to status in Kongo society. They are constructed with wood or bark liners to ensure their strength, and the exterior is covered with woven natural and dyed raffia and rattan fibers using plainweave or twill work. The complex patterns, shifting subtly across the entire surface, dazzle and impress; the outer richness portends treasures within and proclaims the wealth of the owner. More significantly, motifs on baskets are ideograms redolent of Kongo cosmological meaning. The most commonly seen motif, the lozenge, is one of the most profound, as it signifies the human life cycle, each of its four corners representing an important phase or passage—of birth, adulthood, death and rebirth in the ancestral realm. The repeated interlocking lozenge-within-lozenge pattern visually affirms the interconnectedness of family, of the living and the dead, and the continuity of life as a fundamental principle of Kongo thought. The interlace pattern, as seen as the dominant motif on the cylindrical basket, is interpreted as a python—its undulating form and amphibious capacity to traverse the watery realm of the ancestors, and back to the earth of the living—the symbol of longevity. The combined impact of these intricately interwoven, multiple and multivalent motifs provides a powerful visual metaphor for Kongo family unity made possible by the inextricable linkage and continuous interaction of the living and the dead.

The Kongo tradition of creating highly adorned baskets lasted from before the seventeenth century to the beginning of the twentieth century. By the seventeenth century, European visitors to the Kongo kingdom collected baskets and documented them in paintings and texts. Among these are a fascinating complex bowl-shaped basket in the Copenhagen National Ethnographic Museum and a painting by A. Eckhout of a woman carrying a Kongo basket. The museum also has a painting attributed to Jasper Beckx of the attendant of Dom de Castro (ill. 5.2), the envoy of Kongo to Brazil, carrying a rectangular lidded basket. Other seventeenth-century examples are in museums in Ulm and Stuttgart. A 1668 painting by Cavazzi shows a trader carrying his textiles in a basketry trunk that he holds up to show the Kongo king. From these early examples it is clear that Kongo basketry was already a highly refined art form and had been evolving long before European contact.

SC

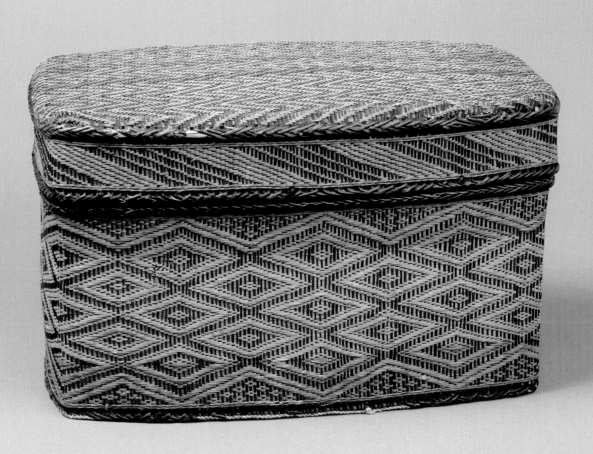

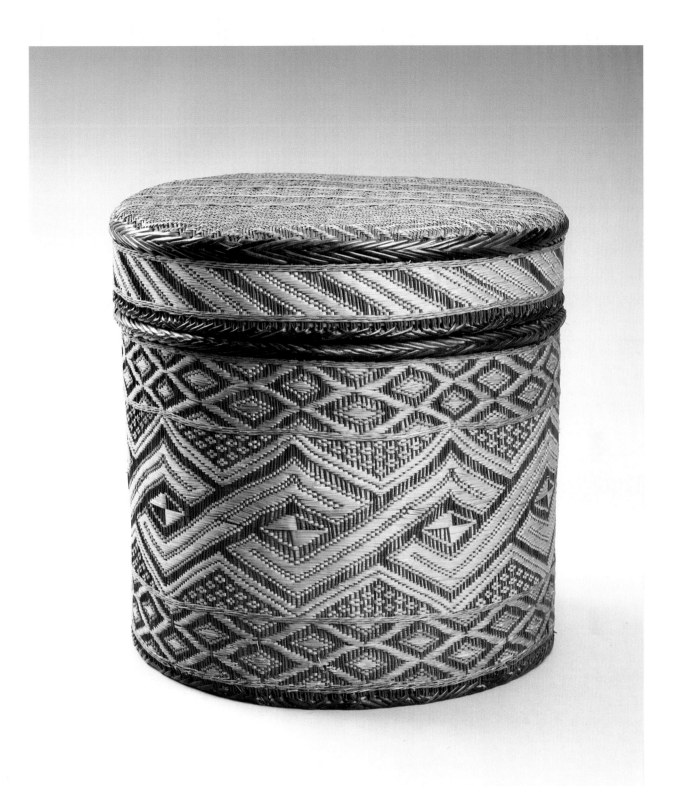

Facing page: Cat. 2.30. Fiber basket, Vili peoples. Loango, Congo-Brazzaville.
Late 19th century. Vegetal fiber, 16.14 × 9.45 × 8.66 in. (41 × 24 × 22 cm).
Collection Royal Museum for Central Africa, Tervuren, Belgium, EO.0.0.7349-1.

Above: Cat. 2.31. Fiber basket, Vili peoples. Loango, Congo-Brazzaville. Late 19th
century. Vegetal fiber, 12 × 12.4 in. (30.5 × 31.5 cm). Collection Royal Museum for
Central Africa, Tervuren, Belgium, EO.0.0.29075.

Ivory Pendants

As the Congo Free State (1885–1908) developed policies that pressured chiefs into a relationship of rights and duties with the new state, many newcomers were able to gain status and position by manipulating the newly introduced system to their own ends. In the process they gained not only wealth but also extensive political power and worked toward redefining their roles in society, manipulating trade, economic endeavors, and colonial politics.

A broad range of insignia and regalia alluded to their new political, economic, and spiritual power. Among these objects were European-produced medals, but locally produced pendants also abounded. Such medals were worn by chiefs to indicate their positions, and they were also depicted on figures carved to honor chiefs as demonstrated in cat. 4.17 and ill. 9.1.

European medals had long been introduced into the region, especially for religious purposes, and Kongo reworking of such medals extends far back. For example, the objects pictured in cat. 1.21 and cat. 1.22 attest to the conscientious modification of imported metal medal forms. Later variations in ivory mimic European form but Kongo-ize the object at the same time. For example, the circular disk in cat. 2.32 suggests the form of European medals with its raised rim, and as with European medals a loop provides the means for suspension. The motif on this pendant, however, is a classic Kongo representation, a circle surrounding an equal-armed cross.

The cross form in cat. 2.33 reflects the European Maltese cross with flared arms. Maltese crosses were common motifs on both Portuguese and Belgian civilian and military medals. The motif in the center of the cross, however, is yet another variation on the so-called Kongo cosmogram, here in the form of a lozenge superimposed on the vertical and horizontal axes within a circle.

The pendant in cat. 2.34 represents a leopard claw, a traditional symbol of political power. Leopards were symbolic of physical force, and the king's power over life and death was equated with that of the leopard. Actual leopard claws were attached to clothing or hats (see cat. 2.23 and cat. 2.25). Such symbols of power were also depicted in sculptural forms, as seen in cat. 4.14.

RP

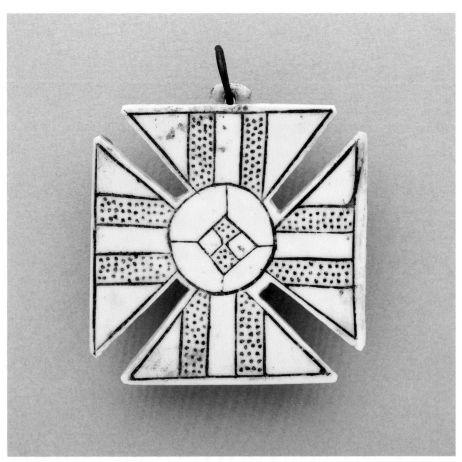

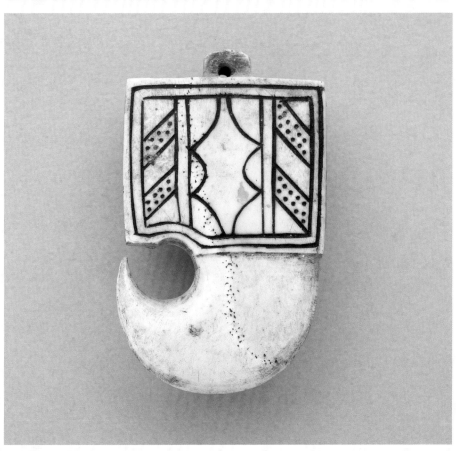

Facing page: Cat. 2.32. Ivory pendant, Mboma peoples. Boma, Lower Congo, DRC. 19th century. Ivory, 1.93 × 1.54 × 0.2 in. (4.9 × 3.9 × 0.5 cm). Collection Royal Museum for Central Africa, Tervuren, Belgium, EO.1953.74.764.

Left: Cat. 2.33. Ivory pendant, Solongo peoples. Banana, Lower Congo, DRC. Early 20th century. Ivory, 1.97 × 1.85 × 0.39 in. (5 × 4.7 × 1 cm). Collection Royal Museum for Central Africa, Tervuren, Belgium, EO.1953.74.740.

Below left: Cat. 2.34. Ivory pendant, Solongo peoples. Boma, Lower Congo, DRC. Early 20th century. Ivory, 2 × 1.22 × 0.39 in (5.1 × 3.1 × 1 cm). Collection Royal Museum for Central Africa, Tervuren, Belgium EO, 1953.74.504.

8 ◈

Renewal and Reinterpretation in Kongo Religion

JOHN M. JANZEN

A Tradition of Renewal

Scholarship on Kongo religious history is pervaded by the contradictory themes of change and continuity. On the one hand there is the dismal record of centuries of disruptive exposure to European exploration and exploitation, mercantilism and slavery, missions, warfare, disease and colonialism. On the other hand, Kongo religion is known for its unique ability to somehow reconnect with or reinvent its central values and perspectives as a veritable "tradition of renewal."[1]

For many observers of Kongo religious and social history, this juxtaposition of "traditional religion" and "Christianity" and the unique way that the Bakongo observe, blend and articulate these seemingly disparate worldviews and belief systems remains perplexing. This brief chapter will interpret, with three case studies and in historical perspective, the story of renewal within multiple overlapping and mutually refracting worlds of Kongo religion.[2] The conclusion will present several theoretical perspectives used to understand this story.

It is advisable to begin this brief essay on the history of Kongo religious renewal with a look at the persistent social realities that have informed the diverse beliefs, cosmologies, cults and practices. An individual is born into and remains for life a juridical member of the mother's lineage and clan, while the tie to the father and father's kin provides a strong lifetime identity. An individual has inherent rights to the matrilineal (usually landed) estate, yet throughout life may enjoy rights to the father's lineage's property. These two sources of rights offer access not just to land, but to financial support, social support and succor in time of crisis. The collective children of a matrilineage's men—the patrifilial children—constitute a continuing source of political consolidation of such a lineage. Alliances between lineages, often in reciprocal "father"-to-"child" marriages, reinforce existing bonds and create the basis of a broader sociopolitical fabric. Both the land and the ancestors buried in it—sources of life and well-being—are the basis of the preoccupation in Kongo thought with the

continuity of the community. Patrifilial relations and other alliances formed in the public sphere bring forth a concern with the nature of power, its sources, its applications and the consequences of its use or misuse.

Such preoccupations with power are directed to the spiritual world, inhabited by the ancestors, nature spirits and other forces, and the ultimate source of power, Nzambi Kalunga, the invisible creator of the universe. Kongo religion, along with much Central African religious outlook, holds a spiritual epistemology comparable in some respects to Judaism and Islam, of a high god who is not to be represented visually, who is in some sense beyond human comprehension. Kongo religion has a distinctive and storied history regarding the mediation between ultimate divine power and humanity's quest. This gap or gulf is populated by a profusion of particular embodiments of knowledge, power and control sanctioned by ancestors or spirits, entrusted to a range of kings, chiefs (*mfumu*), prophets and diviners (*ngunza*), healers (*nganga*) and nefarious individuals (*ndoki*). Especially the nature spirits (*bisimbi*) provide the grounding of knowledge found in the plethora of *minkisi* (*nkisi*, singular), sacralized techniques created by a particular ritualist for the solution of a particular challenge: for example, a woman's difficulty giving birth, protecting gardens from thieves, safety in mercantile caravan expeditions, treating diseases, establishing a chiefly office.

The ethical basis of Kongo religion is closely tied to this same social order. Evil, disorder and injustice are not blamed on a "devil" or ultimate evil being; rather, they are the result of base human motives such as greed, envy, or maliciousness, epitomized in *kindoki*, witchcraft. Order and renewal are achieved—willfully at times, haphazardly at other times—by the tensions and resolutions enacted between the holders of these religious commissions: the chief (*mfumu*), upholder of institutional order; the healer (*nganga*), priestly ritual operator; the witch (*ndoki*), the antisocial perpetrator of selfishness and evil; and the visionary prophet or insightful diviner (*ngunza*) who sees the blockage in social relations and replaces the corrupted with a new order grounded in the power of *mpemba*, the world of the "white" ancestors and spirits.[3] The interaction of these commissions over the centuries offers one explanation of the ability of practitioners of Kongo religion to incorporate or respond to foreign practices and external challenges, while at the same time remaining true to its own tenets and principles.

Yet the role of Christianity in Kongo from its introduction in the late fifteenth century is pivotal in understanding the unique character of Kongo religion and its history of renewal. Kongo peoples were profoundly affected by contacts with European merchants, missionaries and travelers. Historians speak of two evangelizations, the first in the fifteenth to seventeenth centuries in connection with Portuguese influence; the second from the late nineteenth century to the mid-twentieth century during colonialism.[4] The victory of King Mvemba a Nzinga (Afonso I), who had converted to Christianity, over his pagan brother Mpanzu is particularly noteworthy, for it ushered in an era of state Catholicism and the Europeanization of Kongo culture at the court and among the society's elite. The merger of Kongo religion and

Portuguese Christianity began during this period as Portuguese religious figures accepted Nzambi as the Christian god and Portuguese authorities encouraged a Christian Kongo king to forge a more centralized model of government. After Afonso's death in 1545 the kingdom became increasingly subject to extended succession feuds between contending houses and lineages, often exacerbated by Portuguese diplomatic and Catholic missionary meddling. As the slave trade reached its apogee in the eighteenth and early nineteenth centuries, all of the region's historical kingdoms—Vungu, Ngoyo, Kakongo, Kongo, and Loango—had collapsed, either through the loss of tax-levying capability or because of internal feuding, stirred by merchants and outside invaders. A rising theme in Kongo religious renewal movements and initiatives was the restoration of state authority and civic morality, and protection from the arrows of witchcraft aggression. Christian saints and Kongo spirits began to be equated in Kongo thought, as is seen with the prophetess Kimpa Vita, a Kimpasi member and knowledgeable in the lore of *bisimbi* nature spirits, who was converted in the early eighteenth century to the cult of St. Anthony of Padua.

Hardly had the slave trade ended in the 1860s when the Kongo region became the launching ground for colonial exploitation and the establishment of Europe's African colonies: the Congo Free State and the Belgian Congo, the Portuguese colony of Angola and the southern region of French Equatorial Africa. One indicator of the extent of social dislocation and upheaval suffered by Kongo peoples is their gradual decline in population by 50 percent from the fifteenth century to the early twentieth century, a trend that began to reverse itself only in 1930.[5] Again, Kongo religion provided the fertile ground for a new twentieth-century prophetic movement, uniquely Kongo and Christian, when Simon Kimbangu, a Baptist catechist, stood up in 1921 and said he was possessed by the Holy Spirit.

Recharging the Universe in Time of Crisis

Crisis cults and movements of renewal dot the historical landscape of Kongo. They reveal the underlying backdrop and symbolic logic of long-term social actions, of the therapeutic and life-cycle rituals that they activate to resolve pressing problems. Whereas the *nzo Kumbi* initiation lodge for girls illustrates how the personal experience of coming of age was ritually accentuated in Mayombe (fig. 8.1 and cat. 3.12, 3.13), other initiation lodges and movements, by contrast, were more directly expressive of crises in social authority and cohesion. Thus, initiation rites named Kimpasi (widespread south of the river) and Kinkimba (north of the river), mentioned as early as the seventeenth century, are known to have had a periodicity of occurrence that intensified with droughts, political chaos and the perception of rising witchcraft activity.[6] Both initiation orders were promoted by chiefs to legitimize their political regimes, to create support among the youth and to revitalize the moral order. These "schools" were more than gatherings to expose the youth to basic cultural lore.[7] They were attended by those aged eighteen to thirty, both male and female, and some participated up to four and five times in their séances (fig. 8.2).[8]

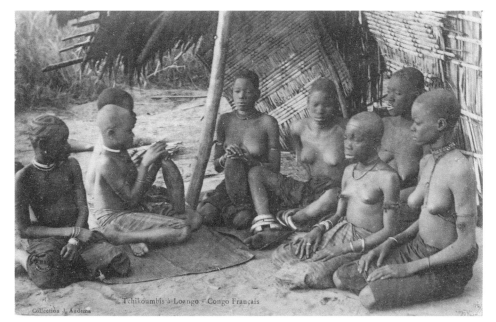

Left: Fig. 8.1. Postcard showing Kumbi girls, Loango, Republic of the Congo, early 20th century. RMCA Photographic Archives, Tervuren, Belgium, HP.2013.1.2. By permission of RMCA.

Below left: Fig. 8.2. Photograph of a Khimba school, Lower Congo, DRC, by C. J. Lindstrom. Published in Sjöholm and Lundahl, 1911.

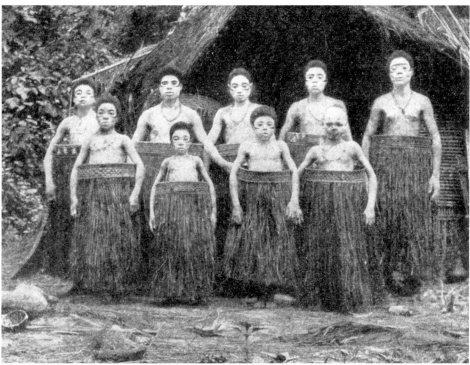

The ceremonial double-headed staff Thafu Maluangu, the grand cosmic rainbow python Mbumba Luangu, was carried in processions by the head of a particular Nkimba séance. One figure represented Ntundu, the male head; the other, Malanda, the female head (cat. 3.10). When not in use, Thafu Maluangu was leaned against the wall of a ceremonial house, above the *diyowa*, a circular cross-shaped altar. The *diyowa* took various forms, both here and in Kongo history generally. It could be simply traced in the earth, or it could be a trench dug out and filled with earth from the ancestors' graves, moistened into a mud used to purify adepts (fig. 8.3). The exhibition displays a *diyowa* made of cement and probably used in a Nkimba ceremony

Fig. 8.3. "Le *diyowa* classique,"
drawing by Leo Bittremieux.
Published in Bittremieux 1936.

Le *diyowa* classique.

(cat. 3.11). Leo Bittremieux documented a particular Nkimba *diyowa* in Mayombe whose quadrants were articulated by plant and other natural objects: (a) two halves of a palm nut; (b) two sticks of the lubota tree; (c) a flat *disevi* sea shell and a *zinga* long shell; (d) several palm leaves stuck into the earth. On either side of the *diyowa* were planted the contrasting lemba-lemba plant, a calmant, and the disisia-sisia, a poison.[9] The quadrants represented the opposed realms of water, earth and sky and aspects of the human community. The entire complex represented the laws (*tsiku*, prohibitions) that protected the Nkimba village. This *diyowa* was thus the place of combined opposites: the male and female of Thafu Maluangu, the beneath-the-water in contrast to the above-the-water of the raised python-rainbow, calming plants versus poisons, the axis of the palm tree from its roots to its branches and fruit and the seashells from the stream shores. *Diyowa* derives from *yoba* or *yobila*, the elementary nominal of which is *yobo*, an expression of benediction while healing. *Diyowa* is the place of benediction in Kinkimba, its most sacred space.[10]

These points of articulation of the world are the same as those invoked in the composition of a *nkisi* as discussed also in chapter 10. Plants, minerals and other living things work by way of metaphor, verbal punning or biochemical efficacy to access the ultimate spiritual power of God and the ancestors and to marshal the power of the physical as well as the human universes. The same ritual logic seen in the Kinkimba altar is evident in other movements and related *minkisi* to resolve fundamental dilemmas or to simply renew the world by tapping into the powers of nature and the divine.

Several examples of widespread *minkisi* addressed the dilemmas of civil collapse, epidemic disease and population decline. Nkita, an ancient medicine of lineage structure, emerged wherever segmentary lineage fragments were beset by misfortune and sought to restore authority and ties to ancestors. North of the Congo River, in Mayombe, Cabinda, and Loango, *Pfemba* was organized by midwives, offering reproductive medicine to assure the perpetuation of local clans. *Pfemba* is known in art history for its famous mother and child figures (ill. 9.3). According to early twentieth-century ethnography, the infants, often smeared with white clay, represent spirit children (that is, deceased children) of prominent female chiefs whose childbearing, kin-producing role is negated in favor of a more generalized social authority.[11]

As the coastal trade increased in intensity in the seventeenth century and caravans moved from the coast to inland markets and trading points, thereby challenging local polities and demanding provisions, Lemba, the great *nkisi* of alliances, markets and successful trade, emerged on the north bank of the Congo from the coast to Mpumbu, the big market at Malebo Pool, overlooking today's Kinshasa. The "altars" of Lemba were either fixed shrines (on the Yombe and Vili coasts) or portable round bark boxes (*lukobe*) that contained material referents to the Lemba household, to its strategic alliances, or to the priestly hierarchy according to which the Lemba novice couple stood as children to their sponsoring Lemba priest "father" (cat. 3.3). In the bark box portable shrine of Lemba, household symbolism was contrasted to the "powers of Lemba," which facilitated the coastal trade and allowed people to go forth in freedom on the caravan trails without being attacked (cat. 3.1). A small drum for use in Lemba ceremonies (cat. 3.7) and bracelets of cast copper, brass or lead with the couple's (or household's) figured representation on it (cat. 3.2) gave Lemba adherents an immediate public recognition as the region's mercantile elite.

These major *minkisi* represented innovations, reinterpretations, in the tradition of drawing strength from society, the earth and the powers within them.

Prophets Arising

The Kongo "tradition of renewal" is often an appeal for restoration of public morality and order. Individualized charms are hereby commanded to be destroyed, the ancestors' tombs are restored and group authority is renewed. Although often the originators of new cultic forms are unknown, some exceptional founding individuals are remembered and may be identified.

An especially severe and prolonged succession crisis in the Kongo kingdom in the eighteenth century (1704–6) brought to the fore Kongo prophetess Dona Beatriz Kimpa Vita, a Kimpasi adherent whose visionary mission was to reoccupy the capital, São Salvador (Mbanza Kongo), and restore authority to the throne. Her doctrine of national salvation combined royalist ideals of assertive kingship directed at Pedro IV, who was in retreat, and an appeal to Christian love, subsumed under the banner of Saint Anthony of Padua, by whom she claimed to be possessed. She was, she asserted, St. Anthony.[12] Beatriz's program for renewal also included the destruction of *minkisi* and personal ceremonial paraphernalia, including crucifixes and other objects distributed by the church. She scorned empty rituals, including baptism, stressing that only action to restore the kingdom would bring salvation to Kongo. She and her followers were clothed in bark cloth of the *nsanda* fig tree, which in Kongo custom and learning is a harbinger for the presence of water at new village sites, and evidence of *simbi* spirits. Little wonder that she drew the ire of Capuchin priest Bernardo da Gallo, who had the reticent king Pedro IV arrest her on charges of heresy and burn her at the stake (fig. 1.3).[13] After Dona Beatriz's execution, the Antonine movement that she had founded continued for several decades, during which many of its adherents were taken captive and sent to the Americas as slaves.[14]

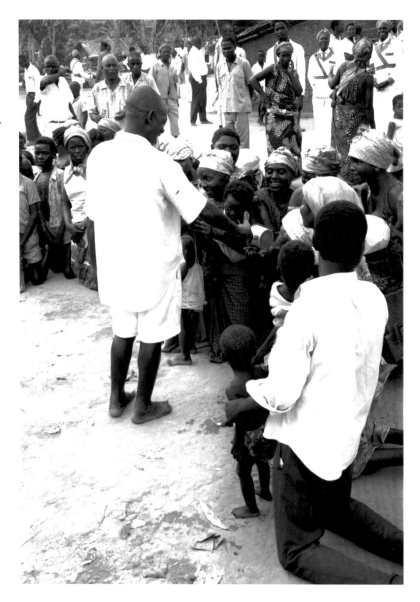

Fig. 8.4. Photograph of Simon Kimbangu's son Dialungana Kiangani Solomon in the Kimbanguist holy city of Nkamba-Jerusalem, while blessing mothers and children, by John M. Janzen, 1964. By permission of the author.

Renewal movements became increasingly common, and better documented, during the Free State era (1885–1908) as colonial labor recruitment, epidemic diseases, population decline and renewed missionary efforts to defame traditional beliefs subjected the Kongo peoples to a loss of values and the disintegration of leaders' authority. By 1920 Kongo chiefs were generally ineffective; their judicial techniques were suppressed by the colonial authorities. Especially important in the context of Kongo religious leaders is the twentieth-century Kongo prophet Simon Kimbangu, whose widely influential teachings eventually gave rise to the largest independent church in Africa (fig. 8.4).

The Revival of Investigative Divination

Mission Christianity, implanted during the Free State and subsequent colonial era by British, Swedish and American Protestant groups and by Belgian, French and

Portuguese Catholics, has given rise to many congregations and conferences, as well as to schools, hospitals, seminaries and other specialized institutions. Furthermore, it has brought about the far-reaching Christianization of the Kongo populace. Most Bakongo in the early twenty-first century are nominal Christians who nevertheless adhere to the fundamental tenets of the Kongo religion and worldview, including the role of ancestors in their lives, and the reality of witchcraft in social relations.

In the northern Kongo region where the prophetic movement of 1921 had created the Kimbanguist Church as well as numerous other prophetic "*ngunzist*" movements, mission-led churches struggled to incorporate the passion of spirit-filled singing, dancing, drumming and righteous living on its own terms. In the late 1940s to mid-1950s, new revivals occurred in both Protestant and Catholic circles that again reflected many of the themes of social purification and spirit-filled prophetic leadership. Following the precipitous collapse of fiber cash crop prices in 1951, the Munkukusa purification movement swept through the north bank region. It emphasized the neutralization of all sorcery power (*makundu*), embodied in "fetishes" and also foreign money, in the cruciform *diyowa* trench filled with ancestral tomb earth and palm wine.[15] A comparable movement, the Croix Koma, emerged near Brazzaville, as a pilgrimage site to which adepts brought their "fetishes" and underwent purification

Fig. 8.5. Photograph of a night service of the Church of the Holy Spirit in Africa, involving a rite called "weighing the spirit," at Nzieta, Luozi Territory, Lower Congo, DRC, by John M. Janzen, 1965. By permission of the author.

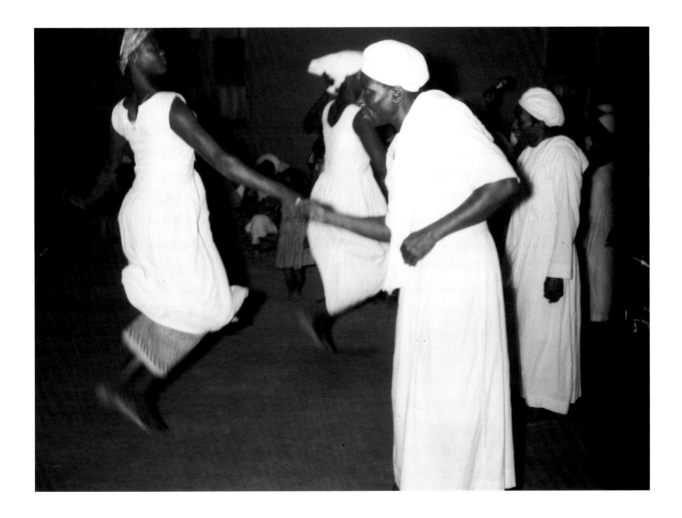

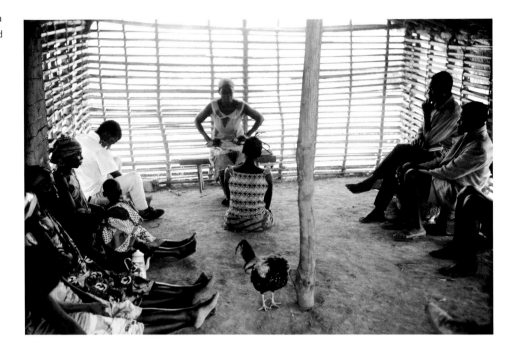

Fig. 8.6. Photograph of Mama Marie Kukunda, a *ngunza* and church deaconess, during a divination session in her airy chapel, by John M. Janzen, 1969. By permission of the author.

in a masslike liturgy, receiving certificates of purification.[16] Early participants of these movements were held in suspicion by missions. Where such movements were seen as having a political or protonationalistic tinge, colonial authorities arrested and deported adherents. The European authorities in the Swedish Covenant church, however, came to accept trance-inducing spirit singing and drumming in its services. Protestant pastors like Daniel Ndoundou and lay leaders such as Marie Kukunda, shown here (fig. 8.6), began to conduct "investigative" divination that reinstituted the identification of sources of ill will that caused misfortune and affliction. Since the iconoclasm of 1921, when all *ngombo* divination baskets and paraphernalia had been discarded, Protestant leaders had "prayed only" rather than "investigated" (*fimpa, or fyela*) the cause of illness and other misfortunes. This return to a more aggressive type of divination that sought out the source of witchcraft represented a return to a former central tenet of Kongo religion, this time in Christian garb, grudgingly accepted by European missionaries.

Understanding Renewal in Kongo Religion

The three preceding case studies need to suffice, in this brief essay, to suggest the varied types of renewal that have occurred in Kongo religion. They also remind us that Kongo religion is more complex and profound than any single doctrine or congregation represented within it.[17] It is a set of perspectives about life, of symbolic traditions and roles that have formed over centuries of human experience at the mouth of the Congo River. This experience includes the adversities of the slave trade, massive depopulation, epidemics, colonialism and droughts, as well as the challenges of Christianization and independence. Kongo religion is at the heart of one of the great

historic, and living, civilizations. Scholars have applied various analytical models to the way that Kongo religious practice and beliefs bring together an internal "Kongo" tradition with external practices, beliefs and influences, including Christianity. Syncretism, an accidental blending of practices, beliefs and symbols, has been charged especially by those who abhor the seeming continued "pagan" practices within Kongo Christian churches. Creolization, a concept widespread in literature and linguistics, suggests that the grammar of one language (or cultural structure) remains constant and that lexical elements, words and expressions from another language are sprinkled into the first.[18] Heywood and Thornton feature this concept in their study of Portuguese Kongo in the emergence of an Atlantic creole culture, offering a specific definition of its origins in Kongo royal decisions to foster Christianity and literacy while retaining control of the process.[19] A parallel revelation is John Thornton's proposition of how Kongo religion blends the tenets of Kongo traditional ritual forms with those of Christianity.[20] Both are practiced simultaneously, often side-by-side, or in concert. James Denbow, with the backing of Jan Vansina, suggests that cultural programs became scrambled as old codes were forgotten or abandoned, and European or Christian codes were partially adopted, leading to a kind of "cultural schizophrenia."[21] Some of the writing about possession, prophets and antiwitchcraft movements has adopted the conceptual lens of anthropology of religion, with the use of the concept of messianism, or one of its equivalents (revitalization, millenarism).[22]

All of these approaches, however, are too static to satisfactorily account for some of the more dramatic moments and examples of renewal, change and integration of Kongo historic religion with Christianity. Following the work of Kenelm Burridge on millenarian movements worldwide, a Hegelian dialectic seems to be a better fit.[23] Again and again, in Kongo history, in situations where existing structures and legitimating ideas are challenged, prophets and ritual leaders find within the stock of cultural knowledge and perspective an alternative that is rooted in the world of *mpemba*, the ancestors, water spirits, the Holy Spirit and ultimately Nzambi-God.[24] In its most dynamic form, such movements led by prophet reformers have a strong iconoclastic effect that sweeps away preexisting divisive personal attachments such as many *minkisi*, while on the other hand calling for the cleansing of the cemeteries, restoration of public morality and the institution of a new social order. At the most abstract level of Kongo thought, Mpemba—the "white"—is contrasted to the "world" and used as a metaphor of renewal, postulating the ever-ready tendency of Mpemba to pervade, to replace, renew and purify the human world.[25]

Western scholars who have witnessed this process at close range, in the form of possession trance or appeal to the ancestors or other spiritual forces, acknowledge that it is a powerful rhetorical device that evokes intense emotions in the support of a line of change or reform. The notion of "dialectical intention" acknowledges the willful agency of reformers to invoke spiritual powers to renew the social and cosmological order with ever-changing, traditional or borrowed, inside or outside, concepts, symbols and legitimating anchors of the contemporary world.[26]

Notes

1. Janzen, "Tradition of Renewal."

2. Hersak, "There Are Many Kongo Worlds," 614–40; Janzen and MacGaffey, *Anthology*.

3. MacGaffey, *Religion and Society*.

4. F. Bontinck, *L'Evangélisation du Zaire*; Mahaniah, *L'impact du Christianisme*.

5. Sautter, *De l'Atlantique au fleuve Congo*.

6. Van Wing, *Études Bakongo*, 176, 426–30; Bittremieux, *La société secrète des Bakhimba*, 211–12; Janzen, *Towards a History of Cultural Revitalization*, 28–32.

7. Ngoma, *L'initiation Bakongo*.

8. Van Wing, *Études Bakongo*, 176.

9. Bittremieux, *La société secrète des Bakhimba*, 37–38.

10. Laman, *Dictionnaire Kikongo-Français*. A related blessing consists of spitting on the hands, or blowing into open palms, following which the recipient responds with a *yobo* of thanks.

11. Janzen, "Review of *Les Phemba du Mayombe*."

12. Jadin, "Le Congo et la secte des Antoniens"; Gonçalves, *La symbolization politique*; Thornton, *Kongolese Saint Anthony*.

13. Thornton, *Kongolese Saint Anthony*, 177–98.

14. Thornton, *Kongolese Saint Anthony*, 199–214.

15. Janzen, "Kongo Religious Renewal."

16. Sinda, *Le messianisme congolais*, 358–68.

17. Hersak, "There Are Many Kongo Worlds," 615–21.

18. Aqualusa, *Creole*. The heroine of this novel by one of Angola's best-known contemporary authors is a Kongo princess who, although caught up in Portuguese life in Luanda and Brazil, remains steadfast in her commitment to historic Kongo language and values.

19. Heywood and Thornton, *Central Africans, Atlantic Creoles*, 62.

20. Thornton, *Africa and Africans*.

21. Denbow, "Heart and Soul"; Vansina, *Paths in the Rainforests*.

22. Sinda, *Le messianisme congolais*; Anderson, *Messianic Popular Movements*.

23. Burridge, *New Heaven, New Earth*.

24. Janzen, "Deep Thought."

25. Fu-Kiau, *N'kongo ye Nza*, puts this as *Mpemba ye Nza* (*Mpemba* and the World).

26. Janzen, "Deep Thought."

On Nsambi Pluriarcs

RÉMY JADINON

The term *pluriarc* was first used in Georges Montandon's *Genealogy of Musical Instruments*, published in 1919.[1] The etymology of the term refers explicitly to its manufacture: several curved arms project as arcs from a resonating body that has the form of a box. The instrument has two to eight vegetable fiber strings attached to the soundboard (cat. 3.28, 3.29).[2] In terms of the placement of the strings, the morphology of the pluriarc situates the instrument somewhere "between the harp and the lute."[3] The geographical range of its occurrence is concentrated in Central Africa, although some models were observed in "English West Africa" and in South Africa.[4] The first historical traces of the pluriarc are found in early seventeenth-century Europe. It was referred to as an "Indian" instrument in the *Syntagma Musicum* published by Michael Praetorius in 1620 (ill. 8.2). Engravings in Girolamo Merolla's published account of his travels to Kongo attest to it again in 1692 (fig. 9.1).[5]

The first verbal description of the *nsambi* is from the pen of the Capuchin Father Giovanni Antonio Cavazzi at the end of the seventeenth century. The *nsambi*, he wrote, like Spanish guitars that have no bottom, is an instrument equipped with small strings made from fine fibers that are found in palm leaves and some other plants. In his opinion, the instrument offered but very little means to the player to get some harmony out of it.[6] These unflattering words reflect accurately the prevailing thought of early observers, but time would eventually do justice to *nsambi* music. Field recordings by several ethnomusicologists collected in the last decades demonstrate a fascinating musicality that nicely blends diverse musical themes repeated *in ostinato* [in loop].[7] Solid proof of the instrument's musical grandeur is undoubtedly also its longevity in the history of musical instruments.

Of its various names, *nsambi* and *ngomfi* are recurrent in the Lower Congo region.[8] Pierre Sallée noted that the various terms are linguistic variants of the *-gombi* root in the Bantu areas A, B, C and H according to Guthrie's language classification, and that they designate a stringed musical instrument. The tuning of the instrument is either tetrachord at intervals of relative minor thirds, pentatonic anhemitonic or hexatonic.[9]

Playing techniques differ according to the size and placement of the strings. Either it is played like a lute, holding a plectrum with the right hand and stopping the strings with the left hand, or the soundboard is put on the abdomen and the strings are

Fig. 9.1. Engraving of African musicians with their instruments, showing the *nsambi* pluriarc among other instrument types. Published in Merolla 1692.

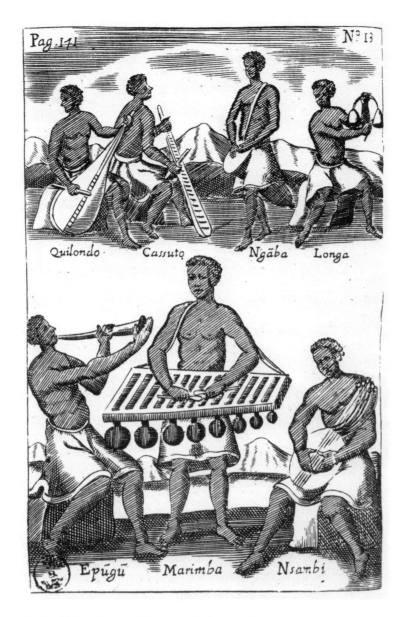

plucked like a "*sanza*."[10] The melody motifs are always *in ostinato*. The function of the pluriarc is varied. While it is played "as an instrument of private life" for "individual songs," it is also used for "healing" and may be considered a "magical cult" object. The *nsambi* may also be employed during the installation of a traditional chief.[11]

Like many chordophones in Central Africa, the *nsambi* is an instrument intimately linked to patterns of speech. Its low volume commands silence and attention, and its particular timbre makes it an appropriate accompaniment for the humming of *chantefables* or for other storytellers. It is also plucked to accompany hunting songs, mourning songs, drinking songs or songs that recount the life and qualities of a noble person. The *nsambi* is played alone or with drums, bells or rhythm sticks.

A particular series of pluriarcs in the collection of the Royal Museum for Central Africa is most intriguing because of the similarities in shape and detail that they display. It seems that all of them have been collected among the Sundi in the region of Maduda in Mayombe. Careful analysis of their manufacture and sculptural

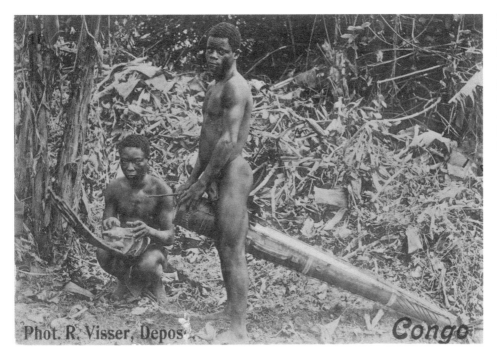

Fig. 9.2. Postcard showing two Kongo musicians playing a pluriarc and a long drum, Lower Congo, DRC, from a photograph by R. Visser, early 20th century. RMCA Photographic Archives, Tervuren, Belgium, HP.2013.1.1. By permission of RMCA.

decoration strongly suggests that they are the work of one single artist or workshop (cat. 3.28).

The Maduda pluriarcs are characterized by a particular pattern of binding together the arcs that string the instrument, and by the finely sculpted human head on the extension of the sound box reminiscent of Mayombe funeral statuary, painted with a white face and a black cap.[12] The sides of the instrument have geometrically shaped cutaways and a sound hole in the shape of a cross whose lines intersect in the middle. Their general form corresponds to the model characteristic for the southwest region of Gabon and Lower Congo, which Pierre Sallée calls the "Loango type." Sallée also suggests that their morphology may have been influenced by the European lute.

District Commissioner Hector Deleval collected the first specimens in 1910.[13] In his ethnographic notebooks he recorded that such pluriarcs were played by men and usually at dusk and in the evening.[14] This was confirmed in the 1950s by Albert Maesen, who added that they were used to accompany singers and that they no longer had a ritual function.[15]

The *nsambi*'s aesthetic qualities and ability to produce remarkably beautiful sounds combine to make this Central African instrument an apt mediator between the visible and invisible worlds. It is regrettable that much has been lost and will remain unknown of the rich musical culture of Kongo in which the *nsambi* clearly occupied a prominent place.

Notes

1. Montandon, *La généalogie*.
2. Bertil Söderberg noted that pluriarcs with two strings were merely children's toys; Söderberg, *Les instruments de musique*, 169.

3. Schaeffner, *Origine des instruments de musique*, 188.

4. Laurenty, *L'organologie*, 53; Chauvet, *Musique nègre*, 104; Kirby, *The Musical Instruments*, 243.

5. Hirschberg, *Monumenta ethnographica*, 194.

6. Hirschberg, *Monumenta ethnographica*, 160.

7. See Gerard Ciparisse and Charles Duvelle, among others.

8. Laurenty, *L'organologie*, 59; Sallée, *Deux études*, 11.

9. Söderberg gives the following chord for the Kasaï *lukamb*: LA B–FA–MI B–DO. Sallée notes the chord SOL–LA–SI–RE–MI for the Teke pluriarc, emphasizing that while the relative heights can change, the intervals remain the same; Sallée, *Deux études*, 11. Gerhard Kubik observed the scale LA–DO–RE–MI–FA#—SOL in 1973; Kubik, *Muziek van de Humbi en de Handa*.

10. A "finger," *o-lièmi* in Teke; Sallée, *Deux études*, 9; Laurenty, *L'organologie*, 59.

11. Laurenty, *L'organologie*, 64.

12. Laurenty, *L'organologie*, 53.

13. Three specimens registered as MO.0.0.1046-1, MO.0.0.1046-2 and MO.0.0.1046-3.

14. Ethnographic file 74, RMCA archives, Tervuren.

15. Laurenty, *L'organologie*, 63.

Praetorius Displays Kongo Instruments, 1619

Several types of Kongo musical instruments, which are now on display in ethnographic museums or shelved inside storage rooms, are of considerable age in the history of music making in Central Africa. This is evidenced by their appearance in an early seventeenth-century encyclopedia of musical instruments. Michael Praetorius, a German composer and theorist of folk music, completed the second volume of his *Syntagma Musicum* in 1619, which was dedicated to organology, or the study of the history and classification of musical instruments.

Praetorius' encyclopedia is a most valuable source for Africanist ethnomusicologists because it includes two plates with drawings of African musical instruments, although Praetorius mislabeled them as "Indian." The first plate shows the *ngongi*, the double iron bell without clapper, and a *mpungi*, a horn with anthropomorphic end (see cat. 3.23 and cat. 3.19). There is a cylindrical conical shaped drum laced up with two skins, called *ndungu* in Kikongo, and a *masikulu-teta*, one made out of a barrel. The second plate features the pluriarc or *nsambi*, with a front and a back view (see cat. 3.28 and cat. 3.29).

RJ

Top right: Ill. 8.1. Drawing of musical instruments including several from West Central Africa, early seventeenth century. Published in Praetorius 1619, Plate XXX.

Bottom right: Ill. 8.2. Drawing of musical instruments including the West Central African *nsambi*, early seventeenth century. Published in Praetorius 1619, Plate XXXI.

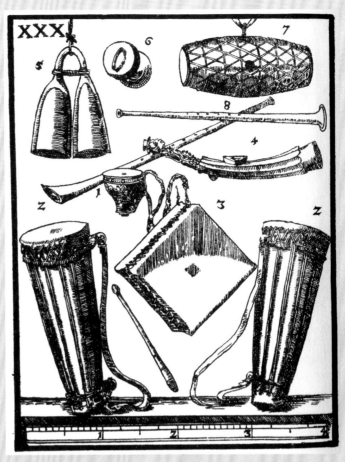

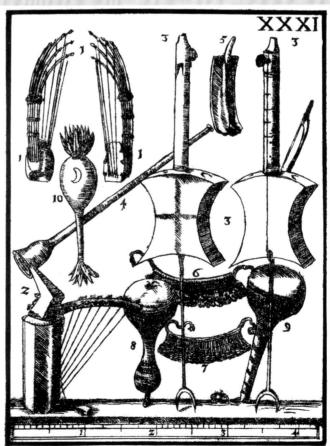

RITES OF PASSAGE

MUSICAL INSTRUMENTS

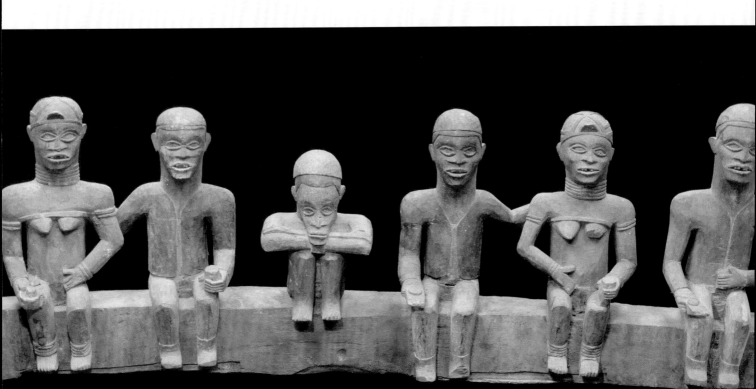

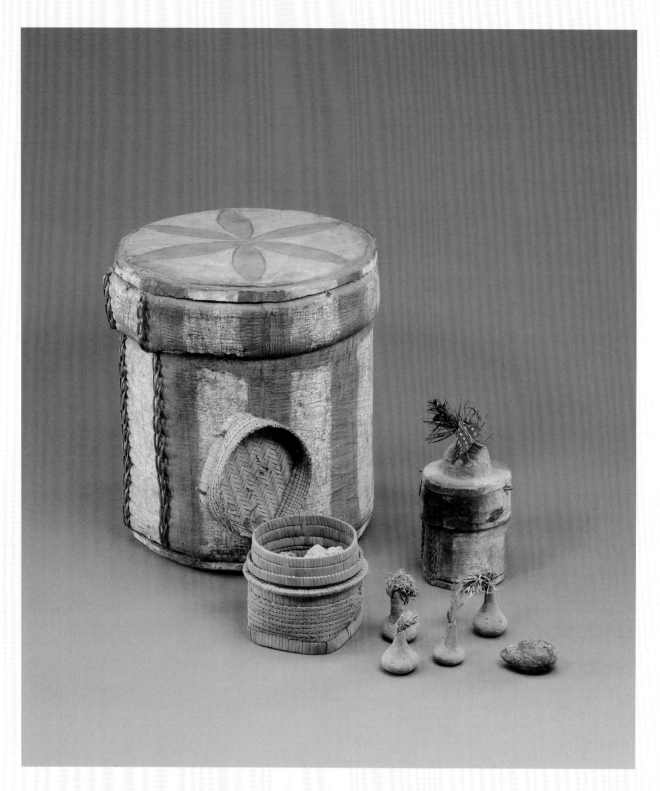

Above: Cat. 3.1. Box, *nkobe* Lemba, Woyo peoples. Banana, Lower Congo, DRC. Late 19th century. Bark, vegetal fiber, fruit, pigment, feathers, 9.45 × 9.06 in. (24 × 23 cm). Collection Royal Museum for Central Africa, Tervuren, Belgium, EO.0.0.35191.

Facing page: Cat. 3.2. Lemba bracelet, Kongo peoples. Mayombe, Lower Congo, DRC. 19th century. Brass, 1.18 × 4.25 in. (3 × 10.8 cm). Collection Royal Museum for Central Africa, Tervuren, Belgium, EO.1954.60.2.

Lemba and the Atlantic Trade

The sixteenth and seventeenth centuries saw the development of a flourishing trade between Europe and the coastal kingdoms of Ngoyo, Kakongo and Loango. At first, the trade was controlled by the kingdoms' ministries of trade, to the advantage of the kings, who prospered greatly. Gradually, however, a growing and influential mercantile elite bypassed royal taxation and dealt directly with the Europeans. Lemba had originally emerged as a *nkisi* used for the well-being of the king and the nobility. The decline of the kingdoms, however, allowed Lemba to evolve into a major cult of affliction. In an increasingly decentralized society, Lemba addressed the contradictions between the ideology of lineage egalitarianism and the accumulation of wealth by those directly or indirectly involved in the Atlantic trade.

Lemba actively recruited the wealthy and influential, including merchants, chiefs, healers and judges. Diviners would identify individuals for initiation by diagnosing them with "the Lemba sickness." The initiation involved the composition of a healing *nkisi*, a marriage ceremony, and the establishment of a strong father-child relationship between the neophyte and the patron Lemba priest. The ethos of healing, marriage and paternity worked as an antidote for the productive elite against the possible envy of their kinsmen. In addition, the multiple stages of initiation required them effectively to periodically redistribute their wealth.

HV

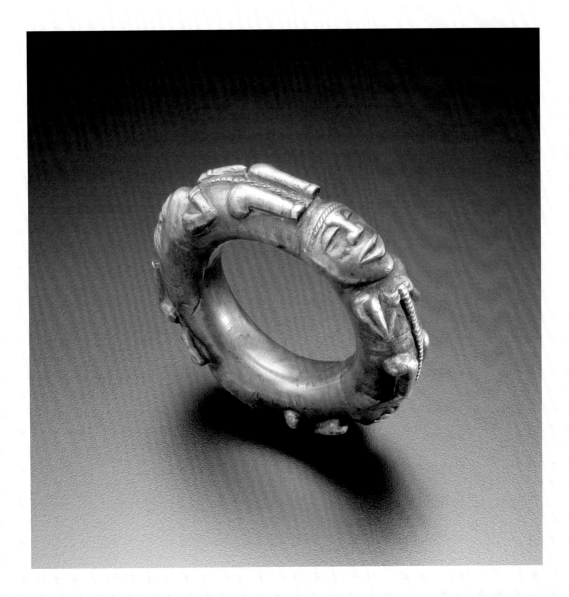

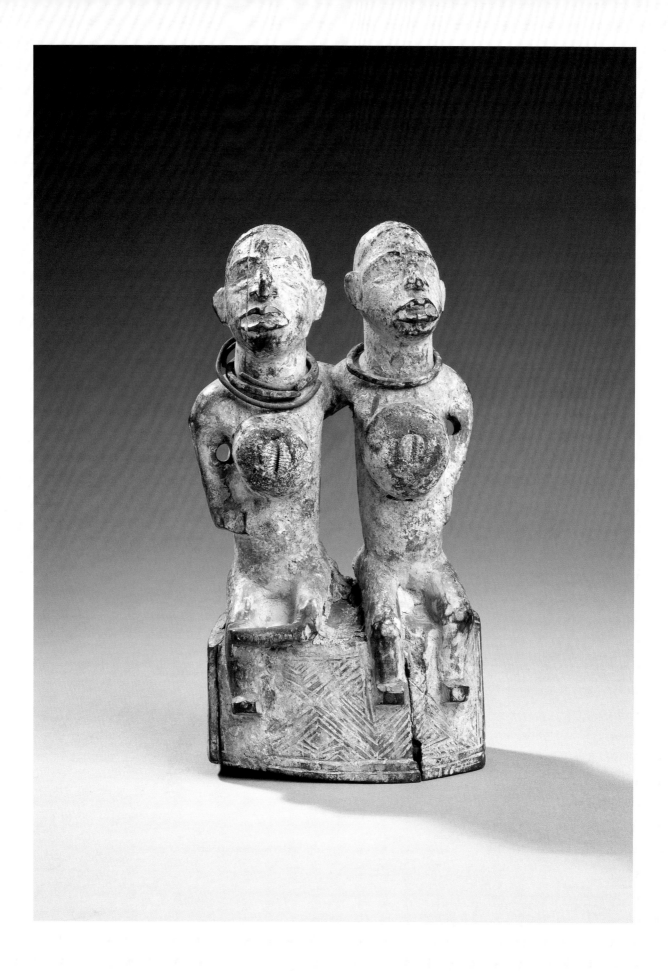

Lemba's Art

Lemba developed a rich material culture, including prestigious tokens of membership and a distinct iconography. A central object in Lemba was the round *nkobe* box, made of bark and wood, and often colored red and white. The box contained the medicines assembled during initiation. The name or form of these ingredients metaphorically evoked particular ideas, and their juxtaposition created statements about Lemba and its members. The most enduring Lemba object was the *nlunga* bracelet, most frequently made of copper or brass. The one displayed in cat. 3.2 shows the Lemba couple, with the man holding a carved staff and the woman touching her breasts, a symbolic gesture of generosity. Lemba initiates wore the bracelet for the rest of their life, and they were buried with it.

The object to the left also shows the Lemba couple, sitting on a carved chest used to store raffia currency. Both husband and wife have medicines and a cowry shell fixed above the belly, visual references to the empowerment of the Lemba marriage. The figures were colored white during the initiation ritual. Another prominent Lemba object was the handheld crescent-shaped slit drum, the *koko*, decorated with a serrated rim and small figures in bas-relief.

HV

Facing page: Cat. 3.3. Two figures, Lemba couple, Yombe peoples. Mayombe, Lower Congo, DRC. Late 19th century. Wood, shell, iron, pigment, clay, 8.66 × 4.92 × 3.54 in. (22 × 12.5 × 9 cm). Collection Royal Museum for Central Africa, Tervuren, Belgium, EO.0.0.42920.

Below left: Cat. 3.4. Wooden pendant, Woyo peoples. Lower Congo, DRC. Early 20th century. Wood, 0.63 × 1.81 in. (1.6 × 4.6 cm). Collection Royal Museum for Central Africa, Tervuren, Belgium, EO.0.0.45234-1.

Below right: Cat. 3.5. Bell with three clappers, Kongo peoples. Lower Congo, DRC. Early 20th century. Wood, 8.27 × 6.1 × 3.54 in. (21 × 15.5 × 9 cm). Collection Royal Museum for Central Africa, Tervuren, Belgium, MO.0.0.33980.

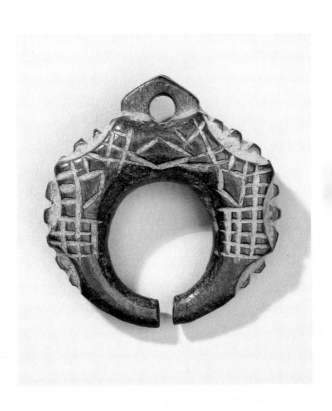

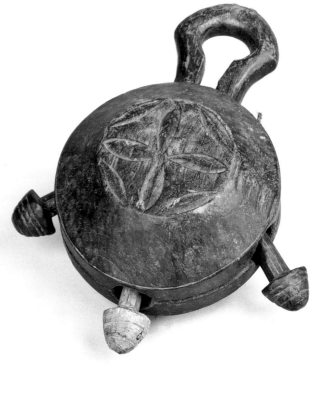

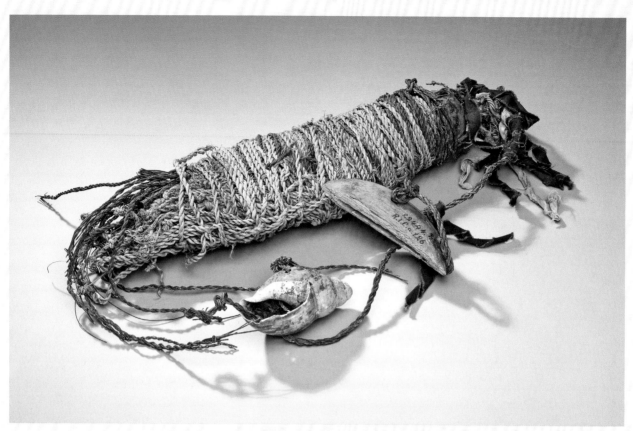

Above: Cat. 3.6. Nkisi bundle, Yombe peoples. Mayombe, Lower Congo, DRC. Early 20th century. Vegetal fiber, textile, shell, 17.72 × 7.87 in. (45 × 20 cm). Collection Royal Museum for Central Africa, Tervuren, Belgium, EO.0.0.22444.

Right: Cat. 3.7. Handheld slit drum, Woyo peoples. Lower Congo, DRC. Early 20th century. Wood, 4.72 × 10.63 × 3.15 in., length of rope and wood 13 in. (12 × 27 × 8 cm; length of rope and wood 33 cm). Collection Royal Museum for Central Africa, Tervuren, Belgium, MO.0.0.34774.

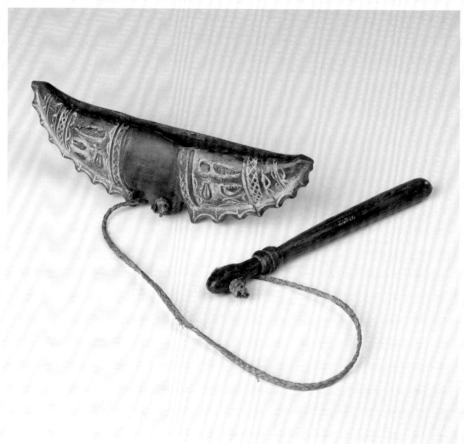

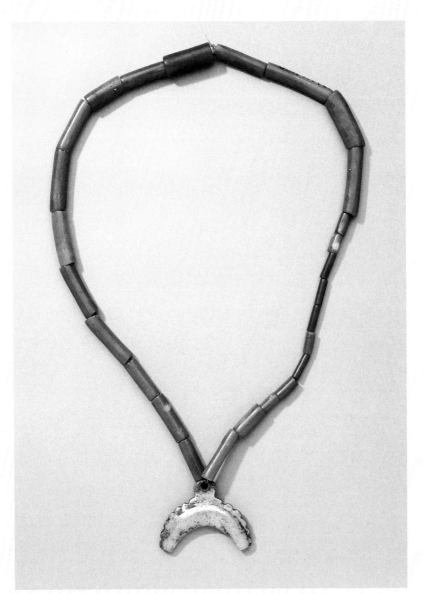

Variations on Lemba's Crescent

The iconography of Lemba included representations of plant and animal species that are often also found inside the medicine box. Several Lemba objects had a bas-relief rendering of the spiral *zinga* shell, which evoked life (*zinga*), or of the *kiala-mioko* pod, which resembles open hands and signified generosity. The most distinct Lemba icon was a flowerlike design on the *nkobe* box with four, six, or eight petals, often found on the *nkobe* box, on bracelets, on bells and on other objects.

The shape of the crescent handheld drum was replicated in other objects. Roughly carved versions were attached to objects in order to identify them as a part of Lemba. The crescent shape was also found in pendants worn by Lemba initiates who wished to show off their status. They were made of wood, metal or ivory. The example in ivory below features a crocodile with a fish between its teeth, presumably a metaphoric reference to successful hunting and trading.

HV

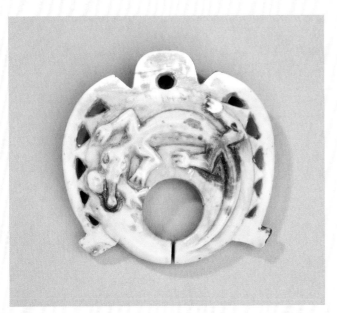

Above: Cat. 3.8. Necklace, Mboma peoples. Boma, Lower Congo, DRC. Early 20th century. Beads, metal, 7.87 × 3.15 × 0.39 in (20 × 8 × 1 cm). Collection Royal Museum for Central Africa, Tervuren, Belgium, EO.1953.74.717.

Left: Cat. 3.9. Ivory pendant, Woyo peoples. Cabinda, Angola. Late 19th century. Ivory, 1.97 × 1.97 × 0.59 in (5 × 5 × 1.5 cm). Collection Royal Museum for Central Africa, Tervuren, Belgium, EO.1979.1.1022.

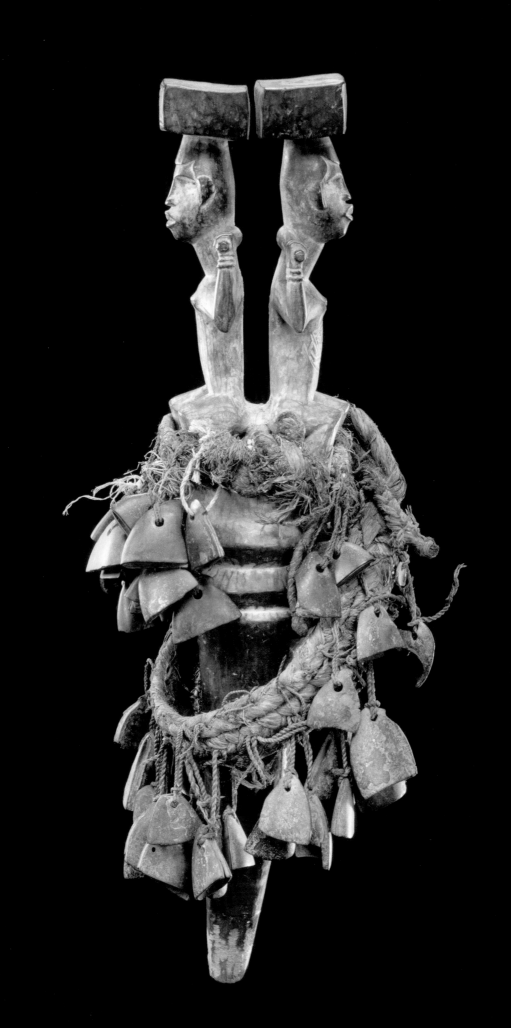

Khimba, for boys

Khimba was a boys' initiation in Mayombe, Kakongo and Ngoyo, which could be organized at the initiative of a chief. The initiation happened in seclusion in a camp in the forest and could last several months. Under the guidance of a master, the participants would learn many things, including the vocabulary of an esoteric Khimba language. At important moments during the initiation, the participants would be completely colored white and dance with skirts made of fibers (see fig. 8.2). At the end, each initiate would be given a new Khimba name.

The objects to the left and below were used during the closing ceremony. The dance scepter, called *Thafu Maluangu*, shows the two figures who lead the group in procession out of the initiation camp. They were called Matundu, the first, and Malanda, his immediate follower. The lower part of the object is wrapped with a string of seed pods. The rattling sound of *Thafu Maluangu* accompanied the dancing *bakhimba* when they reappeared in the village.

Below is a unique version of the *diyowa*, the point of contact between the world of the living and the world of the dead, established by the Khimba master during the closing ritual. The *diyowa* takes the form of a cross and is usually drawn in the earth. The *diyowa* here is unique in that it has taken a material and portable form. Collected and identified by the missionary ethnographer Leo Bittremieux in the early twentieth century, it is made of cement and mounted on a small wooden platform. Four intersecting red lines and white shells bedded in the cement indicate a double cross and divide the object into eight parts. The center has a hollow in which palm wine was mixed with other substances into a paste with which the Khimba participants were anointed.

HV

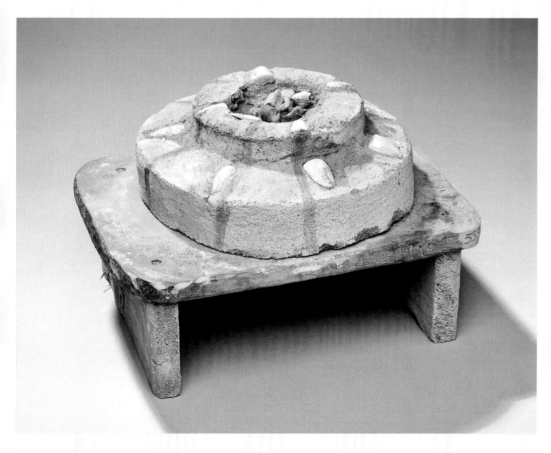

Facing page: Cat. 3.10. Dance scepter, *Thafu Maluangu*, Woyo peoples. Banana, Lower Congo, DRC. Late 19th century. Wood, vegetal fiber, nut, 15.35 × 6.3 × 4.72 in. (39 × 16 × 12 cm). Collection Royal Museum for Central Africa, Tervuren, Belgium, EO.0.0.35045.

Left: Cat. 3.11. Portable shrine, *diyowa*, Woyo peoples. Banana, Lower Congo, DRC. Early 20th century. Cement, wood, shell, pigment, 6.22 × 10.08 × 7.87 in. (15.8 × 25.6 × 20 cm). Collection Royal Museum for Central Africa, Tervuren, Belgium, EO.0.0.33961.

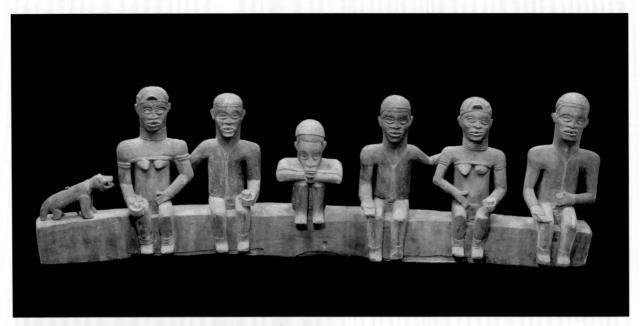

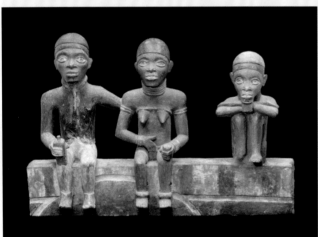

Above: Cat. 3.12. Fragment of bedpost, Yombe peoples. Mayombe, Lower Congo, DRC. Late 19th century. Wood, pigment, 10.95 × 33.86 × 4.72 in. (27.8 × 86 × 12 cm). Collection Royal Museum for Central Africa, Tervuren, Belgium, EO.0.0.35776.

Left: Cat. 3.13. Fragment of bedpost, Yombe peoples. Mayombe, Lower Congo, DRC. Late 19th century. Wood, pigment, 16.41 × 10.63 × 3.54 in. (41 × 27 × 9 cm). Collection Royal Museum for Central Africa, Tervuren, Belgium, EO.0.0.38560.

Ladies in Red

In Ngoyo, Kakongo and Mayombe, when a young girl had reached marriageable age, she was called to enter into the *nzo Kumbi*, the house of preparation for marriage. The Kumbi girl would stay in this house for a period of five to ten months. During this time, her skin was rubbed with a red cosmetic called *tukula*, a mixture of powder rasped from a piece of *lukunga* wood mixed with palm oil. She received instruction from her mother or from another elderly woman about marriage and the rights and duties that come with it. Her young female friends frequently kept her company (fig. 8.1), and her future husband was allowed to visit her occasionally and bring small presents like clothing or palm wine.

The *nzo Kumbi* was furnished with a bed that had a plaited bottom and stood on four poles about one and a half meters (five feet) above the ground. The Kumbi girl had to sleep alone in this bed every night during the initiation. The sides of the bed were decorated with red and white geometric motives, while the head and footboards had figurative sculpture depicting various human and animal figures. The examples here depict the Kumbi girl, her future husband with his hand resting on her back, and the girl's maternal uncle, who represents her clan. On the lower example, cat. 3.13, the husband holds a square jenever bottle, a reference to the exchange of goods that was part of the marriage agreement.

HV

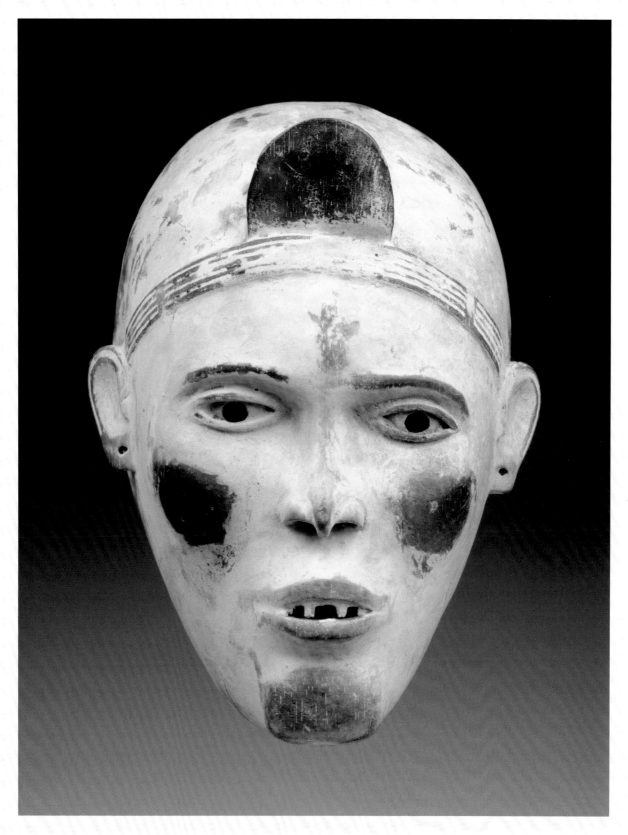

Cat. 3.14. Mask of the *nganga* Diphomba, Yombe peoples. May-
ombe, Lower Congo, DRC. Late 19th century. Wood, pigment, clay
(kaolin), 9.45 × 7.48 × 5.51 in. (24 × 19 × 14 cm). Collection Royal
Museum for Central Africa, Tervuren, Belgium, EO.0.0.43573.

Masks and Diviners

The material attributes of a *nkisi* included the ritual outfit of the *nganga*. This outfit consisted of special garments, jewelry, a feathered headdress and sometimes a wooden mask. On the previous page is a mask of the *nganga* Diphomba, known in Mayombe as a diviner. He was consulted in order to discover the hidden causes of someone's illness or misfortune. The *nganga* Diphomba had a box that contained various figurines and instruments for the job. During the most dramatic moments of his performance, he would go into a possession trance and communicate with the spirit world to disclose the facts.

Similar functions were performed in Ngoyo by the ritual experts who wore the *ndunga* masks. When there was a long drought in a particular region, the chief sent the *bandunga* out to investigate who had disturbed the earth spirits by violating one of their regulations or taboos. Some of these taboos had to do with funerals, such as the prohibition to bury a corpse that had a physical imperfection. After lots of searching, the *bandunga* would drag the culprit in front of the chief, and the mistake would have to be rectified. The *bandunga* have been described as a sort of "police force" because they seemed to be at the chief's command. In the first decades of the twentieth century, they became part of a cultural folklore as they performed their masked dances at funeral ceremonies and public feasts.

HV

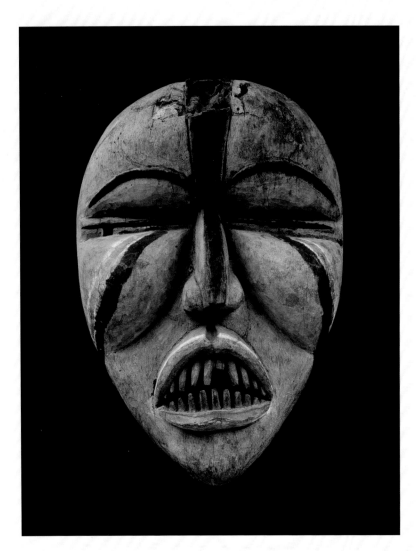

Left: Cat. 3.15. *Ndunga* mask, Woyo peoples. Banana, Lower Congo, DRC. Early 20th century. Wood, pigment, 14.76 × 10.43 × 5.9 in. (37.5 × 26.5 × 15 cm). Collection Royal Museum for Central Africa, Tervuren, Belgium, EO.0.0.34575.

Facing page: Cat. 3.16. *Ndunga* mask, Woyo peoples. Banana, Lower Congo, DRC. Early 20th century. Wood, pigment, 18.5 × 12.2 × 9.06 in. (47 × 31 × 23 cm). Collection Royal Museum for Central Africa, Tervuren, Belgium, EO.0.0.34579.

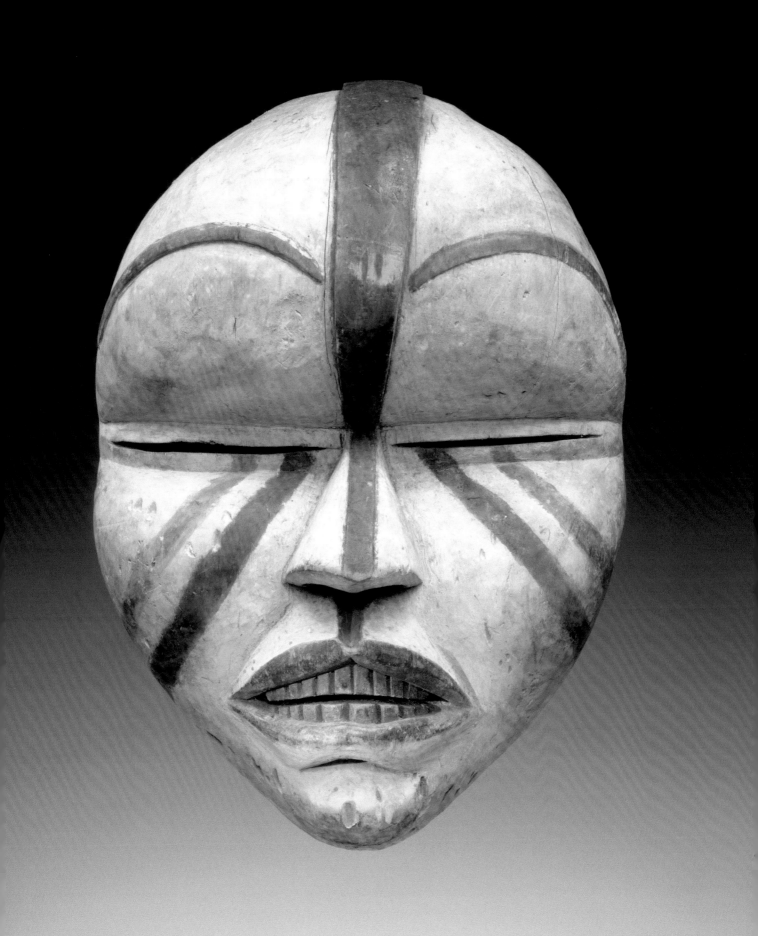

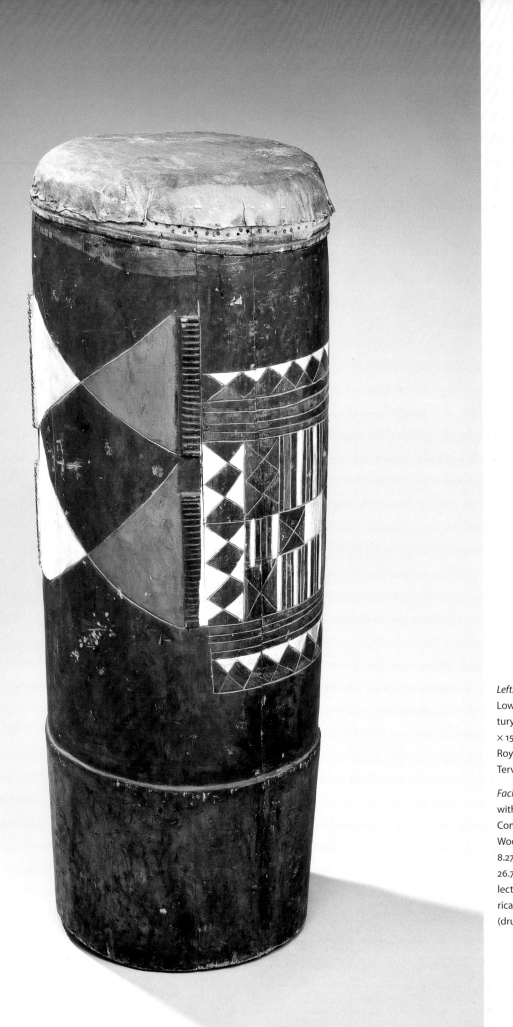

Left: Cat. 3.17. Drum, Kongo peoples. Lower Congo, DRC. Late 19th century. Wood, leather, pigment, 43.3 × 15.75 in. (110 × 40 cm). Collection Royal Museum for Central Africa, Tervuren, Belgium, MO.0.0.3400.

Facing page: Cat. 3.18. Long drum with support, Kongo peoples. Lower Congo, DRC. Early 20th century. Wood, skin, pigment, drum: 70.08 × 8.27 in. (178 × 21 cm), support: 22.05 × 26.77 × 3.94 in. (56 × 68 × 10 cm). Collection Royal Museum for Central Africa, Tervuren, Belgium MO.0.0.35998 (drum) and MO.0.0.6558 (support).

Drums

The drum is the musical instrument most closely linked to the African continent in the popular imagination. The sheer numbers of drums, the variety of shapes and different methods for creating demonstrate the importance of drumming in African culture.

The example in cat. 3.17 is referred to as *ngoma*, a generic name for drums in the region. Kongo *ngoma* drums are crafted in a variety of shapes—cylindrical, chalice-shaped, supported by figural sculpture. The type is considered to be a fairly simple drum, with the skin membrane tacked to the body. This example is an unpretentious cylinder, but its surface is covered with geometric patterns. The shallow relief and painted decoration consists of both large and small geometric patterns in red and white on a dark ground.

The term *ngoma* can refer equally to the type of instrument and the dance for which it plays, the place of performance and the repertoire. *Ngoma* is played in an orchestra consisting of three to four drums for festivities, for entertainment or at weddings. In some parts of Lower Congo, the drummer plays codes for the dancers, advising them when to enter, how to dance, or when to move faster.

Ngoma can also accompany ritual. The *ngoma* announced a death in a community, sometimes playing nonstop until the burial was complete. One source states that a "secret ghost" inside the drum is an ancestral voice that responds to crises, thus playing a role in communicating between two worlds.

The *ndungu* is an impressive drum, long and narrow. Some examples are provided with carved drum carriages (*dikalu di ndungu*), such as the example in cat. 3.18 (*below*). *Ndungu* drums are usually played in pairs, one referred to as the *ngudi* (the mother, with a lower tone) and the *mwana* (the child, a higher tone). *Ndungu* have multiple functions, including ritual, public events and political occasions, but their primary use seems to be for dancing. On occasion, the drum may be carried in processions, when it is hoisted above the heads of the carriers, while the drummer works it with his hands or sticks. More often it is positioned slanted, its narrow end resting on the ground or in its carriage, while the drummer straddles the upper end and leans forward to strike the membrane with his hands (see ill. 2.1, ill. 2.2 and fig 9.2).

RP

Trumpets

Large transverse or horizontal trumpets carved from the tusk of an elephant were used throughout the Kongo area. Those described from an earlier period, called *mpungi*, were crafted with great care (see cat. 1.4). Nowadays, *mpungi* is a generic term for horns.

The horn in cat. 3.19 (*below*) is a type illustrated in Praetorius' 1620 engraving (ill. 8.1). Although it is of the *mpungi* type, Merolla recorded the name as *embuchi* in 1682. Conceivably such horns could be used either for entertainment or for ceremonial occasions. Its elegant design, with a minimal amount of subtle relief carving, is enhanced by delicate transverse bands that wrap around the narrow end, while the surface is slightly faceted. The end of each facet is rounded to create scallops that seem to drape around the mouthpiece. The figure of a chief wearing a European hat crowns the trumpet.

A hybrid trumpet made of ivory and wood is also referred to today as *mpungi* (cat. 3.20, *facing page, top*). Five horns of different sizes in the *masikulu* orchestra play different tones. The trumpets, along with two drums, perform in an ensemble for burials and accompany dancers. The trumpet's bell, carved of wood, amplifies the sound by extending the air column. At the same time, the use of both ivory and wood and the wrapping of basketry makes it more visually imposing.

Horns made of roots (*mpolomono*) (cat. 3.21, *facing page, bottom*) were used in burials for powerful leaders. Tree roots naturally hollowed through decay or by the actions of termites were used. The twisting forms emphasize the difference between the root trumpet and other instruments such as the elegant *mpungi*. They were part of an orchestra of slit gongs (*nkonko*), *ngoma* drums, and vertical wooden trumpets (*biludi*) played in the burial ceremony known as *niombo* in which the body of the notable was encased in a huge mummy bundle and taken in procession to the burial ground. The root trumpet was also used, presumably, during the invocation of a *nkisi* spirit. This is suggested by a drawing in a 1907 book by Eduard Pechuël-Loesche, in which he published the results of his participation in the 1870s German Loango expedition. The use of root trumpets in both burial ceremonies and *nkisi* work implies powerful medicines in which roots and herbs figured. The instruments facilitate communication between the living community and the realm of the dead in both rituals.

RP

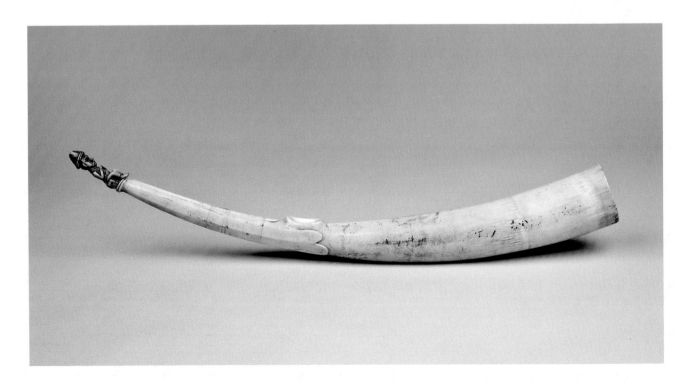

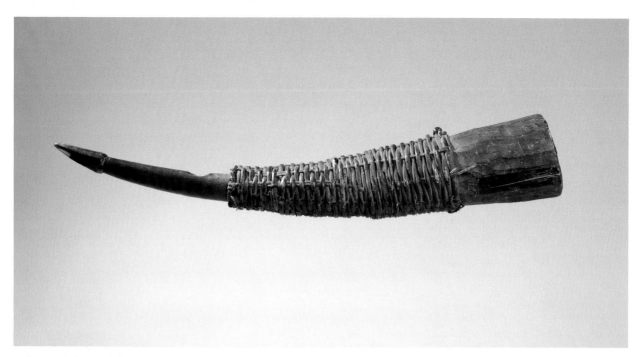

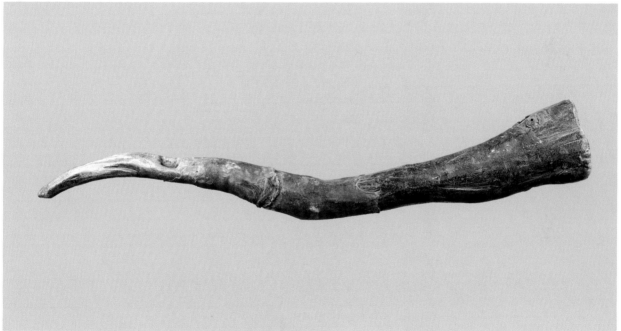

Facing page: Cat. 3.19. Horn, Kongo peoples. Lower Congo, DRC. 19th century. Ivory, 25.2 × 2.36 × 3.54 in. (64 × 6 × 9 cm). Collection Royal Museum for Central Africa, Tervuren, Belgium, MO.1954.62.1.

Top: Cat. 3.20. Horn, Kongo peoples. Lower Congo, DRC. Early 20th century. Wood, ivory, vegetal fiber, 19.69 × 3.74 × 3.54 in. (50 × 9.5 × 9 cm). Collection Royal Museum for Central Africa, Tervuren, Belgium, MO.1955.95.411.

Bottom: Cat. 3.21. Horn, Kongo peoples. Lower Congo, DRC. Late 19th century. Wood, leather, 36.61 × 5.59 in. (93 × 14.2 cm). Collection Royal Museum for Central Africa, Tervuren, Belgium, MO.0.0.469-2.

Bells and Gongs

A number of bell-like instruments are used in Kongo for a variety of functions—utilitarian, ritual and political. Ordinary bells, for example, are attached to the collars of hunting dogs since they cannot bark. A *nganga* (diviner or healer) would likely use an elaborately carved bell, like that in cat. 3.22 (*right*), along with a *nkisi* to hunt down witches. The wooden bell, which can have multiple metal or wooden clappers, calls the spirits of the dead. Multiple lozenge-shaped designs carved in different configurations across the surface in this example likely had meanings to the *nganga* who manipulated it.

Carved round bells like that in cat. 3.24 (*facing page*) were also used by *banganga*. Two or three wooden clappers suspended through slits or holes provided the means of communicating with spirit forces. While some bells of this sort were decorated with geometric patterns—as in cat. 3.5, which has a Lemba rosette pattern incised into it—this example has been turned into a face.

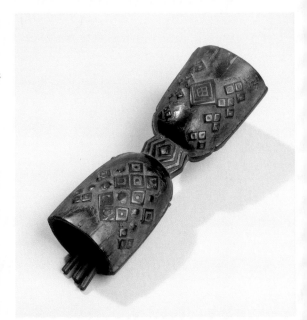

Likely the most important type of bell in Kongo is the iron clapperless bell or gong (*below*). Iron as a material is closely associated with kingship, and the histories of Central African leadership and smithing are intricately linked. Called *ngongi*, the double bells rank among the most important of chiefly insignia in Kongo, as it is in much of sub-Saharan Africa.

Ngongi bells appear in a number of proverbs, usually in reference to the authority of rulers. For example, a Woyo proverb states, "The *ngongi* create the country; the country will not be brought to death." In proverbs double bells seem to substitute for the chief as well as for the power he wields.

RP

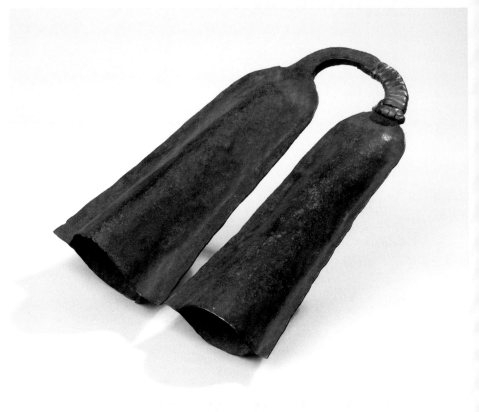

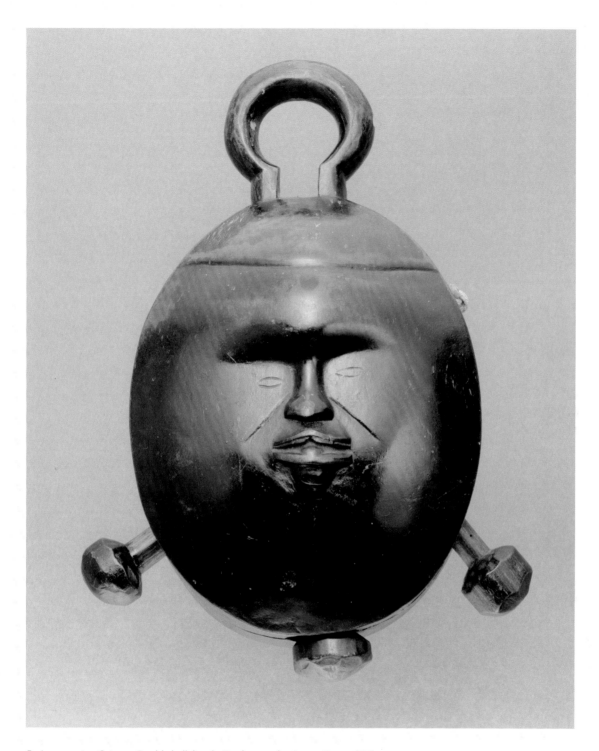

Facing page, top: Cat. 3.22. Double bell, *kunda*, Yombe peoples. Lower Congo, DRC. Early 20th century. Wood, 8.27 × 2.68 × 1.97 in. (21 × 6.8 × 5 cm). Collection Royal Museum for Central Africa, Tervuren, Belgium, MO.1948.10.3.

Facing page, bottom: Cat. 3.23. Double bell, *ngongi*, Yombe peoples. Mayombe, Lower Congo, DRC. Iron, vegetal fiber, 10.63 × 9.25 × 2.76 in. (27 × 23.5 × 7 cm). Collection Royal Museum for Central Africa, Tervuren, Belgium, MO.1979.23.25.

Above: Cat. 3.24. Anthropomorphic bell, Kongo peoples, Lower Congo, DRC. Early 20th century. Wood, 7.87 × 5.51 × 4.33 in. (20 × 14 × 11 cm). Collection Royal Museum for Central Africa, Tervuren, Belgium, MO.1958.16.2.

Whistles

Whistles, usually made of small antelope horns, are ornamented by attaching tiny sculptural forms carved atop platforms on an ornamental shaft. Used by both hunters and diviners, these whistles were believed to have mystical powers. Hunters used them not only to signal each other during the hunt but also to charm and thus to control the movements of their prey. *Banganga* used them in various ceremonies to gain the attention of assisting spirits. Descriptions by visitors advise that they were employed especially for healing, while others suggest they were used to call for or to stop rains. Such supernatural functions are further implied by the example in cat. 3.25. Rather than being mounted on an antelope horn, it is attached to a wooden cone. The bulging addition on the lower portion of the whistle suggests it has been transformed into a *nkisi* by activating materials being embedded in paste.

The miniature ornamental forms atop whistles include a wide range of subject matter. Here we see what appear to be a leopard (*right*), a male and female pair (*facing page, left*), and a bird (*facing page, right*). Such imagery could easily refer to the subject of the hunt but could also evoke proverbs or ideas of social order.

RP

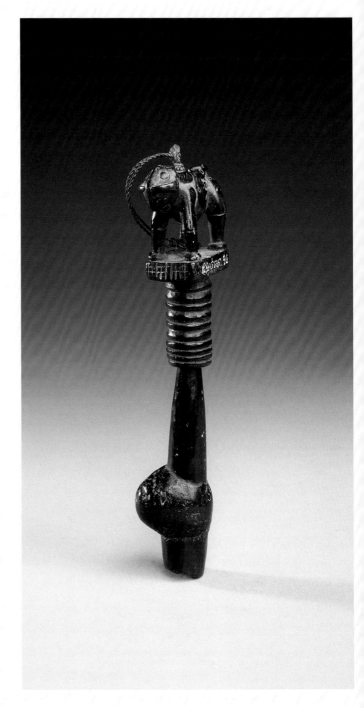

Right: Cat. 3.25. Whistle, Kongo peoples. Lower Congo, DRC. Early 20th century. Wood, 7.7 × 1.18 × 1.97 in. (17 × 3 x 5 cm). Collection Royal Museum for Central Africa, Tervuren, Belgium, MO.0.0.24675.

Facing page, left: Cat. 3.26. Whistle, Woyo peoples. Lower Congo, DRC. Early 20th century. Wood, horn, 6.5 × 1.97 in. (16.5 × 5 cm). Collection Royal Museum for Central Africa, Tervuren, Belgium, MO.1951.50.190-1.

Facing page, right: Cat. 3.27. Whistle, Kongo peoples. Lower Congo, DRC. Early 20th century. Wood, horn, 7.68 × 1.18 × 1.77 in. (19.5 × 3 × 4.5 cm). Collection Royal Museum for Central Africa, Tervuren, Belgium, MO.1973.36.8.

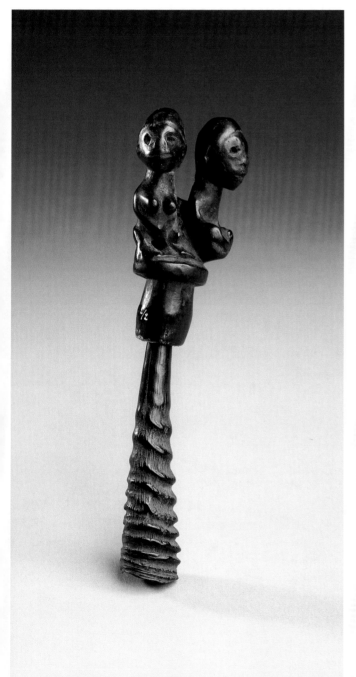 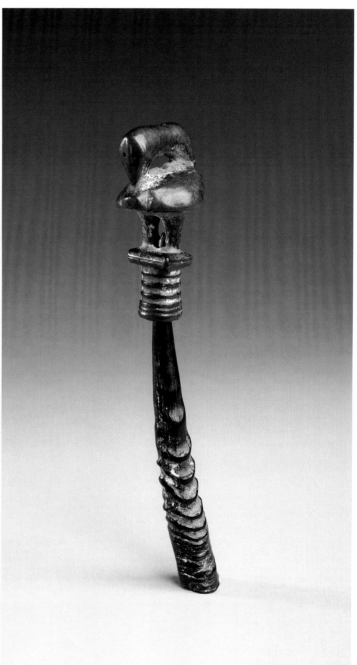

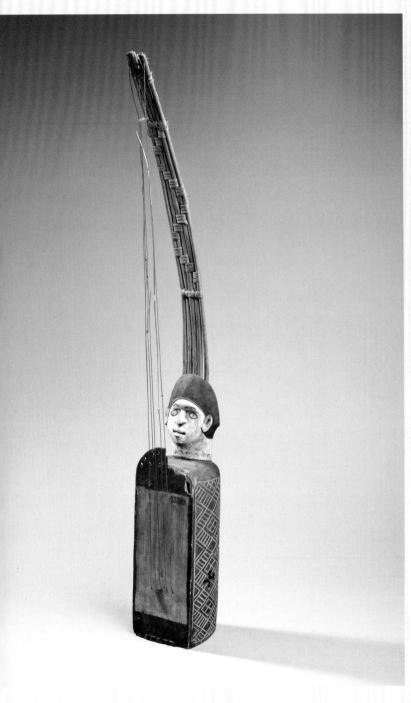

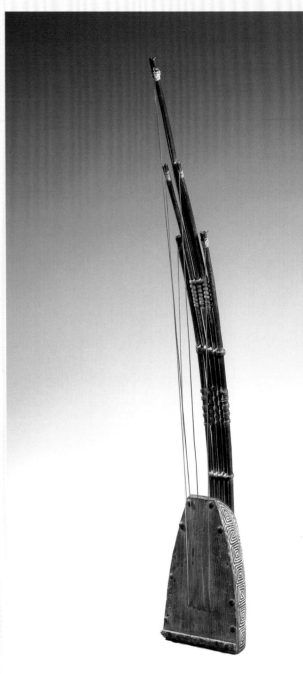

Above left: Cat. 3.28. Pluriarc, Kongo peoples. Lower Congo, DRC. Early 20th century. Wood, bark, vegetal fiber, 31.7 × 4.92 × 7.48 in. (80.5 × 12.5 × 19 cm). Collection Royal Museum for Central Africa, Tervuren, Belgium, MO.0.0.34194.

Above right: Cat. 3.29. Pluriarc, Kongo peoples. Lower Congo, DRC. Early 20th century. Wood, iron, vegetal fiber, pigment, 31.69 × 4.92 × 7.48 in. (80.5 × 12.5 × 19 cm). Collection Royal Museum for Central Africa, Tervuren, Belgium, MO.1954.10.81.

Facing page: Cat. 3.30. Lamellophone, Solongo peoples. Lower Congo, DRC. Early 20th century. Wood, bead, iron, 6.69 × 3.74 × 1.97 in. (17 × 9.5 × 5 cm). Collection Royal Museum for Central Africa, Tervuren, Belgium, MO.1953.74.551.

Pluriarcs and Lamellophone

As early as 1620 the German composer Michael Praetorius had described the Kongo instrument known as *nsambi* or pluriarc (ill. 8.2). The stringed instrument consists of a deep box-like resonance chamber from which a number of curved arms project. Attached to each arm is a fiber string that runs to the front of the box. Strings may be plucked with the fingers or with picks.

Pluriarcs may be used for a number of occasions: for personal entertainment, in healing practices, during ritual, to accompany hunting songs, during mourning, for occasions such as the installation of a chief or for songs that extol the exploits or the character of a man of standing. The pluriarc may be played alone or in an orchestra with such instruments as drums, bells, and other instruments as suggested in ill. 2.1, which illustrates a chief greeting a Capuchin missionary.

Some *nsambi* are plain, but others are beautifully decorated with incised geometric patterns inlaid with light pigment against the dark ground, as in cat. 3.29 (*facing page, right*). Others are finished with a sculpted human head on the extension of the sound box, as in cat. 3.28 (*facing page, left*). Geometric openings in the form of an equal-armed cross are cut into the sound box of the figurated pluriarc.

Another plucked instrument, the lamellophone or *sanza*, is almost ubiquitous in sub-Saharan Africa. A number of metal or split-cane tongues are attached to a sound chamber, with one end of each tongue held in position by a wire or a bar. The free end of the tongue can be plucked, usually with the thumbs, to produce a vibrating tone. The example in cat. 3.30 (*below*) has eight metal tongues held tightly in position by a wire over two metal frets. Red, yellow and blue beads add to the visual impact of an otherwise somewhat plain example.

RP

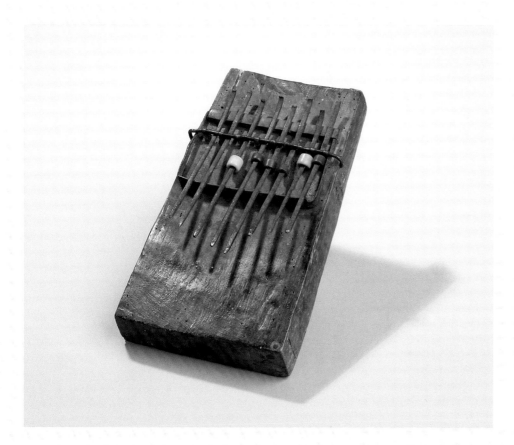

10 ◈

Meaning and Aesthetics in Kongo Art

WYATT MACGAFFEY

Interest in the aesthetics of form has often been missing from scholarly studies of African art, which pay more attention to meaning and function. According to Susan Vogel, "Recent publications tend to concentrate on the growing body of information about the function and significance of African art and limit remarks about form to praiseful descriptions."[1] Scholars are still reluctant to adopt a specifically aesthetic critical stance; collectors and curators have done much better in this regard.[2] Many collectors say things like, "Owning this piece has changed my life," while they remain indifferent to its ethnographic context. A review of exhibition catalogues will show, however, that it is above all *sculptural* form that they value, even though they no longer limit themselves to "realistic" sculptures nor strip them of added material or varnish them. African objects now collected and shown as art should be fully treated as such.

Most of the Kongo objects now in museums were collected between 1880 and 1920, the period in which France, Belgium and Portugal divided the territory of the Kikongo-speaking people into their colonies of Moyen Congo, Belgian Congo and Angola. On the coast the collectors were traders acting as agents for the new ethnographic museums: for example, the Peabody Museum at Harvard, 1866; the Folklore Museum, Berlin, 1868; and the Trocadero Museum of Ethnography, Paris, 1878. Inland, the collectors were usually missionaries. They collected Kongo objects not as art but as tokens of barbarism overcome and as evidence to support the evolutionary thesis that African culture was primitive and destined to be superceded. At the end of the nineteenth century, Africans themselves were "exported," exhibited in mockups of African villages in World Fairs to convey the same message of white superiority.[3]

Most of the objects collected were called *minkisi* (sing. *nkisi*) in Kikongo. Europeans called them fetishes, a term embodying the conviction that *minkisi* were random collections of oddments endowed by their makers with imaginary powers; fetishes stood, in the European mind, for a sort of irrational anti-religion they called "fetishism," a term coined by a French scholar in 1760.[4] Accordingly, the collectors of fetishes generally made no effort to understand what they were collecting, rarely noting even the indigenous name of the object or the function attributed to it. After 1920, the combined efforts of colonial governments and Christian missions thoroughly

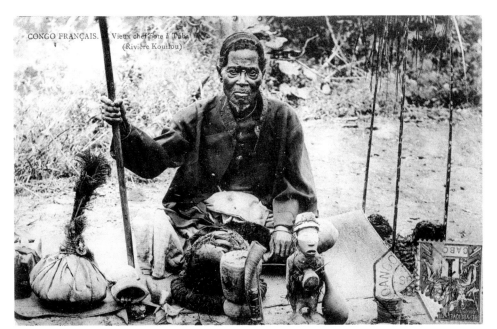

Fig. 10.1. Postcard of a *nganga* holding a staff and sitting behind several *minkisi*, from a photograph by P. A., printed by A. Bergeret & Co. Nancy, France, ca. 1906–10, EEPA Postcard Collection, CF-03-01, Eliot Elisofon Photographic Archives, National Museum of African Art, Smithsonian Institution. By permission of EEPA.

repressed the production of *minkisi*, which were still widely used but took the form of little bundles furtively worn about the body or hidden in the house. Within a generation the composition and operation of what in the past had been famous and spectacular *minkisi* were forgotten. Their expert makers and operators, the *banganga* (sing. *nganga*), took to calling themselves "traditional healers"; after the independence of the French and Belgian Congos in 1960, the functions of divination, healing and dispute settlement were largely taken over by mission-derived "prophet" churches.

At the same time, Europeans discovered that African "fetishes" were Art, to be moved from ethnographic museums to art galleries and to be written up in new magazines, such as *African Arts*, founded in 1967. But what could one write? Art theory required the critic to identify individual artists, to situate their work in an evolving tradition and to comment on technique, form and relative aesthetic value. African artists were anonymous, and it had long been assumed that they mindlessly reproduced forms characteristic of their respective tribes. Was it appropriate to apply European aesthetic criteria to African art? An editorial in *African Arts* in 1974 commented on the situation:

> African art begins to become—what shall we say—popular? . . . At one level we have little right to be other than grateful that suddenly such interest is pushing its green spring shoots through the arid soil of a monumental and historically entrenched indifference. . . . Yet there are features [of recent exhibitions and critical responses to them] that make one a little anxious. Two aspects are apparent. One is the consistent air of surprise. . . . I wonder how much longer African art exhibitions can be justified by their novelty and the gratifying sense of satisfying curiosity in a virgin field. The other element is the complicated attempt to define an appropriate stance from which to pontificate about this material.[5]

For parts of Africa where artistic traditions continued to be vital, scholars could belatedly obtain information about meaning and practice, but in most of Kongo the sculptural tradition was dead. Some information about *minkisi* and the performances of *banganga* was recorded in Catholic missionary studies carried out in the early decades of colonial rule, but these reports were shaped by their authors' evangelical and political commitments. Modern fieldwork, begun in the early 1960s, could do little to recover the original contexts and significances of objects that had been locked away for half a century or more, while the lives of Bakongo changed rapidly.

Exceptional for their early interest in ethnography, Swedish missionaries pioneered the colonial advance into the interior north of the Congo River in Manianga and adjacent areas of Moyen Congo; from the beginning in the 1880s they took an active interest in Kongo language and culture. Outstanding among them was K. E. Laman, who worked in Kongo from 1891 to 1932. His many publications included a translation of the Bible, a grammar of Kikongo and his monumental *Dictionnaire Kikongo-Français* (1936). This last was based on his own knowledge but more importantly on his project, begun in 1912, to collect "a copious native literature," which would display "the people's own manner of speaking and reasoning" and would be printed and translated to help missionaries study the language and to benefit future generations of the people. The project, far ahead of its time, resulted in 10,000 manuscript pages written in Kikongo by converts to Protestant Christianity, in response to Laman's detailed ethnographic questionnaire. Thousands of pages are devoted to the composition and use of *minkisi* alone. A synthesis of this extraordinary collection of information, with comments of Laman's own, was eventually published in English translation from the Swedish in four large volumes between 1953 and 1968. The synthetic nature of the text obscures the identities of the original authors and often scrambles their contributions in summary form, making the result difficult to use. Fortunately, the original manuscripts are preserved in Swedish archives.[6]

Laman himself was a collector of *minkisi* and of many other objects that he studied in detail and discussed with *banganga* and others. No other source of information on Kongo culture as it was in his day has anywhere near the same authority. Unfortunately, he and his collaborators lived and worked in the area of the Protestant missions, inland; we can only extrapolate from there to other areas, notably the Atlantic coast, where most *minkisi* were collected and where language, custom and practice varied considerably.

Laman tells us that artists were popular and admired members of their communities and often competed in producing exquisite works to increase their renown. Some artists worked purely for artistic pleasure, but most artistic endeavor was governed by practical and commercial considerations. Everything that was sold in the market or handed over at social events such as weddings was made as ornamental as possible, since the more beautiful the object the higher the price it would fetch. Because coloring techniques and materials were limited, ornament mostly took the form of carving on wood, but similar designs were woven into baskets and the walls of houses, and appeared on the human body in the form of raised cosmetic scars

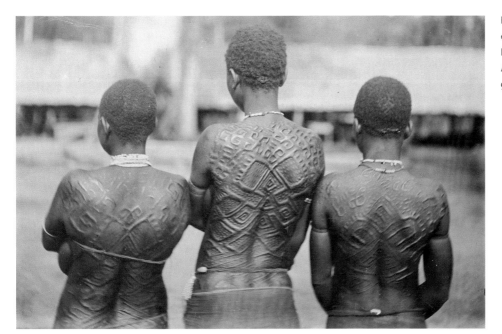

Fig. 10.2. Photograph of women's scarifications, Mayombe, DRC, early 20th century. CICM Archives, KADOC, Leuven, Belgium. By permission of CICM.

(keloids, miscalled "tattoos"). The term for carving, *nwata nsamba*, also means "scarification." Many designs had names, such as "tsetse fly," "leopard's paw," or "snake on a branch," from things they were thought to resemble (fig. 10.2).

On chief's staffs, however, and (on the coast) on wooden lids for cooking pots, ornaments could convey messages, usually by depicting proverbs (cat. 2.16, 2.17). Some lids carried only one pictorial element associated with a single proverb, but many of them conveyed multiple proverbs subordinate to a dominant one (cat. 4.23, 4.24). In modern times it may be impossible to identify the proverbs, but in any case, as Joseph Cornet, the leading authority, tells us, the interpretation of pot lids and of proverbs in general was always an art; interpretations varied from one locality to another, or even from one speaker to another, from one occasion to another. A dictionary of proverbs and of signs that attempted to pin down their meanings would deny the intellectual creativity that gave and continues to give pleasure to Bakongo.[7]

Laman found the same creative variety in *minkisi*. A *nkisi* is a container for empowering animal, vegetable and mineral ingredients called "medicines," packed into it or attached to it; it may be a pot, buffalo horn, basket, bundle, gourd, wooden figure, or almost anything else. Laman made a list of 130 elements he had found in different *minkisi*. To only seventeen of them could he assign a definite significance; most of those he called "the usual medicines" because they appeared in many *minkisi* and their meanings were well known. For the rest, one would have had to ask the *nganga*. Nevertheless, the general principles that might give an item a place in the whole are known. Its name might be the basis of a pun that invoked some quality that the *nkisi* should have: *kala zima* (charcoal) that it might "extinguish" (*zima*) witchcraft; *ndingi* (copal resin) that it might flash like lightning and warn of the approach of witches; *lufulangi* (a plant) that it might revive (*fula*) the soul. Or the metaphor might be visual: the claw of a hawk, that the *nkisi* might seize wrongdoers; the crossing fibers of a weaver bird's nest, that the medicines might be bound together; stones, to cure

tumors. But all these things might refer to something else: *ndingi* might be there to invoke *dingalala*, "to calm" a sufferer; *zima*, that sickness might be extinguished; stones, that a man who broke the rules of the *nkisi* might suffer a scrotal hernia; and so on. Some items were included just because they were astonishing; one of Laman's contributors wrote, "A mirror is placed on the belly of the *nkisi* to allow the *nganga* to inspect the soul of the patient, or in some cases just to make the *nkisi* look good." A *nkisi*, even when it resembled others in name and function, was always unique, not the product of a formula.[8]

Minkisi have been called "personified medicines"; they were made and used to solve specific problems ranging from bad dreams to theft to infertility to epidemics to the attainment of political office; if one was thought not to work it would be discarded and a new one created. They formed a field of constant experimentation, which explains why lists of *minkisi* varied greatly from place to place and from one period to another. Most of them were minor, but some were famous, carried from place to place to deal with serious matters. This was particularly true of the coast, whence came most of the *minkisi* now in collections, and where, after the breakdown of the Loango kingdom in 1870, three families of aggressive *minkisi* were largely responsible for the maintenance of such law and order as there was: Mangaaka, Mambiala Mandembe, and Mavungu. They belonged to the class of wooden *nkisi* figures stuck full of nails, blades and other hardware, called *nkondi* or, on the coast, *nkisi a mbau* (these are terms of convenience, not rigid categories) (cat. 4.1, 4.2, 4.3, 4.4). The remarkable thing is that these objects, not made as art, and later collected as barbarities, are nowadays among the most sought-after works of African art, in a cultural environment entirely foreign to them. They "work" as art for one of the reasons why, a century ago, they worked to solve problems: their aesthetic power. Alisa LaGamma says about the Metropolitan Museum's recently acquired Mangaaka, "Its commanding presence assaults the viewer and demands a response." This is not how we normally speak of an inanimate object, but it is what we say about great art, and resembles what Bakongo once said about great *minkisi*.[9]

A *nkisi* in a museum is inert and in fact dead, in terms of its original function as a "personified medicine." In Kongo theory, a *nkisi* loses its power when it loses any of its medicines, when people break the rules it imposes on them (not to eat certain foods, for example) or when the *nganga* who made it dies. In and of itself it is nothing. When it was alive and working it was the centerpiece of a theatrical ensemble of esoteric chants, song, dance and behavioral rules that, combined with the disappointments and jealousies of real life and the memory of punishments supposed to have been inflicted by this and other *minkisi* in the past, created tension and excitement. The *nkisi* was made to be frightening. An accumulation of unknowable medicine charges and hammered hardware created an intriguing but also alarming texture; we wince at the thought of nails driven into a human body. But that is not all; a judicial *nkisi* was an entity in four dimensions. The public knew that it came into existence as an extraordinary revelation to a particular individual, followed by a complex and bloody process of composition by which, or so it was believed, the souls of victims were

imprisoned in it to provide its energy. (Deaths among the neighbors during and after the ritual would be the "evidence" that such an immolation had taken place. We may be more comfortable referring to such transfers as "mystical," but for Bakongo then and now they are real.) As Alfred Gell explains, illustrating his theory of the agency of art objects, an instructed person would not see in a fetish a mere form. "What is seen is the visible knot which ties together an invisible skein of relations, fanning out into social space and social time. These relations are not referred to symbolically, as if they could exist independently of their manifestation in this particular form; for these relations have produced this particular thing in its concrete, factual presence; and it is because these relations exist(ed) that the fetish can exercise its judicial role."[10]

Any Kongo person was "instructed" at a deeper level than the explicit, contingent and variable knowledge of the meanings of *ndingi* or *kala zima*. He or she knew that the powers of *minkisi* (and of witches and *banganga*) came from the dead, which is why violent *minkisi* were supposed to contain the imprisoned souls of human beings. Minor ones invoked the dead by including grave dirt or, above all, white kaolin clay (*mpemba*) from streambeds. The land of the dead (also *Mpemba*) was something everybody knew about, though it was so woven into daily consciousness that nobody thought of it as a stand-alone belief or bothered to explain it to foreigners until Kimbwandende Kia Bunseki Fu-Kiau, after collaborating in ethnographic research with the anthropologist J. M. Janzen, published it in the form of a diagram now widely referred to as a "cosmogram": a cross inscribed in a circle.[11] It is important to note that K. Kia Bunseki Fu-Kiau's diagram is an ethnographer's product, not produced spontaneously for quotidian purposes but an explanation addressed to outsiders. Bakongo never needed to "explain" the land of the dead to each other.[12]

To ethnographers such as Janzen or myself, the cosmological assumptions of Bakongo were revealed by incidents such as this: one of two women quarreling amid

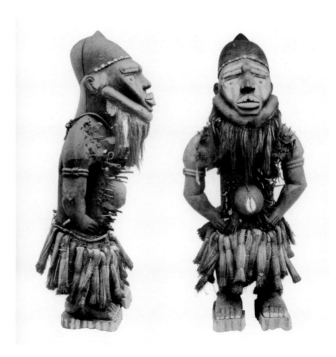

Fig. 10.3. Frontal and lateral views of a *nkisi nkondi*. EO.o.o.7777 in RMCA collection. Published in Maes 1935. By permission of RMCA.

their cultivations draws a cross in the dirt, stands on it, and snaps her fingers to swear that she is in the right. So doing, she situates herself on the boundary between the living and the dead, the vertical stroke being the path from here to there, which she expects to travel if she is in the wrong. In the Laman manuscripts we find many anecdotes such as this and the beliefs associated with them, some of which Laman himself mentions without realizing their systematic character, which K. Kia Bunseki Fu-Kiau began to reveal.[13] Of course, in Kongo as in the rest of the world, there are lots of circles and crosses, design elements that have no cosmological significance whatever. It is a basic scholarly responsibility to provide some evidential basis for imputed meanings or to admit that they are speculative.

In African societies where one's identity is established by reference to grandparents rather than by wealth or occupation, the dead are intimately present. In Kongo they are not dead; they are thought to have moved to another place across some boundary (often a body of water), from which they may return and to which, in some circumstances, the living may go and come. Unlike the living, the dead have knowledge of both worlds, of things seen and unseen; those who can visit them, or are visited by them, may obtain skills that ordinary people lack. Initiations into chieftaincy, witchcraft and the mysteries of *minkisi* are described as time spent in the land of the dead. This fundamental belief explains why the most convincing examples of proposed Kongo influence in the Americas are related to graves.

The instructed person has learned what Arthur Danto calls a theory. Theory defines what is art, providing information but also reorganizing perception so that we see and feel what the uninstructed miss. For formerly excluded objects such as "fetishes" to be recognized as art requires not so much a change in taste as a theoretical revision.[14] In the case of African art, the revision was prompted by the independence of most African countries in 1960 and by the social upheaval in the Western world after 1968. So far, the revision remains incomplete. For nineteenth-century Europeans, Africans were so primitive as to have no religion but fetishism instead. The liberal reaction of the late twentieth century, particularly in the United States, moved people to reverse the signs and endow Africans, collectively, with a pervasive spirituality superior to the materialism of the West. This apparent commendation is a form of orientalism, preserving the distinction between "us" and "them" and denying Africans the right to be recognized and understood as ordinary human beings. Far too much ink has been wasted to describe *minkisi* in the vocabulary of Western religion, especially the word *sacred*. They are technical devices; the supposed relations of cause and effect on which they are based may be erroneous, but error alone does not constitute "religion," nor does it need to be euphemistically excused. The awe they inspire, in modern viewers as once among Bakongo, is like that of other works of art. Their "sacredness" is that of other objects and places distinguished by the particular events that they uniquely evoke, such as a Rembrandt self-portrait, of which a copy, no matter how good, is only a copy, or Gettysburg, where the uninstructed see only a field.

Kongo "theory" and art theory both enable us to see what otherwise we could

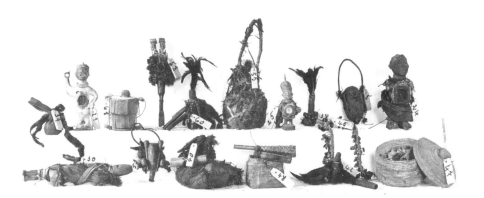

Fig. 10.4. Photograph of *minki-si* brought to the Catholic mission of Kangu, Mayombe, DRC, 1915. CICM Archives, KADOC, Leuven, Belgium. By permission of CICM.

not see and to feel that we understand obscure creative drives. Despite their obvious differences, the two have in common their central focus on visually compelling objects whose power can transcend time, place and cultural context. For Michèle Coquet, writing about the fetishes of the Bwaba in Burkina Faso but with reference to *minkisi* also, the "fetish style," the "aesthetic of the fetish," depends not on sculptural form, of which there may be none, but on the motivated totality of accumulated elements, which gain *new* meaning (as in early collages by Picasso) by their incomplete incorporation with others in a new form (cat. 4.6, 4.9, 4.10, 4.11). Comments focused on ethnographic information and on decoding real or supposed "meanings" look sideways at the object itself; it, however, remains autonomous, partly independent of context and thus capable of being appropriated into other contexts and subjected to new interpretations.[15] Coquet's commentary is an aesthetic one, focused on the object in its entirety. If African objects are to be fully art, there should be more such commentary.

Notes

1. Vogel, *Closeup*, 7.
2. McNaughton, "Notes on the Usefulness of Form," 17–19.
3. Lindfors, *Africans on Stage*.
4. de Brosses, *Du culte des dieux fétiches*.
5. African Arts, "First Word," 1.
6. Laman, *The Kongo* (4 vols.); MacGaffey, *Kongo Political Culture*, 34–37.
7. Cornet, *Pictographies Woyo*.
8. Laman, *The Kongo*, vol. IV, 73.
9. LaGamma, "The Recently Acquired Kongo Mangaaka," 201.
10. Gell, *Art and Agency*, 62.
11. Fu-Kiau, *Le Mukongo*.
12. Seeking a term for a sort of cosmographic shorthand, I first used the word *cosmogram* (without realizing that I had invented it) during the early 1970s in private communications with Robert Farris Thompson, who popularized it in his stimulating lectures. I discussed the significance of circles and squares in Kongo in an unpublished paper, "Conceptual Use of Space in the Lower Congo," prepared for a conference on traditional African architecture in May 1970.
13. MacGaffey, *Religion and Society*, chap. 2, 3.
14. Danto, "The Artworld."
15. Coquet, "Esthétique du fétiche."

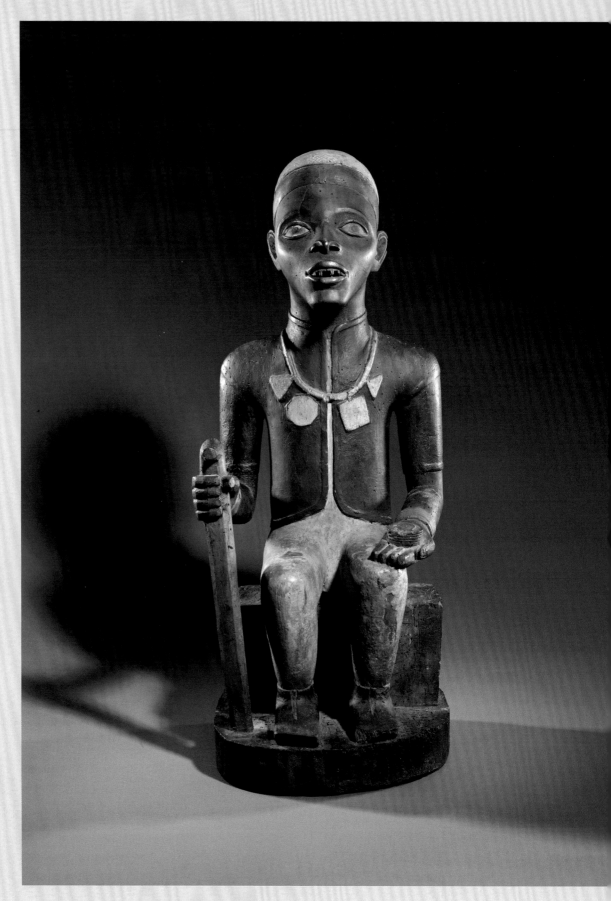

Ill. 9.1. Seated grave figure, Yombe peoples. Mayombe, Lower Congo, DRC.
Early 20th century. Wood, pigments, 24 in. (61 cm). Collection of Ethnic Art and
Culture, Hong Kong, FX95 0264.

The Master of Kasadi

In the last two decades, art historians have moved away from the paradigmatic concept of "tribal styles" in favor of the recognition of the oeuvre of individual artists. Such artists often emerged unexpectedly from the stylistic analysis of works of art produced within the same broad region. Since the names of artists were generally not recorded in colonial Africa, art historical practice bestowed new honorary titles on them, to be used as new name tags in museums and galleries around the globe.

In 2001 art historian Ezio Bassani launched the posthumous career of the "Master of Kasadi," a Yombe artist whose craftsmanship and power of expression appeared unparalleled. His signature can be read in a number of distinct stylistic features that blend into perfectly balanced compositions. The Master of Kasadi was first known for a series of mother and child figures, which included the one to the lower right, collected in Mayombe between 1911 and 1913. The big eyes rimmed with a lenticular relief, the hollow cheeks with prominent cheekbones, the open mouth with the filed teeth and the strong chin reveal the master's hand.

The bearded mask covered with white clay to the right is one of the artist's creations collected in Kasadi—hence his "name"—by missionary ethnographer Leo Bittremieux. It had belonged to the *nganga* of *nkisi* Diphomba, a diviner whose interventions were still common in the first decades of the twentieth century. Some sources have nevertheless situated the artist in the (early) nineteenth century. Our seated chief to the left, however, wearing colonial medals and collecting coins, clearly identifies our master as a witness of the early colonial period, when after the turn of the century chiefs were increasingly involved in tax collecting and labor recruitment.

HV

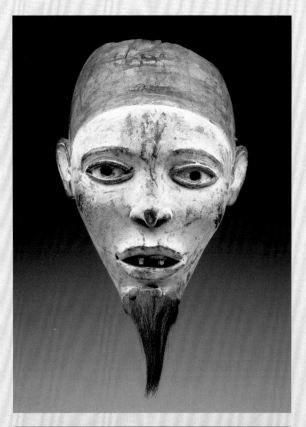

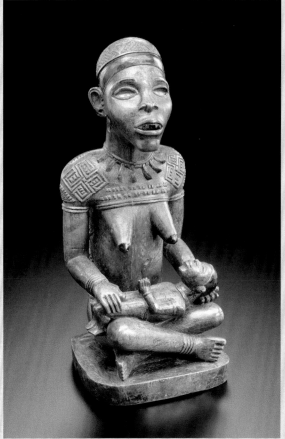

Ill. 9.2. Mask of the *nganga* Diphomba, Yombe peoples. Mayombe, Lower Congo, DRC. Early 20th century. Wood, skin, hair, white clay, pigment, 11.4 × 6.9 × 5.5 in. (29 × 17.5 × 14 cm). Collection Royal Museum for Central Africa, Tervuren, Belgium, EO.0.0.37966.

Ill. 9.3. Mother and child figure, Yombe peoples. Mayombe, Lower Congo, DRC. Early 20th century. Wood, glass, 11.2 × 5 × 4.7 in. (28.5 × 12.8 × 12 cm). Collection Royal Museum for Central Africa, Tervuren, Belgium, EO.0.0.24662.

11 ◇

A Touch of Exoticism

"European Fashion" in Kongo

JULIEN VOLPER

In the 1950s, Albert Maesen collected in the Mboma territory various objects of European craftsmanship that originally adorned the graves of former chiefs. An English Toby jug was found among these artifacts (cat. 2.8).

Toby jugs are anthropomorphic pottery vessels, most of which show a plump man dressed in eighteenth-century fashion sitting on a chair. The most common examples depict a man equally jovial as kitschy, holding a bottle and a glass, or hugging a pitcher as in this example. The origin of such objects is often said to date from the second half of the eighteenth century and originated in Staffordshire.[1] The example shown here is clearly of the "soldier" type, which was produced around 1830.

There is evidence that in the nineteenth century and in the early twentieth century, the Toby jug had great success among the Kongo populations of the DRC and Angola. After the death of the owner, the object was often placed on the grave among other goods of European manufacture (plates, umbrellas, jugs, bottles, and so on). Fig. 11.1 and ill. 10.3 show two such graves photographed in the first decade of the twentieth century. One is adorned with two Toby Jugs and a faïence shepherdess, and the other shows a Toby among numerous other imported objects.

This use of the Toby jug as a grave item is further indicated by the etymology of the term used for it in Kikongo: *mbungwa kimanzi*. If the term *mbungwa* clearly refers to a pot or mug, it is also apparent that the term *kimanzi* derives from *mánzi*. According to Karl Laman, the *bimánzi* (plural of *mánzi*) were "brittle things" of all sorts that were put on the grave.[2]

Besides the imported Toby jugs, there were also objects made by Kongos that were clearly inspired by the English drinking character.[3] The earliest mention of a "Kongo toby" is that of Charles Jeannest. In the 1870s, possibly in the Cabinda region, the author observed a "snuffbox" carved similarly to a Toby jug in every way, of which he made a drawing (fig. 11.2). The collection of the Royal Museum for Central Africa (RMCA) holds a particular *ntadi* or stone funerary sculpture (fig. 11.3) and a fragment of a ceramic vessel modeled in the form of a human head (cat. 2.9), both of

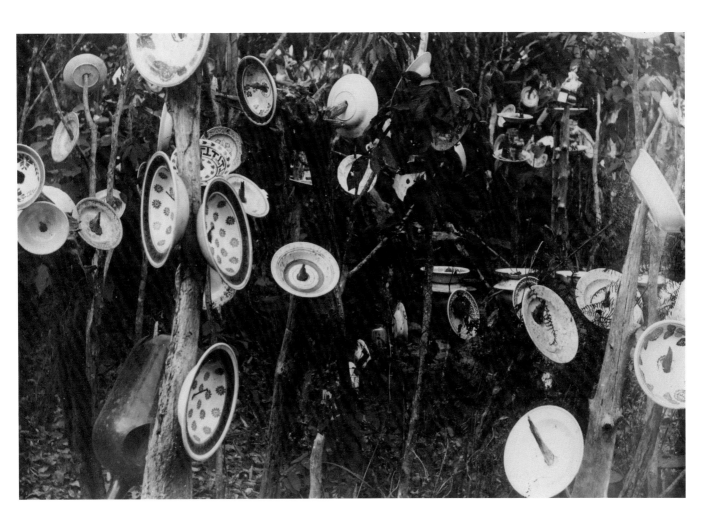

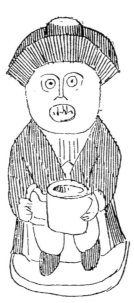

Above: Fig. 11.1. Photograph of a Kongo tomb with Toby jugs and plates, region of Mbanza-Ngungu (formerly Thysville), Lower Congo, DRC, by R. P. Gérard, 1910. RMCA Photographic Archives, Tervuren, Belgium, AP.0.0.21124. By permission of RMCA.

Left: Fig. 11.2. Drawing of a Kongo copy of a Toby jug that was presumably made in the second half of the 19th century. Published in Jeannest 1883.

Fig. 11.3. Grave figure whose iconography is inspired by the English Toby jug, Angola or Lower Congo, DRC. Late 19th or early 20th century. Soapstone, 7.3 × 2.8 in. (18.5 × 7 cm). Collection Royal Museum for Central Africa, Tervuren, Belgium, EO.1986.13.1.

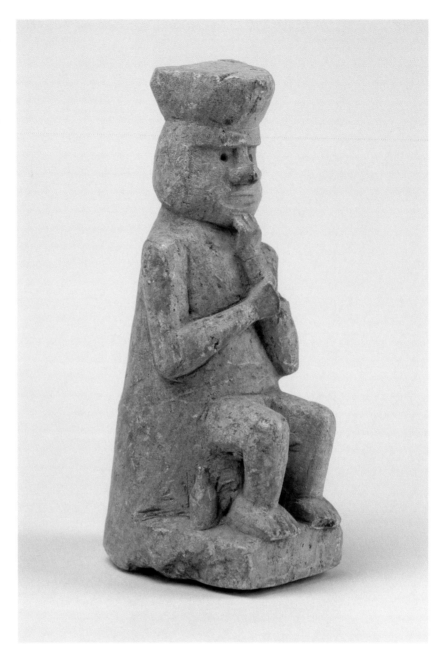

which faithfully reproduce the iconography of the Toby jug even to the representation of the tricorn hat.

A number of Kongo pieces can be seen to move further from the "English model" toward a more pronounced "Kongoization." The best examples are found among the large wooden figures decorating the funerary altars that used to exist among the Yombe. Some of these works have preserved elements that may refer to the English Toby jug, through their gestures, their clothing or even the shape of the mug held by the sculpted figure. In this way, the example in cat. 4.19 shows a gesture that can clearly be related to that of the Toby jug in cat. 2.8. We can also mention the existence of a funerary figure in the collection of the RMCA that closely resembles the appearance of a relatively rare Toby jug that English collectors of ceramics know by

the name "Sailor" (fig. 11.4). This type of Toby jug was developed in Europe around 1790–1820.

In contrast, other examples show a certain artistic evolution of the Kongo-made Toby jug, most apparent in the depiction of the costume, which seems to have been "updated." This is the case of the example shown in cat. 4.17, which depicts a *chef médaillé* (a chief appointed by the colonial government) wearing both a medal and a colonial helmet.

Other Kongo variations of the little English drinker show even more marked iconographic distinctions. We may note here the sculpted figurines depicting standing or seated women holding a bottle and a glass in their hands (cat. 4.18). Kongo artists

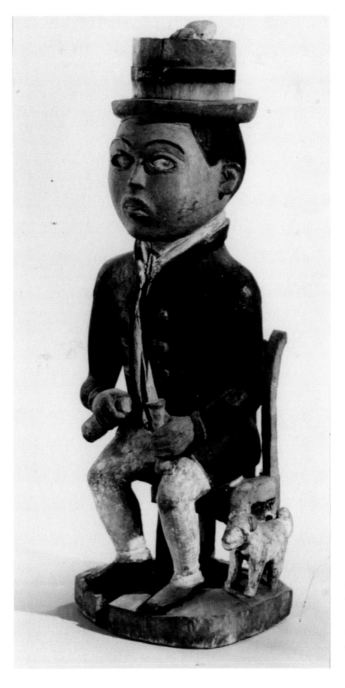

Fig. 11.4. Grave statue depicting a drinking man. Lower Congo, DRC. Late 19th century. Wood, pigment, 16.9 × 5.9 × 5.3 in. (43 × 15 × 13.5 cm). Collection Royal Museum for Central Africa, Tervuren, Belgium, EO.0.0.16627.

Fig. 11.5. Portuguese zoo-morphic teapot found in the region of Noki, Angola. Late 19th century. Majolica, 8 × 3.9 × 6.9 in. (20.2 × 10 × 17.4 cm). Collection Royal Museum for Central Africa, Tervuren, Belgium, EO.1953.74.158.

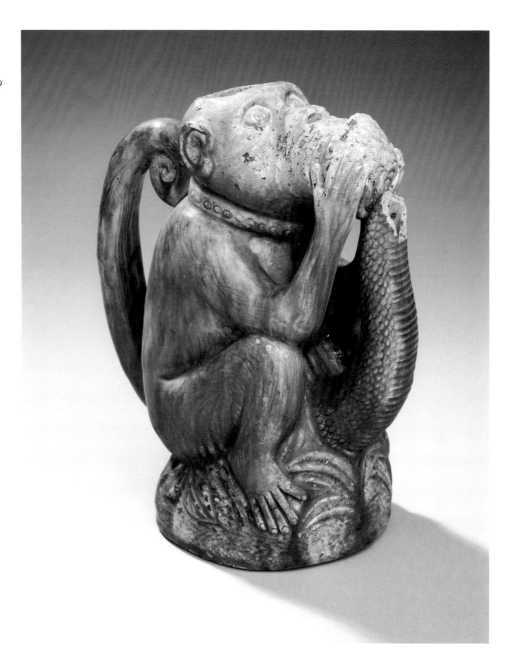

possibly took the attributes of the male Toby jug and put them in the hands of female figures. On the other hand, these sculptors may have found their inspiration in the female examples of the Toby jug of the "Martha Gunn" or "Gin Woman" type.

Given the abundance of examples, we may ask the question of what prompted various Kongo artists to embrace the figure of the Toby jug and its derivatives.[4]

According to Norm Schrag, one possible explanation may lie in the memory of an ancient practice of Kongo lords who, allegedly, drank from human skulls to impress their visitors and to display the power they possessed over the life and death of their subjects.[5] When the first Toby jugs arrived on African shores, they may have replaced the "goblet" of the old and macabre practice, given their similarly cephalomorphic and anthropomorphic aspect and their function as a container.

While the possibility of such a functional replacement cannot be ruled out, one may wonder if Toby's success in Kongo was not part of a wider phenomenon. Toby jugs on graves were not the only prestige items from abroad (see fig. 11.1 and ill. 10.3). Tableware items such as plates, bowls and pitchers were also found on graves, and these objects were similarly copied by Kongo artists (cat. 4.26).

Therefore, we can ask ourselves if the craze for Toby jugs was not part of a broader fashion vogue, related to European tableware. It may be that ceramic manufacturers among the Kongo were naturally attracted to these new products, resulting from diverse techniques such as faïence or salt glazing, which were unknown to them. Ultimately, could the little English drinker not be the most vibrant expression of a Kongo desire for "*Europeaneries*" comparable to that for "*Chinoiseries*" in Europe?

This seems to be an apt explanation, one that accounts for the thousands of artifacts, found in both archaeological and ethnographic contexts, that show the amazing diversity of exotic curios from Europe that arrived on the coasts of West Central Africa in the nineteenth and twentieth centuries. The blue and gray stoneware of "Alsace and the Rhineland" type present more examples of this (cat. 2.4), as do the Portuguese majolica, which includes zoomorphic teapots that were very popular in Europe in the 1880s. One of these (fig. 11.5) was found on the same grave as the Toby jug we are considering here (cat. 2.8). Like the Toby jug, this type of object inspired artists to innovate and experiment, and to come up with local interpretations.

These exotic imports also included Netherlands faïence from Delft and Maastricht. Examples of this produced by Petrus Regout in the second half of the nineteenth century characteristically use "Chinese motifs." Such hybrid ceramics collected on African soil intimately blend the aesthetic exoticisms of the two worlds of Africa and Europe. European and African tastes also converged around the Toby jugs that became extremely popular in Europe between 1775 and 1825 and still seduce lovers of pottery today.[6] Could the collector of Toby jugs portrayed by Charles Spencelayh in his painting titled *The Latest Addition* have shared his passion with Kongo peoples from Central Africa?

Notes

1. The appearance of the Toby jug seems to coincide with the popularization of a mezzotint by Robert Dighton, who illustrated the poem called "The Brown Jug." This text, published in 1761, was written by Francis Fawkes. It is an English adaptation of a Latin text written in the sixteenth century by Geronimo Amalteo. Schuler, *British Toby Jugs*, 3; Eyles, *Good Sir Toby*, 17.

2. Laman, *Dictionnaire Kikongo-Français*, 502, 542.

3. Jeannest, *Quatre années au Congo*, 96–97.

4. In fact, other European pitchers, including zoomorphic examples, were found on Kongo graves, although less frequently. One of these appeared in the second half of the nineteenth century in Europe and was called "King Charles Spaniel."

5. Thompson and Cornet, *Four Moments of the Sun*, 102.

6. Woodhouse, *Old English Toby Jugs and Their Makers*, 9.

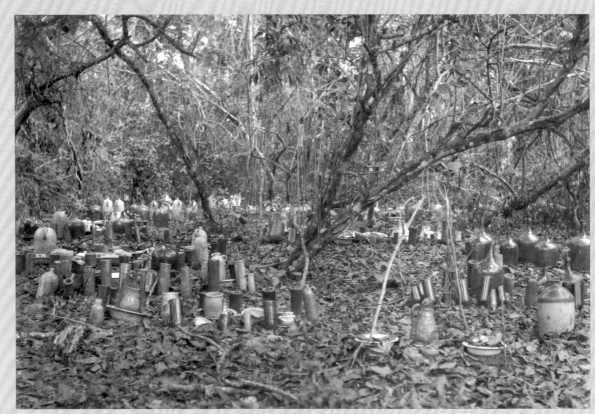

Ill. 10.1. Photograph of the cemetery of the chiefs of Kionzo, Lower Congo, DRC. KADOC archives, Leuven, Belgium. By permission of KADOC.

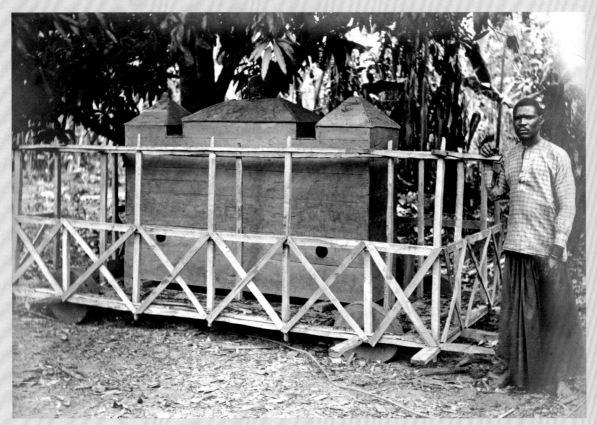

Ill. 10.2. Photograph of a coffin on a cart, Chintwala, Lower Congo, by A. Cabra, late 1890s. Cabra Papers, RMCA Archives, Tervuren, Belgium, Fol. 71.45. By permission of RMCA.

The Land of the Dead

Hardly any European explorer or resident in West Central Africa failed to report on the peculiar ways in which Bakongo marked and decorated their cemeteries. Some of these looked like vast dumping grounds for abandoned glass and stoneware bottles and jars, left in a disorderly manner around particular trees in the forest. Others had a more carefully organized spatial arrangement of the graves, with the imported pitchers and bowls firmly planted in the earth, following a neatly laid-out design. Some graves were seen topped by an old English cannon or by other metal objects, like the curious bronze helmet (cat. 2.10). The European pottery included peculiar forms like the English Toby jug (cat. 2.8) or other fine porcelain mantel figures (ill. 10.3). All this served to indicate the prominent status of the deceased as a successful merchant or chief, well situated within the Atlantic trade system.

The photograph on the facing page, bottom, shows a late-nineteenth-century version of the coffin of an important chief being transported on a wooden carriage to the cemetery. Documented as early as the seventeenth century, this tradition still existed around 1900 on the Loango coast and in parts of Mayombe. Inspiration for the fencelike construction around the coffin may have come from houses built by Europeans in previous centuries along the Atlantic coast.

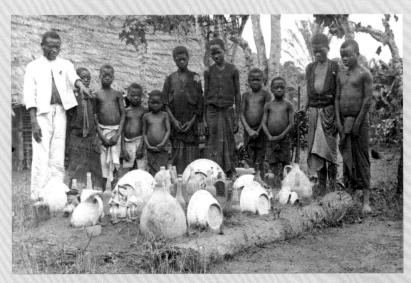

Above: Ill. 10.3. Photograph of a Kongo tomb decorated with European wares, Lower Congo, DRC, early 20th century. CICM Archives, KADOC, Leuven, Belgium. By permission of CICM.

Right: Ill. 10.4. Photograph of a Kongo tomb with a helmet on top of a canon, Kinguvu, Angola, by A. Maesen, 1953. RMCA Photographic Archives, Tervuren, Belgium, EP.1953.74.112. By permission of RMCA.

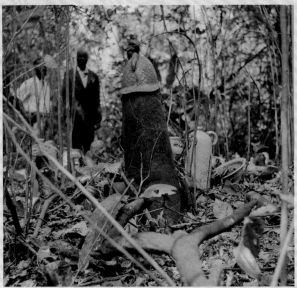

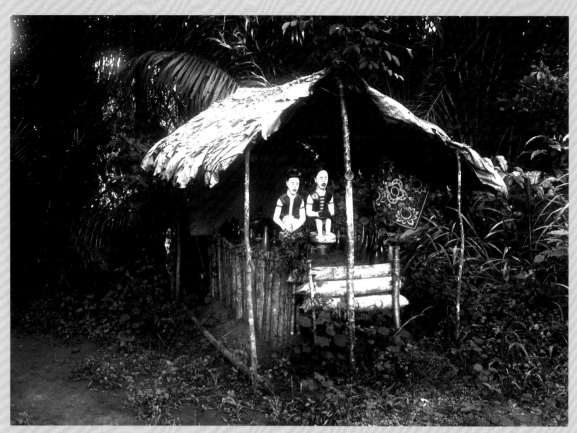

Ill. 10.5. Photograph of a Yombe tomb with bottles, human figures, a European textile and a woven mat, Mayombe, Lower Congo, DRC, early 20th century. RMCA Photographic Archives, Tervuren, Belgium, AP.0.0.5111. By permission of RMCA.

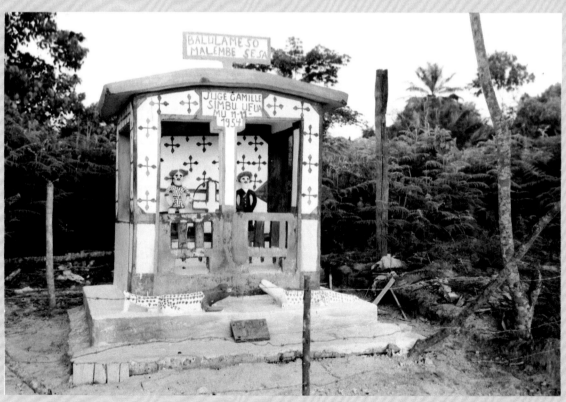

Ill. 10.6. Photograph of a Yombe tomb, Mayombe, Lower Congo, DRC, 1950s. CICM Archives, KADOC, Leuven, Belgium. By permission of CICM.

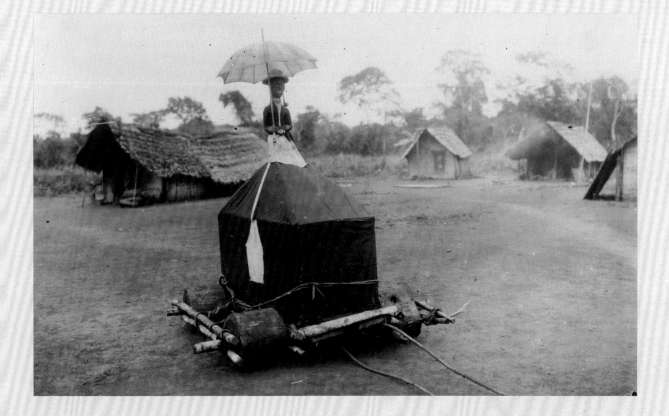

The increasing economic and political competition around important trade centers, such as Boma, and in parts of Mayombe favored innovation in the rituals of burial and in the decoration of graves. Besides the usual status symbols, such as glass bottles or a carriage for the coffin, artists were commissioned to make anthropomorphic figures in wood or stone, and later also in cement. Graves were also decorated with beautifully woven mats, and printed textiles imported from Europe.

Colorful wooden figures were seen on graves in Mayombe in the first decade of the twentieth century. They show a man or a woman who is often holding a particular object. This object could be a musical instrument, a jenever bottle, or a glass. Some figures were holding an umbrella, while others were protected from the rain by a shelter made of banana leaves. Later on, this shelter became a true monument made of bricks and cement, on which the name of the deceased was often painted. Figures of humans continued to adorn such graves, as did additional creatures such as lizards and turtles, all made in cement and painted with bright colors. The statues in soapstone (steatite) in the photograph below were typical of the region of Boma (see cat. 4.13 and cat. 4.14).

HV

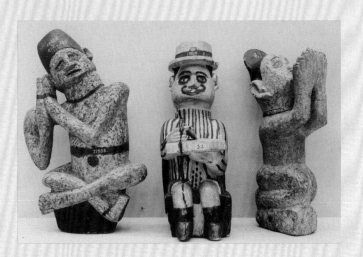

Above: Ill. 10.7. Photograph of a coffin on a cart topped by a human figure, Maduda, Mayombe, Lower Congo, DRC, early 20th century. RMCA Photographic Archives, Tervuren, Belgium, AP.0.0.8457. By permission of RMCA.

Left: Ill. 10.8. Photograph of three stone grave sculptures, Lower Congo, DRC. RMCA Photographic Archives, Tervuren, Belgium, AP.0.0.24352. By permission of RMCA.

PROTECTION AND HEALING

COMMEMORATING THE DEAD

TRADITIONAL FORMS AND INDIVIDUAL CREATIVITY

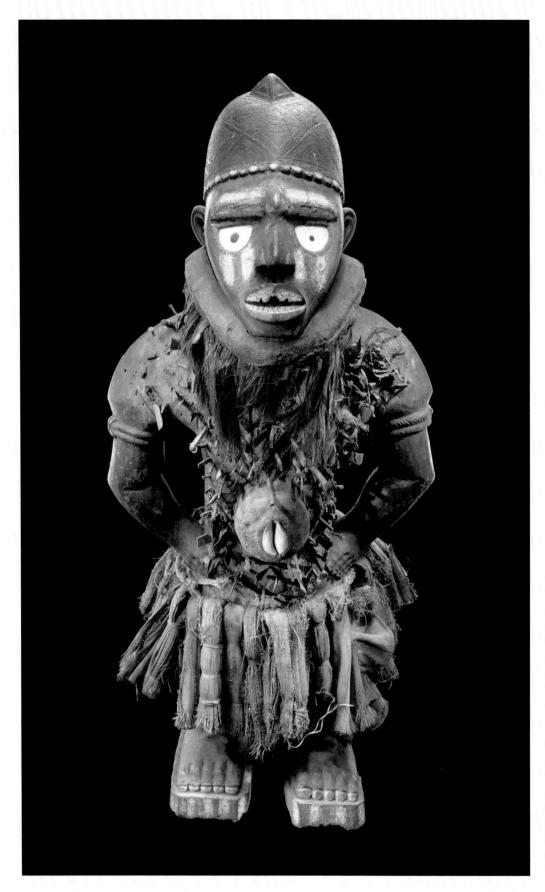

Left: Cat. 4.1. Anthropomorphic power figure, *nkisi nkondi* (presumably *nkisi* Mangaaka), Yombe peoples. Mayombe, Lower Congo, DRC. 19th century. Wood, shell, vegetal fiber, metal, pigment, glass, 51.97 × 19.29 × 13.78 in. (132 × 49 × 35 cm). Collection Royal Museum for Central Africa, Tervuren, Belgium, EO.o.o.7777.

Facing page: Cat. 4.2. Anthropomorphic power figure, *nkisi nkondi*, Kongo peoples. Boma, Lower Congo, DRC. 19th century. Wood, cotton, iron, vegetal fiber, pigment, glass, 45.28 × 17.72 × 13 in. (115 × 45 × 33 cm). Collection Royal Museum for Central Africa, Tervuren, Belgium, EO.o.o.7943.

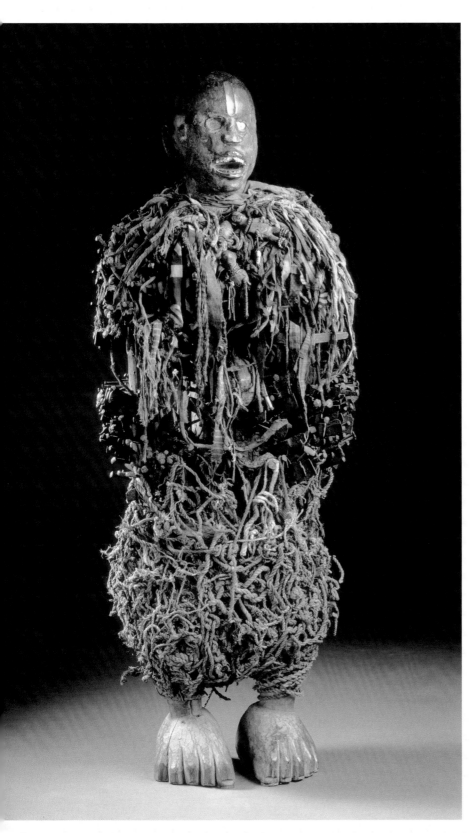

Fearsome Agents of Law and Order

Personalized charms called *minkisi* could take the form of nearly life-sized anthropomorphic statues, made out of wood and various added materials. Such was the case with most *minkisi* of the *nkondi* type. Standing with glaring eyes, open mouth and arms akimbo, and covered with nails and blades, they made a frightening appearance. Their spirit was activated in a number of ways, including by hammering a nail into the *nkisi*. This could be done at the request of a victim of theft, upon which the *nkondi* would then hunt down and punish the thief. The *nkondi* also worked as a deterrent. Important agreements related to trade and politics were publicly sealed in front of it, whereby the *nkondi* was urged to punish all future violators.

On the facing page is *nkisi* Mangaaka, a *nkondi* used effectively to settle trade agreements along the Chiloango River in the second half of the nineteenth century. Over a dozen statues remarkably similar in style and now preserved in various museums have been attributed to a single "Chiloango workshop." To the left is a *nkondi* that in the 1870s belonged to Ne Cuco, one of the principal chiefs of Boma. Interestingly, it was once used by the Belgian trader Alexandre Delcommune to track down thieves. Delcommune eventually seized it as booty during a short but violent toll war with the chiefs of Boma in 1878.

HV

Manyangu to Inflict and Cure
Lubanzi

Two stunning examples of *nkisi* Man-yangu were collected in 1915 in Kangu in Mayombe (DRC). They were described as male and female, representing "a married couple." Each has a crusty patina on its face, shoulders and chest, resulting from the offerings that were sprinkled on them. Nails and blades abound on the upper part of the body, while the loins and legs are covered with a tangle of ropes, holding a mixture of clay and other substances. The male *nkisi* is raising his right arm, which originally held a knife, while the female counterpart, recognizable by her breasts, has her hands firmly planted on her hips.

There are other *minkisi* of the *nkondi* type that existed in a pair of figures, husband and wife, and the idea seems to have been that the female could soften, when necessary, the more vigorous powers of the male. *Minkisi* of the *nkondi* type were sent after thieves and witches, and *nkisi* Manyangu was known to inflict them with *lubanzi*, a disease described as a stitch in the side, causing difficulty in breathing. A person so attacked had to be treated by the *nganga* of Manyangu, who could provide the cure and lift Manyangu's curse, in exchange for a fee.

HV

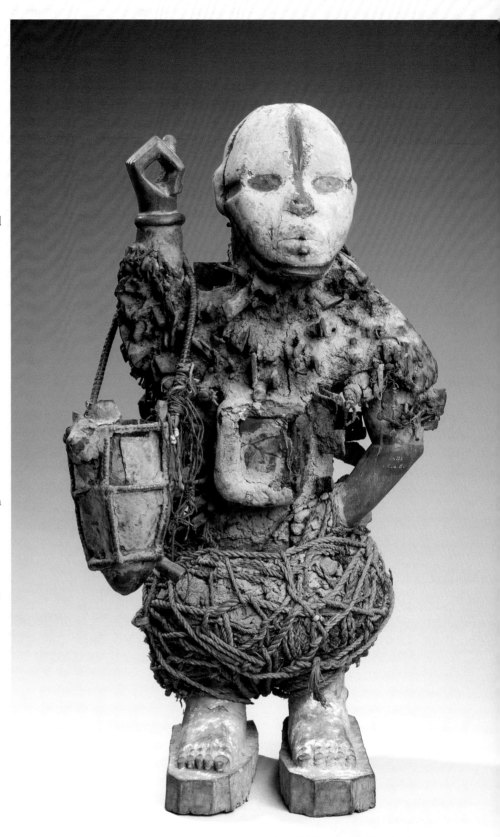

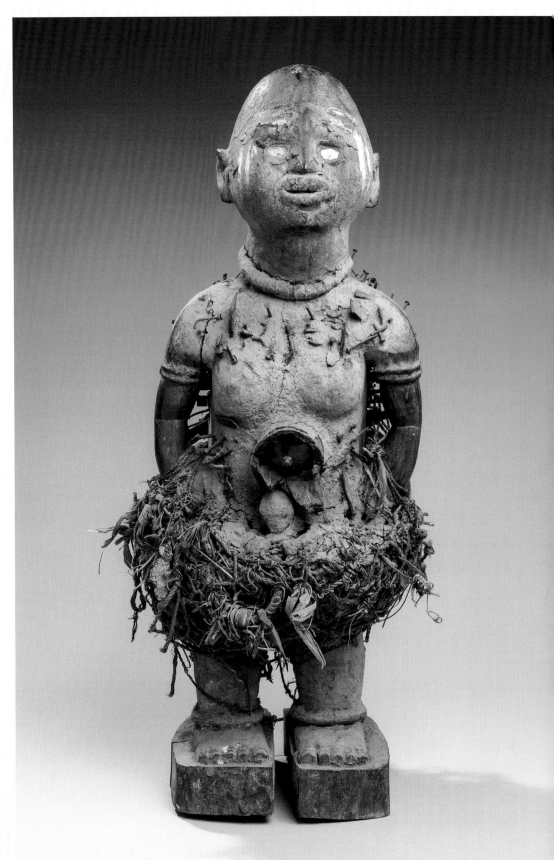

Facing page: Cat. 4.3. Anthropomorphic power figure, *nkisi* Manyangu, Yombe peoples. Mayombe, Lower Congo, DRC. Late 19th century. Wood, iron, vegetal fiber, pigment, resin, glass, 29.13 × 15.75 × 13.78 in. (74 × 40 × 35 cm). Collection Royal Museum for Central Africa, Tervuren, Belgium, EO.0.0.22485.

Right: Cat. 4.4. Anthropomorphic power figure, *nkisi* Manyangu, Yombe peoples. Mayombe, Lower Congo, DRC. Late 19th century. Wood, vegetal fiber, clay, iron, fat, pigment, glass, resin, 32.28 × 16.93 × 13.38 in. (82 × 43 × 34 cm). Collection Royal Museum for Central Africa, Tervuren, Belgium, EO.0.0.22462.

Mawenze and Mandombe

Nkisi Mawenze could take the form of an anthropomorphic statue but occurred also in the form of a dog with a curled tail. According to the missionary ethnographer Leo Bittremieux, this was one of the appearances of lightning in Yombe mythology. The barking of this dog could be heard as a rattling thunderclap. The form was thus appropriate for a *nkisi* associated with violence and retribution, the sort capable of causing and curing mostly diseases of the upper part of the body, or mental disorders. We know that in 1915 *nkisi* Mawenze was held responsible for sleeping sickness, together with at least half a dozen other *minkisi*. At the turn of the century, sleeping sickness claimed thousands of victims in Central Africa, and our *nkisi* was part of a tragic attempt to control it.

Nkisi Mandombe was collected by Bittremieux in the coastal region of Banana, on the north bank of the Congo estuary. The *nkisi* shows a human figure covered with many different sorts of "medicines." They were carefully selected in order to evoke, through visual or linguistic metaphor, the various characteristics of the *nkisi*. The medicines were mixed into a paste that was applied on top of the head or else simply attached with fine cords to the body. The head also has mirrors pointing in different directions that allowed the *nkisi* to see and detect witches, wherever they might be or come from.

HV

Below: Cat. 4.5. Zoomorphic power figure, *nkisi* Mawenze, Yombe peoples. Mayombe, Lower Congo, DRC. Late 19th century. Wood, vegetal fiber, metal, 9.45 × 8.66 × 24.41 in. (24 × 22 × 62 cm). Collection Royal Museum for Central Africa, Tervuren, Belgium, EO.o.o.22451.

Facing page: Cat. 4.6. Anthropomorphic power figure, *nkisi* Mandombe, Woyo peoples. Banana, Lower Congo, DRC. Early 20th century. Wood, gourd, vegetal fiber, shell, fruit, nut, pigment, resin, skin, approx. 14.96 × 18.9 × 17.71 in. (38 × 48 × 45 cm). Collection Royal Museum for Central Africa, Tervuren, Belgium, EO.o.o.33956.

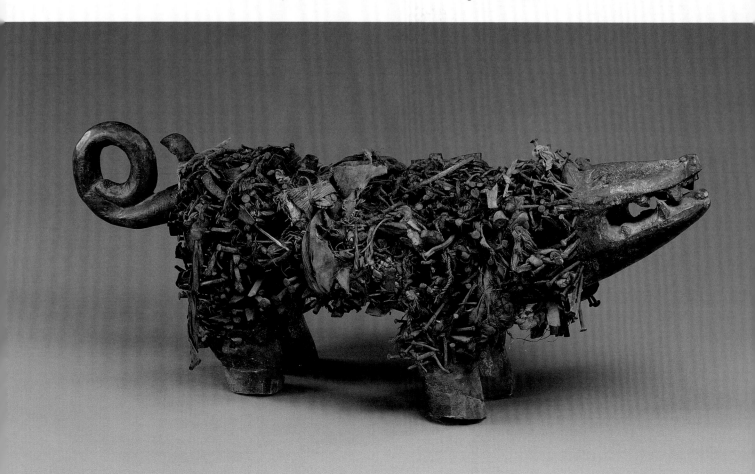

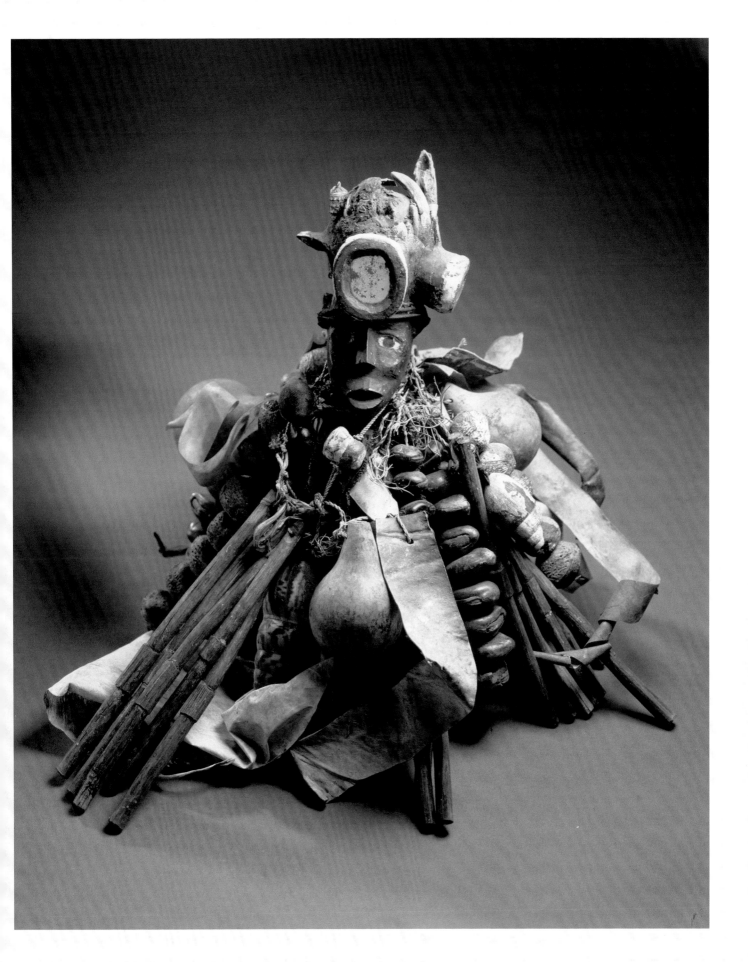

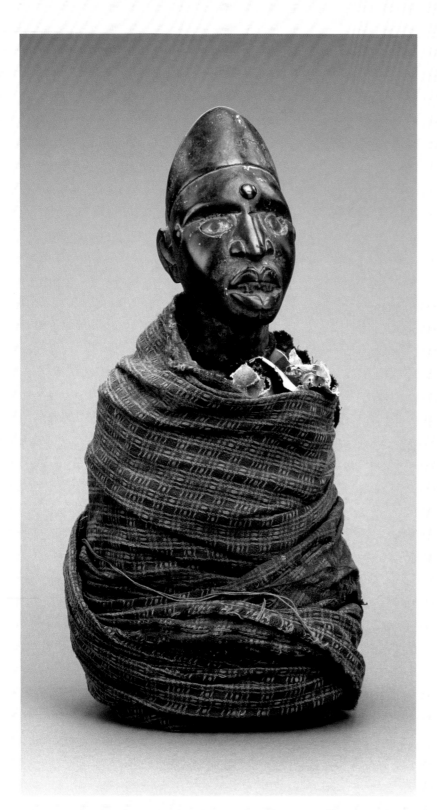

Simbu and Nduda, for Protection

The beautifully carved figure to the left is almost entirely wrapped in nineteenth-century imported trade cloth, concealing its empowering "medicines" and thereby enhancing its mysterious look. Its proper name was recorded as Simbu, a *nkisi* widely known along the coast north of the Congo River and in Mayombe. Simbu was a "war-*nkisi*" and used to protect warriors who went into battle. Warfare in West Central Africa often consisted more of a spiritual contest than of real fighting. Ritual preparations, which included song and dance, dressing up and the use of *minkisi* to render the body invulnerable, were essential. The *nganga* of Simbu carefully inspected all warriors and excluded those whom he thought would not be safe. Simbu continued to be invoked throughout the twentieth century by young men hoping to escape from military service.

The figure on the facing page is a typical example of a *nkisi* belonging to the *nduda* category. The owner kept it in the house to provide protection against nightly attacks from witches. The little tubes sticking out of the bulges on the arms of the figure are "night guns" to shoot at witches. The metaphor was pushed to surreal proportions; in the morning the owner would point to the bullets in his porch that had been fired during the night! The feathers of a bird of prey sticking out of the figure's headdress also point to the *nduda*'s effectiveness as a witch hunter.

HV

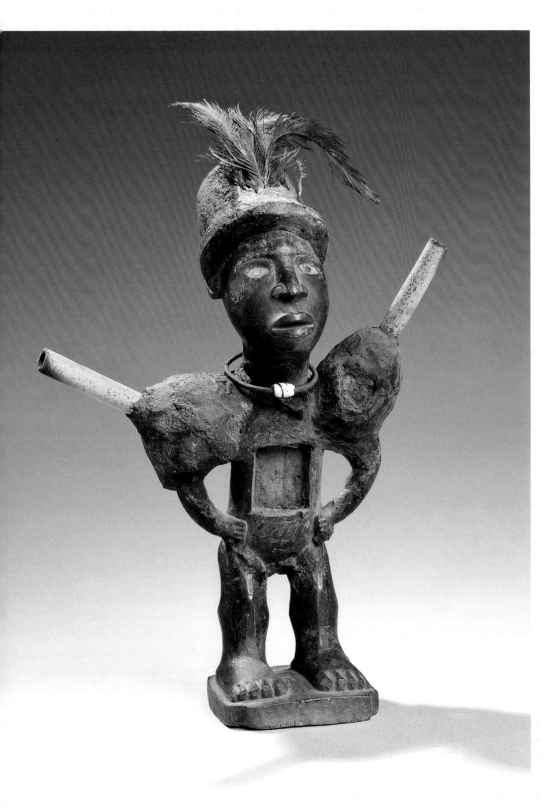

Facing page: Cat. 4.7. Anthropomorphic power figure, *nkisi* Simbu, Yombe peoples. Mayombe, Lower Congo, DRC. Late 19th century. Wood, textile, 11.02 × 6.3 × 5.51 in. (28 × 16 × 14 cm). Collection Royal Museum for Central Africa, Tervuren, Belgium, EO.0.0.22464.

Left: Cat. 4.8. Anthropomorphic power figure, *nkisi nduda*, Kongo peoples. Banana, Lower Congo, DRC. Early 20th century. Wood, glass, feathers, resin, iron, 10.23 × 6.3 × 5.11 in. (26 × 16 × 13 cm). Collection Royal Museum for Central Africa, Tervuren, Belgium, EO.0.0.16674.

Nonfigurative *Minkisi*

The range of possible forms of a *nkisi* was indefinite. Besides the impressive anthropomorphic and zoomorphic forms, many *minkisi* took the shape of a bag, a basket, a box, a bottle, a pot, a small chest or any other type of container that could hold the "medicines." Ritual experts (*banganga*) regularly impressed their clients with innovations. Virtually any type of object could be turned into a *nkisi*, and museum collections nowadays reveal that indeed *nkisi* "medicines" were added to objects as diverse as flywhisks, tortoise shells and wooden bells.

Several *minkisi* existed in both anthropomorphic and nonfigurative forms, such as *nkisi* Mambuku Mongo in a basket to the left below, which also had its human form. Mambuku Mongo was essentially a *nkisi* for divination, and the basket contained several instruments of the *nganga*. However, it could also attack and afflict its victim with headaches or madness. The empowering medicines included a particular copal resin (*ndingi*) which was believed to be a product of lightning. On the bottom right is *nkisi* Mbumba Mbondo, consisting of a bag decorated with white porcelain buttons, with the upper part laced up with raffia cord and topped with feathers. It was believed to cause and cure body swellings. On the facing page, top, is *nkisi* Maziolo in a bottle, held responsible for dysentery. Both the bag and the bottle *minkisi* have their creolized descendants in the Americas (see cat. 6.3, cat. 6.4 and cat. 6.5).

HV

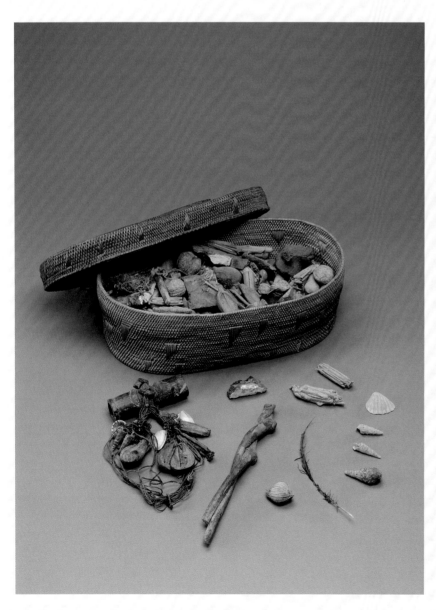

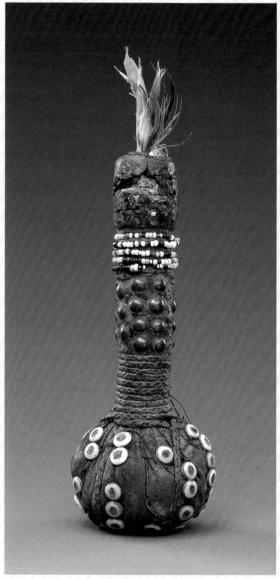

Facing page, left: Cat. 4.9. Basket, *nkisi* Mambuku Mongo, Yombe peoples. Mayombe, Lower Congo, DRC. Late 19th century. Wood, shell, vegetal fiber, seed, nut, stone, feather, 6.3 × 14.96 × 8.66 in. (16 × 38 × 22 cm). Collection Royal Museum for Central Africa, Tervuren, Belgium, EO.0.0.22472.

Facing page, right: Cat. 4.10. Bag, *nkisi* Mbumba Mbondo, Yombe peoples. Mayombe, Lower Congo, DRC. Early 20th century. Vegetal fiber, metal, beads, feather, 10.63 × 3.15 in. (27 × 8 cm). Collection Royal Museum for Central Africa, Tervuren, Belgium, EO.0.0.22435-4.

Right: Cat. 4.11. Bottle, *nkisi* Maziolo, Yombe peoples. Mayombe, Lower Congo, DRC. Early 20th century. Glass, vegetal fiber, glass, fruit, feather, textile, 11.02 × 4.72 in. (28 × 12 cm). Collection Royal Museum for Central Africa, Tervuren, Belgium, EO.0.0.22455.

Below: Cat. 4.12. Bell turned into ritual object, *nkisi*, Yombe peoples. Lower Congo, DRC. Early 20th century. Wood, vegetal fiber, glass, iron, 14.17 × 7.09 × 6.3 in. (36 × 18 × 16 cm); 19.69 in. (50 cm) total height. Collection Royal Museum for Central Africa, Tervuren, Belgium, MO.0.0.41231.

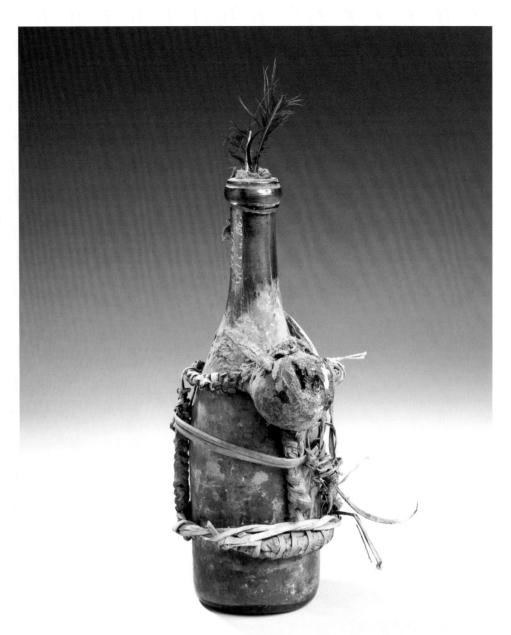

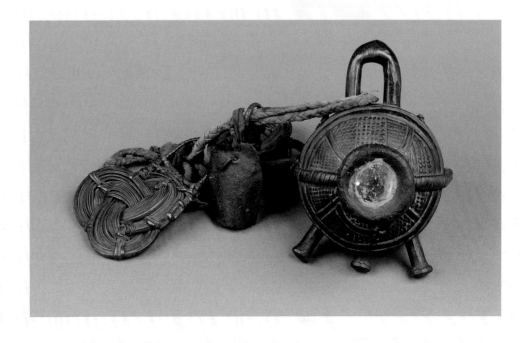

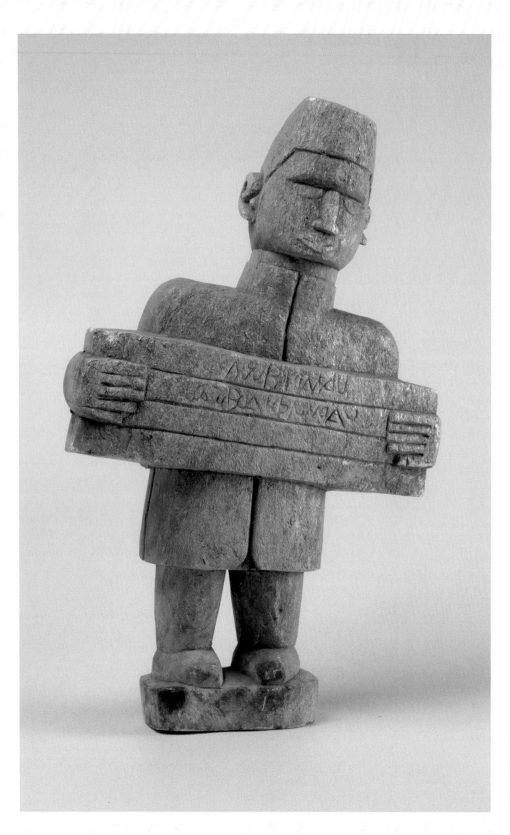

Left: Cat. 4.13. Stone grave sculpture, *ntadi*, Mboma peoples. Zaire (province), Angola. Late 19th century. Steatite, 16.54 × 10.63 × 3.15 in. (42 × 27 × 8 cm). Collection Royal Museum for Central Africa, Tervuren, Belgium, EO.1953.32.36.

Facing page: Cat. 4.14. Stone grave sculpture, *ntadi*, Mboma peoples. Lower Congo, DRC. Late 19th century. Steatite, 14.96 × 8.46 × 3.74 in. (38 × 21.5 × 9.5 cm). Collection Royal Museum for Central Africa, Tervuren, Belgium, EO.1955.45.6.

Kongo Modernity Commemorated in Stone

At the end of the nineteenth century in the region of Boma, Kongo artists made anthropomorphic statues in soft stone, to be put on the graves of important members of the community. They were called *mintadi* (sing. *ntadi*, stone) and generally measured about fifteen inches high. The stylistic analysis of museum and private collections has revealed that there were about twenty workshops. Together they produced a limited number of types, and some of these were very popular. They are not portraits, but rather representations of particular abilities or traits to suggest the power, dignity or prestige of the deceased.

Nineteenth-century chiefs were often represented as violent rulers in other media, but other capacities are also emphasized, such as a person's intelligence or wisdom or the fact that he or she had learned to read and write. The latter skill commanded great respect, and this explains the specific pose of our statue on the left. Our male figure holds a board or piece of paper on which an indecipherable "text" is scribbled. The *ntadi* below wears a necklace and the chief's hat, with the leopard claws rendered in stone. European dress was painted onto the statue. This object belongs to a type that has been described as "the thinker," with a wink at the French modern sculptor Auguste Rodin.

HV

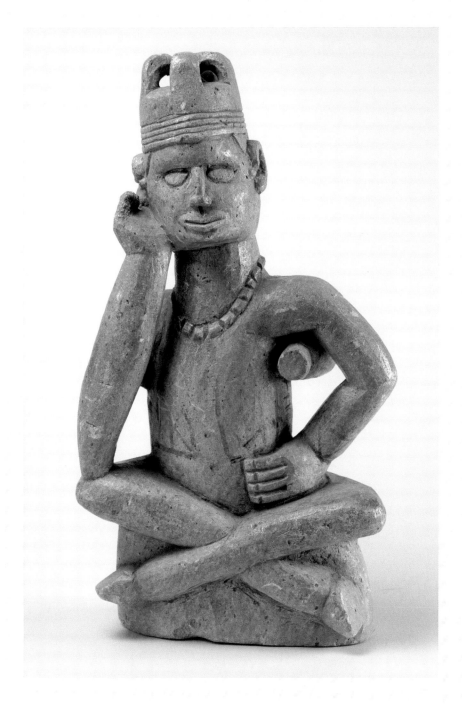

Grave Cylinders

On a journey through Kongo in 1666–67, Father Denis de Carli remarked on clay objects adorning graves of Kongo nobles. In describing what he referred to as a "tomb of a duke," de Carli stated that an object made of clay "like our mortars" had been placed on the grave. Some 240 years later, another visitor described "funerary columns in terra cotta" decorating a cemetery, and another visitor described "curious pottery forms" decorating the graves in an "extremely ancient cemetery." The early-twentieth-century reports are undoubtedly descriptions of terra-cotta cylinders known as *diboondo* or *sa kya boondo* (plural *maboondo*). Whether the earlier description was for the same type object as the latter, we do not know. We do know that the tradition of making the extraordinary form had died out by the mid-1930s.

Maboondo are hollow terra-cotta cylinders that adorned graves of important individuals in the Boma and Yombe regions as memorials and to demonstrate the wealth of the deceased. The average size is about sixteen inches high by eight inches in diameter. The largest documented *diboondo*, cat. 4.16 (*facing page*), is about three feet tall. The exterior of this example is typical, divided into registers by raised bands creating tiers richly decorated with openings and crisply incised geometric patterns suggestive of textile or basketry motifs. Others, such as that in cat. 4.15 (*right*), might have human figures applied, raised in relief, cut into the sides or placed on lids. In this *diboondo*, the figures seem to move through the openings in the surface.

RP

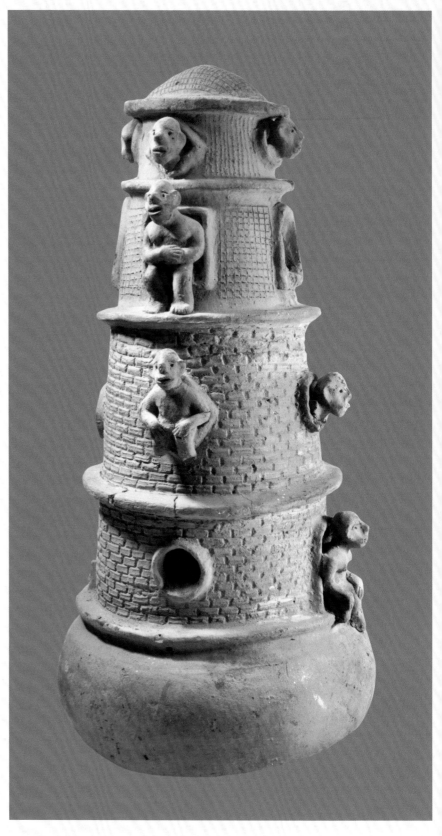

Above: Cat. 4.15. Terra-cotta grave urn, Kongo peoples. Boma, Lower Congo, DRC. 19th century. Terra-cotta, 19.7 in. (50 cm). Collection of Marc Felix, FX95 0063.

Facing page: Cat. 4.16. Terra-cotta grave urn, Kongo peoples. Boma, Lower Congo, DRC. 19th century. Terra-cotta, 34.65 × 13.78 in. (88 × 35 cm). Collection Royal Museum for Central Africa, Tervuren, Belgium, EO.1973.62.1.

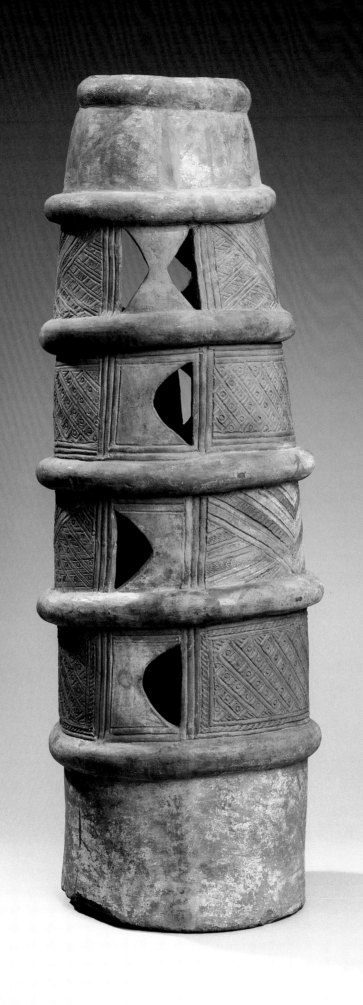

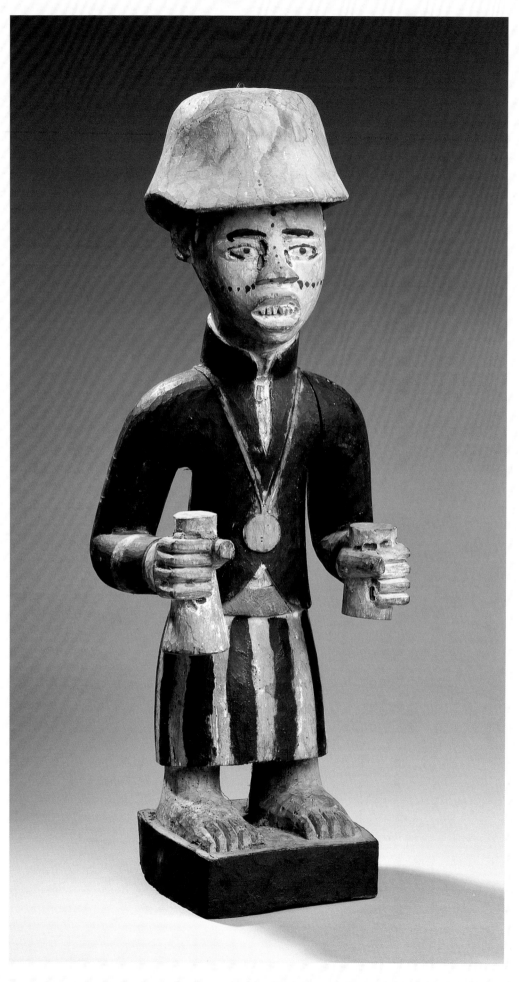

Left: Cat. 4.17. Wooden grave figure, Yombe peoples. Mayombe, Lower Congo, DRC. Early 20th century. Wood, pigment, 22.24 × 9.1 × 7.1 in. (56.5 × 23 × 18 cm). Collection Royal Museum for Central Africa, Tervuren, Belgium, EO.1953.74.1330.

Facing page, left: Cat. 4.18. Wooden grave figure, Yombe peoples. Mayombe, Lower Congo, DRC. Early 20th century. Wood, pigment, 24.8 × 7.1 × 9.84 in. (63 × 18 × 25 cm). Collection Royal Museum for Central Africa, Tervuren, Belgium, EO.1960.32.1.

Facing page, right: Cat. 4.19. Wooden grave figure, Yombe peoples. Mayombe, Lower Congo, DRC. Early 20th century. Wood, pigment, glass, 21.93 × 9.64 × 10.63 in. (55.7 × 24.5 × 27 cm). Collection Royal Museum for Central Africa, Tervuren, Belgium, EO.1979.23.1.

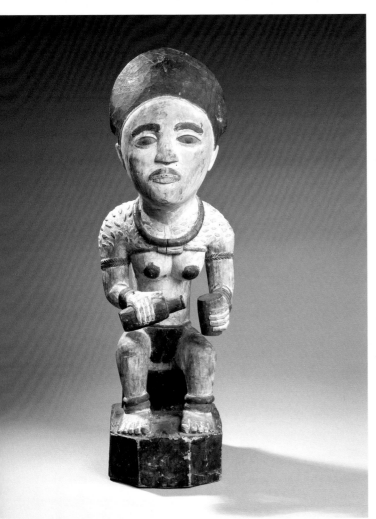
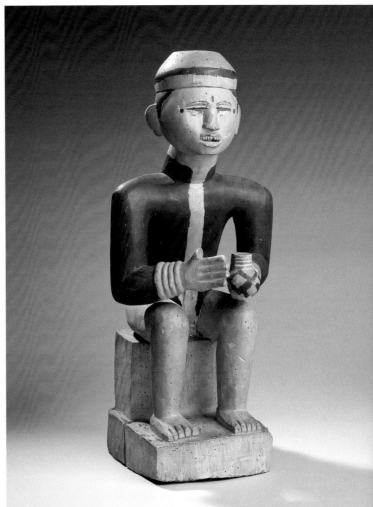

Wooden Grave Figures

In 1907, the Belgian engineer Claessens reported on the occurrence of colorful wooden statues placed on the tombs of chiefs in Mayombe. They were protected from the rain by a shelter made of wood and leaves of the banana tree. The wooden figures could be one meter high. Around the same time, district commissioner Hector Deleval photographed some of these tombs. Besides the figures, they were decorated with numerous glass bottles and European printed textiles (ill. 10.5).

The figure to the left shows a man standing with a European-style jacket and a military helmet, both fancy articles of the late-nineteenth-century trade. In his hands, he holds a glass and a bottle, most probably referring to the imported liquor offered by European merchants in exchange for African produce. Around his neck is a circular medal, the sign and symbol of a chief's alliance with the colonial state. Invented in 1891, this medal conferred new rights and privileges on the chief but also subjected him to a number of duties.

The female figure above pours out a square jenever bottle. Thousands of bottles of this type were imported in the nineteenth century. The male figure to the right is shown while holding another imported object, a jug produced in Westerwald in Germany. This type of jug can still be found in Mayombe. They often bear the monogram *GR*, which stands for *Gregorius Rex* and refers to one of the several English kings named George in the eighteenth and nineteenth century. Westerwald potters had long appealed to the English court and honored their royal clients by marking their pots with the king's initials. Bakongo were particularly fond of the Westerwald jugs and used them for a variety of purposes.

HV

Leopards, Bottles, and Dancers on Raffia Funerary Mats

Woven raffia mats were used for funerary purposes. Both figurative and geometric mats served as wrappings for the body in preparation for burial, and they were displayed on graves in commemoration of the deceased. Ill. 10.05 shows a raffia mat hung in the rear of a grave structure. The number and quality of the mats used in the burial indicated the deceased's status.

The two examples with figurative images mark the transition from the practice of using only geometric designs (cat. 1.6). However, continuity with past practices and purposes of textiles is revealed when considering the meaning behind the figures. Earlier textiles were used to show their owner's status and prestige, while the iconography referred to Kongo cosmology and the communication between the world of the living and the world of the dead. The leopard depicted on cat. 4.21 corresponds to both ideas of status and spirituality. Not only are skins and teeth of leopards an integral part of a chief's regalia, but these items also have a spiritual connection. The chief is equated to the leopard, a leader in the land of the dead. The depiction of bottles had a similar purpose. Not only are bottles containers for spirits, but the glass types suggested in these mats also reflect the involvement of the deceased in the trade with Europeans and the wealth gained from that trade (cat. 2.5). The addition of the dancing figures indicates the funerary ceremonies that took place upon the death of important individuals.

CSF

Below: Cat. 4.20. Woven mat, Kongo peoples. Boma, Lower Congo, DRC. Early 20th century. Vegetal fiber, 41.33 × 63.78 in. (105 × 162 cm). Collection Royal Museum for Central Africa, Tervuren, Belgium, EO.0.0.29225.

Facing page, top: Cat. 4.21. Woven mat, Kongo peoples. Luvituku, Lower Congo, DRC. Early 20th century. Vegetal fiber, 44.1 × 60.63 in. (112 × 154 cm). Collection Royal Museum for Central Africa, Tervuren, Belgium, EO.0.0.29259.

Facing page, bottom: Cat. 4.22. Woven mat, Kongo peoples. Lower Congo, DRC. Early 20th century. Vegetal fiber, 42.51 × 61.02 in. (108 × 155 cm). Collection Royal Museum for Central Africa, Tervuren, Belgium, EO.0.0.29088.

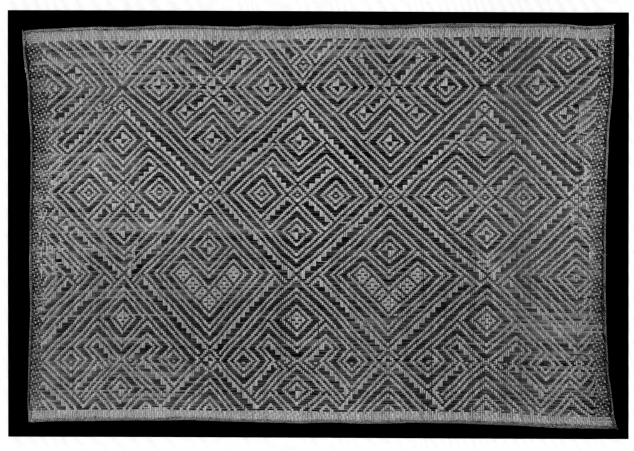

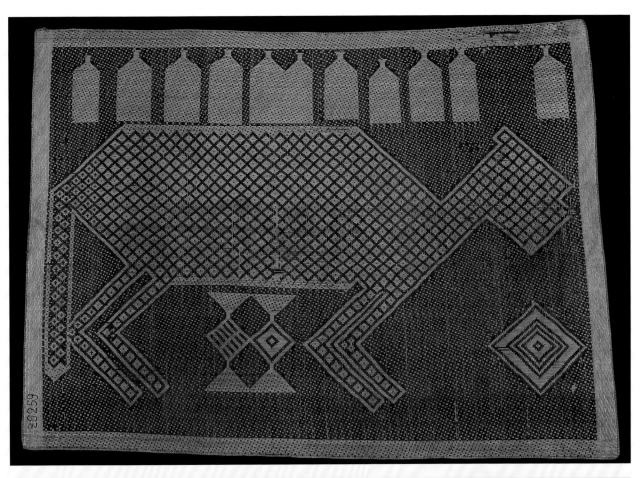

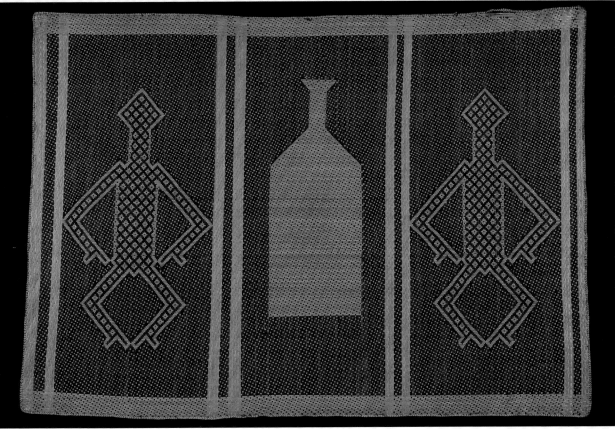

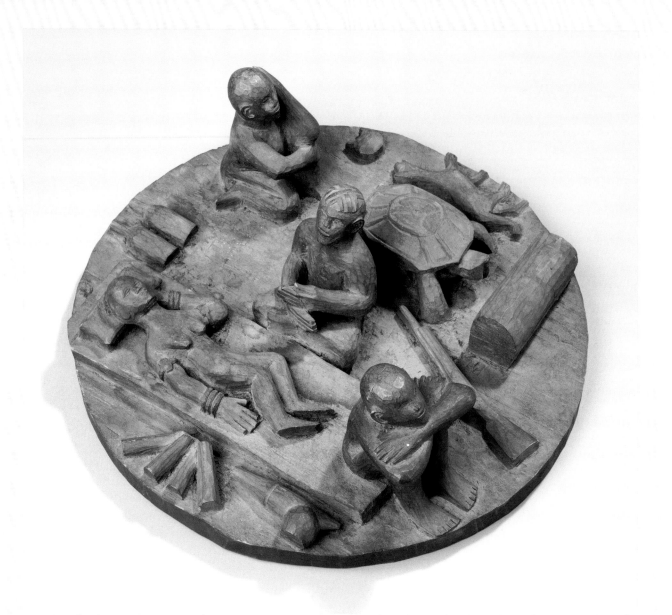

Above: Cat. 4.23. Proverb lid, Woyo peoples. Lower Congo, DRC. Early 20th century. Wood, 5.04 × 13.54 in. (12.8 × 34.4 cm). Collection Royal Museum for Central Africa, Tervuren, Belgium, EO.0.0.42871.

Facing page: Cat. 4.24. Proverb lid, Woyo peoples. Lower Congo, DRC. Early 20th century. Wood, 3.66 × 7.48 in. (9.3 × 19 cm). Collection Royal Museum for Central Africa, Tervuren, Belgium, EO.0.0.37125.

Pot Lids

Among the Woyo, carved wooden lids communicated domestic issues, usually between husband and wife but also between parents and children. A container of food was usually covered with leaves to transport it from the food preparation area to the place where the men ate. But if a disgruntled wife wanted to communicate feelings about some family concern or dispute with her spouse, a carved wooden disk could be used to cover the pot, thus presenting the matter to the broader community. Conversely, the husband could cover his empty bowl after the meal with such a lid to communicate his concerns to his wife. Sometimes there was a playfulness in such "visual banter" between spouses, but at times it was very serious. Parents could impart their opinions to children whose actions or decisions concerned them.

Some lids provided only a few iconic images, but sometimes complicated genre scenes conveyed the message, as is the case in these two lids. Each motif might be associated with a proverb, and the entire scene might suggest a narrative reading as well. All could pertain to problems that must be addressed in the home. Icons did not have fixed meanings. For example, the lid in cat. 4.23 (*facing page*) shows a woman lying in bed. A man, likely her husband, sits at the foot, his chin resting on crossed arms. Beside the bed another figure sits cross-legged, facing the woman. The scene and its icons could be interpreted variously. Conceivably, it could be a healing scene, with the figure on the end displaying a mourning gesture. The prominent figure of the turtle, who lives on land and in the water, is a mediator between the world of the living and the dead. Its presence warns that something serious is going on.

The lid in cat. 4.24 (*below*) depicts a man sitting on a mat, his meal next to him. Turning to his wife, he points to the plate. The reproach may have to do with the quality of food prepared.

While such communication was an important part of marital communication among the Woyo in the nineteenth century, it had for the most part disappeared by the middle of the twentieth century.

RP

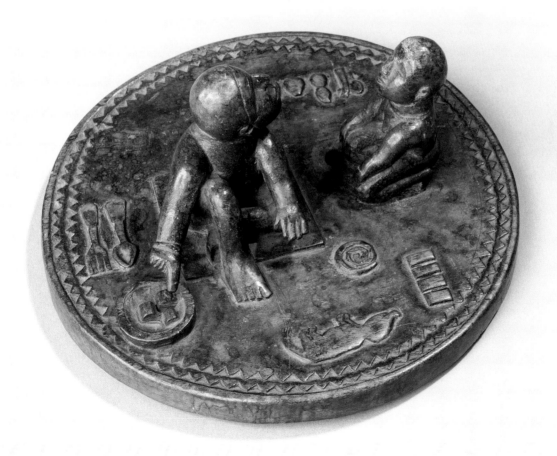

Above: Cat. 4.25. Cooking pot, Kongo peoples. Lower Congo, DRC. Early 20th century. Terracotta, 5.43 × 9.67 in. (13.8 × 24.6 cm). Collection Royal Museum for Central Africa, Tervuren, Belgium, EO.0.0.5033.

Right: Cat. 4.26. Mug, Yombe peoples. Mayombe, Lower Congo, DRC. Late 19th century. Terra-cotta, 4.13 × 4.21 in. (10.5 × 10.7 cm). Collection Royal Museum for Central Africa, Tervuren, Belgium, EO.0.0.7658.

Facing page, left: Cat. 4.27. Pitcher, Mboma peoples. Matadi, Lower Congo, DRC. Early 20th century. Terra-cotta, 8.3 × 6.61 in. (21.2 × 16.8 cm). Collection Royal Museum for Central Africa, Tervuren, Belgium, EO.1953.74.102.

Facing page, right: Cat. 4.28. Pitcher, Mboma peoples. Lower Congo, DRC. Early 20th century. Terra-cotta, 8.77 × 6.96 in. (22.3 × 17.7 cm). Collection Royal Museum for Central Africa, Tervuren, Belgium, EO.1953.74.35.

Kongo Pottery

Ceramics in Kongo society are based on ancient traditions, yet potters were responsive to changes in taste and economic circumstances throughout history. Ceramic production in the Kongo region occurred in the second millennium BCE and continues to the present. Ceramics provide a historical record of key Kongo ideographic motifs, as seen in potsherds excavated in Loango by James Denbow, with stamped interlocking lozenge motifs, carbon-dated to as early as the twelfth century CE. The stamped patterns are similar to those found on Kongo textiles, baskets, ivory carvings and body scarification of a much later date. After the fifteenth century, ceramics reflected European influence both in form and medium. Gourd-shaped bottles bearing lozenges and serpentine motifs are undoubtedly ancient forms, but the addition of brass tacks and multiple handles show the influence of European imports. The addition of white glass seed beads from Europe on the ornate gourd-shaped vessel, and perhaps its dramatically flared handles, demonstrate Kongo potters' desire to incorporate precious trade items, once used for currency, and the innovative and attractive form to produce a highly prestigious object. Clearly these ornate bottles were made as prestige items. On the other hand, the carinated vessel inscribed with a zigzag double line on the shoulder is both an elegant and functional vessel, for everyday use in preparing and cooking food. The simple motif can be read as a serpent, a reference to the ancestors who can mediate for humans between the earthly world of the living and the world beneath the water that is the home of ancestors and spirits.

SC

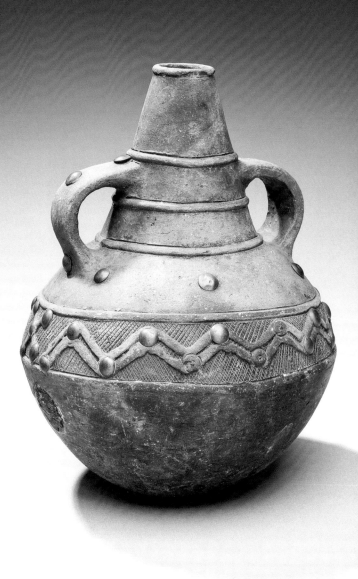

Domestic Kongo Baskets

While baskets made for use in Kongo households are highly functional, they are also exquisitely designed. The shallow round basket used for winnowing grain is constructed using the coil technique, as is a lidded basket used for storing small objects. The perfectly aligned coils made from bundled fibers create a subtle spiral pattern, slightly accented by the addition of bands of lighter hues in the cylindrical form. Some scholars have suggested that the spiral motif signifies the path taken into and out of the world of the ancestors and more generally refers to longevity. The stepped-lid form, an elaborate two-tiered knob, may be purely functional, but it could allude to the Kongo conception of life's progression through upwardly ascending levels.

SC

Below: Cat. 4.29. Basket, Kongo peoples. Lower Congo, DRC. Vegetal fiber, 3.74 × 17.71 in. (9.5 × 45 cm). Collection Royal Museum for Central Africa, Tervuren, Belgium, EO.0.0.19647.

Facing page, top: Cat. 4.30. Basket, Kongo peoples. Banana, Lower Congo, DRC. Early 20th century. Vegetal fiber, 12.6 × 13.39 in. (32 × 34 cm). Collection Royal Museum for Central Africa, Tervuren, Belgium, EO.0.0.1989-2.

Facing page, bottom: Cat. 4.31. Basket, Yombe peoples. Mayombe, Lower Congo, DRC. Early 20th century. Vegetal fiber, 6.7 × 11.8 × 6.88 in. (17 × 30 × 17.5 cm). Collection Royal Museum for Central Africa, Tervuren, Belgium, EO.0.0.35819.

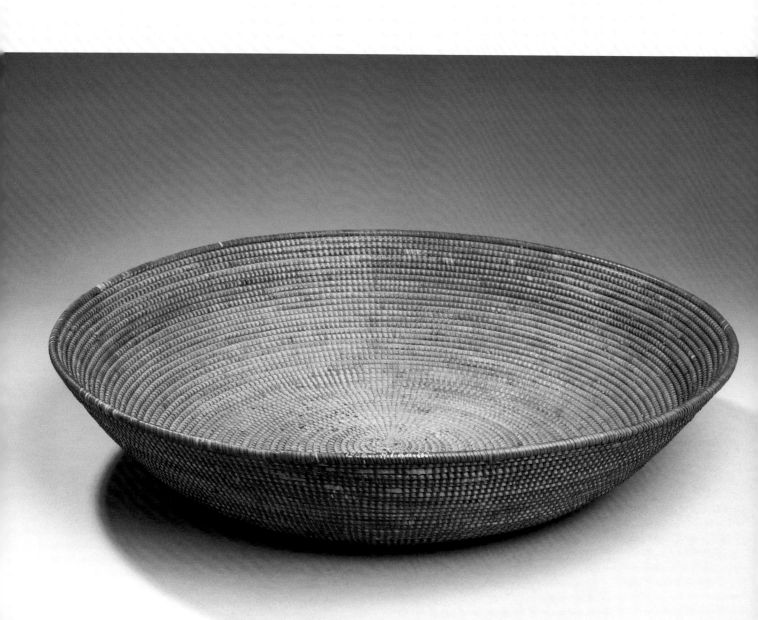

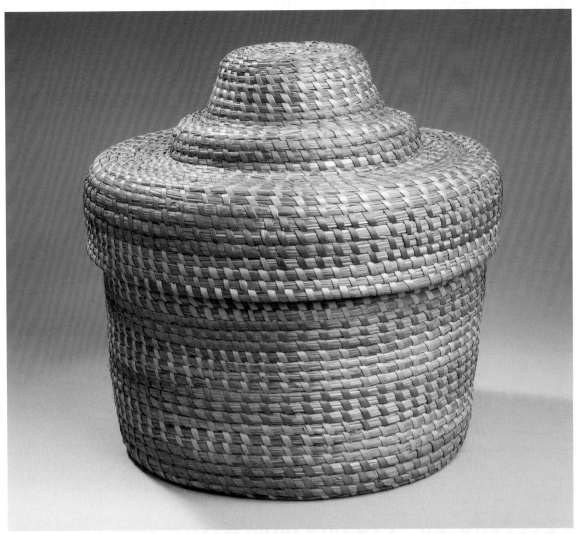

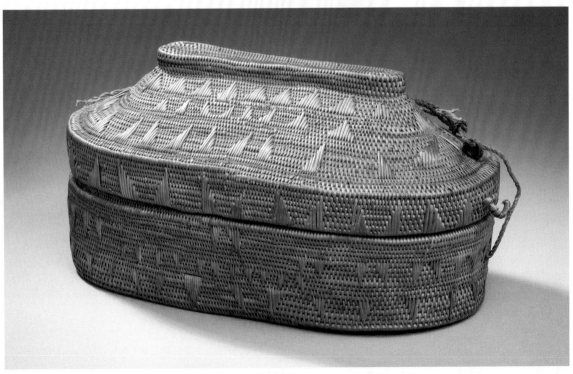

Vase-Shaped Basket

A vase-shaped basket with flaring rim uses the techniques of plainweave and twill work to create a variety of patterns, most dramatically the diagonal bands encasing a stepped pattern that sweeps across its form. While this basket was designed for transporting goods on the back, the shift in patterns and motifs is a subtle version of those found on baskets for ritual use or for storage of precious objects.

SC

Cat. 4.32. Basket, Yombe peoples. Matadi, Lower Congo, DRC. Early 20th century. Vegetal fiber, 16.73 × 20.27 in. (42.5 × 51.5 cm). Collection Royal Museum for Central Africa, Tervuren, Belgium, EO.0.0.30635.

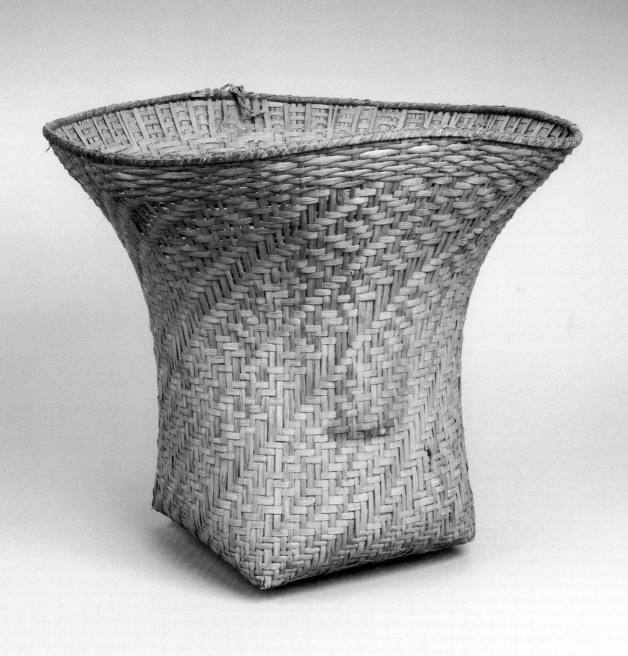

Right: Cat. 4.33. Figure of kneeling man, Yombe peoples. Mayombe, Lower Congo, DRC. Early 20th century. Wood, glass, 7.09 × 2.75 × 2.75 in. (18 × 7 × 7 cm). Collection Royal Museum for Central Africa, Tervuren, Belgium, EO.0.0.32390.

Facing page: Cat. 4.34. Headdress, Kongo peoples. Boma, Lower Congo, DRC. Early 20th century. Wood, pigment, 9.06 × 7.5 × 10.24 in. (23 × 19 × 26 cm). Collection Royal Museum for Central Africa, Tervuren, Belgium, EO.0.0.17695.

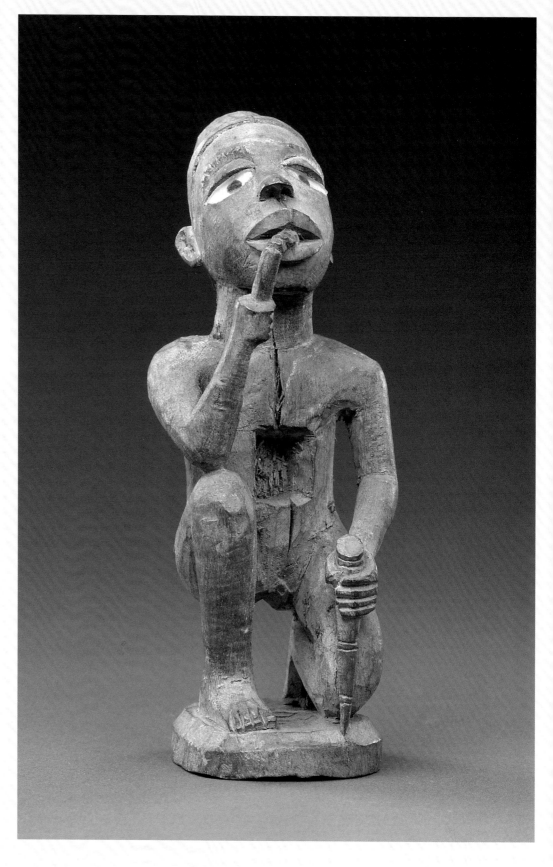

Artists and the Dynamics of the Market

Artists did not have a particularly high status in Kongo society, although some of them were renowned and enjoyed a reputation in the wider region. Either they worked on commission or they produced objects that they thought would appeal to buyers on the market. Their figures were often used by a ritual practitioner or *nganga* as basic material to compose a *nkisi*. Wood carvers made figures that were particularly fit for this purpose. As the figure to the left shows, they left room for the "medicines" on the belly and on the head of the figure. The *munkwisa* root held between the teeth and the scepter or flywhisk in the left hand of the figure are both symbols of the power of a chief. These features, together with the bright eyes and the lively pose of the kneeling figure, contributed to the overall visual impact of the *nkisi* as something powerful and alive. The object to the left lacks the *nganga*'s additions and was collected before becoming a *nkisi*.

Artists worked according to symbolic and aesthetic conventions but also tried to innovate in order to meet new demands. An artist from the region of Boma made the object below here, a fancy headdress inspired by a colonial cap. The sides and the top are embellished with a red snake and a leopard. Both are important creatures in Kongo mythology. The chief who owned this object would certainly have made good rhetorical use of them as illustrations of proverbs or old stories.

HV

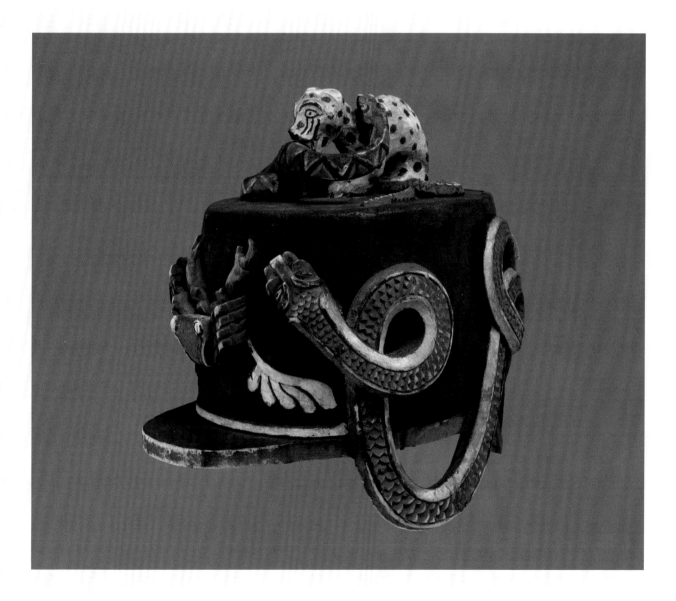

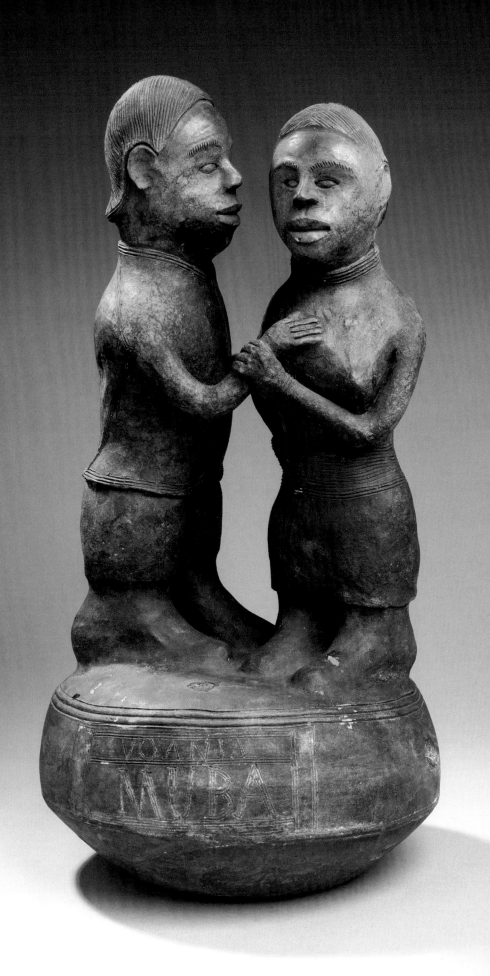

The Art of Voania Muba

A remarkable artist emerged at the turn of the twentieth century in the region of the old Ngoyo kingdom, in a village called Muba, on the road between Lukula and Muanda. He specialized in figural pottery and his art is preserved in many museums and private collections around the world. He usually mounted one or two standing, sitting or kneeling human figures on a bowl, modeling them with mild facial expressions. His name was carved with single or double lines in the wet clay: VOANIA MUBA, in block letters. The almond-shaped eyes, the short incisions to suggest the eyebrows, the neatly combed hair and the often delicate smile are equally part of his signature.

Research into local oral history in the 1970s revealed that Voania Muba worked mostly alone, in seclusion, assisted only by his younger nephew to transport the pottery to the markets of Boma and Banana. It seems that his works were sold exclusively to Europeans. The object to the left was acquired by the Belgian colonial administrator Nicolas Arnold, who donated it to the RMCA in 1917. Pottery making ceased to exist in Muba when Voania died around 1928.

HV

Facing page: Cat. 4.35. Pot with human figures, Voania Muba, Woyo, d. 1928. Lower Congo, DRC. Early 20th century. Terra-cotta, 18.9 × 9.92 in. (48 × 25.2 cm). Collection Royal Museum for Central Africa, Tervuren, Belgium, EO.0.0.20241-2.

Right: Cat. 4.36. Pot with human figure, Voania Muba, Woyo, d. 1928. Lower Congo, DRC. Early 20th century. Terra-cotta, 18.75 × 7.5 × 6.75 in. (47.62 × 19 × 17.14 cm). Collection of Hyatt and Cici Brown.

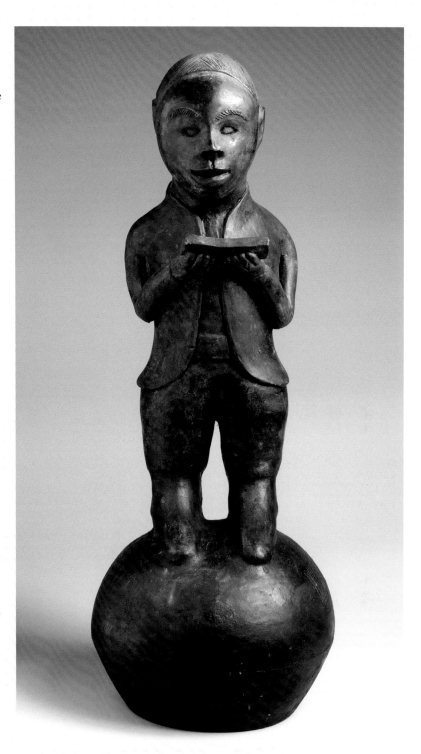

The Way of the Calabash

Another medium in which emerging self-conscious Kongo artists expressed themselves in the first half of the twentieth century was the calabash, the dried fruit of a vine (*Lagenaria siceraria*) that could be used as a bottle to keep palm wine. The smooth light brown exterior was decorated by carving various designs in the surface. Heated iron was used to blacken particular areas, and a white paste made of crushed oyster shell accentuated the incisions. The interest manifested by European residents and travelers gave a great boost to an old Lower Congo tradition. Competing artists signed their works and sought to innovate.

Some of the calabashes are decorated with familiar motives such as birds, lizards, turtles, bells and bellows, which we also find on the wooden pot lids (see cat. 4.23 and cat. 4.24). They refer to proverbs and popular stories, as on the calabash below, signed "Augustin T." The one to the right shows the more developed art of Benoît Madia from the coastal village of Kitombe. Madia was greatly encouraged by a few European residents. In the 1930s, Jeanne Maquet-Tombu, who had founded the association of the *Amis de l'art indigène*, invited him to Kinshasa to demonstrate his talent. Interestingly, Madia developed a number of themes that brought out the inequality and forced labor of colonialism. Lacking a proper framework to discuss African art, Maquet-Tombu compared Madia's calabashes with the art of ancient Egypt and Greece.

HV

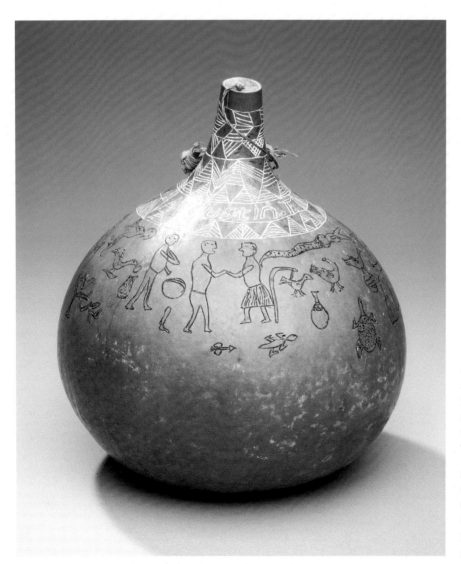

Left: Cat. 4.37. Decorated calabash, Augustin T. Banana, Lower Congo, DRC. Early 20th century. Calabash, pigment, 8.38 × 7.64 in. (21.3 × 19.4 cm). Collection Royal Museum for Central Africa, Tervuren, Belgium, EO.0.0.34703.

Facing page: Cat. 4.38. Decorated calabash, Benoît Madia. Banana, Lower Congo, DRC. Early 20th century. Calabash, 8.3 × 8.3 in. (21 × 21 cm). Collection Royal Museum for Central Africa, Tervuren, Belgium, EO.1952.46.4.

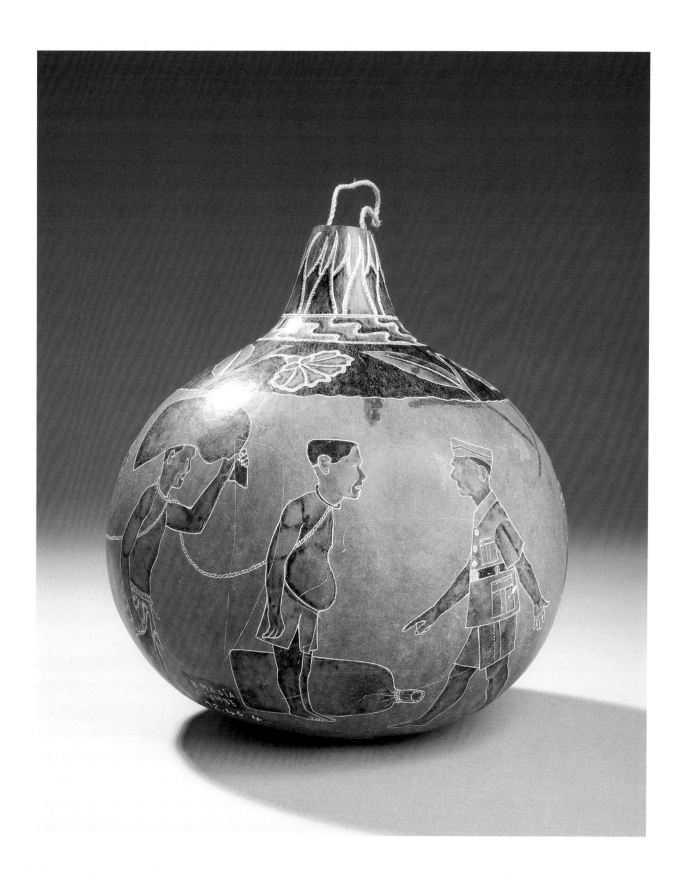

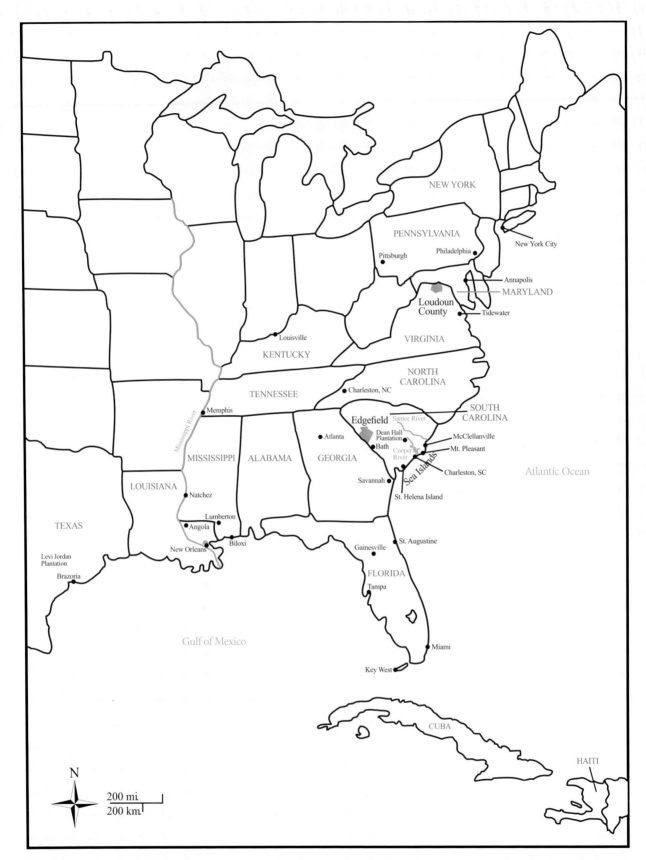

Map of the southeastern United States

II

Kongo in the Americas

12

Kongo and the Archaeology
of Early African America

CHRISTOPHER C. FENNELL

The *Kongo across the Waters* exhibition and publication are very timely from the perspective of archaeologists. Researchers employing archaeology to obtain greater insights into the cultural lives of African descendant populations in the Americas are enjoying a period of great vitality and interdisciplinary collaboration. As a result, numerous archaeological studies have uncovered the impacts of Kongo culture on communities across the Americas over the past few centuries. Archaeologists find these legacies of the Kongo in the tangible remains of private spaces made sacred, in the material compositions that attended ritual and prayers and on pottery transformed from the mundane to the profound. People who subscribed to cultural belief systems such as the Kongo experienced wrenching social upheavals and transformations in those time periods, as did their descendants in the Americas. Cultures evolved dynamically as well, in interactive encounters that analysts often refer to as *processes of creolization*. This chapter focuses on observable cultural connections that existed even within the currents of such dramatic changes.

Archaeological research on African diaspora populations has expanded significantly over the past few decades in scope and in the diversity of locations, time periods and questions pursued. Our work has been enlivened by interdisciplinary approaches, collaborative projects and a resulting abundance of new data sets. Colleagues studying the history of the transatlantic slave trade have compiled exceptionally detailed, comprehensive data sets that provide insights into the movements of captive Kongo people over time. Oral history accounts of specific locations and individuals provide additional data for comparative study. Interpretations of past oral histories and documentary evidence can be tested against the data uncovered in the archaeological record, and points of correlation and contrast can be further analyzed. In the brief space of this chapter, I highlight several of these interdisciplinary projects and archaeological finds. To provide such a concise overview, I refer the reader to recent publications for detailed bibliographies and source discussions for the numerous studies that I summarize here.[1]

As discussed in other chapters of this volume, Kongo society was dramatically impacted by the transatlantic slave trade from the late sixteenth century onward, with factional wars forcing diverse members of the culture into the holds of slave vessels bound for the Americas. Individuals of all social statuses, including defeated political officials, craftspeople, priests, healers, farmers and laborers were swept into bondage by cycles of warfare. As a result, captives from the Kongo comprised up to a third of the enslaved laborers in many locations and time periods in sites throughout the Americas. The Kongo culture thus had significant impacts on the cultural expressions found in those many locations spanning North America, the Caribbean and South America in the sixteenth through nineteenth centuries. Many poignant artifacts and cultural expressions have been uncovered in the Americas and interpreted as representations of evolving facets of Kongo cultural beliefs and practices. Enslaved laborers newly arriving in the Americas from the Kongo continued to shape material culture in accordance with beliefs and practices learned in their homeland before capture. Later generations born on plantations in the Americas learned those traditions from their elders and continued to develop those beliefs and practices in new ways.

Artifacts and expressions in the Americas that have been related to Kongo culture have typically been interpreted as evolving representations of a core symbolic repertoire deployed extensively within Kongo society. This core symbolic repertoire included an ideographic expression, or cosmogram, called *tendwa kia nza-n' Kongo* or *dikenga dia Kongo* in Kikongo, which I will refer to as the *dikenga* (fig. 12.1).

Material culture evidence and ethnohistorical accounts of Kongo culture demonstrate that the *dikenga* had developed as a long-standing symbolic tradition long before European contact in the late fifteenth century. This core symbol summarized an array of metaphors and beliefs concerning the nature of the cosmos, the identity of the Kongo as a people and their relationships and interactions with ancestors and powerful spiritual forces. The diagram to the right in fig. 12.1 depicts a rendering of the more embellished form of the *dikenga*, which consists of perpendicular axes set within a circle or ellipse, with four smaller disks at the ends of the axes. The small circles represent the "four moments" of the turning cycles of the sun, cosmos, spirits and life. The larger and central circle or ellipse represents such a cyclical nature of earthly life and the natural world, the spiritual journey of the soul and the evolution of spirits. The axes communicate multiple metaphors of boundaries, relationships and oppositions. The horizontal axis was referred to as the "line of Kalunga" and represented a permeable boundary between the land of the living and that of the spirits. The vertical axis emphasizes that this boundary can be crossed and manifestations of spirits can be summoned into the realm of the living for aid and protections. A principal metaphor for the Kalunga line is the reflective surface of a body of water, showing a mirror world of the dead and spirits in relation to the realm of the living.

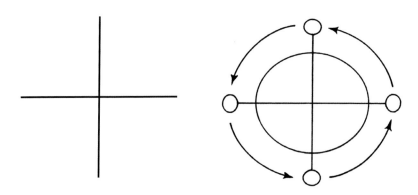

Fig. 12.1. Rendering of the *dikenga dia Kongo*.
Diagram by Christopher Fennell.

Relating to the cycles of the sun and cosmos, these intersecting axes were also viewed as aligning with the cardinal directions of north-south and east-west.

Fully embellished, ideographic versions of the *dikenga* were incorporated as material compositions in the regalia of political rulers, high-status individuals, priests and healers in the Kongo (see cat. 2.32). Such embellished renderings can be interpreted as "emblematic" expressions that represented the sodality of the social group and were typically displayed in overt, public settings, much like the deployment of national flags. A simpler, more abbreviated form of the *dikenga* was used as well, but for more personal and instrumental purposes (see the diagram on the left of fig. 12.1). The crossed lines of the central axes were the simplest form of the *dikenga*, drawn on the ground along the cardinal directions to designate a ritual space for an individual to testify as to their truthfulness and righteous intentions. Healers in the Kongo transformed mundane spaces into stages for healing ceremonies and supplications to the spirits by demarcating these axes along the cardinal directions within a private space.

Priests and healers also created material compositions that invoked the permeable boundary of the Kalunga, using reflective objects such as quartz crystals, to connote the flash of scintillating water and the realm of spirits. These constituent objects selected for symbolic connotations were called *bilongo* in Kikongo. Such compositions also frequently included *bilongo* colored white as a symbol of the purity and power of the dead and spirits. Collections of *bilongo* were concentrated in compositions called *minkisi* (or *nkisi* in the singular), which also contained *bilongo* such as binding vines, animal claws and teeth to communicate the strength and vitality of the spirit to be summoned for aid and protection (cat. 4.9). Smaller-scale *minkisi* could be placed at the axis ends within a private space to define the crossed lines and intersection point of the *dikenga*. Supplicants and ritual specialists would then open a ceremony by standing at the intersection of the axes—the point of contact with the spirits—and proclaim their truthfulness and virtuous intention.

More elaborate *nkisi* compositions included *nkisi nkondi*, which consisted of a wood sculpture of a powerful figure, with a cavity carved in the abdomen area, into which reflective and white colored *bilongo* were placed (see cat. 4.1 to cat. 4.4, for

example). The eyes of a *nkondi* were typically highlighted in white to communicate its direct engagement with the spirit world. When supplicants made requests of the powerful spirit invoked by a *nkondi*, the ritual specialist and supplicant drove a small iron wedge or nail into the wood of the figure as a testament of their intentions and to animate the prayer. Examples of smaller *minkisi* and of *minkisi nkondi* from the late nineteenth century are to be found in several museum collections (such as those shown in cat. 4.5 to cat. 4.12). However, multiple lines of evidence demonstrate that these cultural practices and compositional designs were in use by Kongo people from the outset of the period of the transatlantic slave trade.

Extensive data from the records of Portuguese missionaries and colonial officials, as well as surviving material culture dating back centuries, provide evidence of the remarkable spectrum of *minkisi* compositions within the Kongo culture. From simple to elaborate, these material compositions were employed in a range of public and private settings in the Kongo (see cat. 3.6, for example). Turning to the Americas, we find continuing developments in these beliefs and practices performed in the private and public spaces of the Kongo Diaspora.

Symbolic Configurations of Materials and Spaces in the Americas

Numerous archaeology sites in the Americas have yielded artifacts that have been linked to Kongo cultural heritage. Investigations of these sites involved multiple lines of evidence. Documentary evidence and oral history accounts related to these sites indicated that the particular locations excavated by archaeologists had been the work or residence spaces for enslaved Africans. These sites were located in regions in which Kongo people comprised a significant percentage of the enslaved labor force during the relevant time periods of the occupations under investigation. Such sites yield a few main types of material compositions that have been interpreted as having strong connections with Kongo cultural practices. These include pottery marked with crossed lines and cast into bodies of water, figural pottery forms reminiscent of Kongo aesthetics, personal objects with symbolic motifs consistent with *nkisi* compositions and personal spaces containing caches of material compositions that served to demarcate the crossed axes of a *dikenga* within that dwelling.

Pottery Incised, Cast into Waters and Sculpted

Colonoware is a term applied by archaeologists to a form of earthenware pottery found extensively on plantation sites along the eastern coast of North America and dating from the late 1600s through the early 1800s (fig. 12.2 and cat. 5.5 to cat. 5.7). Some analysts propose that this pottery was produced by enslaved African laborers on plantations for their own use and at times for trade to nearby plantations and markets. Others contend that some distributions of colonoware were produced by Native Americans for trade to plantations. There is a strong consensus about the end users of this type of pottery that considers them to be predominantly the enslaved

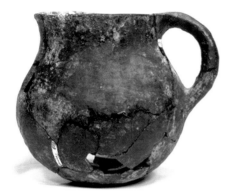

Fig. 12.2. Colonoware vessel. Courtesy Judicial Center Site, Charleston, South Carolina.

African laborers on plantations. Enormous volumes of colonoware were produced, used and discarded at those sites.

A highly intriguing subset of colonoware artifacts consists of twenty-six bowl bases on which the end users had etched crossed lines within a circular base rim, and these bowls were apparently cast into estuary rivers adjacent to rice plantations in South Carolina (fig. 12.3). Scuba divers in South Carolina have brought these artifacts to archaeologist Leland Ferguson over the years, reporting the locations in estuaries where they retrieved the artifacts.[2] These were small bowls and a form of ceramic container consistent with *minkisi* compositions used among the Kongo. Ferguson and other analysts have speculated that the enslaved laborers sanctified these bowls as ritual offering containers by scratching the axes of the *dikenga* within the surrounding circle of the bowl's base rim and filling the bowl with herbs as *bilongo* ingredients to which they attributed metaphoric meanings in prayers. If the bowls and their contents were then cast into the glimmering surface of the estuary by a supplicant standing at the water's edge, one can speculate that this was a poignant invocation for a spirit to cross the Kalunga line into the realm of the living to provide aid and protection. Research by Luis Symanski and his colleagues in Brazil has uncovered similarly constructed and marked earthenware pottery at plantations sites once occupied by enslaved Kongo laborers.

Archaeologists have recently investigated possible connections between colonoware produced on coastal plantations in South Carolina and stoneware vessels produced in the backcountry region called Edgefield, South Carolina. The Edgefield potteries were founded by European Americans who relied on enslaved African Americans for both unskilled and craft labor. Stoneware storage vessels of remarkable size and aesthetic beauty were shaped by African American craftsmen in those potteries starting in the early 1800s. Archaeologist J. W. Joseph and his colleagues have proposed that cross-line markings on Edgefield vessels may have related to Kongo symbols and may also provide evidence of a connection between earlier colonoware potters on coastal plantations and ornamental practices later adopted in Edgefield operations.[3]

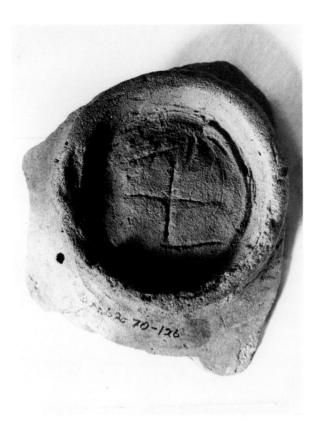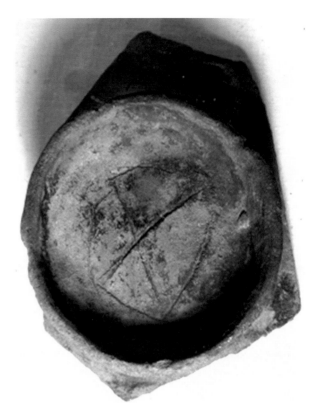

Fig. 12.3. Colonoware vessels with etched cross marks. Courtesy of the South Carolina Institute of Archaeology; photographs by Emily Short.

By the early 1860s, potteries in Edgefield also produced a new set of remarkable figural vessels, called "face vessels" due to their sculptural configuration (see cat. 6.21 to cat. 6.24 and ill. 12.1). Whole and fragmented face vessels have been curated in private and museum collections and recovered in archaeological sites. Analysts observe the resonance of these face vessel designs with the sculptural qualities of ritual figures produced in Kongo traditions, such as the use of white color symbolism for the eyes and teeth, reminiscent of sculptural forms such as a *nkisi nkondi* (e.g., see cat. 4.1). These face vessels were also produced in Edgefield just after the arrival of numerous new captive laborers brought directly to that area in 1858 on an illegal slave shipment aboard the *Wanderer* from West Central Africa. Oral history interviews of those 1858 captives and their descendants demonstrated their Kongo heritage and uses of terms from the Kikongo language.

Elements of Bilongo and Minkisi

Numerous work and residential sites of enslaved African and African American laborers in North America have yielded individual artifacts consistent with the *bilongo* elements with cross-line configurations, white color symbolism and reflective surfaces invoking the metaphors of the Kalunga line and flash of spirits. Mark Leone and his students discuss such examples in the following chapter, describing the space occupied by African Americans in a residence and work space in Annapolis, Maryland. A number of excavations in the city have yielded such finds. Other prominent

examples include the Locust Grove plantation site near Louisville, Kentucky, which dated from the 1790s through emancipation in 1865 and was investigated by Amy Young and her colleagues.[4] The living space of enslaved laborers at Locust Grove included notable artifacts clustered within that space—a white clay marble with cross lines etched across it, three glass prisms from a chandelier and a pewter spoon with cross lines scratched into its handle, bringing out the white color of the metal. Along with these objects was a Chinese coin, which was made with a circular shape and a square punched out of the center, yielding an object one could perceive as representing perpendicular axes within a surrounding circle. For a number of finds at such sites, it is unclear if the separate objects found associated in a space were once encompassed within a *nkisi*-like container of organic material that later disintegrated.

Archaeologists must proceed with great care in formulating interpretations of artifacts uncovered in occupation sites. For example, symbols such as crossed lines are prosaic in character and appear as independently developed motifs with varying significance in many different cultures. In one research project, I investigated the history and archaeology of neighboring farms owned by two generations of an extended German American family named Demory in the backcountry of northern Virginia. A small house on their property was built around 1780 using distinct German building traditions and occupied through the nineteenth century. That extended family of German American immigrants and farmers also owned enslaved African Americans who worked on their lands and who may have been housed in that small cabin. Fig. 12.4 shows a small clay sculpture of a skull that I recovered from the floor space of that small house; it was located in association with other artifacts dating from the 1830s through the 1860s. The back of the sculpture includes cross-line marks and inscribed initials. As I have detailed elsewhere, the most persuasive interpretation of this artifact, all of its attributes and context, is that it was created by German Americans in accordance with their own beliefs in methods for spiritual invocations that were developed independent of African traditions.[5]

Fig. 12.4. Clay skull from Loudon County, Virginia. Photograph courtesy of Christopher Fennell; diagram of inscription on back of skull courtesy of Christopher Fennell.

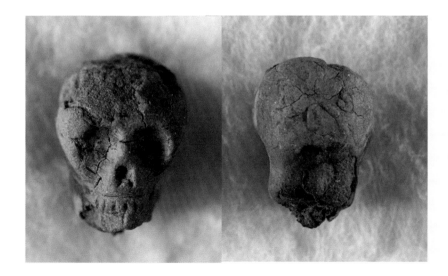

Other sites in North America have shown the ways in which people of Kongo heritage very likely created ritual spaces within private residences configured to invoke the *dikenga* (see, for example, chapter 13 in this volume). Kenneth Brown and his colleagues investigated the remains of residences of enslaved and later free African American families at the Levi Jordan plantation in Brazoria, Texas, near Galveston on the Gulf Coast. The plantation operated from 1848 until emancipation at the end of the Civil War.[6] Documentary evidence shows that Jordan owned a sloop and very likely traveled to Cuba and transported captive Africans to his plantation before the Civil War. Families of free African Americans stayed on in the previous slave quarters until 1888, raising crops as tenant farmers and paying rents to Jordan's heirs. Those families summarily abandoned the quarters in 1888 and had little time to remove their possessions from the houses that they and previous generations had occupied for decades. What they left behind astounded the archaeologists.

In a house site that Brown referred to as a "curer's cabin," the space of the residence was demarcated as a ritual area by deposits of objects in the floor (fig. 12.5). Concentrated materials were deposited at the four cardinal directions along the perimeter of the room. This was notable since the building was not oriented along the cardinal directions. Deposits in areas 1, 2 and 4 in the space of this small house, as depicted in fig. 12.5, were consistent with *bilongo* and *minkisi* materials. The deposit in area 1 (to the east) included objects consistent with the remains of a *nkisi nkondi* composition—contrived iron wedges like those driven into *nkondi* to activate it, and internal *bilongo* objects such as a small white porcelain doll figure and glass thermometer that once contained shimmering mercury. No wood sculpture was recovered in area 1; such an organic element would have disintegrated in the soils that filled the abandoned house site after 1888. The deposit in area 2 (north) consisted of a stack of silver coins dated 1853 and 1858. White ash, burned white shells and iron nails were located in a cache within the hearth wall in area 4 (south).

Fig. 12.5. Floor plan of the "curer's cabin" at the Levi Jordan plantation site and location of caches of objects. Diagram by Christopher Fennell based on Kenneth Brown's data.

The west deposit, in area 3 within this spatial configuration, contained something different—three nested iron kettles, iron chain fragments that likely once wrapped around those kettles and numerous other metal objects in a concentrated deposit. This west side of the space appears to have held a small altar composition, called an *amula* to Zarabanda, which consisted of iron kettles filled with other iron objects as symbols of resilience, power and vitality. This religious observation was developed by Kongo people in Cuba, which incorporated Kongo cultural practices and the Yoruba people's symbolism for the powerful *orisha* Ogún, a subdeity for whom the Yoruba often dedicated private altars in their homes and residential compounds. Along with Kongo captives, enslaved members of the Yoruba culture in West Africa were brought in large numbers to the ports and plantations of Cuba. After decades of interactions in Cuba, people of Kongo heritage began to create similar altars to this powerful figure and referred to the subdeity as Zarabanda. This small residence at the Levi Jordan site in Texas thus presents evidence of the rich continuation of Kongo beliefs and practices and also of their development in new directions over time.

Legacies of Perseverance and Power

This chapter has provided just a brief overview and a few examples of archaeological discoveries of the cultural creativity of the Kongo people and their descendants in the Americas. One can see in these material compositions a powerful and enduring heritage of Kongo cosmological beliefs and artistry in engaging with the world in a dynamic and profound way. As researchers, we experience a great privilege in uncovering, explicating and honoring these material traces of creativity and perseverance by cultural actors who confronted formidable adversities.

Notes

1. Fennell, *Crossroads and Cosmologies* and "Early African America."
2. Ferguson, *Uncommon Ground*, "The Cross Is a Magic Sign" and "Early African-American Pottery."
3. Joseph, "One More Look" and "'All of Cross.'"
4. A. Young, "Risk Management Strategies."
5. Fennell, *Crossroads and Cosmologies*.
6. Kenneth Brown, "Interwoven Traditions" and "Ethnographic Analogy"; Brown and Cooper, "Structural Continuity."

Crossing the South

Variations on crosses that may be related to Kongo iconography abound in archaeological sites and other places throughout the American Southeast. Archaeologists find pottery vessels with X marks incised within a circle. Deposits of material in purposefully placed configurations are arranged according to the cardinal directions, with caches placed at the east, north, west and south ends of the intersecting axes forming a cross. Uncovered from the Chesapeake area to the Gullah area of South Carolina and Georgia, through Louisiana and into southeast Texas, such caches were positioned beneath workers' spaces in mansions, in curers' and midwives' cabins and beneath praise house floors. Archaeologists, historians and art historians have interpreted such configurations as a sign of Kongo continuity, referencing symbolic diagrams that played significant roles in Kongo spiritual thinking, the *diyowa* or the *dikenga*, consisting of perpendicular axes inscribed in a circle. The symbol denoted the cyclical nature of life, referring to the natural world above and the spiritual world below, to the journey of the spirit through both zones and to the movement of the sun.

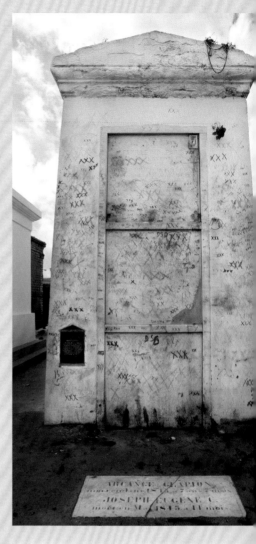

The frequency with which crosses are found in early African American homes and workplaces can be interpreted variously—a reference to the Christian cross, a reference to West or Central African concepts linked to the iconic form, a combination or something else that has evolved over time as African culture was creolized and became American culture.

Beneath the Levi Jordan praise house in East Texas, the east deposit contains plaster in the form of a cross. A jeweled cruciform pendant on a chain marked the intersection of the axes. At another site, the Richmond Hill plantation in Georgia, the north deposit included a cross-shaped accumulation of shells. At the Magnolia Plantation site in Louisiana, the south deposit included a downward-facing crucifix.

Objects used within the context of Christianity could clearly take on the Christian meaning intended, or they could as easily refer both to Kongo and to Christian meanings. The discovery of a jeweled crucifix in an eighteenth-century Kongo-related grave in New Orleans suggests Christian meaning. The mariner's compass on the reverse side of a St. Christopher medal from Fort Mose in Florida could refer solely to the compass or it could have been construed as a fanciful variation on *dikenga*. Kenneth Brown suggests that the Xs incised on portable objects and the cross deposits under floors do not necessarily represent the Kongo cosmogram explicitly, nor are they necessarily only Christian crosses. Instead, their meaning as well as placement may have changed over time and in many cases died out. But in some cases, such as that of Marie Laveau's tomb in New Orleans, where tourists scrawl X marks to secure the blessing of the "Voodoo Queen," the power of the cross continues, though the meaning remains a mystery.

RP

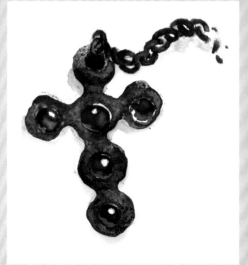

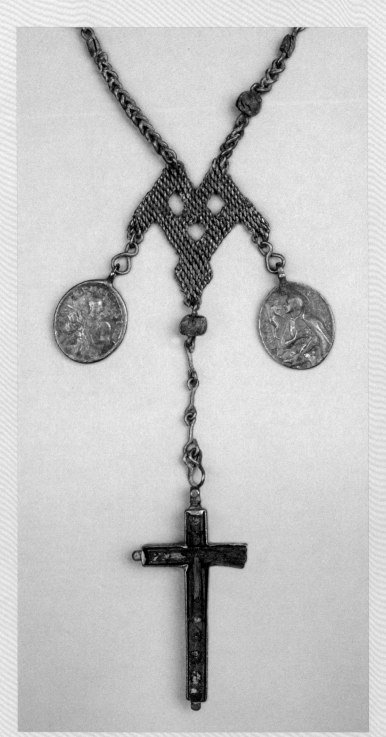

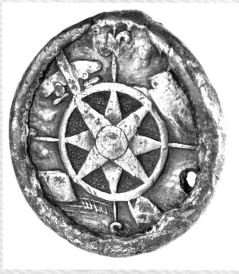

Ill. 11.1. Marie Laveau's tomb is covered with Xs, most left by tourists. Photograph by Michael Smith, 2013. By permission of the author.

Ill. 11.2. A cruciform pendant on a chain marked the intersection of the north-south/east-west axes beneath the floor of the praise house at the Levi Jordan plantation. Illustration by Patrick Grigsby, 2013. By permission of the author.

Ill. 11.3. A jeweled rosary with a cross pendant was discovered in the eighteenth-century grave of an African in New Orleans. Photograph by Michael Smith, 2013. By permission of the author.

Ill. 11.4. St. Christopher medal found at Fort Mose, St. Augustine, Florida. Presumably 18th century. Silver alloy, 1 in. (2.2 cm) diameter. Courtesy of the Florida Museum of Natural History, Historical Archaeology Collections, F. E. Williams III collection.

13 ◇

West Central African Spirit Practices in Annapolis, Maryland

KATHRYN H. DEELEY, STEFAN F. WOEHLKE, MARK P. LEONE
AND MATTHEW COCHRAN

Archaeology in Annapolis

For the last two decades, work by Archaeology in Annapolis has focused on the archaeological investigation of African American cultural traditions in the city of Annapolis.[1] Several excavations in the city show West Central African customs evident as early as the middle of the eighteenth century and continuing through the nineteenth century and into the twentieth century.

Great numbers of West Central Africans were brought into the Chesapeake region between 1619 and 1860. At least a quarter of these enslaved Africans came from ports on the Congo and Angola coasts. Most of those came between 1720 and 1800. (See Vos, chapter 4 in this volume.) However, as Africans and African Americans became familiar with the position and environment into which they were forced, which made them interact with people of very different backgrounds and traditions, a local or American version of African practices developed. This pattern of adaptation did not begin in the Americas, however, but is a continuation of adaptive practices in Central Africa. Evidence of this is seen in Kongo through the use of Catholic symbolism as a proxy for traditional symbols. This chapter discusses two sets of artifacts excavated in Annapolis that attest to the longevity and the creativity of Central African influences on life in Annapolis. Neither of them, however, shows Christian influences.

Bundle from the 1740s

In April 2008, two archaeologists working with Archaeology in Annapolis uncovered a bundle with distinctly African roots (fig. 13.1a). Though not the first deposit derived from African traditions identified over the twenty years of excavations in Maryland's capital city, it is the oldest, dating to the end of the seventeenth century.[2] This bundle was found four feet below the sidewalk of Fleet Street, near the circle surrounding

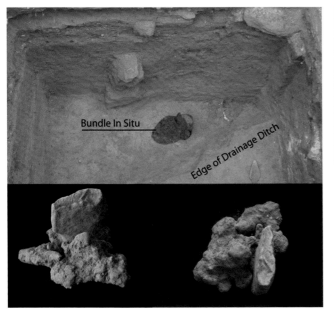

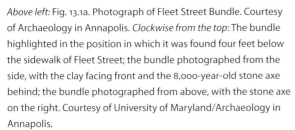

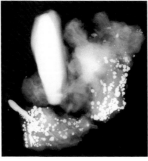

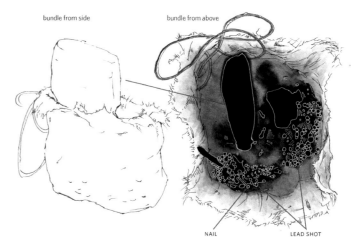

Above left: Fig. 13.1a. Photograph of Fleet Street Bundle. Courtesy of Archaeology in Annapolis. *Clockwise from the top:* The bundle highlighted in the position in which it was found four feet below the sidewalk of Fleet Street; the bundle photographed from the side, with the clay facing front and the 8,000-year-old stone axe behind; the bundle photographed from above, with the stone axe on the right. Courtesy of University of Maryland/Archaeology in Annapolis.

Above right: Fig. 13.1b. An X-ray image of Fleet Street Bundle makes the roughly 300 pieces of round lead shot visible beneath the clay that encases them. Courtesy of University of Maryland/Archaeology in Annapolis.

Right: Fig. 13.1c. Artist's representation of Fleet Street Bundle showing the way in which it was likely bound by its maker. Courtesy of University of Maryland/Archaeology in Annapolis.

the Maryland State House building. During the excavation of this sidewalk and gutter, archaeologists found a compact but amorphous object made of hard clay with a prehistoric stone axe head sticking out of its top. This object was quickly identified by the archaeologists as a cache of artifacts bundled together. The bundle was deliberately placed in a gutter that ran next to a seventeenth- and eighteenth-century road, also found four feet under the sidewalk of Fleet Street. The compact clay around the bundle made it impossible to see what was inside. X-ray images of the artifact show that its interior was organized and filled with metal objects and clay (fig. 13.1b). The bottom consisted of more than 300 pieces of lead shot of various sizes. The middle of the bundle contained approximately two dozen straight pins, some bent at a right angle, and several dozen nails of different sizes below the pins. The stone axe was wedged between the pins and nails and extended through the top. The whole bundle was held together in a pouch of cloth or leather whose creases left impressions in the clay (fig. 13.1c).[3]

Brice House Cosmogram, 1870–90

West African Spirit practices, more archaically known as hoodoo or conjure in North America, existed at the James Brice House in Annapolis (fig. 13.2). The Brice House east wing consists of two rooms oriented north-south with a central wall dividing it into a kitchen in the north and a laundry in the south. A hearth is located in each room, in the center of the north wall in the kitchen and the south wall in the laundry. The site was clandestinely transformed into an African American safe space through the practice of depositing materials under the brick floor, creating a cosmogram similar to those in the Kongo *dikenga* tradition (cat. 5.2 and fig. 13.3). The ends of the vertical axis reveal caches associated with two opposing hearths and chimneys. The northern one contained doll parts. The southern one contained a cache of feathers. Another deposit consisting of a pierced coin was identified in the northeast corner of the southern room, adjacent to the central dividing wall. This marked the east end of an east-west or horizontal axis. Its counterpart would have been located in the northwest corner of the same room, but the removal of a staircase in that location disturbed the soil, ruining any deposits.

At the center of the cosmogram around the door between the rooms, a series of caches was identified, seen to be stratified, being placed there at different times over many years, from the 1860s to the 1890s. One contained a perfume bottle with a single seed inside. Around it was a concentration of shells, buttons and matchsticks that were lit and quickly extinguished (fig. 13.3). Other artifacts were scattered around the deposit with the bottle, including a wide array of materials such as a brass Union button from the Civil War, a holster boss with an eagle in flight, more than fifty glass buttons and beads, scraps of red fabric, a root ball, polished black stones and three coins that date from 1870 to 1900. Adjacent to this assemblage, on the west side of the doorway, was another deposit with a penknife with a brass shield inlay, a large black bead, two buttons and two rings.

African Spirit Practices in Annapolis

Both of these excavations suggest Central African religious practices alluded to elsewhere in this volume. Along the coasts of Congo and Angola, and reaching into the interior, *banganga*, spiritual practitioners, created bundles of materials referred to as *minkisi*, sometimes described as "power packets." *Minkisi*, realized through containers such as ceramic vessels, gourds, animal horns, shells, bundles or any other object, enclose spiritually charged substances and an assortment of materials (see cat. 4.9 to cat. 4.12).

Both the bundle discovered beneath the sidewalk and the multitude of deposits uncovered in the Brice House can be interpreted in light of the Central African practice of creating *minkisi*. The Brice House east wing was transformed into a spiritual space through the practice of depositing a variety of materials likely for protection and curing.

Fig. 13.2. Photograph of the front exterior of the Brice House, Annapolis, ca. 2011. Courtesy of Benjamin Skolnik, Courtesy of University of Maryland/Archaeology in Annapolis.

These two examples, the cosmogram and the bundle, represent the longevity and evolution of African American spirit practices in Maryland's capital city. The bundle found beneath the sidewalk of Fleet Street is the earliest example of West Central African spirit practices found in Annapolis. The *Maryland Gazette* reported slave ships arriving in Annapolis as early as 1729 and these people likely came from the Bight of Biafra, where most early-eighteenth-century shipments to the Chesapeake region originated.[4] At the same time, however, shipments of enslaved people from Central

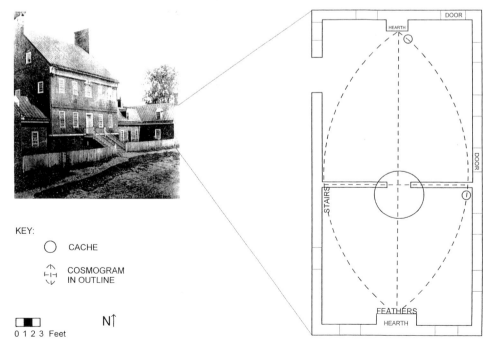

KEY:

○ CACHE

⌐⌐⌐ COSMOGRAM
⌐⌐⌐ IN OUTLINE

▯▮▯ N↑
0 1 2 3 Feet

Fig. 13.3. Historic photograph of the front exterior of the Brice House and a drawn representation by Jessica Neuwirth of the cosmogram with locations of distinct caches in cardinal directions and under the central, interior doorway. Courtesy of University of Maryland/Archaeology in Annapolis.

Africa were increasing, and therefore the development of African spirit practices was likely influenced by the beliefs of people from both regions.[5] These practices persisted, and the presence of the cosmogram at Brice House demonstrates that practices derived from Africa continued in the city through the eighteenth century and into the nineteenth century, well after Emancipation.

It is to be expected that Africans and their descendants, forced into captivity and bondage, would find their new environment filled with unfamiliar situations and gaps in their knowledge that required religious and magical practice. The unknown invited practices that drew on the enslaved Africans' own cultural knowledge and understanding. These two examples and others from Annapolis demonstrate that African spiritual practices in this city were not static but changed over time, going from public to secret, traditional to creole and African to Afro Christian. This change resulted from the mixing of traditions, belonging to different groups of people with different backgrounds, to people learning to cope with their forced captivity and bondage in the Americas.

Notes

1. Archaeology in Annapolis is a partnership between the University of Maryland, College Park and the City of Annapolis. The project was founded in 1981, with the goal of using archaeology to preserve heritage and to educate students, residents, and visitors to Annapolis. Ruppel et al., "Hidden in View," 327.

2. Ten years prior to the excavation of the bundle, Archaeology in Annapolis excavated an area underneath the east wing of the James Brice House, a national historic landmark on East Street. The central element of the Brice House cosmogram was excavated by Dr. James Harmon, who saw that it was stratified. Dr. Jessica Neuwirth identified the Brice House cosmogram from its component parts (Harmon and Neuwirth 2000).

3. Leone, Knauf and Tang, "Ritual Bundle in Colonial Annapolis."

4. Ives, "Black Community Development," 132.

5. Chambers, *Murder at Montpelier*, 12.

KONGO IN EARLY AMERICA

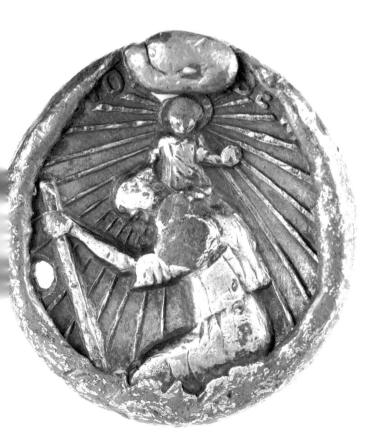
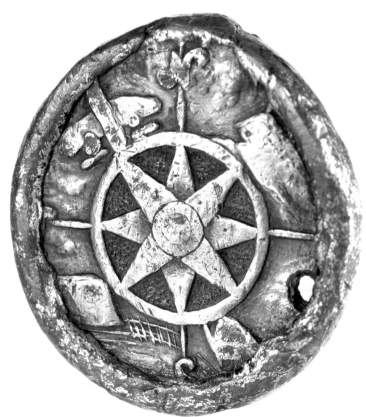

African American Archaeology

For several decades now archaeologists examining sites where enslaved Africans and their descendants have lived and worked have determined new ways to interpret materials left behind. They have expressed more interest in the history of the people, group dynamics and belief systems and attempt to focus on how such archaeological deposits shed light on the lives of those who left the material.

A number of sites demonstrate purposeful placement of materials beneath floors in efforts to control forces that might make a difference in the lives of those who lived or worked there. Such deposits were placed in the mansions of wealthy Europeans in colonial Annapolis as well as in modest cabins where Africans or their descendants lived. They have been discovered in the Chesapeake area, the Lowcountry of South Carolina and as far west as Texas.

Both of these examples from Annapolis were excavated in homes of wealthy families. In the Charles Carroll House, a bundle (cat. 5.1) had been buried in the late eighteenth century in the room where Carroll's enslaved African servant Mary lived. Containing a dozen rock crystals, polished pebbles, white disks and common pins, the bundle had been covered by a bowl base. The contents compare with the types of ingredients used to create *minkisi* in the Kongo region. The discovery of the bundle led to a search for similar remains of Central African religious practices in Annapolis, where at least ten other sites dating from 1720 to 1920 have been discovered.

In the James Brice House, materials had been deposited under the floor in a kitchen (cat. 5.2). Examination suggests they were intentionally aligned with the cardinal points, thus creating ritual space not unlike that of Kongo *dikenga* or *diyowa*. The northern deposit contained doll parts. The southern one consisted of feathers. Another containing a pierced coin was in the east end of the horizontal axis. The removal of a staircase to the west disturbed the soil where the fourth deposit should have been. At the point of intersection, several caches were buried over time, variously containing a small bottle, shells, buttons, matchsticks, a Civil War Union button, a holster boss, more than fifty glass buttons and beads, scraps of red fabric, a root ball, polished black stones and three coins dating from 1870 to 1900.

RP

Facing page, top: Cat. 5.1. Conjurer's cache, Charles Carroll House excavation, Annapolis, Maryland. 1790–1800. Pearlware, glazed white body ceramic with asterisk motif, stone, pins, quartz, bone disks. Collection of the Charles Carroll House.

Facing page, bottom: Cat. 5.2. Cache, James Brice House excavation, Annapolis, Maryland. 1860–1900. Various materials (porcelain doll, buttons, bone, shell), varied dimensions. Historic Annapolis Foundation.

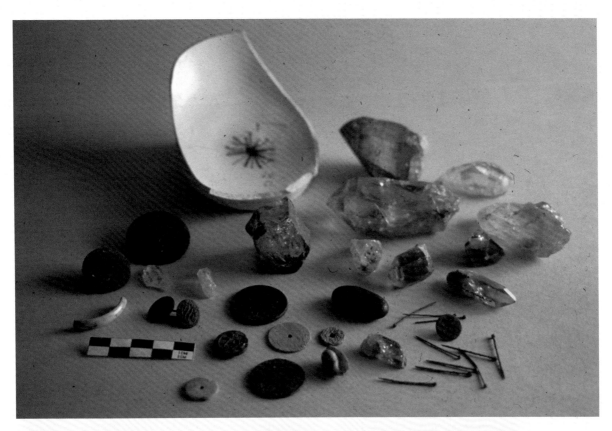

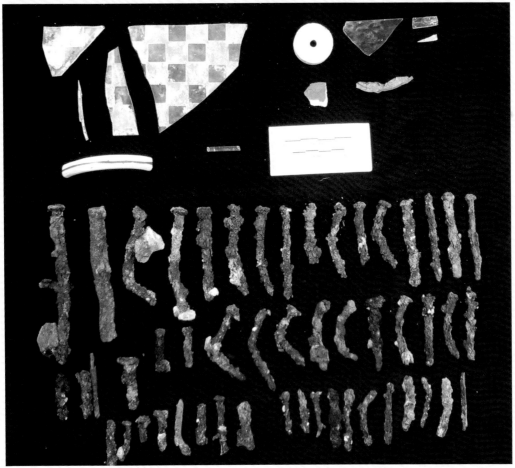

Religious Medals in North America

Just as Kongolese Christians in seventeenth- and eighteenth-century Kongo modified and used European medals, Africans or African Americans of Kongo ancestry owned and manipulated religious medals.

The St. Peter Cemetery, New Orleans' first burial ground (ca. 1725–88), was excavated in 1984. The most notable burial was that of an African man in his forties. Great care had been taken in his burial, suggesting he was a man of position. His was the only coffin to contain burial objects. The jewel-set rosary here (*facing page*) was apparently wrapped around his hands. Two saint medals were attached to the rosary. Also in the grave was a silver and gold medallion. On close examination of the medals, Ryan Gray has identified *S. ANDREAS* (St. Andrew) on the front of one, while the other appears to represent St. Camillus of Lellis. Camillus, patron of doctors and nurses, wasn't beatified until the 1740s, so this gives another hint as to the date of the burial. The image on the reverse of the Camillus medal may be St. Joseph. Shannon Dawdy suggests the person in the grave was likely born in Africa and sent to Louisiana in his youth. Two of his lower incisors bear decorative notching not unlike that in Kongo.

Another church medal (*below*) was discovered at the Fort Mose site in north Florida. Fort Mose was an African fortification that guarded the north side of St. Augustine and was known to have Kongolese among those who lived there and manned it. The navigator's compass on the back of the shiny, circular St. Christopher's medal, according to historian Jane Landers, could easily be interpreted as a metaphor for the Kongo cosmogram. However, she suggests that its surface imagery may carry a fascinating dual allusion as well. St. Christopher, shown carrying the child on his shoulders, would have been an apt patron saint for Africans, some of whom were African Catholics and had moved through dangerous swamps and estuaries to get to Florida from British Carolina. She suggests the image may have been seen by them as a reference to their expectation to cross the watery divide separating the living and the dead, after which they would reunite with the world of their Kongo ancestors. Like the medals in cat. 1.21 and cat. 1.22, the original medal was modified.

RP

Below: Cat. 5.3. St. Christopher medal. Fort Mose, St. Augustine, Florida. n.d. Silver alloy, 1 in. (2.54 cm) diameter. Courtesy of the Florida Museum of Natural History, Historical Archaeology Collections, F. E. Williams III collection.

Facing page: Cat. 5.4. Jeweled rosary with two medals. New Orleans, Louisiana. 18th century. Metal, glass, approx. 14 × 3 in. (35.6 × 7.6 cm). Custody of the State of Louisiana. Photograph by and with permission of Michael J. Smith.

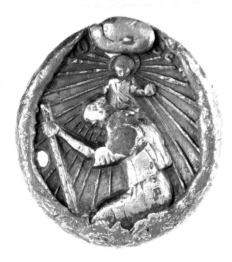 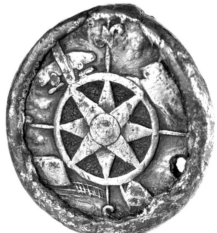

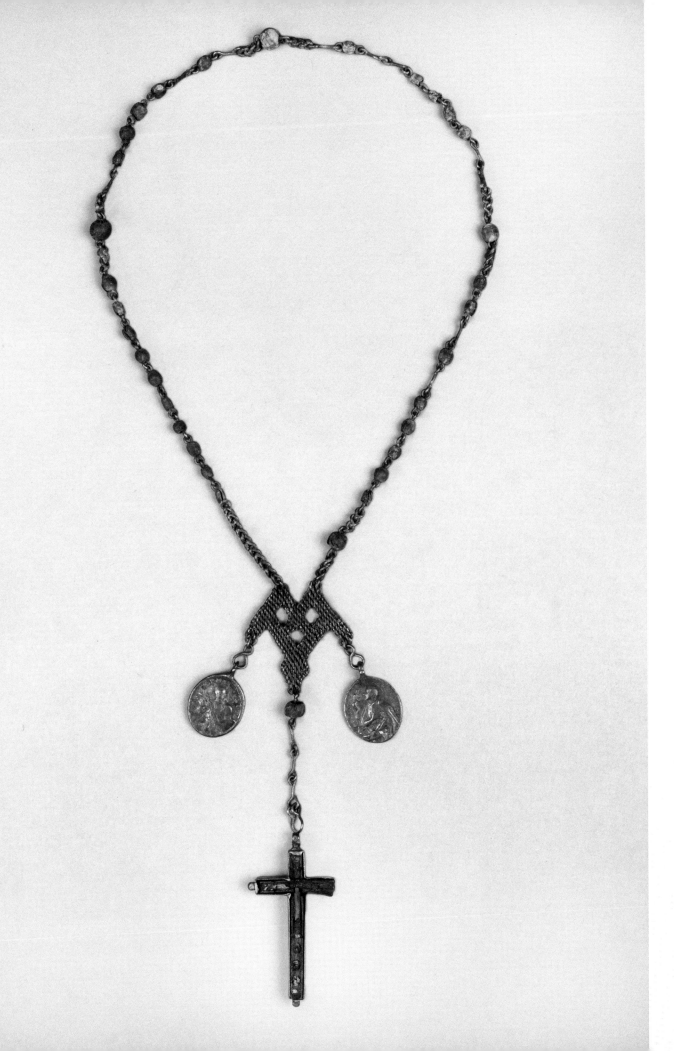

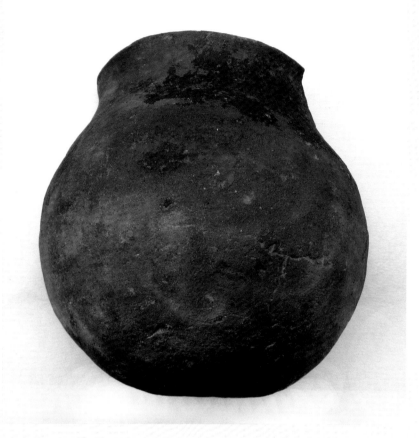

Colonoware from the Dean Hall Plantation

Excavations on the sites of seventeenth- through nineteenth-century plantations from Virginia to Florida have revealed a plethora of locally made ceramics that can, in some cases, be attributed to African American potters. Archaeologists have termed locally produced wares *colonoware* to include both African American made ceramics and Native American ceramics, as well as hybrid wares that have African, Native American and European attributes. Excavations at the Dean Hall Plantation in South Carolina yielded 59,000 samples of colonoware made on site, the largest find of African American–made ceramics from one site in the United States. Most colonoware was produced in the eighteenth century, a time when most of South Carolina's slave population was made up of West Central Africans, of which a high percentage would have come from the region that was home to the Kongo people. It is likely, then, that Kongo people were making pottery at Dean Hall, which was built in 1725.

Slaves made ceramic wares for their own use. The most typical domestic wares were plain, round-bottomed pots for cooking and serving stews in African fashion. However, the Dean Hall potters also made dozens of decorated vessels, as evidenced by roughly 1,100 decorated sherds. Among the motifs of these adorned wares are twenty-seven styles of Xs and other types of inscribed marks. Cross marks, according to some scholars, are the Kongo *dikenga*, a potent and multivalent cosmological sign. A fascinating mark found on another sherd, a double circle inscribed with a double cross, has been translated by Kongo scholar K. Kia Bunseki Fu-Kiau as the world without sun or light, as chaos, and as the end. Some scholars believe these marked vessels were made as medicine containers and used in rituals that parallel the use of Kongo medicine containers or *minkisi*. Two Dean Hall sherds are emblazoned with zigzag lines that are similar to nineteenth-century Kongo vessels in the collection of the Royal Museum for Central Africa (cat. 4.25). On the Kongo vessel, this motif was associated with serpent mediators between the world of the living and the dead and infers the harmony of these realms that ensures continuity of life beyond death.

SC

Facing page: Cat. 5.5. Round-bottomed vessel, Dean Hall Plantation, South Carolina. 1785. Earthenware, approx. 7 in. (17.8 cm) diameter. The DuPont Company Collection from their Cooper River site, Moncks Corner, South Carolina, 6098:3:37. Photo by and with permission of Nicole Isenbarger.

Above: Cat. 5.6. Four cross-marked vessel fragments, African American. Dean Hall Plantation, South Carolina. 1762–1820. Earthenware, variable dimensions. The DuPont Company Collection from their Cooper River site, Moncks Corner, South Carolina, 6654:2. Photo by and with permission of Nicole Isenbarger.

Right: Cat. 5.7. Colonoware vessel fragment with dogtooth motif, African American. Dean Hall Plantation, South Carolina. Post-1820. Earthenware, approx. 4 × 4.5 in. (10.16 × 11.43 cm). The DuPont Company Collection from their Cooper River site, Moncks Corner, South Carolina, 40322:3:21. Photo by and with permission of Larry Mccrea.

14 ◆ ◇

Africanisms in American English

Critical Notes on Sources and Methodology

JACKY MANIACKY

While the African linguistic heritage in the United States is less apparent than farther South (in Brazil and Cuba, for example), there are still ample possibilities for doing interesting research. In this respect, the best-documented language variety today in the United States is Gullah, a creole spoken in South Carolina and Georgia. Also in Florida we find evidence of African linguistic heritage. Lorenzo Dow Turner's 1949 publication was an important step in recognizing a real African legacy in American culture, particularly with regard to language.[1] Turner's study led to the publication of a series of reviews, and the topic of "Africanisms" in the broadest sense was developed further through the work of linguists such as Holloway (1991) and Mufwene and Condon (1993).[2] With regard to lexical analyses, we should mention Dalby (1972), Dalgish (1982), Vass (1979) and Holloway and Vass (1993), works that expand on Turner's research.[3] However, a number of critical remarks need to be made with respect to methodology and the critical use of sources. This is the aim of the present article.

Bantu languages (map 3) are a group of 500 to 600 languages spoken from Cameroon to South Africa, and linguists classify them into sixteen zones, moving from east to west (A to S; zones I, O and Q do not exist). Kongo languages are classified in zone H. Within his set of recorded Africanisms, Turner identified a large group as having a Kongo origin, even making a slight distinction between Kikongo as spoken in the current Democratic Republic of Congo (DRC), and Kongo, referring to the southern variety spoken in Angola. In his opinion, 826 terms in his corpus are of Kongo origin, and these are part of a group of 1,891 that he identified as Bantu (within a total corpus of 3,382 terms).

Kongo languages therefore would constitute the main linguistic source of Africanisms identified in Gullah, followed closely by Yoruba. There are, however, several reasons to be cautious about asserting such precise origins: the nature of the Africanisms identified, the semantic looseness one may encounter or the wide distribution of terms supposed to be typical of one single region. The Africanisms that Turner identified consist overwhelmingly of proper names. Several linguists have already

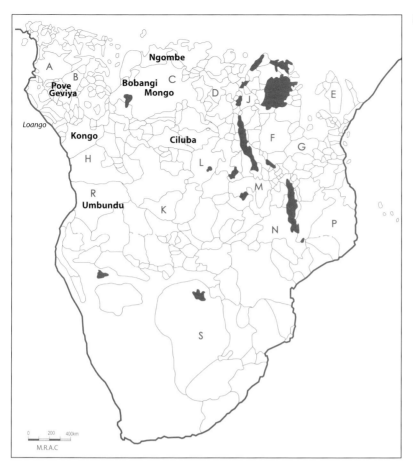

expressed reservations about this characteristic of Turner's corpus. The actual use of these proper names is rare. If we are to count only the more commonly used "Kongo" terms, then this amounts to no more than 300. We should ask to what extent proper names can demonstrate an African essence of the Gullah language, knowing that names could easily be borrowed. Arguments about lexical origins should take into account a more general corpus of words as well as grammatical structures.[4] Like Morris Swadesh, we may also wonder why the meanings of these proper names have been lost, while they remain an important element in African traditions.[5] This loss of original meaning may caution us for yet another problem when making use of data that are supposed to abound in Africanisms: that of random morphological comparisons without regard for meaning. Turner, for instance, allows a pure linking of similar forms between Gullah and almost any language in sub-Saharan Africa, and then looks at this African language to determine the original meaning(s) of his Gullah term.[6] The meanings he proposes for his Africanisms do not reflect meanings as recorded for Gullah terms—as we might expect—but meanings of similar forms in an African language. The designation of the language of origin is often not more than one possibility among others. For instance, Turner assigns a Bobangi origin or a Ciluba origin to some words. This would not be without interest from the point of view of the history of the slave trade, as these two Bantu languages are not spoken along the coast. Indeed, the coastal languages, particularly those of the DRC

and Angola, seem to be those that have most marked the linguistic landscape on the other side of the ocean, at least in the case of Brazil.[7] When considered more closely, however, such Bobangi or Ciluba origins do not appear very reliable. The form *etu*, for instance, one of the most widespread in the Bantu region, is used to express possession in the first person plural.[8] There is no good reason to think that this form—if this is an Africanism at all—comes from Ciluba rather than from any other Bantu language. Similarly, to say that the form *bando* comes from the Bobangi language, where *mbando* means "the fee given to a doctor," is a risky proposal. One may as well hypothesize that it comes from the Mongo language in the DRC, where *mbandó* means "count"; or from the Pove term *mbándo* for "start, beginning"; or even from the Geviya *mbando* for "lucky protector," both languages being spoken in Gabon.[9]

Is it useful to dwell on work dating back several decades now? Of course it is! First, because Turner's 1949 book remains a seminal work in the field, having paved the way for the recognition of the African linguistic heritage in the United States. Second, because similar studies that appeared later have been unable to enrich Turner's pioneering work. A more recent study by Holloway and Vass reinforces the errors of predecessors and does not take into account the valuable criticisms and analyses that had already been published.[10] The idea of Holloway and Vass was to start from the Bantuisms identified by Turner and to compare these to Ciluba, a language spoken in the Kasai region of the DRC. Holloway and Vass's choice of Ciluba was due to the fact that Vass spoke it as a result of a long career in the region. Holloway and Vass therefore systematically make parallels between the Bantuisms in Gullah as described by Turner and Ciluba words considered (quasi-) identical, morphologically speaking. Already at this level, many of the connections are unjustifiable—for instance, the Luba *pakisha* for *pakasa* in Gullah, *lupapa* for *luha*, *kusomba* for *kizomba*, and *pikula* for *kikula*. As in these cases they insufficiently looked at semantics, and as we know that Turner fairly arbitrarily defined one or more meanings for most of his Africanisms, we can expect only an approximation of meaning, in any event.

Holloway and Vass, although warned about these uncertainties, took Turner's proposals of meanings into account to define the equivalents in Luba, which occasionally caused a conflict of preference between form and meaning. Thus for the Gullah name *pinda*, allegedly connected to the meaning of "peanut," they proposed the Luba word *kabindi*, the meaning of which is identical. There is also a form *pinda* in Luba, but with a different meaning: "to accumulate," "to acquire property." This, however, they prefer to relate to the Gullah word *hinda*, meaning "place, thing, circumstance"! Sometimes, the connection is not justified by the supposed meaning, nor can it be justified by the form, as for the Gullah word *landu*, "disobedience," and the Luba word *ngandu*, "crocodile."

The problem with this approach, which systematically draws parallels between Turner's Gullah Bantuisms and words in a selected Bantu language, is that it mistakenly confirms hypotheses simply because the same methodological shortcomings are at the basis. We could multiply such analyses as many times as there are Bantu languages, each time giving the illusory impression that the language in which one

looks for evidence significantly contributed to the lexical origins of the target language, Gullah in this case.

The same untenable conclusion applies to the terms qualified as Africanisms that were identified as place names (Vass 1979).[11] Again, the meanings are not available and the connections of forms are not always convincing: *alakana* for Alcolu (South Carolina), *itunua* for Etonia (Florida), *pa tshitulu* for Ponchatoula (Louisiana). Note the significant presence of the place names Congo (Alabama, North Carolina) and Angola (Louisiana, North Carolina). Loango (Alabama), the name of the West Central African coastal kingdom, also exists, but Vass surprisingly prefers to connect this to *luangu*, a word in Bantu for "transpiration." Given the aforementioned methodological shortcomings, I agree with other scholars who have critiqued the publications of Vass and Holloway.[12]

African heritage and even Bantu in American English cannot be questioned, as there is sufficient linguistic evidence for it.[13] But is there a reasonable possibility to talk of a more precise heritage—Kongo, for instance?

The methodology necessary to define the origin of a term as accurately as possible is twofold. Not only do we need to show that a given word on the American continent is of African origin, having an identical or related meaning (or at least to have the data needed to trace the change in meaning), but it must also be possible to confirm that this word is unique to a specific region, as limited as possible.[14] If the word *goma* refers to the Bantu term *gòmà*, used for "drum" throughout the large group of Bantu languages, its precise origin cannot be traced unless it is present in a peculiar form on the American side and in the same form in a restricted area on the African side. For instance, the general term in Bantu for "rain" is *búdà*. In the various Bantu languages it gives rise to words like *mbula* and *mvula*. However, the form *ombela*, which is attested to be a proper name in Gullah, exists only in a single Bantu language, spoken in southern Angola: Umbundu.

In the absence of real meanings for each of the terms identified by Turner as Africanisms, this method is severely compromised from the start in the case of Gullah. By limiting ourselves to forms, there is always the risk of connecting two forms that have originally nothing in common. Some of Turner's terms may in the end not be Africanisms at all! For instance, in Brazil, where the African linguistic heritage is much more visible, some Portuguese words could easily be mistaken for Africanisms, even though they are in fact terms of Amerindian origin. The risk of confusion is even greater if the forms identified are short. For example, Turner's list includes *ba, be, bi, bu, di, fa, fu, ja, je, ka, ke, ko*. What to do with these? Suppose that there is a noun *yo*, without any context or meaning. How can one determine where it comes from? If we wish to argue in favor of African origin, we could say that in Lingala, spoken in Congo, *yó* means "you." But *yo* also exists in Spanish to mean "me," or in the French Caribbean Creole to mean "them," to stay only within the semantic field of personal pronouns! Even if we study changes in the meanings of a word over time, an initial meaning is required.[15]

Using current knowledge of Bantu languages and, insofar as possible, the historical

comparative studies of them, we could support the theory of a Kongo origin for several words from Turner's inventory that combine form with the assumed meaning to direct them exclusively to the Kongo linguistic zone and its surroundings (essentially Bantu zones H, B and K). Examples of this are *bangi*, "herbalist"; *gombo*, "charm, sorcerer" (or more precisely, "soothsayer"); *mongo*, "hill." But another initial meaning could rightly steer toward other origins. If the original meaning of *bangi* in the United States should prove to be "hemp," this would be closer to Bantu zone C with languages like Ngombe or Lingala (Congo), and no longer with the Kongo linguistic zone. If *gombo* rather related to "cow," we would move toward the languages that harmonize the final vowel of the Bantu term *gombe* for "cow," which is widespread.[16] The same is true for *mongo*. To refer to a language previously mentioned, in Ngombe this word means "journey." The hypotheses are countless, especially as elements such as tone, distinctive in Bantu languages, are completely absent in the American forms we use as the starting point.

Taking the Africanisms identified in other countries on the American continents into account may provide significant help. In this way *pwita*, "a dance" according to Turner, is a term present in Brazil where it means a "friction drum," as in some Kongo languages.[17]

Certainly, the absence of meaning diminishes the possibilities for in-depth analysis of these apparent Africanisms. Fortunately, there are also a number of Africanisms with a well-known meaning in contemporary English in the United States, both in specific dialects of black American communities and in wider use: *bambi, banana, zombie, yam, gumbo*.

In my opinion, other words like *jazz, samba* or *banjo* seem to require more research; the etymologies commonly advanced are less convincing than one tends to believe.

It is important not to lose sight of the fact that some of these Africanisms have known a different route from those of the original African populations present in the United States. The history of words contributes to the history of populations who use them, but these histories are not necessarily identical. The English word *chimpanzee*, for instance, comes from the Kongo region and its surroundings, but it reached America through Portuguese.

Two other terms used in the United States (but also in Jamaica, for instance) deserve special attention: *pinder* and *goober* (for another discussion of these terms, see chapter 15). Both refer to peanuts, an American plant. Nevertheless, these are names that have come from Africa. This is what I call "boomerang linguistics": I receive your product but send you back my name for it. On the African continent, the terms are mainly found in the forms *mpinda* and *nguba*, respectively. Helma Pasch noted a distribution centered on the Kongo region, but extending to Gabon in the north, for the term *mpinda*, and in southern Angola and in the forest in the center of the DRC for the term *nguba*.[18]

The concept of "forms" relates to the distribution of words that are considered to be linguistically related. Thus *mpinda*, found in the Kongo zone, corresponds to the

form *mbenda* as used in Gabon, and *onguba* from southern Angola corresponds with *nguba* in the Kongo zone. The latter term is also found in Bantu zone C, with other words for "peanut." The Kongo zone is found to be the region that has forms that are closest to those used in the United States. Therefore, there is good reason to believe that these two terms, *pinder* and *goober*, originally came from the Kongo zone and its surroundings.

Despite their presence over four current states—Gabon, the two Congos and Angola—none of these terms are taken into account today in the data collected for the reconstruction of the theoretical parent language of the Bantu languages, the proto-Bantu.[19] This is a vast work in progress, based on the collection of linguistic data and the comparison of a maximum of languages in the Bantu group, in order to establish lexical reconstructions. The more rich and refined this database becomes, the better it will facilitate research on Bantuisms on the other side of the Atlantic, notably by highlighting the terms that exist only in a restricted region. In the case reported earlier with the forms of the terms *mpinda* and *nguba*, it is already possible to suggest the Bantu reconstructions °-píndá and °-gúbá, respectively.

A better understanding of African languages in general, as well as in their particularities, is crucial to be able to refine our knowledge of America's linguistic heritage.

Notes

1. Turner, *Africanisms in the Gullah Dialect*.

2. Holloway, *Africanisms in American Culture*; Mufwene and Condon, *Africanisms in Afro-American Language Varieties*.

3. Dalby, "The African Element," 170–86; Dalgish, *A Dictionary for Africanisms*; Vass, *Bantu Speaking Heritage*; Holloway and Vass, *African Heritage of American English*.

4. Mufwene, "The Linguistic Significance."

5. Swadesh, "Review of Africanisms," 82–84; Hair, "Sierra Leone Items," 79–84.

6. Turner, *Africanisms in the Gullah Dialect*.

7. Maniacky, "Thèmes régionaux Bantu," 153–65.

8. Muzenga, *Substitutifs et possessifs en bantou*.

9. Hulstaert, *Dictionnaire lomongo–français*; Manfoumbi, *Lexique pove–français, français–pove*; Van der Veen and Bodinga-Bwa-Bodinga, *Gedandedi sa geviya*.

10. Holloway and Vass, *African Heritage of American English*; Carter, "Kongo Survivals"; Cassidy, "Sources of the African Element," 75–81.

11. Vass, *Bantu Speaking Heritage*.

12. Hancock, "Review of *The Bantu Speaking Heritage*," 412–19; Wald, "Review of *The African Heritage*," 755–56.

13. Mufwene and Gilman, "How African Is Gullah, and Why?" 120–39.

14. Maniacky, "Thèmes régionaux Bantu," 153–65.

15. Wade-Lewis, "The Status of Semantic Items," 26–36.

16. Bastin et al., *Bantu Lexical Reconstructions* 3.

17. Turner, *Africanisms in the Gullah Dialect*.

18. Pasch, *Linguistische Aspekte*.

19. Bastin et al., *Bantu Lexical Reconstructions* 3.

15 ◆

Kongo Cuisine and the Middle Passage in Terms of Peanuts

BIRGIT RICQUIER

I had a peanut butter sandwich for breakfast—on each side of the Atlantic. One sandwich had peanut butter from a jar, purchased at the nearby grocery store and spread with jelly on bread from a packaged loaf. The other had peanut butter from an egg-sized plastic bag, sold at a food stall in the center of the village and spread on a French-style baguette. Both the American and the Congo sandwiches are representative of their respective culinary traditions, yet each is a mouthful of foreign ingredients.[1]

When European vessels sailed across the Atlantic in the fifteenth and following centuries, they inevitably also transported foods. Plants and food products were brought home as proof of the conquered land's riches. Others were shipped from one colony to feed another. But, of course, the ships also carried provisions for the long journey. The Columbian Exchange, or the introduction of plants from the New World to the Old World and vice versa, had a major impact on Kongo culinary traditions.[2] It was, however, not a one-way trajectory. Enslaved Kongolese also introduced foodstuffs in the Americas.

On the eve of the Columbian Exchange, Kongo meals consisted of porridge, a stew and/or legumes.[3] Porridge (*mfundi*) was made from flour of African cereals such as pearl millet, finger millet or sorghum.[4] It could be substituted by plantains or yams. The stew was reported to be *mwamba*, a palm nut sauce with vegetables and optionally meat. Other staples included a variety of legumes, for instance pigeon peas, and palm products. Culinary applications of the latter were the mentioned palm sauce, but also palm oil and palm wine, both much appreciated by European observers. Spices that flavored Kongo dishes included Guinea pepper (*Piper guineense*) and grains of paradise (*Aframomum melegueta*). Animal products were obtained by fishing and hunting. People also kept domestic animals, more specifically fowl, pigs, sheep, goats and in the south even cattle. Cooking equipment consisted of ceramic pots, mortar and pestle, a sieve, gourds to serve drinks, wooden plates and a wooden spit to roast meat.

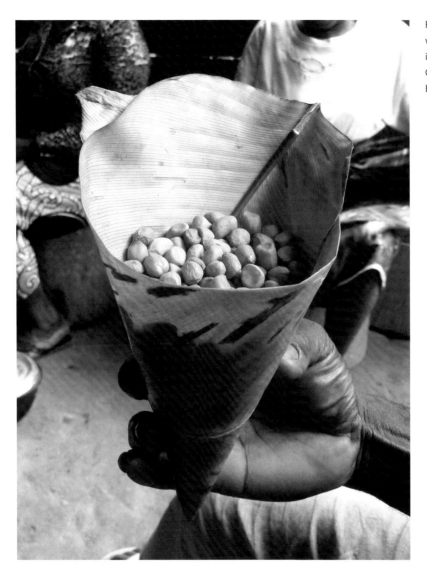

Fig. 15.1. Photograph of a cone with peanuts, Malemba, Kouilou Province, Republic of the Congo, by Birgit Ricquier, 2010. By permission of the author.

Soon after the first Europeans set foot on Kongo shores, American foodstuffs entered Kongo culinary practice. By the end of the sixteenth century, maize had been introduced, and it had replaced the indigenous cereals as the main ingredient of flour porridge by the end of the eighteenth century. Today, the main starch food of the region is cassava, which was introduced in the third decade of the seventeenth century. In terms of flavor, chilis and tomatoes have become important seasonings, and so have peanuts (*Arachis hypogaea*). In contemporary Kongo cuisine, peanuts are ground into a paste, which forms the base for stews. Peanuts furthermore serve as a snack, boiled, roasted and even raw (fig. 15.1). Peanuts were first grown in tropical South America, in eastern Bolivia. It was an important crop for the Incas, and by the arrival of the first Europeans, the crop was widely present in Brazil and the Caribbean.[5] The Portuguese transported the legumes from Brazil to their African colonies, and because of the similarity with local legumes, namely the Bambara groundnut (*Vigna subterranea*), peanuts were quickly adopted.[6] Early documents on the Kongo

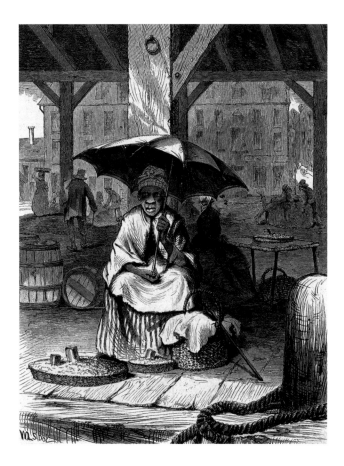

Fig. 15.2. Illustration of an African American peanut vendor, Savannah. Published in *Harper's Weekly*, July 16, 1870.

language mention the names that currently refer to the American crop. The first Kongo dictionary translates "legumen" as *zangúba*.[7] The twentieth-century editors of the same manuscript adapt the term to *nguba* with the contemporary reference to peanuts.[8] The Besançon dictionary of 1773 mentions another name that currently refers to peanuts, *i pinda*, as the translation for "pistache."[9] The first term (*nguba*) occurs in inland varieties of the Kongo language, the second (*pinda*) at the coast. Considering that the seventeenth- and eighteenth-century terms do not explicitly refer to American peanuts, it should be remembered that the names may also have been used for the Bambara groundnut. However, both words have a larger but regional distribution, indicating loanword dispersal.[10] Therefore, the terms may have accompanied the introduction of the new legume. If so, peanuts were already part of the Kongo culinary repertoire in the first half of the seventeenth century.

While American crops like cassava and peanuts reached West Central Africa in order to feed the Portuguese colonies, African crops were not intended to be grown in the New World. Bambara groundnuts, pigeon peas, okra, yams and other staples merely served as provisions for the slave ships. However, the surpluses often found their way to the gardens of plantation slaves.[11] Although many of the mentioned plants have a wider distribution in sub-Saharan Africa, some appear to have been introduced from West Central Africa. Pigeon peas, for instance, were called *Congo* or *Angola peas*.[12] Another clear import of Kongo origin is the Bambara groundnut, which was referred to as *Congo goober* or *mandubi d'Angola*.[13] The word *goober* is a loan

from the mentioned Kongo term *nguba*. *Mandubi*, on the other hand, is the name for peanuts in Tupi, an indigenous language from Brazil. Curiously, enslaved Kongolese are also responsible for the spread of the American peanut into several parts of the New World. The loanword *goober* is well known in the southern United States, and also the other term found in old Kongo dictionaries, *pinda*, traveled along with the crop. In fact, the recordings of *pinda(r)* and *pindall* with reference to peanuts planted in Jamaican and Suriname maroon and slave gardens are contemporary to the entry in the Besançon dictionary of 1773. An eighteenth-century captain observed that in Suriname, peanuts ("pistachio or *pinda*") were processed into butter used to make stews.[14] This description fits the contemporary use of peanuts in Kongo cuisine (fig. 15.3). In North Carolina, slaves were reported to eat peanuts raw or roasted.[15] Because of the crop's popularity among the slave populations, plantation owners believed peanuts to be of African origin. Although slave food was not considered worthy of

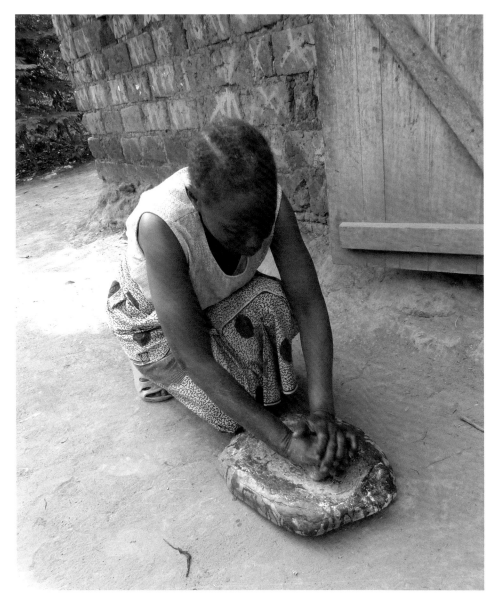

Fig. 15.3. Photograph of a traditional method to grind peanuts, Kimbonga-Louamba, Bouenza Province, Republic of the Congo, 2010, by Birgit Ricquier. By permission of the author.

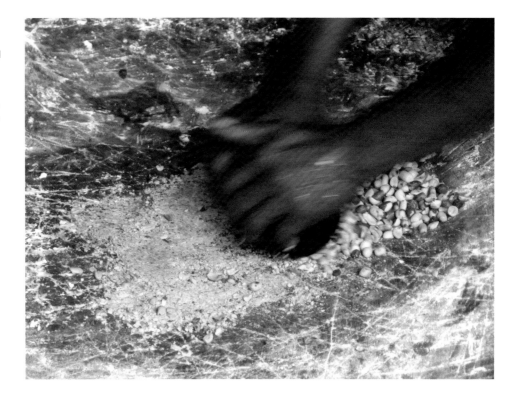

Fig. 15.4. Photograph of a traditional method to grind peanuts, on a wooden board and with a wooden roller, Malemba, Kouilou Province, Republic of the Congo, 2010, by Birgit Ricquier. By permission of the author.

the planter's table in the beginning, African foodstuffs slowly entered the culinary traditions of the southern United States. *Gumbo*, a stew containing the African crop okra, for instance, is a signature "soul food" dish.[16] Peanuts have become popular all over the United States. Although not an African plant in origin, *goobers* owe their glory to Kongo slaves.

Peanut butter is an exotic element on both the American and the Congo sandwich. The legume originated in central South America, was transported to sub-Saharan Africa and finally was introduced in North America. The terms *goober* and *pinda* offer linguistic proof of the Kongo part of the story. The confection of peanut butter for stews was reported in maroon societies in the eighteenth century. The slaves concerned must have brought the knowledge of this culinary use from the Kongo kingdom or other West (Central) African regions involved in the slave trade. To spread peanut butter on sandwiches, however, is a typically Western use, popular in the United States but, for instance, also in the Netherlands. Considering that bread is a colonial introduction, hence the baguette in the ex–French colony Congo-Brazzaville, this use of peanut butter is also relatively new in West Central Africa. In combining American, African and European elements, a peanut butter sandwich thus bears witness of an alternative culinary triangle.[17]

Notes

1. Research for this essay was conducted at the Linguistics Service of the Royal Museum for Central Africa as part of the project "The Social Ecology of Language Change in Central Africa: The Kongo Kingdom as a Test Case for Historical Linguistic Method," funded by the Belgian Federal Science Policy. Collaboration with the KONGOKING project (Ghent University, coordinated by Koen Bostoen) enabled consultation on scans of the historical dictionaries cited. Furthermore, I would like to thank Hein Vanhee, Gilles-Maurice de Schryver, Igor Matonda and an anonymous reviewer for comments on an earlier draft.

2. The term *Columbian Exchange* was introduced by Crosby, *Columbian Exchange*.

3. The information offered in this paragraph is mostly retrieved from Obenga, "Traditions et coutumes alimentaires"; Hilton, *Kingdom of Kongo*, 5, 78–79; Nsondé, *Langues, culture et histoire*, 139–60; and Thornton, *Kongolese Saint Anthony*, 15–16.

4. *Mfundi* is another story of a West Central African food prepared on the other side of the Atlantic. The name, found in Kikongo but also in Kimbundu, another language of Angola, entered the culinary lexicon of Brazilian Portuguese.

5. Smith, *Peanuts*, 2–4.

6. Smith, *Peanuts*, 8. The Bambara groundnut is cultivated throughout Africa. The English denomination of the crop refers to the Bambara ethnic group from Mali, one of the main export countries of Bambara groundnuts; see National Research Council, *Lost Crops of Africa*, 57.

7. Van Gheel, *Vocabularium Latinum*, 51.

8. Van Wing and Penders, *Le plus ancien dictionnaire bantu*, 254.

9. *Dictionnaire congo et français*, copy made by R. F. Cuénot in 1773 of an original attributed to J.-J. Descourvières. Bibliothèque Municipale de Besançon—MS. No. 525, 512.

10. Pasch, *Linguistische Aspekte*, 102–3.

11. Carney and Rosomoff, *In the Shadow of Slavery*, 124–25.

12. Carney and Rosomoff, *In the Shadow of Slavery*, 103.

13. Carney and Rosomoff, *In the Shadow of Slavery*, 141.

14. Carney and Rosomoff, *In the Shadow of Slavery*, 97.

15. Carney and Rosomoff, *In the Shadow of Slavery*, 143.

16. The word *gumbo* is also a loan from Bantu names for okra. However, it cannot be claimed to be Kongo since the Kongo name is *dongo-dongo* (Ricquier fieldnotes).

17. Reference is made to the famous culinary triangle (raw—cooked—rotten) of Claude Lévi-Strauss; see Lévi-Strauss, "Culinary Triangle."

16 ◈

Africa Is What You Make It

Kongo in African American Folk Arts

JASON YOUNG

> Some time in de greathouse wall
> Is like a thumb mark de stone,
> Or a whole han.
> Granny say is de work sign, she say
> It favor when a man tackle de stone, an' mek
> To tear it down, till de mortar tek de same shape
> as him han. But I feel say
> is like summaddy push de wall
> an' hole it dere until de brick dem dry
> out. Now dat is hard.
>
> Dennis Scott, "Construction"

This is the legacy of enslaved Africans captured and carried through the Middle Passage onto American shores from the sixteenth to the nineteenth centuries. In one sense, these captives and their progeny were crucial in the formation of the modern world. Working the land on slave plantations, laboring under it in mines and traversing the nether spaces between as sailors, merchants and slaves, blacks were central to the development of emerging forms of modernity. They pushed modernity's wall up and "hole it dere until de brick dem dry." The evidence of this "holding up" is well documented and can be seen in the development of plantation economies based on cash crop production and in the subsequent rise of global capitalism. Eric Williams long ago insisted that slavery and the slave trade "provided one of the main streams of that accumulation of capital . . . which financed the Industrial Revolution."[1] More recently, Paul Gilroy highlighted the experiences of black people whose labors—physical, intellectual and cultural—were key components of an emerging modernity in the nineteenth and twentieth centuries.[2]

But if blacks were central to the creation of modernity, they have also provided perhaps the clearest and most consistent challenge to its ugliest legacies: its forced labor, racial oppression and colonial domination. Here, blacks have worked both under slavery's yoke and in its aftermath to "tackle de stone, an' mek / To tear it

down." These efforts bore fruit in slave rebellions and conspiracies in New York (1712, 1741), South Carolina (1739, 1822), Jamaica (1760), Haiti (1791), Virginia (1800, 1831), New Orleans (1811) and Brazil (1835), to name but a few. Short of open, armed rebellion, these efforts also bore fruit in ever-simmering traditions of resistance evident in enslaved Africans' persistent attempts to run away, feign illness, engage in collective work slowdowns and otherwise disrupt the easy operation of the plantation enterprise.

Outside these more standard arenas of slave resistance, scholars are increasingly looking to the role that the very act of cultural formation played in slaves' responses to enslavement. In folklore, religion, language and material culture, enslaved Africans created worlds of meaning that were simultaneously inside and outside the cultures of the West. Indeed, slave cultural formation reveals "a historical relationship in which dependency and antagonism are intimately associated and in which black critiques of modernity may also be, in some significant senses, its affirmation."[3] For this, one need look no further than the oft-cited example of African American musical traditions, and especially jazz, whose African-derived themes of antiphony, percussion and syncopation articulate a scathing critique of traditional European musical forms, even while using Western instruments. In this vast world of slave resistance—or what might be called black cultural criticism—West Central Africa played a crucially central role. That is to say that Kongolese-derived culture fueled much of what emerged in the Americas as black folk arts, which, in turn, produced the armed revolts, day-to-day resistance and cultural formation(s) that are at the heart of slave resistance.

Writing in "Through the Prism of Folklore," Sterling Stuckey suggests not only that Kongo-derived folk traditions persisted in the United States, but also that some of these practices, including the ubiquitous ring shout, constituted the cultural center around which African Americans formed themselves into a people. In this sense, folkways were the source of African American identity. In creating folk cultures around the Diaspora, enslaved Africans drew on remarkably resilient aspects of African culture that spurred on black cultural developments in the Americas. Still, the cultures that enslaved Africans created remained plastic, being malleable enough to adapt to new conditions.

In this vast field of cultural inheritance and ingenuity, *Africa is what you make it*. It is a language and the folklore that flows from it: a song and the ring shout that encircles us. It is carved, molded and crafted into shape. As Robert Farris Thompson notes in a similar context, art is a rich and peculiar field for investigating the relationship between Africa and the Americas, because even when slaveholders suppressed the more visible aspects of African life in the Americas, art, and folk art in particular, retained "the more intimate expressions" of a people.[4] Or, put another way: "here is the transplanted African learning to conjure with new roots, new herbs, and old meanings."[5]

This process of making the old new again began, of course, in Africa. As they were pushed and pulled from Africa's interior toward the slave ships on the coast,

Africans quite literally carried their culture with them in the form of "large coiled baskets on their heads, filled with provisions for the journey."[6] Some of these baskets would certainly have been put to use aboard the slave ship, before being deposited first in American port cities and later on small farms, large plantations, mines and docks to be filled with tools and seeds, textiles and trash. As Dale Rosengarten notes, enslaved Africans would have recognized African baskets being imported into the Americas and would have re-created and restyled them for new uses. The Lowcountry region of Georgia and South Carolina is full of luxurious and varied grasses that Native Americans have long used in their own basket-weaving traditions. These same grasses provided ample opportunity for the continuation of basket-weaving practices for enslaved Africans. But despite Native American weaving expertise, the style and techniques of basket weaving in the Lowcountry derived both from West African rice-growing regions and from West Central Africa (cat. 6.9 and cat. 6.10).[7] What's more, the very means of carrying these baskets recalled African practices. Unlike the Native American method of carrying "burden baskets" strapped to the back, and contrary to the European practice of using hand-gripped baskets, slaves in the Lowcountry carried rice out of the fields in baskets placed atop their heads (see fig. 17.3, ill. 13.1, and ill. 13.2). This practice rarely failed to win the attention of white observers who marveled not only at the skill required to carry these baskets, but also at the grace and "uprightness of carriage so peculiar to the whole race."[8]

While these baskets were put to various uses, they were employed principally in the production of rice (fig. 16.1). Lowcountry planters' stated reliance on and preference for the varied and sundry expertise of laborers from rice-growing regions of Africa is well documented. Slaves found in the Lowcountry a climate similar to that in rice-producing areas of West Africa and quickly began growing rice as a preferred dietary staple while teaching crucial aspects of its production to planters. From preferred dietary staple, rice soon became a profitable cash crop in the late seventeenth century. Noting their dependence on African expertise, one planter noted, "we perceive the ground and Climate is very proper for rice cultivation as our Negroes affirme, which in their Country is most of their food, and very healthful for our bodies."[9] Notably, planter reliance on African expertise made possible a whole range of slave-planter negotiations, which granted slaves more control over their lives and afforded key moments in the work week and on Sundays when slaves might steal away to engage in their own pursuits.[10] Many slaves used this time to tend small "provision gardens" or to sell their wares at market. But some slaves had other designs.

Hidden away in "hush harbors" outside the purview of the master class, some slaves used their time away from the fields to ready themselves for rebellion. Writing in *Fighting for Honor*, T. J. Desch Obi traces the development of African-derived martial arts training in the African Diaspora. Combining skills and techniques from a wide variety of African fighting styles, "knocking and kicking" emerged in the Lowcountry as a composite martial art that carried on the legacy of West and West Central African fighting styles.[11] These techniques were often hidden in plain sight during holidays and at community dances. Frederick Douglass, for example, noted that most

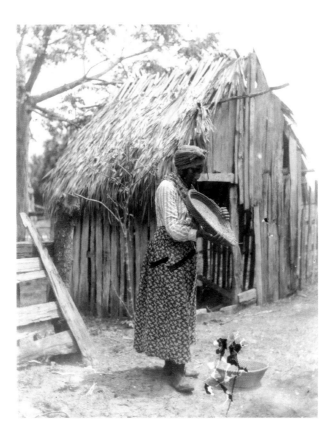

Fig. 16.1. Rebecca Green winnowing rice. St. Helena Island, South Carolina, ca. 1909. Photograph by Leigh Richmond Miner. From the Penn School Collection at the UNC Chapel Hill Wilson Library. Permission granted by Penn Center, Inc. St. Helena's Island, SC.

plantation slaves "spent the holidays in sports, ball playing, *wrestling, boxing,* running foot races, dancing and drinking." Henry Bibb offered a visual representation of these holiday exploits in his own narrative under the title "The Sabbath among the Slave" wherein slaves can be seen dancing, plucking a banjo, knocking, kicking, butting and wrestling.[12] But these entertainments were not designed for mere sport.

John Thornton suggests that at least some of the participants in the well-known Stono Rebellion of 1739 were likely Kongolese soldiers who had been captured and sold into slavery. Given the military expertise that they displayed during the rebellion, they likely received extensive combat training in their homeland. Moreover, their use of colorful banners, military-styled dancing and music, along with their stated adherence to Catholicism, connected them to the social and military cultures of Kongo.[13] On September 9, the Stono rebels marched with "two drums beating, pursuing all the white people they met" until later in the day when, having won early and quick success in the uprising, they stopped in a field and "set to dancing, singing and beating drums to attract more Negroes."[14] The extensive use of drums in the Stono Rebellion immediately calls to mind the close connections throughout the plantation Americas between the cultures of ritual fighting with those of ritual dancing. This blending is very much on display, of course, in the practice of capoeira in Brazil and stick-fighting in Trinidad.[15]

In North America, perhaps no place better illustrated the close connections between song, dance and rebellion than Congo Square in New Orleans (see ill. 14.1). For many, the image of Congo Square is frozen in the anthropological gaze of George Washington Cable's late-nineteenth-century description: "Now for the frantic leaps!

Now for frenzy! What wild—what terrible delight! The ecstasy rises to madness; one—two—three of the dancers fall . . . *boum!*—with foam on their lips . . . No wonder the police stopped it." In this and in other contemporary descriptions, the curious fascination with black dance and drum is inextricably linked to white fears of the same. They knew, as Langston Hughes did, that the "tom-tom cries and the tom-tom laughs."[16] Likewise, Frederick Douglass cryptically noted that the wild cathartic releases of slaves on Sabbath days, festivals and holidays were conductors, or safety valves, serving as the most effective means in the hands of the slaveholders of keeping down the spirit of insurrection among the slaves: "But for these, the slave would be forced up to the wildest desperation; and woe betide the slaveholder, the day he ventures to remove or hinder the operation of those conductors."[17] In this sense, the drums of Stono and those of Congo Square are more alike than different: *the tom-tom cries and the tom-tom laughs.*" Freddi Williams Evans demonstrates in this volume and elsewhere that Congo Square emerged not only as a gathering place, but also as a key crucible combining wonderfully diverse African, European and Native American musical and ritual cultures together toward the creation of black cultural forms. In this process, West Central Africa played a central role owing to the large numbers of Kongolese slaves in the lower Delta region. In particular, Kongo-derived musical instruments provided the soundtrack for much of Congo Square's Sabbath-day dances (see fig. 18.3).

The drums of Stono and Congo Square call to mind the carving that created them. In wood, blacks around the Diaspora carved, etched and scratched together a vocabulary of life and history in the New World. As Nichole Bridges notes in this volume, these carving traditions, drawn largely from Kongolese styles, memorialized the Middle Passage and the larger histories that brought Africans to the plantation Americas. In the Conjurer's Cane (cat. 6.1), multiple generations of African American healers drew on the power of the cane's past, seen in the accumulated bundles of medicines and spiritual elements that are taped and tied to its shaft. At the same time, new generations of healers add their own layers of medicines, thereby increasing the power of the cane. The cane is, in effect, a text to be read, a narrative of its own past. Black artists achieved much the same effect in other media as well.

In clay and other earthen materials, slaves molded a world of meaning. Speaking to WPA interviewers in the 1930s, former slave Shad Hall remembered his grandmother and the "pots and cups that she had made of clay."[18] Shad's grandmother had brought that pottery and the knowledge of how to make it with her from Africa. Well-known examples of African-inspired pottery can be seen in the African-inspired face vessels predominant in South Carolina (cat. 6.21 to cat. 6.24 and ill. 12.1). Very much reminiscent of the *minkisi* tradition in West Central Africa, these vessels were created by potters who were illegally shipped from Kongo to the United States on board the *Wanderer* in 1858, some fifty years after the transatlantic slave trade was officially made illegal. Other famous examples of slave pottery include the colonoware bowls described in this volume by Christopher Fennell (see fig. 12.2 and fig. 12.3, cat. 5.5, cat. 5.6 and cat. 5.7). With a history that extends back to the middle of the seventeenth

century, the provenance of these bowls, their connections to African pottery construction and their persistence over two centuries in the Americas demonstrates the depth of African American culture in North America.[19] These bowls were put to great and varied use by slaves while they were alive but continued to serve them even in death.

In the late nineteenth century, scientist H. Carrington Bolton described the funerary practices of South Carolina blacks, noting that "numerous graves are decorated with a variety of objects, sometimes arranged with careful symmetry, but more often placed around the margins without regard to order. These objects include oyster-shells, white pebbles, fragments of crockery of every descriptions, glass bottles, and non-descript bric-a-brac of a cheap sort,—all more or less broken and useless" (fig. 16.2).[20] A chemist by profession, Bolton could imagine no positive use for what he regarded as so much detritus cast carelessly atop African American graves. He was likely unaware that at roughly the same time, observers of African burial customs were making very similar remarks regarding funerary rites on the other side of the Atlantic. In 1891 *Century Magazine* published E. J. Glave's description of Kongo funerary ritual: "The natives," Glave noted, "mark the final resting-places of their friends by ornamenting their graves with crockery, empty bottles, old cooking-pots, etc., all of which are rendered useless by being cracked, or perforated with holes."[21] Described in this volume by Grey Gundaker, funerary ritual remains one of the richest fields connecting the cultures of West and West Central Africans with those of African Americans (see ill. 16.1 to ill. 16.4). Indeed, Robert Farris Thompson argues that "nowhere is Kongo-Angolan influence on the New World more pronounced, more profound, than in black traditional cemeteries throughout the South of the United States."[22] In this volume, Grey Gundaker and Kellim Brown extend this notion by analyzing African American yard shows (fig. 16.3) configured as hallowed grounds (see fig. 20.2, fig. 20.4, fig. 21.2, fig. 21.5 and fig. 21.6).

Indeed, African American funerary ritual reveals the central, driving theory that defines black folklore and art in the plantation Americas: namely the relationship

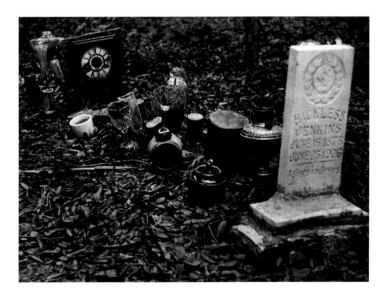

Fig. 16.2. Grave covered with various domestic items: clock, cup, goblet, and pots. Gravestone reads: "Hackless Jenkins, June 15, 1878–June 25, 1926; Asleep in Jesus." Sea Islands, Georgia, 1933. Photograph by Doris Ulmann. Photographic Archive, Library of Congress.

Fig. 16.3. William Winston yard. Charles City County, Virginia. Photograph by and permission from Grey Gundaker, 1998.

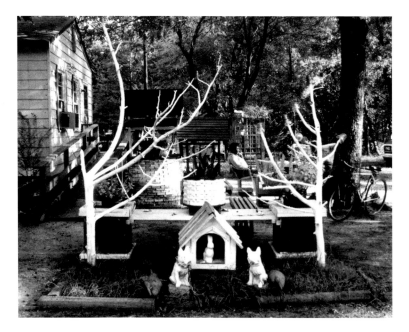

between the dead and the living; between this world and the next. Christopher Fennell, drawing on the work of K. Kia Bunseki Fu-Kiau, details the circular movements of the *dikenga* as a central organizing principle defining life, death and rebirth throughout what might be called the Kongo-Atlantic. In the Americas, this concept animated slave religious beliefs and codified ritual practice toward the care of ancestors, elders and children. To do this properly, enslaved Africans had first to weave and mold and carve and craft objects to be used by the living and placed atop the gravesite after they died. The maintenance of African-derived folk traditions was key in the creation of black culture in the Americas. These skills had to be mobilized much in the manner suggested by poet Kamau Brathwaite, who implores us to:

> . . . build build
> again the new
> villages: you
> must mix spittle
> with dirt, dung
> to saliva and
> sweat, making mortar. Leaf
> work for the
> roof and vine
> tendrils.
> But square frames
> crack, wood
> rots, smooth mortar
> too remains mortal,
> trapped in its own salt,
> its unstable foundations of water.
> So grant, God

that this house will stand
the four winds
the seasons' alterations
the explorations of the worm.[23]

But despite best efforts and sincerest prayers, this work to build and build again—like that of the unseen hand in the greathouse wall that *mark de stone, tackle de stone, an' mek to tear it down*—is often for naught. For, soon enough, "Flame burns the village down."[24]

In many ways, Brathwaite leaves us where we began: in the unending cycles of construction and destruction that perhaps most marked the lives of enslaved Africans. In their varied traditions of weaving, sculpting, carving, dancing and drumming, enslaved Africans insisted on the primacy of their pasts in the construction of new worlds and new ways of being. In their varied forms of resistance in dance and drum, they tended raging flames of discontent. In this vast field of building and destroying, and between cultures of inheritance drawn from Africa and cultures of creativity made in the Diaspora, *Africa is what you make it.*

Notes

1. Williams, *Capitalism and Slavery*, ix.
2. Gilroy, *The Black Atlantic.*
3. Gilroy, *The Black Atlantic*, 48.
4. Thompson, "African Influence on the Art of the United States" (1969), 127.
5. Harris, "Resonance, Transformation, and Rhyme," 134.
6. Rosengarten, "By the Rivers of Babylon," 104.
7. Carney, *Black Rice*, 113, 114; Rosengarten, "By the Rivers of Babylon," 104–5; Rosengarten, "Social Origins," esp. chap. 3: "The Congo Connection"; Schildkrout and Rosengarten, "African Origins," esp. 44–48, 58–77.
8. Morgan, *Slave Counterpoint*, 198–200.
9. Quoted in Knight, "Labor in the Slave Community," 161.
10. Carney, *Black Rice*, 99–100.
11. Desch Obi, *Fighting for Honor*, 84.
12. Quoted in Desch Obi, *Fighting for Honor*, 95.
13. Thornton, "African Dimensions of the Stono Rebellion," 1111. Notably, Thornton makes a similar argument in relation to the Haitian Revolution, noting the presence of military chanting conducted in the Kikongo language. See Thornton, "'I Am the Subject of the King of Congo,'" 181–214.
14. Rucker, *The River Flows On*, 104.
15. Desch Obi, *Fighting for Honor*, chap. 5 and passim.
16. Hughes, "The Negro and the Racial Mountain."
17. Douglass, "Narrative of the Life of Frederick Douglass," 66.
18. Georgia Writers' Project, *Drums and Shadows*, 166.
19. Ferguson, *Uncommon Ground*, 8–10.
20. Bolton, "Decoration of Graves," 214.
21. Glave, "Fetishism in Congo Land."
22. Thompson, *Flash of the Spirit*, 132.
23. Brathwaite, *Arrivants*, 7.
24. Brathwaite, *Arrivants*, 8.

Kongo Ideas and Aesthetics in African American Ceramics

Throughout much of their history in the United States, Africans and their descendants have worked with clay to produce both utilitarian and ritual wares. Early African ceramists in America used the plasticity of clay to create figurative and nonfigural forms that reflected particular ideas and their own aesthetic preferences. By the eighteenth century, African Americans, some of Kongo descent, produced cooking and serving vessels (fig. 12.2, cat. 5.5 and cat. 5.7), and shallow bowls, possibly used as medicine containers (fig. 12.3 and cat. 5.6). In the decade before the Civil War, people of African descent were employed in potteries producing jars, jugs and pots for food and other objects in clay.

At the time, a large concentration of people of African descent, including some from the Kongo region, resided in Middle Georgia and in the Edgefield district of South Carolina. It is possible that Kongolese were employed at the local potteries where workers also produced jars with relief facial features for their own use (cat. 6.21 to cat. 6.24). Reputedly, these face vessels were used on graves or for apotropaic purposes. A small, white clay face vessel (ill. 12.1) may have served as a medicine container, its whiteness evoking the realm of ancestral spirits called to assist in healing.

By the end of the nineteenth century, African Americans adapted clay jars by coating them in plaster and embedding them with mementos of a deceased relative (cat. 6.25 and cat. 6.26). An early example of these memory jars that may have been used on a grave was created in Edgefield around 1880. The presence of shells and ceramic objects on this example and on other memory jars links them to Kongo beliefs about the afterlife and the practice of placing broken crockery and other vessels on the grave. The Bakongo think of the gravesite as both a place of passage between worlds and a meeting ground for the living to communicate with the dead.

Blending the practices of marking the grave as a site of passage with the tradition of placing large, tubular ceramic sculptures on Kongo graves (cat. 4.15 and cat. 4.16) may have carried over into African American cemeteries in the form of pipes inserted on graves. In a cemetery in Florida, a single clay pipe, stamped with the factory name in Milledgeville, Georgia, serves as a marker for a grave. Ramona Austin has identified clay figures that inventive workers in a Middle Georgia sewer pipe factory adapted much like face vessels, with expressive facial features. Austin sees a strong Central African connection to these clay busts, particularly the stamped intersecting oblong patterns that she relates to an ideograph that appears on Kongo textiles, and in women's scarifications especially among the Yombe subgroup of the Kongo (fig. 10.2).

SC

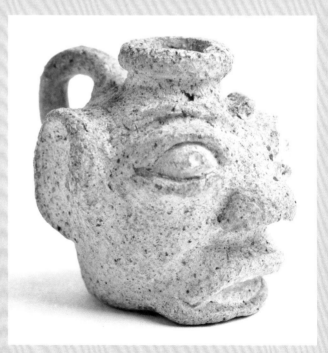

Ill. 12.1. Face vessel, Edgefield, South Carolina, white clay, 1.19 in. (3.04 cm). Collected first quarter 20th century. Charleston Museum, Charleston, South Carolina. Photograph courtesy of the Charleston Museum.

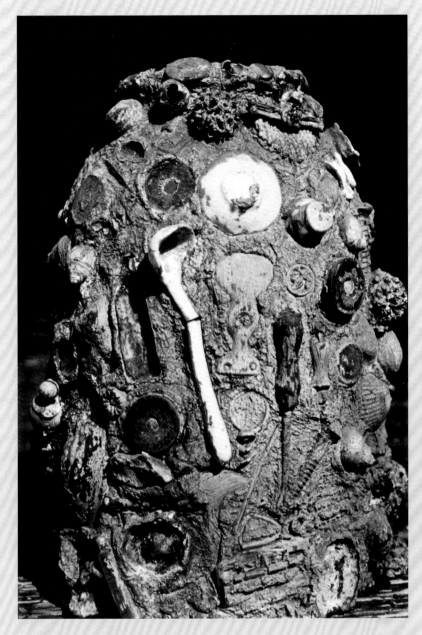

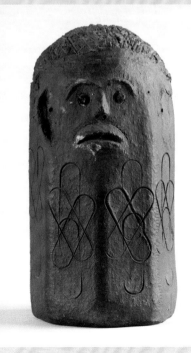

Above left: Ill. 12.2. Memory jar, Edgefield County, South Carolina. Ca. 1870. Pottersville Museum, Georgia.

Above right: Ill. 12.3. Clay pipe grave marker, Gainesville, Florida. Photograph and permission by Scot Smith, 2013.

Right: Ill. 12.4. African American memorial portrait bust, Middle Georgia. Collection of Jane and Bert Hunecke. Photograph and permission by Minh Doan, 2013.

17 ◈

The Kongo Connection

Central African Baskets and Their American Kin

DALE ROSENGARTEN

The African ancestry of South Carolina's famous sweetgrass baskets is a selling point and source of pride for the people who make them (fig. 17.1). Contemporary makers are acutely aware that they are practicing a tradition that has been unbroken for more than 300 years. Within a decade or two after the founding of the British colony of Carolina in 1670, enslaved Africans were producing quantities of coiled baskets. Where in Africa do the origins of Lowcountry basketry lie? A top contender is the Upper Guinea coast, source of a workforce skilled in the production of rice, the crop that became South Carolina's chief export.[1] An equally strong claim can be made for the region of Central Africa that encompasses parts of modern-day Angola and the Democratic Republic of the Congo. Demographically, Upper Guinea and Central Africa each account for roughly 40 percent of the total number of Africans who passed through Charleston harbor. While not rice growers at the time of the slave trade, people from the Congo and Angola were experienced in making coiled baskets to winnow and process a variety of crops, including maize and cassava, both introduced earlier as a result of the Columbian Exchange. Besides similarities in form and function, spiritual connections expressed in the shapes of Kongo baskets that have persisted for three centuries argue in favor of the Kongo's kinship with what is now widely known as Gullah culture.[2]

From the Benguela Highlands to the Lower Congo, abundant grasslands supply the essential ingredient in coiled baskets[3]—the most important factor in determining what kind of basketry is made in any given region. "Bush grass," second only to raffia palm as a basket-making material in the Congo, grew "out of proportion to anything else," wrote G. Cyril Claridge in his 1922 account of a twelve-year sojourn in Africa. Grass was woven into fine cloth and used for house thatch, sleeping mats and vessels of all shapes, including basketry dinner plates, pudding dishes, drinking cups—"unbreakable kitchen ware"—and "artistic little baskets with lids and handles to match"[4] (fig. 17.2).

The peoples of south central and eastern Congo showed great skill in basketry. Using plaiting techniques, they made fish traps, hats, shields, sheaths, sandals; caps

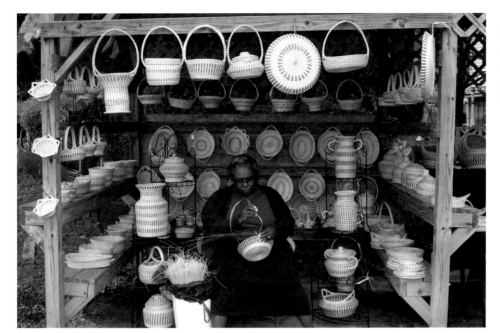

Fig. 17.1. Elizabeth Kinlaw working in her family's basket stand, Mt. Pleasant, South Carolina, 2012. Photograph by and permission from Nancy Santos.

of straw, rushes or palm fiber; and vessels of all kinds. They wove string baskets tight enough to hold water, coating the inside with resin and the outside with red clay or kaolin, so the basket could withstand the heat of a slow fire. "Basket-making," wrote British scholar and imperialist Sir Harry Hamilton Johnston, "is well developed in the Kongo kingdom and in the Kwango-Kwilu-Kasai countries. It is somewhat neglected amongst the riverain peoples of northern Congo, who devoted their energies rather to the manufacturing of pottery or fishing-nets." Except for the Pygmies who inhabited the rain forest, basket making "is an art possessed by all the Congolese in greater or less degree."[5]

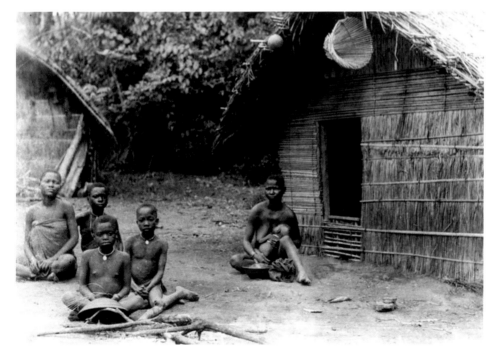

Fig. 17.2. "Coin d'un village indigène, Kongo, Nlenfu, Bas-Zaïre." Photograph by R. P. Gerard, 1909. RMCA Photographic Archives, Tervuren, Belgium, AP.0.0.21068. By permission of RMCA.

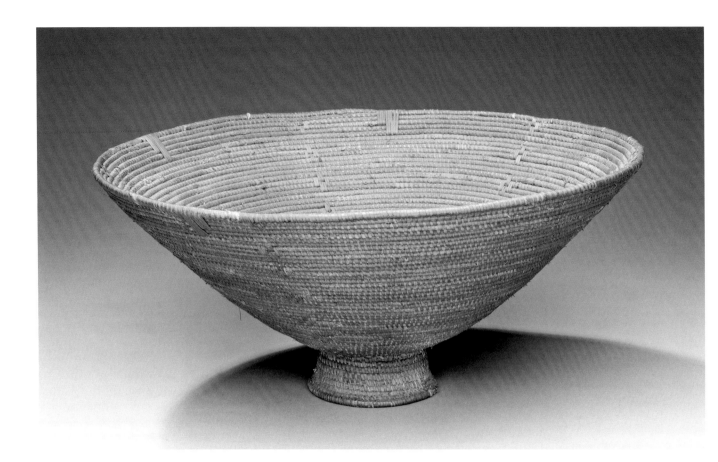

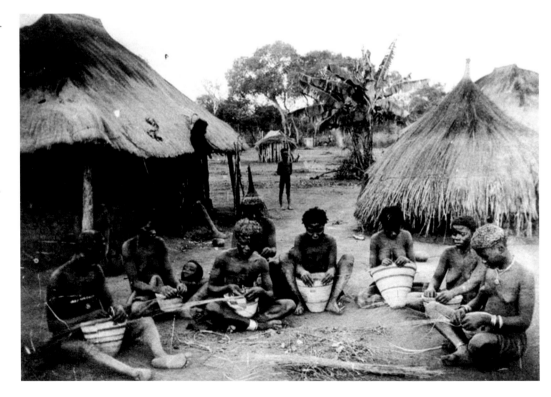

Above: Fig. 17.4. Footed basket. Cataracts region, Lower Congo, DRC. 9 ⅞ in. (25 cm). Collection Royal Museum for Central Africa, Tervuren, Belgium, EO.0.019672.

Right: Fig. 17.5. "Women fashioning baskets: Lunda, Sandoa, Shaba," photograph by R. P. Vandevelde, 1928. RMCA Photographic Archives, Tervuren, Belgium, AP.0.0.24266. By permission of RMCA.

Baskets and basket making in Central Africa were strongly associated with women's work, but men were responsible for making particular forms.[10] As a rule of thumb, men made the baskets they themselves used, including hats, caps, divination trays and other "high-status" baskets; traps, cages and mats; and enormous coiled grass baskets used for storing grain. Perhaps granaries fell into the realm of men because they crossed the line between basketry and building, or because they were of great economic and spiritual importance. This was true in general of baskets associated with power. *Kinkungu*—large covered baskets used for storing valuables—were made exclusively by men. Karl Laman, a Swedish missionary who lived in the Congo between 1891 and 1919, described *kingungu* (an alternate spelling) as "baskets with lids." They were, he wrote, among the "relatively few objects" found in the house of an unmarried Sundi man.[11] The *kinkungu* at the Royal Museum for Central Africa were made by coiling a single, flexible element and passing the binder over two rows at a time, a technique also used in Tshokwe divining trays (fig. 17.6).

The distinctive stepped lids of the *kinkungu* resemble in form the stepped tiers of rocks built on the graves of Kongo kings (see fig. 1.4).[12] The stepped form, I learned, signifies in Kongo cosmology the passage of the soul through birth, life and death.[13] Four steps represent the "four moments of the sun," an idea expressed in its simplest form as four points around a circumference, a cross or a cross within a circle.[14] Three points on the circle—three of the steps—refer to the physical world of the living, and

Fig. 17.6. Tiered-lid basket (*kikungu*), Woyo or Yombe peoples. Lower Congo, DRC. Vegetal fiber, 7 × 17 × 20 in. (17.9 × 43 × 51.5 cm). Collection Royal Museum for Central Africa, Tervuren, Belgium, EO.1988.40.1.

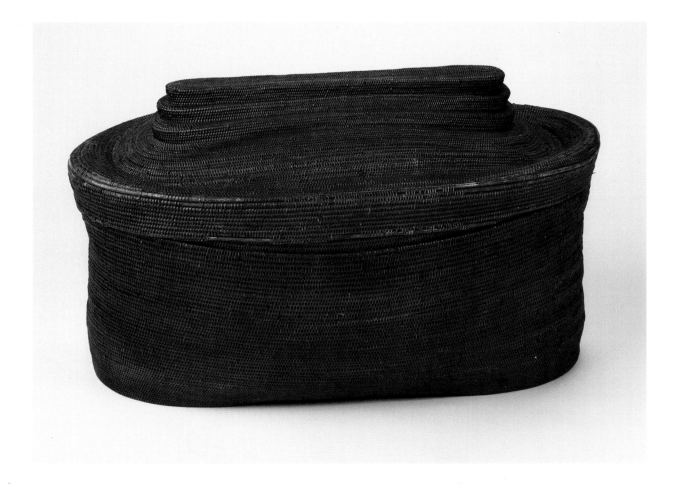

one refers to the spiritual world of the dead. A Kongo basket with a three-tiered lid, I was told by Kongo scholar K. Kia Bunseki Fu-Kiau, would be used only in the upper world, not on a grave.[15]

At the American Museum of Natural History I encountered a covered basket that appears to embody the Kongo "four moments of the sun"—a large coiled container with three cylindrical baskets sewn around the circumference of the lid, and one in the center. The construction of this intricate stacked basket, acquired in 1911, calls to mind a tiered sewing basket made in South Carolina before the Civil War and still produced today, but only by the most experienced sewers. Double and triple baskets were described by David Doar, the last commercial rice planter on the Santee River, as "very neat sewing basket[s]," made from "a finer kind of grass, sewed with palmetto or oak strip." Some baskets were "three-storied, that is, one on top of the other, each resting on the cover of the one below and getting smaller as they went up."[16]

Stepped lids appear on Kongo vessels of various shapes—cylindrical, oblong, some taller than they are wide, others squat (cat. 4.30 and cat. 4.31). The uppermost tier of the lid, which is where the sewer starts the cover, sometimes forms what Lowcountry basket makers call a "nipple" or "knob" (cat. 6.12).[17] A shape or number system that embodies an idea may endure long after the idea is forgotten. The cosmogram that inspired stepped lids on baskets in the Lower Congo may be unknown to Mt. Pleasant basket makers who sew "double" and "triple" baskets, yet these shapes recall three- and four-tiered *kinkungu*. Perhaps it is not coincidental that the numbers three and four, which recur in Kongo diagrams of the universe, also recur in Mt. Pleasant, in the grouping of rows of pine straw to make bands of color on the sides of a basket.

Anthropologist Greg Day has cited the double basket as an example of the African "additive approach to design"—a linear repetition of units that shows up in the African American strip quilt and in the Lowcountry "haul in and play out" or "in and out" basket, named for the technique of "hauling in" and then "playing out" the basket's sides (cat. 6.13).[18] The late Mary Jane Manigault, basket maker and matriarch, told Day that "double [and triple] baskets are usually called twins baskets and triplets baskets, referring to multiple child birth" (fig. 17.7). Manigault, winner of a 1984 National Heritage Award and Day's mentor in Mt. Pleasant, "often said that making a basket was like giving birth and that she never knew how it would turn out until it was finished."[19]

When I suggested to Bernard Gardi at the Museum für Völkerkunde in Basel, Switzerland, that Lowcountry stacked and "in and out" baskets echo the three or four zones of the Kongo cosmos, he cautioned that basketry techniques were so widespread, formal similarities so unconvincing, that I would need to find corroborating evidence, preferably linguistic, to back up the Kongo connection.[20] As Jacky Maniacky's essay "Africanisms in American English: Critical Notes on Sources and Methodology" in this volume suggests, specific links between Kongo and African American languages are difficult to trace because of the great amount of creolization that has occurred. The comparative study of vocabularies needs to be subjected to

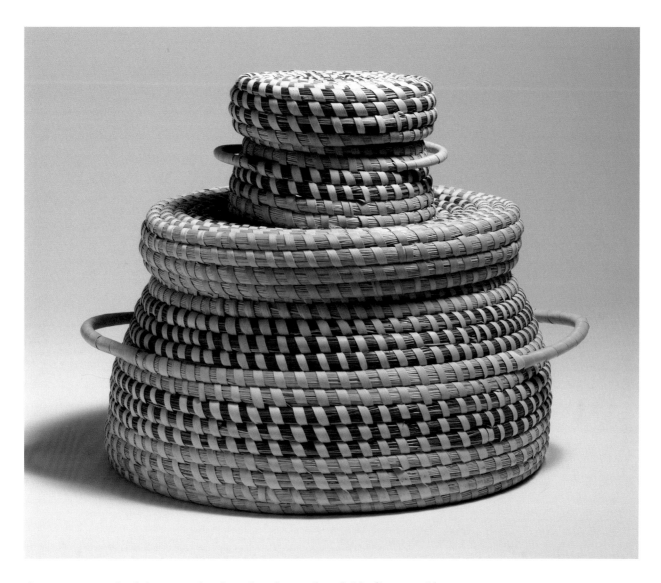

the rigorous methodologies as developed in the modern field of historical linguistics. An example of this is given by Birgit Ricquier in this volume, where she discusses the linkage between Central African terms for peanuts, *mpinda* and *nguba*, with the African American terms *pinder* and *goober*. Maniacky and Ricquier call for a re-evaluation of the glossary proposed by the pioneering American linguist Lorenzo Dow Turner, who claimed to have found two terms with Kongo roots that are related to baskets in the Gullah language. The Gullah '*bundu*, "a basket made of palmetto straw or of marsh grass and sewn with palmetto," he paired with the Kongo *mbende*, "a large basket." The Gullah '*kula*, "a round basket made of palmetto or rush," he suggested, came from the Kongo *nkela*, or "basket."[21]

At least five other African words that mean "basket"—two Kikongo, one Kimbundu, one Yoruba and one Ewe—appear on Turner's long list of personal names.[22] Called "basket names" by Gullah speakers, these nicknames are given in infancy when a child is small enough to fit in a basket. "The nickname," Turner found, "is nearly always a word of African origin," and when it is not African it follows African naming practices. Nicknames alternately referred to the weather or a natural event at

Fig. 17.7. Mary Jane Manigault (1913–2010), double basket, 1985. Sweetgrass, bulrush, palmetto, 13.54 in. (34.3 cm). McKissick Museum, University of South Carolina, 14.37. Photograph courtesy of Karin Willis. Permission granted by Museum for African Art, New York.

the time of the child's birth; to physical or emotional qualities of the child; to the day, season or time of birth; or to an incident or object associated with the child or his or her parents.[23] Turner was the first linguist to systematically study this vast repository of African names. His informants continued to use the old names, even when the meanings were forgotten, "because their older relatives and friends so used them."[24]

Here is an instance, like the stacked sewing basket, where a form or practice, this time a name, persists after its original meaning is lost. Graveyard landscapes, architectural traditions, decorative symbols on pots and tools and slow-stepping dances that crossed the Atlantic only to speed up in the social cauldron of the New World are among the most visible Kongoisms that have proven highly adaptive outside Africa and have taken on new meanings.

In the American milieu, African traditions changed in response to the physical and human imperatives of the new environment. Basket makers learned to use local plant materials, such as white oak and, later, longleaf pine needles. They borrowed European elements, such as cross handles, and developed forms that refer explicitly to "Anglo" sources of inspiration—wall pockets, missionary bags, cocktail trays and thermos bottle baskets, for example. They responded, and continue to respond, to the rise of markets for crafts and works of art. Yet the long evolution of the Lowcountry basket merely highlights values that were always there but were submerged in the cruel era of slave-based rice production. Basket makers believe this is the case. They make new things, as authentic as ever, with cultural competence unfazed.

Notes

1. Schildkrout and Rosengarten, "African Origins," 24–31, 42–44.

2. See Rosengarten, "Social Origins," esp. chap. 3, "The Congo Connection," on which this essay is based; also Schildkrout and Rosengarten, "African Origins," 44–47, 58–77.

3. For a discussion of similarities and differences among cultures of the Central African savanna, see Vansina, *Kingdoms of the Savanna*, 19–24.

4. Claridge, *Wild Bush Tribes*, 215.

5. Johnston, *George Grenfell and the Congo*, vol. II, 808–9. For a profile of Johnston, see Shepperson, Introduction to *The Negro in the New World*, v–xi.

6. Schildkrout and Keim, "Objects and Agendas," esp. 11–17; Mauer, "Representations of Africa," 14–15.

7. Mauer, "Representations of Africa," 18–19; see also Willey, "An Annotated Bibliography."

8. *Publication of the Commission pour la Protection des Arts et Métiers Indigenes*, 15.

9. The Musée de l'Homme in Paris has in its collection even older examples of this type—three baskets acquired in 1873 by M. Charles Jeannest.

10. Among the Sundi, for example, work baskets, carrying baskets and baskets used to dry beans, store pepper and make salt were woven by women; "tube-baskets" (*nseba*) and colorful, patterned *mbangu* baskets were made exclusively by men. Laman, *The Kongo*, vol. I, 142.

11. Laman, *The Kongo*, vol. I, 81–82.

12. I thank the Royal Museum for Central Africa's former head of ethnography, Huguette Van Geluwe, who pointed this out to me. "Occasionally," Joachim John Monteiro wrote, "in the case of a big 'soba,' there are several tiers of earth raised one above the other. . . ." Monteiro, *Angola and the River Congo*, 276–77.

13. Personal communication with K. Kia Bunseki Fu-Kiau, December 2, 1991. For a recent critique of Fu-Kiau and Robert Farris Thompson's promotion of "the Kongo cosmogram as a kind of dominant metaphor of deep Kongo tradition," see Janzen, "Teaching the Kongo Transatlantic," 11–12.

14. Thompson, *Flash of the Spirit*, 113; Thompson and Cornet, *The Four Moments of the Sun*, 43–44.

15. An alternate mapping of the Kongo cosmos, described by Wyatt MacGaffey as "the three-zone model, as it were a stack of plates," begins with a circle divided in four by a cross but interprets it differently. The cosmos is made up of three zones, not four: "the visible world . . . of land and water; the sky, abode of God and the spirits; and the place of the dead." MacGaffey, *Religion and Society*, 46. In this view, a three-tiered basket might represent the whole universe of the living and dead, which MacGaffey calls "the spiral universe" (75)—a particularly apt allusion for coiled baskets.

16. Doar, Salley and Ravenel, *Rice and Rice Planting*, 33–34.

17. Greg Day observes that "most of the anthropomorphic names given to basket shapes by women basket makers refer to female and male body parts such as breast (Nanny), belly, butt (Boodie), (top-knot) nipple and penis (Bedie)." Day, e-mail to the author, September 15, 2012. "Bedie" or "beaty," Kate Porter Young reported, was the sewers' name for the "in and out" basket. Letter to the author, March 14, 1994. It is interesting to note that 'bidi is associated in Turner's list of Gullah personal names with the Kongo word *mbidi*, "an abundance." Turner, *Africanisms in the Gullah Dialect*, 63.

18. Day, "Afro-Carolinian Art," 19. Day also attributed the Charleston triple chest and the Charleston single house to African influences—claims that are hotly disputed.

19. Day, e-mail to the author, September 15, 2012. For a biography of Manigault, see K. Young, "Mary Jane Manigault," 307–21.

20. "Although ethnographic data alone are limited in the extent to which they can answer vital questions about the direction or manner of transmission of a culture trait or complex, a combination of both ethnographic and linguistic evidence can greatly increase the probability of a given reconstruction." H. Lewis, "Ethnology and African Culture History," 30. Language is regarded by anthropologists as a highly stable cultural element, yet it proved "the least likely element of African cultures to survive and develop in the Atlantic world." For a discussion of this anomaly, see Thornton, *Africa and Africans in the Making of the Atlantic World*, 211–18.

21. Turner, *Africanisms in the Gullah Dialect*, 191, 197. All of Turner's references to Kongo "are to the language as spoken in Angola and as treated by W. Holman Bentley in his 1887 *Dictionary and Grammar of the Kongo Language*," 304, n. 14.

22. Turner, *Africanisms in the Gullah Dialect*, 65, 81, 111, 143, 162.

23. Turner, *Africanisms in the Gullah Dialect*, 40–41. The Baptist missionary John H. Weeks cites Kongo names for twins, a child born with teeth, an albino, and so on, and says, "To hear these names is to know at once the birth-history of the person bearing them." Weeks, *Among the Primitive Bakongo*, 116. In the vicinity of San Salvador, Weeks reports, all men and women have a Christian name, or *santu*, from the Portuguese word *sancto*, but also names given by secret societies. In his teens, an individual takes a *santu*, "a Portuguese name Congoised." Over his lifetime, Weeks notes, "a man could possess five names, viz. his birth-name, his selected name, his *santu*, his *ndembo*, and his *nkimba* names." Weeks, *Among the Primitive Bakongo*, 48–49.

24. Turner, *Africanisms in the Gullah Dialect*, 41.

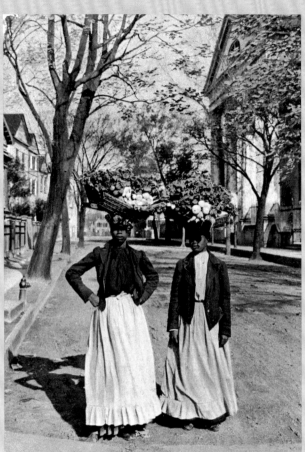

Left: Ill.13.1. "Female vegetable vendors—an every morning scene on the streets of Charleston, South Carolina." Courtesy of South Caroliniana Library, University of South Carolina, Columbia. Postcards char. co. 68.

Below: Ill. 13.2. Harry Fenn (British, 1845–1911). Charleston street scene, etching, 1872. Illustration in *Picturesque America*. Photograph and permission by Randy Batista.

Facing page: Ill. 13.3. Barbara Manigault sewing a basket at her stand in Mt. Pleasant, South Carolina, 2012. Photograph and permission by Nancy Santos.

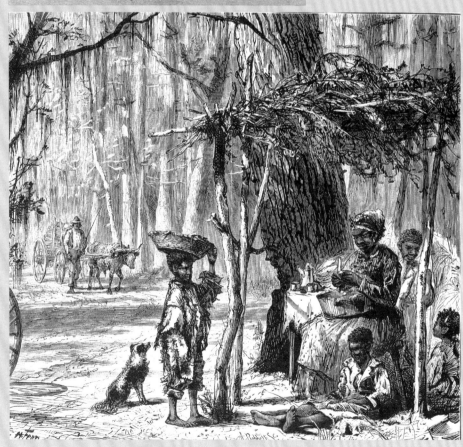

Continuing the Legacy of Lowcountry Coiled Baskets

One of America's oldest Kongo-rooted art forms, coiled basketry, is thriving today in the Lowcountry of South Carolina and Georgia (cat 6.8 to cat. 6.15). With the passage of three centuries, the role of baskets has shifted from agricultural necessity to luxury item to fine art. Early depictions of baskets in use focus on African American workers carrying them in fields, on docksides and in markets (fig. 16.1 and fig. 17.3). Artists painted and photographed female vendors who bore coiled baskets filled with colorful flowers and vegetables on their heads, as seen in a 1908 postcard of the Charleston Market. As need for agrarian baskets waned, men and women began to make baskets for sale and expanded their repertoire to include more decorative forms. Gradually, women took over much of basket production, selling their wares from roadside stands and markets. Women still dominate the coiled basket market and have honed their entrepreneurial skills as they have developed websites, shown at national art fairs and worked on commissions for individuals and institutions, including major museums. For some, basket making is a full-time career. Other contemporary basket makers have had dual careers throughout their lives or have devoted themselves to making baskets full time after retirement from other professions. Contemporary basket makers say they devote themselves to "sewing" (making coiled baskets) for the pleasure it brings them, more than economic advantage. Elizabeth Kinlaw, a Mt. Pleasant basket maker whose family has made baskets for generations, remarked that they sew because they want to continue a tradition that has been important to their families, and because they are proud of coiled basketry's historical and aesthetic value as an African American art form.

SC

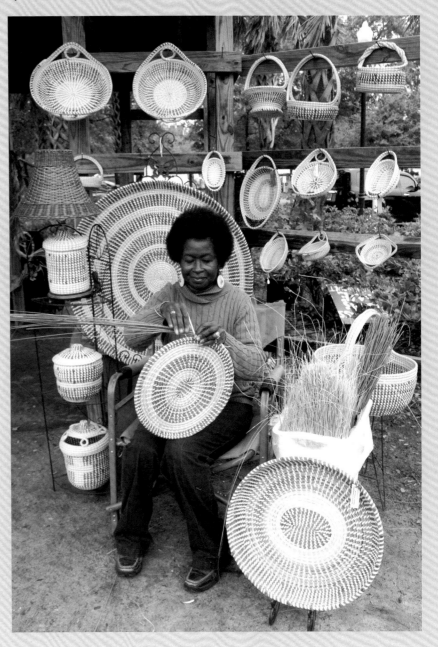

18 ◇

Kongo Music and Dance at New Orleans's Congo Square

FREDDI WILLIAMS EVANS

Congo Square on Rampart Street was one of several places in New Orleans where enslaved Africans congregated from the earliest days of the city until 1817 when a city ordinance made it their only gathering place (fig. 18.1). African descendants, enslaved and free, gathered there by the hundreds—sometimes thousands—discontinuously on Sunday afternoons until within a decade of the Civil War.

Those gatherers represented the numerous ethnic groups that slave traders brought to Louisiana. Under French rule, less than one third of the Africans originated in the Kongo-Angola region, but during the Spanish and American periods, the Kongo nation represented the largest group brought to Louisiana. By 1820, most of the Africans in Louisiana were of Kongo-Angola origin.[1]

Referring to this nation, George Washington Cable wrote, "These are they for whom the dance and the place [Congo Square] are named."[2] The Congo dance, to which Cable referred, was also observed in other parts of the city, and eyewitnesses wrote about it more than any other African-derived dance. The 1900 *Times Picayune Guide* noted that hundreds of white spectators came to Congo Square to see the Congo dance.

One of the spectators was Benjamin Latrobe, who in 1819 sketched musical instruments (fig. 18.2 and fig. 18.3) and wrote about the circles of dancers and musicians. Gatherers encircled performers and clapped, stomped, shook gourds, sang songs—often in call-and-response style, and replaced fatigued dancers.

In one circle, Latrobe observed two women holding handkerchiefs by the corners as they danced in a slow fashion, making slight, measured steps to the music of drums and a string instrument while the gatherers sang an African song in call-and-response style.[3] Latrobe's brief description contains key features of the Congo dance; one of the drummers in that circle straddled his drum while playing with his hands—a cultural practice of Kongo origin (see, for example, fig. 2.3 and fig. 9.2). The absence of male dancers in this account suggests that they may not have entered the dance before Latrobe left that circle.

Fig. 18.1. Congo Square, New Orleans, Louisiana, 2013. Photograph by Ned Sublette.

Fig. 18.2. Benjamin Latrobe. Sketch of musical instrument from Congo Square. From *Latrobe Journal IV*, February 21, 1819. Courtesy of the Maryland Historical Society, MS2009.

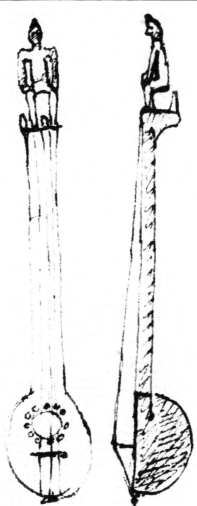

Some sixty years later, Lafcadio Hearn wrote that he, along with many others, had witnessed this dance in New Orleans.

> . . . they danced the Congo, and sang a purely African song . . . That sort of accompaniment and that sort of music, you know all about: it is precisely similar to what a score of travelers have described . . . As for the dance—in which the women do not take their feet off the ground—it is as lascivious as is possible. The men dance very differently . . . leaping in the air.[4]

Hearn added that the women writhed their bodies and swayed in undulating motions from ankles to waist, and the men leaped about with small bells strung around their ankles. When Hearn asked some of the women to recite the song, they replied that he could never understand it. "*C'est le Congo!*—It is the Congo!" they stated.

Over time, a Creole song, "*Quan Patate-Latchuite*" ("When the Sweet Potato Will Be Cooked") also accompanied the Congo dance in Congo Square and other places. In the early 1900s, New Orleans native Alice Nelson Dunbar wrote that every child in New Orleans could sing the melody to the Congo dance.[5]

The Bamboula dance, of Kongo origin and closely related to the Congo dance, was also performed in Congo Square, as was the Juba dance, which derived its name from the Kikongo verb *zuba*, meaning "to slap." Art historian Robert Farris Thompson found that the dance itself derived from *nzuba*, a thigh-slapping dance of Kongo origin.[6]

Along with specific performance practices, certain musical instruments originated in the Kongo. The practice of the drummer straddling his drum while playing with his hands and pressing the heel of his foot against the drum's head to alter the tone originated with the Kongo nation. Latrobe's sketches included such an image as well as that of a stool-shaped drum that also existed in regions of the Kongo, and

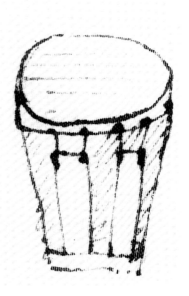

Fig. 18.3. Benjamin Latrobe. Sketch of musical instrument from Congo Square. From *Latrobe Journal IV*, February 21, 1819. Courtesy of the Maryland Historical Society, MS2009.

drummers played it using the same concept. The drummer sat on the ground and situated the instrument so that his toe touched the drum's head from underneath to alter the tone as he played with his hands.

The practice of scraping an animal jawbone with a stick or other metal object was common in Congo Square. This concept was not unlike an instrument used for scraping among the Kongo in the Lemba society (see cat. 3.7). A prototype for this concept is also found among the Kumbundu-speaking people of Angola in the form of a notched board that musicians rubbed with a stick. The instrument, referred to as the *cassuto*, was widely imitated in Congo Square as well as among black musicians in Louisiana and was not unlike the practice of scraping washboards as seen today in Zydeco music (see also scraped instruments in fig. 9.1).[7]

Other instruments with Kongo-derived prototypes include the *cata*, a small version of the slit drum, which musicians used to accompany the Congo dance and which existed among the Banda-linda people of Central Africa. The lamellophone (also *mbira*, *kalimba*) and bells, gourd rattles and scrapers are among the numerous idiophones as well as wind and string instruments played in Congo Square that were made similar to instruments found among the Kongo (see Kongo examples in cat. 3.22, cat. 3.23 and cat. 3.30).

The influence of Kongo music and dance in New Orleans did not end with the Sunday gatherings. The Congo dance as well as the name existed in the city for more than a century, and spin-offs from the dance included the Shake Babe and the Shimmy. The habanera rhythm that embodied the music and dance lay at the core of early New Orleans jazz, and variations of that rhythm embody the present-day New Orleans second-line beat and Mardi Gras Indian chants. Such longevity, prevalence and influence affirm the resilience of cultural memory and the impact of Kongo-Angola culture on the city. Indeed the Kongo music and dance in New Orleans' Congo Square influenced local music and dance as well as that of the nation and the world.

Notes

1. Hall, *Slavery and African Ethnicities,* 70–74.
2. Cable, *Dance in Place Congo,* 6.
3. Latrobe, *Journals,* 204.
4. Bland, *Life and Letters,* 331.
5. Dunbar, "People of Color in Louisiana: Part II," 361–376.
6. Robert Farris Thompson, "Kongo Carolina, Kongo New Orleans."
7. Evans, *Congo Square,* 71–74.

Remembering Congo Square

In the eighteenth and nineteenth centuries, hundreds of enslaved Africans and free people of color flocked to a spot behind the city of New Orleans on Sunday afternoons to sing, dance and buy and sell goods and produce. There they could use African languages and practice ancestral beliefs. African songs and dances based on African rhythmic patterns were played on instruments manufactured following African prototypes. The square has always captured the imagination of both New Orleanians and visitors to the city. In the 1880s, illustrator E. W. Kemble imagined how it might have been in earlier days, illustrating the Bamboula dance as described by past visitors.

Congo Square has been known over time by different names: Place de Negres, Place Publique, Place Congo, Circus Place, Circus Park, Circus Square or Beauregard Square. In 1993, it was officially renamed Congo Square and was added to the national register of historic places. Today, it is but a nook in the cultural center, in the shadow of the Municipal Auditorium and adjacent to Louis Armstrong Park. It lies between the French Quarter and the Treme neighborhood, which played a dramatic role in the development of New Orleans jazz. Today its memory is recalled as groups gather to perform and to pay homage to the city's African past and to perform African-related music with brass bands, dances and drum circles.

RP

Below: Ill. 14.1. E. W. Kemble. *The Bamboula*, 1886. From Century Magazine. Courtesy of Cornell University Library, Making of America Digital Collection.

Facing page, top: Ill. 14.2. *Duke Ellington & Mahalia Jackson at First New Orleans Jazz Fest*, Congo Square, 1970. Photograph by Michael P. Smith. By permission of The Historic New Orleans Collection, 2007.0103.2.205.

Facing page, middle: Ill. 14.3. Chuck Davis performing ritual in Congo Square, March 2013. Photograph and permission by Bruce Sunpie Barnes.

Facing page, bottom: Ill. 14.4. Drum circle in Congo Square, New Orleans, March 2013. Photograph and permission by Dr. Freddye Hill.

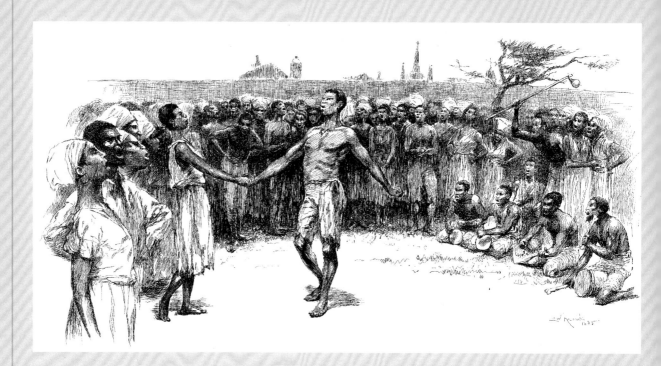

19 ◈

Nineteenth-Century Americans Shed Light on Kongo

MATHILDE LEDUC-GRIMALDI

> "La première question que l'on fait aux voyageurs est de leur
> demander s'ils ont pénétré bien loin dans l'intérieur."
> L. de Grandpré, 1801

When the Florida territory became the twenty-seventh state of the Union in 1845, slavery was still in common use in the country, the freed-slave settlement under the patronage of the American Colonization Society (ACS) in Liberia was about to declare its independence (1847), the Congo River was unknown to Europeans for most of its course and the famous American traveler-to-be Henry Morton Stanley was a poor illegitimate Welsh boy of four.

Twenty years later, after a deadly civil war, slavery was abolished in the United States. For many of the freed slaves, even though getting back to Africa could possibly mean healing for those who had endured the terrible wrench from their mother country, repatriation was not even contemplated. With no connections across the ocean, and with too few tracks to their ancestry, the newly freed slaves who had survived multiple transports across the ocean and over the American continent could only raise the name of "Africa" as a common bond.

The Bakongo, whose kingdoms Portuguese travelers had described as early as the fifteenth century, were certainly one of the best-known political entities of all peoples of West Central Africa by European merchants. Established along the west coast (roughly from Pointe Noire to Luanda) and the banks of the lower Congo River, they were well connected with the populations of the hinterland and ready for participating in globalized trade. Though Christianized, they were the main suppliers of slaves for the Atlantic slave traders. As a consequence, human beings of these kingdoms and neighboring countries should have been best known had Americans of the time been interested in the culture of their enslaved laborers. But no ethnological inquiries were conducted among them to discern more about African groups or individuals.

Thus, representations of Kongo culture started passing to us through the early accounts of the slave traders. One, the French captain L. de Grandpré, who knew rudiments of Kikongo, gave a lively description of the matrilineal devolution of the nobility.[1] His own drawings from life, like the burial of the "Mafouc Andris Poucouta, macaye" are more informative than the same scene reported a century later by Pierre de Brazzà, near the Mission of Linzolo.[2] De Grandpré drew an interesting portrait of Tati, his associate in the slave trade, wearing the cap of dignitaries (fig. 19.1). The weaving pattern and the shape of his cap is strikingly close to the headdress (early twentieth century) in the Royal Museum for Central Africa (cat. 2.24), thus giving evidence of the persistence of customs and techniques.

By the 1870s, learned societies of Europe had long been editing instructions for travelers—adventurers, merchants or missionaries, whatever their motivations for traveling—and were eager to obtain information, objects, skeletons, animals dead or alive, maps or more simply representations of the little or unknown parts of Africa. The Kongo region was not the most attractive area, especially for English travelers, who were certainly the most numerous of all. With the support of the Royal Geographical Society, the British were trying to reach Central Africa via the Nile valley, from Zanzibar, or from their settlements in South Africa. Americans, who were more centered on their own country at the time, were even less concerned. The region was more attractive for French-speaking travelers who started their journey inward from the French outposts on the coast of Gabon.

Fig. 19.1. "Tati surnommé Desponts, courtier de Malembe, venant de sa petite terre, en hamac." Illustration in de Grandpré 1801. By permission of the Library Company of Philadelphia.

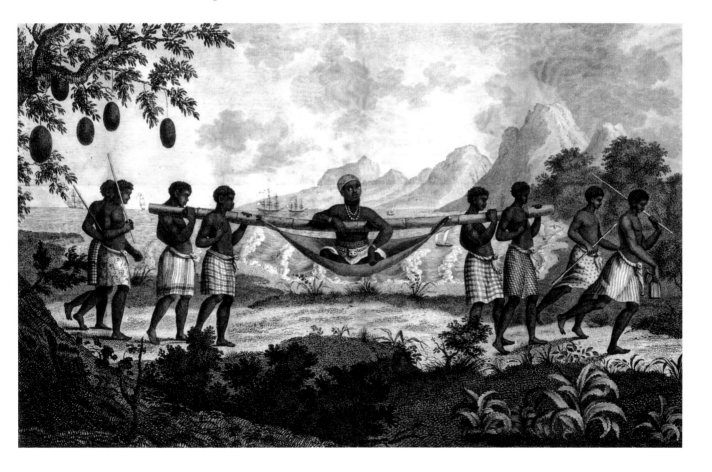

However, representing the inner Kongo area fell to two English-speaking travelers, both Americans by adoption, one, born French, Paul Belloni du Chaillu, the other Henry M. Stanley, born Welsh. Paul Belloni du Chaillu was quite unknown when he left America in 1855 with the intention of exploring the territory between latitude 2° N. and 2° S., "as far as I should be able to penetrate." Three American learned societies had given him their patronage: the Boston Society of Natural History, the Geographical and Statistical Society of New York and the American Ethnological Society. The narrative of his four-year expedition, though more oriented toward fauna and especially gorillas, abounds with illustrations and details on the various peoples he encountered.[3] His first book was ill-received in England, as he stated in his second book: "the accounts of animals and native tribes stigmatized as false" and his "journey into the interior pronounced a fiction."[4] However, among the objects collected and his many drawings of tools, musical instruments, and weapons published in his book, he brought back much new information concerning the Kongo peoples.

Two objects are relevant to our topic: "Idol of the slaves" and "Bag with poisoned arrows," made of animal skin, which echoes the idea of the bundle excavated at Annapolis, Maryland (fig. 13.1a, fig. 13.1b, and fig. 13.1c). Du Chaillu described "a small bag which is suspended round the neck or to the side of the warrior. This bag is made of the skin of some rare animal, and contains various fragments of others, such as dried monkey's tails, the bowels and claws of other beasts, shells, feathers of birds, and ashes of various beasts."[5] The missionary Robert Hamill Nassau, who spent the last quarter of the nineteenth century in the interior of Gabon, reports in *Fetishism in West Africa*:

> They say there is one great spirit, who rules over all the other spirits; but they worship and sacrifice to the spirits of ancestors, so far as I can learn, and have a mass of fetich medicines and enchantments. The hunter takes one kind of charm with him; the warrior another. For divining they have a basket filled with bones, teeth, finger-nails, claws, seeds, stones, and such articles, which are rattled by the diviner till the spirit comes and speaks to him by the movement of these things.[6]

His notes about religious beliefs of the Kongo people are quite interesting since we can follow their persistence over more than half a century, whatever disruptions the scramble for Africa might have brought to them.

Henry M. Stanley was the first to travel down the lower Congo River at the end of the Trans Africa Anglo-American Expedition (August 1877). He was famous as a journalist after his search for Dr. Livingstone, and sneered at by the Royal Geographical Society for a while, but his outstanding success in mapping the Congo's course won him world recognition and the attention of Leopold II, king of Belgium. By 1879, Stanley was again at the mouth of the river, to build stations along the Congo for the International African Society, which would be the first step to colonization. While taking hold of the country for Leopold II, Stanley provided an account of life in the villages and encounters such as those he had with chief Lusalla of Banza Uvana and

his medicine man and their "great gods." "In this village, there is a double-headed wooden bust, with its crown adorned with old iron scraps and bits of mirror glass, and two wooden idols, about 4 feet high, ferocious in appearance, placed under a small shed, as a chapel, I suppose."[7] In the engraving that illustrates this in his publication (fig. 19.2), two figures stand, closely resembling the types of anthropomorphic power figures (*nkisi nkondi*) in *Kongo across the Waters* (cat. 4.1 and cat. 4.2). One may note in the center a "native" supposedly bowing and praying to his "gods."[8] Although there is no mention of him in the text, a photograph on which the drawing is surely based shows a man to one side, definitely not in the act of prostrating himself but more in a pose of lamentation (fig. 19.3). Artists very often took the liberty of fanciful additions to illustrations under the pressure of publishers to please their readers' imaginations. Many examples of sketches from life created by travelers, or even photographs they took, demonstrate that artists in Europe reworked them. On the other hand, Verney L. Cameron's visit to the king of Kongo ends up in a drawing much less informative than the story itself.[9] This shows the limitations of illustrations, which are not always true or sincere, and some are even completely made up. But the public was unceasingly avid for images.

Very early on, travelers recognized the need for pictures that could be used upon their return in publications about their adventures (fig. 19.4). Stanley's publishers mentioned the number of sketches he was to provide with his text. Then the images

Left: Fig. 19.2. Drawing of "Fetish Idols." Published in Stanley 1885.

Right: Fig. 19.3. Photograph of a person kneeling in front of two *nkisi* figures. Published in da Cunha Moraes 1885.

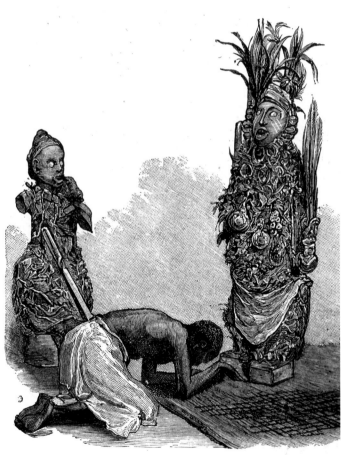

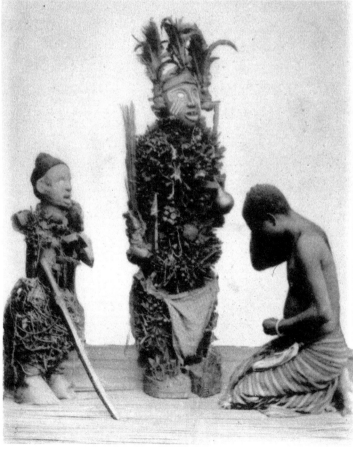

Fig. 19.4. Anglo-American quarters at Kabinda, August 1877, from *Album Congo*, Inv. 5154. *The Anglo-American Expedition (1874–1877)* (1880), Inv. 38. The Henry M. Stanley Archives, property of King Baudouin Foundation, held in trust at the RMCA, Tervuren, Belgium.

Fig. 19.5. "On the Manyanga Plateau," photograph turned into a lanternslide, from the Henry Morton Stanley expedition. RMCA photographic archives, Tervuren, Belgium, HO 1954.72.297. By permission of RMCA.

could "travel" between English and American publishers, but they were also sent to France or Germany in order to make the launching of the book an international event.

Images were a must for the lecture tours organized in Europe and the United States. The great majority of the travelers, after paying their respects by appearing before the learned societies, engaged in tours to promote their books or only to earn their living and finance their next expedition. From du Chaillu to de Brazza to Stanley, pictures and lantern slides greatly contributed to accounts for the armchair audiences of their travels into Kongo countries (see fig. 19.5 for an example).[10] But unfortunately, raising interest and better knowledge of the Kongo peoples in Europe and the United States coincided with colonization and loss of freedom, and led to the show of disturbing "African villages" in international exhibitions.

Notes

1. L. Grandpré, *Voyage à la côte occidentale d'Afrique*, vol. 1, 98. Louis Ohier de Grandpré knew the slave trade very well for having been a trader himself. He was also a member of the Société de Géographie de Paris.

2. de Brazzà, *Trois explorations dans l'Ouest africain*, 361.

3. du Chaillu, *Explorations and Adventures*.

4. du Chaillu, *Journey to Ashango-Land*, v.

5. See du Chaillu, *Explorations and Adventures*, 78 (drawing of a leather bag), 96 (content of a fetish-bag) and 238 (idol). X-rays of the Fleet Street Bundle discussed by Mark Leone and colleagues in this volume show that the leather sack contained metal shot, nails, pins and a Native American axe head.

6. R. H. Nassau (1835–1921) was sent to Gabon by the American Board of Commissioners for Foreign Missions. He narrated his life in *My Ogowe*, published in 1914, with many photographs. The quotation is from Nassau, *Fetishism in West Africa*, 115; for an example of a basket *nkisi*, see cat. 4.9.

7. Stanley, *The Congo and the Founding of Its Free State*, vol. 1, 199–200.

8. The image was previously published and discussed in Vanhee, "Agents of Order and Disorder," 90–91. The image is derived from a photograph published in da Cunha Moraes, *Africa occidental*.

9. Cameron, *Across Africa*, 413.

10. See "Du Chaillu's Lectures for the Young Folks"; Stanley's Lectures Route in the United States, 1890–91, at the King Baudouin Foundation/Royal Museum for Central Africa, Stanley Archives, Inv. 5086; Lecture flyers, Henry M. Stanley, June 1891 (British tour), December 1891 (Sydney), at the King Baudouin Foundation/Royal Museum for Central Africa, Stanley Archives, Inv. 5089; Lanternslides collection, Royal Museum for Central Africa, Tervuren, Belgium, Inv. 6995.

Kongo in the Engravings of Pieter van der Aa

Pieter van der Aa, who lived from 1659 to 1733, was a Dutch publisher best known for preparing maps and atlases. These three engravings of the Kongo king and his nobles were part of a plate of four images, published in 1706–8 and again in his 1725 *Galerie Agréable du Monde*. This hefty twenty-seven-volume work was typical of the lavishly illustrated works of Dutch cartographers in the Enlightenment era. The *Galerie Agréable* became a standard reference for Europeans, priming them for further expansion into Africa, Asia and the Americas with romanticized views of the exotic plants, animals and people they might encounter. Since Diego Cão's late fifteenth-century encounter with the Kongo kingdom, European fascination with the Bakongo had shaped and been shaped by artistic renderings, such as in Olfert Dapper's *Naukeurige beschrijvinge der Afrikaensche gewesten* [description of Africa] in 1668. These renderings, however, were rarely based on firsthand observation. Dapper also has an illustration of the Kongo court, but his lacks the overt Europeanization of Van der Aa. Van der Aa's Kongo king is seated on a throne, upon a draped and plumed dais, surrounded with prostrate subjects, bowing Europeans and elegantly dressed nobles. Some elements such as the weaponry in the drawings of soldiers and noblemen may be based on more careful observation. For the most part, however, the figures, their attire and architectural forms bear more resemblance to medieval Europe than West Central Africa in the eighteenth century. Exoticized and romanticized views of the Bakongo waned in the next century, and by the advent of the colonial era visual media focused on the perceived degradation of Africans, to more fully glorify Europeans in their conquest of Africa.

SC

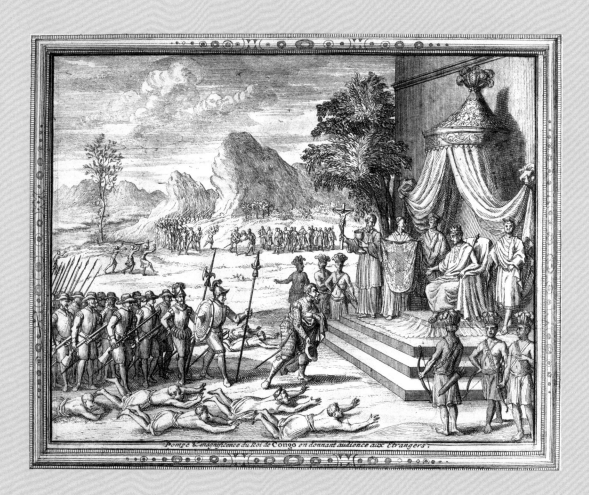

Pompe & magnificence du Roi de Congo en donnant audience aux Etrangers.

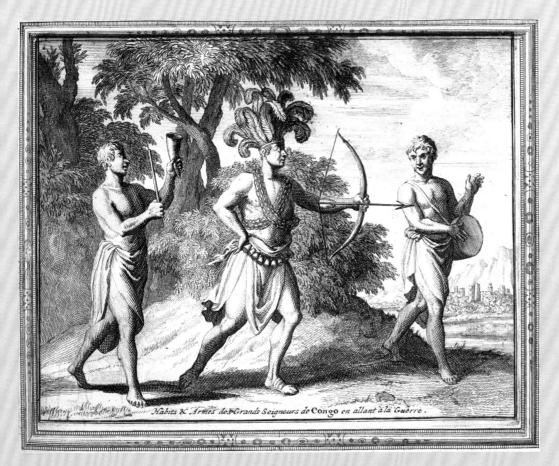

Habits & Armes des Grands Seigneurs de Congo en allant à la Guerre.

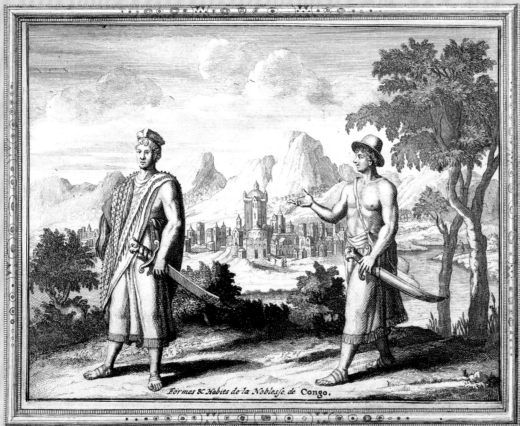

Formes & Habits de la Noblesse de Congo.

Facing page: Ill. 15.1. *"Pompe et Magnificence du Roi de Congo en donnant audience aux Étrangers"* ("The pomp and magnificence of the king of Kongo granting an audience to foreigners"). Copperplate engraving, in Pieter Van der Aa, *Galerie Agréable du Monde*, 1725. Plate size 19.3 × 14.8 in. (49 × 37.5 cm); image size approx. 16.3 × 13.4 in. (41.5 × 34 cm). Harn Museum of Art collection, 2012.59. Photo by Randy A. Batista.

Left: Ill. 15.2. *"Habits et Armes des Grands Seigneurs de Congo en Allant á la Guerre"* ("Clothing and weapons of the great noblemen of Kongo going to war"). Copperplate engraving, in Pieter Van der Aa, *Galerie Agréable du Monde*, 1725. Plate size 19.3 × 14.8 in. (49 × 37.5 cm); image size approx. 16.3 × 13.4 in. (41.5 × 34 cm). Harn Museum of Art collection, 2012.59. Photo by Randy A. Batista.

Below: Ill. 15.3. *"Formes et Habits de la Noblesse de Congo"* ("Appearance and clothing of the nobility of Kongo"). Copperplate engraving, in Pieter Van der Aa, *Galerie Agréable du Monde*, 1725. Plate size 19.3 × 14.8 in. (49 × 37.5 cm); image size approx. 16.3 × 13.4 in. (41.5 × 34 cm). Harn Museum of Art collection, 2012.59. Photo by Randy A. Batista.

20 ◈

"Seeing Kongo"

A Lens on African American Landscapes

GREY GUNDAKER

> Habit is a full-grown mountain, hard to get over or pull down.
> Kongo proverb

Essays in this catalog offer persuasive evidence that the complex linguistic and cultural matrix summed up as "Kongo," as well as the kingdom of Kongo itself, are generative roots of "America" as we know it. Although it is impossible to trace provenience for all of Kongo's reach into the present, knowledge of Kongo philosophy and aesthetics expands opportunities for seeing what Americans perform and make.[1]

The questions that frame this essay come from looking back through twenty-five years of research on African Diaspora landscapes, mainly in the southeastern United States. Far from typical, these places were marked as special because their makers worked to make them so. Many contained references to special powers of sight: figures with carefully positioned lines of gaze, images of eyes over doors and windows, eagles with exceptional vision—recalling birds on staffs in this volume and accompanying exhibition (fig. 7.1 and cat. 6.20)—and much more.[2] Yet neighbors and passersby often saw only a mess because these places contained old objects, asymmetrical arrangements and plants and trees allowed to flourish in emergent patterns of growth. Along with relics of the past, which were frequently painted white, these areas often contained reflective materials strung in the shrubs and trees (fig. 20.1). Most were separated from a more formal, symmetrical area closer to the house. Graves in some of the oldest cemeteries I visited had offerings like those in the "wilder" areas of yards. I tried to show how these places meshed with Christianity while adding avenues of ancestral memorialization that were not part of European-oriented Christian practices.

This process offered an education in vision that profoundly altered how I understand the world. Now, rather than covering this ground again, I ask what "Kongo" gave me and what "America" would look like without "seeing Kongo" here. With no

Fig. 20.1. Glasses with one lens in, one out: sight of both material and immaterial dimensions of reality. Bennie Lusane, Royston, Georgia, 1992. Photograph by Grey Gundaker. By permission of author.

"Kongo" lens, what kinds of vision would remain? What categories would name, sort, and judge places like those where I was welcomed? How would Americans handle anomalies to their habitual categories? What modes of vision would be left to project onto African descendants, African American arts and widening diasporic influence in everyday life, the arts and global media?

Most of the answer remains all too apparent. When white observers described African American grave offerings at the turn of the twentieth century, they found them lacking in order and decorum when compared to their own customs. From a research standpoint, one might also add that the philosophies and practices of other African peoples brought to the Americas from Senegambia through the Bight of Biafra and southward also enrich the mix of alternatives when dominant American discourses fail. Yet how many Americans ever look anywhere in Africa for understandings of ordinary landscapes? Aside from researchers, those who do are *already* keenly aware of biases built into "America" as an ideal and know from hard experience that racism has been editing the nation's vision for more than three centuries.

Yet even those who are alert to erasure of African contributions would still find scant guidance for serious transatlantic research without Kongo. Robert Farris Thompson's chapters in *The Four Moments of the Sun: Kongo Arts in Two Worlds,* published in 1981, mark the first effort to explore in depth how the arts and thoughts of an African people informed art making in the African diasporic United States before the final quarter of the twentieth century.[3] Since then much work has taken up the

challenge to go forth and learn.[4] Yet little seems to have changed in what "America" can see.

Figure 20.2 is a case in point. Shot through a car window at a traffic light in a working-class black neighborhood in Memphis, Tennessee, this image is part of an archive I made to map the geographic scope of practices found in places I came to know well. When I show it to students they gamely list what they see: a statue of a snail and a toilet on either side of a door. The students use the best-fitting categories they know, yet realize these can't be adequate. This makes some angry: how to get an A when the right answer seems to be "toilet"? When I ask why someone might place these objects beside their door, the predictable reply is "poverty." Maybe the person could buy only one snail and had to stick whatever they had on the other side.[5] But a toilet?

Art-aware students bring along more to work with. They've seen Picasso's bicycle bull head; the notions of eye-play and abstraction aren't alien. Some remember Marcel Duchamp's urinal. But this raises more worries. Picasso and Duchamp are "great artists." If the snail-toilet pairing isn't an accident but instead a purposeful conversation among materials and degrees of abstraction that some nobody in Memphis can create—or worse, if, as the teacher argues, such arrangements are relatively commonplace—then what happens to the uniqueness of great art? Here, some art-aware students hit a wall. Either they must radically revise their assumptions about art or insist on explanations like happenstance and poverty. A few find a loophole: even if the Memphis nobody created an amazing visual analogy on purpose, it is still *nowhere*.

Great artists intervene in the capital-A Art World at key moments: found objects and *assemblage* radically altered vision in Modern Art. Picasso and Duchamp have philosophy, history, politics; they are instantiating Ideas That Matter at the right time and place.

But what if Art, rather than pushing vision to see more, pushes it to see less? What if people learn to look harder within the Art frame but concurrently learn to write off art everywhere else as simply "daily life" with extra embellishments?

Although it spills into the Art World, the mode of vision I associate with "Kongo" manifests materially in a struggle to channel daily life away from negativity and toward productive relationships. Art making—stylizing and foregrounding bits of the everyday for strategic purposes—makes landscape a repository of reminders that mature people should perceive reality as a continuous intersection of multiple dimensions. The surface dimension seductively promises that it is trustworthy. Falling prey to this seduction makes people vulnerable to lies and self-delusion and tips society out of balance because its members fail to recognize how the past is at work in the present. Such narrow vision also beguiles us into irresponsible obliviousness about the consequences of actions for those around us and in the future. Women and men adept at making this point visually and materially assume responsibility for reminders to look beyond surface impressions, not because they want to change the course of art but because their particular gifts make them specialists in the pedagogy of sight.

Further, *past*, *present* and *future* parallel *life*, *death* and *transition*: a mobile network represented through a repertoire of signs that emphasize cyclical movement. The snail shell is a Kongo sign of the spiral of transition and the snail's glistening trail a classic emblem of mediation—*across the waters*.[6] But even if the Kongo history of these signs is long forgotten, the spiraling action remains for anyone who sees "art in motion." The toilet becomes a perfect double for the snail and an abstract extension of its salient qualities, pushing them from the literal toward the unseen. Like silent offbeat notes between sounded ones in polymetric music, water that spirals around the pure white vessel is a present absence. Further, the snail scans the path to the door while the white bowl, an enlargement of the snail's head, faces frontally. When I drive past a door like this, I see ancestors guarding it. I would not knock without clearing clutter from my heart because I know that the person who lives here will look deeply and will not settle for superficial judgments.

Johnson Smith was just such a person (fig. 20.3). In the summer of 1987 Judith McWillie took me along on a trip across the deep South for her project to document Black Atlantic artists. On the way from Hattiesburg to New Orleans, we got off at the Lumberton exit of I-59 to locate a painter McWillie had heard about in Hattiesburg. We never found the painter, but as we crested a hill, we both noticed something white a couple of blocks down the road. The day was gray and drizzly, so the white form seemed to hover in the air, looking for all the world like a skull.

What we saw was an earlier permutation of Figure 20.2. When we reached the house, Mrs. Ethel Smith invited us to join her on the sunporch. She offered iced tea

Fig. 20.3. Johnson Smith, 1989. Photograph by Grey Gundaker. By permission of the author.

and began to work out a genealogical connection to explain our presence, asking who we were related to, and when we said we were just passing through, telling us which white people in Lumberton looked so much like us that they *could* be our relatives. When we explained we had come because of the "figure" by the back gate, Mrs. Smith drew up in her chair. "That old man," she said, "that's his stuff all over the place. He's off somewhere now, probably collecting more junk he'll drag back home. It makes my housekeeping look bad. People must think inside the house looks like outside." When McWillie asked if she could take photographs, Mrs. Smith was enthusiastic. "Oh, yes, you take some pictures and send them to the mayor! Get him down here with the sanitation department to haul that stuff *away*. Oh, yes, do it *now*!"[7]

A year later I came back to Lumberton alone, documenting special yards and cemeteries. This time, Johnson Smith seemed to be waiting for me. Before I could introduce myself, he asked why it took me so long to get there. When I wondered at this he explained in a matter-of-fact way that he had heard I was coming in the breath of his personal tree, pointing at a loblolly pine on the far side of the house. Then he took in the longish black skirt I was wearing and asked if I was one of those woman's kind of woman. I didn't understand what he meant then, but later figured out that he was asking if I was a nun or lesbian and did not have sexual relations with men.

Although the breathing tree might paint him as a rather mystical character, Mr. Smith was solidly down to earth in all respects. He was eighty-four years old when I met him but still a firm believer that keeping one's "nature" going strong (*libido*, more or less) was essential to good health. As he explained when I showed him his photograph (fig. 20.3), "the women love me because I have such a pretty smile." Seeing a pickup truck of local white men bucketing down the hill toward his gate, he quickly pushed me into the road, wrapped me in a hug, and planted a wet kiss on my mouth as the truck slowed down and its occupants gaped. "Show those ol' boys I can kiss any white woman I want to these days." He went on to explain that Lumberton had a very

violent history, with a black man lynched as recently as 1968 "just for looking." This, too, was part of his landscape, and claiming full manhood through an in-your-face reeducation of whites was far more important to him than the half-playful lessons in vision he taught with objects.

The skull/helmet (fig. 20.4 and 20.5) was one of these lessons in a yard full of allusions to the dead. Over the next six years Johnson Smith altered this figure several times. For a while it seemed to fly on a bicycle; later it seemed to hold a sword; always it looked like a pile of junk on the surface that somehow coalesced into a guardian. "*It* won't keep thieves out," he said, "but what it *says* about me and this place will."

One of our most important conversations occurred after we walked around the yard together for the first time. Women's high-heeled shoes hung from a holly; a garden hose wound around through the branches of a smaller japonica (its circulatory

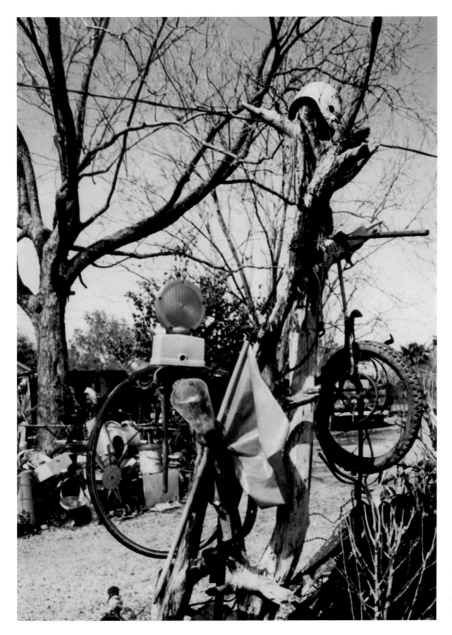

Fig. 20.4. Guardian of Johnson Smith's gate, Lumberton, Mississippi, 1989. Photograph by Grey Gundaker. By permission of author.

Fig. 20.5. Guardian of Johnson
Smith's gate as it appeared
in 1991. Photograph by Grey
Gundaker. By permission of
author.

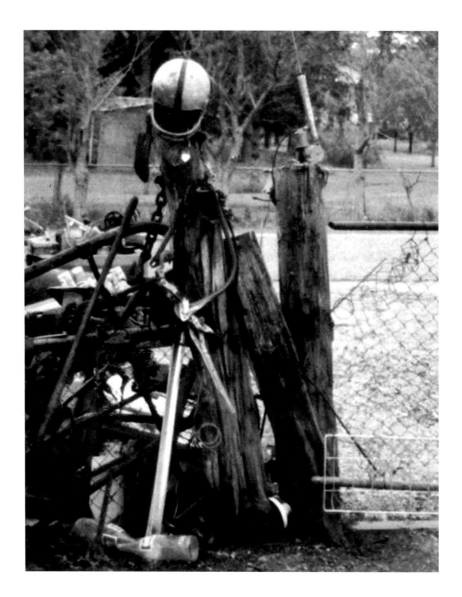

system, he explained); and a smooth-barked crepe myrtle stood beside a "river" of glass blocks. In front of the house, tucked under tall pines, Mr. Smith set aside an area of pipes stuck in the ground and surmounted with shiny glass power line insulators—a miniature cemetery. When I asked about this, he was quiet for a while and then said, "Every home should have a place for the old folks." Eventually, I mapped a dozen more burial-like areas in other states and came to see them as assertions of the right to influence the community: those with ancestors *belong* and have the wisdom and power of past generations backing them up. When we visited cemeteries together, Mr. Smith checked the pipes on graves, which, he said, must touch the top of the casket to connect it with the outside world.[8]

 After the tour, I asked Mr. Smith what he was doing when he arranged his stuff. I said it looked as though he wanted people to see two ways at once—the castoffs, the trees and places they grew, but also his memories of a woman, the light on a river and the roots of his family. He didn't answer but instead went inside the house, returning with a stereoscopic viewer and cards printed with pairs of identical photographs

captioned "Old Times in the South." As he put each card in the viewer, he asked me to describe in detail what I saw. Each showed a landscape of plantation labor—picking, baling and ginning cotton; tapping pine sap for turpentine; washing and mending clothes outdoors. Mr. Smith never answered my question directly. He said, "See how real those pictures look. I walked all over Mississippi back in those times."

I realize now that a direct answer would have been no answer at all. To see, really see, means seeing stereoscopically at a minimum: the past in the present, the labor and the landscapes and homes and people working that he was memorializing in the yard, but also as his ties to a landscape claimed by walking it. Spelling out this kind of seeing would negate his lesson in *doing it*. Further, he wanted the long sequence of looking and describing to erode any vestige of sentimentality for a South when whites controlled black labor and grew rich from it. He wanted to remind me that he lived in a landscape where his people had survived hell, and had come through even stronger because of it.

Mr. Smith loved to ride. On one trip Mr. Smith guided me through the woods to what looked like a boat ramp into the Mississippi River. With us was Gyp Packnett, maker of another remarkable memorial to his ancestors. They explained that this place is where their African great-grandparents were hustled ashore at night by slavers operating illegally out of New Orleans. Neither knew where their forebears came from, beyond that. But they brought with them a way of seeing that was far broader and deeper than the hard lives forced on them, and that still holds out the potential for broader, deeper vision of art and life today.

Notes

1. While slave ship records, census records and other records can give a general picture of where Central Africans arrived and were held in the United States, the internal slave trade and migrations, along with intermarriage, complicate this picture. Genetic testing offers a partial solution but does not yield straightforward results and may gloss over migrations that occurred on the African continent for centuries before the slave trade became a factor.

2. See, for example, Gundaker, "Creolization, *Nam*, Absent Loved Ones," 68–108; Gundaker and McWillie, *No Space Hidden*; Gundaker, "At Home on the Other Side," 25–54; Gundaker, "Tradition and Innovation in African American Yards," 58–71, 94–96.

3. Thompson and Cornet, *Four Moments of the Sun*.

4. Among these are Kuyk, *African Voices*; Heywood, *Central Africans*; Fu-Kiau, *African Cosmology of the Bântu-Kôngo*; Walker, *African Roots/American Cultures*; Thompson, *Face of the Gods*; Piersen, *Black Legacy*.

5. This fails to account for similar arrangements around more prosperous homes.

6. Fu-Kiau, *African Cosmology of the Bântu-Kôngo*, 43; MacGaffey, *Religion and Society*, 96; Kuyk, *African Voices*, 77.

7. Interview, June 1987.

8. Thompson and Cornet, *Four Moments of the Sun*, 181–203. Many of Robert Farris Thompson's writings discuss the relationship between burials and yard shows. Especially see Thompson, "The Song That Named the Land," 104–20.

Kongo Afterlife in Florida

African American cemeteries in Florida are visually rich sites that reveal the living legacy of Kongo funerary practices, concepts of death and communication with ancestors. White shells, stones, tiles and ceramic figures placed on Florida graves recall the Kongo use of white as a reference to ancestors. Seashells gathered along Florida's vast shorelines and placed on graves recall the metaphysical line, *kalunga*, where the land of the living meets the watery realm of the ancestors. Spiral crowns of conch shells echo the spiraling path to the next life and return to life envisioned by the Kongo. Accumulations of cherished ceramic figurines and other objects on African American graves hark back to the Kongo practice of placing utilitarian and decorative objects on graves (ill. 10.3). A slab of embedded broken white tiles on a Florida grave may indicate that the deceased was a tile setter, but may also refer to breaking ceramic objects on graves to demonstrate the broken connection with the world of the living and encourage the departure of the deceased to the spirit world. On Kongo graves, objects were intentionally broken, or "killed," so that they would be able to travel to the land of the dead with the deceased (cat. 2.6, cat. 2.7, cat. 2.8). Other objects averted evil forces on Kongo graves. Ceramic angels, dogs and sea creatures placed on Florida graves are likewise eternally vigilant, protective figures. Solar lights illuminate the path of the deceased spirit to the other world. Kongo graves are sites of communication with ancestors. Shining objects, such as mirrors, silver paint, glitter, gleaming wind chimes, iridescent glazed figures and snow globes summon spiritual presence to Florida gravesites (fig. 0.5), and benches placed nearby encourage the living to linger and commune with the departed.

SC

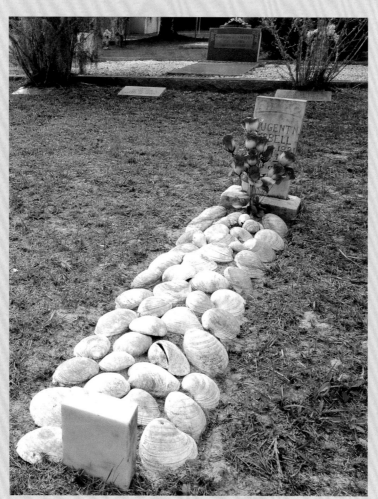

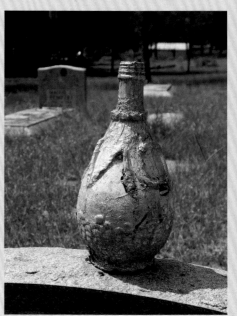

Left: Ill. 16.1. Shells covering a grave near Archer, Florida, 2011. Photograph by Meghan Kirkwood.

Below: Ill. 16.2. A bottle covered with silver foil on a tombstone in south Florida. Photograph by Kellim Brown, 2003.

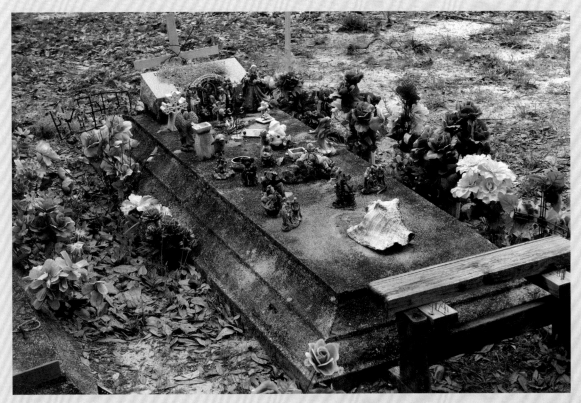

Ill. 16.3. A central Florida grave with bench, covered with ceramic angels, sea creatures, conch shell, snow globe, mirrors, and lined with silk flowers. Photograph by Scot Smith, 2013.

Ill. 16.4. Grave covered with broken white tiles, central Florida. Photograph by Meghan Kirkwood, 2011.

21 ◈

From Tidewater to Tampa

Yard Activation in the Kongo-Atlantic Tradition

KELLIM BROWN

One could drive by 2109½ North A Street in Tampa on any day to find a welcoming man smoking a cigarette on his front porch (fig. 21.1). Usually alone, his mellow manner left the impression of someone waiting as he observed passing cars and pedestrians, who occasionally gave the "junk" filling his yard a double take (fig. 21.2). Clifton B. Coefield was waiting. Contemplating the arrangements of found objects before him, Cliff was busy "decoratin'" his yard. His style of adorning the property enabled him to reconstruct significant moments from his eighty-one years and honor deceased family, but it also instructed passersby in behavior and presented a sketch of his personal history.

Those unfamiliar with a decorative vernacular used in some African American yards easily missed Cliff's messages echoing distant African traditions. Although the personal goings-on behind his yard are not entirely clear, we can describe and offer interpretations based on Cliff's words coupled with research on African American grave and "yard show" decoration.[1]

Such "yard shows" are assemblages of found objects that beautify surroundings, establish boundaries, defend the home from evil, and pay homage to the deceased. What appears as "junk" are coded messages through which the arranger "speaks." Yard shows, like that created by Cliff, are linked to grave decoration and *nkisi* traditions frequent to the Kongo-Atlantic paradigm. For Cliff, however, yard decorating was a family practice dating from the nineteenth century in the Tidewater region of Virginia.[2] Born in 1924, Cliff spent his childhood in the hamlet of Swoback, eleven miles from Tidewater, where his mother decorated her yard.[3] "When my mother died at thirty-four years old I kept decoratin' the yard like she did. She learned that kind of decoratin' from her mother."

His yard can be addressed through recurring motifs documented in other African American yard shows (see the preceding chapter by Grey Gundaker). The Coefield yard had boundaries, thresholds, emblems of motion, thrones and objects of defense, communication and flight, as identified in previous research of yard decoration.[4]

Left: Fig. 21.1. Photograph of Clifton B. Coefield on front porch, Tampa, Florida, 2005, by Kellim Brown. By permission of the author.

Below: Fig. 21.2. Photograph of view of the Coefield yard, Tampa, Florida, 2005, by Kellim Brown. By permission of the author.

Fig. 21.3. Photograph of a watcher figure, Tampa, Florida, 2005, by Kellim Brown. By permission of the author.

The yard may be considered as space protected, for example, *nkisi* medicine or grave boundaries. Cliff sheltered his world with the heft of iron fencing, concrete and mighty colors: yellow, white, gray, silver, blue, green and red—all of which are visible in other African American yards and graves.[5] The sidewalk, a ready-made boundary, was the initial threshold between the community and the yard's symbolically loaded interior. Painted yellow arrows pointed both into the yard and toward the street as the first codes defining the protective perimeter.[6] Next, the all-framing blue curb can be viewed as the sky, and beyond that were concrete fragments painted yellow, gray and silver.[7] In some African American graves, blue and yellow have "ancestral and protective overtones."[8]

A number of "watcher figures" assisted in defense, including wooden and plastic animals facing the street. These guardians reminded "those who approach that, upon entering the yard, one should behave as if all the world is watching."[9] Cliff refused to comment on these objects such as the plastic Spuds McKenzie mascot, painted brown and white (fig. 21.3).[10] Red highlighted its defensive aspects: the seeing eyes, the listening ears, and the sniffing nose. The red on its mouth and toes emphasized dangerous and protective teeth and claws.

Among these barriers were objects concealed by ferns and other plants. Large multi-object constructions were built around trees. The largest incorporated a common yard show motif—the wheel or objects of circular motion, both suggested as deriving from the Kongo cosmogram.[11] In the center of the yard a tree supported a red, silver and white[12] wagon wheel (fig. 21.4). Below the wheel, a sawed-off branch painted silver echoed the shape of the wheel's hub. Silver, a color of "flash," and other

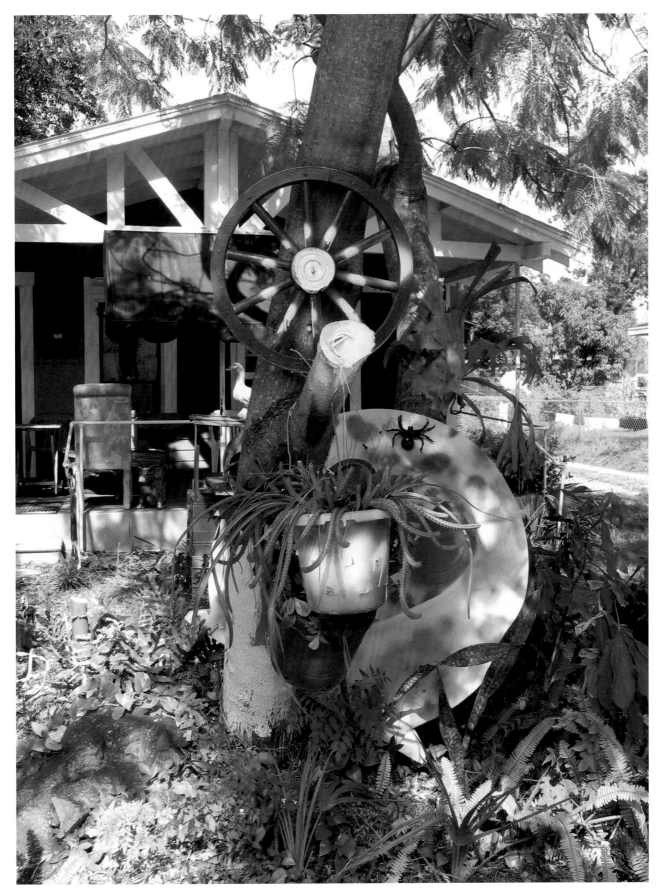

Fig. 21.4. Photograph of wheels in motion, Tampa, Florida, 2005, by Kellim Brown. By permission of the author.

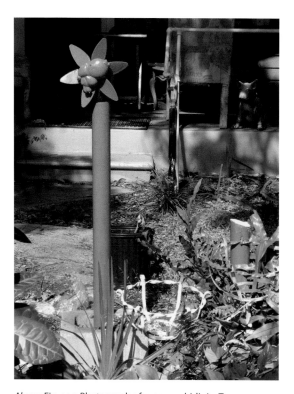

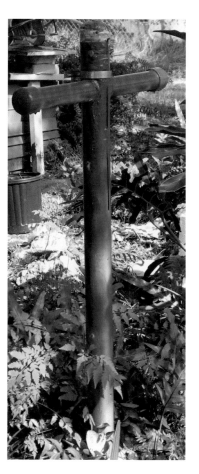

Above: Fig. 21.5. Photograph of orange whirligig, Tampa, Florida, 2005, by Kellim Brown. By permission of the author.

Right: Fig. 21.6. Photograph of green PVC pipe crucifix, Tampa, Florida, 2005, by Kellim Brown. By permission of the author.

reflective surfaces such as mirrors, foil and the surface of water act on trespassers and wandering evil spirits, "deflecting negativity and unwanted energy back onto the sender."[13] A larger circular white table leaned against the tree, coded with Cliff's color palette; at its center, two large black eyes and smiling mouth served as a welcoming image, but a rubber spider on top simultaneously gave warning.

Other objects of motion—fan blades and whirligigs—"mystically 'wheel' anti-social spirits off the premises."[14] A whirligig atop a PVC pipe, painted an alarming orange, stood before the porch (fig. 21.5). To the right another PVC pipe, sawed in half, was perhaps inspired by grave decoration where pipes on or next to graves are conduits of communication with the deceased. The pipe as "conduit" is all the more convincing given its location next to a green PVC crucifix (fig. 21.6).

One overarching theme, likely evident in all African American yard shows, becomes obvious and serves as a means for addressing the whole—autobiography. Family, friends and private beliefs are illustrated with the traces of one's trade(s). Cliff's skilled work with concrete, paint, and irrigation were included in the way he prepared his yard. When asked if family members were honored, he said yes, "I have the crucifixes here." Curiously, the two crucifixes, both green, also exhibit spiritual defense with the inclusion of silver paint on the wooden example in the porch window (fig. 21.1), and the more subtly placed silver metal band on the PVC version (fig. 21.6), both a continued tribute to the protective power of the color.

The most complex of Cliff's assemblages, something he avoided discussing as much as possible, was a table for "sittin' and drinkin' with friends." Made of two gray sawhorses, the same color as his house and furniture, it was connected to a tree by wooden planks with a large multicolored backboard displaying objects: a horse-shoe, barbecue tongs, two mass-produced aluminum butterflies, a cinder block and a throwing dart, all beneath an aluminum lamp and red birdhouse. On the ground were a mason's brick painted gray with a shiny aluminum mason's platter and concrete rake, tools of former occupations. Whatever this loaded work of poetry meant, Cliff would not elaborate. Two hand-painted gray and green chairs leaned against the table, suggesting they were not to be used by the uninvited. Empty seats in such locations are "thrones" for the spirit of the deceased. Furthermore, empty chairs "remind visitors of unseen watchers,"[15] yet another defensive permutation.

Fig. 21.7. Photograph of spirit table and chairs, Tampa, Florida, 2005, by Kellim Brown. By permission of the author.

When considering his route from Tidewater to Tampa, the presence of family and his trades in the yard, a prescient observation made about African American yards rings true about Cliff's property: "What appears to be a random accumulation is in fact the distillation of a life."[16] It served as an expression of his past and, perhaps, a map of his future.

Cliff passed away on April 27, 2009. Since then the yard was cleared—an *almost* total erasure. A visit to the home in August 2012 revealed he had not entirely vacated the premises. In Cliff's stylized black magic marker script the name *Coefield* remains on the mailbox. Below, a self-portrait sketched in black marker graces the wall above a vacant porch chair. The current tenant did not know who drew the image. I did, and I had a good idea who was sitting in that empty chair.

Notes

1. We casually discussed his work in the spring of 2005 on the porch or while walking around the yard.

2. The region around Tidewater was documented during the late 1970s and 1980s as having a number of graves and yards arranged in this style.

3. His mother's passing forced Cliff to run away as a youth. Leaving Swoback, he was taken in by an Italian couple who thought he was too young to be on the road. After high school Cliff wandered around America occupying a variety of jobs: milk delivery, house painting, concrete and stucco, working for Planters Peanuts and Allied Van Lines in Georgia, potato irrigation on Long Island and cutting grapes at a vineyard in Oxnard, California. Later, while working for the United Fruit Company, he took the "banana boat" to St. Petersburg, where he built sea walls. He moved to the first of two Tampa residences, which he decorated for twenty-four years. In 2000 he moved to the home discussed here, which he began decorating "about two years ago" when we met in 2005.

4. See Gundaker and McWillie, *No Space Hidden.*

5. Colors are central to an effective yard, but further investigation of their use is warranted. Gundaker, "Tradition and Innovation," 64.

6. For a similar image, see the grave marker illustrated in Thompson, *Face of the Gods,* 286 (plate 287), where a similar image is "intimating dynamic motion."

7. Blue on the trim of windows equates the sky—something evil is unable to cross. See Gundaker, "Tradition and Innovation," 64.

8. Gundaker, "Tradition and Innovation," 64.

9. Gundaker and McWillie, *No Space Hidden,* 33.

10. Gundaker said, "They will talk about the objects that stand to remember their past or deceased family but refuse to discuss the objects doing the work." The "work" is of a defensive/protective nature involving spiritual beliefs (personal communication, March 2004).

11. The Kongo cosmogram is the foundational conception of the soul's spiritual path, a cycle of birth, death and rebirth, mapped by a cruciform ideogram called *dikenga.* It is depicted in circular, diamond, or lozenge forms equating life's path with that of the sun, beginning at dawn with birth, moving toward the zenith of life at noon, and descending at sunset into the ancestral world with a return at dawn as rebirth.

12. White in Kongo terms is the color of the spirit world. Additionally the tree trunk was painted white up to the first branch separating from the trunk.

13. Gundaker and McWillie, *No Space Hidden,* 30.

14. Thompson, "The Circle and the Branch," 30.

15. Gundaker and McWillie, *No Space Hidden,* 35.

16. Thompson, "African Influence on the Art of the United States," 35.

KONGO RESONANCE IN

AFRICAN AMERICAN CULTURES

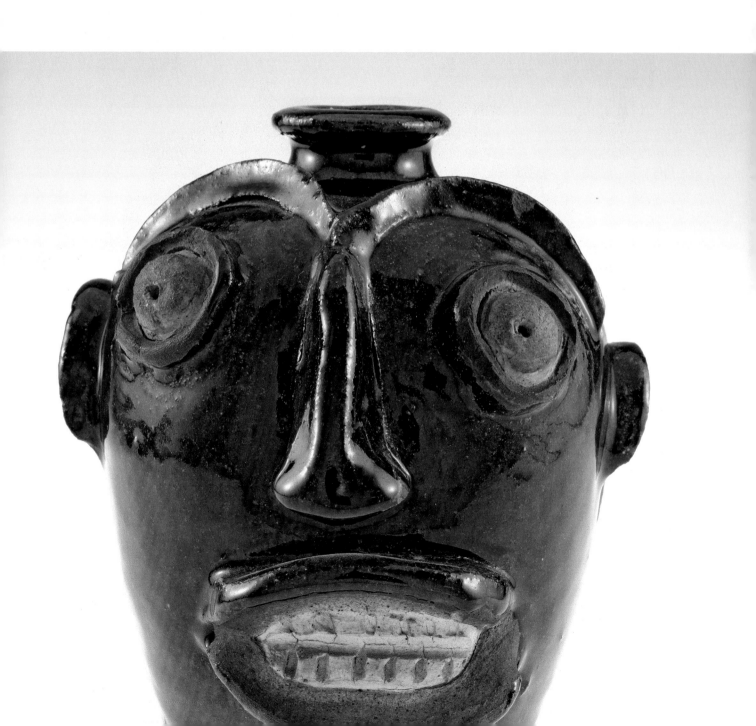

African American Conjure

Hoodoo, *conjuration*, *conjure* and *rootwork* are all terms applied to various African American folk practices developed from blending beliefs and customs from different African cultures as well as Native American and European traditions. Voudou as practiced in New Orleans, on the other hand, was a New World Afro-Catholic *religion* with a structured theology; a pantheon of deities, saints and ancestors; a priesthood; and a congregation of believers who meet for regular worship ceremonies.

In both conjure and Voudou, creating assemblages of various materials seemed to be effective in calling the attention of supernatural forces and beseeching them to unravel and to solve problems. They created these tools by combining materials—animal and plant substances as well as human-made things. Such practices can be linked to the Kongo practice of composing *minkisi*. In all, substances are added to enhance the efficacy of the object.

Descriptions of root doctors have included discussion of their use of canes. In Kongo, ritual healers (*banganga*) employed staffs charged with supernatural power through the application of substances. The cane in cat. 6.1 was created as a conjurer's cane in South Carolina. For two generations, members of a family are said to have applied layers of materials. The similarity of the practice of American conjurers to those of Kongo *banganga* can be seen in the way the American cane employs a chicken foot, not unlike the use of vulture claws or those of other birds in making *minkisi*. Likewise, red plastic on the cane can be seen as a modern substitute for red cloth used in the manufacture of *minkisi*.

Voudou priests and priestesses, like conjurers, performed some of the same services. Voudou charms more often consisted of *gris-gris* or *wanga* placed in glass bottles, cans, or fabric pouches. All of this is suggestive of *minkisi*. The doll in cat. 6.2 is said to be a "voodoo doll." Popular folklore is rife with ideas of so-called voodoo dolls. An early-nineteenth-century description of a Voudou meeting in New Orleans describes a makeshift altar with a "black doll with a dress variegated by cabalistic signs and emblems." Although popular folklore links Louisiana Voudou with so-called dolls, they were rarely used. Tourist hype in New Orleans has popularized the idea of voodoo dolls even more, and they are indeed a profitable item, most made in China (see ill. 17.1). This object from Eunice, Louisiana, a small Cajun community, is made of old fabric with human hair on its head. Its owner is not sure whether it was made for use in rural Louisiana Hoodoo or for Voudou. Was it perhaps a roughly made child's toy from an earlier era?

RP

Right: Cat. 6.1. Conjurer's cane. South Carolina. 20th century. Various materials (wood, cloth, metal, plastic), 37 × 6.4 in. (93.98 × 16.25 cm). Collection of Tubman African American Museum, Macon, Georgia.

Facing page: Cat. 6.2. Voodoo doll. Eunice, Louisiana. 20th century. Cloth, ink stain, medicines, approx. 12¾ × 6⅛ × 1¾ in. (32.38 × 15.5 × 4.44 cm). Collection of Barrister Gallery, New Orleans. Photo by Randy A. Batista.

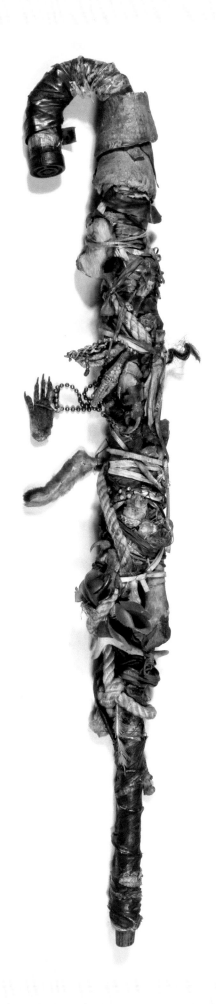

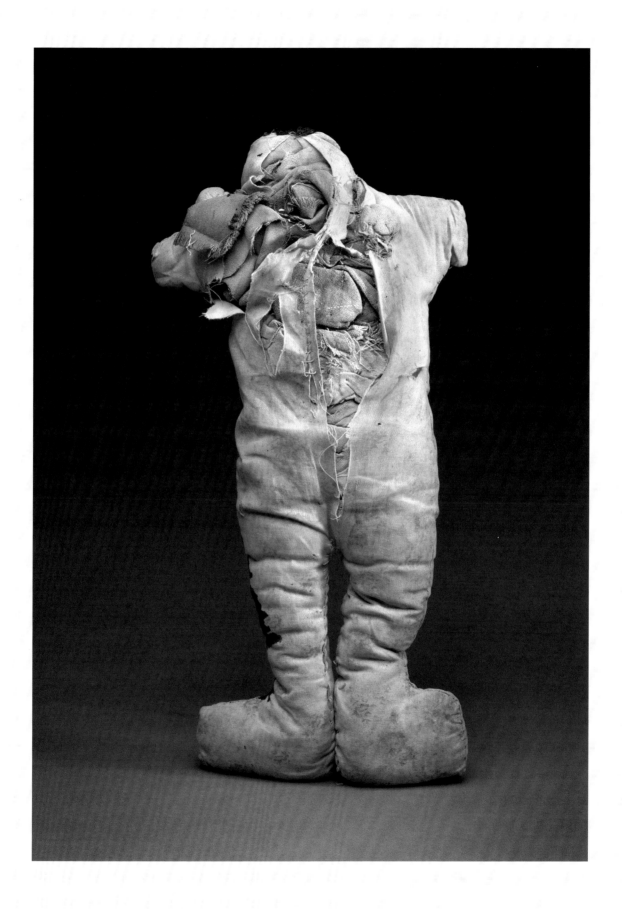

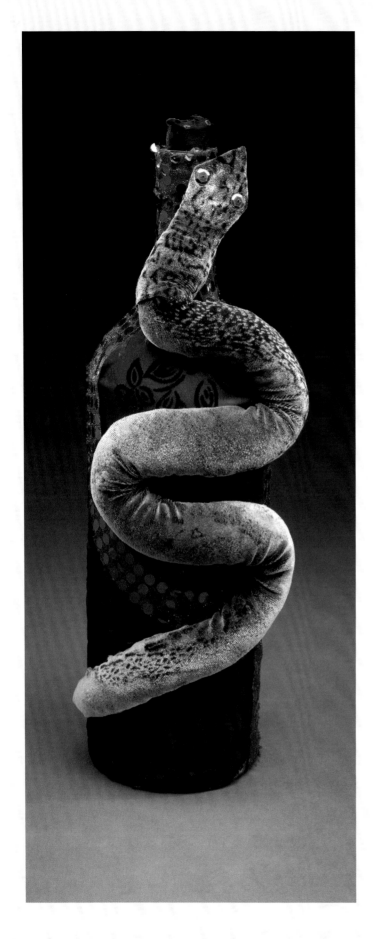

Haitian American Permutations of Kongo Religion

Kongo culture still reverberates throughout the Caribbean, especially in Cuba in the Kongo-based religion known as Palo Monte Mayombe and in Haiti as Vodou. As more Cubans and Haitians move to the United States, more people have become aware of the tenets of these religions as they are practiced in Miami, New York and elsewhere.

Although the word *Vodou* derives from the Fon word for deity, *vodun*, it is a syncretic religion with Fon, Ewe, Yoruba and Kongo contributions. Kongo, in fact, plays a prominent role in its practice. It may well be that the blending of Roman Catholic Christianity and Kongo religious traditions that took place in sixteenth- and seventeenth-century Kongo may have resulted in the development of Vodou in Saint-Domingue and its continuance in Haiti. Historical links through material culture can be demonstrated by the bottle imported from Haiti into Miami to be sold in Vodou botanicas (see ill. 17.4). The bottle (cat. 6.3) as *nkisi* can be seen as strikingly Kongo (see cat. 4.11, for example). In Vodou, such bottles are designated for specific spirits or *lwa*. The serpent moving up the bottle and the colors indicate that this example is for Damballah, a Fon deity. Each bottle can be accompanied by a bound package (cat. 6.4 and cat. 6.5), which can also be seen as a separate *nkisi*. The small, bound object made of cloth, ribbons and enclosed materials is referred to as a *paket kongo*, recognizing the Kongo roots for the practice. In fact, a comparison of the *paket kongo* with the *nkisi* Mbumba Mbondo in cat. 4.10, also made of a bound bag, is suggestive. The *paket kongo* is green, the color for Damballah, and thus matches the colors on the bottle (cat. 6.5), while that for another *lwa* is red (cat. 6.4).

RP

Cat 6.3. Bottle for Vodou spirit, Damballah. Haitian-Floridian. 2012. Cloth, glass, unidentified substances, 14.63 × 3.63 in. (37.16 × 9.2 cm). Gift of Robin Poynor, Samuel P. Harn Museum of Art, University of Florida, Gainesville, Florida, 2013.30. Photo by Randy A. Batista.

Cat. 6.4. Vodou medicine packet (*paket kongo*), Haitian-Floridian. 20th century. Cloth, feathers, sequins, unidentified substances, approx. 15 in. (38.1 cm). Collection of Museum of HistoryMiami, 2005.06.001.

Cat. 6.5. Vodou packet for Damballah (*paket kongo*), Haitian-Floridian. 2012. Cloth, thread, feathers, unidentified substances, 8¼ × 3⅛ in. (20.95 × 9.84 cm). Collection of Robin Poynor. Photo by Randy A. Batista.

Palo Monte as a Cuban-American Kongo Religion

Palo Monte Mayombe is one of two major African-derived religions in Cuba that have become important in North America as well. Palo Monte is the Cuban variation of Kongo religion, its ritual practices deriving from those of Central Africa. The other variant, Yoruba-based, is referred to as Ocha, Santeria or Lucumi.

Although believers acknowledge a High God, Zambi or Nzambi, it is the spirits of the dead and other spirits that are venerated and called upon. Natural objects containing forces and other power-infused materials are placed in a special container, the *nganga*, which is the focus of the initiate's practice. Each spirit (*mpungu*) is associated with that sacred object. Also known as a *prenda*, the consecrated vessel normally contains sacred earth (usually associated with the cemetery), sticks (*palos*), a human skull, bones and other objects. The individual develops a relationship with the *mpungu* or spirit through tending the container, accumulating power through caring for the many objects collected and placed in it over time.

Different *mpungus* have different types of *ngangas*. Sarabanda is the spirit associated with iron and metal. One theory for the *mpungu's* name ties it to the Kikongo phrase *nsala banda* for the cloth used in composing *minkisi*. Although Sarabanda is the spirit of work and strength, he is also associated with destruction and accidents. His *nganga* is fashioned from an iron pot with three legs and eventually filled with sticks, a skull, bones, railroad spikes and other powerful materials and substances (cat. 6.6).

Other Palo *mpungus* use distinctive types of *ngangas*. For example, the *nganga* for Baluande, a spirit associated with water and fertility, is a clay pot. That for Chola Wengue, the spirit of rivers, wealth, seduction and pleasures and the protector of women, is also made of clay. The pot, called a *tinaja*, is colored, each *mpungu* requiring a different hue. The container pictured in cat. 6.7 is likely for Chola Wengue, whose *nganga* is yellow.

RP

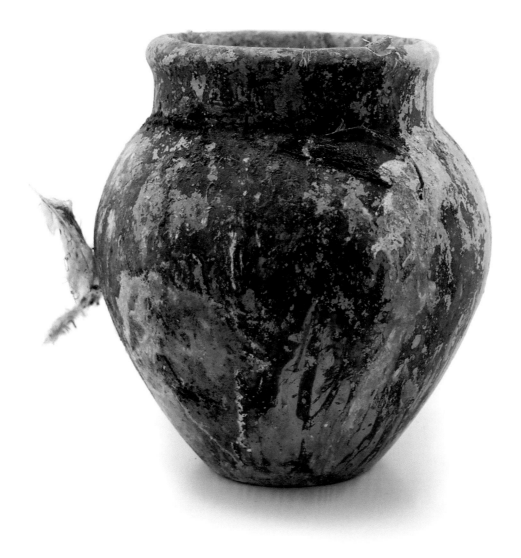

Facing page: Cat. 6.6. Sacred vessel for Palo Mayombe (*prenda* or *nganga*). Cuban-Floridian. 20th century. Iron, wood, medicinal substances, 10 in. (25.4 cm). Collection of Museum of HistoryMiami, 1987.024.

Above: Cat. 6.7. Offering pot for Palo Mayombe (*tinaja*). Cuban-Floridian. 20th century. Ceramic, medicinal substances, 7 × 8 in. (17.78 × 20.32 cm). Collection of Museum of HistoryMiami, 1987.024.

Lowcountry Coiled Baskets

In the Sea Islands of South Carolina and Georgia, people of West African and West Central African descent have produced coiled grass baskets since the eighteenth century. The Lowcountry coiled technique—starting with a coiled bundle of grass and binding it to successive bundles with palmetto leaf strips—is identical to the technique found in West Central Africa. Using the coil technique, Kongo basket makers in Lower Congo and Angola made baskets of the same shapes as Lowcountry baskets. Among them are fanners (large flat baskets for removing the hulls from grains), vegetable baskets, double baskets and stepped lid baskets. In America, coiled baskets in the early nineteenth century were made for fanning rice, carrying food and equipment and storage. By the late nineteenth century, coiled basket making was declining. The art was revived at the Penn Center in St. Helena Island, South Carolina, in keeping with its mission to retain Gullah culture and provide a livelihood to local people. While Penn emphasized traditional basket techniques and styles, newer styles emerged as baskets became more commercially viable. Although men made baskets originally, by the early twentieth century women began making baskets and soon outnumbered men. With the increased demand for their wares, basket makers competed for greater visibility by introducing new techniques, materials and designs. This intensive innovation has culminated in the recognition of Gullah artistry both nationally and internationally.

The small coiled basket shown in cat. 6.8, dating from the late nineteenth century was found at the Aiken-Rhett House in Charleston, South Carolina. Aiken was a rail magnate and governor of South Carolina. The coiled technique and cylindrical form with a knobbed lid closely resembles Kongo baskets. The Aiken-Rhett House basket shows some wear and may have been used as a sewing workbasket or to store small valuables.

SC

Cat. 6.8. Lidded work basket. Aiken-Rhett House, Charleston, South Carolina. Ca. 1875. Bulrush, palmetto, 2.5 × 5 in. (6.35 × 12.7 cm). Collection of Charleston Museum, Charleston, South Carolina, HW095.

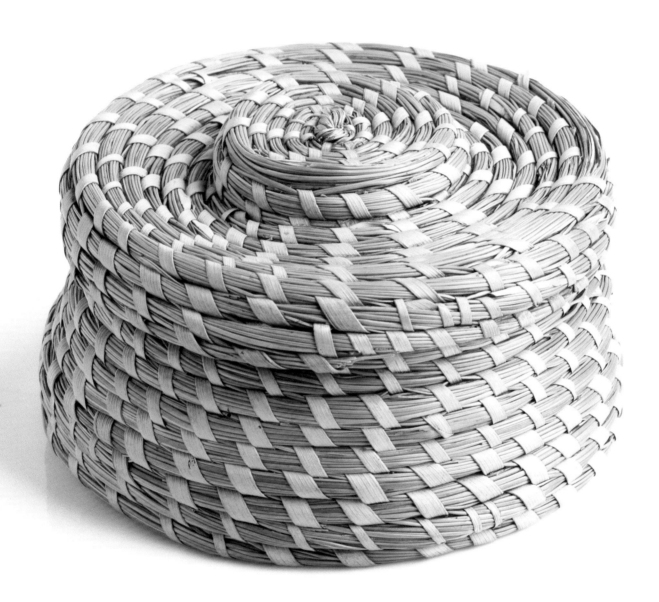

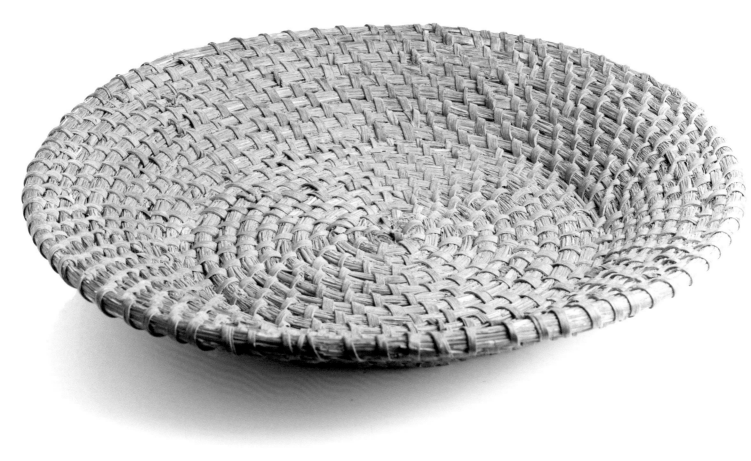

Fanner Baskets

Wide, flat baskets are ideal tools for fanning rice, which was a major crop in the southeastern United States in the nineteenth century. Fanner baskets made with a coil technique have dual parentage, both West Africa and West Central Africa, and peoples of both regions were brought to the area in great numbers in the transatlantic slave trade, specifically for rice cultivation. However, the great number and relative isolation of African peoples in the rice-growing Sea Islands of Georgia and South Carolina allowed the direct transmission and retention of the coiled grass technique. The nineteenth-century example is typical of large utilitarian Sea Island baskets of that time, which were made exclusively of bulrush. Unlike most fanners, the more delicate basket from the 1920s shows little wear and has a ringed foot, suggesting it was made for lighter use inside the home. The foot may be a vestigial element recalling elaborate Kongo footed baskets, also made in the nineteenth and early twentieth century.

SC

Facing page: Cat. 6.9. Fanner basket. South Carolina. Ca. 1900. Bulrush, palmetto, 21.25 in. (54 cm) diameter. Collection of Charleston Museum, South Carolina, HW028.

Below: Cat. 6.10. Footed fanner basket. South Carolina. Ca. 1920. Bulrush, oak strips, 3.5 × 21 × 21 in. (8.89 × 53.34 × 53.34 cm). Collection of William L. Buggel and Jane C. Hart. Photograph by Randy A Batista, 2012.

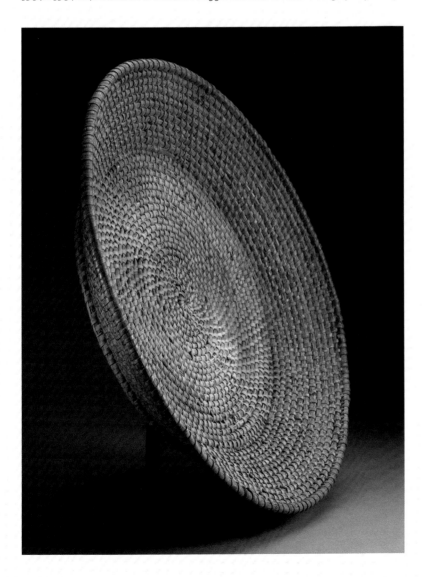

Oval-Shaped Basket

Oval-shaped steep-sided baskets without handles were indispensable to workers in the Sea Islands who carried them on their heads to transport vegetables, flowers and utensils. In addition to its mode of transport and function, the shape and technique of coiling used to create this basket are identical to those made by Bakongo of West Central Africa in the same time period.

SC

Cat. 6.11. Vegetable basket, South Carolina. 20th century. Bulrush, palmetto, 3.25 × 13.75 in. (8.3 cm × 34.9 cm). Collection of Charleston Museum, 1991.79.2 A.

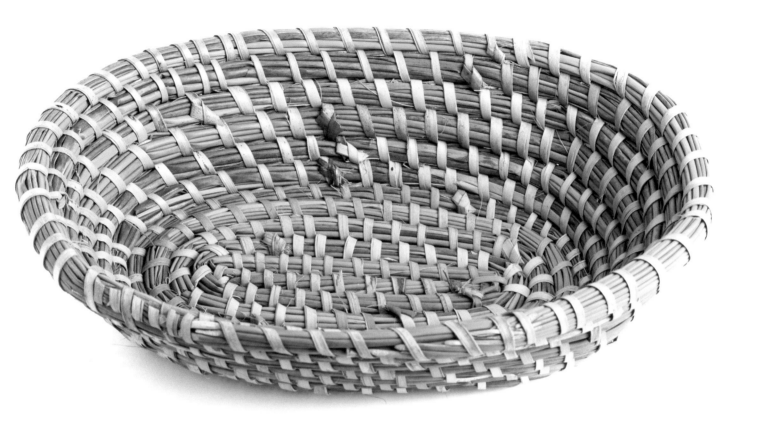

Stepped-Lid Basket

This large stepped-lid basket is a contemporary version of an older type that dates to at least the nineteenth century in the southeastern United States. It has its roots, however, in West Central Africa among the Kongo people. The multitiered stepped lids of the Kongo baskets have up to four levels that relate to the Kongo belief in the four moments of life: birth, adulthood, death and afterlife. The stepped form connection to Kongo cosmology is reinforced by the similar configuration of ancient stepped pyramidal graves of Kongo kings and chiefs.

 SC

Cat. 6.12. Stepped-lid basket, Barbara Manigault, American. 2012. Bulrush, sweetgrass, pine needle, palm, 13 × 9 × 10.1 in. (33.02 × 22.86 × 25.65 cm). Collection of Samuel P. Harn Museum of Art. Museum purchase, funds provided by the David A. Cofrin Acquisition Endowment, 2013.4. Photo by Randy A. Batista.

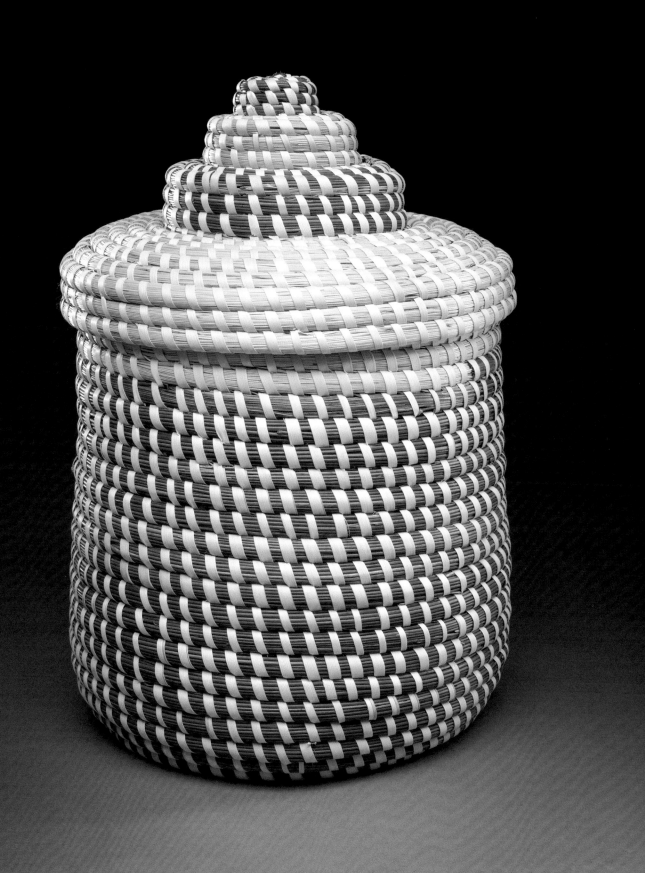

In-and-Out Basket

The Gullah people of South Carolina and Georgia named this basket *in and out* because of the accordion-like form. Only highly skilled basket makers can produce the in and out form, which emerged in the Gullah area in the mid-twentieth century. The in and out basket exemplifies the continual innovation and show of virtuosity fueled by competition among Sea Island basket makers. Elizabeth Kinlaw, who created this basket, noted that few basket makers attempted this form in the last few decades. The carinated form is descended from the stepped-lid baskets that originated in West Central Africa among the Bakongo.

SC

Cat. 6.13. In-and-out basket, Elizabeth F. Kinlaw, American. 2012. Bulrush, sweetgrass, pine needle, palmetto, 12.5 × 12.5 × 11 in. (31.75 × 31.75 × 27.94 cm). Collection of Samuel P. Harn Museum of Art. Museum purchase, funds provided by the David A. Cofrin Acquisition Endowment, 2012.60.1. Photo by Randy A. Batista.

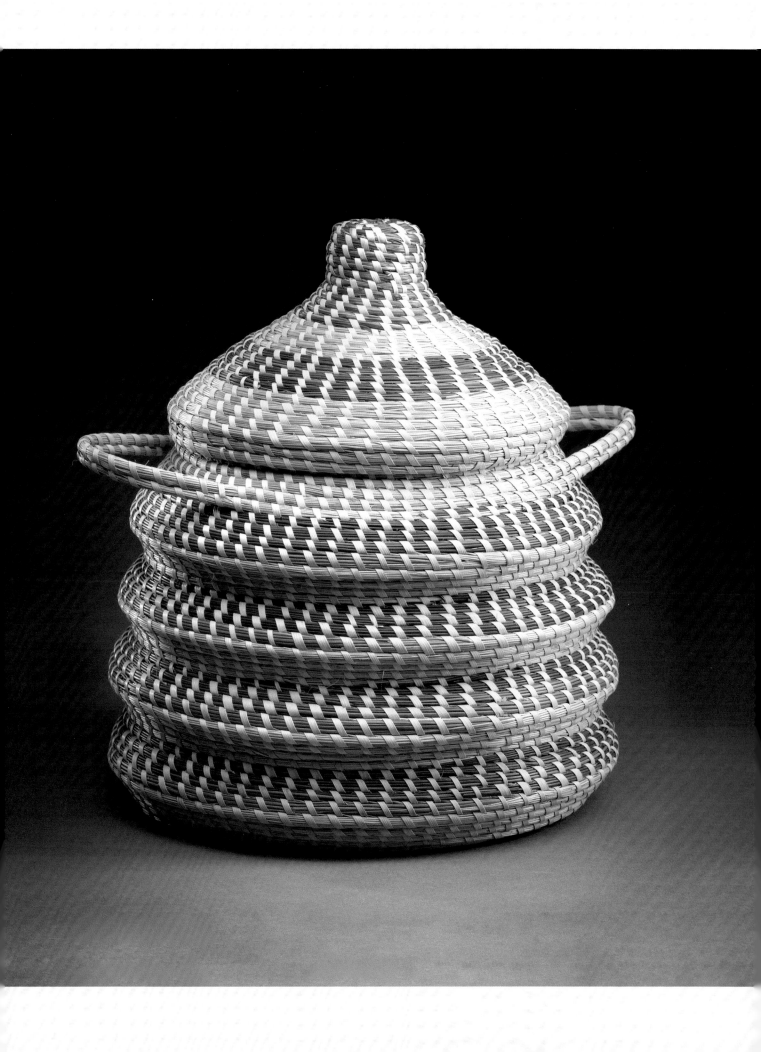

Sewing Basket

After two centuries of producing coiled grass baskets, Sea Island basket makers began to add new materials, techniques and shapes to their repertoire. Sweetgrass became a favored fiber in the early twentieth century, as it added color and textural variation. Highly pliable longleaf pine needles were also incorporated as coils and for decorative French knots. This sewing or pocketbook basket maximizes the use of four fibers for color, texture and structure in producing an attractive and innovative design.

SC

Cat. 6.14. Sewing or pocketbook basket, Linda F. Blake, American. 2012. Bulrush, sweetgrass, pine needle, palmetto, 12 × 9.5 × 9.5 in. (30.48 × 24.13 × 24.13 cm). Collection of Samuel P. Harn Museum of Art. Museum purchase, funds provided by the David A. Cofrin Acquisition Endowment, 2012.60.2. Photo by Randy A. Batista.

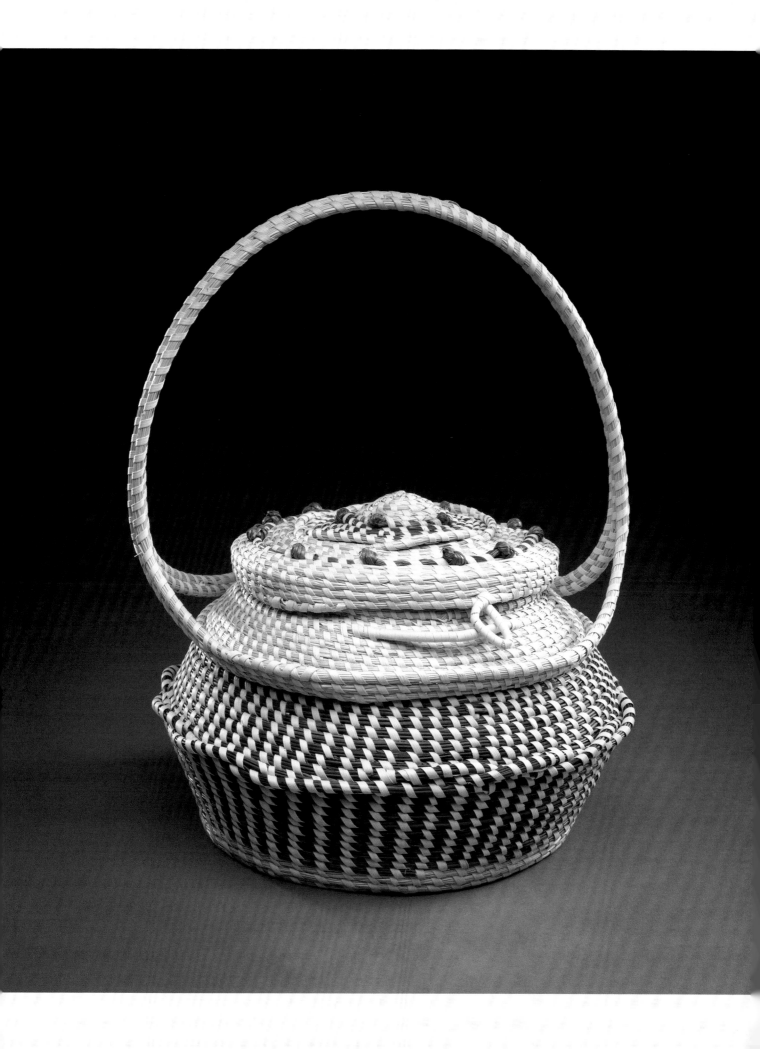

Elephant Ear Basket

Sea Island basket makers dubbed this basket *elephant ear* because of its undulating motif. According to Elizabeth Kinlaw, the sister of Alethia Foreman, who made this basket, this design was invented around 2007 and has gained popularity among basket makers and patrons ever since.

SC

Cat. 6.15. Elephant ear basket, Alethia Foreman, American. 2012. Bulrush, sweetgrass, pine needle, palmetto, 7.5 × 12 × 12 in. (19.05 × 30.48 × 30.48 cm). Collection of Samuel P. Harn Museum of Art, 2012.60.3. Photo by Randy A. Batista.

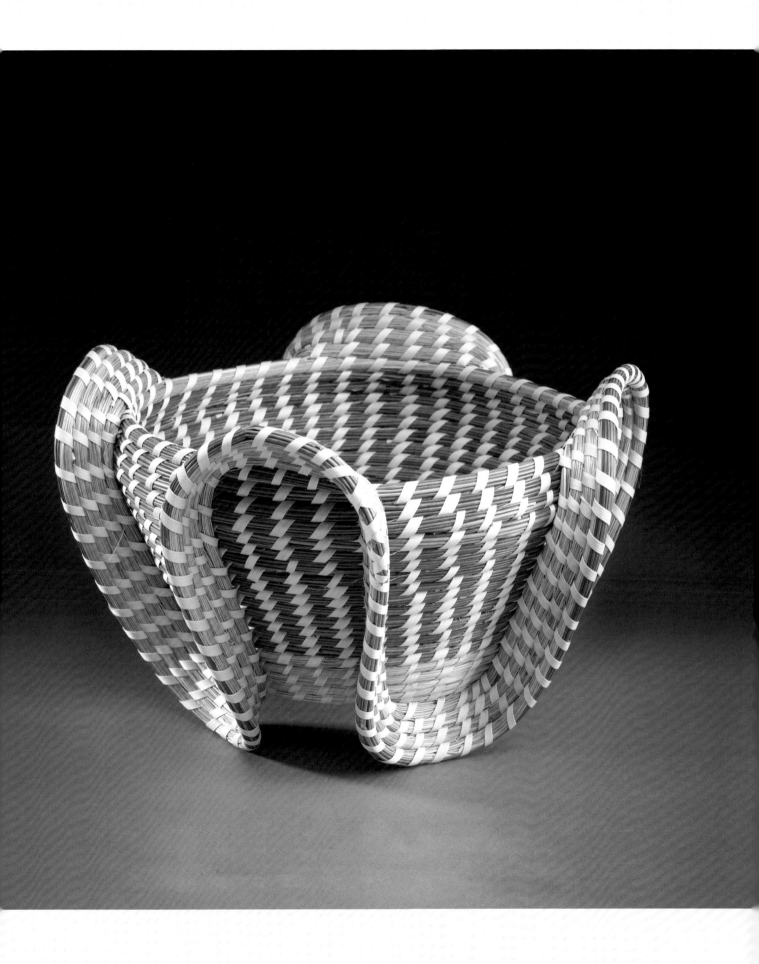

African American Canes

Elaborately carved wooden canes made by African Americans resonate with Kongo chiefly staffs, ivory tusks and scepters. Both canes and Kongo carvings have figuration as well as geometric ideographic motifs signifying leadership. In America, a finely carved cane lends a sense of prestige, but it may also function as a weapon. For the Kongo, a chief's staff not only demonstrates the power of the chief to mediate with the spirit world, but is considered an entity imbued with lethal supernatural force. The power of Kongo staffs was transferred to American canes in mutually intelligible symbols of metaphysical and physical power. Both staffs and canes prominently feature reptiles, such as snakes, lizards and crocodiles (or alligators in America). The Kongo believe that these creatures, which travel between land and water, can negotiate the earthly realm of the living and the world of ancestral spirits below the waters. Kongo staffs are thought to have the power to protect the chief and his people from malignant forces, and the idea of the cane as spiritual protection is retained in African American canes. African Americans embed nails, tacks, rhinestones and other objects in the canes as means of enhancing and engaging spiritual powers, just as Kongo staffs are sometimes studded with metal bosses, wrapped with wire or woven fibers or embellished with carved ivory finials. Conjuration canes with accumulated substances compare to staffs packed with medicines that are used by Kongo healers. The visual composition of some canes recalls chiefly staffs, scepters and carved tusks embellished by relief carving that wraps around the tusk in a continuous spiral. Some African American canes narrate historical events, as do Kongo *lusumu*, which record events and gestures of Kongo rulers (see fig. 7.8).

The African American cane shown in cat. 6.16 bears compelling evidence of its Kongo influence. Henry Gudgell, a former slave from Kentucky, carved this cane for a Civil War veteran. The array of reptiles and amphibians—a snake, tortoise and lizard—and the male figure on the shaft are arranged in much the same fashion as a Woyo chief's staff in the Royal Museum for Central Africa's collection (cat. 2.15). A row of contiguous diamond shapes encircling the handle of the Gudgell cane are similar to those featured on Kongo chiefly regalia. The four points of the diamond form the Kongo cosmogram, which also appears on Woyo staffs.

SC

Cat. 6.16. Cane, Henry Gudgell, American (1826–95). Ca. 1867. Wood, 37 × 1.5 in. (94 × 3.8 cm). Collection of Yale University Art Gallery, Director's Purchase Fund, 1968.23.

Cane with Reptiles

The arrangement of serpents, frogs, turtles and lizards, with other motifs punctuated by spheres with incised diagonals, recalls the style of Kongo chiefly staffs that bear similar motifs. The carving style and composition using oppositional and hieratic figures compares favorably to the staffs made for Yombe and Woyo chiefs.

SC

Facing page, left: Cat. 6.17. Cane, American. Late 19th century. Wood, 35 × 1.25 in. (88.9 × 3.2 cm). Collection of George H. Meyer. Photo by Randy A. Batista.

Cane with Man Wearing a Bowler Hat

This finely carved cane demonstrates the hand of a master carver and was undoubtedly a prestige item. However, the technical expertise and arrangement of images resonate with chiefly staffs from Kongo. The finial of a man in a bowler hat and the relief-carved images of a bird, leaves, lizards, turtles, dog and rifles are particularly reminiscent of the delicately carved and highly figurated staffs of the Woyo people. An image of a man in a bowler hat also appears on a twentieth-century Woyo staff in the collection of the Royal Museum for Central Africa (cat. 2.15). In both contexts, American and Kongo, the figure conveys prestige and modernity.

SC

Facing page, right: Cat. 6.18. Cane with man wearing a bowler hat, American. Early 20th century. Polychromed wood, 1 in. (2.5 cm) steel ferrule with brass washer, 34.13 × 0.75 in. (86.7 × 1.9 cm). Collection of George H. Meyer. Photo by Randy A. Batista.

Lenard Megarr, Cane

Lenard Megarr, while incarcerated in a Georgia prison, boldly carved a cane that bore his own name besides the date and place of the cane's creation: *1932, GA*. All carved in deep relief, the shaft also has the words *Keep Me*. This graphic inscription is visually counterbalanced by a large rattlesnake consuming a frog or toad, and a lizard grasping the opposite side of the shaft. Scholars have suggested that this configuration resonates with the Kongo mythological creatures of the lizard and the frog. The lizard and frog had opposite attributes, and Kongo mythology held that men and women respectively assumed their forms after death. The frog's flesh studded with nails recalls the use of nails by Kongo healers to activate spiritual forces in *nkisi* figures. A Victorian-era metal button embedded in the shaft resonates with the use of shiny objects in *minkisi*.

SC

Cat. 6.19. Cane, Lenard Megarr, American. 1932. Polychrome softwood, nail and glass eyes, metal button, 38 × 2.63 × 2.25 in. (96.5 × 6.68 × 5.7 cm). *Right*, side view. Collection of George H. Meyer. Photo by Randy A. Batista.

Arthur Pete Dilbert, Cane

Arthur Pete Dilbert, a longshoreman living in Savannah, Georgia, began carving wood canes and other sculptural forms in the 1960s. Dilbert's work draws on a vocabulary of images seen in the work of renowned Savannah artists Ulysses Davis and James "Stick Daddy" Cooper. Other Lowcountry carvers whose repertoires include human and animal figures, particularly snakes, alligators and other toothy, ferocious beasts, also provided inspiration. The bird finial and the stately female figure on this cane convey a sense of authority and vigilance. Dilbert's iconic and dignified matriarch recalls, in spirit, female figures on Kongo chieftaincy staffs representing female chiefs or matrilineal ancestors.

SC

Cat. 6.20. Cane, Arthur Pete Dilbert, American (b. 1928). 1988. Carved and stained wood, 38.25 × 4.5 × 2.31 in. (97.1 × 11.43 × 5.86 cm). Collection of Smithsonian American Art Museum, Gift of James E. Allen, 1991.105.

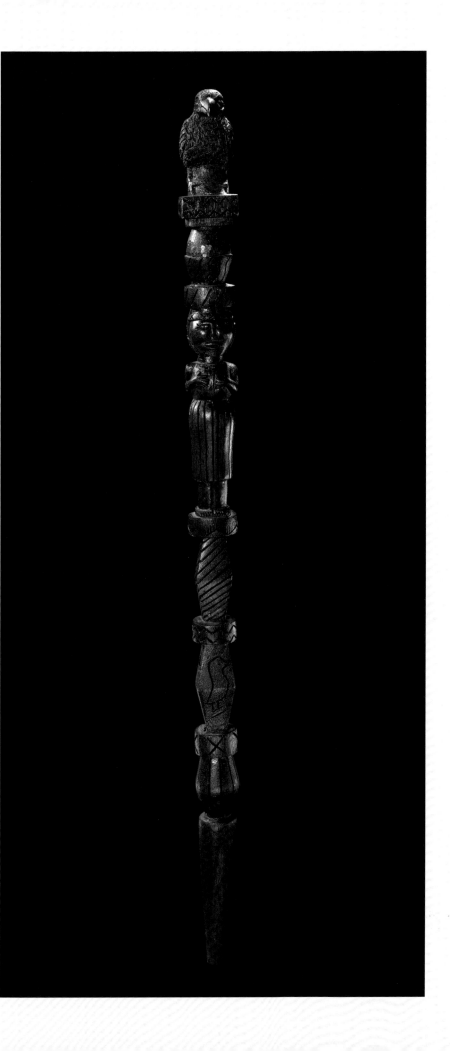

Face Vessels

When ceramics historian Edwin Atlee Barber interviewed Thomas Davies, owner of a pottery in Edgefield District at Bath, South Carolina, in 1862, Davies commented that slaves "made homely designs in coarse pottery. Among these were some weird looking water jugs, roughly modeled in the front in the form of a grotesque human face evidently intended to portray the African features." Davies was the first to describe these face vessels and identify their makers as African Americans. Earlier, in 1858, a man called Romeo, whose African name was Tahro and who was of Kongo origin, had been brought to Georgia aboard the illegal slave vessel the *Wanderer*. Charles Montgomery, an anthropologist, reported that 170 people from the *Wanderer* were brought to a plantation just south of Edgefield, and Tahro was well known by a woman who was a slave on a plantation in Edgefield. Business ledgers from the Palmetto Fire Brick Works in Edgefield show that in 1863 a slave named Romeo, very likely Tahro, was hired out by his owner to work in the factory on seven occasions. There, he may have produced face vessels inspired by Kongo sculptures, masks or English Toby jugs that were imported to the Kongo region by the nineteenth century. The juglike form of the face vessels, with a canted spout and stirrup handle, can be traced to a type of Kongo water jug called *mvungu* that inspired "monkey jugs" in the Caribbean and made its way to the southern United States. Although no one has documented the use of face vessels, some scholars think they may have functioned as Kongo medicine containers, or *minkisi*. Pure kaolin added to the turned vessel to form eyes and mouths would have, like Kongo white river clay, signified the realm of spirits. It is also possible that they were placed on graves. This would be in keeping with the Kongo tradition of placing ceramic vessels, both handmade by Kongo potters and imported bottles and Toby jugs, on graves.

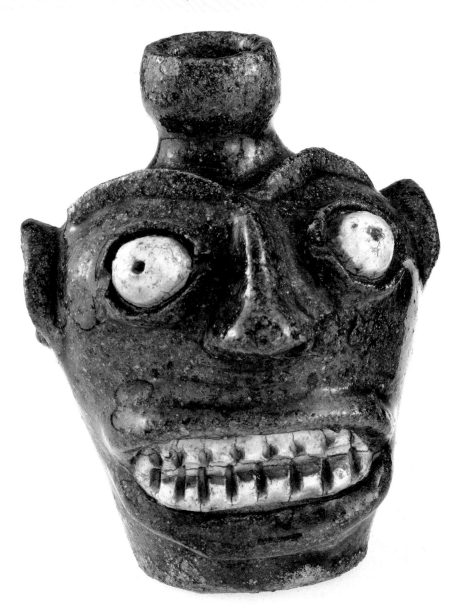

The face vessel shown in cat. 6.24, now in the Philadelphia Museum of Art collection, was made in the Thomas Davies Pottery in Bath, Edgefield District, South Carolina. Edwin Atlee Barber collected wares from Edgefield, including this example.

SC

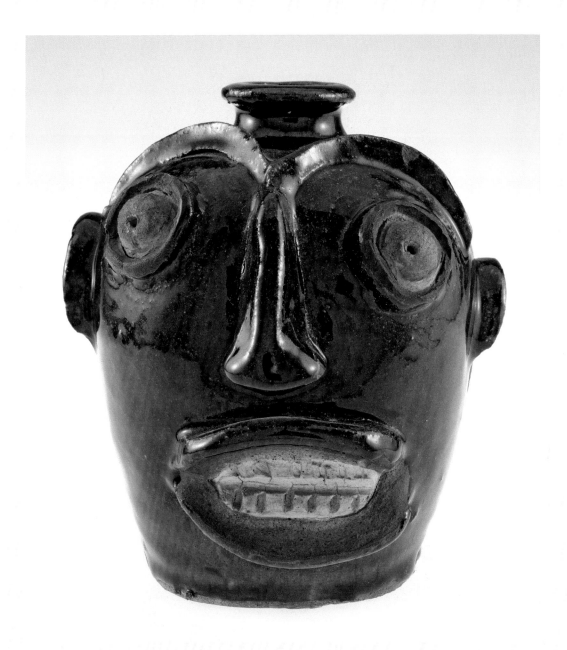

Facing page: Cat. 6.21. Face vessel. Edgefield, South Carolina. Mid-1800s. Alkaline-glazed stoneware, 5 × 3 in. (12.7 × 7.62 cm). Estate of Mary Elizabeth Sinnott, Smithsonian Institution, National Museum of American History, Kenneth E. Behring Center, 68233.

Above: Cat. 6.22. Face vessel. Edgefield, South Carolina. Mid-1800s. Stoneware, 5.38 × 5.5 in. (13.66 × 13.97 cm). Marcus Benjamin Collection, Smithsonian Institution, National Museum of American History, Kenneth E. Behring Center, 150313.

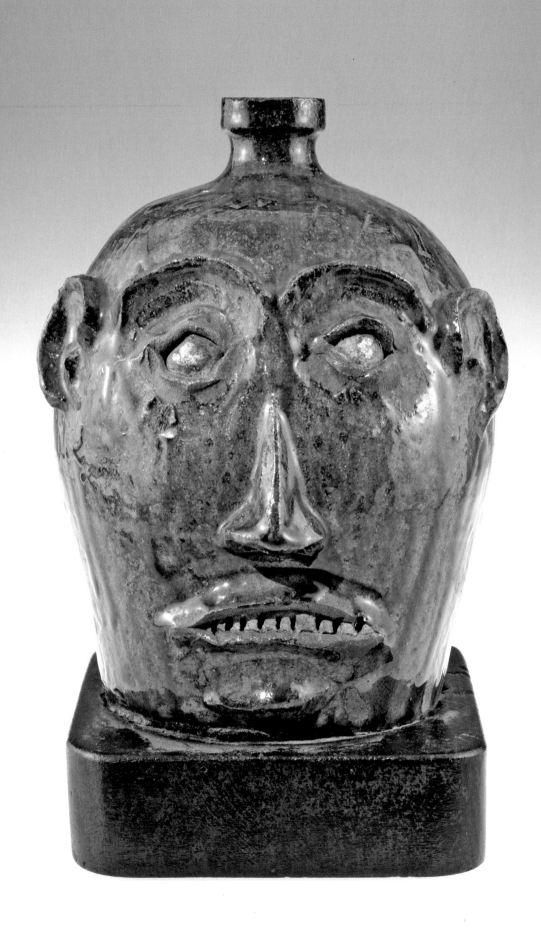

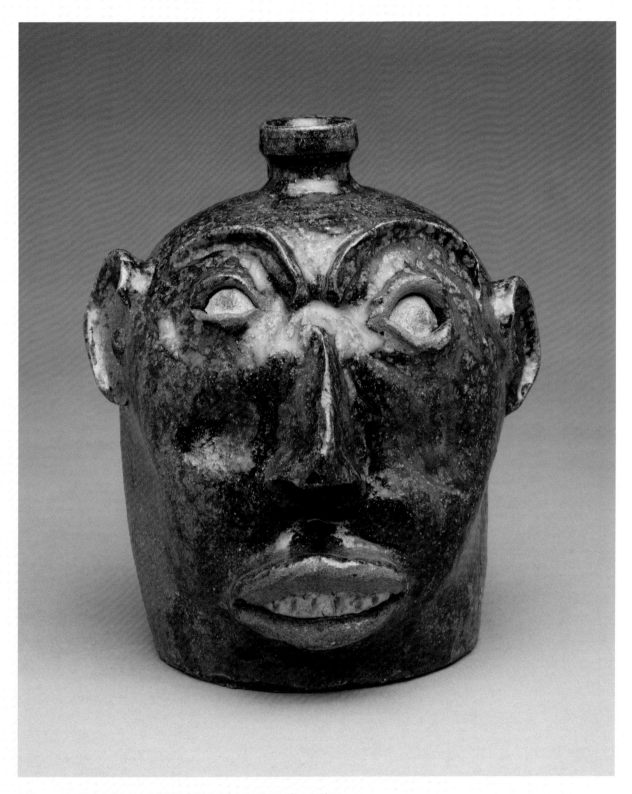

Facing page: Cat. 6.23. Face vessel, Edgefield District, South Carolina. Mid-1800s. Stoneware, coarse (overall material), wood (overall material) mount, 9 × 7 in. (22.86 × 17.78 cm). Eleanor and Mabel Van Alstyne Collection of American Folk Art, Smithsonian Institution, National Museum of American History, Kenneth E. Behring Center, 256396.

Above: Cat. 6.24. Face vessel, attributed to Thomas J. Davies Pottery, Bath, Edgefield, South Carolina. 1860–70. Stoneware, 6.75 × 5.06 in. (17.1 × 12.9 cm). Gift of Edward Russel Jones, 1904, Collection of Philadelphia Museum of Art, 1904-36.

African American Commemorative Objects

African Americans have commemorated deceased family members using a diverse array of objects, both found and constructed, placed on graves or kept in the home. Throughout the post–Civil War era in the southern United States, images of African American cemeteries show that they were filled with graves marked with personal objects, such as clocks, lamps, glass bottles, figurines, crockery and materials related to the deceased's faith or occupation (fig. 16.2). Many graves were adorned with seashells, arranged around the perimeter or placed on the mound. In Georgia, an 1880 report of a clay jar covered with items associated with the deceased, then placed on a grave, was the first documentation of African American use of memory jars as grave adornments. A twentieth-century jar coated with plaster and embedded with a medal with the inscription *To The Emmett Cole / Funeral Home. / Presented By. / B.Y.M.B'S of / North Broad Baptist / Church. / Rome, Georgia*, suggests it belonged to one of the church's African American congregants. The use of assembled objects on graves is a legacy of the Bakongo, whose chiefs and elite members of society had elaborate graves that were covered with personal objects that bore their last connections with life (see fig. 11.1, ill. 10.1, and ill. 10.3). The Kongo concept of the grave as a site of passage and contact for ancestral spirits is reflected in African American graves and memory jars. Mirrors or other shiny objects were meant to evoke the spirit of the deceased, so that he or she might provide guidance to the living. Seashells, typically large conch shells, alluded to the deceased's passage to the realm of the ancestors below the water and to immortality.

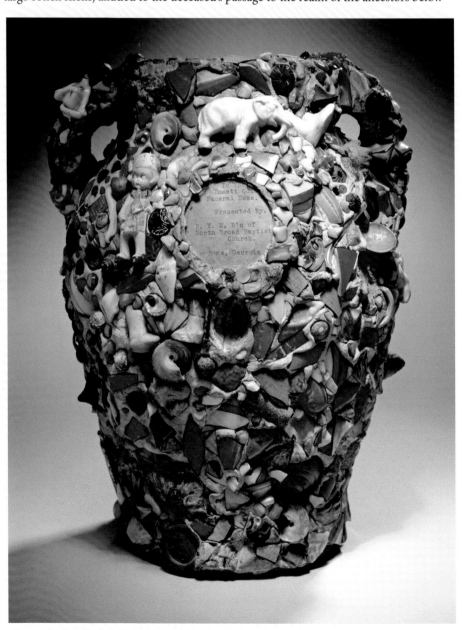

The African American grave adornment shown in cat. 6.27 from Georgia has several elements that link it to Kongo funerary practices. The white coating of the cabinet interior suggests the white realm of the ancestors, *mpemba*, in the Kongo worldview. Natural tree branches twisted into a cross is surely Christian inspired, but the encircled cross with each arm accentuated by a rosette is strikingly similar to the Kongo cosmogram, or *dikenga*, which marks the four points of passage of human life from birth to adulthood to death, and the afterlife. The carefully painted silver ends of the cross, like other shiny objects placed on graves, stem from the Kongo practice of embedding shiny objects inside medicine bundles to invoke spiritual presence and power.

SC

Cat. 6.25. Memory jar, American. 20th century. Hand-built clay with encrusted shards and found objects, 13 × 11 × 9 in (33 × 27.9 × 22.9 cm). Collection of the High Museum of Art, purchased with funds from the Decorative Arts Acquisition Trust, 1997.37.

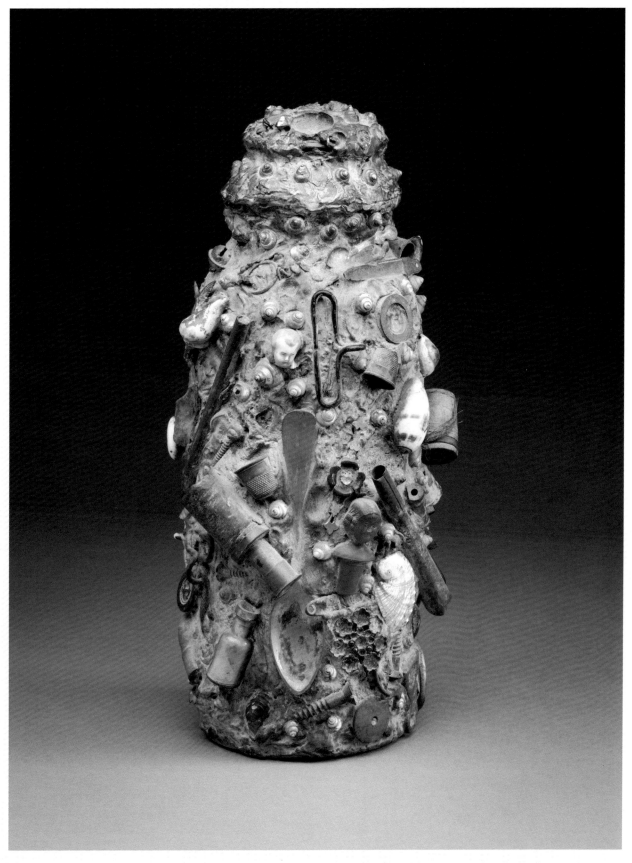

Cat. 6.26. Memory jar, American. Early 20th century. Mixed media, 12.5 in. (31.75 cm). Collection of Renée Stout. Photo by Randy A. Batista.

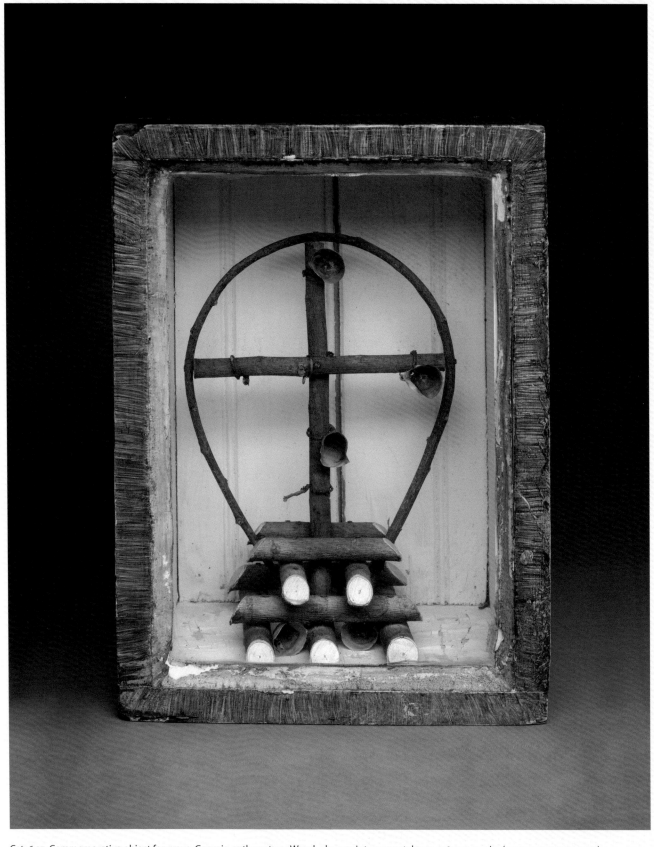

Cat. 6.27. Commemorative object for grave. Georgia. 20th century. Wood, glass, paint, rose petals, 9.5 × 6.75 × 13.5 in. (24.13 × 17.15 × 34.3 cm). Private collection. Photo by Randy A. Batista.

Kongo in Contemporary Art

<div style="text-align: right">**22**</div>

Kongo Inspiration in Contemporary World Art

SUSAN COOKSEY AND ROBIN POYNOR

Many artists presently working in Africa, South America, the Caribbean and North America mine Kongo history, philosophy, religion, and iconography to create new art.[1] They may be attracted to Kongo culture because they share its heritage, identify with the territory as an ancestral homeland or think of it as part of their national identity. Others look to African art in general for inspiration, finding suitable forms or fitting iconography in Kongo sources. Each form of appropriation is complex and may be traced to the early period of colonialism when African material culture was introduced into the West.

European Modernists and Kongo Art in "Primitivism"

In the West, the first attempts to mine African art for inspiration took place in Europe, a continent with a long history of looking to other cultures for creative stimulation. Artists often responded more to their own imaginings than to anything real about those cultures. In the mid-seventeenth century, for example, European artists reacted to their understandings (or misunderstanding) of a distant China in creating fanciful forms known collectively as *Chinoiseries*. In the mid-nineteenth century Japanese woodblock prints inspired *Japonisme*. Post-Impressionist Paul Gauguin was lured by the seemingly exotic cultures of Southeast Asia, the Caribbean, South America and the Pacific, referencing their art in his own work. Indeed, one of the first examples of Kongo forms catching the eye of European modernists was Gauguin's visit to the mock African village in which Loango carvers worked in the 1889 Universal Exposition in Paris.[2] Two objects attributed to Gauguin are sometimes believed to be Loango pieces that he reworked.[3]

By the beginning of the twentieth century, African objects had become commodities. Many artists saw such objects in ethnological museums or elsewhere. For example, the poet and art critic Apollinaire and his friend Joseph Brummer, a Hungarian artist who also ran a small gallery in Paris, discovered African objects in the window

of an automobile supply shop. The objects got there because shipments of tire rubber from French Equatorial African plantations had apparently included curios from Central Africa.[4] Paul Guillaume, then a young clerk, agreed to seek more African materials for Brummer and Apollinaire. Shortly after that, he was in the business of selling African art.

By the early twentieth century, numerous European intellectuals collected African objects. A large Kongo power figure (*nkisi nkondi*) dominated Apollinaire's study. Photographs of Picasso's studio show a profusion of objects from "exotic" cultures, some of them from Central Africa.[5] But cultural specificity was not as important for European modernists as were the assumptions artists made about the objects from non-European cultures. Living and working about half a century before the development of the professional study of African art, they had little understanding of either the purposes for which such objects were created or the meaning of iconographic details. Yet these works encouraged European artists to seek different ways of seeing. Gauguin saw such objects as emphasizing the Rousseauian concept of "the noble savage." For Expressionists, the rawness of African art corresponded to their ideas of emotional immediacy. For Cubists, geometric abstractions in African art led to new ways of looking at form. For Surrealists, the objects provided links to the subconscious. For the American artists attuned to Jungian ideas, they attested to the collective unconscious, providing links to "mythic images."

African American Modernists and African Art

For artists in the Caribbean, Latin America and the United States whose own ancestors had come from Africa, the African continent was a source for personal and collective recollection. They sought their own histories, content and style by looking to African art. The quests of European modernists and African Americans interconnected. In the 1930s, Lois Mailou Jones studied painting in Paris, where she saw African art as a source of inspiration for avant-garde artists. Recognizing its beauty and strength, Jones incorporated references to African masks and figures into her own paintings. Alain Locke's appreciation of African art had an even greater impact. As the first African American Rhodes Scholar, Locke visited Paris and met Apollinaire, Guillaume and other intellectuals. He introduced Guillaume to a number of young African American scholars, among them Langston Hughes, Charles S. Johnson and W.E.B. Du Bois. Guillaume in turn introduced Locke to Albert Barnes, Carl Van Vechton and other European Americans there.[6] When Johnson returned to America, he became editor of the literary magazine *Opportunity* in Harlem. In articles published in the magazine, Locke admonished African American artists to use African art and African American folk culture to inspire creativity.

In 1935, African Americans saw an exhibition produced by the Museum of Modern Art, *African Negro Art*, featuring some six hundred objects. A selection of those toured seven American cities.[7]

While Lois Mailou Jones was drawn to the elegance of African art, others saw in it a chance to make people aware of a past that was once denied and shunned. This past, they insisted, needed to be invoked as inspiration. Taking Locke's advice, Aaron Douglas looked at African objects in the American Museum of Natural History and in the collections of both Barnes and Locke. The result was a mural titled *Aspects of Negro Life*.[8] Another artist who took Locke's advice to heart was Hale Woodruff. On his return from Paris in 1931, Woodruff established the art department at Atlanta University, where he painted a set of six murals, *The Art of the Negro* (fig. 22.1). He wanted to provide students at the historically black university with images of African and African American cultures so they could tie their own histories to those of Africa.[9]

Romare Bearden's interest in African art began in the 1930s when, as a boy, he saw the Museum of Modern Art exhibition.[10] Ralph Ellison stated in 1977 that Bearden "has discovered his own uses for the metaphysical richness of African sculptural forms."[11] By the mid-1960s Bearden had incorporated images from popular magazines in photomontages, integrating photographic reproductions of fragments of African masks and sculptures and images from African American culture into the collages as a beginning for his art, thus realizing Locke's goals for the "New Negro" artist to represent African American culture through carefully looking at both African art and African American folkways.[12] Of African art, Bearden said he wanted to "see what the philosophy was, discover what were some of the ideas that emanated from this work. I wanted to try and understand the African vision of the world. . . ."[13]

New Approaches to the Study of African Art

Bearden was not alone in his interest in the African artist's philosophy or the ideas behind the art. By the late twentieth century art historians, like the cultural anthropologists who had inspired them, began to delve into the arts of Africa by carrying out research on the continent, seeking its creators, pursuing answers to questions concerning identity, patronage and interpretation.

At the same time, the investigation about the persistent development of African culture in the West, begun by Locke and the anthropologist Melville Herskovits in the 1930s, continued. Specific strains of African culture were traced by historians, anthropologists and art historians—recognizing not only the general African past but also making specific connections to African cultural groups evident in historical cultures in the Caribbean, Brazil and North America. Among these, as manifested in the preceding chapters, Kongo sources are evidenced in archaeological excavations as well as in continuing folkways.

In the past few decades Kongo culture has become subject matter for much contemporary art. The range of approaches to creating art in response to Kongo is broad, and those who have looked to Kongo for inspiration or source material include a large number of artists—in Africa, Europe, the Caribbean, South America and North America.

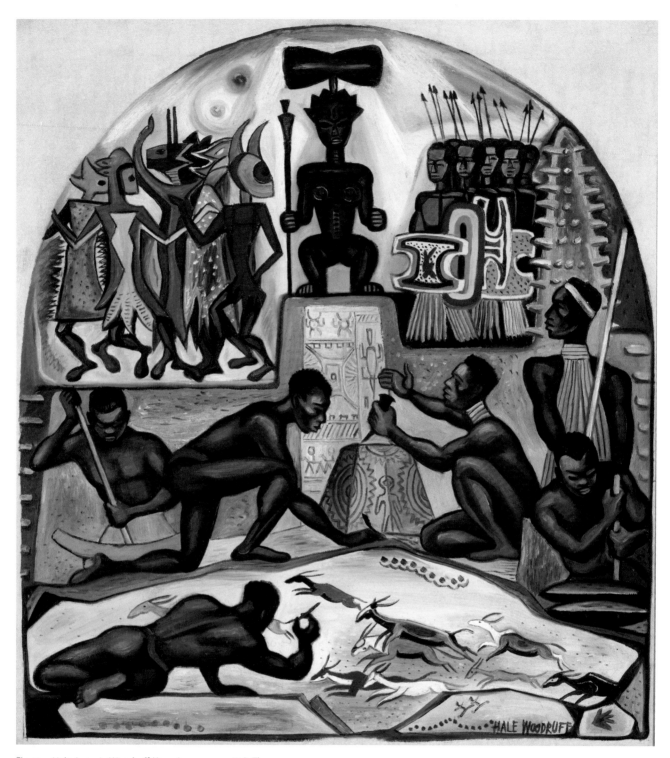

Fig. 22.1. Hale Aspacio Woodruff (American, 1900–1980), *The Art of the Negro: Native Forms* (study). 1945. Oil on canvas, 22 ¾ × 20 ⅞ in. (57.8 × 53 cm). Collection of the Samuel P. Harn Museum of Art, University of Florida, Gainesville, Florida, museum purchase, gift of an anonymous donor with additional funds provided by exchange, gift of Helen Sawyer Farnsworth, 2005.17. Courtesy of the Estate of Hale Woodruff/Licensed by VAGA, New York, New York.

In Africa a number of artists continue to allude to Kongo in their art, among them the Congolese Steve Bandoma (represented in the *Kongo across the Waters* exhibition), Trigo Piula, Antonio Ole and Paulo Kapela. Bandoma began his art training in Kinshasa but soon became frustrated by what he considered a traditionalist approach in Congolese academia that precluded conceptual art. In 2003, he and three others formed a movement called *Librisme Synergie* to encourage greater academic support for new media and contemporary art. Seeking further development as a conceptual artist, in 2005 he left Kinshasa for Cape Town, where he has experimented with mixed media, performance and installation.[14]

Bandoma uses found objects and imagery, including material from contemporary advertising and magazines.[15] His recent works feature violent splotches of color and cutouts from high-fashion magazines exploding across pristine voids of white. Bandoma says he wanted to capture the chaotic movement of life on Kinshasa's streets. The urban landscape's rapidly changing visual culture, full of new media and technology, is what Bandoma's art explores. His Lost Tribe series is a humorous, if perplexing, look at the transformation of traditional Africa into a culture of hypermodernity. He paints figures based on Kongo *minkisi nkondi* but replaces their activating blades with cutout photographs of arms and legs from magazines. In *Trésor Oublié* (cat. 7.9), the *nkisi* is put on a base bearing the dates of Congo's colonial period, thus paradoxically depicted as a monument to African tradition but bolstered by a colonial past. The monument is pulled down with ropes and toppled from its base. His legs break, and nails fall away into the white void surrounding the *nkisi*, which grasps a broken spear. The artist's humor is evident in the *nkisi's* cutout lipsticked lips, which match its tugging red ropes. A small St. Michael figure, dwarfed by the monumental *nkisi*, acts as its ineffectual Western companion-in-arms, wielding his sword to fend off temptations that ensnare the figure. Notions of spiritual or moral decay are implied by the black void in the *nkisi's* abdomen that would normally hold spiritually charged medicines.

In *Acculturation* (cat. 7.10), Bandoma's *nkisi* is a faded monochrome wash, suggesting its weakened state. Cutout images of hands holding long nails sprout from its torso. Only one large mascaraed eye confronts us directly, perhaps a sign that it is either aware of its own demise or simply showing its transformative state. The television color test bar inserted in the abdominal cavity replaces activating medicines, informing us that the media have replaced the spiritual powers of *bilongo*, the object's medicinal charge.

Other African artists likewise use *minkisi* and other recognizable Kongo objects to symbolize wide-ranging problems pertinent to present-day Africans. The imagery, although deriving from Kongo, can be read as symbolic of Africa in general. In *Materna* (fig. 22.2), Trigo Piula grafts the head of a white woman lifted from an imported milk label onto the body of a Kongo figure type called *pfemba* (see ill. 9.3). Milk cans and candles, some newly lit, some extinguished and melted, stand before the figure as if

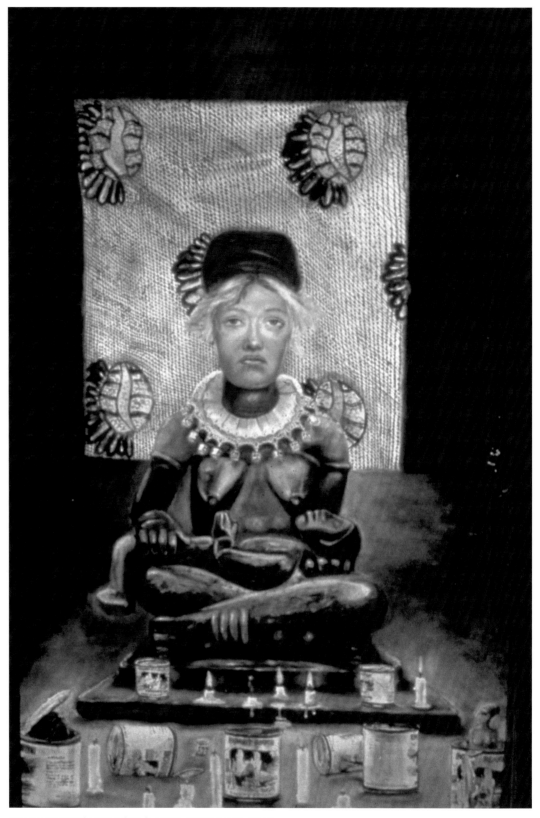

Fig. 22.2. Trigo Piula (Congolese, b. 1950s), *Materna*. 1984. Oil on canvas, 48 × 34½ in. (122 × 88 cm). Image courtesy of the New Museum.

on an altar. Susan Vogel states that "Piula uses Westernisms systematically to comment upon the cultural predicament of his people. The nursing Kongo mother in his *Materna* feeds her child with imported, canned evaporated milk; as the slang expression goes, we can see where her head is: it has become the head of a white woman."[16]

In another Piula painting, *Ta Tele*, an African audience stands before a large *nkisi*. Rather than a mirror to encase activating materials, a television set fills the abdomen. Beyond the *nkisi*, multiple screens present images of foreign goods that entice the African audience. Although Piula comments on Kongo culture, he addresses a new type of "fetish" that captures and infects a broader African audience—consumerism.[17]

Paulo Kapela of Angola goes a step beyond merely incorporating recognizable African or Kongo imagery. He employs the aesthetic principles of accumulation and juxtaposition recognizable in the production of *minkisi*. Kapela, whose ancestry is Kongo, combines disparate objects in installations suggestive of worship spaces. In collages of recognizable public figures, foreheads are set with small mirrors, perhaps references to *minkisi* whose mirrors seal off empowering *bilongo*. Kapela regards his art as reconciling European and African cultures. It serves as an agent for "the remembering of a fractured and amputated society after the years of war."[18] Dunja Hersak suggests these "altars" protect against intruders, and in that sense, they function as aggressive *minkisi*.[19]

Angolan artist Antonio Ole juxtaposes images that refer to the Kongo kingdom at the height of its power in the sixteenth century with tourist versions of *minkisi* (fig. 22.3), alluding to western consumption of Kongo visual culture. In the juxtaposition of such politically and culturally charged images, he questions the nature of art and

Fig. 22.3. Antonio Ole's studio. Photograph by Barbaro Martinez-Ruiz, 2006.

how art can or even should be used to shape a new, unified national identity at the expense of culturally specific definitions of and responses to art and beauty.[20]

Kongo and Contemporary Caribbean Art

Echoes of Kongo culture resound throughout the Caribbean in different forms. Palo Monte Mayombe, an Afro-Cuban religion, maintains numerous practices from Kongo, and its graphic writing system (*firmas*) relates to Kongo symbols.[21] Vodou's various practices have many African elements. Petwo spirits use medicines and charms called *paket kongo* and *wangole*, showing continuity with Kongo both in the materials of manufacture and in nomenclature.[22] Both Caribbean creole religions have inspired artists who employ Kongo elements and pay homage to their own island traditions.

Palo adherents refer to their homeland as *Ngola* and use Kongo-derived terminology and iconography.[23] Judith Bettelheim points out that a number of Cuban contemporary artists incorporate Palo imagery in their work. José Bedia, an initiated practitioner from Cuba, lives and works in Miami. He attempts to reconcile his Western academic training with the visual inheritance of the Kongo-based religion he embraces. He recalls that in art school "they tried to teach me Western traditions—how to make a landscape or a still life, how to work from nature." He was frustrated until he realized that he had what he was looking for in his own backyard, in the Cuban community, in Palo Monte Mayombe.[24] In *Nkisi Malongo Prueba Fuerza*, 1995 (fig. 22.4), he depicts a somewhat realistic Kongo *nkisi*, but in installations, he may create an actual container of materials (known as a *nganga* or *prenda*) to represent the spirit or turn some other object such as a boat into a *nkisi* (see fig. 26.2a and fig. 26.2b). In others, he may insert a *paket kongo* (fig. 26.1a) or a figure of Francisco, who represents the Kongo ancestor (fig. 26.1b).

Haitian Vodou was developed from a number of African sources including Fon, Yoruba and the blending of Kongo religion and Catholicism that had developed in eighteenth-century Kongo.[25] The range of deities in Vodou is extraordinary, including not only the *lwas* (divinities) but also other spiritual agents falling into the general divisions of Rada and Petwo.[26] Rada deities, which some Vodouists associate with the pure unadulterated tradition from Ginen (Guinea or Africa), are traced to the historic Dahomean empire located in the southern portion of the present-day country of Benin.[27] Rada rituals contain cool drum rhythms, movements and spiritual demeanors appropriate to revered authority. Hot Petwo deities, on the other hand, act with volatile fury and abandonment, and their drum rhythms are defined by faster tempos and accentuated off-beats. Vodou is self-consciously aware of the contrasts in the two families of gods deriving from West Africa and Central Africa, respectively.[28]

Edouard Duval-Carrié, a Haitian artist now living and working in Miami, creates much of his work in response to Vodou and the verbal literature describing the *lwas*.

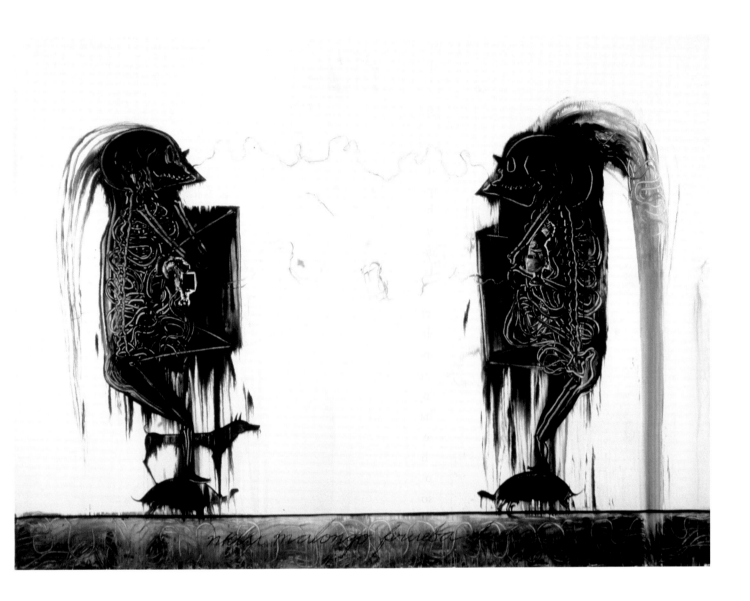

He generates visual narratives to capture the essence of the divinities through anthropomorphized forms, incorporating the graphic patterns known as *vévé* into the borders of his paintings. In his Migration series, Duval-Carrié follows the movements of the spirits from Africa to Haiti to Miami. The various *lwas* mix and mingle, but their sources are identifiable as in *Le débarquement á Miami Beach* (fig. 25.3), *Le départ* (cat. 7.5), *La traverse* (cat. 7.6), and *La calebasse magique* (fig. 25.2). For example, cool colors may define Rada spirits while warmer colors may suggest Petwo.[29] Specific Rada and Petwo *lwas* are recognized by iconography as well. For example, the Rada deity Damballa is acknowledged by his serpentine form in fig. 25.3, his upper body that of a human, his lower body that of a serpent. His cool Rada nature is suggested by the bluish coloring of his body. The Kongo Mayaka standing to the far right is dressed in forest leaves and wears a feathered headdress. Thus the Rada and the Petwo spirits arrive in Miami together.

Fig. 22.4. José Bedia (Cuban-American, born in Havana, 1959), *Nkisi Malongo Prueba Fuerza*, 1995. Acrylic on canvas, 71 ¼ × 91 ¼ in. (181 × 231.7 cm). Photograph by George Adams Gallery. By permission of the artist.

By the late twentieth century, artists of African descent throughout the black Atlantic world foregrounded multicultural identities and reinforced common ties to Africa. With Bedia and Duval-Carrié, they shared the strategy of reappropriating African elements.[30] African American artists such as Betye Saar, Carrie Mae Weems, Renée Stout and David Hammons scrutinized and challenged Western ideas of Africa and African American identity. In their quest to deepen the understanding of African presence in their own lives, they turned toward vernacular art in their own communities and personal lives, both as a source and as a medium. Renée Stout and Radcliffe Bailey both embrace multiple African elements. Each explores Kongo cultural ideas and visual expression. Stout is drawn to the idea of power through multisensory and multivalent elements as represented by *minkisi*. Bailey is fascinated with Kongo cosmology. Recent trends of tracing ancestry through newly accessible Internet records and increasingly accurate genetic testing have inspired artists like Bailey.

Like many African Diaspora artists, Stout approaches Africanity in her work from two directions—from conscious retrieval and through vernacular renditions (see chapter 23 in this volume). Stout casts herself, literally and figuratively, as a *nkisi*, in Kongo-inspired work such as *Fetish No. 2* (fig. 23.1). Later work, like *Self-Portrait no. 2 (Self-Portrait as Inkisi)* (cat. 7.1) and *Master of the Universe* (cat. 7.2), is the fruition of a lifetime of intellectual, aesthetic and intuitive engagement with Kongo art. Stout "found" Kongo art close to home at age ten at the Carnegie Museum in Pittsburgh, which housed a *nkisi* figure, and in a yard display of watcher figures composed of dolls (see chapters 20 and 21). As a young artist, her study of African and African American art, coupled with her own introspection, led her to Kongo art and philosophy. Stout turned from super-real paintings of community scenes to sculpting *nkisi*-like objects that compelled her with their aura of hidden power. Stout's bundles and heavily patinated assemblages demonstrate her intuitive grasp of Kongo form and aesthetics, as well as their purpose and meaning. Her art functions on both personal and universal levels, as Wyatt MacGaffey and Michael D. Harris recognized in *Astonishment and Power: Kongo Minkisi and the Art of Renée Stout*. Stout's work is a creative analog with Kongo, neither mimetic nor passive derivation.[31] Her insight is more than the result of intense looking at Kongo art; it is achieved by exposing works in progress to family and friends whose cultural backgrounds challenge and inform her understanding of Kongo praxis.[32] Through this dialogue Stout has discovered a personal art history. Her artistic process, based on the gleanings of family history, African American history and African history, is focused through the lens of her creator persona, which she likens to a conjure woman, whose presence is felt in *Self-Portrait No. 2 (Self-Portrait as Inkisi)* and *Master of the Universe* (cat. 7.1, cat. 7.2 and fig. 22.5). In negotiating between the world of present-day artist and conjure woman manipulating sacred space, powerful substances, both creator and created, she positions herself in the analogic Kongo world as *nganga* and *nkisi*.

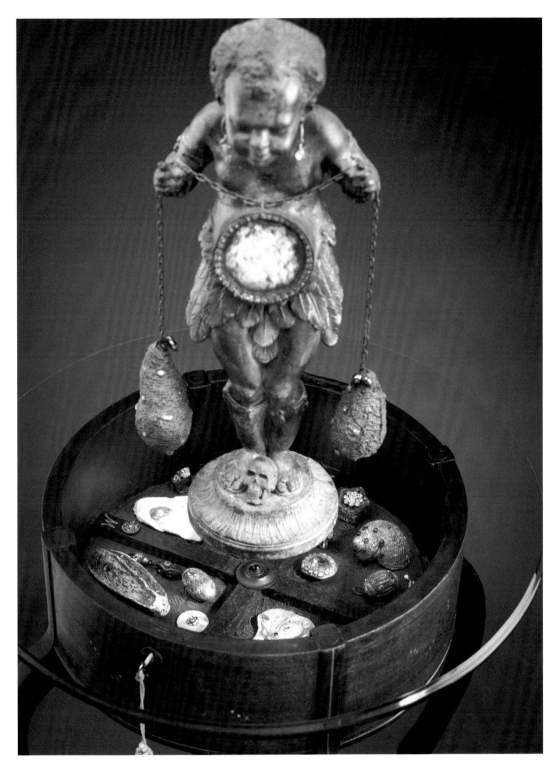

Fig. 22.5. Renée Stout (American, b. 1958), detail of *Master of the Universe*, 2011–12. Found objects, organic materials, rhinestones, glass beads, mirror, 48 × 18 × 18 in. (121.9 × 45.7 × 45.7 cm). Collection of the artist. Photograph by Randy A. Batista. By permission of the artist.

Much of the work of Atlanta-based artist Radcliffe Bailey focuses on the Black Atlantic (see chapter 24; cat. 7.3 and cat. 7.4). He amalgamates visual and conceptual information from West and Central Africa with images and cultural elements from the southeastern United States. Bailey's artistic identity was forged in urban centers of African American art and culture, Philadelphia and Atlanta. He draws on the improvisational methods of African American folk artists—like blacksmith Phillip Simmons, the Gee's Bend quiltmakers and Bill Traylor. He is likewise inspired by jazz greats like John Coltrane and Thelonious Monk. In his medicine-cabinet sculptures, Bailey interweaves these diverse sources as he maps African American history. Like Stout, he infuses his works with both iconographic references and personal narrative. Sculptures in this series may be read as metaphors for Bailey's concept of art as a medicine cabinet for memory, both collective and personal.[33] Bailey's intense interest in decoding his own history, linking it to the history of his forebears in America and in Africa, is seen literally in letters inscribed on the surface of his works representing his own DNA sequences, but also in the act of tracing the "complex network of his 'aesthetic DNA' to create antidotes to cultural and historical amnesia."[34]

Notes

1. We thank numerous individuals for encouraging us in writing this chapter and for advising us on its content. We have benefited from the writing of Barbaro Martinez-Ruiz and relied on our interaction with the authors of the four chapters that follow this one: Michael D. Harris, Carol Thompson, Judith Bettelheim, and Don Cosentino. Our colleagues at the University of Florida—Victoria Rovine, Rebecca Nagy and Kerry Oliver-Smith—have offered helpful suggestions, and Poynor's co-authors on other projects, Amanda Carlson and Monica Blackmun Visona, have provided invaluable guidance in thinking through the chapter.

2. Peffer, "Notes on African Art," 76.

3. Peffer, "Notes on African Art," 76.

4. Visona, "Agent Provocateur," 112.

5. Photographs of Apollinaire's study and of Picasso's studios reveal numerous objects from Africa.

6. Visona, "Agent Provocateur," 117.

7. Visona, "Agent Provocateur," 117.

8. Visona, "Agent Provocateur," 117.

9. http://www.cau.edu/Academics_Murals.aspx (accessed on April 3, 2013).

10. Visona, "Agent Provocateur," 118.

11. Ellison, "The Art of Romare Bearden," 679.

12. Patton, *African-American Art*, 189.

13. Visona, "Agent Provocateur," 118.

14. In 2012, when he was denied a visa to go to Britain for his solo exhibition, he commented that such obstacles are thrown in the path of emerging Congolese artists, and African artists in general, whose work may be shocking to a country mired in traditional media, such as wood sculpture or pottery. http://www.bbc.co.uk/news/world-africa-19593312 (accessed on April 4, 2013).

15. http://www.artdaily.org/index.asp?int_sec=2&int_new=57065 (accessed on April 3, 2013).

16. Vogel, *Africa Explores*, 39.

17. Mirzoeff, *An Introduction to Visual Culture*, 152.

18. Nadine Siegert, "Mestre Paulo Kapela—re-membering," http://www.buala.org/en/face-to-face/mestre-paulo-kapela-re-membering-the-disparate (accessed on April 4, 2013).

19. Hersak, "New Spaces," 1.

20. Martinez-Ruiz, "Kongo Ins-(ex)piration."

21. Bettelheim, "Palo Monte Mayombe and Its Influence," 36.

22. Apter, "On African Origins," 241.

23. Bettelheim, "Palo Monte Mayombe and Its Influence," 36.

24. Sims, "Individuality and Tradition," 37.

25. Vanhee, "Central African Popular Christianity."

26. Apter, "On African Origins," 238.

27. Rada alludes to the kingdom of Allada, associated with the kingdom of Dahomey.

28. Apter, "On African Origins," 238.

29. Cosentino, *Divine Revolution*, 50–55.

30. Sims, "Introduction," xi.

31. R. Thompson, "Illuminating Spirits," 108.

32. R. Thompson, "Illuminating Spirits," 108.

33. Diawara, "Radcliffe Bailey," 138.

34. C. Thompson, *Radcliffe Bailey*, 13.

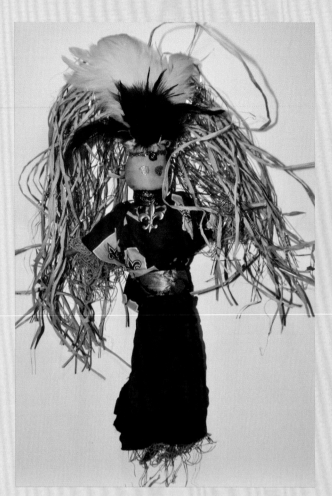

Left: Ill. 17.1. This Hoodoo root doll was made by Mama Sara in New Orleans using a mix of Spanish moss, small sticks, glass beads, store-bought tinsel and chicken feathers and fabric bearing a corporate logo. It was crafted to draw luck to a popular local sports team. Photograph and permission by Alissa Jordan, 2012.

Below left: Ill. 17.2. A magical human-shaped cloth figure (*pwen*) hangs from a sacred tree in a sorcerer's courtyard in rural Haiti. It is activated with herbal medicines, mirrors, rope and metal pins. Its job will be complete when it falls from the tree. Photograph and permission by Alissa Jordan, 2012.

Below right: Ill. 17.3. A Vodou book with Baron Lakwas's several incantations and *vévé* symbols. Arcahaie, Haiti. Photograph and permission by Alissa Jordan, 2012.

Facing page: Ill. 17.4. A statue of Baron Lakwa in front of his cross, surrounded by a rich variety of burnt offerings, money and other gifts, standing in a botanica in Little Haiti, Miami, Florida. Photograph and permission by Susan Cooksey, 2012.

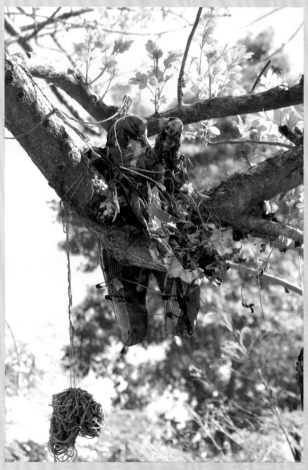

Kongo Memory in the Afro-Atlantic

Across the Americas and the Caribbean today, modern religious artists continue to celebrate Kongo aesthetics through multimedia artworks that tie contemporary worshippers to the vibrant world of the ancestors. Central Africans believe that the living, the recent dead, and divinities are linked in complex relationships that crosscut each other's realities. These beings are thought to be animated by multifaceted essences, some of which can be taken and invested in sacred sculptures of bone, wood, nails, cloth and earth. Similar to Kongo *minkisi* (see cat. 4.1 to cat. 4.12), figures made in New Orleans Hoodoo, Haitian Vodou, and Cuban Palo are cared for and used for healing, fortune-seeking and other purposes.

In many Central African and Afro-Creole traditions, such power figures work because the earthly world and the ancestor's world share passage with one another through a crossroad guarded by a powerful spirit. This spirit, who mediates spirit and human realms, is served under many different names, sometimes used simultaneously, in the Americas and the Caribbean. Baron Lakwa (Baron of the Cross) is one widely served Gede Vodou version of this spirit, whose multicolored cross bears witness to the enduring strength of Kongo roots in the contemporary Western Hemisphere, a heritage that was not overcome by slavery or time.

AJ

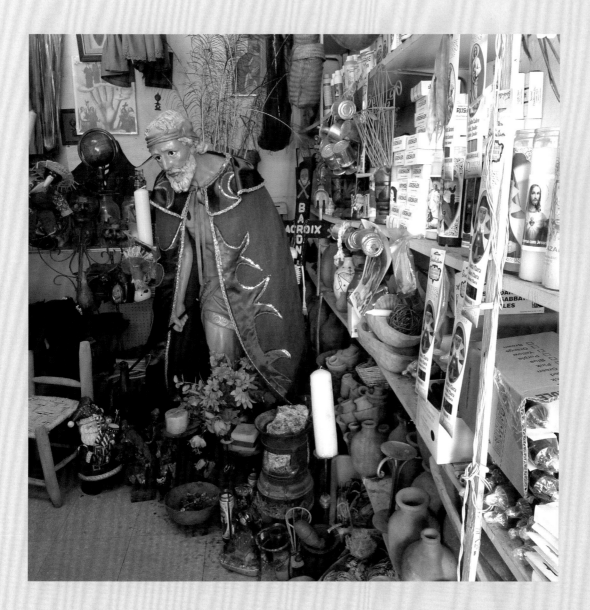

23 ◈

Kongo Squared

The Art of Renée Stout

MICHAEL D. HARRIS

> I see each one of my pieces as a fragment or installment in
> an ongoing narrative that's my contribution to telling the story
> of who we are as a society at this point in time.
> Renée Stout

Congo Square in New Orleans in the eighteenth century was a place African slaves were free to congregate, play music, and express themselves. It was, in many ways, a public sanctuary, a cultural safe space, where Africans could be as they were rather than as the masked beings they were in the context of slavery and its immediate aftermath. Today it is an open space inside Louis Armstrong Park in the Tremé neighborhood across Rampart Street from the French Quarter (see chapter 18 in this volume by Freddi Williams Evans).

Early observers reported hearing the beat of *bamboulas* and the sound of *banzas* (an early banjo-like instrument), and seeing varied African dances. In 1819 the architect Benjamin Latrobe visited the city and recorded in a journal his surprise at seeing 500–600 unsupervised slaves assembled to dance and play in the square.[1] At some point it was reported that the audience and various musicians and dancers represented ethnic groupings taking their places in different parts of the square and using

> a range of instruments from available cultures: drums, gourds, banjo-like instruments, and quillpipes made from reeds strung together like pan flutes, as well as marimbas and European instruments such as the violin, tambourines, and triangles.[2]

The presence of Kongo culture in New Orleans in abundance along with Yoruba traditions in the Mississippi and Louisiana Gulf and Delta regions, especially notions of trickster figures and legends of the crossroads, bled into the lore that later became embodied in personalities such as the Hoodoo priestess Marie Laveau (whose daughter by the same name succeeded her). She was part of a world of charms, medicines

called *nkisi* that direct the spirit, and ritual experts who might, like Laveau, create and activate materials and objects on behalf of believer clients. Robert Farris Thompson has written that Kongo heritage "is clearly evident in the making of love charms in black American communities—charms whose purpose is to bring back errant lovers."[3] It is here that Kongo heritage encounters Renée Stout and vice versa. However, in African diasporic cultures, we often find doubling of meaning, layering and dialectics. These are the kinds of complications we might associate with trickster figures and the signification and allusions so common to the art objects from nineteenth-century Kongo culture.

In contemporary African American culture, African cultural foundations often are approached from two directions: up through vernacular renditions, and back through conscious retrievals. In Renée Stout's work, the two directional acquisitions merge. She first burst into visibility with her 1988 self-portrait as a *nkisi nkondi*, *Fetish no. 2* (fig. 23.1). This work blew up the traditional Western artist's self-portrait by turning

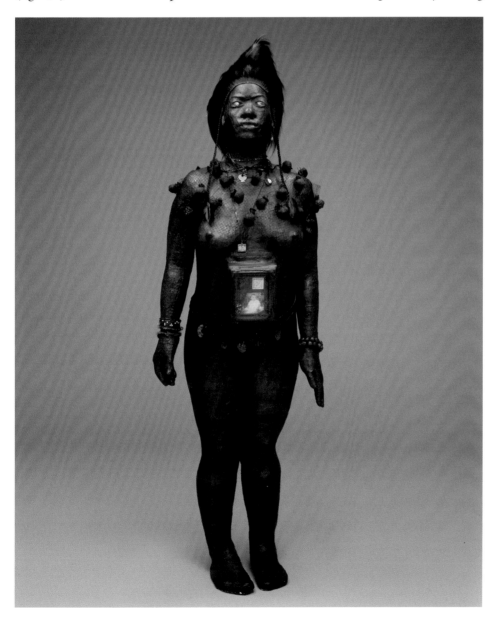

Fig. 23.1. Renée Stout (American, b. 1958), *Fetish no. 2*, 1988. Mixed media, 64 in. (162.6 cm). Metropolitan Life Purchase Grant, Dallas Museum of Art, 1989.27. By permission of the artist.

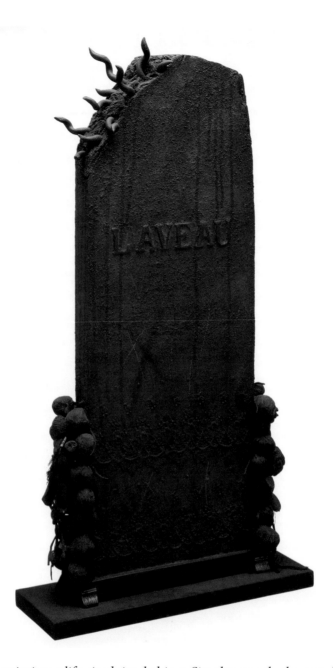

the artist into a life-sized ritual object. Simultaneously she casts herself as the *nganga* (ritual expert, or conjurer) who controls and directs the healing power of the spirit, invoked and controlled through the object during ritual, and as the client seeking its benefits. She also recast the male gaze associated in Western art with the female nude by shifting the nudity to a ritual form and degendering viewers into virtual observers of sacred ceremonies of efficacy. She achieved what Thompson describes as a jazz music funk, or *lu-fuki* in Kikongo, a term used "to praise persons for the integrity of their art, for having 'worked out' to achieve their aims."[4]

Stout moved in the other direction, up through the vernacular, by working out *Headstone for Marie Laveau* (1990) (fig. 23.2), and more recently, in a multipart installation dealing with the legend of bluesman Robert Johnson, *"Dear Robert, I'll See You at the Crossroads"* (1993–94). The double founts of the Deep South/Gulf Coast, the

Kongo and Yoruba cultures and their presence in African-derived spiritual traditions such as Candomblé, Vodou and Santería (or Lucumí) combine in Stout's oeuvre, where they evoke spiritual encounter or activism.

The grave, according to Thompson, is *nzo a nkisi*, a place of charms and final consideration of the spirit of a departed one. Thompson writes of grave decoration with some of the objects last used by a person as a means of satisfying the spirit, to tie up "the emanations or effluvia of a person" to direct the spirit to rest in peace.[5] Laveau's headstone has long served in New Orleans as a site for continual encounter with her conjure powers, as people still mark the headstone and leave offerings in St. Louis Cemetery No. 1 with requests for healing or other kinds of help to move on with their lives (fig. 23.3).

Stout's work is adorned with small *nkisi* bags, lace, dirt, dried pigment and a series of appendages that seem to be growing out of the top left area of the object. The headstone is a sort of charm and *nkisi* complex with an appearance of old accumulations of ritual usage. It is, as Thompson describes, a spirit-directing medicine as well as a spirit-embodying charm.[6]

"Dear Robert" builds upon the legend of Johnson's sudden musical and lyrical virtuosity being attributed to his meeting the devil at the crossroads. This is spiritual intervention at the spot often suggested by the graphic sign of a cross, an element at the

Fig. 23.3. Marie Laveau's grave in St. Louis Cemetery No. 1, New Orleans. The X-marks are made by people who have come to the cemetery to make requests of Laveau's spirit. Photograph by Michael Smith, 2013.

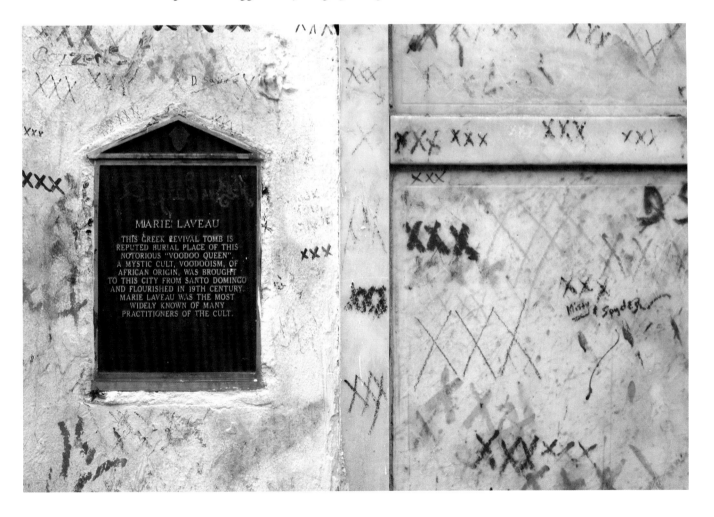

center of the Kongo cosmogram called *tendwa nzá*. This in Kongo terms is the point of intersection between ancestors and spiritual beings and the living. The devil, or dark figure, linked to Johnson is interchangeable with trickster figures like Eshu of the Yoruba or Papa Legba in African American lore. Folklorist Harry Hyatt discovered during his research in the South in the late 1930s that when African Americans born in the nineteenth or early twentieth century said they or anyone else had "sold their soul to the devil at the crossroads," they had a different meaning in mind. Evidence indicates African religious retentions surrounding Legba and the making of a "deal" with this so-called devil at the crossroads.[7]

In folklore, people in the dark, secular world—particularly musicians and gamblers—were thought to have made deals with the devil or shady, trickster characters at the crossroads to gain some metaphysical edge.

Stout uses another Kongo referent in her work that is a part of the *"Dear Robert"* installation, and that is the use of love charms. The 1993 work *Louisiana Love Icon* (fig. 23.4) evokes mystic, spiritual and transformative ideas associated with accessing the supernatural to effect love in this world. A small heart prickly with pins placed in it lies bloody on a small altar space at the bottom of the stele-like object. In African art, accumulation such as the sacrificial residue of dried blood or layers of small, attached objects often accompany rituals of secrecy and spiritual effectuation. Stout's *Icon* is the materialization of a plea for love and implies the underground system, openly feared and quietly practiced, that also causes admonitions about keeping one's hair clippings or fingernails from falling into the wrong hands and making a person susceptible to spells or bad effects. For example, if a bird uses a woman's hair to make a nest, it causes madness. Men have been told to burn their hair because a woman could use it to cast a love spell.

"Dear Robert" and *Louisiana Love Icon* capture a sense of the spiritual weaponry to which folk turned in negotiating a hostile environment to create hope of even small triumphs. The blues is a form grown from pain and pathos as a means of coping, sharing and getting through. Stout's work succeeds as art, legible across cultures, but it is African American in its evocations and cultural codes.

Stout's initial encounter with vernacular spiritual practices and Kongo power objects came during her youth in Pittsburgh. She happened upon a *nkisi nkondi* at the Carnegie Museum when she was ten. She says, "I saw a piece there that had all these nails in it. And when I first saw that one, it was like I was drawn to it. I didn't really know why."[8] Additionally, she repeatedly saw and was fascinated by a sign in the window of a row house that read *Madame Ching*. She was unsure if the woman was a palm reader or fortune-teller, but Stout knew that she was part of a mystical tradition. These two encounters ever marked her art life, career, and consciousness and both still play out in her artwork.

Stout's more recent works included in this exhibition, *Master of the Universe* (2011–12) (cat. 7.2) and *Self Portrait no. 2* (or *Self Portrait as Inkisi*) (2008) (cat. 7.1), continue her Kongo multiplication and embody the kind of seeing in multiple worlds implied by the double-headed dog figures found among Kongo *nkisi* objects. She is looking at

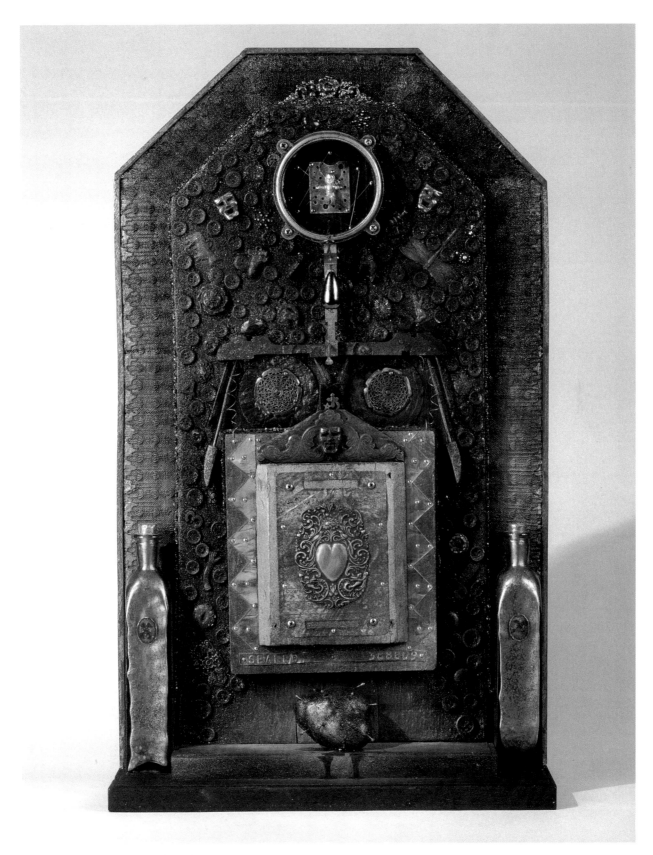

Fig. 23.4. Renée Stout (American, b. 1958), *Louisiana Love Icon*, 1993. By permission of the artist.

the African past coming up through vernacular practices and at the original objects, which worked in spiritual more than aesthetic ways. She has a cultural bilingualism in negotiating her African American foundations and experiences along with the way art works in the art world of galleries and museums and patronage. She elides between artist, ritual expert, love-hungry woman and the kind of playfulness found in a trickster figure.

Like those Africans dancing and playing music in Congo Square two centuries ago, she is joyful to express herself as herself, yet she is mindful of the context within which she is operating. It is these contexts that, perhaps, make love distressful and in need of spiritual aid found in the world of conjure and *tobys* (a type of charm) and rootwork. Yet she is a masquerader dancing culture in front of and for us to a Kongo backbeat. Hers is a complicated narrative that is compelling and fascinating and full of healing magic.

Notes

1. Kolchin, *American Slavery*, 47.
2. See Latrobe, *Journals of Benjamin Latrobe*.
3. Thompson, *Flash of the Spirit*, 117–29.
4. Thompson, *Flash of the Spirit*, 104.
5. Thompson, *Flash of the Spirit*, 134.
6. Thompson, *Flash of the Spirit*, 117–19.
7. Many tales of musicians and gamblers selling their souls at the crossroads are recorded in Harry Middleton Hyatt, *Hoodoo—Conjuration—Witchcraft—Rootwork*.
8. Renée Stout, interview with the author, Philip Ravenhill, and Bryna Freyer, Washington, D.C., June 1, 1992.

<div style="text-align:right">24</div>

Minkisi and *Dikenga* in the Art of Radcliffe Bailey

Multiplied Exponentially

CAROL THOMPSON

Radcliffe Bailey had just begun to create *EW, SN* (2011) (fig. 24.1) when I visited him in April 2009.[1] At that moment, his studio was filled with a series of large-scale canvases, twelve feet high and eight feet wide, all in progress. Trained as a sculptor, Bailey defines his art as being between painting and sculpture. He has become most known for his large-scale installations made with found objects.

As Bailey told me during that 2009 studio visit, he had just "returned to painting." *EW, SN* is a seminal work. Its title is a coded instruction. It directs the tracing, invisibly, as a mental image, of intersecting lines—one horizontal and one vertical, from east to west and south to north—to create a *dikenga*, the Kongo cosmogram that charts the cycle of life.

Bailey, the quintessential trickster/artist, is forever mining crossroads of all kinds: Eshu is his alter ego. Even Bailey's early work, *Mound Magicians* (1997), an homage to Negro League baseball heroes, reveals the artist's love of the game as it transforms a baseball diamond into an all-American *dikenga*.[2] The artist's footprints, made with red earth paint, run the bases, and baseballs become constellations.

Seeing *EW, SN* in many stages of its creation over the course of more than three years and considering it in relation to other works made during the same time frame provides insights into Bailey's larger oeuvre. The extended label that accompanies the work as it is currently on view at the High Museum of Art to celebrate its recent acquisition states,

> *EW, SN* reveals Bailey's signature layering of evocative and culturally resonant images—here, railroad tracks suggest the Underground Railroad while simultaneously referring to Bailey's father, who was a railroad engineer. The title refers to the Great Migration, which took place between 1910 and 1970, when more than six million African Americans, including Bailey's own relatives, migrated

from the south to the north to pursue economic opportunity in industrial urban centers.

En route to Canada, traveling on the Underground Railroad, Bailey's ancestors instead settled in Bridgeton, New Jersey, where over many generations they populated a community and where today, members of Bailey's extended family farm asparagus. A book published in 1913, *Gouldtown, a Very Remarkable Settlement of Ancient Date*, documents this extraordinary, while also ordinary, family history.

The title *EW, SN* also suggests a vision that looks further back in time, to the movement—from east to west—of millions of Africans across the Atlantic. The image of a slave ship, made from a cutout template that Bailey recycles, is a reminder of that traumatic history, as it emerges from a white halo. Two white lines extending from the silhouetted head at the lower left corner of the canvas bring to mind the concept

Fig. 24.1. Radcliffe Bailey (American, b. 1968), *EW, SN*, 2011. Mixed media, 144 × 96 × 8 in. (365.76 × 243 × 20.32 cm). High Museum of Art Collection. Courtesy of the High Museum of Art. By permission of the artist.

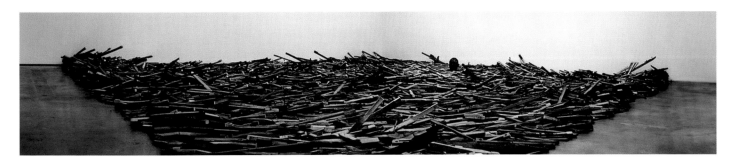

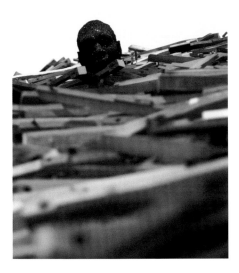

Fig. 24.2. Radcliffe Bailey (American, b. 1968), *Windward Coast*, 2009. Piano keys, plaster bust and glitter, variable dimensions. *Left*: detail. Photograph courtesy of the High Museum of Art. By permission of the artist.

of double-consciousness, as first coined by W.E.B. Du Bois. These white lines extend through the ship toward Africa and then, above the head, bounce back, with arrows pointing in the opposite direction, from east to west, to America.

An in-progress studio view (April 10, 2009) of this ambitious work, *EW, SN*, shows a profusion of black, white and red arrows radiating from the canvas's lower right edge, implying an uncontainable explosion of energy, a diagram of the genesis of the Black Atlantic world, as it took shape over the past 400-plus years. A network of perpendicular lines overlaying a rough outline of the African continent's west coast evokes city grids as it also, as Bailey describes, recalls the work of African American scientist, surveyor and almanac author Benjamin Banneker (1731–1806). This studio view also shows an oar leaning against a small boat, painted sparkling black, positioned in front of the work. The boat, acquired by the artist when he visited Senegal in 2005 as part of his artistic research related to DNA, holds a globe. In another view of *EW, SN*, from August 2010, a broad swath of paint made with Georgia red earth divides the canvas vertically, and the image of a machete, painted sparkling black, points toward the canvas's upper edge. A series of oars, like those in the large-scale work on paper, *Winged* (2008), radiate to the right, as though in motion. The sparkling black silhouetted head, to become a focal point in the final work, as mentioned earlier, has been added toward the lower left corner of the canvas.

This profile of a man's head, two-dimensional in *EW, SN*, becomes three-dimensional in *Windward Coast* (fig. 24.2), a work created during the same time frame, and the centerpiece of *Radcliffe Bailey: Memory as Medicine*.[3] During this time, Bailey

also created a related small-scale, *nkisi*-like sculpture made with an antique lamp to contain a small head, coated with sparkling black paint.

In another studio view, from July 2010, the lamp sits on a small table: a stack of works on paper sits on the floor, and on the adjacent wall is an in-progress drawing of a Kongo *nkisi* with an anatomical model of a heart attached to it (fig. 24.3). Eventually, Bailey detached the heart from the drawing to create the sculpture *Pullman* (2010). An earlier, closely related drawing from April 16, 2010, shows the artist's experimentation with the same theme, though in this drawing, Bailey incised a small square of paper from the center of the image of the *nkisi* to outline a cube in the void (fig. 24.4). Both works on paper show spheres suspended at the end of long lines. They radiate from a central vortex, to suggest a constellation echoing the 2011 sculpture, *Other Worlds' Worlds*. An in-motion studio shot of the artist shows the sculpture in progress with the Sun RA CD, *Saturn*, at its center. Similar spheres suspended from long lines radiate from the center of *EW, SN*.

A companion painting from the same series of large canvases that Bailey began in 2009 shares imagery similar to *EW, SN* (fig. 24.5). At the center, in the lower section of the work, the Kongo *dikenga* is outlined within a green oval, like a plant bud. Next to it is the word *kalunga*, and farther to the right, a ship within a white halo, as in *EW, SN*. Additional details include a drawing of a boat, a reference to Marcus Garvey's steam liners, stamped with a black star encircled by the letters *UNIA* (United Negro Improvement Association).

In 2003, Bailey began to create medicine-cabinet sculptures. With glazed surfaces containing a wide variety of culturally charged images and materials, these richly layered, accumulative sculptures, in their overall construction and composition, take

Fig. 24.3. Studio view of Radcliffe Bailey with *nkisi* images in painting and sculpture with lamp. August 12, 2010. Photograph by Carol Thompson. By permission of the artist.

Fig. 24.4. Radcliffe Bailey's *nkisi* drawing with cutout square. April 6, 2010. Photograph by Carol Thompson. By permission of the artist.

inspiration from Kongo *minkisi* and the mirrored medicine packets that they often contain. Loaded with references to the history of the Black Atlantic experience, each of Bailey's medicine-cabinet sculptures becomes a kind of twenty-first-century *nkisi*. Three medicine-cabinet sculptures made between 2006 and 2009 share imagery related to themes presented in *EW, SN*.

Within the deep, square frame of *A-bil* (2006) are waves made from cut paper and a three-dimensional ship coated in white, to imbue them with spirit (fig. 24.6). A *dikenga* is traced in white, in the form of a crossroads inside a diamond. In the upper left corner, the words *Long Live UNIA* encircle a black star. Alongside a nearly life-size photographic image of a woman with a broad-brimmed hat are two sheets of musical notation paper sprinkled with indigo from West Africa.

A sparkling-black ship sits at one end of the long, horizontal medicine-cabinet sculpture, *Chapter 7* (2007), balanced at the opposite end by a drawing of an ocean liner (fig. 24.7). In between is the image of a Kongo *nkisi nkondi*. To give added power to its mediation, Bailey includes boxer's hands "fighting for you" within the *nkisi*'s outline.

The large medicine-cabinet sculpture, *Returnal* (2008), includes a similar constellation of imagery: ships, painted black and white, as pendants, along with images of Punu masks, one black and one white (cat. 7.3). A man wearing a hat gazes from the photo blow-up at the center of the work. Black star imagery repeats at the work's upper edge. To the right, the image of a Kongo *nkisi* faces down a white ship.

An actual sculpture from Central Africa (a recent replica) stands within a ship in a work currently in progress in the artist's studio (fig. 24.8). An accumulation of piano keys buoy the ship. Made of two large sheets of steel joined together—one square and one rectangular—to form a shelf, this large-scale wall sculpture resonates with *Windward Coast*.

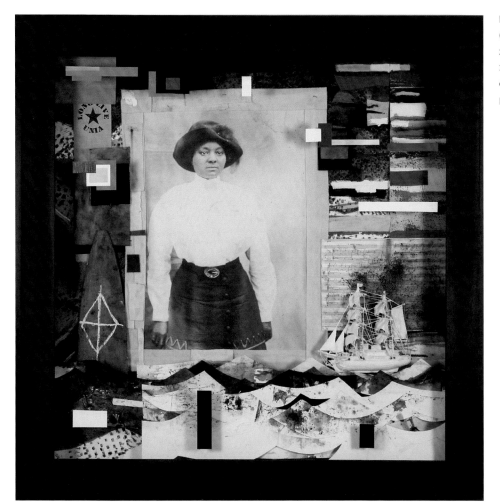

Fig. 24.6. Radcliffe Bailey (American, b. 1968), *A-Bil*, 2006. Mixed media, 55.5 × 56.5 × 6 in. (140.97 × 141.2 × 15.24 cm). Private collection. By permission of the artist.

A small, related work, made with steel, glass, and other elements, presents a colorful ring of concentric circles radiating outward, an image of Saturn's rings. Bailey considers this work a self-portrait, revealing a prodigious level of abstract thinking, reminiscent of Marcel Duchamp, an artist whom Bailey admires. This self-portrait also reverberates conceptually with the Kongo *dikenga* as it charts the cycle of life—from birth, to prime of life, to elderhood, to the ancestral realm—a soul circling through time and across generations. As a Nina Simone song describes a soul as coming back and back and back for nearly 9,000 years, Radcliffe Bailey's art nurtures his "ancient

Fig. 24.7. Radcliffe Bailey (American, b. 1968), *Chapter 7*, 2007. Paper, acrylic, glitter, model ship, and gold leaf, 18 × 63 × 5 in. (45.7 × 160 × 12.7 cm). Private collection. By permission of the artist.

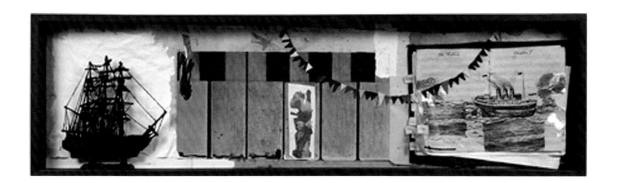

Fig. 24.8. Radcliffe Bailey's current work in progress featuring Central African sculpture. Ship and piano keys with steel plate. September 27, 2012. Photograph by Carol Thompson. By permission of the artist.

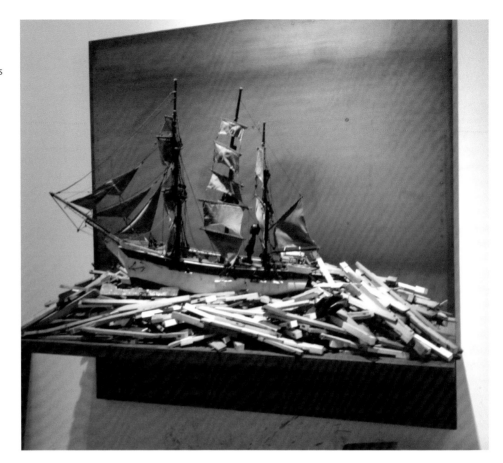

soul," tracing the complex network of his "aesthetic DNA" to create an antidote to cultural and historical amnesia.

Bailey's work places African Americans at the center of American and world history. The *New York Times* describes his art as being fueled by an exploration of "Black Atlantic culture, the vital, nurturing, agitated link between Africa and the Americas." As Stuart Keeler notes, Bailey's creations function "as a private séance for viewers to encounter icons so personal that they have, in fact, become universal."[4] By forging links between the personal and the universal, Bailey's art presents history as a shared, interdependent experience, open to all, without exclusion, to encourage healing and transcendence through art.

Notes

1. This was shortly after we had learned that the High Museum of Art's NEA grant to do a show of his work with a book and a national tour was successful.
2. As first observed by Michael Rooks, Curator of Modern and Contemporary Art, High Museum.
3. C. Thompson, *Radcliffe Bailey*, Cover, Plate 4, Plate 61, 142.
4. Keeler, "Radcliffe Bailey at Solomon Projects," 69.

\diamond **25**

Kongo Resonance in the Paintings of Edouard Duval-Carrié

DONALD COSENTINO

For more than two decades, Haiti's most cosmopolitan artist, Edouard Duval-Carrié, has painted the *lwas* (Vodou spirits) in various stages of migration, from Africa to Haiti in slavery, and from Haiti to the United States, often in desperate flight. As the artist explains, the *lwas* are *doppelgangers* for the Haitian people. "First of all they are there to help the people, to be part of them. They look like them too. I'm talking about the Haitian people when I paint the spirits; their capacity for being more than they really are."[1]

The first four paintings described next depict these migrations, often led by spirits whom Vodouists identify as Kongo or Petwo (creolized Kongo). The final painting testifies to the powerful presence of Kongo spirits in the contemporary life of the Black Republic.

Le depart, 1996, from *Milocan, ou la migration*

Vodouists draw the *milocan vévé* (cosmogram) to summon manifestations of all their *lwas* from Ginen, a mystical Africa that flourishes under the sea. Duval-Carrié in-scribes his own *milocan* on the frame of this painting to make manifest the *lwas* as they appeared on their forced march through the woods of Ginen to join their cap-tive children in Haiti (cat. 7.5). And what raffish cosmopolitans these divinities are. Goddesses in hot Kongo pink and cool Dahomey blue. The skeletal trickster Gede sporting his fetish jacket. *Lwas* in top hats, electric sombreros, and golden diadems that recall the drip castle towers of Djenne mosque. Leading the divine captives is a leaf-crowned forest spirit, perhaps Kongo Makaya, incongruously tarted up with the kind of facial makeup favored by Tuareg men of the Sahara and the Sahel. Bringing up the rear is Gran Bwa (Great Tree), oldest and wisest of the Kongo/Petwo spirits, who holds the deepest secrets of men and gods.

La vraie histoire des Ambaglos (The True History of Underwater Spirits), 2003

The *lwas* maintain a heaven in Lavilokan (City of Camps), but their divine digs cannot be compared in size or population to the world of the *Ambaglos*: spirits of the dead who float in their submarine paradise (fig. 25.1). Migrations of men and gods have fed the population of *Ambaglos* with victims of the Middle Passage, drowned there before ever reaching the slave markets of St. Domingue. The tendrils that weave through the painting connect *Ambaglos* to each other and to Ginen, which can only be reached from under the sea. Corresponding to Kongo ideas about the "Four Moments of the Sun," the transit of souls around the diamond of existence, Duval-Carrié further explains, "In African culture everything moves under water . . . There are a lot of water spirits. In Haiti they have huge ceremonies to send spirits back to Africa; they reunite dead people and ship them back underwater."[2]

Fig. 25.1. Edouard Duval-Carrié (Haitian born, 1954), *La vraie histoire des Ambaglos* (The True History of Underwater Spirits), 2003. Mixed media on wood, 96 × 144 in. (244 × 366 cm). Collection of Norma Canelas and William D. Roth. Photograph courtesy of the Fowler Museum at UCLA. By permission of the artist.

La calebasse magique (The Magic Calabash), 1997

The *lwas* are launched in a fragile bark, leaving Haiti after 500 years. Just as they followed their children from Africa to Hispaniola, they must now migrate to join the "tenth department," as Haitians refer to their American Diaspora (fig. 25.2). But there

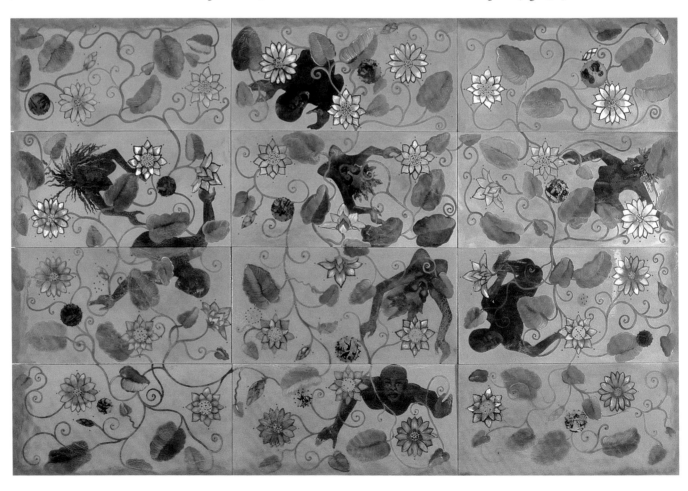

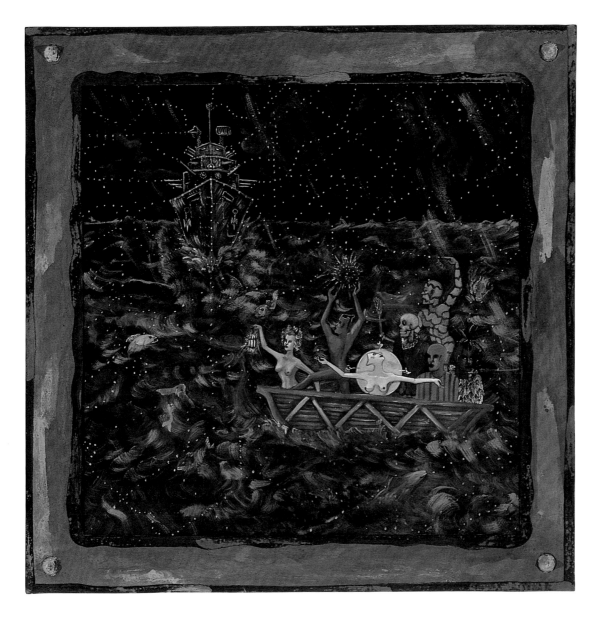

Fig. 25.2. Edouard Duval-Carrié (Haitian born, 1954), *La calebasse magique* (The Magic Calabash), 1997. Oil on canvas, 59 × 59 in. (150 cm × 150 cm). Collection of David Wallack. Photograph courtesy of the Fowler Museum at UCLA. By permission of the artist.

are storms at sea, an armed Coast Guard cutter is bearing down and the only source of light emanates from mysterious specks of light that spangle the sky and sea. These are *pwen*, as Vodouists call them: distilled points of power often realized as dots painted or sewed onto sacred objects, usually to evoke or assuage Kongo spirits. The *pwen* now seem to be flowing from the divinities themselves, and from the calabash *wanga* (talisman) raised in their hands. The *pwen* are bisecting the cutter, suggesting the dangerous *kalfou* (crossroads) where every vital transition must occur.

Le débarquement à Miami Beach (Landing at Miami Beach), 1997

The *lwas* are safe for now, tossed onto some grassy knoll overlooking the causeway to Miami Beach (fig. 25.3). Kongo Makaya, robed in his healing leaves, is staring cross-eyed at his fellow divinities. What a motley crew of boat gods, washed-up carnival revelers on Ash Wednesday morning. Are these bizarre divinities an advance party

for the whole Vodou pantheon, or some remnant of *les invisibles* still at home in Haiti? Whatever, these divine aliens have made Miami Beach look sexier than ever, with their webs of *pwen* flung over the city like twinkling lights on a movie marquee.

La Voix des Sans-Voix (Voice of the Voiceless), 1994

"*Niombo* is a massive 'mummy' meant to be displayed, wept over by descendants, and then perambulated in glory to its grave . . ." As Kongo scholar K. Kia Bunseki Fu-Kiau states, "when you die you automatically become an ancestor. But not everyone becomes a *niombo*. Being buried in a *niombo* figure means the community believes the person will become our medium . . . saying to our ancestors, 'I am their mediator. I move between worlds.'"[3] So it is that in *La Voix des Sans-Voix* (Voice of the Voiceless), Niombo (who bears an uncanny resemblance to Ronald McDonald) stands between a fallen Jean-Bertrand Aristide and the leaders of the coup that overthrew

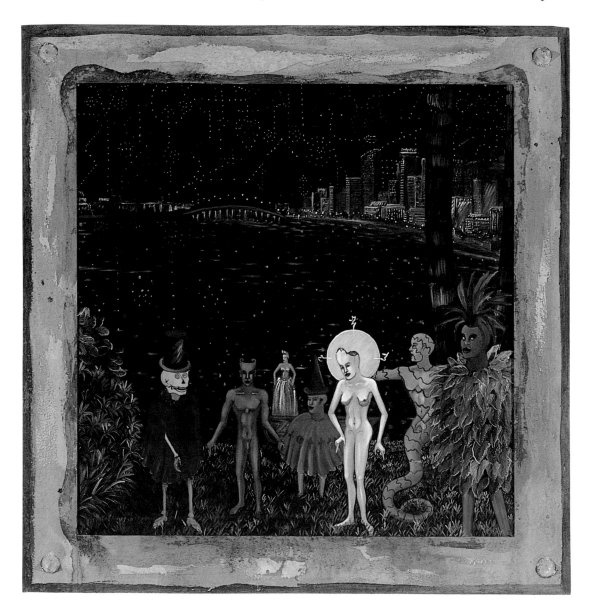

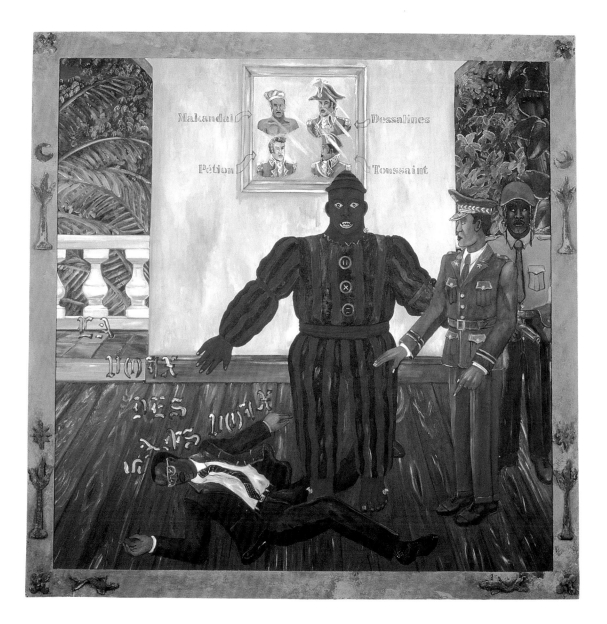

the popularly elected Haitian president in 1991 (fig. 25.4). On behalf of *pep la*, Haiti's common people, Niombo presents the country's political calamities to its historical divinities, the heroes of the 1804 Revolution, whose portraits hang on the wall. Duval-Carrié's choice of Niombo is a testament both to the persistence of Kongo *mentalité* in Haiti and to an ever-widening search for objective correlatives that mark the aesthetic of both the artist and Vodou.

Fig. 25.4. Edouard Duval-Carrié (Haitian born, 1954), *La Voix des Sans-Voix* (Voice of the Voiceless), 1994. Oil on canvas, 65 × 65 in. (165 × 165 cm). Collection of Michael and Juliana Marcellino-Campbell. Photograph courtesy of the Fowler Museum at UCLA. By permission of the artist.

Notes

1. Cantor, "Painting the Body Politic."
2. Jerome, "Spirited Art from a Mystical Mind."
3. Thompson and Cornet, *Four Moments of the Sun*, 63.

26 ◈

José Bedia

Crossing the Waters

JUDITH BETTELHEIM

In the two installations discussed here, the Cuban-American artist José Bedia expresses his relationship with Palo Monte, which forms the foundation and inspiration for his artistic production. Palo Monte is a distinct Afro-Cuban religion with sources in the Kongo area of Central Africa. Bedia was initiated into Palo Monte in 1983.

Ngola-La Habana, 1994

The installation *Ngola-La Habana* (1994) (fig. 26.1a and fig. 26.1b) summarizes the theme of *Kongo across the Waters*, yet it was conceived more than fifteen years ago. Over the years Bedia developed a deep understanding of the history of his religion, the impact of the transatlantic slave trade from Kongo to Cuba, and the concomitant changes in Palo Monte as it flourished in Cuba.[1]

The central section of this installation reveals a horizontal series of photocopies with small pieces of calico fabric tacked below each one, forming the horizon line, or the *kalunga* line (see the following section). These images form a personal and cultural genealogy: historical photos from African ethnological studies, photos of Bedia himself while serving with the Cuban army in Angola (in 1985–86), religious leaders in both Central Africa and in Havana and religious objects, all marking the connection of Bedia and Palo Monte to Angola. At the far left of this horizon line is a miniature wooden boat (fig. 26.1a), a slaver's ship with the name *Ngola-La Habana* written on it. This name derives from a comment published by the important Cuban ethnographer Lydia Cabrera, whose work Bedia continually studies. Cabrera was told by one of her informants, a Palo Monte religious leader, that there was one room in his *templo* that held all the sacred *prendas* of his godchildren, and one of them was named Ngola-La Habana, and it ruled over the others.[2]

The boat carries a bundle wrapped in red cloth with feathers protruding from the top. This is the iconic power bundle (*nkisi*) used by religious practitioners in Central Africa and in Cuba's Palo Monte.

At the other end of the *kalunga* line on a small shelf is a mass-produced figurine known as Francisco or El Congo (fig. 26.1b). He sits in a white-enameled washbasin, a version of the sacred pot of Palo Monte. El Congo embraces the powers inherited from the source of Palo Monte, whose practitioners refer to their ultimate homeland as Congo as well as Ngola, from which the Europeanized name Angola derives. El Congo is also a visual reminder of the strength of the rural slave. This central section of the larger installation situates Bedia's artistic practice well within a transcultural dialogue, which combines experimental conceptual vocabularies with personal spiritual references.

Fig. 26.1a and fig. 26.1b. José Bedia (Cuban-American, born in Havana, 1959), details of installation of *Ngola-La Habana*, 1994 (from the exhibition *De Donde Vengo*, Miami Art Museum). Photograph by author. By permission of the artist.

Kalunga (2000)

Painted on the wall is Bedia's signature black figure, here named Kalunga (fig. 26.2). With broad shoulders, protruding arm sockets and a large torso, each oversized arm and the torso terminate in drips. The head has a distinct pointed chin and nose. Bedia admits that he is personalizing the figure with his own idealized profile. The entire body is covered with *firmas*, the Spanish word that refers to the sacred calligraphy used in Palo Monte. A *firma* is at once a signature, a composite name and a cosmogram that opens a path to communication with the spirits. Particular *firmas* may have specific meaning, but even within an ostensibly sacred composition, interpretations may vary. Bedia uses *firmas* to refer to specific *mpungos*, the Palo name for spirits, as well as design motifs on diverse surfaces. Emphasizing their aesthetic rather than religious dimensions, Bedia says they are "only a little bit sacred."[3]

Strands of wire connect a boat to the large figure. The wire is configured as wavelike undulations, emphasizing a journey across water, suggesting a physical reality as well as a spiritual connection that can never be broken. The small boat, dragging a blue cloth trimmed in white lace, appears to glide across the sea. Here Bedia references multiple journeys: a person leaving his homeland, as Bedia left Cuba in 1991, or more general journeys like the Mariel boatlift from Cuba to Miami in 1980. Or the

Right: Fig. 26.2a. José Bedia (Cuban-American, born in Havana, 1959), *Kalunga (2000)*, 2000 (installation at the Virginia Museum of Contemporary Art). Photo courtesy of George Adams Gallery.

Below: Fig. 26.2b. José Bedia (Cuban-American, born in Havana, 1959), *Kalunga (2000)*, (detail), 2000. Photograph by author. By permission of the artist.

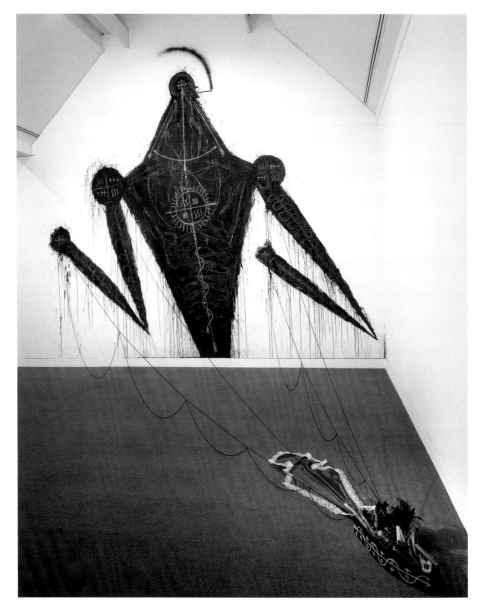

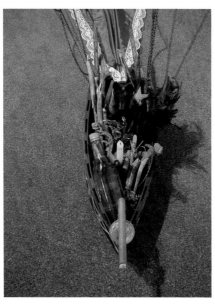

reference could be to the greater forced migrations of millions of Africans across the Atlantic to destinations in the Americas. Or, it could be more specifically glossed because the miniature boat can be read as a sacred pot, the *nganga* or *prenda* of Palo Monte.

The blue cloth (blue as the sea) alludes to a spirit helper. Her Palo names are Baluandé or Ma Kalunga, or Madre de Agua (Mother of the Water).[4] The white lace can be read as the foam a wave creates when hitting the shore. Kalunga is at once both the dividing line between the world of the living (above) and the world of the dead (below), and is also thought of as the horizon line where water meets the sky. Bedia also refers to Kalunga as the goddess of the sea. "Kalunga, the goddess of the sea, is someone you must get on your side to make the journey. You have to pray and offer her sacrifices in order to win what you want. She is very powerful. She rules the whole sea. If she doesn't want you to have a safe journey, there is no way you can succeed."[5]

The sacred pot of Palo Monte (here the boat) is filled with offerings associated with the religion. The distinctive sticks are the *palos*, the sticks from the bush or the mountains, the *palos* of the *monte*, the forest or a rural area (Palo Monte). A commercially produced miniature dog is wrapped in blue cloth from which his head emerges. With an advanced sense of smell, a dog helps to secure a safe path and is often part of a Palo sacrifice, as are birds. In this case the bird's dark feathers allude to the vulture (*nsusu mayimbe*).

The glass of water is an offering to the spirit of someone who has died, an ancestor whose strength can help on a journey. The cigar reminds one that tricksters smoke cigars, as do special elders. So beware, be strong. There is a bottle of *aguardiente*, which is used for libations. As millions have journeyed across the waters, Kalunga watches over them; Baluandé guides them, and José Bedia is protected. He created this installation to pay homage to his spiritual groundings as he continually traverses many waters.

Notes

1. It is best to be flexible when referring to Cuban religions. There is no standardized vocabulary. For instance, some use the designation Palo Monte Mayombe, or just Palo, while others may say La Regla de Congo, or Congo Reglas. And various branches are named la Regla Kimbisa, la Biyumba, Brilumba, and so on.

2. The sacred pot of Palo Monte is known by many names: *nganga, prenda,* or *cazuela.* Cabrera, *Reglas de Congo*, 132–33.

3. Bedia, telephone conversation, May 3, 1999.

4. In the Lucumí tradition she is known as Yemayá, and her Catholic name is Virgen de Regla.

5. Hanzal and Bedia, *José Bedia*, 9.

KONGO INSPIRATION IN CONTEMPORARY ART

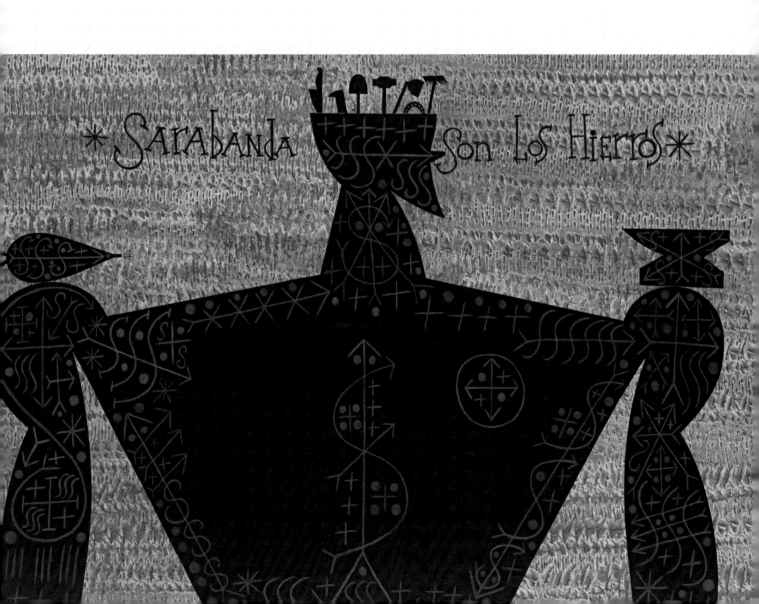

Renée Stout

For most of her career, Renée Stout has pursued her fascination with Kongo aesthetics and ideas epitomized in *minkisi*. In many of her works, the Kongo ideas of embodiment and containment of spiritual forces are both self-referential and inclusive of diverse sources of spiritual power. She seeks old perfume bottles and makes pouches and other containers that she fills with aesthetically and psychically charged materials—medicines she creates—from America, Africa and other parts of the globe. Some are combined with highly personal objects, as in *Self-Portrait no. 2 (Self-Portrait as Inkisi)* that includes a denture brace of a departed elder friend. The metal brace suspended from a metal horse's bit metaphorically links the power of the ancestral voice with the power to harness tremendous forces. Stout, as *nkisi* and as persona, is energized by the multicultural roots of the blues. She was mesmerized by Koko Taylor's "I'm a Woman," which became her theme song for her self-portrait, evocative of her conjure woman alter ego, Fatima Mayfield. Stout recounts how the song inspired her: "as I listened to the song, It seemed that the woman herself was a powerful force to be reckoned with, like an *inkisi* ... I ran with that vision and created a kind of power object, that when viewed from certain angles, evokes the abstracted form of a woman."

In a second work, *Master of the Universe*, Stout interprets a *nkisi* as an embodiment of the complex power relationship between master and slave. A Victorian clock representing a slave balances two hand-beaded bundles of medicines Stout has created, and she has also filled the empty cavity once holding the clock with mystical substances. The figure stands on a glass-topped table filled with medicines—High John the Conqueror root, embellished with gold, silver and rhinestones—configured as a crossroads. Stout has fitted out the slave figure as a *nkisi*, fortified by the power of his spiritual history, and master over all he surveys.

SC

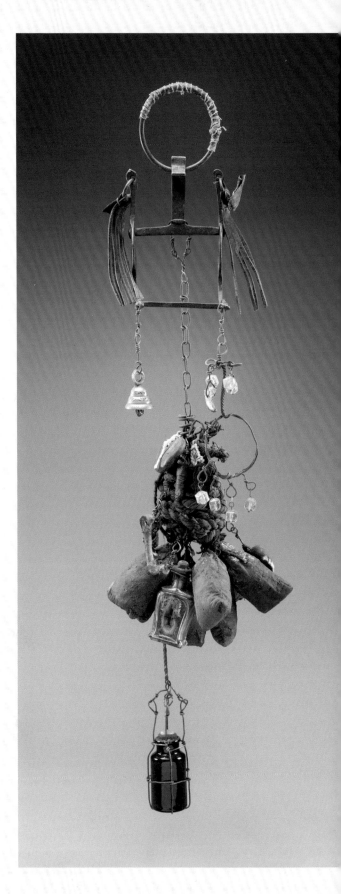

Right: Cat. 7.1. Renée Stout (American, b. 1958). *Self-Portrait no. 2 (Self-Portrait as Inkisi)*. 2008. Metal, fabric, glass and organic materials, 32 × 7 × 7 in. (83.82 × 17.8 × 17.8 cm). Collection of the artist. Photo by Randy A. Batista, with permission of the artist.

Facing page: Cat. 7.2. Renée Stout (American, b. 1958). *Master of the Universe*. 2011–12. Found objects (Victorian-era clock with figure, glass-top table) wood, glass, bronze, silk, organic materials, rhinestones, glass beads, mirror, paint, 48 × 18 × 18 in. (121.9 × 45.7 × 45.7 cm). Collection of the artist and Hemphill Fine Arts. Photo by Randy A. Batista, with permission of the artist.

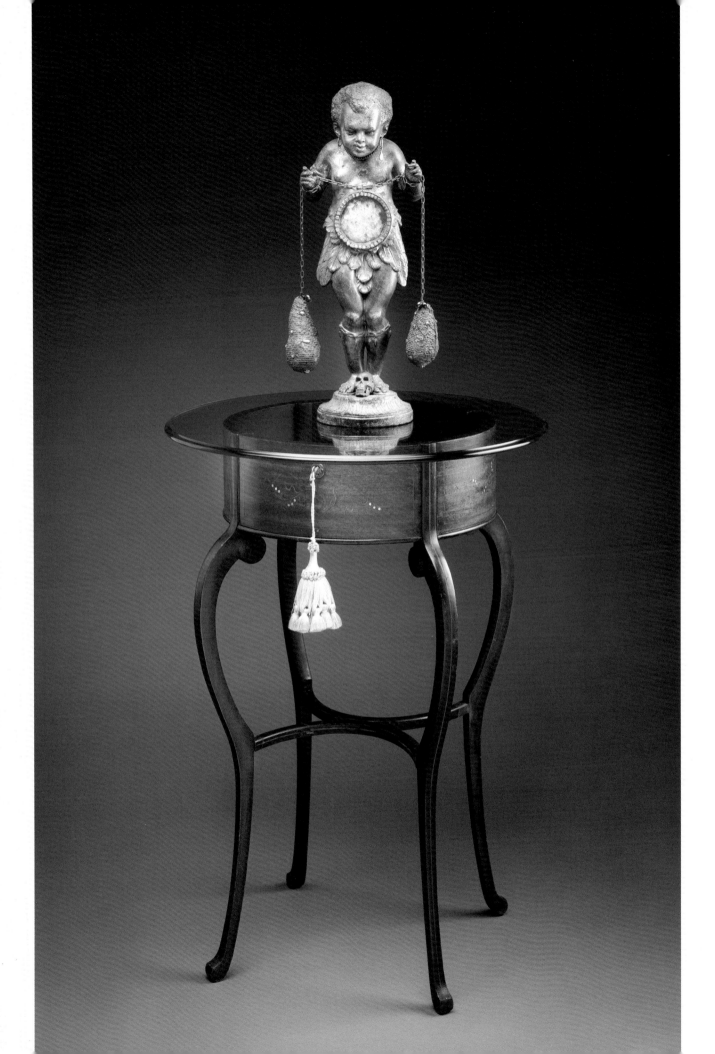

Radcliffe Bailey, *Returnal*

Bailey's series of sculpted reliefs, such as *Returnal* and *By the River*, which he refers to as "medicine cabinets," are assemblages of images and objects that he likens to Kongo medicine containers, or *minkisi*. Bailey's medicine boxes refer to, and attempt to reconcile, history, personal memory and collective memory within the framework of African American experience. For Bailey, both the literal and visual process of recollection is an act of healing. In *Returnal*, images of sailing ships heading west, a series of Central African sculptural figures and flags of the Black Star Line remind us of the history of Africans and their African American descendants crossing the Atlantic. The completion of this great circuit, from Africa to America and back again, mirrors the Kongo concept of the cosmic journey from birth to death and rebirth. Rebirth and return to the land of the living are suggested by the white ship at the right and the green palmetto leaf, which partially covers a photographic image of a Kongo *nkisi* figure. The Kongo belief in the continued presence and power of the ancestors, echoed in many African religions, is asserted by the dominant, central photographic portrait of a man.

Returnal was made during a time when Bailey was on a quest for his own history. Through genetic testing he discovered that his ancestors came from Sierra Leone and Guinea, and *Returnal* includes a series of letters taken from one of his own DNA sequences. He also mixed his paint with tobacco and water from the area of Charleston, North Carolina, his ancestors' early homeland in America.

SC

Cat. 7.3. Radcliffe Bailey (American, b. 1968). *Returnal*. 2008. 64.5 × 96 × 5.5 in. (163.83 × 243.84 × 13.97 cm). Shainman Gallery.

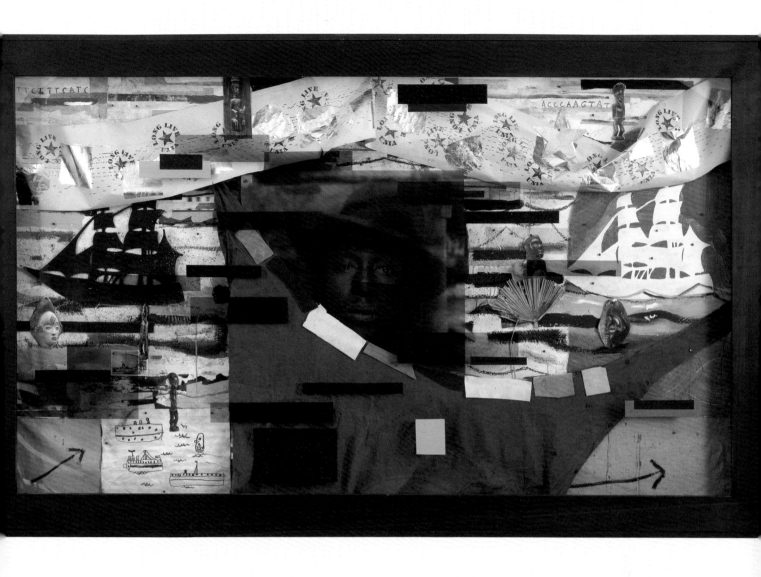

Radcliffe Bailey, *By the River*

Bailey's work *By the River* pays homage to multiple African American ancestors who are identified by signs, symbols and country of origin spelled out across the surface. The word *Angola*, surmounted by one of the three diamond clusters—to the right and left of the woman, and also in the back of the chair she leans on—are overt references to Kongo ancestry. The seashell, mounted below the image of the woman, matching the color of her pale dress, suggests the Kongo association of ancestors with whiteness and the sea where they are thought to dwell. The flowing rhythms also allude to passage of time—whether materially, as over the Atlantic Ocean, or rivers of the Lowcountry, or in music, another of Bailey's recurrent metaphors of African American continuity and cultural contribution.

SC

Cat. 7.4. Radcliffe Bailey (American, b. 1968). *By the River*. 1997. Mixed media on wood, 80 × 80 × 8 in. (203.2 × 203.2 × 20.3 cm). Collection of Blanton Museum of Art, University of Texas, Austin.

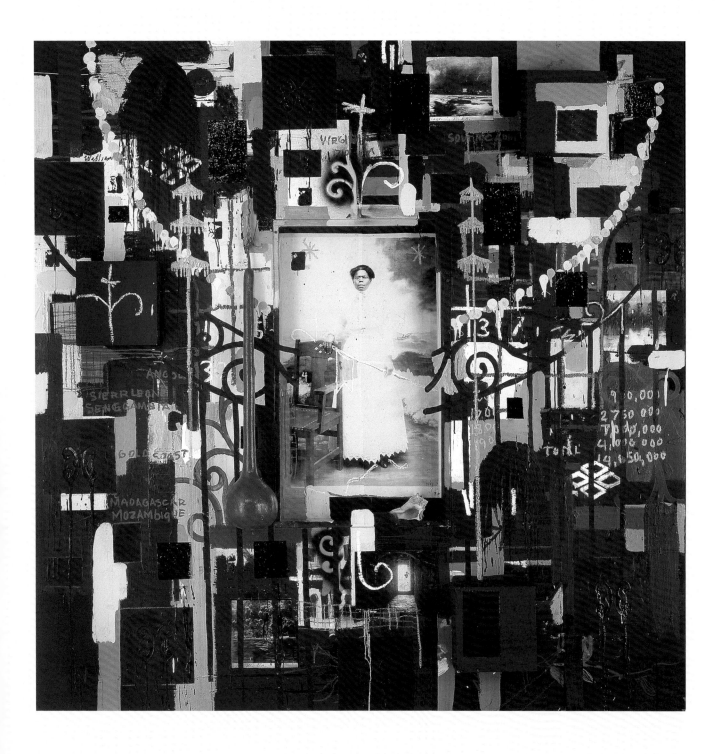

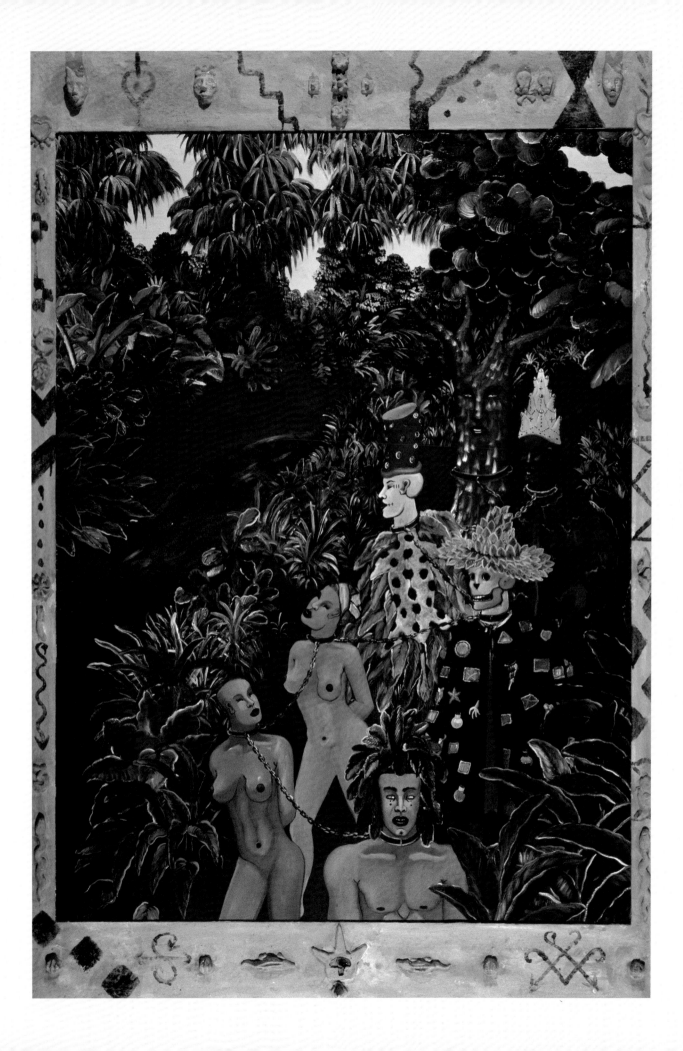

Edouard Duval-Carrié

Although Edouard Duval-Carrié lives and works in Miami, he is Haitian by birth, and his work continuously mines the Haitian experience, much of it centered on the practice of Vodou. Key elements of Vodou can be traced to Kongo religion and to the blending of Kongo beliefs and Christianity that had occurred in Kongo prior to the development of the slave trade. Duval-Carrié's paintings here, *Le départ* (cat. 7.5) and *La traverse* (cat. 7.6), are two of a series in which he follows the migrations of the Vodou spirits from Africa to Haiti and from there to the United States. They move through forests and across water. The borders of the paintings in the series are suggestive of the borders on Vodou flags. They are painted in a watery blue, and *vévé* signs—the graphic writing system used in Vodou—are inscribed on them. He represents most of the Vodou divinities as anthropomorphic figures, humanizing them. In fact, the artist states that when he paints the *lwas* he is also speaking about the Haitian people. Like the *lwas*, they have journeyed, against their will, from Africa to Haiti, and other circumstances bring them now to the United States.

In *Le départ*, the spirits, chained and shackled as slaves, march through the forest, skirting a body of water. Colors may differentiate the hot *lwas* of the Kongo-based Petwo family from those of the Fon-based Rada family, in cool colors. The leaves on the forest spirit in the lead may indicate Kongo connections.

In crossing the waters, the *lwas* are packed tightly into the boat in *La traverse*. The water-colored spirit at the prow is Simbi, the water spirit. The question mark on his ear may indicate the uncertain course and destination.

RP

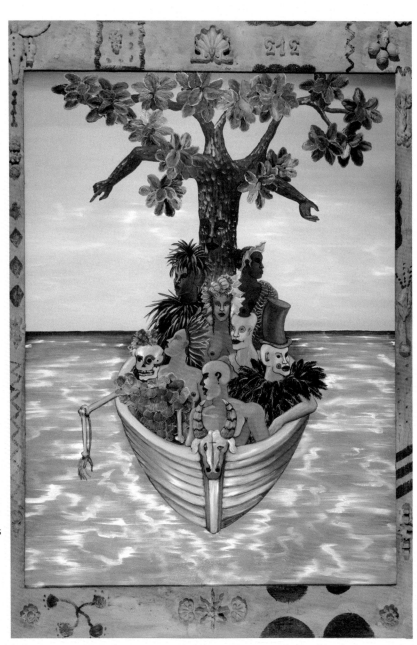

Facing page: Cat. 7.5. Edouard Duval-Carrié (Haitian, lives in Miami, b. 1954). *Le départ.* 1996. Oil on canvas in artist's frame. 95 × 64.96 in. (241.5 × 165 cm). Collection of Bass Museum of Art. Gift of Dr. Jean Claude Compass.

Right: Cat. 7.6. Edouard Duval-Carrié (Haitian, lives in Miami, b. 1954). *La traverse.* 1996. Oil on canvas in artist's frame, 95 × 64.96 in. (241.5 × 165 cm). Collection of Bass Museum of Art. Gift of Sanford A. Rubenstein.

José Bedia

Many practitioners of Cuban Palo Monte Mayombe refer to their homeland as Ngola, and indeed the religion is seemingly a Cuban version of Kongo religion. The belief system, and thus the art of José Bedia, a Palo initiate, is filled with Kongo-derived iconography. A central object in the religion is the *nganga*, a container filled with objects and substances, related to the Kongo *nkisi*. The Kikongo term *nganga* refers to the ritual practitioner. In Cuba and places such as Miami, however, it is the receptacle. The most commonly depicted *nganga* in Bedia's work is the iron pot, associated with the spirit of Sarabanda. The painting in cat. 7.7 refers to the powers of Sarabanda, to whom Bedia is dedicated. Sarabanda is associated with things made of iron and metals. A large black silhouette dominates the painting. The title is emblazoned across its surface. The profile face is a typical Bedia trope, a type of abstracted self-portrait. The surface of the large black torso with broad shoulders, rounded deltoids, and narrow waist is filled with signs and symbols, the *firmas*, iconographic signs essential to the practice of Palo. Such symbols act as a type of cosmogram that opens the way to communicate with the spirit. On one shoulder, Sarabanda's anvil stands. Tools project from the top of the head, turning it into a sort of *nganga*.

In *Piango Piango Llega Lejos* (cat. 7.8), Bedia depicts a human figure morphing into a turtle. The horizontal bands on the undershell of the turtle's body are filled with linear drawings suggestive of *firmas*. Many of the elements important to Palo are seen—the anvil, the *nganga*, the knife. In fact, the circular form of the undershell, filled with such symbolic images, is suggestive of the cauldron itself. Spots of color on the linear outlines of the bodies can be read as glowing stars in a constellation or as *pwen*, distilled points of power. One turtlelike body seems to be in our plane, the other as if seen beneath water. Is one being in our world and the other beneath the *kalunga* line in the world of the dead?

The title of the painting, drawn in black on the surface, translates "step by step you go far." The idea is that it takes a long time and much work to fill one's *nganga*, but once filled, it works for the practitioner and the practitioner will go far.

RP

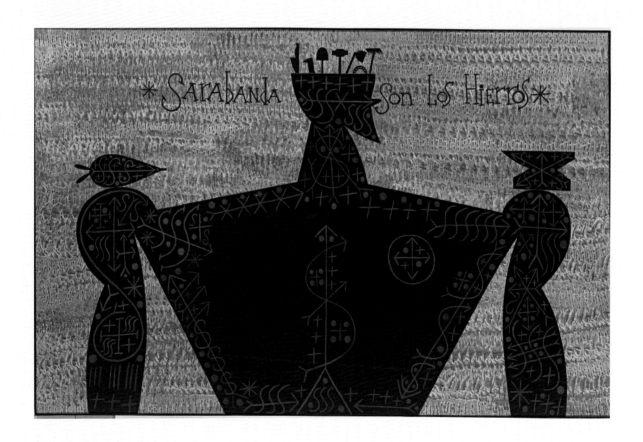

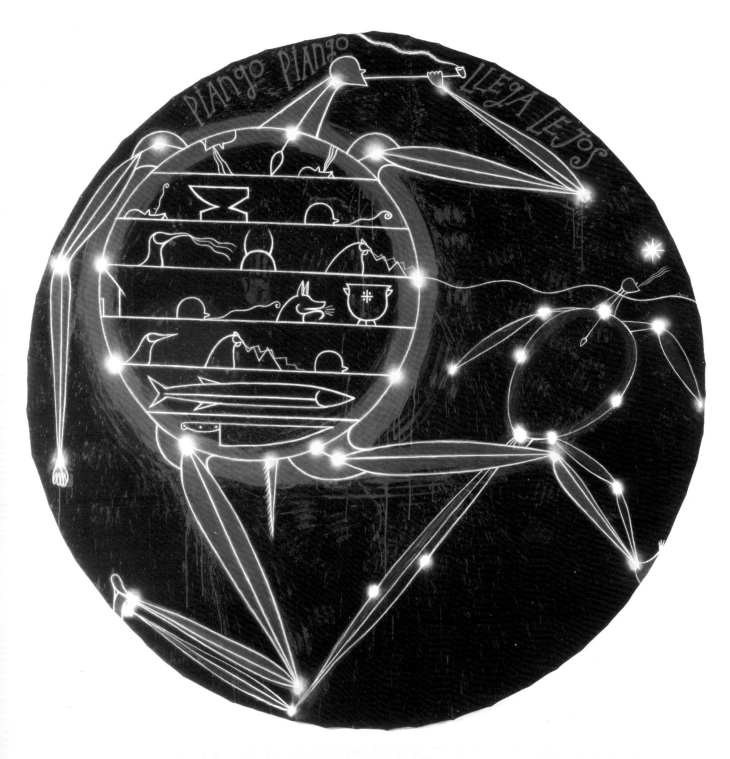

Facing page: Cat. 7.7. José Bedia (Cuban-American, born in Havana, 1959). *Sarabanda son los Hierros.* 1993. Acrylic on canvas, 61.88 × 95 in. (157.2 × 241.3 cm). Courtesy of the Farber Collection.

Above: Cat. 7.8. José Bedia (Cuban-American, born in Havana, 1959). *Piango Piango Llega Lejos* (Step by Step You Can Go Far). 2000. Acrylic stain and oil pastel on canvas, 96.63 in. (245.43 cm). Collection of Ackland Art Museum, the University of North Carolina at Chapel Hill, Ackland Fund, 2001.2.

Steve Bandoma

Steve Bandoma is an artist from the Democratic Republic of Congo who resides in South Africa. Bandoma interrogates postcolonial politics focusing on issues such as race, religion, fashion and consumerism. In his *Lost Tribe* series, he has chosen the Kongo *nkisi* as a monolithic symbol of African traditional culture. Replacing blades inserted into the traditional *nkisi nkondi* with cutout arms from fashion magazines, he instigates a humorous dialogue about the impact of Western culture with its new technologies and excesses—of images, desires and affluence. As we see in *Forgotten Treasure*, the monumental *nkisi*—a symbol of Kongo heritage conflated with African heritage—is toppled from its base, marked with dates of the colonial era in Congo. We are shown what has been destroyed and lost, but not what lies ahead for the Congolese people, for Africans, and for our global heritage.

SC

Cat. 7.9. Steve Bandoma (Congolese, b. 1981). *Trésor Oublié* (from the *Lost Tribe* series). 2011. Watercolor/mixed media on paper, 39.4 × 55.1 in. (100 × 140 cm). Collection of Samuel P. Harn Museum of Art. Museum purchase, funds provided by the David A. Cofrin Acquisition Endowment, 2012.61.1. Photo by Randy A. Batista.

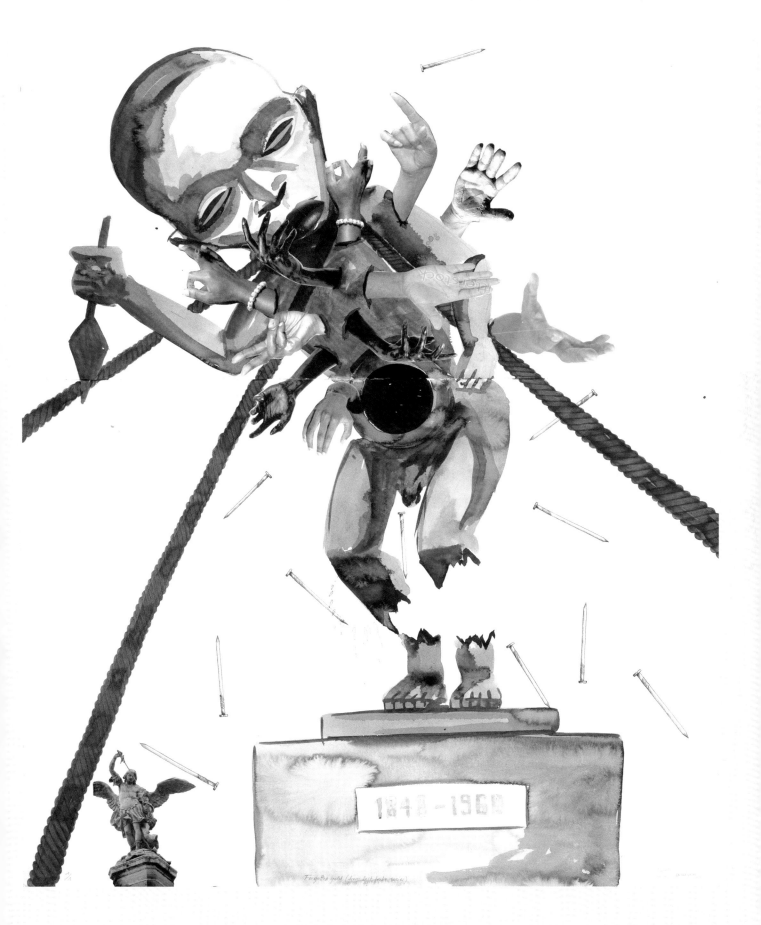

Forgotten gold (...)

Steve Bandoma, *Acculturation*

In *Acculturation*, a Kongo *nkisi* is pierced by many cut-out hands, the agents of excessive materiality; it is waving a broken liquor bottle, and its abdominal cavity is filled with a television color bar in place of *nkisi* medicines. Multiple interpretations are possible. We may see the figure as losing its aggressive spirit, which is redirected and pacified within the grip of Western media, as it has become enslaved by new technology. An alternate reading is that the *nkisi* represents a spirit made aggressive by Western media, who seeks acculturation through the subjugation of all peoples to Western consumerism.

SC

Cat. 7.10. Steve Bandoma (Congolese, b. 1981). *Acculturation*. Watercolor, ink and paper collage, 30 × 41.3 in. (75 × 105 cm). Collection of Samuel P. Harn Museum of Artt. Museum purchase, funds provided by the David A. Cofrin Acquisition Endowment, 2012.61.2. Photo by Randy A. Batista.

Acceleration (from Lost Tribe series)

Acknowledgments

The editors are grateful to a number of individuals who have contributed their time, energy and expertise to this publication. The initial inspiration for this book, *Kongo across the Waters* and the exhibition it complements, came from Amanda B. Carlson and Robin Poynor's jointly edited publication *Africa in Florida: Five Hundred Years of African Presence in the Sunshine State*. Carlson and Poynor's ten years of scholarly work challenged us to look more closely at connections between Africa and Florida, and then more broadly between Africa and America. Our next great impetus came from colleagues of the Royal Museum for Central Africa who transformed our vision of two distinct but related projects to one intensively focused project on Kongo art and culture as it pertains to America. To those scholars, here and across the waters, who laid the foundation for *Kongo across the Waters*, we say thank you.

First of all, those whom we must thank for realizing this publication are the essayists who wrote brilliantly and adhered to our short deadlines without fail. From the beginning, we consulted with many scholars who helped us shape and refine the concept for the book, many of whom also contributed essays. We are particularly grateful to a core group who made the trek to Washington, D.C., in 2011, for our first advisory meeting: Wyatt MacGaffey, John Janzen, Grey Gundaker, Jelmer Vos, John Vlach, Cécile Fromont, Nichole Bridges, Mathilde Leduc-Grimaldi, John Thornton, Linda Heywood and Kerry Oliver-Smith. This group has continued to help us develop the themes and content of the book, and we are greatly in their debt. Many others have assisted us in our research throughout the course of the project, including Dale Rosengarten, who helped us with all aspects of research related to Lowcountry basketry and other aspects of local art and culture that have proved invaluable. We would like to thank Susan Taylor, the director of the New Orleans Museum of Art, who was receptive to our project in its early stages and gave us excellent advice. Bill Fagaly, curator of African art at the New Orleans Museum of Art, was a superb guide, host and informant, led us to important sites and archives and connected us to some fascinating artists and scholars in the city. It was through his work *Ancestors of Congo Square* that we learned about the important work of Freddi Williams Evans, who discussed the significance of Congo Square in African American music with us as we

convened in Louis Armstrong Park. Ned Sublette has also provided insight into the Kongo roots of New Orleans music. Thanks to Jude Solomon and Cynthia Becker, who have provided us with photography of historical sites of New Orleans. Also, thanks to Michael Smith who photographed the jeweled rosary and tomb of Marie Laveau in New Orleans. Dr. Freddye Hill and Bruce Sunpie Barnes assisted us with photographic documentation. Royce Osborn discussed New Orleans performative arts and provided video footage. Barbaro Martinez-Ruiz assisted us with research on music and contemporary artists in the Diaspora, DRC and Angola. We are grateful to Robert F. Thompson for his encouragement. We met with Ramona Austin, who generously shared her research on African American clay sculptures from Georgia. In many ways, Marc Felix was the instigator of this project, and we thank him for that, and for generously sharing his insights into Kongo art. We also thank him for his hospitality in Brussels. Other scholars who have shaped this book include Gwendolyn Midlo Hall, Jane Landers and Carolyn Morrow Long.

We have solicited and received sage advice from a group of University of Florida faculty, Santa Fe College faculty and individuals from the community of Gainesville and environs, including Josephine Badinga, Naana Banyiwa Horne, Patricia Hilliard Nunn, Alicia Antone, Be Astingo, Joan Frosch, Debbie Gallagher, Agnes Leslie, Victoria Rovine, Megan Covey, Vivian Filer, Faye Harrison, Murray Laurie and Kenneth Nunn. We are grateful to these individuals for sharing their response to our project as the voice of our community.

Staff members of several institutions supported our research in many ways. Janet Stanley, director of the Warren M. Robbins Library, National Museum for African Art, Smithsonian Institution, Bryna Freyer and Karen Milbourne directed us to many useful resources. We are grateful to have had the assistance of Jackie Serwer and Deborah Mack of the National Museum of African American History and Culture. Robert Hall and Alcione Amos of the Anacostia Museum pointed us to resources on African American art and culture. Faith Ruffins, of the National Museum of American History, Smithsonian Institution, kindly took time to speak to us about accessing their extensive collections. Deborah Wright and Curtis Frank of the Avery Research Institute in Charleston gave us a tour of storage and directed us to archival materials. At the McKissick Museum of the University of South Carolina, Mark Smith showed us their holdings in storage and supplied us with publications, and John Quirk, archivist in the Folklife Resource Center of the University of South Carolina, generously allowed us to peruse their database. We are grateful to Cindy Sommers, who gave us a tour of the Owens Thomas House, and Jessica Mumford, curator, for informing us about various resources in Savannah. We are also grateful to the staff of the Beach Institute for opening the museum to us and teaching us about local artists.

Walter Mack and Emory Campbell of the Penn Center directed us to resources on Gullah art and culture while giving us a tour of the center. Victoria Smalls, director of history and culture at Penn, also assisted with procuring images from the Penn archive, as did Tim West and Matthew Turi of the Wilson Library of the University

of North Carolina, Chapel Hill. Canter Brown, Larry Rivers, Barry Jordan and Betty Rivers at Ft. Valley State University gave us a wealth of information and materials about local Congo descendants related to the Biggs family and a wonderful tour of the Anderson House and its holdings. Jeffrey Bruce of the Tubman museum graciously gave us a tour of the museum and discussed relevant holdings. Martha Zierden and Grahame Long of the Charleston Museum helped us find rare samples of early coiled baskets from the museum's collection that are included in the catalogue. Sarah Arnold, curator at the Gibbes Museum, graciously provided archival materials and references for early Lowcountry photographs and prints. Greg Lambousy, director of collections at the Louisiana State Museum, allowed us to investigate storage and generously advised us on locating sources of objects and information about Louisiana-related topics. The staff of the Museum of HistoryMiami were marvelously efficient in providing collection information.

Jack Bell very graciously connected us with Steve Bandoma, an artist featured herein. Joeonna Bellrado-Samuels of the Shainman Gallery in New York City, undaunted by the horrendous havoc of Hurricane Sandy, continually provided us with information about Radcliffe Bailey's work. We are grateful to Andy Antipas of Barrister Gallery, New Orleans, for his help in finding and lending Louisiana voodoo objects.

In our research of archaeology in the southeastern United States, several scholars assisted us. Mark Leone and his graduate students at the University of Maryland directed us to the rich archaeological record of Annapolis and provided information about the Brice House and other sites. Eileen Leahy assisted us with materials in the Charles Carroll House. Patricia Samford gave us vital information about the Annapolis caches included in the catalogue. We are grateful to Chris Fennell, whom we've consulted about a variety of topics relevant to early African American artifacts. Shannon Lee Dawdy guided us to Ryan Gray, who has worked diligently to provide documentation and procure and photograph the jeweled rosary excavated in New Orleans. Kenneth Brown discussed his work on African American archaeological sites with enthusiasm. We also wish to thank University of Florida faculty member Luise White for her suggestions about the publication and exhibition.

Sarah Stroud and Trish Smith arranged a tour and a viewing of colonoware and other artifacts at Drayton Hall in South Carolina. Nichole Isenbarger and Andrew Agha alerted us to the findings of the Dean Hall plantation excavation and helped locate and document the colonoware and reviewed the essay in this volume. Dwight Williams, director of Cypress Gardens; Sheldon Owens and Ralph Bailey of Brockington and Associates; and Jerry Good, manager of DuPont Company's Cooper River Plant, allowed access to the fascinating examples of colonoware excavated on the site of Dean Hall Plantation and encouraged us to publish them. Jennifer Farrington, Carol McAuliffe and other staff of the Map and Imagery Library and Digital Collections at the University of Florida's Smathers Libraries have our gratitude for helping us locate and obtain wonderful map images.

We also wish to thank Maaike Kool of the Afrika Museum in Berg en dal, Nijmegen, the Netherlands, and the staff of the Vatican Library and the Archives of the Propaganda Fide in Vatican City, Rome. We are grateful to Patrizio Sauzzi of Fotogioberti for his photograph of the bust of Antonio Manuel in the Basilica Santa Maria Maggiore in Rome, and to Emily Burgoyne, of Regents' Park College, University of Oxford, for help with research in the BMS archives. Greet De Neef of KADOC in Leuven, Belgium, kindly assisted us in locating photographs in Belgian missionary archives.

Throughout this two-year period of research, several people have supported us in unexpected ways. Murray Laurie guided us to African American cemeteries in Gainesville and surrounding areas and has proven to be a wealth of information about African American history in Alachua County.

We have learned much from artists who are featured in the exhibition and others whom we contacted. José Bedia and his son José Bedia Jr. graciously gave us a tour of his exhibition in Miami and his collections. Renée Stout discussed her work at length in several phone conversations and e-mails and kindly loaned her work and a memory jar from her collection. Edouard Duval-Carrié made us feel welcome at his studio, and Mireille Gonzalez kindly gave us a tour of the adjoining Little Haiti Cultural Center. The basket makers in Mt. Pleasant and Charleston, Elizabeth Kinlaw and Barbara Manigault, were particularly kind in allowing us long interviews on cold rainy days as they tended their stands outdoors. Thanks also to photographer Nancy Santos for beautifully documenting these interviews and visiting the basket makers on her own for extra shots. We are grateful to Scot Smith for his photography in the Gainesville area and to Nancy Santos for her photography in Charleston. We would also like to thank Javed Khanni, Houston Wells and Royce Osborn for their assistance with the film on Kongo-inspired American music.

Others artists and practitioners opened their homes and studios to us and allowed us to interview them. We are grateful to Charles C. Williams, cane carver and cast net maker extraordinaire, who spoke to us in his home studio in McClellanville. Thanks also to Mambo Lucy, who allowed us an impromptu tour and interview at her botanica in Little Haiti. We were thrilled to be able to visit Victor Harris in his home in New Orleans and to see his marvelous beaded costumes and discuss his founding of Fi Ya Ya. Sylvester Francis graciously gave us a tour of the Backstreet Museum in New Orleans.

Thanks also to the lenders to the exhibition who also arranged to produce images for this book. Thanks to George and Kay Meyer for allowing us to tour their collection and borrow three extraordinary African American canes seen in this catalogue. We also are indebted to Cici and Hyatt Brown for lending two exceptional Kongo objects and having photography made for the catalogue. Thanks also to David Swoyer for his assistance with documentation of the Brown objects. We offer our thanks to Dana Williams, who generously offered to allow us to replicate the Ft. Mose medal. Many thanks to Holly Ross, who kindly provided access to historically important

postcards in her collection. Thanks also to Howard Farber, for his loan of the work by José Bedia. June Arias was extremely helpful to us in acquiring images of works by Edouard Duval-Carrié. Bert and Jane Hunecke graciously had images made of their clay sculptures, and Jane Hart and Bill Buggel were kind enough to lend their fanner basket to us.

The incredible energy, enthusiasm and professionalism of both the Harn Museum of Art staff and the Royal Museum for Central Africa's staff can never be praised enough. Without their relentless support we could not have managed to produce this publication. Warm thanks to general director Guido Gryseels, who launched this ambitious collaboration and has nourished the bond between our institutions, and to Rebecca Nagy for her unwavering leadership in every aspect of this project. The curatorial staff of the Royal Museum for Central Africa, mobilized to help us shape this project from the beginning, included Anne-Marie Bouttiaux, Julien Volper, Bambi Ceuppens, Jacky Maniacky, Mathilde Leduc-Grimaldi, Birgit Ricquier, Rémy Jadinon, Ignace De Keyser, Sabine Cornelis, Els Cornelissen, Alexander Smith and Koeki Claessens. We are grateful also for the great efforts made by our registration and other staff who have tirelessly worked on many vital tasks in preparing for both the exhibition and this publication. Harn staff members we wish to thank include Jess Uelsmann, associate registrar of exhibitions; Laura Nemmers, chief registrar; Michael Peyton, chief preparator; and Tim Joiner, assistant preparator; Tami Wroath, PR and marketing director; Brandi Breslin, curatorial assistant and docent and adult program coordinator; and Cecile Sands. Exhibition designer Jordan Gil worked tirelessly on the exhibition layout. Jason Raimondi provided video for the exhibition and website. At the RMCA, we are grateful to Annick Swinnen, chief registrar, and to Françoise Therry and Nathalie Minten, conservators. We wish to thank An Cardoen and Anne Welschen for their wonderful help in locating specific photographic materials within the extensive RMCA archives, and for providing us with high-quality reproductions. Photographers Jo Van de Vyver and Jean-Marc Vandyck made beautiful new object photographs, and librarian Fleur De Jaeger assisted with locating important sources. Other Collection Management staff at the RMCA, including Nancy Vanderlinden, Alexander Vral and Stef Keyaerts, helped in many different ways. Several people helped with translations of book contributions and correspondence, including Greta Holmer, Cristiana Panella and Jelmer Vos. Carla Banjai supported us in many ways, including translation of correspondence in Portuguese.

We thank the University of Florida and University of North Florida students who worked as curatorial interns during the initial stages of the project, Jennifer Potter and Molly Reifler. We cannot say enough to thank our dedicated assistant, Carlee Forbes, who devoted her incredible energy, optimism and organizational skills to keeping this publication on track. Only with her help did we manage to steer through the daunting tasks of selecting and cataloguing images, handling all correspondence from contributors, troubleshooting technical issues, seeking all image permissions and many other chores.

We are especially grateful for the many forms of support that Aase and Rick Thompson have given us. Their hospitality, enthusiasm and drive has buoyed our spirits throughout the project.

At the University Press of Florida, Meredith Babb has guided us and advocated for us throughout the entire process of preparing this volume; we greatly appreciate her patience and persistence.

Susan Cooksey
Robin Poynor
Hein Vanhee

Photograph and Map Credits

The following objects were photographed and copyrighted by George A. Smathers Libraries, University of Florida, Gainesville, Florida: cat. 0.1, map by Filippo Pigafetta, and cat. 0.2, map of Joan Blaeu.

The following objects were photographed by J. Van de Vyver and are copyrighted by RMCA Tervuren, Belgium: cat. 1.1 (HO.1955.9.22), cat. 1.2 (HO.1955.9.20), cat. 1.3 (HO.1955.9.21), cat. 1.5a (MO.1967.63.802), cat. 1.5b (MO.1967.63.802), cat. 1.21a (HO.1955.66.12), cat. 1.21b (HO.1955.66.12), cat. 1.22a (HO.1954.19.7), cat. 1.22b (HO.1954.19.7), cat. 2.1 (EO.1951.55.3), cat. 2.2 (EO.1979.1.408), cat. 2.4 (GR.0.0.154), cat. 2.5 (GR.0.0.155), cat. 2.6 (PO.0.0.80851), cat. 2.7 (PO.0.0.80852), cat. 2.8 (EO.1953.74.163), cat. 2.9 (EO.1949.1.18-1), cat. 2.11 (EO.1977.33.1), cat. 2.12 (EO.1952.15.11), cat. 2.13 (EO.1979.1.77), cat. 2.14 (EO.1953.74.1212-2), cat. 2.15 (EO.0.0.7942), cat. 2.16 (EO.1980.2.560), cat. 2.17 (EO.1955.18.1), cat. 2.18 (EO.0.0.34793), cat. 2.22 (EO.1979.1.260), cat. 2.23 (EO.0.0.17797), cat. 2.27 (EO.1953.74.8033), cat. 2.28 (EO.1971.70.1-1), cat. 2.31 (EO.0.0.29075), cat. 2.32 (EO.1953.74.764), cat. 2.33 (EO.1953.74.740), cat. 2.34 (EO.1953.74.504), cat. 3.3 (EO.0.0.42920), cat. 3.5 (MO.0.0.33980), cat. 3.6 (EO.0.0.22444), cat. 3.7 (EO.0.0.45234-1), cat. 3.8 (EO.1953.74.717), cat. 3.9 (EO.1979.1.1022), cat. 3.11 (EO.0.0.33961), cat. 3.17 (MO.0.0.3400), cat. 3.18 (MO.0.0.35998), cat. 3.19 (MO.1954.62.1), cat. 3.20 (MO.1955.95.411), cat. 3.21 (MO.0.0.469-2), cat. 3.22 (MO.1948.10.3), cat. 3.23 (MO.1979.23.25), cat. 3.24 (MO.1958.16.2), cat. 3.25 (MO.0.0.24675), cat. 3.26 (MO.1951.50.190-1), cat. 3.27 (MO.1973.36.8), cat. 3.28 (MO.0.0.34194), cat. 3.29 (MO.1954.10.81), cat. 3.30 (MO.1953.74.551), cat. 4.3 (EO.0.0.22485), cat. 4.4 (EO.0.0.22462), cat. 4.8 (EO.0.0.16674), cat. 4.11 (EO.0.0.22455), cat. 4.16 (EO.1973.62.1), cat. 4.17 (EO.1953.74.1330), cat. 4.18 (EO.1960.32.1), cat. 4.19 (EO.1979.23.1), cat. 4.23 (EO.0.0.42871), cat. 4.24 (EO.0.0.37125), cat. 4.25 (EO.0.0.5033), cat. 4.26 (EO.0.0.7658), cat. 4.27 (EO.1953.74.102), cat. 4.28 (EO.1953.74.35), cat. 4.29 (EO.0.0.19647), cat. 4.30 (EO.0.0.1989-2), cat. 4.31 (EO.0.0.35819), cat. 4.32 (EO.0.0.30635), cat. 4.33 (EO.0.0.32390), cat. 4.35 (EO.0.0.20241-2), cat. 4.37 (EO.0.0.34703), cat. 4.38 (EO.1952.46.4), fig. 11.5 (EO.1953.74.158), fig. 2.1 (HO.1955.9.20), ill. 7.1 (EO.1953.26.18), ill. 7.2 (EO.1953.26.18), ill. 7.3 (EO.1953.26.18), ill. 7.4 (EO.1953.26.18), ill. 7.5 (EO.1953.26.18).

The following objects were photographed by J.-M. Vandyck and are copyrighted by RMCA Tervuren, Belgium: cat. 1.7 (HO.1949.21.1), cat. 1.8 (HO.1955.9.2), cat. 1.9

(HO.1955.9.17), cat. 1.10 (HO.1953.46.1), cat. 1.11 (HO.1998.52.3), cat. 1.12 (HO.1955.9.13), cat. 1.13 (HO.1973.48.1), cat. 1.14 (HO.1955.9.29), cat. 1.15 (HO.1953.100.1), cat. 1.16 (HO.1955.9.23), cat. 1.17 (HO.1998.52.5), cat. 1.18 (HO.1964.29.3), cat. 1.20 (HO.1955.9.24), cat. 2.10a (EO.1953.74.156), cat. 2.10b (EO.1953.74.156), cat. 2.24 (EO.0.0.34448), cat. 2.25 (EO.1948.27.45), cat. 2.30 (EO.0.0.7349-1), cat. 3.1 (EO.0.0.35191), cat. 3.10 (EO.0.0.35045), cat. 3.15 (EO.0.0.34575), cat. 4.5 (EO.0.0.22451), cat. 4.7 (EO.0.0.22464), cat. 4.9 (EO.0.0.22472), cat. 4.10 (EO.0.0.22435-4), cat. 4.12 (MO.0.0.41231), cat. 4.13 (EO.1953.32.36), cat. 4.14 (EO.1955.45.6), cat. 4.20 (EO.0.0.29225), cat. 4.21 (EO.0.0.29259), cat. 4.22 (EO.0.0.29088), cat. 4.34 (EO.0.0.17695), fig. 7.8 (EO.0.0.27312), fig. 11.2 (EO.1986.13.1), fig. 17.4 (EO.0.0.19672), fig. 17.6 (EO.1988.40.1).

The following objects were photographed by R. Asselberghs and are copyrighted by RMCA Tervuren, Belgium: cat. 2.19 (EO.1950.29.1), cat. 2.21 (EO.0.0.43708), cat. 3.2 (EO.1954.60.2), cat. 3.12 (EO.0.0.35776), cat. 3.13 (EO.0.0.38560), cat. 3.14 (EO.0.0.43573), cat. 3.16 (EO.0.0.34579), cat. 4.1 (EO.0.0.7777), ill. 9.2 (EO.0.0.37966), ill. 9.3 (EO.0.0.24662).

The following objects were photographed by H. Dubois and are copyrighted by RMCA Tervuren, Belgium: cat. 2.20 (EO.1979.1.71), cat. 2.26 (EO.1979.1.308).

The following objects were photographed by PlusJ and are copyrighted by RMCA Tervuren, Belgium: cat. 4.2 (EO.0.0.7943), cat. 4.6 (EO.0.0.33956).

The following object was photographed by Lefevre and is copyrighted by RMCA Tervuren, Belgium: cat. 3.4 (MO.0.0.34774).

The following objects were photographed by Randy A. Batista and are copyrighted by the Samuel P. Harn Museum of Art: ill. 15.1, ill. 15.2, ill. 15.3, ill. 13.2, cat. 6.2, cat. 6.3, cat. 6.5, cat. 6.10, cat. 6.12, cat. 6.13, cat. 6.14, cat. 6.15, cat. 6.17, cat. 6.18, cat. 6.19, cat. 6.27, cat. 7.9, cat. 7.10.

The following objects were photographed by Sean Money and are copyrighted by the Charleston Museum of Art: cat. 6.8, cat. 6.9, cat. 6.11, ill. 12.1.

The following object photograph is copyrighted by the Philadelphia Museum of Art: cat. 6.24.

The following object photograph is copyrighted by the Smithsonian Institution, American Art Museum: cat. 6.20.

The following object photographs are copyrighted by the National Museum of American History, Smithsonian Institution: cat. 6.21, cat. 6.22, cat. 6.23.

The photograph of the following object is copyrighted by the Tubman Museum, Macon, Georgia: cat. 6.1.

The following object photographs are copyrighted by the Museum of History Miami: cat. 6.4, cat. 6.5, cat. 6.5.

The following object was photographed and copyrighted by Minh Doan: ill. 12.4.

The following object was photographed by Ric Hal and is copyrighted by the Blanton Museum of Art, University of Texas, Austin: cat. 7.3.

The following object photograph is copyrighted by the Shainman Gallery, New York: cat. 7.4.

The following objects were photographed by Randy A. Batista and copyrighted by Renée Stout: cat. 7.1, cat. 7.2, cat. 6.26.

The following object photograph is copyrighted by the Dallas Museum of Art: fig. 23.1.

The following object photographs are copyrighted by the DuPont Company: cat. 5.5, cat. 5.6, cat. 5.7 (cat. 5.7 photograph by Larry Mccrea).

The following object was photographed by the Florida Museum of Natural History: cat. 5.3.

The following object was photographed and copyrighted by the High Museum of Art: cat. 6.25.

The following objects were photographed and copyrighted by the Bass Museum: cat. 7.5, cat. 7.6.

The following object photograph is copyrighted by the Farber Collection: cat. 7.7.

The following object was photographed and copyrighted by the Ackland Art Museum: cat. 7.8.

The following object was photographed by Michael Smith and copyrighted by the Samuel P. Harn Museum of Art: cat. 5.4.

The following object was photographed and copyrighted by Archaeology in Annapolis: cat. 5.1.

The following objects were photographed and copyrighted by the James Brice House: cat. 5.2a, cat. 5.2b.

Map of the Kongo kingdom and surrounding regions and map of the southeastern United States, by Megan Pugh, 2013, Harn Museum of Art (introduction).

Map of Bantu languages, by Jacky Maniacky, 2013, copyright RMCA Tervuren, Belgium.

Bibliographic Notes for Focus Series
and Catalogue Sections

Bibliographic Notes for Focus Series

Focus 1. King Pedro VII of Kongo

Almeida, "Subsídio," 680; Esteves, Kiangala and Yambo, *Catálogo da Exposição Permanente*; photographs by Linda Heywood and John Thornton in 2002 in Mbanza Kongo, kindly shared with the author.

Focus 2. The Capuchins' Didactic Documents

Fromont, "Collecting and Translating Knowledge across Cultures," passim; see also chapter 2 in this volume.

Focus 3. The Kongo Cross across Centuries

See chapter 3 in this volume.

Focus 4. Images of the Middle Passage

Voyages: The Trans-Atlantic Slave Trade Database, http://www.slavevoyages.org; chapter 4 in this volume.

Focus 5. Portraits of Kongo Diplomats

"Albert Eckhout"; Bindman and Gates, *Image of the Black in Western Art*, 217–18; Caraman-Chimay Borghese, *Belges et africains.*

Focus 6. Antonio, Mambouc of Nzobe in the 1890s

See chapter 6 in this volume.

Focus 7. Depicting the Slave Trade

Bassani and McLeod, *African Art and Artefacts*; Bassani and Fagg, *Africa and the Renaissance*. See also chapter 7 in this volume.

Focus 8. Praetorius Displays Kongo Instruments, 1619

Bachmann, Besseler and Schneider, *Musikgeschichte in Bildern.*

Focus 9. The Master of Kasadi

Bassani, "Un grand sculpteur du Congo"; RMCA Archives, division of Ethnography, D.E. 593.

Focus 10. The Land of the Dead

Bontinck, "Vestiges du commerce européen"; MacGaffey, *Kongo Political Culture.*

Focus 11. Crossing the South

Fennell, *Crossroads and Cosmologies*; Kenneth Brown, "Material Culture and Community Structure," passim; Kenneth Brown, "BaKongo Cosmograms"; personal communication with Kenneth Brown, February 2013.

Focus 12. Kongo Ideas and Aesthetics in African American Ceramics

Austin, "Two Middle Georgia Figures."; Thompson and Cornet, *Four Moments of the Sun*, 160; R. Thompson, *Flash of the Spirit*, 139; Vlach, *Afro-American Tradition*, 145; personal communication with Ramona Austin, November 2012–January 2013.

Focus 13. Continuing the Legacy of Lowcountry Coiled Baskets

Rosengarten, Rosengarten and Schildkrout, *Grass Roots*, 117, 144; personal communication with Elizabeth Kinlaw, November 2012; personal communication with Barbara Manigault, November 2012; personal communication with Dale Rosengarten, November 2012.

Focus 14. Remembering Congo Square

Evans, *Congo Square*; personal communication with Freddi Williams Evans, May 2012.

Focus 15. Kongo in the Engravings of Pieter van der Aa

Schmidt, "Geography Unbound," 39, 44; Thornton, "Cavazzi, Missione Evangelica."

Focus 16. Kongo Afterlife in Florida

Janzen and MacGaffey, *Anthology of Kongo Religion*, 46, 73; Thompson and Cornet, *Four Moments of the Sun*, 198; Thompson, *Flash of the Spirits*, 135, 140; Kirkwood, "Kongo-Influenced Burial Practices"; Kellim Brown, "TransAtlantic Kongo," 207–8; Ferguson, *Uncommon Ground*, 175; personal communication with Murray Laurie, March 2012.

Focus 17. Kongo Memory in the Afro-Atlantic

Heusch, "Kongo in Haiti," passim; McAlister, "A Sorcerer's Bottle," passim; MacGaffey, *Religion and Society in Central Africa*, passim; Ochoa, *Society of the Dead*, passim; Rey and Richman, "The Somatics of Syncretism," passim; Szwed, "Vibrational Affinities," passim; R. Thompson, *Face of the Gods*, passim; R. Thompson, "Big-Hearted Power," passim; Vlach, "Roots and Branches," passim; personal communication with Marie Charlinette, May 2012.

Bibliographic Notes for Catalogue Sections

Catalogue Section 1

Bassani and McLeod, *African Art and Artefacts*; de Bouveignes, "Saint Antoine et la pièce de vingt reis"; Dapper, *Naukeurige Beschrijvinge*; De Donder, "Les Vieux Crucifix"; Fromont, "Under the Sign of the Cross"; Thornton, "The Development of an African Catholic Church"; Wannyn, *L'art ancien du metal*; Wannyn, "Objets anciens en métal du Bas-Congo."

Catalogue Section 2

Bassani and McLeod, *African Art and Artefacts*, xxxi–xxxii, 281–82; Bontinck, "Vestiges du commerce européen"; Laman, *The Kongo*, Vol. I, 140–47; MacGaffey, *Kongo Political Culture*; MacGaffey, essay in Verswijver et al., *Masterpieces from Central Africa*, 142; MacGaffey, "Complexity, Astonishment and Power," 188–203; MacGaffey, *Custom and Government in the Lower Congo*, 229, 236; Moraga, *Weaving Abstraction,* 29–33; notes from RMCA collection files for EO.1971.70.1-1 and EO.1953.74.8033; Van Bockhaven, *Collections of the RMCA: Headdresses.*

Catalogue Section 3

Bittremieux, *La société secrète des Bakhimba*; Bittremieux, "Badunga's"; Cornet, *Pictographies Woyo*; Janzen, "Review of Les Phemba du Mayombe"; Janzen, *Lemba*; Janzen and Janzen, "The Art of Lemba in Lower Zaire."

Catalogue Section 4

Bassani and McLeod, *African Art and Artefacts*, 281–82; Bassani, "Kongo Nail Fetishes"; Bittremieux, "De Mayombsche Regenboog"; Denbow, "Pride, Prejudice, Plunder and Preservation," 383; Felix and Lu, *Kongo Kingdom Art*, 157; Janzen, *Lemba*; Coart and de Haulleville, "La Ceramique," 11, 74, 80; Laman, *The Kongo*, Vol. I, 126–27; MacGaffey and Janzen, "Nkisi Figures of the Bakongo"; MacGaffey, "The Eyes of Understanding"; MacGaffey, *Kongo Political Culture*; MacGaffey, "Substance and Smells"; Maquet-Tombu, "Madya"; Moraga, *Weaving Abstraction,* 29–33; Thompson and Cornet, *Four Moments of the Sun*; Volavka, "Voania Muba."

Catalogue Section 5

Agha, Isenbarger and Philips, "Traditions in Rice and Clay"; Fu-Kiau, *N'kongo ye Nza yakun'zungidila*, table 29; Ferguson, *Uncommon Ground*, 44, 114; Galke, "Colonowhen, Colonowho, Colonowhere, Colonowhy," 303–26; Ralph Bailey, personal communication, November 20, 2012; Andrew Agha, personal communication (email), July 23, 2012, and February 5, 2013; Nicole Isenbarger, personal communication (email), July 25, 2012, and February 2, 2013; Christopher Fennell, personal communication, February 24, 2013.

Catalogue Section 6

Austin, "Defining the African-American Cane," 222–27; Austin, essays on Kongo chief's staffs, 148–49; Baldwin, *Great and Noble Jar,* 81; Kellim Brown, "TransAtlantic Kongo," 207–8; Burrison, "South Carolina's Edgefield District," 13; Harris, "Resonance, Transformation and Rhyme," 107–24, 130–53; Janzen and MacGaffey, *Anthology of Kongo Religion*, 7; MacGaffey, "Complexity, Astonishment and Power," 191, 193, 199; MacGaffey, "Fetishism Revisited," 175; Montgomery, "Survivors," 613; Thompson and Cornet, *Four Moments of the Sun*, 214; Vlach, *The Afro-American Tradition in Decorative Arts*; Kellim Brown, personal communication, January 16, 2013; Renée Stout, personal communication, June 2012 and July 25, 2012; Carol Thompson, personal communication, July 30, 2012; Kellim Brown, personal communication (email), July 9, 2012.

Catalogue Section 7

Harris, "Resonance, Transformation and Rhyme," 107–24, 130–53; Rooks, "Beauty and Purpose in the Art of Radcliffe Bailey," 127; Thompson, *Radcliffe Bailey*, 37, 43; Kondile, "First Encounter with Steve Bandoma"; "Steve Bandoma the First Young Black Artist at NIROX Foundation"; Radcliffe Bailey, "By the River," http://blantonmuseum.org/interact/aac/assemble_context.swf (accessed March 1, 2013); Steve Bandoma, personal communication (email), November 23, 2012; Joeonna Bellrado-Samuels, personal communication (email), October 17, 2012; Renée Stout, personal communication (email), June 2012 and July 25, 2012; Carol Thompson, personal communication, December 2012.

Bibliography

African Arts. "First Word." *African Arts* 8, no. 1 (1974): 1.

Agha, Andrew, Nicole M. Isenbarger, and Charles Philips. "Traditions in Rice and Clay: Understanding an Eighteenth-Nineteenth Century Rice Plantation, Dean Hall Plantation (38BK2132), Berkeley County, South Carolina." Moncks Corner, SC: DuPont, 2012.

"Albert Eckhout (1610–66), Don Miguel de Castro, Emissary of Congo, c. 1643–50." In *Collection Highlights*. Staetens Museum for Kunst (National Gallery of Denmark), 2013. Available at http://www.smk.dk.

Almeida, Antonio do. "Subsídio Para a História Dos Reis Do Congo." *Congresso Do Mundo Português. Publicacoes* VIII, 485–696. Lisbon: Imprensa Nacional, 1940.

Anderson, Efraim. *Messianic Popular Movements in the Lower Congo.* Uppsala, Sweden: Almqvist and Wiksells, 1958.

Apter, Andrew. "On African Origins: Creolization and Connaissance in Haitian Vodou." *American Ethnologist* 29, no. 2 (2002): 233–60.

Aqualusa, Jose Eduardo. *Creole.* London: Arcadia Books, 2007.

Austin, Ramona. "Defining the African-American Cane." In *American Folk Canes: Personal Sculpture*, edited by George H. Meyer, 222–27. Bloomfield Hills, MI: Sandringham Press, 1992.

———. Essays on Kongo chiefs' staffs, in *Masterpieces from Central Africa: The Tervuren Museum*, edited by Gustaaf Verswijver, 148–49. Munich: Prestal-Verlag, 1996.

———. "Two Middle Georgia Figures." Unpublished essay, 2013.

Ayes, John J. Browne. *Juan Ponce de Leon: His New and Revised Genealogy.* Raleigh, NC: Lulu.com, 2010.

Bachmann, Werner, Heinrich Besseler, and Max Schneider. *Musikgeschichte in Bildern.* Leipzig, Germany: Deutscher Verlag für Musik, 1974.

Baldwin, Cinda K. *Great and Noble Jar: Traditional Stoneware of South Carolina.* Athens: University of Georgia Press, 1993.

Barnes, Jodi A., ed. *The Materiality of Freedom: Archaeologies of Postemancipation Life.* Columbia: University of South Carolina Press, 2011.

Bassani, Ezio. "Ivoires et Tissus Kongo. L'Italie, le Portugal, et le Congo aux XVe–XVIe Siècles." In *La nouvelle histoire du Congo: mélanges eurafricains offerts à Frans Bontinck, CICM*, edited by Mabiala Mantuba-Ngoma, 61–72. Tervuren, Belgium: Royal Museum for Central Africa, 2004.

———. "Kongo Nail Fetishes from the Chiloango River Area." *African Arts* 10, no. 3 (1970): 36–40, 88.

———. *Un Cappuccino nell'Africa nera del Seicento: i disegni dei Manoscritti Araldi del Padre Giovanni Antonio Cavazzi da Montecuccolo.* Milan, Italy: Poro, 1987.

———. "Un grand sculpteur du Congo: le maître de Kasadi." In *Mains de maîtres: à la découverte des sculpteurs*, edited by Bernard De Grunne, 163–77. Brussels: Espace Culturel BBL, 2001.

Bassani, Ezio, and William Fagg. *Africa and the Renaissance: Art in Ivory.* New York: Center for African Art, 1988.

Bassani, Ezio, and M. D. McLeod. *African Art and Artefacts in European Collections: 1400–1800*. London: British Museum Press, 2000.

Bastian, Adolf. *Die deutsche Expedition an der Loango-Küste, nebst älteren Nachrichten über die zu erforschenenden Länder.* Jena, Germany: Costenoble, 1874.

Bastin, Yvonne, A. Coupez, E. Mumba, and Thilo Schadeberg. *Bantu Lexical Reconstructions 3.* Tervuren, Belgium: Royal Museum for Central Africa, 2003. Available at http://www.africa museum.be/collections/browsecollections/humansciences/blr.

Bentley, William Holman. *Dictionary and Grammar of the Kongo Language.* London: London Baptist Missionary Society, 1887.

Berlin, Ira. *Generations of Captivity: A History of African-American Slaves.* Cambridge, MA: Harvard University Press, 2003.

———. *Many Thousands Gone: The First Two Centuries of Slavery in North America.* Cambridge, MA: Harvard University Press, 1998.

Bettelheim, Judith. "Caribbean Espiritismo (Spiritist) Altars: The Indian and the Congo." *Art Bulletin* 87, no. 2 (2005): 312–30.

———. "Palo Monte Mayombe and Its Influence on Cuban Contemporary Art." *African Arts* 34, no. 2 (2001): 36–49, 94–96.

———. *Transcultural Pilgrim: Three Decades of Work by Jose Bedia.* Los Angeles: UCLA Fowler Museum, 2011.

Bindman, David, and Henry Louis Gates, Jr., eds. *The Image of the Black in Western Art*, vol. 2. Cambridge, MA: Harvard University Press, 2010.

Bittremieux, Leo. "Badunga's." *Missiën Van Scheut* 6 (1933): 211–12.

———. *Mayombsch Idioticon.* Ghent, Belgium: Erasmus, 1922.

———. "De Mayombsche Regenboog." *Onze Kongo* IV (1913): 83–112.

———. "Overblijfselen van den Katholieken Godsdienst in Lager Kongo-land." *Anthropos* 21 (1926): 797–805.

———. *La société secrète des Bakhimba au Mayombe.* Brussels: Institut Royal Colonial Belge, 1936.

Bland, Elizabeth, ed. *The Life and Letters of Lafcadio Hearn Including the Japanese Letters*, vol. 1. New York: Houghton Mifflin, 1923.

Bolton, H. Carrington. "Decoration of Graves of Negroes in South Carolina." *Journal of American Folklore* 4 (1891): 214.

Bontinck, Frans. *L'Evangélisation du Zaire.* Kinshasa, DRC: Editions St. Paul Afrique, 1980.

———. "Pedro V, roi de Kongo, face au partage colonial." *Africa: rivista trimestrale di studi e documentazione Africa (Roma)* 37, no. 1/2 (1982): 1–53.

———. "Vestiges du commerce européen au Mayombe (Zaïre)." *Ngonge. Carnets des Sciences Humaines* 38, no. série 5, nr. 3 (1990).

Bouveignes, Olivier de. "Saint Antoine et la pièce de vingt reis." *Brousse* 3–4 (1947): 17–22.

Brasio, Antonio. *D. Antonio Barroso: missionario, cientista, missiologo.* Lisbon, Portugal: Centro de Estudos Historicos Ultramarinos, 1961.

———, ed. *Monumenta Missionaria Africana*, 1st series, 15 vols. Lisbon, Portugal: Agencia Geral do Ultramar, 1952.

Brathwaite, Kamau. *The Arrivants: A New World Trilogy.* New York: Oxford University Press, 1988.

Broadhead, Susan Herlin. "Beyond Decline: The Kingdom of the Kongo in the Eighteenth and Nineteenth Centuries." *International Journal of African Historical Studies* 12, no. 4 (1979): 615–50.

———. "Slave Wives, Free Sisters: Bakongo Women and Slavery ca. 1700–1850." In *Women and Slavery in Africa*, edited by C. C. Robertson and M. A. Klein, 160–81. Madison: University of Wisconsin Press, 1983.

Brosses, Charles de. *Du culte des dieux fétiches.* Paris, 1760.

Brown, Kellim. "TransAtlantic Kongo: Echoes of the Cosmogram." In *Kongo Kingdom Art*, edited by Marc Felix, 207–8. Hong Kong: Ethnic Art and Culture, 2003.

Brown, Kenneth L. "BaKongo Cosmograms, Christian Crosses, or None of the Above: An Archae-

ology of African American Spiritual Adaptations into the 1920s." In *The Materiality of Freedom: Archaeologies of Postemancipation Life*, edited by Jodi A. Barnes, 209–29. Columbia: University of South Carolina Press, 2011.

———. "Ethnographic Analogy, Archaeology, and the African Diaspora: Perspectives from a Tenant Community." *Historical Archaeology* 38, no. 1 (2004): 79–89.

———. "Interwoven Traditions: Archaeology at the Conjurer's Cabins and African American Cemetery at the Jordan and Frogmore Plantations." In *Places of Cultural Memory: African Reflections on the American Landscape*, 99–114. Washington, DC: National Park Service, 2001.

———. "Material Culture and Community Structure: The Slave and Tenant Community at Levi Jordan's Plantation, 1848–1892." In *Working toward Freedom: Slave Society and Domestic Economy in the American South*, edited by Larry E. Hudson, Jr., 95–118. Rochester, NY: University of Rochester Press, 1994.

Brown, Kenneth L., and Doreen C. Cooper. "Structural Continuity in an African-American Slave and Tenant Community." *Historical Archaeology* 24, no. 4 (1990): 7–19.

Burridge, Kenelm. *New Heaven, New Earth: A Study of Millenarian Activities.* London: Blackwell, 1969.

Burrison, John A. "South Carolina's Edgefield District: An Early International Crossroads of Clay." *American Studies Journal* 56 (2012). Available at http://www.asjournal.org/archive/56/.

Burton, Richard Francis. *Two Trips to Gorilla Land and the Cataracts of the Congo.* London: Sampson Low, Marston, Low & Searle, 1876.

Cable, George W. *The Dance in Place Congo: Creole Slave Songs.* New Orleans: Faruk von Turk, 1974.

Cabrera, Lydia. *Reglas de Congo.* Miami, FL: Ediciones Universal, 1986.

Cameron, Verney L. *Across Africa.* New York: Harper and Brothers, 1877.

Cantor, Judy. "Painting the Body Politic." *Miami New Times*, July 20, 1994.

Capelli, Adriano. "A Proposito di Conquiste Africane." *Archivo Storico Lombardo* (1896): 416.

Caraman-Chimay Borghese, Alys de. *Belges et africains.* Rome: Imprimerie du Sénat, 1916.

Carney, Judith A. *Black Rice: The African Origins of Rice Cultivation in the Americas.* Cambridge, MA: Harvard University Press, 2001.

Carney, Judith Ann, and Richard Nicholas Rosomoff. *In the Shadow of Slavery: Africa's Botanical Legacy in the Atlantic World.* Berkeley: University of California Press, 2009.

Carter, Hazel. "Kongo Survivals in United States Gullah: An Examination of Turner's Material." Paper presented at the Conference on Semantics, Lexicography and Creole Studies, Society for Caribbean Linguistics at the University of West Indies, July 17–21, 1978.

Cassidy, Frederic G. "Sources of the African Element in Gullah." In *Studies in Caribbean Language*, edited by Lawrence D. Carrington in collaboration with Dennis Craig and Ramon Todd Dandaré, 75–81. St. Augustine, Trinidad: Society for Caribbean Linguists, 1983.

Cavazzi da Montecuccolo, Giovanni Antonio. *Istorica descrizione de' tre' regni Congo, Matamba et Angola.* Bologna, Italy: Giacomo Monti, 1687.

Chambers, Douglas B. *Murder at Montpelier: Igbo Africans in Virginia.* Jackson: University Press of Mississippi, 2005.

Chauvet, Stéphen. *Musique nègre.* Paris: Société d'Éditions Géographiques, Maritimes et Coloniales, 1929.

Claridge, G. Cyril. *Wild Bush Tribes of Tropical Africa.* 1922. New York: Negro Universities Press, 1969.

Coart, E., and A. de Haulleville. *La céramique.* Tervuren, Belgium: Musée du Congo Belge, 1907.

Coquet, Michèle. "Une esthétique du fétiche." In *Fétiches: objets enchantés, mots réalisés*, edited by Albert de Surgy. Paris: Ecole Pratique des Hautes Études, 1985.

Cornet, Joseph. *Pictographies Woyo.* Milan, Italy: Quaderni Poro, 1980.

Cortona, Serafino da. "Breve Relatione dei riti gentilichi e ceremonie diaboliche e superstition del infelice Regno de Congo." In *La prefettura apostolica del Congo alla metà del XVII secolo: la relazione inedita di Girolamo da Montesarchio*, edited by Calogero Piazza. Milan, Italy: Giuffrè, 1976.

Cosentino, Donald J. *Divine Revolution: The Art of Edouard Duval-Carrié.* Los Angeles: UCLA Fowler Museum of Cultural History, 2004.

Crosby, Alfred W. *The Columbian Exchange: Biological and Cultural Consequences of 1492.* Westport, CT: Greenwood Press, 1972.

Cuvelier, J. *Documents sur une mission française au Kakongo, 1766–1776.* Brussels: Institut Royal Colonial Belge, 1953.

da Cunha Moraes, J. A. *Africa occidental. Album photographico e descriptivo. Com una introducçao da Luciano Cordeiro.* Lisbon, Rio de Janeiro, 1885–88.

Dalby, David. "The African Element in American English." In *Rappin' and Stylin' Out: Communication in Urban Black America*, edited by Thomas Kochman, 170–86. Urbana: University of Illinois Press, 1972.

Dalgish, Gerard M. *A Dictionary for Africanisms.* Westport, CT: Greenwood Press, 1982.

da Montesarchio, Girolamo. "Viaggio al Congo." In *La prefettura apostolica del Congo alla metà del XVII secolo: la relazione inedita di Girolamo da Montesarchio*, edited by Calogero Piazza, fols. 61v–62. Milan, Italy: Giuffrè, 1976.

Danto, Arthur. "The Artworld." *Journal of Philosophy* 61, no. 19 (1964): 571–84.

Dapper, O. *Naukeurige Beschrijvinge der Afrikaensche gewesten.* Amsterdam: Jacob van Meurs, 1668.

da Silva Maia, Antonio. *Dicionario Complementar Portugues-Kimbundu-Kikongo.* Cucujaes, Portugal: Tipografia das Missoes, 1964.

Day, Greg. "Afro-Carolinian Art: Towards the History of a Southern Expressive Tradition." *Contemporary Art / Southeast* 1, no. 5 (1978): 10–21.

De Brahm, John Gerar William. "A Map of South Carolina and a Part of Georgia." London: Jefferys, 1757.

de Brazzà, Pierre Savorgnan. *Trois explorations dans l'Ouest africain (1876–1885).* Paris: Dreyfous, 1887.

De Donder, Eudore. "Les Vieux Crucifix du Bas-Congo." *Grands Lacs* 63, no. 8 (1947): 431–34.

de Ghela, Giorgio. *Vocabularium Latinum Hispanicum e Congense.* Rome: Biblioteca Nazionale Centrale di Roma, 1652.

de la Lindi, J. H., and A. Gilliaert. *La Force Publique de sa naissance à 1914.* Brussels: Institut Royal Colonial Belge, 1952.

Delcommune, Alexandre. *Vingt années de vie Africaine.* Brussels: Larcier, 1922.

Denbow, James. "Heart and Soul: Glimpses of Ideology and Cosmology in the Iconography of Tombstones from the Loango Coast of Central Africa." *Journal of American Folklore* 112, no. 445 (1999): 404–23.

———. "Pride, Prejudice, Plunder and Preservation: Archaeology and the Re-Envisioning of Ethnogenesis on the Loango Coast of the Republic of Congo." *Antiquity* 86, no. 332 (2012): 383–408.

de Rouvre, Charles. "La Guinée Méridionale Indépendante: Congo, Kakongo, N'goyo, Loango, 1870–1877." *Bulletin de la Société de Géographie de Paris* 20, no. 2 (1880): 289–327, 401–34.

Desch Obi, T. J. *Fighting for Honor: The History of African Martial Art Traditions in the Atlantic World.* Columbia: University of South Carolina Press, 2008.

Diawara, Manthia. "Radcliffe Bailey: One World under the Groove." In *Radcliffe Bailey: Memory as Medicine*, edited by Carol Thompson, 135–42. New York: Prestel, 2011.

Dictionnaire Congo et Français. Besançon, France: Bibliothèque Municipale de Besançon, 1773.

Doar, David, A. S. Salley, and Theodore D. Ravenel. *Rice and Rice Planting in the South Carolina Low Country.* Charleston, SC: Charleston Museum, 1936.

Douglass, Frederick. "Narrative of the Life of Frederick Douglass." In *Frederick Douglass: Autobiographies*, edited by Henry Louis Gates, 39–108. Philadelphia: Library Company of America, 1994.

Doutreloux, Albert. *L'ombre des fétiches: société et culture yombe.* Québec: Éditions Nauwelaerts, Presses de l'Université Laval, 1967.

du Chaillu, Paul Belloni. *Explorations and Adventures in Equatorial Africa.* London: Murray, 1861.

———. *A Journey to Ashango-Land and Further Penetration into Equatorial Africa.* New York: Appleton, 1867.

"Du Chaillu's Lectures for the Young Folks." *Harper's Weekly*, 6 March 1869.

Dunbar, Alice Nelson. "People of Color in Louisiana: Part I." *Journal of Negro History* 1, no. 4 (1916): 361–76.

Ellison, Ralph. "The Art of Romare Bearden." *Massachusetts Review* 18, no. 4 (1977): 673–80.

Eltis, David. "Construction of the Trans-Atlantic Slave Trade Database: Sources and Methods." 2010. *Voyages: The Trans-Atlantic Slave Trade Database*, available at http://www.slavevoyages.org/tast/database/methodology-01.faces.

———. "The U.S. Transatlantic Slave Trade, 1644–1867: An Assessment." *Civil War History* 54, no. 4 (2008): 347–78.

Eltis, David, and David Richardson. *Atlas of the Transatlantic Slave Trade.* New Haven, CT: Yale University Press, 2010.

Emerling, Jae. *Theory for Art History: Adapted from Theory for Religious Studies, by William E. Deal and Timothy K. Beal.* New York: Routledge, 2005.

Esteves, Emmanuel, Francisco Xavier Yambo, and Manuel Kiangala. *Catálogo da Exposição Permanente do Museu dos Reis do Kongo.* Luanda, Angola: Governo de Angola, Ministério da Cultura, Inst. Nacional do Património Cultural, 2007.

Evans, Freddi Williams. *Congo Square: African Roots in New Orleans.* Lafayette: University of Louisiana at Lafayette Press, 2011.

Eyles, Desmond. *"Good Sir Toby": The Story of Toby Jugs and Character Jugs through the Ages.* London: Doulton, 1955.

Fabian, Johannes. *Remembering the Present: Painting and Popular History in Zaire.* Berkeley: University of California Press, 1996.

Felix, Marc Leo, Charles Meur, and Niangi Batulukisi. *Art & Kongos: les peuples kongophones et leur sculpture = Biteki bia Bakongo.* Brussels: Zaïre Basin Art History Research Center, 1995.

Felix, Marc, and Henry C. C. Lu. *Kongo Kingdom Art: From Ritual to Cutting Edge.* Hong Kong: Ethnic Art and Culture, 2003.

Fennell, Christopher C. *Crossroads and Cosmologies: Diasporas and Ethnogenesis in the New World.* Gainesville: University Press of Florida, 2007.

———. "Early African America: Archaeological Studies of Significance and Diversity." *Journal of Archaeological Research* 19, no. 1 (2011): 1–49.

Ferguson, Leland G. "'The Cross Is a Magic Sign': Marks on Eighteenth-Century Bowls from South Carolina." In *"I, Too, Am America": Archaeological Studies of African-American Life,* edited by Theresa A. Singleton, 16–131. Charlottesville: University Press of Virginia, 1999.

———. "Early African-American Pottery in South Carolina: A Complicated Plainware." *African Diaspora Archaeology Newsletter,* June 2007. Available at http://www.diaspora.uiuc.edu/news0607/news0607.html#1.

———. *Uncommon Ground: Archaeology and Early African America.* Washington, DC: Smithsonian Institution Press, 1992.

Fromont, Cécile. "Collecting and Translating Knowledge across Cultures: Capuchin Missionary Images of Early Modern Central Africa, 1650–1750." In *Collecting across Cultures: Material Exchanges in the Early Modern Atlantic World,* edited by Daniela Bleichmar and Peter C. Mancall, 134–54. Philadelphia: University of Pennsylvania Press, 2011.

———. "Dance, Image, Myth, and Conversion in the Kingdom of Kongo, 1500–1800." *African Arts* 44, no. 4 (2011): 52–63.

———. "Under the Sign of the Cross in the Kingdom of Kongo: Religious Conversion and Visual Correlation in Early Modern Central Africa." *RES: Anthropology and Aesthetics* 59–60 (2011): 109–23.

Fu-Kiau, Kimbwandende Kia Bunseki. *N'kongo ye Nza yakun'zungidila / Le Mukongo et le monde qui l'entourait.* Kinshasa, DRC: Office National de la Recherche et du Développement, 1969.

———. *African Cosmology of the Bântu-Kôngo: Tying the Spiritual Knot, Principles of Life and Living.* Brooklyn, NY: Athelia Henrietta Press, 2001.

Galke, Laura J. "Colonowhen, Colonowho, Colonowhere, Colonowhy: Exploring the Meaning behind the Use of Colonoware Ceramics in Nineteenth-Century Manassas, Virginia." *International Journal of Historical Archaeology* 13, no. 3 (2009): 303–26.

Gansemans, Jos, Heinrich Besseler, Max Schneider, Werner Bachmann, and Barbara Schmidt-Wrenger. *Musikgeschichte in Bildern: Bd. 1, Musikethnologie, Lief. 9, Zentralafrika.* Leipzig, Germany: VEB Deutscher Verlag für Musik, 1986.

Gell, Alfred. *Art and Agency: An Anthropological Theory.* New York: Clarendon Press, 1998.

Georgia Writers' Project. *Drums and Shadows: Survival Studies among the Georgia Coastal Negroes.* Athens: University of Georgia Press, 1940.

Gerhard, Peter. "A Black Conquistador in Mexico." *Hispanic American Historical Review* 58, no. 3 (1978): 451–59.

Gilroy, Paul. *The Black Atlantic: Modernity and Double Consciousness.* Cambridge, MA: Harvard University Press, 1993.

Glave, E. J. "Fetishism in Congo Land." *Century Magazine* 41, no. 6 (1891): 825–37.

Góis, Damião de. *Chronica do felicissimo rei Dom Emanuel.* Lisbon, Portugal: Casa de Françisco Correa, Impressor do Serenissimo Cardeal Infante, 1566.

Gonçalves, Antonio C. *La symbolization politique: Le "prophétisme" Kongo au XVIIIième Siècle.* Munich: Weltforum Verlag, 1980.

Grandpré, Louis. *Voyage à la côte occidentale d'Afrique, fait dans les années 1786 et 1787, contenant la description des mœurs, usages, lois, gouvernement et commerce des états du Congo fréquentés par les Européens, et un précis de la traite des Noirs, ainsi qu'elle avait lieu avant la Révolution française.* Paris: Dentu, 1801.

Gundaker, Grey. "Creolization, *Nam*, Absent Loved Ones, Watchers, and Serious Play with 'Toys.'" In *Creolization as Cultural Creativity*, edited by Robert A. Baron and Ana C. Cara, 68–108. Jackson: University Press of Mississippi, 2011.

———. "At Home on the Other Side: African American Burials as Commemorative Landscapes." In *Death, Commemoration, Search for Identity, and Landscape Design*, edited by Joachim Wolschke-Bulmahn, 25–54. Washington, DC: Dumbarton Oaks Research Library and Collection, 2001.

———. "Tradition and Innovation in African American Yards." *African Arts* 26, no. 2 (1993): 58–71, 94, 96.

Gundaker, Grey, and Judith McWillie. *No Space Hidden: The Spirit of African American Yards.* Knoxville: University of Tennessee Press, 2005.

Güssfeldt, Paul. "Zur Kenntniss des Loango-Luz-Flusses." *Correspondenzblatt der Afrikanischen Gesellschaft* 1 (1874): 160–69.

Hair, P.E.H. "Sierra Leone Items in the Gullah Dialect of American English." *Sierra Leone Language Review* 4 (1965): 79–84.

Hall, Gwendolyn Midlo. *Slavery and African Ethnicities in the Americas: Restoring the Links.* Chapel Hill: University of North Carolina Press, 2007.

Hancock, I. F. "Review of *The Bantu Speaking Heritage of the United States* by Winifred Kellersberger Vass." *Research in African Literature* 12 (1981): 412–19.

Hanzal, Carla M., and José Bedia. *José Bedia: Rodeado de Mar*, edited by Sonya V. Harmon. Virginia Beach: Contemporary Art Center of Virginia, 2001.

Harmon, James, and Jessica Neuwirth. *Archaeological Investigations at the James Brice House (18AP38): A National Historic Site, 42 East Street, City of Annapolis, Anne Arundel County, Maryland. Technical report.* 2000. Available at http://hdl.handle.net/1903/11034.

Harris, Michael. "Resonance, Transformation, and Rhyme: The Art of Renée Stout." In *Astonishment and Power*, edited by Wyatt MacGaffey and Michael Harris, 107–56. Washington, DC: Smithsonian, 1993.

Hastings, Adrian. *The Church in Africa, 1450–1950.* Oxford: Clarendon Press, 1994.

Heimlich, Geoffroy. *Un Archéologue au Congo.* Web documentary produced by Le Monde.fr and ARTE Radio.com, n.d.

———. "Lower Congo Rock Art Revisited." *Nyame Akuma* 74 (2010): 42–50.

Hersak, Dunja. "New Spaces for Art and Artists in Africa." *African Arts* 42, no. 2 (2009): 1–4.

———. "There Are Many Kongo Worlds: Particularities of Magico-religious Beliefs among the Vili and Yombe of Congo-Brazzaville." *Africa* 71, no. 4 (2001): 614–40.

Herskovits, Melville J. *The Myth of the Negro Past.* Boston: Beacon Press, 1958.

Heusch, Luc de. "Kongo in Haiti: A New Approach to Religious Syncretism." *Man* 24, no. 2 (1989): 290–303.

Heywood, Linda. "Mbanza Kongo/São Salvador: Culture and the Transformation of an African City, 1491 to 1670s." In *Africa's Development in Historical Perspective*, edited by James Robinson, Nathan Nunn, Robert Bates, and Emmanuel Akyeampong. Cambridge University Press, forthcoming.

———. "Slavery and Its Transformation in the Kingdom of Kongo: 1491–1800." *Journal of African History* 50, no. 1 (2009): 1–22.

———, ed. *Central Africans and Cultural Transformations in the American Diaspora.* Cambridge: Cambridge University Press, 2002.

Heywood, Linda M., and John K. Thornton. *Central Africans, Atlantic Creoles, and the Foundation of the Americas, 1585–1660.* Cambridge: Cambridge University Press, 2007.

———. "Central African Leadership and the Appropriation of European Culture." In *The Atlantic World and Virginia, 1550–1624*, edited by Peter C. Mancall, 194–224. Chapel Hill: University of North Carolina Press, 1996.

———. "King Diogo of Kongo's Legal Inquest into Treason." In *Afro-Latino Voices: Narratives from the Early Modern Ibero-Atlantic World, 1550–1812*, edited by Kathryn Joy McKnight. Indianapolis, IN: Hackett, 2009.

Hilton, Anne. *The Kingdom of Kongo.* Oxford: Oxford University Press, 1985.

Hirschberg, Walter. *Monumenta ethnographica frühe völkerkundliche Bilddokumente. Band 1, Schwarzafrika.* Graz, Austria: Akademische Druk, 1962.

Hogg, Johnny. "Steven Bandoma's Struggle for Congolese Art." *BBC News* interview, September 13, 2012. Available at http://www.bbc.co.uk/news/world-africa-19593312.

Holloway, Joseph E. *Africanisms in American Culture.* Bloomington: Indiana University Press, 1991.

Holloway, Joseph E., and Winifred K. Vass. *The African Heritage of American English.* Bloomington: Indiana University Press, 1993.

Hudson, Larry E. *Working toward Freedom: Slave Society and Domestic Economy in the American South.* Rochester, NY: University of Rochester Press, 1994.

Hughes, Langston. "The Negro and the Racial Mountain." *The Nation* 122, no. 3181 (1926): 692–94.

Hulstaert, Gustaaf. *Dictionnaire lomongo–français.* Tervuren, Belgium: Musée Royal du Congo Belge, 1957.

Hyatt, Harry Middleton. *Hoodoo—Conjuration—Witchcraft—Rootwork, Beliefs Accepted by Many Negroes and White Persons.* New York: Alma Egan Hyatt Foundation, 1970.

Ibekwe, Patrick. *Wit and Wisdom of Africa: Proverbs from Africa and the Caribbean.* Trenton, NJ: Africa World Press, 1998.

Ives, Sallie M. "Black Community Development in Annapolis, Maryland, 1870–1885." *Geographical Perspectives on Maryland's Past* (1979): 129–49.

Jadin, Louis. *L'Ancien Congo et l'Angola, 1639–1655: d'après les archives romaines, portugaises, néerlandaises et espagnoles*, vol. 1. Brussels: Institut Historique Belge de Rome, 1975.

———. "Le Congo et la secte des Antoniens: restauration du royaume sous Pedro IV et la 'saint Antoine' congolaise (1694–1718)." *Bullétin de l'Institut Historique Belge de Rome* Fasc. XXXIII (1961).

———. "Recherches dans les archives et bibliothèques d'Italie et du Portugal sur l'Ancien Congo." *Bulletin des Séances de l'Académie Royal des Sciences Coloniales* 2, no. 6 (1956): 951–90.

Janzen, John. "Deep Thought: Structure and Intention in Kongo Prophetism, 1910–1921." *Social Research* 46 (1979): 106–39.

———. "Kongo Religious Renewal: Iconoclastic and Iconorthostic." *Canadian Journal of African Studies* 5, no. 2 (1971): 135–43.

———. "Laman's Kongo Ethnography: Observations on Sources, Methodology, and Theory." *Africa: Journal of the International African Institute* 42, no. 4 (1972): 316–28.

———. *Lemba, 1650–1930: A Drum of Affliction in Africa and the New World.* New York: Garland, 1982.

———. "Review of *Les Phemba du Mayombe.*" *African Arts* 11, no. 2 (1978): 88–89.

———. "Teaching the Kongo Transatlantic." *African Diaspora Archaeology Network*, Spring 2012, 11–12. Available at http://www.diaspora.uiuc.edu/news0312/news0312-4.pdf.

———. "Towards a History of Cultural Revitalization among the BaKongo: 1890–1925." M.A. thesis, University of Chicago, Department of Anthropology, 1964.

———. "The Tradition of Renewal in Kongo Religion." In *African Religions: A Symposium*, edited by Newell Booth, 69–114. New York: NOK, 1977.

Janzen, John M., and Reinhild Kauenhoven Janzen. "The Art of Lemba in Lower Zaire." *Iowa Studies in African Art* 3 (1990): 93–118.

Janzen, John M., and Wyatt MacGaffey. *An Anthology of Kongo Religion: Primary Texts from Lower Zaïre.* Lawrence: University of Kansas, 1974.

Jeannest, Charles. *Quatre années au Congo.* Paris: Charpentier et Cie, 1883.

Jerome, Paul. "Spirited Art from a Mystical Mind." *Flavour Magazine*, n.d.

Jewsiewicki, Bogumil, and V. Y. Mudimbe. *History Making in Africa.* Middletown, CT: Wesleyan University Press, 1993.

Johnston, Harry Hamilton. *George Grenfell and the Congo*, vol. 2. London: Hutchinson, 1908.

———. *The River Congo from Its Mouth to Bolobo.* London: Low, Marston, Searle, and Rivington, 1884.

Joseph, J. W. "'All of Cross'—African Potters, Marks, and Meanings of Folk Pottery in Edgefield District, South Carolina." In "Crosses to Bear: Cross Marks as African Symbols in Southern Pottery," thematic forum of articles edited by Charles R. Ewen. *Historical Archaeology* 45, no. 2 (2011): 134–55.

———. "One More Look into the Water—Colonoware in South Carolina Rivers and Charleston's Market Economy." *African Diaspora Archaeology Newsletter*, June 2007. Available at http://www.diaspora.uiuc.edu/news0607/news0607.html#2.

Keeler, Stuart. "Radcliffe Bailey at Solomon Projects." *Sculpture* 29, no. 9 (2010): 69.

Kirby, Percival Robson. *The Musical Instruments of the Native Races of South Africa.* Johannesburg, South Africa: Witwatersrand University Press, 1965.

Kirkwood, Meghan. "Kongo-Influenced Burial Practices in the African-American South." Unpublished paper, 2011.

Knight, Frederick. "Labor in the Slave Community." In *A Companion to African American History*, edited by Alton Hornsby, 159–76. Malden, MA: Blackwell, 2005.

Koelle, Sigismund Wilhelm. *Polyglotta Africana*, edited by P.E.H. Hair. Freetown, Sierra Leone: Fourah Bay College, University College of Sierra Leone, 1963.

Kolchin, Peter. *American Slavery: 1619–1877.* New York: Hill and Wang, 1993.

Kondile, Unathi. "First Encounter with Steve Bandoma." Available at http://stevebandoma.blogspot.com/2008/08/greatmores-interview.html (accessed June 10, 2013).

Kosuth, Joseph. *Art after Philosophy and After: Collected Writings, 1966–1990.* Cambridge, MA: MIT Press, 1991.

Kubik, Gerhard. *Muziek van de Humbi en de Handa uit Angola.* Tervuren, Belgium: Royal Museum for Central Africa, 1973.

Kuyk, Betty M. *African Voices in the African American Heritage.* Bloomington: Indiana University Press, 2003.

"La Ceramique: L'evolution de la Ceramique au Congo: (ch. 1) Les Industries Indigènes," Livre I, *Notes Analytiques sur les collections ethnographiques du Musee du Congo*, Tome II, Fasc. I. Brussels: Royal Museum for Central Africa, 1907.

Ladeiras, P. Daniel. "Notícia Sobre a Missão de S. Salvador Do Congo." *O Missionário Católico* 3, no. 30 (1927): 117–19.

LaGamma, Alisa. "The Recently Acquired Kongo Mangaaka Power Figure." *Metropolitan Museum Journal* 43 (2008).

Laman, Karl Edvard. *Dictionnaire Kikongo-Français: avec une étude phonétique decrivant les dialectes les plus importants de la langue dite Kikongo.* Brussels: Falk, 1936.

———. *The Kongo*, vols. I–IV. Uppsala, Sweden: Uppsala, 1953.

Landers, Jane. *Black Society in Spanish Florida.* Urbana: University of Illinois Press, 1999.

Latrobe, Henry B. *The Journal of Latrobe.* New York: Appleton, 1905.

———. *The Journals of Benjamin Latrobe*, edited by Edward Carter II, John C. Van Horne, and Lee W. Formwalt. New Haven, CT: Yale University Press, 1980.

Laurenty, Jean-Sébastien. *L'organologie du Zaïre. Tome IV: Les cordophones.* Tervuren, Belgium: Royal Museum for Central Africa, 1997.

Lehuard, Raoul. *Art Bakongo*, 4 vols. Arnouville, France: Arts d'Afrique Noire, 1989–98.

Leone, Mark P., Jocelyn E. Knauf, and Amanda Tang. "Ritual Bundle in Annapolis." In *Materialities, Meanings, and Modernities of Rituals in the Black Atlantic*, edited by Akin Ogundiran and Paula Saunders. N.d.

Lévi-Strauss, Claude. "The Culinary Triangle." In *Food and Culture: A Reader*, edited by Carole Counihan and Penny Van Esterik, 36–43. New York: Routledge, 2008.

Lewis, Herbert S. "Ethnology and African Culture History." In *Reconstructing African Culture History*, edited by Creighton Gabel and Norman R. Bennett, 27–44. Boston: Boston University Press, 1967.

Lewis, Thomas. "The Ancient Kingdom of Kongo: Its Present Position and Possibilities." *Geographical Journal* 19, no. 5 (May 1902): 541–58.

Lindfors, Bernth. *Africans on Stage: Studies in Ethnological Show Business.* Bloomington: Indiana University Press, 1999.

Long, Carolyn Morrow. *A New Orleans Voudou Priestess: The Legend and Reality of Marie Laveau.* Gainesville: University Press of Florida, 2006.

Lopes, Duarte, and Filippo Pigafetta. *Relatione del reame di Congo et delle circonvicine contrade.* Rome: Grassi, 1591.

MacGaffey, Wyatt. *Art and Healing of the Bakongo, Commented by Themselves: Minkisi from the Laman Collection.* Bloomington: Indiana University Press, 1991.

———. "Complexity, Astonishment and Power: The Visual Vocabulary of Kongo Minkisi." *Journal of Southern African Studies* 14, no. 2 (1988): 188–203.

———. *Custom and Government in the Lower Congo.* Berkeley: University of California Press, 1970.

———. "Economic and Social Dimensions of Kongo Slavery (Zaire)." In *Slavery in Africa: Historical and Anthropological Perspectives*, edited by Suzanne Miers and Igor Kopytoff. Madison: University of Wisconsin Press, 1977.

———. "The Eyes of Understanding: Kongo Minkisi." In *Astonishment and Power*, edited by Wyatt MacGaffey and Michael D. Harris, 21–103. Washington, DC: Smithsonian Institution Press, 1993.

———. "Fetishism Revisited: Kongo 'Nkisi' in Sociological Perspective." *Africa* 47, no. 2 (1977): 172–84.

———. *Kongo Political Culture: The Conceptual Challenge of the Particular.* Bloomington: Indiana University Press, 2000.

———. *Religion and Society in Central Africa: The Bakongo of Lower Zaire.* Chicago: University of Chicago Press, 1986.

———. "Substance and Smells in the Pursuit of Evil: A Kongo Figure (Nduda)." In *See the Music,*

Hear the Dance: Rethinking African Art at the Baltimore Museum of Art, edited by Frederick Lamp, 242–43. New York: Prestel, 2004.

MacGaffey, Wyatt, and Michael D. Harris, eds. *Astonishment and Power*. Washington: Smithsonian Institution Press, for the National Museum of African Art, 1993.

MacGaffey, Wyatt, and John M. Janzen. "Nkisi Figures of the Bakongo." *African Arts* 7 (1974): 87–89.

Maes, Joseph. *Fetischen of tooverbeelden uit Kongo*. Tervuren, Belgium: Musée du Congo Belge, 1935.

Mahaniah, Kimpianga. *L'impact du christianisme sur le Manianga, 1880–1980*. Kinshasa, DRC: Centre de Vulgarisation Agricole, 1981.

Manfoumbi, Mickala. *Lexique pove–français, français–pove*. Libreville, Gabon: Editions Raponda-Walker, 2004.

Maniacky, Jacky. "Thèmes régionaux Bantu et africanismes brésiliens." In *Proceedings of the Special World Congress of African Linguistics São Paulo 2008. Exploring the African Language Connection in the Americas*, edited by Margarida Petter and Ronald Beline Mendes, 153–65. São Paulo, Brazil: Humanitas, 2009.

Maquet-Tombu, Jeanne. "Madya: graveur de calebasses." *Brousse* no. 1 (1939): 8–9.

———. "Madya: graveur de calebasses." *Brousse* no. 2 (1939): 27–29.

Martin, Phyllis M. *The External Trade of the Loango Coast, 1576–1870: The Effects of Changing Commercial Relations on the Vili Kingdom of Loango*. Oxford: Clarendon Press, 1972.

Martinez-Ruiz, Barbaro. "Funerary Pots of the Kongo in Central Africa." In *African Terra Cotta: A Millenary Heritage*. Geneva: Musée Barbier Mueller Press, 2008.

———. "Kongo Atlantic Body Language." In *Performance, art et anthropologie (les actes)*. Available at http://actesbranly.revues.org/462.

———. "Kongo Ins-(ex)piration." Unpublished paper, 2013.

Mauer, Evan M. "Representations of Africa: Art of the Congo and American Museums in the Twentieth Century." In *Spirits Embodied: Art of the Congo*, edited by Evan M. Mauer and Niangi Batulukisi, 14–15. Minneapolis, MN: Minneapolis Institute of Arts, 1999.

McAlister, Elizabeth. "A Sorcerer's Bottle: The Visual Art of Magic in Haiti." In *Sacred Arts of Haitian Vodou*, edited by Donald J. Cosentino, 305–321. Los Angeles: UCLA Fowler Museum of Cultural History, 1995.

McNaughton, Patrick R. "Notes on the Usefulness of Form." In *The Power of Form: African Art from the Horstmann Collection*, edited by Ezio Bassani and Patrick R. McNaughton, 17–20. Milan, Italy: Skira, 2002.

Mel Fisher Maritime Heritage Society. "The Last Slave Ships," n.d. Available at http://www.melfisher.org/exhibitions.htm (accessed June 26, 2013). http://www.melfisher.org/exhibitions/lastslaveships/africancemetery/cemetery.pdf.

Merolla, Girolamo. *Breve e succinta relatione del viaggio nel regno di Congo nell'Africa meridionale*. Naples, Italy: Mollo, 1692.

Meurant, Georges, and Robert Farris Thompson. *Mbuti Design: Paintings by Pygmy Women of the Ituri Forest*. New York: Thames and Hudson, 1996.

Mintz, Sidney Wilfred, and Richard Price. *The Birth of African-American Culture: An Anthropological Perspective*. Boston: Beacon Press, 1992.

Mirzoeff, Nicholas. *An Introduction to Visual Culture*. New York: Routledge, 2009.

"Mission du Congo. Cté de St. Jacques de Landana. Nov. 1875–Juin 1879." *Bulletins Généraux de la Congrégation du Saint-Esprit*, 1877–1881, 458–502.

Montandon, Georges. *La généalogie des instruments de musique et les cycles de civilisation: étude suivie du catalogue des instruments de musique du Musée ethnographique de Genève*. Geneva: Kundig, 1919.

Monteiro, Joachim John. *Angola and the River Congo*, vol. 2, 1875. London: Cass, 1968.

Montgomery, Charles J. "Survivors of the Cargo of the Negro Slave Yacht *Wanderer*." *American Anthropologist* 10, no. 4 (1908): 611–23.

Moraga, Vanessa Drake. *Weaving Abstraction: Kuba Textiles and the Woven Art of Central Africa.* Washington, D.C.: Textile Museum, 2011.

Morgan, Phillip D. *Slave Counterpoint: Black Culture in the Eighteenth-Century Chesapeake and Lowcountry.* Chapel Hill: University of North Carolina Press, 1998.

Mudimbe, V. Y., and Bogumil Jewsiewicki. *History Making in Africa.* Middletown, CT: Wesleyan University Press, 1993.

Mufwene, Salikoko S. "The Linguistic Significance of African Proper Names in Gullah." *New West Indian Guide* 59, no. 3–4 (1985): 149–66.

Mufwene, Salikoko, and Charles Gilman. "How African Is Gullah, and Why?" *American Speech* 62 (1987): 120–39.

Mufwene, Salikoko S., and Nancy Condon. *Africanisms in Afro-American Language Varieties.* Athens: University of Georgia Press, 1993.

Muzenga, J. G. Kamba. *Substitutifs et possessifs en bantou.* Leuven, Belgium: Peeters, 2003.

Nassau, Robert H. *Fetishism in West Africa: Forty Years' Observation of Native Customs and Superstitions.* New York: Scribner, 1904.

———. *My Ogowe.* New York: Neale, 1914.

National Research Council. *Lost Crops of Africa. Volume II: Vegetables.* Washington, DC: National Academies Press, 2006.

Ngoma, Ferdinand. "L'initiation Bakongo et sa signification." Paris: University of Paris, 1963.

Nora, Pierre. "Between Memory and History: Les Lieux de Mémoire." *Representations*, no. 26 (1989): 7–24.

Nsondé, Jean de Dieu. *Langues, culture et histoire Kongo aux XVIIe et XVIIIe siècles: à travers les documents linguistiques.* Paris: Harmattan, 1995.

Obenga, Théophile. "Traditions et coutumes alimentaires kongo au xviie siecle." *Muntu: revue scientifique et culturelle du CICIBA Muntu*, no. 3 (1985): 17–40.

Ochoa, Todd Ramón. *Society of the Dead: Quita Manaquita and Palo Praise in Cuba.* Berkeley: University of California Press, 2010.

Pasch, Helma. *Linguistische Aspekte der Verbreitunglateinamerikanischer Nutzpflanzen in Afrika.* Magisterarbeit, Germany: Universitat zu Köln, 1980.

Patton, Sharon F. *African-American Art.* New York: Oxford University Press, 1998.

Peffer, John. "Notes on African Art, History, and Diasporas Within." *African Arts* 38, no. 4 (2005): 70–77, 95–96.

Piersen, William Dillon. *Black Legacy: America's Hidden Heritage.* Amherst: University of Massachusetts Press, 1993.

Pinto, Francisco Antonio. *Angola e Congo.* Lisbon, Portugal: Livraria Ferreira, 1888.

Praetorius, Michael. *Syntagma Musicum*, vol. 2. Wolfenbüttel, Germany: Wittebergae, 1619.

Proyart, Liévin-Bonaventure. *Histoire de Loango, Kakongo et autres royaumes d'Afrique.* Paris: Berton et Crapart, 1776.

Publication of the Commission pour la Protection des Arts et Métiers Indigenes, 15. Belgian Colonial Office, 1936.

Puleston, Fred. *African Drums.* New York: Farrar and Rinehart, 1930.

Radulet, Carmen M. *O cronista Rui de Pina e a "Relação do Reino do Congo": manuscrito inédito do "Códice Riccardiano 1910."* Lisbon, Portugal: Comissão Nacional para as Comemorações dos Descobrimentos Portugueses: Imprensa Nacional—Casa da Moeda, 1992.

Restall, Matthew. "Garrido, Juan." *Encyclopedia of African-American Culture and History*, 2nd ed., vol. 3, edited by Colin A. Palmer, 901–2. Detroit, MI: Macmillan Reference USA, 2006. *Gale Virtual Reference Library*. Web.

Rey, Terry, and Karen Richman. "The Somatics of Syncretism: Tying Body and Soul in Haitian Religion." *Studies in Religion* 39, no. 3 (2010): 379–403.

Rooks, Michael. "Beauty and Purpose in the Art of Radcliffe Bailey." In *Radcliffe Bailey: Memory as Medicine*, edited by Carol Thompson, 119–34. New York: Prestel, 2011.

Rosengarten, Dale. "By the Rivers of Babylon: The Lowcountry Basket in Slavery and Freedom." In *Grass Roots: African Origins of an American Art*, edited by Dale Rosengarten, Theodore Rosengarten, and Enid Schildkrout, 104–21. New York: Museum for African Art, 2008.

———. "Social Origins of the African American Lowcountry Basket." PhD dissertation, Harvard University, 1997.

Rosengarten, Dale, Theodore Rosengarten, and Enid Schildkrout, eds. *Grass Roots: African Origins of an American Art*. New York: Museum for African Art, 2008.

Rucker, Walter. *The River Flows On: Black Resistance, Culture, and Identity Formation in Early America*. Baton Rouge: Louisiana State University Press, 2006.

Ruppel, Timothy, Jessica Neuwirth, Mark P. Leone, and Gladys-Marie Fry. "Hidden in View: African Spiritual Spaces in North American Landscapes." *Antiquity: A Quarterly Review of Archaeology* 77, no. 296 (2003): 321–35.

Sallée, Pierre. *Deux études sur la musique du Gabon.* Paris: ORSTOM, 1978.

Sautter, Gilles. *De l'Atlantique au fleuve Congo: une geographie du sous-peuplement.* Paris: Mouton, 1966.

Schaeffner, André. *Origine des instruments de musique.* Paris: Payot, 1936.

Schildkrout, Enid, and Curtis A. Keim. "Objects and Agendas: Re-Collecting the Congo." In *The Scramble for Art in Central Africa*, edited by Enid Schildkrout and Curtis A. Keim, 1–36. London: Cambridge University Press, 1998.

Schildkrout, Enid, and Dale Rosengarten. "African Origins: Ancestors and Analogues." In *Grass Roots: African Origins of an American Art*, edited by Dale Rosengarten, Theodore Rosengarten, and Enid Schildkrout, 20–77. New York: Museum for African Art, 2008.

Schmidt, Benjamin. "Geography Unbound: Boundaries and the Exotic World in the Enlightenment." In *Boundaries and Their Meanings in the History of the Netherlands*, edited by Benjamin Jacob Kaplan, Mary Beth Carlson, and Laura Cruz, 35–61. Boston: Brill, 2009.

Schuler, Vic. *British Toby Jugs.* London: Kevin Francis, 1987.

Scott, David. *Refashioning Futures: Criticism after Postcoloniality.* Princeton, NJ: Princeton University Press, 1999.

Scott, Dennis. *Uncle Time.* London: Timbale Prints, 1971.

Shepperson, George. Introduction to *The Negro in the New World*, v–xi. 1910. New York: Johnson Reprint, 1969.

Sims, Lowery Stokes. "Individuality and Tradition: A Conversation with Three Contemporary Artists." *African Arts* 32, no. 1 (1999): 36–39, 93.

———. "Introduction." In Robert F. Thompson, *Aesthetic of the Cool*, vii–xvi. Pittsburgh, PA: Periscope, 2011.

Sinda, Martial. *Le messianisme congolais et ses incidences politiques; kimbanguisme, matsouanisme, autres mouvements.* Paris: Payot, 1972.

Sjöholm, Wilh, and Jakob Emanuel Lundahl. *Dagbräckning i Kongo: illustrerade skildringar av Kongomissionärer.* Stockholm, Sweden: Svenska Missionsförbundets Expedition, 1911.

Smith, Andrew F. *Peanuts: The Illustrious History of the Goober Pea.* Urbana: University of Illinois Press, 2002.

Söderberg, Bertil. *Les instruments de musique au Bas-Congo et dans les régions avoisinantes: étude ethnographique.* Stockholm, Sweden: Statens Etnografiska Museum, 1956.

Stanley, Henry M. *The Congo and the Founding of Its Free State: A Story of Work and Exploration*, vol. 1. London: Sampson Low, Marston, Searle, & Rivington, 1885.

———. Lecture flyers, June 1891 (British tour), December 1891 (Sydney) . . . , King Baudouin Foundation/Royal Museum for Central Africa, Stanley Archives, Inv. 5089; Lanternslides Collection, Royal Museum for Central Africa, Tervuren, Belgium, Inv. 6995.

———. Lectures Route in the United States, 1890–1891. King Baudouin Foundation/Royal Museum for Central Africa, Stanley Archives, Inv. 5086.

———. *Through the Dark Continent: or, The Sources of the Nile Around the Great Lakes of Equatorial Africa, and Down the Livingstone River to the Atlantic Ocean.* New York: Harper, 1878.

Starr, Frederick. *Congo Natives: An Ethnographic Album.* Chicago: Lakeside Press, 1912

"Steve Bandoma: New Work from Kinshasa on View at Jack Bell Gallery in London." *ArtDaily.org*, August 12, 2012. Available at http://www.artdaily.org/index.asp?int_sec=2&int_new=57065.

"Steve Bandoma the First Young Black Artist at NIROX Foundation." Available at http://steve bandoma.blogspot.com/2011/05/steve-bandoma-is-congolese-performance.html.

Stiles, Kristine, and Piter Selz, eds. *Theories and Documents of Contemporary Art: A Sourcebook of Artists' Writings.* Berkeley: University of California Press, 1996.

Stuckey, Sterling. "Through the Prism of Folklore: The Black Ethos in Slavery." *The Massachusetts Review* 9, no. 3 (1968): 417–37.

Swadesh, Morris. "Review of *Africanisms in the Gullah Dialect* (Turner 1949)." *Word* 7, no. 1 (1951): 82–84.

Szwed, John. "Vibrational Affinities." In *Keep Your Head to the Sky: Interpreting African American Home Ground*, edited by Grey Gundaker and Tynes Cowan, 25–36. Charlottesville: University Press of Virginia, 1998.

Thompson, Carol, with René Paul Barilleaux, Manthia Diawara, Michael Rooks, and Edward S. Spriggs. *Radcliffe Bailey: Memory as Medicine.* New York: Prestel, 2011.

Thompson, Robert Farris. "African Influence on the Art of the United States." In *Afro-American Folk Art and Crafts*, edited by William R. Ferris, 27–66. Boston: Hall, 1983.

———. "African Influence on the Art of the United States." In *Black Studies in the University*, edited by Armstead Robinson, 122–70. New Haven, CT: Yale University Press, 1969.

———. "Big-Hearted Power: Kongo Presence in the Landscape and Art of Black America." In *Keep Your Head to the Sky: Interpreting African American Home Ground*, edited by Grey Gundaker and Tynes Cowan, 37–65. Charlottesville, Virginia: University Press of Virginia, 1998.

———. "The Circle and the Branch: Renascent Kongo-American Art." In *Another Face of the Diamond*, edited by Judith McWillie and Inverna Lockpez, 23–59. New York: INTAR Latin American Gallery, 1988.

———. *Face of the Gods: Art and Altars of Africa and the African Americas.* New York: Museum for African Art, 1993.

———. *Flash of the Spirit: African and Afro-American Art and Philosophy.* New York: Vintage, 1984.

———. "La gestuelle kôngo." In *Le Geste kôngo*, 23–129. Paris: Editions Dapper, 2002.

———. "Illuminating Spirits: 'Astonishment and Power' at the National Museum of African Art." *African Arts* 26, no. 4 (1993): 60–69.

———. "Kongo Carolina, Kongo New Orleans: A Transatlantic Art Tradition." Video lecture, Mary Schiller Myers School of Art, 2007. Available at http://art.uakron.edu/visiting-artists/kongo-carolina-kongo-new-orleans-a-transatlanti/.

———. "The Song That Named the Land: The Visionary Presence of African-American Art." In *Black Art: Ancestral Legacy, the African Impulse in African American Art*, edited by Alvia Wardlaw, Robert V. Rozelle, Tom Jenkins, and David C. Driskell, 97–141. Dallas, TX: Dallas Museum of Art, 1989.

Thompson, Robert Farris, and Joseph Cornet. *The Four Moments of the Sun: Kongo Art in Two Worlds.* Washington, DC: National Gallery of Art, 1981.

Thornton, John K. *Africa and Africans in the Making of the Atlantic World, 1400–1800.* Cambridge: Cambridge University Press, 1998.

———. "African Dimensions of the Stono Rebellion." *American Historical Review* 96, no. 4 (1991): 1101–13.

———. "The African Experience of the '20. and Odd Negroes' Arriving in Virginia in 1619." *William and Mary Quarterly* 55, no. 3 (1998): 421–34.

———. "As Guerras Civis No Congo e o Tráfico De Escravos: A História e a Demografia de 1718 a 1844 Revisitadas." *Estudos Afro-Asiaticos (Rio de Janeiro)* 32 (1997): 55–74.

———. "Cavazzi, Missione Angelica, The Araldi Manuscripts." Available at http://www.bu.edu/afam/faculty/john-thornton/cavazzi-missione-evangelica-2/ (accessed June 19, 2013).

———. "The Development of an African Catholic Church in the Kingdom of Kongo, 1491–1750." *Journal of African History* 25 (1984): 147–67.

———. *The Kongolese Saint Anthony: Dona Beatriz Kimpa Vita and the Antonian Movement, 1684–1706*. Cambridge: Cambridge University Press, 1998.

———. "'I Am the Subject of the King of Congo': African Political Ideology and the Haitian Revolution." *Journal of World History* 4, no. 2 (1993): 181–214.

———. *The Kingdom of Kongo: Civil War and Transition, 1641–1718*. Madison: University of Wisconsin Press, 1983.

———. "Master or Dupe? The Reign of Pedro V of Kongo." *Portuguese Studies Review* 19, no. 1–2 (2011): 115–32.

———. "Mbanza Kongo/São Salvador: Kongo's Holy City." In *Africa's Urban Past*, edited by David Anderson and Richard Rathbone, 67–84. London: Currey and Heinemann, 2000.

———. "The Origins and Early History of the Kingdom of Kongo, ca. 1350–1550." *International Journal of African Historical Studies* 34, no. 1 (2001): 89–120.

———. "The Regalia of the Kingdom of Kongo, 1491–1895." In *Kings of Africa: Art and Authority in Central Africa*, edited by Erna Beumers and Hans-Joachim Koloss, 56–63. Maastricht, The Netherlands: Foundation Kings of Africa, 1992.

———. "Religious and Ceremonial Life in the Kongo and Mbundu Areas, 1500–1700." In *Central Africans and Cultural Transformations in the American Diaspora*, edited by Linda M. Heywood, 71–90. Cambridge: Cambridge University Press, 2002.

Tourneur, Victor. "Médailles Religieuses du XVIIIe Siècle, Trouvées au Congo." *Revue Belge de Numismatique et de Sigillographie* 91 (1940): 21–26.

Turner, Lorenzo Dow. *Africanisms in the Gullah Dialect*. 1949. New York: Arno Press, 1969.

Van Bockhaven, Vicky. *Collections of the RMCA: Headdresses*. Tervuren, Belgium: Royal Museum for Central Africa, 2006.

Van der Veen, Lolke J., and Sébastien Bodinga-bwa-Bodinga. *Gedandedi sa geviya, dictionnaire geviya-français*. Sterling, VA: Peeters, 2002.

van Gheel, Joris Willems. *Vocabularium Latinum, Hispanicum, e Congense* (handwritten by Joris Willems van Gheel). Biblioteca Nazionale Centrale di Roma, 1652.

Vanhee, Hein. "Agents of Order and Disorder: Kongo Minkisi." In *Re-visions: New Perspectives on the African Collections of the Horniman Museum*, edited by Karel Arnaut, 89–106. London: Horniman Museum and Gardens, 2001.

———. "Central African Popular Christianity and the Making of Haitian Vodou Religion." In *Central Africans and Cultural Transformation in the American Diaspora*, edited by Linda M. Heywood, 243–64. Cambridge: Cambridge University Press, 2002.

———. "Maîtres et Serviteurs: Les Chefs Médaillés dans le Congo Colonial." In *La Mémoire du Congo: Le Temps Colonial*, edited by J. L. Vellut, 79–82. Tervuren, Belgium: Royal Museum for Central Africa, 2005.

Vansina, Jan. *Kingdoms of the Savanna*. Madison: University of Wisconsin Press, 1966.

———. *Paths in the Rainforests: Toward a History of Political Tradition in Equatorial Africa*. Madison: University of Wisconsin Press, 1990.

Van Wing, Joseph. *Études Bakongo; sociologie, religion et magie*. Bruges, Belgium: Desclée de Brouwer, 1959.

———. *Études Bakongo. Vol. I: Histoire et sociologie*. Brussels: Goemaere, 1920.

———. *Études Bakongo. Vol. II: Religion et magie*. Brussels: van Campenhout, 1938.

Van Wing, Joseph, and Constant Penders, eds. *Le plus ancien dictionnaire bantu. Vocabularium P. Georgii Gelensis*. Leuven, Belgium: Kuyl-Otto, 1928.

Vass, Winifred K. *The Bantu Speaking Heritage of the United States*. Los Angeles: Center for Afro-American Studies, University of California, 1979.

Verswijver, Gustaaf, Viviane Baeke, Els De Palmenaer, and Anne-Marie Bouttiaux-Ndiaye, eds. *Masterpieces from Central Africa.* New York: Prestel, 1996.

Visona, Monica Blackmum. "Agent Provocateur? The African Origin Provenance and American Life of a Statue from Côte d'Ivoire." *Art Bulletin* 94, no. 1 (2012): 99–129.

Vlach, John M. *The Afro-American Tradition in Decorative Arts.* Athens: University of Georgia Press, 1990.

Vlach, John Michael. *By the Work of Their Hands: Studies in Afro-American Folklife.* Charlottesville: University Press of Virginia, 1991.

———. "Roots and Branches: Historical Patterns in African Diasporan Artifacts." In *African Roots/ American Cultures: Africa in the Creation of the Americas,* edited by Sheila S. Walker, 183–205. Oxford: Rowman and Littlefield, 2001.

Vogel, Susan Mullin. *Africa Explores: 20th-Century African Art.* New York: Prestel-Verlag, 1991.

———. *Closeup: Lessons in the Art of Seeing African Sculpture from an American Collection and the Horstmann Collection.* New York: Center for African Art, 1990.

Volavka, Zdenka. "Voania Muba: Contributions to the History of Central African Pottery." *African Arts* 10 (1977): 59–66.

Vos, Jelmer. "Child Slaves and Freemen at the Spiritan Mission in Soyo, 1880–1885." *Journal of Family History* 35, no. 1 (2010): 71–90.

———. "Forced Labour and the Fall of the King of Kongo (1912–1913)." In *Trabalho Forçado Africano: Articulações Com o Poder Politico,* edited by CEAUP. Porto, Portugal: Campo das Letras, 2007.

———. "Kongo and the Coastal States of West Central Africa." In *Oxford Bibliographies Online: African Studies.* Available at http://www.oxfordbibliographies.com/view/document/obo-9780199846733/obo-9780199846733-0052.xml (accessed June 10, 2013).

———. "Of Stocks and Barter: John Holt and the Kongo Rubber Trade, 1906–1910." *Portuguese Studies Review* 19, no. 1–2 (2011): 153–75.

———. "'Without the Slave Trade No Recruitment': From Slave Trading to 'Migrant Recruitment' in the Lower Congo, 1830–1890." In *Trafficking in Slavery's Wake: Law and the Experience of Women and Children,* edited by Benjamin N. Lawrance and Richard L. Roberts, 45–64. Athens: Ohio University Press, 2012.

Voyages: The Trans-Atlantic Slave Trade Database. http://www.slavevoyages.org.

Wade-Lewis, Margaret. "The Status of Semantic Items from African Languages in American English." *Black Scholar* 23, no. 26 (1993): 26–36.

Wald, Benji. "Review of *The African Heritage of American English* by Joseph E. Holloway; Winifred K. Vass." *Man* 29, no. 3 (1994): 755–56.

Walker, Sheila S., ed. *African Roots/American Cultures: Africa in the Creation of the Americas.* Lanham, MD: Rowman and Littlefield, 2001.

Walsh, R. *Notices of Brazil in 1828 and 1829.* London: Westley and Davis, 1830.

Wannyn, Robert L. "Les armes iberiques et autres du Bas-Congo." *La Revue Coloniale Belge* 6, no. 137 (1951): 428–30.

———. *L'art ancien du métal au Bas-Congo.* Champles, Belgium: Éd. du Vieux Planquesaule, 1961.

———. "Objets anciens en métal du Bas-Congo." *Zaïre* 5, no. 4 (1951): 391–93.

Weeks, John H. *Among the Primitive Bakongo: A Record of Thirty Years' Close Intercourse with the Bakongo and Other Tribes of Equatorial Africa, with a Description of Their Habits, Customs and Religious Beliefs.* 1914. New York: Negro Universities Press, 1969.

Willey, Paula. "An Annotated Bibliography." 1999. *American Museum Congo Expedition 1909–1915,* American Museum of Natural History, available at http://diglib1.amnh.org/resources/annot_bibliography/bib_politics.html.

Williams, Eric Eustace. *Capitalism and Slavery.* 1944. Chapel Hill: University of North Carolina Press, 1994.

Woodhouse, Charles Platten. *Old English Toby Jugs and Their Makers.* London: Mountrose Press, 1949.

Young, Amy L. "Risk Management Strategies among African-American Slaves at Locust Grove Plantation." *International Journal of Historical Archaeology* 1 (1997): 5–37.

Young, Jason R. *Rituals of Resistance: African Atlantic Religion in Kongo and the Lowcountry South in the Era of Slavery.* Baton Rouge: Louisiana State University Press, 2007.

Young, Kate Porter. "Mary Jane Manigault: Basket Maker's Legacy." In *South Carolina Women: Their Lives and Times,* vol. 3, edited by Marjorie Julian Spruill, Valinda W. Littlefield, and Joan Marie Johnson, 307–21. Athens: University of Georgia Press, 2012.

Younger, Karen Fisher. "Liberia and the Last Slave Ships." *Civil War History* 54, no. 4 (2008): 424–42.

Contributors

Judith Bettelheim is an art historian whose work addresses Africa and African-related work in the Caribbean. After her retirement as an art historian from San Francisco State University, she has continued to teach as an adjunct at UCLA and curate as an independent scholar. Her publications include Judith Bettelheim and Janet Catherine Berlo, *Transcultural Pilgrim: Three Decades of Work by Jose Bedia*, University of Washington Press, 2012; *AfroCuba: Works on Paper*, 1968–2003.

Nichole N. Bridges is an art historian who works as an independent scholar. Her publications include "Loango Coast Ivories and the Legacies of Afro-Portuguese Arts," in Gitti Salami and Monica Visona, eds., *A Companion to Modern African Art*, Wiley Blackwell, forthcoming 2013, and "Novel Souvenirs: Loango Coast Ivory Sculptures," in Marc Felix, *White Gold, Black Hands, Ivory Sculpture in Congo Ivories*, Vol. 1, Brussels: Tribal Arts, SPRIL, 2010.

Kellim Brown is an independent scholar of art history who currently resides in Brussels. In addition to his studies on African American yard art, he has carried out extensive fieldwork in the Democratic Republic of Congo. His publications include "TransAtlantic Kongo: Echoes of the Cosmogram" in *Kongo Kingdom Art: From Ritual to Cutting Edge*, National Museum of China, Beijing, 2004.

Matthew Cochran is a doctoral student in anthropology at the University of Maryland, College Park.

Susan Cooksey is curator of African Art at the Samuel P. Harn Museum of Art, University of Florida. She has curated a number of original exhibitions on African, Oceanic and Ancient American art. Her recent publications include *Africa Interweave: Textile Diasporas*, Harn Museum of Art, 2011, and "Double Images in Win Divination and the Negotiation of Spirit-Human Identities," in Philip M. Peek, ed., *Twins in African and Diaspora Cultures*, Indiana University Press, 2011.

Donald Cosentino is professor emeritus of world arts and cultures at UCLA. Cosentino has done extensive fieldwork on African and diasporic cultures in Nigeria, Sierra Leone and Haiti. He has a number of publications including *The Sacred Arts of Haitian Vodou*, Fowler Museum, UCLA, 1995/1998, and *Divine Revolution: The Art of Edouard Duval-Carrié*, Fowler Museum, UCLA, 2004.

Kathryn Deeley is a doctoral student in anthropology at the University of Maryland, College Park. She is a co–laboratory director of the Archaeology in Annapolis Laboratory in College Park, Maryland, and an associate director of the Archaeology in Annapolis summer Field School in Urban Archaeology.

Freddi Williams Evans is an independent scholar who currently resides in New Orleans. Her research examines the history and legacy of the Diaspora in New Orleans. Her publications include

Congo Square: African Roots in New Orleans, University of Louisiana at Lafayette Press, 2011, and "New Orleans' Congo Square: A Cultural Landmark" in *Ancestors of Congo Square: African Art in the New Orleans Museum of Art*, New Orleans Museum of Art in association with SCALA, 2011.

Christopher Fennell is archaeologist and associate professor in anthropology and African American studies at the University of Illinois. He focuses on archaeology of the African Diaspora and, in addition to teaching and fieldwork, he is the editor of the *Journal of African Diaspora Archaeology and Heritage.* His publications include *Crossroads and Cosmologies: Diasporas and Ethnogenesis in the New World*, University Press of Florida, 2007.

Carlee Forbes is a doctoral student in African art history at the University of Florida. Her master's thesis research focused on the geometric and figurative imagery on Kongo raffia textiles and mats. She worked as a curatorial and editorial assistant for the *Kongo across the Waters* publication and exhibition.

Cécile Fromont is assistant professor of art history at the University of Chicago. Her publications include "Collecting and Translating Knowledge across Cultures: Capuchin Missionary Images of Early Modern Central Africa," in Daniela Bleichmar and Peter C. Mancall, *Collecting across Cultures: Material Exchanges in the Early Modern Atlantic World*, University of Pennsylvania Press, 2011.

Grey Gundaker is professor of American studies and anthropology at the College of William and Mary, and the Duane A. and Virginia S. Dittman Chair in American Studies and Anthropology at the College of William and Mary. Her work focuses on African American sacred spaces in the context of yards and gravesites. Her publications include *No Space Hidden: The Spirit of African American Yards* (with Judith McWillie as co-author), University of Tennessee Press, 2005, and *Signs of Diaspora/Diaspora of Signs: Creolization, Literacy, and Vernacular Practice in African America*, Oxford University Press, 1998.

Michael D. Harris is an artist and associate professor of art history in the Department of African American Studies at Emory University. His publications include *Colored Pictures: Race and Visual Representation*, University of North Carolina Press, 2003. He was co-author, with Herbert M. Cole, Robin Poynor, and Monica Blackmun Visona, of *A History of Art in Africa*, Abrams, 2000, and editor and essayist for *TransAtlantic Dialogues: Contemporary Art In and Out of Africa*, Ackland Museum, 1999.

John Geoffroy Heimlich is a doctoral student in archaeology at the Free University of Brussels and the University of Paris I. His recent research focuses on Lower Congo rock art, based on his field research in the Democratic Republic of Congo. He is currently completing his dissertation, titled *The Rock Art of the Lovo Massif.*

Linda Heywood is director of the African American Studies Program and a professor of history at Boston University. Her publications include *Diáspora Negra No Brasil*, Editora Contexto, 2008; *Central Africans, Atlantic Creoles and the Foundation of the Americas, 1585–1660* (with John Thornton), Cambridge University Press, 2007; and *Central Africans and Cultural Transformations in the American Diaspora* (editor), Cambridge University Press, 2002.

Rémy Jadinon is assistant curator at the Division of Ethnomusicology of the Royal Museum for Central Africa. He is concurrently conducting doctoral research on repertoires of secular music of the *ngombi* harp of the Tsogo from the southern Gabon. He has published on the musical instruments and traditions of the Kwango, Upper-Uele and Maniema regions of the DRC, and on the *ngombi* harp in particular.

John Janzen is professor of anthropology at the University of Kansas. He is the author of *Lemba, 1650–1930: A Drum of Affliction in Africa and the New World*, Garland, 1982, and of *Ngoma Discourses of Healing in Central and Southern Africa*, University of California Press, 1992, as well as of many articles on Kongo art and religion and on medical anthropology.

Mathilde Leduc-Grimaldi is curator of the Henry M. Stanley Archives at the Royal Museum for Central Africa. Her publications include *Images from Africa: Mr. Stanley, I Presume*, King Baudouin Foundation, 2007, a work that accompanied the exhibition "Mr. Stanley's Beautiful Pictures" held at the Musée de la Photographie, Charleroi, Belgium, January–April, 2007.

Mark Leone is professor of anthropology at the University of Maryland. His publications include *The Archaeology of Liberty in an American Capital: Excavations in Annapolis*, University of California Press, 2005; and *Critical Historical Archaeology*, Left Coast Press, 2010.

Wyatt MacGaffey is professor emeritus of social anthropology at Haverford College. Among his publications are *Religion and Society in Central Africa: The BaKongo of Lower Zaire*, University of Chicago Press, 1986; *Art and Healing of the BaKongo, Commented by Themselves*, Indiana University Press, 1991; *Astonishment and Power* (exhibition catalogue, with Michael D. Harris), Smithsonian Institution, 1993; and *Kongo Political Culture*, Indiana University Press, 2000.

Jacky Maniacky is head of the Division of Linguistics of the Royal Museum for Central Africa. His recent research has expanded to examine the African linguistic legacy in the Americas. His publications include *Studies in African Comparative Linguistics with Special Focus on Bantu and Mande* (co-editor with Koen Bostoen), Royal Museum for Central Africa, Human Sciences Collection no. 1, 2005.

Robin Poynor teaches the arts of Africa and of Oceania in the School of Art and Art History at the University of Florida. He is the author of *African Art at the Harn Museum: Spirit Eyes, Human Hands*, University Press of Florida, 1995, and co-author (with Monica Blackmun Visona and Herbert M. Cole) of *A History of Art in Africa*, Abrams, 2000 (revised 2008 edition by Pearson Education and Prentice Hall). His current book project is *Africa in Florida: 500 Years of African Presence in the Sunshine State*, co-edited with Amanda Carlson (forthcoming, University Press of Florida, 2013).

Birgit Ricquier is a research assistant at the Division of Linguistics of the Royal Museum for Central Africa. Her research focuses on Bantu culinary vocabulary and the history of starch food preparations. Her publications include "Central Africa," in Ken Albala, ed., *Food Cultures of the World Encyclopedia*, Vol. 1: *Africa and the Middle East* (31–41), Greenwood Press, 2011, and "Stirring Up the Porridge: How Early Bantu Speakers Prepared Their Cereals" (with Koen Bostoen), in Ahmed G. Fahmy, Stefanie Kahlheber and A. Catherine D'Andrea, eds., *Windows on the African Past: Current Approaches to African Archaeobotany*, Africa Magna Verlag, 2011.

Dale Rosengarten is historian and curator of Special Collections, College of Charleston Library. Her work examining basketry traditions in the American South and in Africa resulted in a major exhibition and accompanying publication, *Grass Roots: African Origins of an American Art*, Museum of African Art, 2008. Other publications include *Row upon Row: Sea Grass Baskets of the South Carolina Lowcountry*, McKissick Museum, University of South Carolina, 1986.

Carol Thompson is the Fred and Rita Richman Curator of African Art at the High Museum of Art, Atlanta. Her recent exhibition on the work of Radcliffe Bailey, *Memory as Medicine*, is traveling throughout the United States. Her publications include *Radcliffe Bailey: Memory as Medicine* (with René Paul Barilleaux, Manthia Diawara, Michael Rooks, and Edward S. Spriggs), Prestel, 2011.

John Thornton is professor of history in the Department of History and African American Studies Program at Boston University. Among his publications are *Central Africans, Atlantic Creoles, and the Foundation of the Americas, 1585–1660* (with Linda Heywood), Cambridge University Press, 2007, and *A Cultural History of the Atlantic World, 1350–1830*, Cambridge University Press, 2012.

Hein Vanhee works as curator at the Royal Museum for Central Africa in Tervuren in Belgium. Over the past six years he has developed the division of Collection Management within the department of Anthropology and History. He has published articles on Kongo history, Kongo art, colonial history, colonial literature and collection management.

Julien Volper is curator at the Division of Ethnography of the Royal Museum for Central Africa. He has assisted in the creation of many exhibitions and accompanying publications for the RMCA. His publications include *Ora pro nobis: étude sur les crucifix Bakongo*.

Jelmer Vos is assistant professor of history at Old Dominion University. He has contributed to *Voyages: The Trans-Atlantic Slave Trade Database* (http://www.slavevoyages.org). His publications include "'Without the Slave Trade No Recruitment': From Slave Trading to 'Migrant Recruitment' in the Lower Congo, 1830–1890," in Benjamin N. Lawrance and Richard L. Roberts, eds., *Trafficking in Slavery's Wake: Law and the Experience of Women and Children*, Ohio University Press, 2012, and "The Dutch in the Atlantic World: New Perspectives from the Slave Trade with Particular Reference to the African Origins of the Traffic," with David Eltis and David Richardson, in David Eltis and David Richardson, eds., *Extending the Frontiers: Essays on the New Transatlantic Slave Trade Database*, Yale University Press, 2008.

Stefan Woehlke is a doctoral student in the anthropology department at the University of Maryland, College Park. His research focuses on the African Diaspora, which he explores through sites located in Virginia and Maryland.

Jason Young is associate professor of history and Director of Graduate Studies at the University of Buffalo, SUNY. His publications include *Rituals of Resistance: African Atlantic Religion in Kongo and the Lowcountry South in the Era of Slavery*, Louisiana State University Press, 2007; "Between the Crescent and the Cross: W.E.B. Du Bois on Christianity and Islam," in Jason Young and Edward Blum, eds., *The Souls of W.E.B. Du Bois: New Essays and Reflections* (211–32), Mercer University Press, 2009; and "Clamoring at the Gates of Canaan: W.E.B. Du Bois, Frederick Douglass and the Origins of the Niagara Movement," in Sheila Martin and Wanda Davis, eds., *What Price Freedom? The Niagara Movement in Historical and Contemporary Thought, 1905–2005*, SUNY Press, forthcoming.

Focus Series and Catalogue Sections Authors

SC: Susan Cooksey
CSF: Carlee S. Forbes
GH: Geoffroy Heimlich
RJ: Rémy Jadinon
AJ: Alissa Jordan
RP: Robin Poynor
HV: Hein Vanhee
JV: Jelmer Vos

Index

Page numbers in *italics* refer to images.

Aa, Pieter van der: engravings, 298, *298*, *299*
"across the river/water" trope, 12–13
ACS (American Colonization Society), 292.
 See also Monrovia
aesthetics, Kongo: aliveness and power in,
 176–78, *177*, *194*, 195; in ceramics of African
 Americans, 272, *272*, *273*; European criteria
 for, 173–74; ignored by collectors, 172–73;
 ornamentality of, 174–75; theory and art
 theory in, 178–79. *See also* Kongo art and
 cultures
Afonso I (Mvemba a Nzinga, Kongo king):
 Christian conversion, 1, 19–20, 29; coat of
 arms, 37; festival associated with, 21; suc-
 cession feuds after death, 134; Vatican rela-
 tions of, 52; victory over pagan brother, 133
Africa: Atlantic coast factories, 78, 79, 82–83;
 Atlantic history and, 5, 6, 8–9; changing
 European attitudes toward, 81; as common
 bond among freed slaves, 292; internal
 slavery in, 47, *47*–48, 82; railroads in, 79;
 spirit practices of creating safe spaces,
 240–44, *241*, *243*, 246, *247*; traces of, in
 ordinary landscapes, 300–307, *301*. *See also*
 African art; African Diaspora; African
 slaves; Central Africa; West Central Af-
 rica; *and specific kingdoms and countries*
African American art and cultures: African
 art and modernists in, 356–57; African
 spirit practices and, 240–44, *241*, *243*, 246,
 247; approaches to, 3, 4, 7–9; creativity
 and tradition in formation of, 264–71,
 280–82; as creolized African cultures,
 238; folkways as source of identity, 265;
 Great Migration and, 377–78; Kongo art
 influences on contemporary, 364, *365*,
 366; landscapes of, 300–307, *301*; living/
 dead relationship in, 268–71; religious

pendants, 238, *239*, *248*, *249*. *See also*
 archaeology; canes; ceramics and pottery;
 coiled baskets; folkways and folk arts;
 healers; musical styles and traditions; yard
 shows
African art: African American modernists
 and, 356–57; as "art," 173–74; commodifi-
 cation and collectors of, 355–56; conscious
 retrieval and vernacular renditions of,
 364, 371–74, 376; contemporary develop-
 ments in, 359, 361–62; meaning and
 function emphasized, 172–73; revision
 of, 178–79; sacrificial residue in, 374. *See
 also* Kongo art and cultures; *and specific
 peoples*
African Arts (magazine), 173
African Diaspora: approaches to studying,
 3–9; conscious retrieval and vernacular
 renditions of culture in, 364, 371–74, 376;
 creativity and tradition in cultural forma-
 tion of, 264–71, 280–82; demographic
 studies and databases on, 8, 229; legacies
 of perseverance and power in, 237; martial
 arts training in, 266–68; material manifes-
 tation of core Kongo symbols in, 230–32;
 symbolic configurations of materials
 and spaces in, 232–37. *See also* African
 American art and cultures; African slaves;
 transatlantic slave trade
Africanisms, 7–8, 252–57, 260–61
Africanisms in American Culture (essay col-
 lection), 7, 8
African Negro Art (exhibition), 356, 357
African Origins (online database), 8
African slaves: brutal treatment of, 2; charter
 generation of, 8–9, 40–41; coiled baskets
 of, 274; communities of runaway, 43; cre-
 ativity and tradition in cultural formation
 of, 264–71, 280–82; as Edgefield potteries
 laborers, 233–34, *234*; entertainments

of, 266–67; experiences inscribed and
 commemorated, 90, 92–93, 95–96, *98–99*,
 99, 102, *102*, *103*; gathering spot in New
 Orleans, 286 (*see also* Congo Square);
 houses of, 43; internal slave trade and
 migrations of (US), 307n1; Kongo food-
 stuffs in gardens of, 260–61; life stories of,
 47–48; number and origins, 3, 4, 40–49,
 41, 243–44, 286, 292; rebellions and con-
 spiracies of, 265, 266–67; ship conditions,
 50, 51, *51*; stereoscopic slides of, 306–7;
 Underground Railroad of, 377–78. *See
 also* African American art and cultures;
 transatlantic slave trade
Afrikaansche Handels Vereeniging (firm),
 106, 107
Afro-Louisiana History and Genealogy (online
 database), 8
agricultural crops: Columbian Exchange of,
 258, 263n2, 274; in Kongo, 78–82; slaves
 used in U.S. production, 41, 42, *42*, 43, 44.
 See also palm oil production; peanuts; rice
 production; rubber production
AHV (distiller), 107, *107*
Aiken-Rhett House (SC): knobbed basket,
 324, *325*
Albanez (ship), 50, *51*
altars: *amula* to Zarabanda, 237; *diyowa*
 type, 135–36, *136*, 139, 157, *157*, 238; Yombe
 funerary altars, 184–85. *See also* Lemba
 therapeutic cult
Alvaro I (Kongo king), 52–53
Alvaro II (Kongo king), 53–54, 57
Amalteo, Geronimo, 187n1
Ambriz (slaving port), 45
American Colonization Society (ACS), 292.
 See also Monrovia
American Ethnological Society, 294
American Museum of Natural History (NY),
 276, 357

with, 234–35; concept, 231; contemporary artists' references to, 359, 361; "curer's cabin" site and, 236–37; scepter with space for, 120, *120*

bisimbi (nature spirits), 133, 134

Bittremieux, Leo: colonial account of, 5; *diyowa* collected by, 136, *136*, 157, *157*; mask collected by, 181, *181*; on *minkisi*, 198

Black Atlantic, 364, 366. *See also* Middle Passage; transatlantic slave trade

Blaeu, Joan, Regna Congo et Angola, *xx*

Blake, Linda F., basket of, 334, *335*

Bobangi language, 253–54

body decoration: painting in initiations, 135, 157, 158; raised cosmetic scars, 174–75, *175*; red cosmetic (*tukula*), 158

Bolton, H. Carrington, 269

Boma: as slaving port, 46–47; terra-cotta grave cylinders (*maboondo*) of, 206, *206*, *207*

Boston Society of Natural History, 294

bottles: on grave site of African American, 308, *308*; jenever, 107, *107*, 158, *158*; as *nkisi*, 202, *203*; raffia funerary mat depicting, 210, *211*; for Vodou spirit, *320*, 321; wooden grave figures depicting, *208*, 209, *209*

Brathwaite, Kamau, 270–71

Brazil: Africanisms in, 252, 254; Amerindian terms in, 255; capoeira practice in, 267; Kongo-marked pottery found in, 233; Kongo prisoners returned from, 54; *mandubi* (Tupi for peanuts) in, 261; peanuts grown in, 259; slave rebellion in, 265; slave ships of, *50*, 51

Brice, James, 11

Brice House (Annapolis, MD), 242–44, *243*, 246, *247*

Bridges, Nichole N.: chapter, 90–97; referenced, 10, 102, 268

British slave ships: African captives of, 9, 40–41, 51; slave trade and ports of, 44–48

Broadhead, Susan Herlin, 4

bronze helmet, 110, *110*, 189

Brown, Kellim: chapter, 310–16; referenced, 11, 269

Brown, Kenneth, 236, *236*–37, 238

"The Brown Jug" (Fawkes), 187n1

Brummer, Joseph, 355–56

Bry, Johan Israel De, 62

Bry, Johann Theodor de: engraving, *xix*

burial ceremonies: musical instruments used in, 163, *164*. *See also* grave goods and sites; rituals

Burridge, Kenelm, 141

Burton, Richard, 83

Bwabu peoples (Burkina Faso), 179

Cable, George Washington, 267–68, 286

Cabrera, Lydia, 390

calabashes: decorated, 224, *224*, *225*; Duval-Carrié's depiction of, 386–87, *387*

Cameron, Verney L., 295

Camillus of Lellis (saint), 248

canes, African American: Arthru Pete Dilbert's, 344, *345*; bowler hat motif, 340, *341*; conjurer's, 268, 318, *318*, 338; Emancipation, 90, 92–93, *92*–*94*, 95–96; function and power of, 338; Lenard Megarr's, 342, *343*; serpents on, 338, 339, 340, *341*, 342, *343*. *See also* staffs

Cão, Diego, 298

Caporale, Francesco: ambassador's bust by, 53, *57*

Capuchin missionaries: didactic documents of, *30*, 32, *32*–*33*; hospice of, 24

cardinal directions or points: of Brice House cosmogram and cache, 243, 246; "curer's cabin" site and, 236, *236*–37; of figure on staff, 116, *117*; of Kongo cross or cosmogram, 66, 231, 238. *See also* crosses and cruciforms

Cardoso, Matteus, 21

Caribbean region: captives arriving via West Indies, 48n1; Kongo art influences on contemporary art of, 362–63; Kongo resonances for Haitian Americans, *320*, 321, *321*. *See also specific countries*

Carli, Denis de, 206

Carnegie Museum (Pittsburgh), 364, 374

cassava, 259, 260, 274

Castro, Miguel de: as Kongo ambassador, 55, 56, 57; servants and gifts of, 57, *57*, 128

Catholicism: Capuchin missionaries of, 24, *30*, 32, *32*–*33*; enslaved Kongolese and, 43; Kongo leaders converted, 1, 19–20, 28, 29, 66; policy on young slaves, 82; revivals and adaptations of, 139–40, 240; rosary, 238, *239*, 248, *249*; saints of, 74, *74*, 75, 83–84; slaves' adherence to, 267. *See also* crucifixes; Kongo Catholic churches; missionaries; *and specific saints*

Cavazzi, Giovanni Antonio, 35–36, 128, 143

caves, decorated: dating of, 34, *35*, 37; Mbanza Mbota cave, 39; Nkamba cave, 36, *36*–37, 38; Ntadi Ntadi cave, *38*, 39; red and black paintings, 36; Tovo cave, 34–36, *35*, 38

cement: *diyowa* of, 135–36, 157, *157*; figures of, 7, *7*, 191

Central Africa: fighting styles of, 266–68; number and origins of Africans taken from, 3, 4, 40–49, *41*, 243–44, 286, 292. *See also* West Central Africa

Central Africans and Cultural Transformations in the American Diaspora (Heywood), 8

Century Magazine, 269

ceramics and pottery: new European techniques (e.g., faïence) in, 186, *187*; stoneware pitchers, 106, *107*; terms for, 182. *See also* pitchers; teapots; terra cotta; Toby jugs

—AFRICAN AMERICAN: artist specialized in figural, 222, *223*, 223; *dikenga* in decorations and figural, 232–34, *234*, 238; Kongo ideas and aesthetics in, 272, *272*, *273*; memory jars and portraits, *272*, 273, 350, *350*, *351*; for Palo Monte Mayombe religion, 322, *322*, *323*; tradition and creativity in, 268–69. *See also* colonoware; face vessels

—KONGO: fancy ware for ancestors, 108, *108*, *109*; as grave decorations, 188, *189*, *190*, *191*; tradition and innovation in, 215; wooden grave figures depicting, *208*, 209, *209*

Charles Carroll House (Annapolis, MD), 246, *247*

charter generation, 8–9, 40–41

chef médaillé (colonial-appointed chief): Kongo-made Toby jug depicting, 185; wooden grave figure depicting, *208*, 209

Chesapeake region: African captives delivered to, 41, *41*, 43–44, 240, 243. *See also* Annapolis (MD) archaeological findings

chiefs (*mfumu*): authority symbols of, 124, *124*, *125*; *bandunga* used by, 160, *160*, *161*; coffin of, 188, *189*; decline of power, 81, 138; European emblems and local symbols blended, 28–31; helmets in burial of, 110, *110*, 189, *189*; ivory's importance for, 118; legitimation of, 114, 134; as leopard, 210; as mediating power between life and death, 114, *116*, *117*; *nintadi* as depicting traits of, 205; power, knowledge, and control embodied in, 133; seated grave figure depicting, *180*, 181; trade routes and wealth controlled by, 80–81. See also *chef médaillé*; kings; *minkisi*; regalia

Chiloango River: *minkisi* and workshop associated with, 194, *195*; Nzobe region, 88; trade interests along, 78, 79, *80*, 81

chimpanzee: etymology of, 256

Chinoiseries, 355

Chola Wengue (spirit, or *mpungu*), 321, *322*

Christianity: ancestor memorialization blended with, 300–301, *301*; Capuchin-Kongo interactions, *30*, 32, *32*–*33*; conversion of Kongo memorialized, 28–31; conversions to, 1, 2, 18–20, 28, 29, 66; diverse congregations and churches, 138–39; divination, healing,

Christianity—*continued*
and dispute settlement taken over by "prophet" churches, 173; investigative divination in, *139*, 140, *140*; Kongo religion's merger with, 133–34, 139–40, 240; Kongo resistance to, 35–36; limits in conversions, 83–84; objects associated with both Kongo and, 238, *238, 239*; revivals in, 82–86, 137, 139–40, 240. *See also* Catholicism; colonialism and imperialism; crucifixes; Protestantism

Christopher (saint): medal of, 238, *239*, 248, *248*

Church of the Holy Spirit in Africa, *139*

Ciluba language, 253–54

civilizing mission. *See* colonialism and imperialism

Claessens (engineer), 209

Claridge, G. Cyril, 274

clothing: bark cloth, 137; carved ivory tusks' depiction of, 102, *102, 103*; economic status linked to, 114; European style adopted, 122; *nintadi* as depicting chief's, 205; in Pieter van der Aa's depictions of Bakongo, 298, *298, 299*; sailing ship whistle's depiction of, 104, *104–5. See also* hats and headdresses; regalia; textiles; Toby jugs

coats of arms, 29, *30*, 37

Cochran, Matthew: chapter, 240–44; referenced, 11

Coefield, Clifton B.: death, 316; jobs and travels, 316n3; yard show of, 310, *311, 312, 312, 313, 314*, 314–15, *315*

coffee production, 78

coiled baskets, African American: evolution of, 282; legacy of, *284, 285, 285*; market for, 274, 275, 277; revival of, 324; stains and dyes to decorate, 277; sweetgrass and pine needles added to, 277, 334, *335, 336, 337*; techniques in, 276, *285*
—TYPES: elephant ear, *336, 337*; fanner (winnowing), 266, 267, 276, 326, 327, *327*; footed, bowl-shaped, 276–77; in-and-out, *332, 333*; "nipple" or "knob" on, 280, 324, *325*; oval-shaped, vegetable and produce, 276, 277, *284, 285*, 328, *329*; sewing or pocketbook, 280, 334, *335*; stepped-lid, multi-tiered, 280–81, *281*, 330, *331*

coins, medals and stamps: chiefs' wearing of medals, 130, *131*; ivory sculpture attached to stamp, 98–99, *99*; Kongo-Vatican relations commemoration, 55; Maltese cross on, 130; religious, 18th cen., 76, *76, 77*; rosary with cross pendant and medals, 238, *239*, 248, *249*; St. Christopher medal, 238, *239, 248, 248*

collective memory. *See* memory and consciousness

colonialism and imperialism: bread as invention in, 262; evangelization in, 133–34; internal slavery expanded in, 82; objects collected under, 172–74; purification movements and, 139–40; raw materials exports, 78; religious revival and, 82–86; renewal movements under, 138; summary, 86–87; trade production and commerce in, 78–81, *79, 80. See also* Christianity

colonoware: crossed lines etched on, 233, *234*; Dean Hall Plantation, 250, *250, 251*; end users of, 232–33, *233*; history of, 268–69; use of term, 250

Coltrane, John, 366

Columbian Exchange, 258, 263n2, 274

commemoration. *See* ancestors; burial ceremonies; grave goods and sites; memory and consciousness

Condon, Nancy, 252

Congo. *See* Belgian Congo; Congo Free State; Kongo kingdom; maps; Moyen Congo

Congo Free State: established, 134; "indigenous policy" of, 81, 130; renewal movements in, 138

Congo River: Anglo-American quarters at Kabinda, *296*; explorations, 34, 294–95, 297; role in transatlantic slave trade, 40, 42, 43, 44–47, *46*, 48, 51

Congo Square (New Orleans): activities at, 286, 288–89, 290, 370; current view, *287*; meanings of, 267–68; recent celebrations, 290, *291*

conquistadors: free blacks among, 1–3

"Construction" (Scott), 264

contemporary art: African art in, 357, 359, 361–62; conscious retrieval and vernacular renditions in, 364, 371–74, 376; Kongo inspirations in, 359–62; "primitivism" and, 355–56; religious artists and Kongo memory in, 368, *369, 369. See also* Bailey, Radcliffe; Bandoma, Steve; Bedia, José; Duval-Carrié, Edouard; modern art; Stout, Renée

Cooksey, Susan: chapter, 355–67; introduction, 1–14; referenced, 11–12

Cooper, James "Stick Daddy," 344, *345*

copper: bracelets of, 137, 151, 153; crucifixes with, 31, 67, 68, 69; figurines of, 74; trade in, 44

Coquet, Michèle, 179

Cornet, Joseph, 6, 7, 175

Correia de Sousa, João, 54

Cosentino, Donald: chapter, 385–89; referenced, 12

cosmogram (*dikenga*): Bailey's uses of, 377–78, 380, 381, 383; Brice House (MD) evidence of, 242–44, *243*, 246, *247*; colonoware possibly marked by, 233, *234*, 250, *251*; commemorative object with, 350, *352*; diagram, 230, *231*; function in Americas, 270; interpretations, 235, *235*–37, 236; lozenge shape as, 130, *131*; mariner's compass as, 238, *239*, 248, *248*; *minkisi* in relation to, 231–32; Renée Stout's use of, 373–74; symbolic configurations in Americas, 232–37, *234*, 238, *238, 239*; symbolism of, 66, 177, 179n12, 230–31; Vodouists' *milocan vévé* and, 385. *See also* crosses and cruciforms; *diyowa*; Kongo cosmology and ideology

cotton cultivation, 43, *44*

creativity: cultural inheritance combined with, 264–71, 280–82; of healers and ritual experts, 202; in making safe spaces, 240–44, *241, 243*, 246, *247*. See also *minkisi*

creolization: of African culture, 238; of Catholicism with Kongo-Angola culture, 9; defined, 4; Kongo religion and, 133–34, 139–40, 240; processes of, 229. *See also* African American art and cultures

Croix Koma movement, 139–40

crosses and cruciforms: crossroads as symbol of, 60; on decorative trumpet (*mpungi*), 62, *63*; *diyowa* (circular cross-shaped altar) and, 135–36, *136*, 139; on housetop, 84, *85*; on ivory pendants, 130, *130, 131*; on Laveau's tomb, 238, *238*, 373, *373*; in southern U.S., 238, *238, 239*; staff finials' inclusion of, 72, *72, 73*; sword guards as, 29, *30*–31, *31*, 60, *60, 61*; as symbol of power, 28, *30*–31; as talisman, 83–84; in Vodou book, 368; wooden (lower Congo), 2. *See also* cardinal directions or points; cosmogram; crucifixes; Kongo cross

crucifixes: cast, stylized type, 68, *68, 69*; chiefs' uses of, 83–84, *84*; medals incorporating, 76, *76, 77*; unusual variations, 70, *70, 71*; wood and brass or copper alloy, 66, *66, 67*; as yard objects, 311, 314, *314. See also* crosses and cruciforms; Kongo cross

Cuba: Africanisms in, 252; *amula* to Zarabanda observed in, 237; migration from, 391, 393; slave trade of, 46–47, 51, 78. *See also* Bedia, José; Palo Monte Mayombe religion

cuisine: Columbian Exchange and, 258, 263n2, 274. *See also specific foods (e.g., peanuts)*

Haiti: African elements used by contemporary artists of, 362–63; coup in, 388–89, *389*; *lwas* as *doppelgangers* for people of, 385; migration from, 386–88; Revolution in, 48n6, 265, 271n13, 389, *389*. *See also* Duval-Carrié, Edouard; Vodou (Voudou) practices

Haitian Americans: Kongo resonances in Vodou practices of, *320*, 321, *321*

Hall, Gwendolyn Midlo, 9

Hall, Shad, 268

Hammons, David, 364

Hand, Henry, 47

Happy (ship), 45

Harris, Michael D.: chapter, 370–76; referenced, 12, 364

Harvard University, Peabody Museum, 172

hats and headdresses: bowler hat on cane, *115*, 340, *341*; chief's, 122, *122*, *123*, 221, *221*; continuity of style, 293, *293*. *See also* helmets; Toby jugs

Hatton & Cookson (merchants), 80–81

healers, African American: circle for (Congo Square), 290, *291*; conjurer's cane, 268, *318*, *318*; Renée Stout as, 364, *371*, 371–72; root doctors as, 318. *See also* Palo Monte Mayombe religion; Vodou (Voudou) practices

healers and ritual experts (*banganga*, sing. *nganga*): bells used by, 166, *167*; Christian churches as taking over function, 173; creativity, 202; death of, 176; masks, *159*, *160*, *161*, 181, *181*; power, knowledge, and control embodied in, 133; ritual outfit, 160; root doctors compared, 318; spaces transformed by, 231; staff and *nkisi*, 173; warriors inspected by, 200; whistles, 168, *168*, *169*. *See also* *minkisi*; prophets and diviners; regalia

Hearn, Lafcadio, 288

Heimlich, Geoffroy: chapter, 34–37; referenced, 10

Heintze, Beatrix, 5

helmets: as grave goods, 110, *110*, 189, *189*; in yard shows, *305*, 305–6, *306*

Henrique (bishop), 52

Henrique (Kongo king; d. 1856), 24

Herder, Jan van: itinerary mapped, *xx*

Hersak, Dunja, 361

Herskovits, Melville, 7, 8, 357

Heyn, Piet, 55

Heywood, Linda: chapters, 17–25, 52–55; referenced, 5, 8–9, 10, 141

Hilton, Anne, 4

Holland. *See* Dutch merchants; Dutch ships; Netherlands

Holloway, Joseph E., 7, 8, 252, 254–55

honorific swords. *See* swords of honor

Hoodoo religion: practices, *368*, 369; priestess of, 238, *238*, 370–71

horns. *See* trumpets

houses and housing: bedpost for *nzo Kumbi*, 158, *158*; creating safe spaces in, 240–44, *241*, *243*, 246, *247*; cross on top, 84, *85*; *nduda nkisi* as protection against witches, 200, *201*; of slaves, in South Carolina, 43. *See also* yard shows

Hughes, Langston, 268, 356

hunters and hunting: charm for, *294*; role of, 258; songs, 144; whistles, 168, *168*, *169*

Hyatt, Harry, 374

Iberian peninsula: African emissaries in, 1–2; sword forms of, 28, *29*. *See also* Portugal

indentured servitude, 41

indigo cultivation, 42, *42*

initiation lodges and movements: Khimba, for boys, 135, 156, 157, *157*; Kumbi, for girls, 135, 158, *158*; meanings of Kimpasi, 35–36, 38; scepter for, 135–36, 156, 157; as time spent in land of the dead, 178; types of, 134. *See also* Lemba therapeutic cult

International African Society, 294

iron: bells of, 147, *147*, 166, *166*; symbolism of, 29–30, 60. *See also* swords of honor

Isabel (Kongo queen), 26

Islam, 133

ivory: chiefs' scepters, 120, *120*, *121*; exports of, 78; Loango tusk sculptures, 90, 92, 93, 95–96, 98–99, *99*, 102, *102*, *103*; pendants, 130, *130*, *131*, 155, *155*; sailing ship whistle, 104, *104*–5; slaves and, 81–82; staff finials, 118, *118*, *119*; on sword of honor, 60, *61*; transportation of, 82–83; trumpets or horns, 62, *62*, *63*, 164, *164*

Jackson, Mahalia, 290, *291*

Jadinon, Rémy: chapter, 143–46; referenced, 10

Jamaica: slave rebellion in, 265

James (saint), 29, 31, 60

James Brice House (Annapolis, MD), 11, 242–44, *243*, 246, *247*

Janzen, John M.: chapter, 132–42; referenced, 6, 10, 177–78

Japonisme, 355

Jeannest, Charles: on Kongo toby "snuffbox," 182, *183*

Jenkins, Hackless: grave of, *269*

jewelry: bracelet (Lemba), 151, *153*; for Lemba adherents, 137; necklace with beads and metal, 155, *155*. *See also* pendants

J. F. Nagel (distiller), 107, *107*

João I (Kongo king earlier known as Nzinga a Nkuwu), 1, 17–19, 66

João II (king of Portugal), 18–19

Johnson, Charles S., 356

Johnson, Robert, 372, 373–74

Johnston, Harry Hamilton, 108, 275

Jones, Lois Mailou, 356, 357

Jordan, Levi. *See* Levi Jordan plantation site

Joseph (saint), 248

Joseph, J. W., 233

Judaism, 133

Kakongo peoples, 83–84, 113, *113*

Kalunga line: Bailey's reference to, 380; Bedia's references to, 390–91, *391*, *392*, *393*; *bilongo* elements and, 234–35; diagram, *231*; symbols and symbolism of, 230–31, 233, 308, *308*, *309*

Kapela, Paulo, 359, 361

Kasadi, Master of, *180*, 181, *181*

Keeler, Stuart, 384

Kemble, E. W., 290, *290*

Kentucky: Locust Grove plantation site, 235

Key West (FL): intercepted captives released at, 48, 51, *51*

Khimba initiation for boys, 135, 156, 157, *157*

Kikongo language: American English terms from, 255, 256–57, 260–61; dictionaries of, 5, 174, 260, 261; distinctions by area, 252; names for twins and other specific newborns, 283n23; studies of, 6. *See also* Kongo kingdom

Kimbangu, Simon, 134, 138

Kimbanguist Church, 134, 138, *138*, 139

Kimpasi initiation ceremonies, 35–36, 38, 134

Kimpa Vita. *See* Vita, Beatriz Kimpa

kings: Christian conversion of, 1, 19–20, 28, 29, 66; declining power of, 81; European diplomacy of, 52–55, 56, 57, *57*; European emblems and local symbols blended, 28–31; investiture with priest's support, 84–85; ivory's importance for, 118; mourning and coronation festivals for, 21; Pieter van der Aa's engravings of, 298, *298*, *299*; power, knowledge, and control embodied in, 133; power over life and death, 112, 113, *113*; rock tiers on grave, 279–80; succession crises, 134, 137; trade controlled by, 151; Vatican relations of, 52–54, *54*, 55, 57. *See also* chiefs; iron; regalia; swords of honor

Kinkimba: initiation ceremonies, 134; place of benediction in, 136

Kinlaw, Elizabeth: on elephant ear basket, 336; on importance of tradition, 285; in-and-out basket of, 332, *333*

Kinshasa. *See* Malebo Pool

Lincoln, Abraham, 93, *94*

Lingala language, 255, 256

literacy, 19, *204*, 205

Livingston, David, 294

Loango kingdom and coast: carvers of, in Paris exposition, 355; conversion attempts in, 83–84; ivory tusk sculptures of, 90, 92, 93, 95–96, *98–99*, 99, 102, *102*, *103*; role in transatlantic slave trade, 40, 42, 44–46

Locke, Alain, 356, 357

Locust Grove plantation site (KY), 235

Lopes, Duarte, 4, 52, 62

Louisiana: number and origin of African slaves delivered to, 43, 48n6, 286; voodoo doll, 318, *319*. *See also* Congo Square; New Orleans

Lovo Massif: archaeological surveys of, 34, 35; oral traditions in area, 36. *See also* rock art

Lowcountry baskets. *See* coiled baskets

Lower Congo rock art. *See* rock art

lozenge shape: in basket motifs, 128, *128*, *129*; as cosmogram on ivory pendant, 130, *131*; on pottery fragments, 215; on wood bell, 166, *166*

Luali River, 81

Luanda: Kongo attack on, 55; as slaving port, 40, 45

Luba language, 254

lubanzi (disease), 196

Lukula River, 81, 88

Lusalla of Banza Uvana (chief), 294–95

Lusane, Bennie, *301*

maboondo (grave cylinders), 206, *206*, *207*. *See also* grave goods and sites

MacGaffey, Wyatt: chapter, 172–79; referenced, 6, 10, 122, 283n15, 364

Machen, J. Bernard, xiii–xiv

Madia, Benoît, 224, *225*

Maesen, Albert, 110, *110*, 124, 145, 182

Magnolia Plantation site (LA), 238

maize, 21, 259, 274

majolica zoomorphic teapot, *186*, 187

Malebo Pool (later Kinshasa): market and products of, 82–83, 137; railroad to, 79; slave market of, 45, 82

Maniacky, Jacky: chapter, 252–57; referenced, 11, 281

Manigault, Barbara: basket making and sales of, 275, 285, *285*; stepped-lid basket of, *330*, 331

Manigault, Mary Jane: basket of, 280, *281*

Manigault, Raymond: basket stand of, *275*

Manuel, Antonio: as Kongo ambassador,

53, *53–54*, *54*, *55*, 57; papers of, 19; raffia shawl of, 122

Manyanga Plateau, *296*

Many Thousands Gone (Berlin), 8

maps: Bantu languages, *253*; Kongo kingdom, *16*; *Regna Congo et Angola* (Blaeu), *xx*; *Tabula Geogra Regni Congo* (Pigafetta), *xix*; *Tabulam hanc Regni Congo* (noted), 29; U.S. areas discussed, 226

Maquet-Tombu, Jeanne, 224

marriage: communication in, 212, 213, *213*; Lemba, *151*, *152*, *153*; *minkisi* depicted as couple, 196, *196*, *197*; preparation of girls for, 158, *158*

Martin, Phyllis, 5

Maryland: Africans and labor in colonial, 41; origins of African slaves in, 42. *See also* Annapolis (MD) archaeological findings

Maryland Gazette, 243

masks: about, 160; *ndunga*, *160*, *161*; *nganga* Diphomba, *159*, 181, *181*

Master of Kasadi, 180, 181, *181*

Matenda (chief), 80

matrilineage, 81–82, 118, 132

Maurits, Johan, 57

Mayombe: explorations of, 81; toll bars in, 80

Mayumba: slaves imported from, 48n7

Mbanza Kongo (capital; later called São Salvador): captives exported via, 45, 46; Capuchin hospice of, 24; civil war between ex-slaves in, 24; depiction of, *18*; destruction and reoccupation of, 21–22, *22*, 70; Dutch ambassadors at court in, 20, *20–21*; episcopal see in, 52; food and festivals in, 20–21; luxury goods of, 62, *62*, *63*; multiple names of people around, 283n23; Pedro VII's photographs and regalia in museum of, *26*, *27*, 27; Portuguese arrival in, 17–18; Portuguese law adopted in, 19–20; religious revival in, 82–86, 137; religious role of, 23–24; royal graves at, 23; stone building construction in, 18–19; trade role of, 82–83

Mbanza Mbota cave, 39

mbele a lulendo. *See* swords of honor

Mboma peoples: chief's "war fetish," 80; flywhisk, 124, *124*; ivory pendant, 130, *130*; necklace, 155, *155*; pitchers, 215, *215*; stone figure sculptures (*nintadi*), *204*, 205, *205*; swords of honor, 60, *61*

Mbuli trading post, *80*

Mbumba Luangu (grand cosmic rainbow python), 135–36

McWillie, Judith, 303–4

medals. *See* coins, medals and stamps

medicine packets (*paket kongo*), 320, 321, *321*, 362

medicines: copal resin (*ndingi*) as, 202. *See also* disease; healers and ritual experts; *minkisi*

Megarr, Lenard: cane of, 342, *343*

memory and consciousness: in Afro-Atlantic, 368, 369, *369*; inscribed and commemorated, 90, 92–93, 95–96, *98–99*, 99, 102, *102*, *103*; jars and portraits linked to, 272, *273*, 350, *350*, *351*

men and boys: basket making, 279, 282n10, 324; Khimba initiation for boys, 135, *156*, 157, *157*

Merolla, Girolamo, 37, 143, *144*, 164

metalwork: bronze helmet, 110, *110*, 189; ceremonial knives, 110, *111*, *112*, 113, *113*; church masters' staff finials, 72, *72*, *73*; Kongo modification of European, 130; saint figurines, 74, *74*, *75*. *See also* coins, medals and stamps; iron; jewelry; *minkisi*; silver goods; swords of honor

Meurs, Jacob Van, 62

Meynell, Francis, *50*

Michel, Françoise: account and photographs by, 88, *88*, *89*

Middle Passage: deaths during, 386; demographics of, 44; images of, *50*, 51, *51*

Miller, Joseph C., 5

minkisi (sing. *nkisi*): aliveness and power in, 176–78, *177*, 194, 195, *195*; American archaeological evidence linked to, 234–37, 240–44, *241*, 243, 246, *247*; Bailey's uses of, 380, *380*–81, *381*, 382, 398, *399*; Bandoma's use of, 406, *407*, 408, *409*; Bedia's uses of, 390, *391*, 404, *404*, *405*; commodification and collectors of, 172, 356; concept and function, 133, 136, *136*–37, 175, 176; contemporary artists' uses of, 359, 361, 362, *363*, 364; creative variety of, 175–76, 179; *dikenga* in relation to, 231–32; face vessels linked to, 268, 346; healer depicted with, *173*; to inflict and cure *lubanzi*, 196, *196*, *197*; Kikongo written documents on, 174; principles in gathering material for, 176; protection for traders, 79–80; protection for warriors, 200, *200*; Renée Stout as and her uses of, 364, *371*, 371–72, 373, *374*, 376, 396, *396*, *397*; repressed production of, 173; travelers' depictions of, as fetishes, 294, *295*; Vodou and conjure practices linked to, 318, *318*, *319*, 320, *321*, 321; wood carvings intended for, 220, *221*; yard shows linked to, 310, 312. *See also* *bilongo*

392, 393, 404, *404, 405*; graphic writing (*firmas*) in, 362, 391, 404; power figures of, 369; terms for, 393n1; vessels for, 322, *323*

Pasch, Helma, 256

Paul V (pope), *54, 55*

Peabody Museum (Harvard University), 172

peanuts: African terms for, 256–57; grinding of, *261, 262*; Kongo production of, 78; Middle Passage in relation to, 258–62; Savannah vendor of, *260*; serving of, *259*; as women's crop, 82

Pechuël-Loesche, Eduard, 113, 164

Pedro II (Kongo king), 54, 55, 76, *76*

Pedro IV, 21, 22, 137

Pedro V (Kongo king), 24, 83, 85–86

Pedro VII (Kongo king), 26, 27, *27*

pendants: ivory, 130, *130, 131, 155, 155*; jeweled cruciform, 238, *238*; jeweled rosary with cross and medals, 238, *239*, 248, *249*; Virgin Mary depicted on, *75*; wood, *153, 155*. *See also* crucifixes

Penn Center (St. Helena Island, SC), 324

Pereira, Duarte Pacheco, 64

Petwo spirits (Vodou), 362–63, *402, 403*

pfemba (reproductive medicine), 96, 136

Philpot, Toby. *See* Toby jugs

Picasso, Pablo, 302–3, 356

Pigafetta, Filippo: account of, 4; Tabula Geogra Regni Congo, *xix*

Pina, Ruy de, 62

pinder/mpinda: etymology of, 256–57, 260, 261, *262*. *See also* peanuts

pitchers: "King Charles Spaniel," 187n4; Mboma pottery, 215, *215*; stoneware, *106, 107*. *See also* Toby jugs

Piula, Trigo: Kongo allusions in work, 359; Westernisms in work, 361

—works: *Materna, 359, 360, 361*; *Ta Tele*, 361

plantation economy: African slaves as crucial for, 264; growth of, 41–44; rice crop in, 266

plantations: African foodstuffs in gardens of, 260–62; colonoware produced and used on, 232–33, *233, 250, 250, 251*; houses for slaves on, *43*; stereoscopic slides of, 306–7. *See also specific plantation sites*

pluriarcs. See *nsambi* pluriarcs

Ponce de León, Juan, xiii–xiv, xv, 1–3

Ponce de León, Juan Gonzalez, 1, 2–3

Ponta da Lenha: as slaving port, 46, *46*

Portugal: Africans captured from slave ships of, 9, 40–41; diplomatic and military aggression by, 52–53; interference in Kongo diplomacy, 54; Kongo persons in, 18–19, 52; sword forms of, 28, 29. *See also* Angola

Portuguese-Kongo contact: cane's

commemoration of, 92, *92–93*; evangelization in, 133–34; in Mbanza Kongo, 17–24; overview, 1

postcards, *135, 147, 173*

pot lids: proverbs depicted on, 93, 175, *212, 213, 213*

pottery. *See* ceramics and pottery

Pove language, 254

power and power figures: in aggressive type of *minkisi* (*nkisi nkondi* or *nkisi a mbau*), 79–80, 176–77, *177, 194, 195, 195*; diversity in Afro-Atlantic, 368, *369, 369*; preoccupations with, 132–33. *See also* chiefs; kings; *minkisi*

Poynor, Robin: chapter, 355–67; introduction, 1–14; referenced, 11–12

Praetorius, Michael: horn illustrated, 164, *164*; pluriarcs illustrated, 143, *147, 147*, 171

Price, Richard, 8

"primitivism," 355–56

prophets and diviners (*ngunza*): Christian churches as taking over, 173; Kimbangu as, 134, 138; masks of, *159, 160, 160, 161*; *nkisis* Mambuku Mongo for divination, *202, 202*; power, knowledge, and control embodied in, 133; renewal movements of, 137–40, *139, 140*; whistles of, *168, 168, 169*. *See also* healers and ritual experts; Vita, Beatriz Kimpa

protection and healing. *See* healers and ritual experts; *minkisi*; prophets and diviners

Protestantism: missionaries (*see* Laman, Karl E.); policy on young slaves, 82; revivals of, 139–40. *See also* crucifixes; missionaries

proverbs: on calabashes, *224, 224, 225*; on habit, 300; on *ngongi* (double bell), *166, 166*; on pot lids, 93, 175, *212, 213, 213*; on staffs, 114, *117, 117*

pwita: meaning of, 256

quartz crystals, 231, *246, 247*

quilt making, 280, 366

Rada spirits (Vodou), 362–63, *402, 403*

Radcliffe Bailey (C. Thompson et al.), 379. *See also* Bailey, Radcliffe

raffia textiles: chiefly hats and capes, 122, *122, 123*; embellished, 64, *65*; funerary mats, *190, 210, 210, 211*

regalia: chief photographed with, *84*; flywhisks, 124, *124, 125*; hats, capes and headdresses, 122, *122, 123, 221, 221*; helmets, 110, *110, 189, 189*; ideographic versions of *dikenga* in, *130*, 231; ivory pendants, 130, *130, 131*; ivory scepters, 120, *120, 121*; knives, 110, *111, 112, 113, 113*; Pedro VII's, 26, 27, *27*; spoon with figure, 126, *127*; trumpets

(*mpungi*), 62, *62, 63*. *See also* crucifixes; scepters; staff finials; staffs; swords of honor

Regna Congo et Angola (Blaeu's map), *xx*

Regout, Petrus, 187

religions, compared, 133. *See also* Christianity; Hoodoo religion; Kongo cosmology and ideology; Palo Monte Mayombe religion; Vodou (Voudou) practices

rice production: expansion of, 276; fanner baskets used in, *266, 267*, 276, *326, 327, 327*; slaves used in, 42, 44, 274

Richmond Hill plantation site (GA), 238

Ricquier, Birgit: chapter, 258–63; referenced, 11, 281

Rinchon, D.: Pedro VII and, 27; photographs by, *23, 26, 27, 85*

rituals: burial ceremonies, 163, 164; *dikenga* as demarcating spaces for, 231; warfare preparations, 200, *200*. *See also* altars; grave goods and sites; initiation lodges and movements; musical instruments

RMCA. *See* Royal Museum for Central Africa

rock art: dating of, 34, 35, 37; Mbanza Mbota cave, 39; Nkamba cave, 36, *36–37*, 38; Ntadi Ntadi cave, 38, 39; red and black paintings, 36; Tovo cave, 34–36, *35, 38*

Rodin, Auguste, 205

Romeo/Tahro, 346

root doctors. *See under* healers

roots: Hoodoo doll of, *368, 369*; horns made of, *164, 165*; *munkwisa*, as symbol of chief's power, 120, *120*, 126, *127*, 220, *221*. *See also minkisi*

rosary, 238, *239*, 248, *249*

Rosengarten, Dale: chapter, 274–83; referenced, 11, 266

Rousseau, Jean-Jacques, 356

Royal Geographic Society, 293, 294

Royal Museum for Central Africa (RMCA, Tervuren, Belgium): collections and mission, xvii–xviii, 276; partnership with, xiii, xv, xvii–xviii

rubber production, 78–79, 81–82, *82–83*

Saar, Betye, 364

sacredness: use of term, 178

saints: Antonian movement and St. Anthony of Padua, 74, *74, 75, 76, 76, 77*. *See also specific saints*

Sallée, Pierre, 143, *145*, 146n9

Samuel P. Harn Museum of Art: exhibition co-curators and consulting scholars, xv–xvi; university context, xiii–xiv

sangamento dances, 29–30, *30*, 37n6

Thompson, Robert Farris: on Africa-Americas relationship, 265, 371; on burial practices and yard shows, 269, 307n8, 373; "cosmogram" used by, 179n12; on dance and *nzuba*, 288; on jazz music funk, 372; Kongo art research of, 6, 7, 301

Thornton, John: chapters, 17–25, 52–55; referenced, 4, 5, 8–9, 10, 141, 267, 271n13

Times Picayune Guide, 286

tobacco cultivation, 41, 42

Toby jugs: human skulls possibly replaced by, 186; Kongo imports of, 108, *109*; Kongoization and reproductions of, *108*, 182, *183*, *184*, 184–87; "Sailor" type, 184–85, *185*; term for (*mbungwa kimanzi*), 182. *See also* face vessels

Toni Malau (figurines of St. Anthony), 74, *74*, *75*

Tovo cave, 34–36, *35*, 38

trade and commerce: agreements and negotiations for, 80–81, *194*, *195*, 195; artist-created figures for Europeans, 222, 223, *223*; caravans from interior, 79, 82–83; collapse of prices in fiber production, 139; ethnographic museums' interest in, 172; internal slave trade in, 47, *47*, 47–48, 82; of Lemba, 151; man and family involved in, 86; *minkisi* related to, 136–37; Nzobe chiefs' role in, 88, *88*, *89*; production of goods for, 78–81, 82–83; trade routes for, 80, 80–81. *See also* transatlantic slave trade

—SPECIFIC OBJECTS: carved ivory tusks, *98–99*, 99, 102, *102*, *103*; fancy ware for ancestors, 108, *108*, *109*; helmets, 110, *110*, 189, *189*; Kongo baskets (Vili peoples), 128, *128*, *129*; sailing ship whistle, 104, *104–5*; stoneware pitchers and jenever bottles, 106, *107*, *107*, 158, *158*

tradition of renewal. *See* Kongo cosmology and ideology

Trans Africa Anglo-American Expedition (1877), 294

transatlantic slave trade: abolition of, 43, 46; Bailey's reference to, 377–79, *378*; captives arriving via West Indies, 48n1; demographic studies and databases on, 8, 229; end of, 81, 86–87; experiences inscribed and commemorated, 90, 92–93, 95–96, *98–99*, 99, 102, *102*, *103*; illicit, after trade abolished, 43, 46–47, 51, 78, 90, 96n1, 234, 268, 307, 346; Kongo's inability to control, 23; number and origins of Africans taken in, 3, 4, 40–49, *41*, 243–44, 286, 292; shift to produce trade from, 78–81, *79*, *80*; ship

schematics and images, 50, 51, *51*; split tree branch symbol of, *47*, 99, *99*. *See also* African Diaspora; African slaves; ships and boats

transportation: control of trade routes, 80–81; trade caravans from interior, 79, 82–83. *See also* ships and boats

Traylor, Bill, 366

Trinidad: stick-fighting in, 267

Trocadero Museum of Ethnography (Paris), 172

trumpets (*mpungi*): encyclopedia on, 147, *147*; ivory decorative, 62, *62*, *63*; ivory horn, 164, *164*; ivory scepter compared, 120; wood and root horns, 164, *165*

Tshokwe divining trays, 279

Tuckey, James, 34

Turner, Lorenzo Dow, 252–54, *255*, 256, 282

turtle, 212, *213*

Umbundu language, 255

UNIA (United Negro Improvement Association), 380, 381

United States: map of areas discussed, *226*; slave imports in Revolutionary period, 43–44; slave ships of, 44–48, 51, *51*; slave trade abolished, 43, 46; travelers to Kongo from (19th cen.), 292, 294–97, *295*, *296*. *See also* African American art and cultures; *and specific states*

Universal Exposition (Paris, 1889), 355

University of Florida, xiii. *See also* Samuel P. Harn Museum of Art

Valle & Azevedo (firm), 106, *107*

Vanhee, Hein: chapter, 78–87; introduction, 1–14; referenced, 10

Vansina, Jan, 5, 141

Van Vechten, Carl, 356

Vass, Winifred K., 252, 254–55

Vatican-Kongo relations, 52–54, *54*, *55*, 57

vegetal fibers (e.g., banana, seed pods): box (Lemba), *150*, 153; calabashes (banana), *224*, 224, *225*; chiefly hats and capes, 122, *122*, *123*; chief's staff wrapped with, 118, *118*; collapse of market prices for, 139; Khimba initiation objects, *156*, 157, *157*; masks, 160, *161*; in pluriarc construction, 143. *See also* baskets; *minkisi*; roots; textiles

Vellut, Jean-Luc, 5

Vieira, Antonio, 52

Vili peoples: baskets, 128, *128*, *129*; carved ivory tusks, *98–99*, 99, 102, *102*, *103*; slave and commercial trade, 45

Virginia: Africans and labor in colonial, 41; crossed-line artifacts from German American farm site, 235, *235*; number and origins of Africans delivered to, 40, 42, 45; slave rebellions in, 265; yard decorating tradition in (Tidewater), 310; yard show in (Charles City County), *270*

Virgin Mary, 74, *75*, 83–84

Vita, Beatriz Kimpa, 21–22, 70, 134, 137

Viva Florida 500, xv, 1

Vives, Juan Baptista, 54

Vlach, John, 9

Vodou practices: African elements in, 362–63, 403; book with incantations, 368; Haitian-Floridian objects for, 320, 321, *321*; migration of *lwas* (spirits) of, 12, 362–63, 385–89, *386*, *387*, *388*; power figures of, 369, *369*. *See also* Duval-Carrié, Edouard

Vogel, Susan, 172, 361

Volper, Julien: chapter, 182–87; referenced, 11

Vos, Jelmer: chapters, 40–49, 78–87; referenced, 5, 10

Voudou practices: power figures of, 318, *319*

Voyages (online database), 8

Wanderer (schooner), 45, 234, 268, 349

Washington, Adelaide, 277

Weeks, John H., 5, 283n23

Weems, Carrie Mae, 364

West Central Africa: fighting styles, 266–68; grasslands, 274; Lovo Massif, 34, *35*; scholarship on, 4–5. *See also* African slaves; Central Africa; rock art

whistles: sailor's, 104, *104–5*; wood and horn, 168, *168*, *169*

Wildfire (ship), 48, 51, *51*

William (ship), 48

Williams, Eric, 264

Wing, Josef Van, 5

Winston, William: yard show of, *270*

witchcraft (*kindoki*): Beatriz Vita accused of, 22; beliefs in, 133, 139; enslavement for, 45, 47; *minkisi* and, 79–80, 120, 198, 199, 200, 201; proof of, 126, 127

Woehlke, Stefan F.: chapter, 240–44; referenced, 11

women and girls: basket making, 278, 279, 282n10, 285, 324 (*see also* coiled baskets); Christ as female on crucifix, 70, *71*; on Dilbert's cane, 344, *345*; ivory staff finials of, 118, *118*, *119*; Kumbi initiation for girls, 135, 158, *158*; reproduction powers, 82, 124, *124*; scarifications on, 175, *175*